YALE UNIVERSITY PRESS
PELICAN HISTORY OF ART

FOUNDING EDITOR: NIKOLAUS PEVSNER

PAUL WILLIAMSON

GOTHIC SCULPTURE
1140–1300

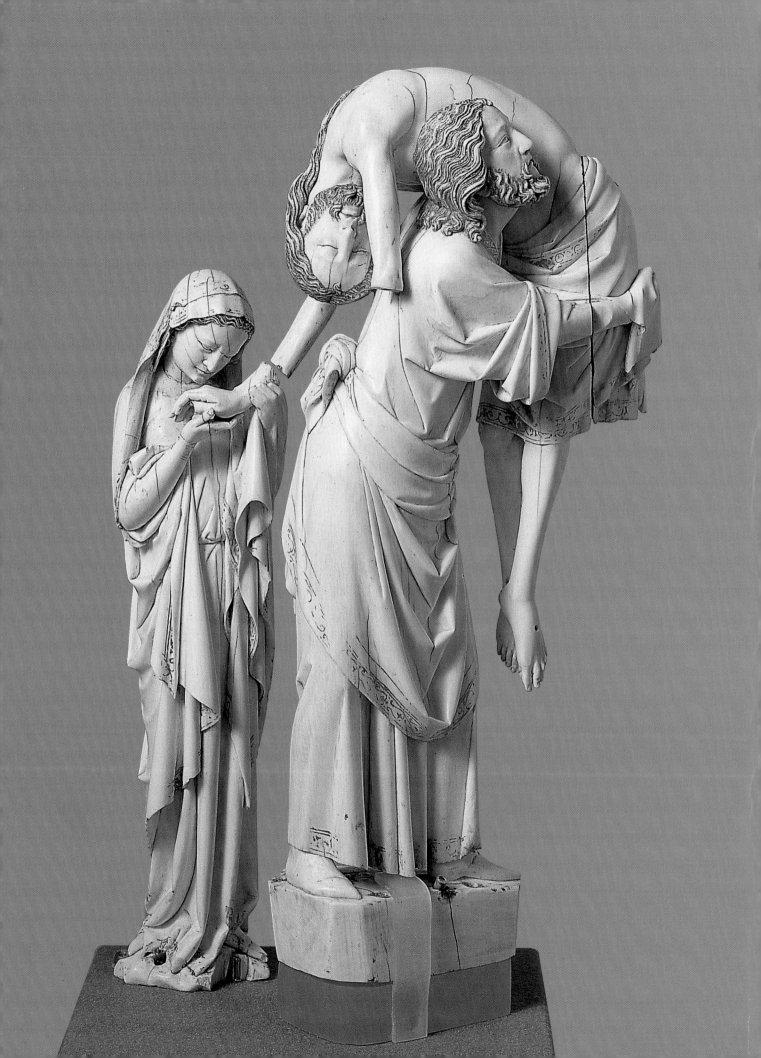

Paul Williamson

Gothic Sculpture
1140–1300

Yale University Press
New Haven and London

FOR EMMA

Designed by Sally Salvesen

Set in Linotron 202 Ehrhardt by Best-set Typesetter Ltd., Hong Kong
Printed in Hong Kong through World Print Ltd.

Library of Congress Cataloging-in-Publication Data

Williamson, Paul, 1954–
 Gothic sculpture 1140–1300 / Paul Williamson.
 p. cm.–(Yale University Press Pelican history of art)
 Includes bibliographical references and index.
 ISBN 0-300-06338-5
 1. Sculpture, Gothic. I. Title. II. Series.
 NB180.W55 1995
 734'.25–dc20

 94-49678
 CIP

Title page illustration: Deposition from the Cross; ivory group, painted and gilded, c.1250–60 (Musée du Louvre, Paris)

Contents

Preface

The period covered by this volume in the *Pelican History of Art* is often justly described as the 'Golden Age of medieval culture', when some of the most celebrated sculptures of post-classical Europe were made. In France alone, the list reads as a roll-call of famous monuments: the Gothic portals of Saint-Denis, Chartres, Notre-Dame in Paris, Amiens and Reims are only the most obvious. Elsewhere in Europe numerous buildings of considerable importance were constructed or modified, including Wells and Lincoln cathedrals and Westminster Abbey in England, the cathedrals of Bamberg, Naumburg and Freiberg in Germany, and Burgos, León and Santiago de Compostela in Spain; and the remarkable works of the Pisani and Arnolfo di Cambio revolutionised the art of sculpture in Italy. Hardly surprisingly, most of these seminal monuments have been written about at length, although often in scholarly journals which are difficult for the average reader to consult and predominantly in the language of the country in which the building is situated. With this in mind, the purpose of the present book is to provide a synthesis of a large amount of widely scattered material for the benefit not only of scholars already familiar with the majority of the sculptures but also for the interested non-specialist looking for a starting point when confronted with a daunting amount of introductory reading. For one monument alone (admittedly the most famous Gothic cathedral of all, Chartres) a recently published bibliography covered over 3500 entries in 1046 pages.

In line with the new editorial policy for the *Pelican History of Art* series I have included both English and Italian Gothic sculpture, although the former was well treated in Lawrence Stone's *Sculpture in Britain: the Middle Ages* and Italian sculpture after 1250 has been discussed in exemplary fashion in John White's *Art and Architecture in Italy 1250–1400*. To have omitted the former would have left English sculpture isolated on the edge of Europe, giving a completely false impression of its importance: self-evidently it forms part of the pan-European picture at this time and in addition much new work has been done since the second edition of Stone's volume in 1972. Likewise, it would be unfair and illogical to expect the reader of a survey of sculpture in Europe between 1140 and 1300 to have to turn elsewhere for coverage of Italian sculpture in the second half of the thirteenth century, having read about the earlier period in the first part of the book. I have attempted to treat the material in a different way from Professor White and to place the later sculptures in a wider European context, taking advantage of recent scholarship by Gardner, Gnudi, Seidel and others.

The chronological span of the book needs to be explained. The slot originally assigned to this volume in the series was 1200–1300. It became clear, however, that difficulties would have arisen had I taken as my starting point the beginning of the thirteenth century and that there would of necessity have been constant references back to sculpture from the second half of the twelfth century, especially in the case of the French material. After discussions with Professor George Zarnecki, who has been commissioned to write the volume

on *Sculpture in Europe 800–1200*, it was agreed that I should start with what are widely regarded as the first 'Gothic' portals, at Saint-Denis and Chartres, even though he would discuss certain French monuments of later date in the Romanesque style – such as Saint-Gilles-du-Gard – in his book. My coverage of German, English, Spanish and Italian sculpture, on the other hand, commences at a slightly later date in the twelfth century. The transition between Romanesque and Gothic in these countries is a complicated subject – indeed the terminology itself is not always appropriate – but, as the spreading influence of *Opus Francigenum* was the dominant artistic current in the period covered by the book, I considered it justifiable to discuss monuments which in other surveys may have been viewed as 'Late Romanesque': this is especially the case in the lands of the Holy Roman Empire. In this I am aware that my approach differs from many German scholars who by and large have not used the term 'Gothic' for German sculptures made before the middle of the thirteenth century. But to my mind it would have been inconsistent to acknowledge the highly important contribution of Mosan and Lower Rhenish metalwork to the development of French Early Gothic sculpture and yet to ignore the contemporary work in stone in those regions until about 1250. It seems to me that any general survey of European sculpture that discusses Senlis should also include the work of the Samson Master in Maria Laach. It is also fitting at the end to break off at the dawn of the fourteenth century, when the patterns of patronage were beginning to change and the sculptors' lodges of Europe were facing new and different challenges. Professor Gerhard Schmidt is in the process of writing the volume on *Painting and Sculpture in Europe 1300–1400*.

No student of French or German Early Gothic sculpture can fail to be indebted to Professor Willibald Sauerländer's sterling contributions to the subject over the last forty years. His fundamental studies include numerous articles, but his primary work, which has provided the starting point for countless students, is his book *Gothic Sculpture in France 1140–1270*, written with the help of Dr Renate Kroos, illustrated by the photographs of Max Hirmer, and translated into English in 1972. However, since Professor Sauerländer's book was written much new material has unexpectedly come to light which would necessitate changes to its structure. Most significant in this respect is the large find of sculpture from the west front of Notre-Dame in Paris in 1977, which provided exciting new evidence for the style of the St Anne portal and the heads of the Kings from the gallery above; the uncovering of a large number of figures from the destroyed cloister at Châlons-sur-Marne; and the discovery of more heads from the west portals and the cleaning of the Porte des Valois on the north transept at Saint-Denis. Alongside these discoveries, much new scholarly work has been carried out on nearly every significant monument and the dating of such key buildings as Amiens and Reims has been challenged.

The same obtains for the study of Gothic sculpture elsewhere in Europe. In England, the figures from St Mary's

Abbey, York, and the Wells west front have been cleaned in the last fifteen years and much has been learnt about their original appearance. The re-unification of Germany has made the study of the magnificent buildings of Saxony easier and the painted portal at Lausanne in Switzerland has been cleaned and fully studied, revealing how splendid most portals would have been. Exhibitions have played a part in exposing previously little-known sculptures and have stimulated further research; outstanding among these for the study of sculpture of the period were *Rhein und Maas* (Cologne and Brussels 1972) and *Die Zeit der Staufer* (Stuttgart 1977) in Germany and *English Romanesque Art 1066–1200* (London 1984) and *Age of Chivalry* (London 1987) in England.

It thus seemed that the time was right for a fresh appraisal of this vast quantity of material. One of the major difficulties, of course, was deciding what to leave out. Because of limitations of space the book cannot pretend to be comprehensive, but I believe that all the most significant developments and important monuments have been discussed and illustrated. The notes at the back of the book should lead the interested reader in need of further information to detailed studies of particular monuments.

While working on the book I was on more than one occasion put in mind of an anecdote recounted by Professor Richard Krautheimer, the author of one of the very best volumes of the Pelican History of Art (*Early Christian and Byzantine Architecture*), about the great medievalist Adolph Goldschmidt. Goldschmidt, then an old man, told Krautheimer in 1938 or 1939: 'You know, when I was young, thirty or so, I thought I knew pretty well the art of the Middle Ages. Later, at fifty, I thought – no, that's too much, but German and French sculpture of the thirteenth and fourteenth centuries, that you *do* know. Now, in my seventies, it seems to me what I know is the sculpture between 1230 and 1250 in Lower Saxony'.[1] Half way between Goldschmidt's first and second *Age*, I am aware that attempting a book of this scope may be viewed by some as a *folie d'ambition*. That I have been able to convince myself otherwise is due to the help I have received from many quarters. I should first mention my colleagues at the Victoria and Albert Museum, and thank them for their support. The grant of a year's study leave in 1993–4 enabled me to write most of the book, and for facilitating this I should like to thank Dr Charles Saumarez Smith, then Head of Research at the Museum, Gwyn Miles, Surveyor of Collections, and Elizabeth Esteve-

Coll, the Director. Without the marvellous resources of the National Art Library at the Victoria and Albert Museum I have no doubt that the book would either have been impossible to write or have taken many years longer. My colleagues in the Sculpture Collection accepted the burden of an increased workload with good grace, and I should especially like to thank Marjorie Trusted, who deputised for me while I was away, and Diane Bilbey, who cheerfully carried out tasks too numerous to remember.

I have been helped by many colleagues in this country and abroad. Neil Stratford read the typescript of the first chapter with great care, made a number of important points, and gave me photocopies of offprints in his possession. Dr Norbert Jopek and Dr Phillip Lindley likewise read the German and English chapters respectively and offered valuable comments and corrections for which I am most grateful. They are not of course to be held responsible for any errors that remain, nor for my final interpretation of the evidence. Others sent me photographs, information or articles over the years in connection with the book, and I should like to thank here Martina Bagnoli, Malcolm Baker, Françoise Baron, Dr Herbert Beck, Dr Michael Brandt, Sharon Cather, Robert Didier, Dr Angela Franco Mata, Jean-René Gaborit, Danielle Gaborit-Chopin, T.A. Heslop, Erla Hohler, Professor Dr Rainer Kahsnitz, Dr Michael Knuth, Philip Lankester, Dr Charles T. Little, Professor Serafín Moralejo, Professor Anita Fiderer Moskowitz, Dr Christopher Norton, Professor Valentino Pace, David Park, Dr Johannes Röll, Professor Dr Christian Theuerkauff, Professor Malcolm Thurlby, Dr Melinda Tóth, Dr Hiltrud Westermann-Angerhausen and Professor George Zarnecki.

I was commissioned to write the book in 1991 by Professor Peter Lasko, the series editor at that time, and I am very grateful to him for his continuing advice and support and for his rigorous reading of the final text. At Yale University Press Sally Salvesen edited and designed the volume with great skill, Sheila Lee efficiently gathered the majority of the photographs and John Nicoll offered welcome encouragement. My principal debt, however, is to my wife Emma, to whom the book is dedicated, for not only suffering from a preoccupied husband for much too long but also for sharing the driving of many hundreds of miles throughout Europe on the trail of Gothic sculpture.

Victoria and Albert Museum, London
February 1995

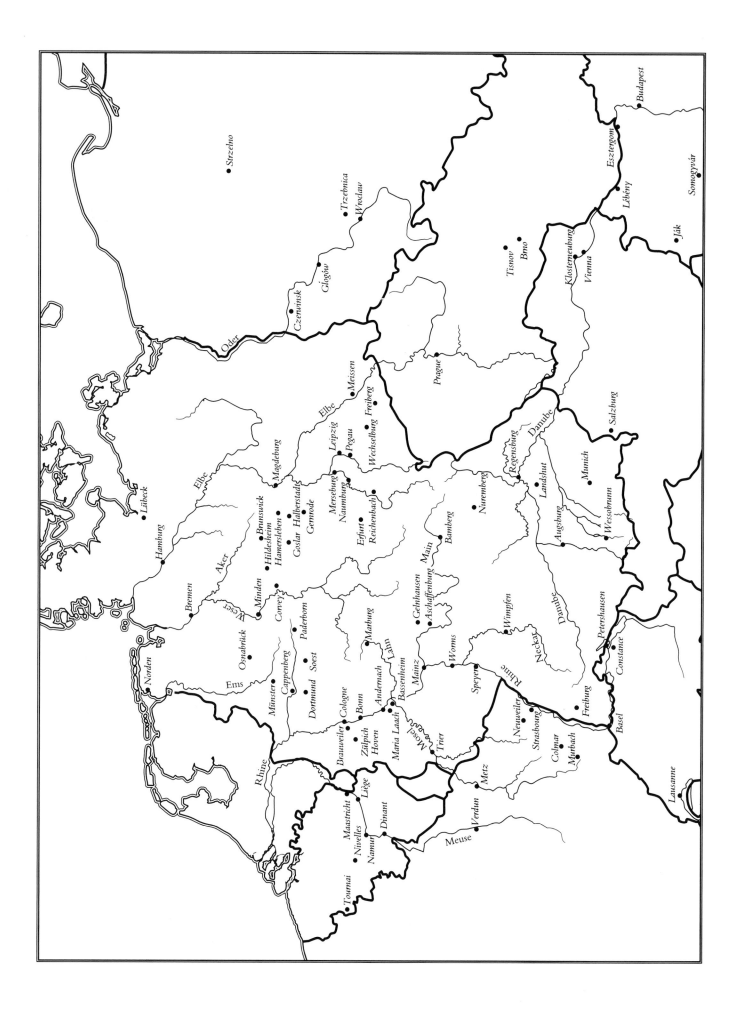

Strzelno

Lübeck

Hamburg

Norden

Bremen

Aker

Weser

Ems

Minden

Osnabrück

Münster

Cappenberg

Dortmund Soest

Brauweiler

Maastricht

Nivelles

Liège

Namur

Dinant

Tournai

Rhine

Brunswick

Hildesheim

Hamersleben

Magdeburg

Goslar Halberstadt

Gernrode

Corvey

Paderborn

Cologne

Bonn

Zülpich

Hoven

Maria Laach

Moselle

Trier

Merseburg

Naumburg

Erfurt

Reichenbach

Andernach

Bassenheim

Mainz

Lahn

Marburg

Gelnhausen

Aschaffenburg

Main

Bamberg

Worms

Speyer

Rhine

Neckar

Neuweiler

Strasbourg

Colmar

Murbach

Freiburg

Basel

Metz

Verdun

Meuse

Elbe

Leipzig

Pegau

Wechselburg Freiberg

Meissen

Prague

Nuremberg

Regensburg

Danube

Landshut

Augsburg

Munich

Wessobrunn

Salzburg

Petershausen

Constance

Lausanne

Czernnisk

Głogòw

Trzebnica

Wrocław

Oder

Tisnov

Brno

Klosternenburg

Vienna

Esztergom

Lébény

Ják

Somogyvár

Budapest

Wimpfen

Danube

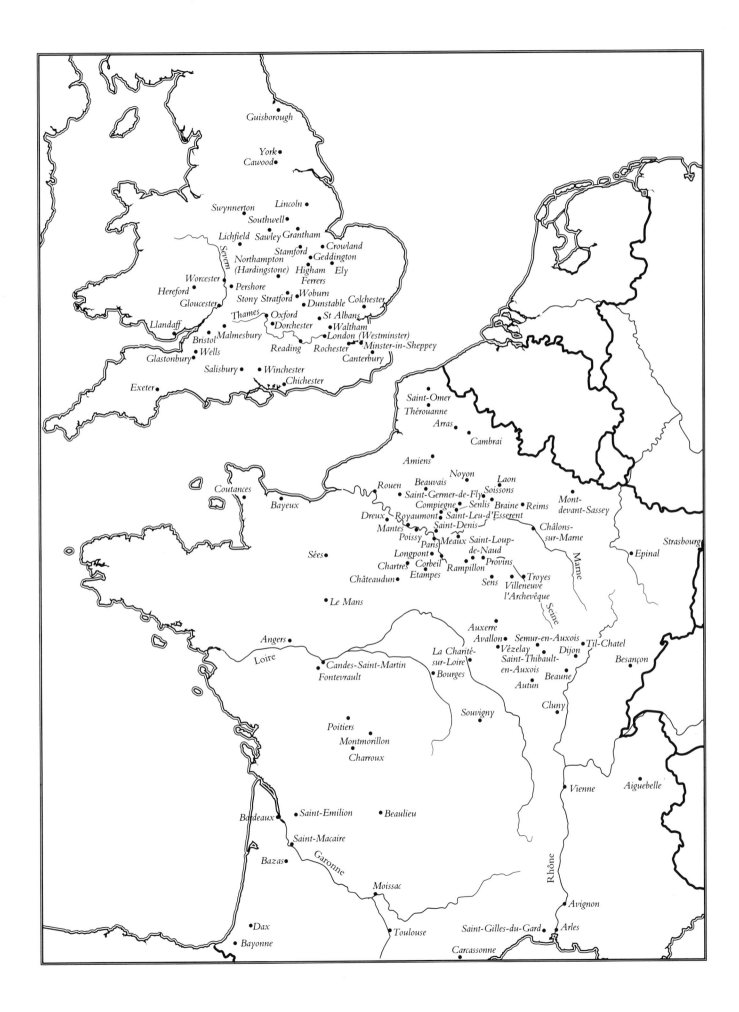

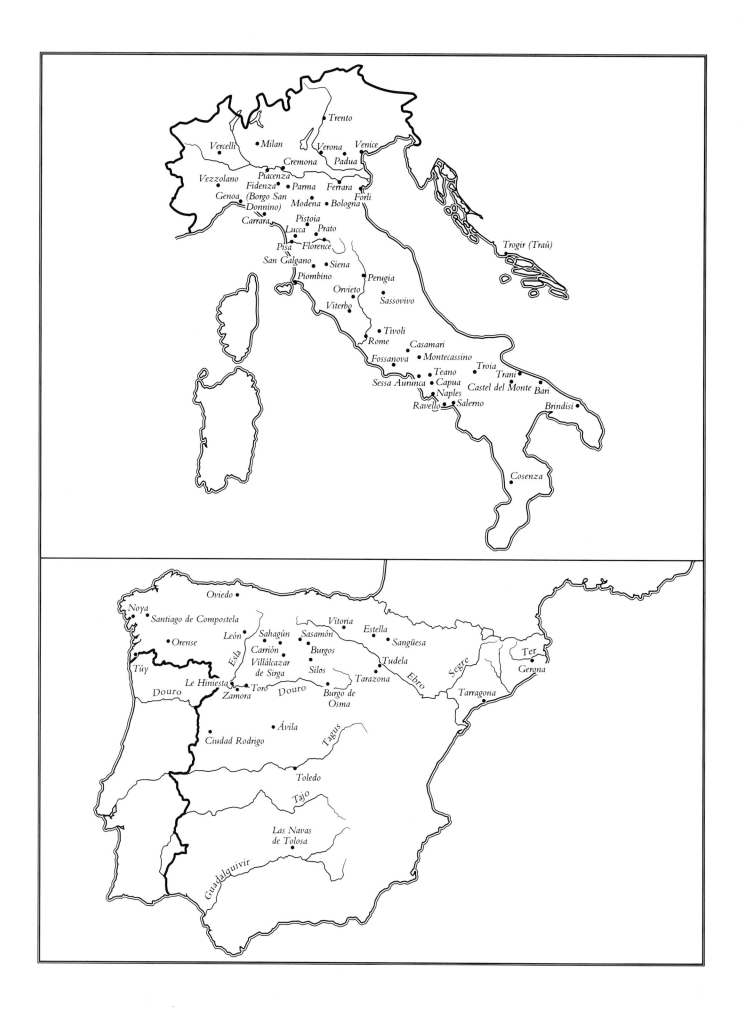

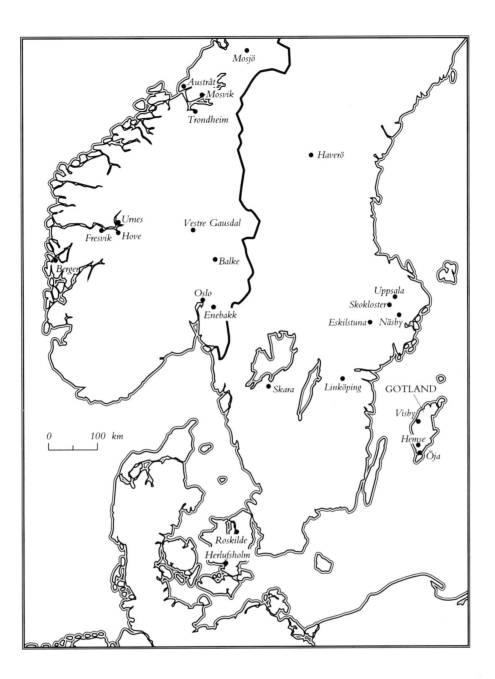

Mosjö

Austråt
Mosvik
Trondheim

Haverö

Urnes
Fresvik Hove

Vestre Gausdal

Balke

Bergen

Oslo
Enebakk

Uppsala
Skokloster
Eskilstuna Näsby

Skara

Linköping

GOTLAND

Visby

Hemse
Öja

0 100 km

Roskilde
Herlufsholm

Introduction

THE CONTEXT OF GOTHIC SCULPTURE

In the middle of the twelfth century the prestige of the great monasteries was unchallenged, the most influential religious and intellectual figures being powerful monks such as the Benedictine Abbot Suger and the Cistercian St Bernard of Clairvaux. Artistic endeavour was, as ever, dominated and controlled by its principal patrons, and at this time the monastic houses provided the greatest opportunities for employment. By 1300 all this had changed. The intervening century and a half witnessed not only events of pivotal importance for the history of European civilisation but also saw a fundamental shift in the perception of man's relation to God, propagated by great thinkers such as Albertus Magnus and St Thomas Aquinas and spread through the agency of the new universities. Towns grew in size, communications and literacy improved, and better technology – including the development of the deep plough and the introduction of the windmill – revolutionised farming methods, bringing a new prosperity which provided the wherewithal for a vast increase in building. By the late twelfth century the traditional monastic orders seemed irrelevant to the lives of the growing urban populace, and a plethora of more accessible new sects – some heretical – had sprung up. It was because of their ability to channel popular support in their own direction, away from these dangerous minorities, that the mendicant orders of the Franciscans and Dominicans were able to exert control so quickly over both the laity and the papacy.

Throughout this period the Pope struggled to retain a position of pre-eminence. His temporal power was increasingly undermined by ambitious leaders and forced alliances and conflicts, first with the Hohenstaufen then with the Angevins. The growing power of Capetian France, set in train by the advances gained by Philip Augustus (1180–1223), culminated in the ignominious 'Babylonish Captivity', when the papal court was transferred to Avignon in 1307. Various attempts were made to unite the Christian community, either by decree – such as the Fourth Lateran Council, convened by the brilliant and successful Innocent III in 1215 – or by military muscle-flexing against an outside enemy. Crusades were one of the most effective ways of doing this as they offered both spiritual profit (through indulgences) and material gain; the Fourth Crusade, which ended with the disgraceful sacking of Constantinople in 1204, was only the most notorious of these adventures. The granting of indulgences, used so effectively to finance many of the cathedrals constructed in the thirteenth century, reached a climax in 1300 with the first Roman Jubilee (the *Anno Santo*). This was the brainchild of the beleaguered Pope Boniface VIII, but rather than signalling a celebration of unity it represented nothing less than a desperate final attempt to raise money, not from wealthy individuals but from the public at large.[1]

The Jubilee was created to harness popular devotion to St Peter, the first saint of Christendom. As a phenomenon, a fixed point in time, it was no more than the essence of a well-established ecclesiastical practice. The standing of every cathedral was dependent on the status of its relics or patron saint, and it was in the interest of any bishop to forge strong links between his church, the civic authorities and the populace. Very few churches had the aristocratic financial support that Cologne Cathedral, for instance, could muster, and instead there was the expectation that contributions would come from a broad spectrum of society. It should never be forgotten how central the cathedral was to the life of the medieval citizen, although it is as well to recognise that most contemporary accounts of the relations between town and chapter were compiled by ecclesiastical chroniclers and are necessarily one-sided. The most well-known illustration of the common devotion of the populace is the celebrated episode of the hauling of *plaustra* (carts filled with building material) by people from all walks of life to help with the construction of Chartres Cathedral in around 1145, an event that was copied elsewhere and again at Chartres itself after the fire of 1194. It has been pointed out that this dedication on the part of the people may not always have been disinterested, as the spending by pilgrims at the time of the Chartres Fair accounted for a large proportion of the town's annual income. Nevertheless, it was important to approach the collecting of building funds with sensitivity, especially in straitened times: the mass rebellion against the chapter of Reims Cathedral in 1233 was a reminder that Christian charity had its limits.[2]

The cathedral also dominated the thirteenth-century town by dint of its sheer size. In a society unused to large buildings the visual effect of a church of Lincoln Cathedral's dimensions can only be imagined. The silhouettes of these structures would have been visible for miles around, dwarfing the shops and domestic buildings in their shadow and acting as magnets for visitors. When the faithful approached the cathedrals more closely they would have noticed, as we do today, that the architecture was articulated by sculpture; and stepping through the main portal, perhaps sculpted with the Last Judgement or the Coronation of the Virgin, they would have been confronted by the figured choirscreen with a painted triumphal cross above. At every turn, in every chapel, they would have seen images of the Virgin and Child and numerous saints, and their progress through the church would have been punctuated by architectural sculpture both ornamental and figurative. How did all this strike the medieval spectator and how was the sculpture understood?

It has long been recognised that one of the most important results of the so-called 'Twelfth-century Renaissance' was to change the common man's attitude to God. The medieval humanism of St Anselm, Master Eckhart and others encouraged philosophers to re-discover the individual and to

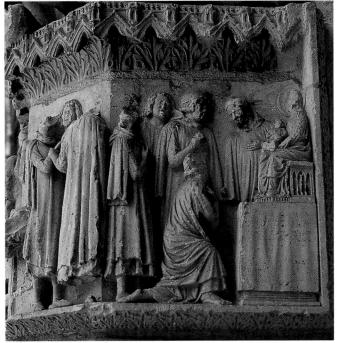

1. Trumeau socle; Judgement portal, north transept, Reims Cathedral; *c.*1230

analyse the relationship between the soul and God. Through the joint channels of the new universities and preaching to the masses, new light pierced the darkness of a blind faith invariably centred on a frightening eschatology. The translation of classical texts – especially Aristotle – in the century between 1150 and 1250 provided a corpus of rational treatises which trickled down into public consciousness, and this independence of thought, of unbiased enquiry, began to permeate the arts. The spirit of scientific curiosity which stimulated the production of herbal manuscripts, for example, allowed the sculptors of Paris, Bourges and Reims, and later at Southwell, to experiment with the carving of naturalistic leaf forms; and the remarkable and epoch-making heads at Reims, grimacing and grinning with a verisimilitude unknown in the twelfth century, are no less eloquent evidence of a new fascination with physiognomy and the mental condition.[3]

Man was freeing himself from a fear bred through ignorance, and the church needed to appeal to an audience quite different from that to be found in the monasteries. No generalisation can escape the criticism of the specialist, but there is something to be said for a view that sets the typical Romanesque Last Judgement tympanum – perhaps exemplified by Conques – against the Gothic *topos* at Reims [93] as an illustration of the changes which took place. In the former Christ sits in Majesty, the Damned to his left, the Blessed to his right, in a straightforward image of the Judgement Day, offering no hope to the sinner. Although at Reims the figure of Christ is still awesomely omnipotent, the prospect of Salvation is emphasised by the presence of the interceding figures of the Virgin and St John to each side of Christ and a reduction in the size of Hell at the bottom right. This comparison could be repeated, using different examples and gaining similar results, but the point has been made.[4] As God, through Christ, was made to appear more

human and more forgiving, so the Virgin assumed an increasingly important rôle as his caring mother and as an intercessor for mankind. The cult of the Virgin grew up as a result of the Queen of Heaven's perceived position at Christ's side, and between 1150 and 1300 this public devotion was also manifested in an expansion of Marian iconography – the appearance of the Coronation of the Virgin on the tympanum being perhaps the most conspicuous development – and the creation of an unprecedented number of statues of the Virgin and Child.[5]

Starting off simply as images of the Virgin, in due course many of these cult statues came to be worshipped in their own right, despite the warnings against idolatry issued by Durandus and several other thirteenth-century commentators. Miracles were often reported in connection with statues of the Virgin, especially at sites of pilgrimage, and in this general climate it is hardly surprising that there should be stories of statues acting as intermediaries or even coming to life.[6] One of the most celebrated fables of this period, the story of Theophilus and his pact with the Devil, invariably shows the former praying before a figure of the Virgin [225] in the hope that his plea for mercy would be rewarded. Many other miracles of this type are recounted in Gautier de Coincy's *Miracles de la Sainte Vierge* and illustrated in the mid thirteenth-century *Cántigas* of Alfonso X El Sabio in the Escorial, and a comparable episode is played out on the trumeau socle of the Judgement portal on the north transept of Reims Cathedral [1]. Similar incidents were recorded in connection with figures of the Crucified Christ.[7]

If these single images offered the greatest emotional and spiritual attraction to the medieval onlooker, the sculptures of the portals were the means by which instruction and moral exegesis were passed on. The sculptures on the outside of the Gothic church provided the approaching public with its first experience of Christian doctrine made visible, while inside the building, narrative programmes in stained glass replaced the wall-paintings and historiated capitals which had fulfilled the same rôle in Romanesque structures. It will be seen that what distinguished the iconographic schemes on the earliest Gothic portals, at Saint-Denis and Chartres, from their predecessors was the amount of thought that went into their creation, and it is self-evident that their value as tools for teaching was recognised by influential theologians. Both Abbot Suger and Thierry, the Chancellor of the School of Chartres in the middle of the twelfth century, seem to have played an important part in the development of the portal as a bearer of intellectually coherent messages, and at the beginning of the following century another chancellor of Chartres, Peter of Roissy, apparently used the decoration of the right-hand portal of the north transept to rebut contemporary heresies.[8] Elsewhere, 'site-specific' iconographic programmes were also planned – most notably on the transepts of Notre-Dame in Paris in the middle of the thirteenth century – which would have had a special resonance for a particular audience.[9]

2. *Locus Appellacionis* column; west portal, León Cathedral; probably late thirteenth-century

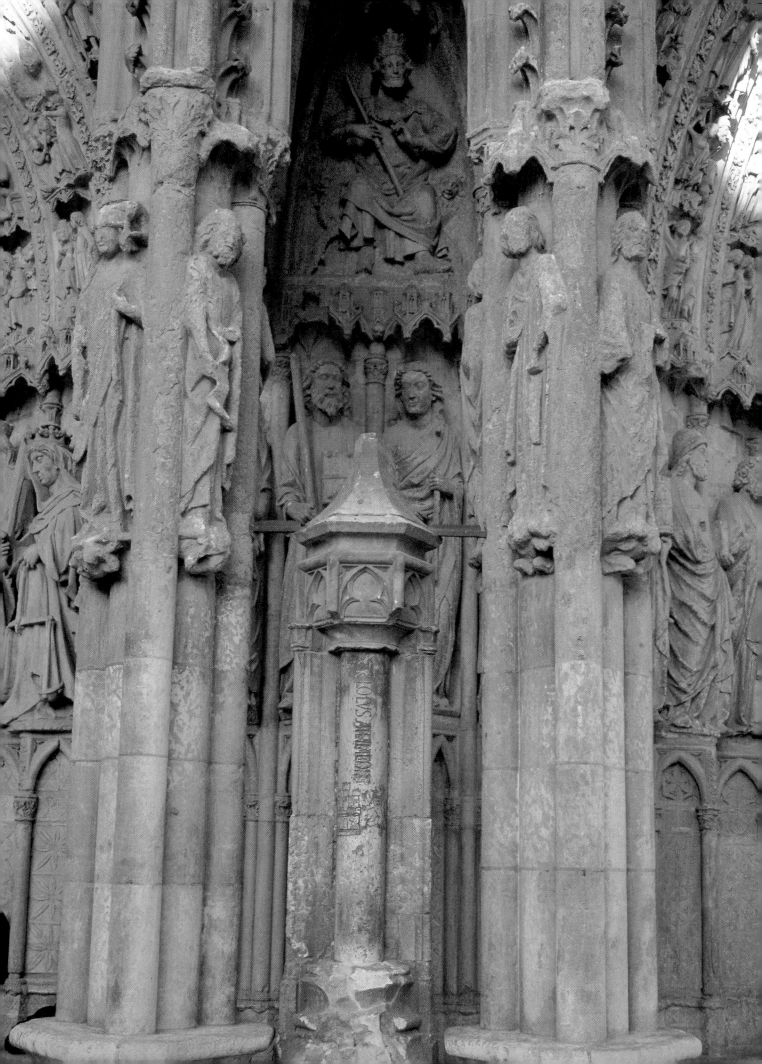

The cathedral was often at the centre of the town, usually next to the market, so was uniquely well-placed for social gatherings. The deep porches of the more ambitious churches would have provided shelter for large numbers of people and could be used in a variety of ways. The ubiquitous subject of the Last Judgement on Gothic portals, often with the supporting figures of Virtues and Vices and Wise and Foolish Virgins, would serve as an especially appropriate backdrop to the dispensation of justice, as was the case at León Cathedral. Here, from an early date, a column set on the front of a Gothic canopied tabernacle was placed between the piers to the left of the Judgement portal [2]. Its function is literally spelt out by the inscription LOCUS APPELLACIONIS carved on its front face, and the arms of León and Castile appear below.[10] Presiding over this symbol, in the niche behind, is the seated figure of King Solomon, and a later personification of Justice, holding a sword and scales, has been inserted among the jamb figures of the adjacent doorway. León was not an isolated case, and it is known that trials were also conducted in the area of the south transept of Strasbourg Cathedral, in the west porches of the Minster of Freiburg im Breisgau, Saint-Urbain at Troyes, and elsewhere.[11]

The centrality of the cathedrals and lesser churches to medieval society is also illustrated by the numbers of workmen involved in their construction and embellishment. At the peak of the great period of rebuilding, roughly speaking in the years between 1180 and 1250, no member of society living within reach of a cathedral undergoing construction would have been untouched by the work, and a good proportion would have been actively engaged on it. Peasants and other unskilled workers normally employed in the fields might have been called upon to carry wood or stone to the building-site, but once the material had arrived it was handed over to the specialist mason, usually described as a *cementarius, lathomus, maçon* or *tailleur de pierre* in contemporary documents.[12] In the absence of any qualifying descriptions referring unequivocally to carvers of figures in the period before about the middle of the thirteenth century, one cannot assume that the masons responsible for sculpting the jamb figures and reliefs on Gothic portals were specialists in that area. It may well have been the case that such people existed, but it is more likely that they formed part of a masons' lodge charged with a wide variety of stone cutting.[13] One of the most significant developments in the production of sculpture throughout Europe in the period with which this book is concerned is the emergence of the specialist *ymagier tailleur* during the thirteenth century, a profession at first limited to the making of smaller images – predominantly in wood – and not part of the building trade. By 1300 such specialists were also engaged in the making of monumental sculpture.

THE MAKING OF GOTHIC SCULPTURE

The mason-sculptor of the Early Gothic cathedral was of course subordinate in all he did to the master mason or architect, who in turn was answerable to a body of canons charged with the supervision of work.[14] Once the design of the portal, for instance, was worked out, the selection of

stone blocks was made and the sculptors set to work in the masons' yard. The freestone used for architectural sculpture was almost always the same as for the rest of the building.[15] It is probable that for large figures instructions were sent to the quarry to hew blocks of the appropriate size, but in numerous instances there is evidence that the sculptors made do with the ready-cut blocks already available. On the west portal of Rochester Cathedral of around 1170 the jamb figures were made from two separate pieces joined together below the knee [155], and the same feature is visible in the thirteenth century on at least four of the life-sized figures of the Wells west front; in Germany, the statues of *Ecclesia* [263] and *Synagoga* in the Paradise porch at Magdeburg Cathedral are also constructed in this way, and Arnolfo di Cambio had to piece together two blocks of marble before carving the seated Virgin and Child for the façade of the Florence Duomo [379].[16] Occasionally two figures from the same ensemble are carved from different stones, as was the case in the famous Annunciation group in the Westminster chapter house [305–6]: the choice of Caen limestone for one and Reigate sandstone for the other goes some way towards explaining the different condition of the two pieces.[17] It also illustrates the pragmatism of the Westminster masons, who would obviously have been aware that the sculptures were destined to be painted. In other instances different types of stone may have been selected in the recognition that some were more amenable to detailed carving than others: this would appear to be the case on the now-dismantled canopy tomb from Sawley [316], of about 1275–80, where the angels are carved from a fine limestone but the sections of roll-moulding are sandstone.[18]

The block was reduced with a variety of tools, ranging from a mason's axe – to rough out the basic shape of the figure – to different types of chisels, drills and points. No working drawings by Gothic sculptors have survived, and it is likely that most carving was done directly on to the block, which had first been marked out.[19] The marks of the larger flat chisels have often survived on the backs of the sculptures, while the herringbone patterns of the finest claw chisels sometimes remain, usually hidden under paint. Although the fine grid of ridges left by the claw chisel would often have acted as a suitable foundation for the application of a ground for pigmentation it was nonetheless the usual practice to finish the carving by rubbing the surface down with files or rasps, and it is this smooth appearance that is now most often encountered. A telling illustration of the different stages of carving a relief is provided by the recently uncovered back face of the mid-twelfth-century lintel at Saint-Germain-des-Prés in Paris. Intended as a relief of the Last Supper – finally completed on the other side – this shows the carving progressing from barely blocked-out figures on the right to a virtually finished head on the far left.[20]

Two different stages of carving can be seen in a stained glass window at Chartres, of about 1225 [3]. On the right a sculptor uses a mallet and chisel on a propped-up semi-carved crowned figure (comparable to a king on the north transept porch) while a second workman stands at rest, lifting a glass to his lips. It can be seen that the figure has reached the intermediate stage between blocking out and the

carving of fine detail, and the facial features have not been completed. On the left the same sculptor has almost completed the figure – note the detailed finish of the head – and is shown using a long flat chisel or scraper to refine the drapery folds. On finishing life-sized statues such as this the sculptor would sometimes hack out the back of the figure – as at Wells and later at Exeter – to reduce the weight and make it easier to lift into position. The sculptures were also frequently given numbers or other assembly marks to ensure correct installation.[21]

There can be no doubt that large jamb figures and much of the relief sculpture associated with portals or other ensembles were almost invariably made on the ground in the masons' yard, and not carved *in situ*. Confirmation of this is provided by occasional evidence of sculptures being cut down, presumably at the point of installation, because of inconsistencies in measurement. The lintels on the south portal of the west façade of Chartres Cathedral were shortened on the right side and the bottom voussoirs truncated for this reason, and it can be seen that many reliefs constructed of more than one block of stone were divided compositionally to take into account the fact that each slab was carved separately.[22] On the other hand it is as well to be aware of the practice of re-using portals within a later architectural context, an occurrence which happened surprisingly frequently and which often involved the adaptation of the earlier composition to its new setting. The most celebrated instance of this is the installation of the largely twelfth-century St Anne portal in the early thirteenth-century façade of Notre-Dame in Paris, but other examples are to be found at Bourges Cathedral (the north and south lateral portals), Dijon (Saint-Bénigne), Laon Cathedral (the right portal of the west front) and Ávila Cathedral (the north portal, formerly on the west façade).

After the sculptures had been installed, the scaffolding would have remained in place while they were painted. Before passing on to this vital component of Gothic sculpture, it should also be pointed out that just prior to the final stage it is likely that some more carving was done and joints were filled. Certain parts of the portal were more likely to be carved *in situ* than others, especially those architectural features which formed an integral part of the construction, such as archivolts; and although there is overwhelming evidence that the vast majority of figured voussoirs were carved in the masons' yard and constructed on site, this was not always the case. In chapter three it will be seen that the two portals of the Lady Chapel at Glastonbury Abbey were in position but unfinished in 1189; the carving of the archivolts of the south doorway – which was clearly being executed *in situ* – had barely started by this time, only two of the scenes being partially indicated on the second order [4]. It is possible that when work came to a halt the decorative programme was completed in paint in the hope that carving might be resumed at a later date. This was not to be the case on the south portal, although the figured archivolts of the north doorway were eventually carved in around 1220.[23] Another probable instance of carving *après la pose* may be found in the north porch of the collegiate church of Candes-Saint-Martin on the Loire (*c*.1240–50). Here the jamb figures were worked from rectangular blocks set into the wall (some

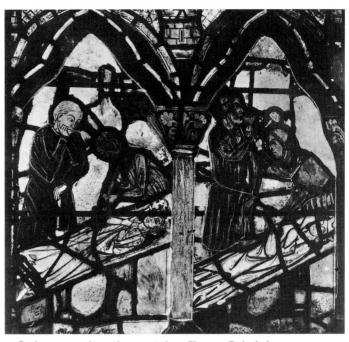

3. Sculptors at work; north apse window, Chartres Cathedral; *c*.1225

4. Detail of the south doorway, Lady Chapel, Glastonbury Abbey; *c*.1189

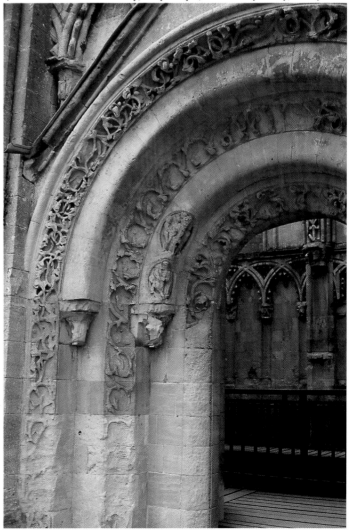

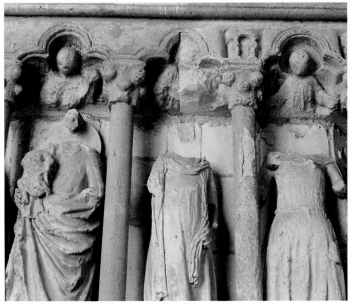

5. North portal, collegiate church of Candes-Saint-Martin; c.1240–50

of these still remain outside the porch), and the architectural sculptures – the voussoirs, the demi-angels above the heads of the jamb figures, the spandrels of the canopies which enclose them, and the bosses – were seemingly in the process of being carved *in situ* before being left in an unfinished state, perhaps because funding had ceased [5].[24]

The painting of stone sculpture would usually have been carried out by specialists rather than the sculptors who had taken the work to its penultimate stage. This is indicated by the Paris guild regulations (gathered together by the provost of Paris, Etienne Boileau, in around 1268) which list how such *ymagiers paintres* (sic) should conduct themselves. It is also apparent from the few thirteenth-century accounts of payments made to individuals for painting sculptures, such as that of April 1253 at Westminster Abbey, 'to Warin the painter for painting 2 images with colour – 11s'.[25] The sculptures were first treated with a sealant or insulation layer, usually of animal or fish glue or casein, to counteract the porosity of the stone, and to this was added a ground – often of gypsum or lead white with a drying medium – upon which the paint would be applied. In some cases, as at Lausanne Cathedral and on a number of sepulchral effigies, the ground was built up and modelled (or cast and applied) before being painted, giving the surface a detailed finish difficult to achieve in carved stone.[26] The original coloured aspect of Gothic sculpture is now difficult to reconstruct in the mind's eye and very few external sculptures retain any visible remains of pigmentation. A fortunate exception is the Lausanne south porch [88, 89], where recent conservation work has revealed the astonishingly high quality of the painted decoration.[27] However, many of the major monuments of Gothic sculpture are beginning to yield something of their original coloured appearance to conservators prepared to make painstaking inspections of their weathered surfaces, and considerable traces of paint have been discovered on the Royal Portal at Chartres, at Etampes and Bourges, the west façade and Kings' gallery at Notre-Dame in Paris, the gabled porch of Ferrara Cathedral, and elsewhere.[28]

Sculptures made for interior settings usually preserve their colouring more completely than those outdoors. Of these, it is the sculptures in wood which offer the largest sample of polychromed work. As already noted, there were guilds of *ymagiers-tailleurs* in Paris from at least the early thirteenth century, and the regulations laid out in Etienne Boileau's *Livre des Métiers* give clear instructions as to how wood (and ivory and bone) sculptures should be made and how they should be painted, so as to protect patrons from inferior workmanship. These imagers worked in small *ateliers*, with only one apprentice; the regulations go into some detail over the training of the latter (which should take at least seven years) and continue with advice on the correct procedures for carving figures and crucifixes:

> None may or should work on a holiday observed by the town, nor at night, because darkness does not allow the work of our profession, which is carving.
> None in the profession above may or should make a figure (*ymage*) or crucifix, or any other thing pertaining to the Holy Church, if he does not make it of the appropriate material, or if it has not been ordered by another, by a cleric or some man of the Church, or a knight or nobleman, for their use. And this has been established by the master of the guild because one of our number had made works which were blameworthy, and the master was held responsible.
> No workers in this profession may or should make a crucifix or figure which is not carved of a single piece. And this has been ordained by the master of the guild because one of our number had made figures and crucifixes which were neither good nor proper, because they were made of many pieces [in the margin is added: No workers in this profession may or should make a figure of more than one piece, excepting the crown, if it is not broken during carving, then one may make it good; and excepting the crucifix, which is made of three pieces, the body of one piece and the arms. And this has been established by the master of the guild because one of our number had made figures which were not well constructed, good or proper, because they were made of many pieces].[29]

Two guild masters were appointed by the King to oversee the standards established by the guild regulations, who were empowered to levy fines for any infringement. The general regulations connected with the painting of sculpture were similar to those for the *ymagiers-tailleurs*, although the painters were allowed to take on as many apprentices as they liked [6] and to work at night; consistent with the regulations for the sculptors the most detailed comments were concerned with the technical side of the work. Hence:

> No figure painters should or may sell something as gilded, where the gold is not applied to silver; and if the gold is applied to tin and is sold as gilded, without saying the work is faulty, then the gold and the tin and all the other colour should be scraped off; and whosoever has sold such a work as gilded should remake it in a good and legal manner, and pay a fine to the King according to the judgement of the provost of Paris.
> If figure painters apply silver over tin, the work is faulty, if it has not been ordered as such or declared at point of sale; and if it is sold without saying, the work should be scraped,

and made good and legal, and a fine should be paid to the King in the manner stipulated above.

No faulty works of the profession above should be burnt, out of respect for the saints, in whose memory they were made.[30]

There is no reason to doubt that other major centres in Europe also had guilds and regulations of a similar type at this date, although it is not until the following century that documentary evidence emerges. Variations obviously existed from country to country, so that in Italy, for instance, crucifix figures were frequently made from five pieces: the arms, legs and torso – including the head – being carved separately and fitted together prior to being painted.[31] Different types of wood were used throughout Europe, depending on local availability, with a preponderance of oak and walnut in the North and pine or poplar in Italy and Spain, and as a general rule the heartwood was removed from large sculptures to prevent splitting.[32] If the common complaint in connection with stone sculpture is that most of it has been stripped of its original colour, the major impediment to the appreciation of wood sculpture is overpainting. Wood sculptures, especially cult statues, were regularly repainted from the Middle Ages onwards (see pp. 113–14), so that their present colouring is often very different from that intended. Inevitably, the later layers of paint – in some cases up to twenty separate applications – distort and coarsen the subtle original relationship between the carved and the painted, but as more sculptures are conserved an increasingly clear picture is emerging of the consummate skill of the statue painters.[33]

Finally, something should be said about the size of the workshops. By the end of the thirteenth century all the evidence points to a common pattern, moving away from the great masons' yards of the cathedrals towards comparatively small workshops, some based in one place, others peripatetic. This was of course at least partly to do with the reduction in the number of large-scale sculptural programmes and a subsequent change in patronage. Around 1300 there was nothing to compare with the volume of work generated by the decoration of Reims or Wells cathedrals, and the new methods of employment, exemplified by the 'taskwork' payments pioneered in the mid century at Westminster Abbey, favoured small groups of sculptors, moving from one job to the next. The *équipe* assembled by the Parisian master mason Etienne de Bonneuil in 1287 to travel to Uppsala Cathedral in Sweden was therefore probably typical, and his arrangements for payment reflect the increasing professionalism of the workshop leaders. An excerpt from the contract bears this out:

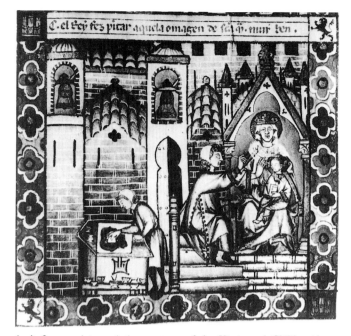

6. A figure painter painting a statue of the Virgin and Child, with an apprentice grinding pigment on a slab; folio 129r, *Las Cántigas* of Alfonso X (Biblioteca Real, Escorial, Ms. T.I.1.); second half of the thirteenth century

To all who will see this letter, Renaut le Cras, Provost of Paris, gives greeting. We make known that before us appeared Etienne de Bonneuil, to be master mason and master of the church of Uppsala in Sweden, proposing to go to said country as he had agreed upon. And he acknowledged having rightfully received and obtained advance payment of forty Paris livres from the hands of Messrs. Olivier and Charles, scholars and clerks at Paris, for the purpose of taking with him at the expense of said church four mates and four yeomen (*bachelers*), seeing that this would be to the advantage of said church for the cutting and carving of stone there. For this sum he promised to take said workmen to said land and to pay all their expenses . . .[34]

It is of interest to compare this document with the slightly earlier agreements made between the *operarius* of Siena Cathedral and Nicola Pisano in 1265–7 for the Siena pulpit (p. 248). Although referring to very different commissions, both sets of documents vest responsibility for the completion of work in one man, the leader of a small team. In their own ways they reveal the beginning of a trend towards independence, setting the agenda for the development of artists in the fourteenth century.

The Transition from Romanesque, and Early Gothic

I am the door; if any one enters by me, he will be saved (John 10: 9)

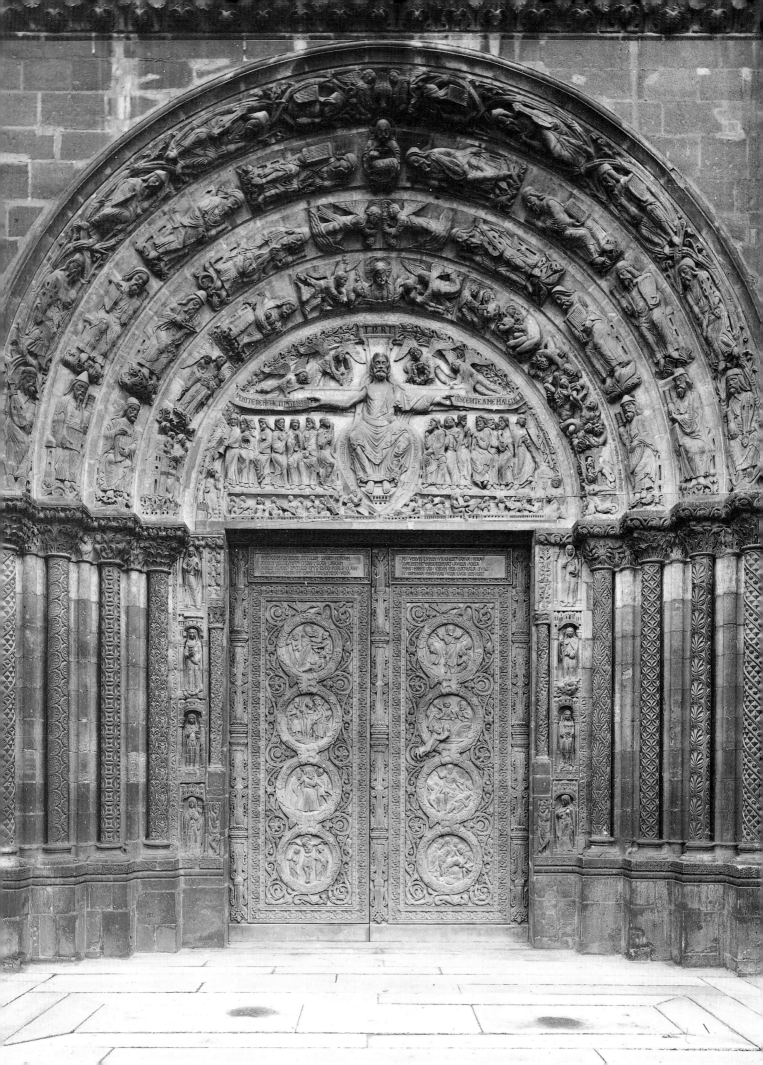

France c.1140–1230

ABBOT SUGER AND SAINT-DENIS

When Suger was ordained abbot of Saint-Denis on 12 March 1122, in his early forties, he had already spent the better part of his life in the service of the abbey. He became an oblate at the age of about ten, and after his elevation to the abbacy he dedicated the rest of his time to Saint-Denis, finishing his days there on 13 January 1151. The autobiographical accounts of his additions to the royal abbey in those years, in the *De rebus in administratione sua gestis* and *De consecratione ecclesiae sancti dionysii*, are among the best known texts of medieval art history but curiously virtually nothing is said in them about the famous sculptural decoration of the façade of the abbey church, which was almost certainly complete by the time of the dedication of the chapels in the upper storey of the west end on 9 June 1140.[1] Great copper-gilt letters on the façade, above the doors, recorded for all to see the year of consecration.[2]

Saint-Denis was by this time one of the most important monastic foundations in France, and under Suger the royal links already established by its use as the principal mausoleum of the Capetian Kings of France were further strengthened by his close friendship with both Louis VI and Louis VII. With this association, carefully cultivated by Suger, came the wealth generated by sound management of the abbey's holdings and by the proceedings of the annual fair nearby. From the first day of his abbacy, Suger set about reforming the working of the abbey and its monastic community, the reconstruction of the abbey church being a major part of this reform. He inherited a late eighth-century basilica of celebrity and soon gave himself the ambitious task of remodelling it, ostensibly to accommodate the ever-increasing congregation: this was not completed in his lifetime, but what he did finish – the west façade and the chevet, the latter consecrated in 1144 – remains of the greatest importance for the history of European art and architecture and is often taken to mark the beginning of Gothic.

The three portals of the west front of Saint-Denis are now only of limited use in assessing Suger's contribution to the history of sculpture. They were already seriously modified by at the latest 1729, again in 1771, and drastically restored in 1839–40 under the architect Debret, but thanks to the work of Crosby and Blum it is at least now possible to ascertain what is original and what is the work of the restorers. With the exception of the north portal they are little changed iconographically, and vital additional information for their original appearance is provided by eighteenth-century drawings (and Montfaucon's engravings after them), unrestored fragments now in the Louvre and the Musée national du Moyen Age (formerly the Musée

de Cluny) and six heads from the jamb figures, now in the Musée national du Moyen Age, the Walters Art Gallery in Baltimore and the Fogg Art Museum of Harvard University.[3]

The façade of Saint-Denis – a fortress-like wall with obvious architectural debts to Norman church buildings such as Saint-Etienne in Caen – is divided into three by four great buttresses [8]. The three doorways fill the spaces between the buttresses almost completely, so that their edges are flush with them. The slightly larger central portal, following the lead of earlier Romanesque portals, has the Last Judgement in the tympanum, with the enthroned Christ above the Resurrection of the Dead, flanked by the Virgin and the apostles [7]. The iconographic programme of the Last Judgement is continued into the first of the four orders of voussoirs, the outer three being filled with the twenty-four Elders of the Apocalypse; below, to either side of the doorway, are the Wise and Foolish Virgins – the parable *par excellence* associated with judgement. The south portal shows the last communion of the patron saint St Dionysius (the third-century bishop and martyr St Denis, then popularly regarded as the patron saint of France) and his companions, Rusticus and Eleutherius, the scene being continued into the first of the two voussoirs, and the doorposts below are carved with scenes from the Calendar. The tympanum of the north doorway now contains a nineteenth-century relief showing the martyrdom of St Dionysius, which in turn replaced a relief of the same subject carved in 1771; to each side of the door are the signs of the Zodiac. The north portal is the only one of the three to be mentioned by Abbot Suger in his *De Administratione*, but not because of its sculptural decoration. Suger describes how he had set up the old doors in the north portal 'beneath the mosaic which, though contrary to modern custom, we ordered to be executed there and to be affixed to the tympanum'. This most unusual feature had no precedent in northern Europe and was not repeated elsewhere in France.[4] By contrast, the formula of a façade with two towers, three sculptured portals and a round window above was to become the norm for the French Gothic cathedrals that followed.

An even more severe loss to the decoration of the façade than the mosaic tympanum is the series of twenty column figures, which originally stood three on each side of the lateral portals and four on each side of the central portal, and which were removed, some apparently before 1729, some in 1771. Only the drawings executed by Antoine Benoist for Montfaucon in the early eighteenth century – from which engravings were made in 1729 [9] – and the heads already mentioned survive to indicate their style and form. By good fortune two of these heads come from the central portal (the head of a queen in the Musée national du Moyen Age in Paris and the head of the so-called 'Childebert' in the Walters Art Gallery, Baltimore), two from the north portal (Fogg Museum and Walters Art Gallery)

7. Central portal, west façade, abbey church of Saint-Denis; c.1135–40

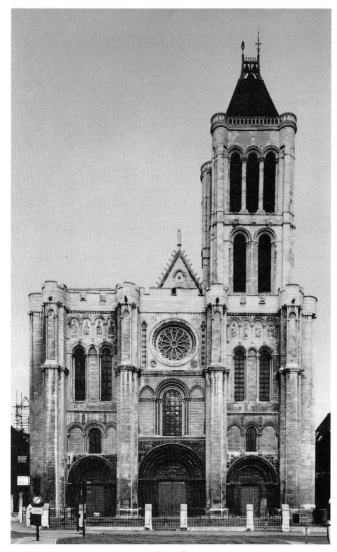

8. West façade, abbey church of Saint-Denis; c.1135–40

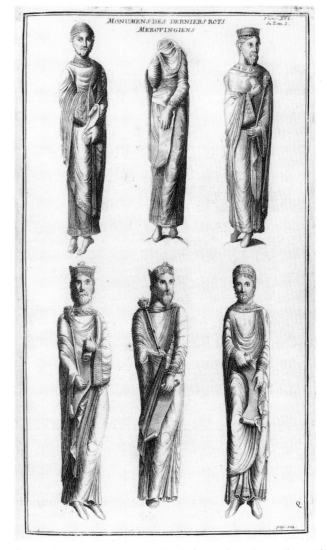

9. Eighteenth-century engravings of jamb figures from the north portal, west façade, abbey church of Saint-Denis; c.1135–40 (after B. de Montfaucon, *Les monumens de la monarchie françoise*, I, Paris, 1729, pl. 16)

and two from the south (Moses and a prophet, both in the Musée national du Moyen Age), so that it is possible to compare them and to investigate their stylistic roots. A now lost standing figure of a bishop saint recorded by Benoist and thought to represent St Dionysius seems to have been later in date than the other figures (perhaps around 1200) and is unlikely to have been placed on the trumeau, as has been proposed; this place was probably occupied by a standing figure of Christ.[5]

The whole decorative scheme, planned by Suger himself – possibly inspired by the writings of the great exegete Hugh of Saint-Victor – is at once more complete and sophisticated in its imagery than what had gone before.[6] Slightly earlier portal designs, further south, at Moissac and Autun, although sharing the Last Judgement iconography, had been limited to a single doorway, and even at Vézelay the three doorways in the narthex are not linked below the level of the tympana.[7] The twenty jamb figures disposed across the façade at Saint-Denis, representing the kings, queens and prophets of the Old Testament (rather than the ancient kings of France, as the Benedictine historians of the seventeenth and eighteenth

centuries believed), not only invoked and celebrated the royal status of Suger's abbey, stressing the relationship between *Regnum* and *Sacerdotium*, but also served to unify the three different portals.[8] This innovation, the creation of a 'royal portal', was taken up shortly after at Chartres and elsewhere in the Ile-de-France in the second half of the twelfth century. More or less contemporary experiments were being made on the use of full-length figures to the sides of doors in other places, such as on the cathedrals at Cremona, Ferrara and Verona – which Suger could well have seen on journeys in Italy if they were finished by that time – but these have the appearance of being carved out of the fabric of the building, within the blocks of the doorway itself, rather than acting as almost free-standing figures flanking the opening. Other novel features found at Saint-Denis are the dedication of a doorway to the patron saint of the church, and the introduction of a trumeau figure to the central portal, both of which would become usual in later portal designs.[9]

We have Suger's own testimony that the tympanum of the north portal was composed of mosaic, an interesting and

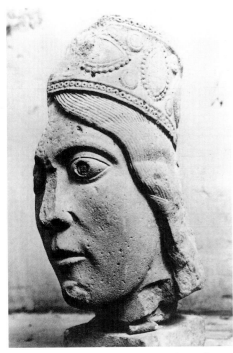 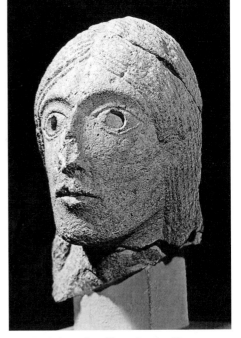

10. Head of a queen from the central portal, west façade, abbey church of Saint-Denis; c.1135–40 (Musée national du Moyen Age, Paris)

11. Eve (detail); probably from the north transept portal, Autun Cathedral; c.1130 (Musée Rolin, Autun)

12. Head from the abbey church, Cluny; c.1115 (Musée Ochier, Cluny)

notable deviation from normal practice. Why should he have ordered this to be done? Recently, it has been demonstrated that although the subject of the nineteenth-century sculpture on the tympanum – the martyrdom of St Dionysius – reflects the eighteenth-century relief which preceded it in that position, it is highly unlikely that this scene originally occupied the space. Because of the presence of Moses and Aaron on the outer voussoir, who have no connection with St Dionysius, and because the iconographic scheme of the façade as a whole points to such a solution, it is likely that the mosaic originally showed the Coronation of the Virgin. There can be no doubt that Suger received the idea of decorating this space with a mosaic from his travels in Italy, where he went four times, and in this case he was probably specifically influenced by the Abbot Desiderius's rebuilding and redecoration of Montecassino in the second half of the eleventh century. Indeed, it seems likely that he even read Leo of Ostia's chronicle of Desiderius's activities at Montecassino, because his own account of rebuilding Saint-Denis borrows some of the former's phrases and there is evidence elsewhere at Saint-Denis (in the use of newly-commissioned bronze doors and in the gilt copper inscription over the doorways) of the debt to Montecassino. Suger's reference to the setting up of the mosaic at Saint-Denis as being 'contrary to modern custom' perhaps reflects Leo of Ostia's description of the mosaics executed at Montecassino by mosaicists which Desiderius needed to bring from Constantinople, 'since *magistra Latinitas* had left uncultivated the practice of these arts for more than five hundred years'. In any case, this highly unusual application of mosaic to a tympanum indicates a gesture in the direction of Rome and the Papacy. It seems that Suger, the reformer of Saint-Denis, was seeking to imitate the greatest reformer's remodelling of the mother church of Benedictine rule, in some instances with features drawn from Montecassino, in other cases by introducing innovations of his own.[10]

Just as Desiderius summoned craftsmen from afar to rebuild Montecassino, so Suger brought in 'a skillful crowd of masons, stonecutters, sculptors and other workmen' to carry out his renovation.[11] There was no tradition of grand church building in the Ile-de-France by the mid-1130s, and the Romanesque sculpture in the Paris region before Suger's works was of modest ambition, so it appears that his sculptors must have been trained elsewhere.[12] This is confirmed by the style of the existing fragments. A connection can be established between the head of the queen from the central portal [10] and the head of Eve on a relief probably coming from the north transept portal of Autun Cathedral in Burgundy [11], which has been convincingly attributed to the sculptor of the west portal at Autun, Gislebertus, and which must be dated to around 1130.[13] Bearing the same stylistic traits is an earlier, smaller, head from the abbey church of Cluny [12], also in Burgundy, which was probably carved just before 1115 and which may represent Gislebertus's earliest work.[14] All share the method of carving the eyeballs with deeply excavated pupils (reminiscent of carvings on a much smaller scale, such as ivories), the hair is treated in the same way, with thin, worm-like corrugations delineating the tresses, and the mouths of the queen and the Cluny head are similar. As far as one can tell from the eighteenth-century drawings and engravings the draperies of the queen also have clear points of contact with Gislebertus's work at Autun and anticipate the treatment of drapery at Chartres.[15]

Different stylistic traits have been identified on the sculptures of the other portals at Saint-Denis, primarily

connecting them with Languedoc.[16] The jamb figures of the left portal, of which only the two heads in Baltimore and Boston remain, may be compared with the apostles from the chapter house of the Cathedral of Saint-Etienne at Toulouse: the date of the latter is far from certain, but it seems likely that they were executed in the years just before the Saint-Denis sculptures, in around 1130–5.[17] At Saint-Denis five of the six jamb figures from the left doorway [9] had the distinctive crossed-leg stance seen at Saint-Etienne, while the elaborately-jewelled borders to their garments are also found at Toulouse. The similarities between the jamb figures at Saint-Denis and the small figures of the apostles on the tympanum at Moissac were noted long ago, and the iconographic connection between the Last Judgement tympana of Saint-Denis and Beaulieu are plain to see.[18] What separated Saint-Denis from the Romanesque compositions of Vézelay, Autun, Moissac and Beaulieu was the clarity of the layout and the expansion of the iconographic and intellectual scheme.[19] This type of sculptural programme – which set the standard for similar schemes throughout northern France in the second half of the twelfth century – is shown to its greatest advantage in the comparatively well preserved west portal of Chartres Cathedral.

CHARTRES ROYAL PORTAL AND RELATED MONUMENTS

Although documentary sources directly concerned with the building of the west portal at Chartres do not appear to exist, the dates of its construction can be arrived at fairly accurately. Because there are references to the building of the north tower as late as 1142 and another reference to both western towers being in the course of construction in 1145, it is probably safe to assume that although the portal could not have been in place by the latter date it had by then been planned for and was possibly even being made. The fact that the lintels on the south doorway have been shortened indicates that the sculpture of the portal was executed before the space between the two towers was definitively calculated; the theory that the portals were originally intended to be incorporated into a different position further east of the towers, attractive as it is, cannot be proved. The Le Mans south portal, probably complete by 1158, has been used as a *terminus ante quem* for Chartres at least two years earlier than its dedication (i.e. 1156), and there is no reason why the work should not have been finished by about 1150.[20]

13. West portal (Royal Portal), Chartres Cathedral; *c.*1145–50

14. (*opposite*) Tympanum, central doorway, west portal, Chartres Cathedral; *c.*1145–50

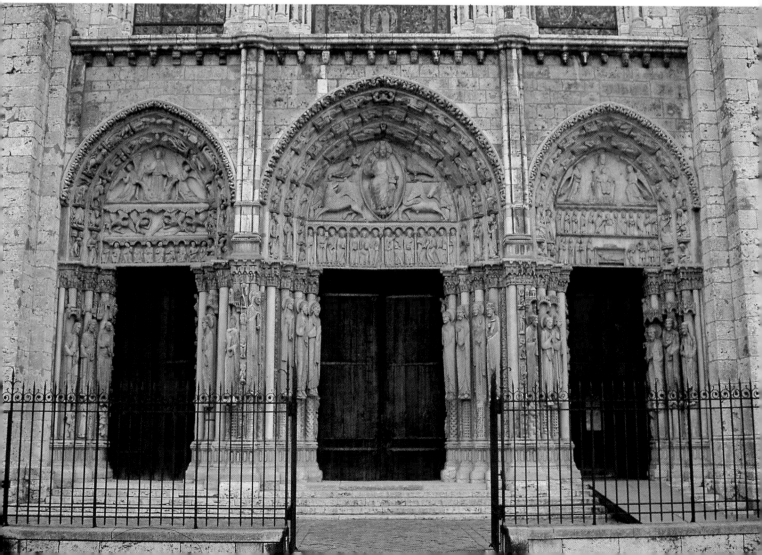

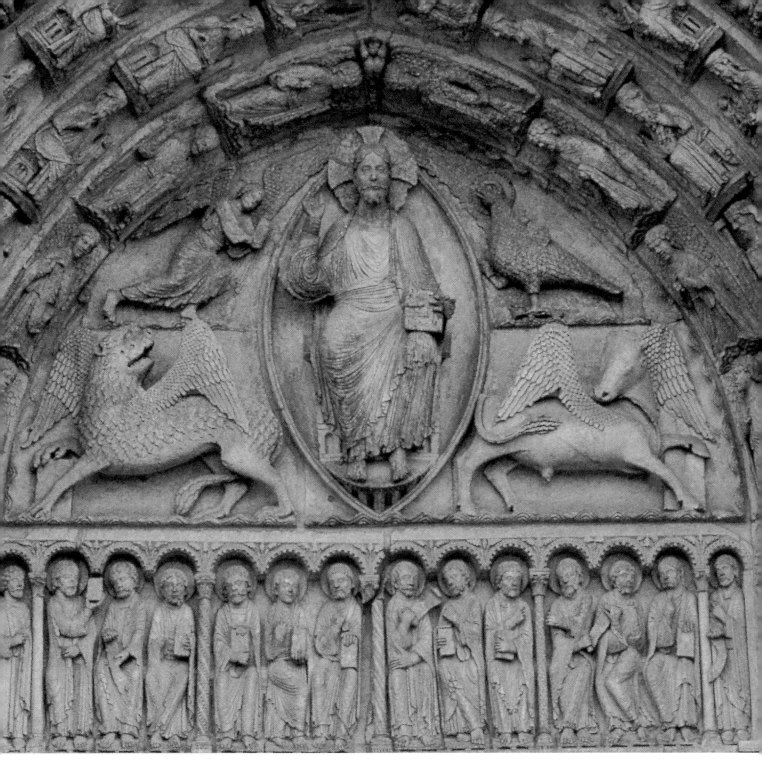

The Royal Portal consists of three openings, as at Saint-Denis; but here the doorways present an unbroken impression as they are not divided by buttresses [13]. Against this, they occupy less of the total mass of the west front – are more insignificant even – and their full effect is only realised at close quarters. Again, the central doorway is slightly larger than those flanking it, but the iconographic theme, more specifically christological than at Saint-Denis, has a unity missing from the earlier programme. It is a rigorously worked out and lucid decorative scheme which could only have been devised by one of the intellectual élite; this was precisely what was to be found at Chartres in the middle of the twelfth century, in the person of Thierry – 'the most complete teacher of the liberal arts of his day' – who was

Chancellor of the School of Chartres between 1141 and his death in 1151.[21] The whole composition is linked horizontally in three bands: the jamb figures of Old Testament personages,[22] the capital frieze, showing scenes from the life of the Virgin and the Passion of Christ,[23] and the three tympana above. The central tympanum shows Christ in Majesty surrounded by the four evangelist symbols, with the apostles and possibly the Old Testament precursors of the Ascension of Christ, Enoch and Elijah, below, in the manner of the earlier Burgundian Romanesque prototypes [14]. The image is expanded by the inclusion of angels in the first order of voussoirs and the twenty-four Elders of the Apocalypse in the second and third. The south doorway has the Virgin and Child (the *Sedes sapientiae*) flanked by two

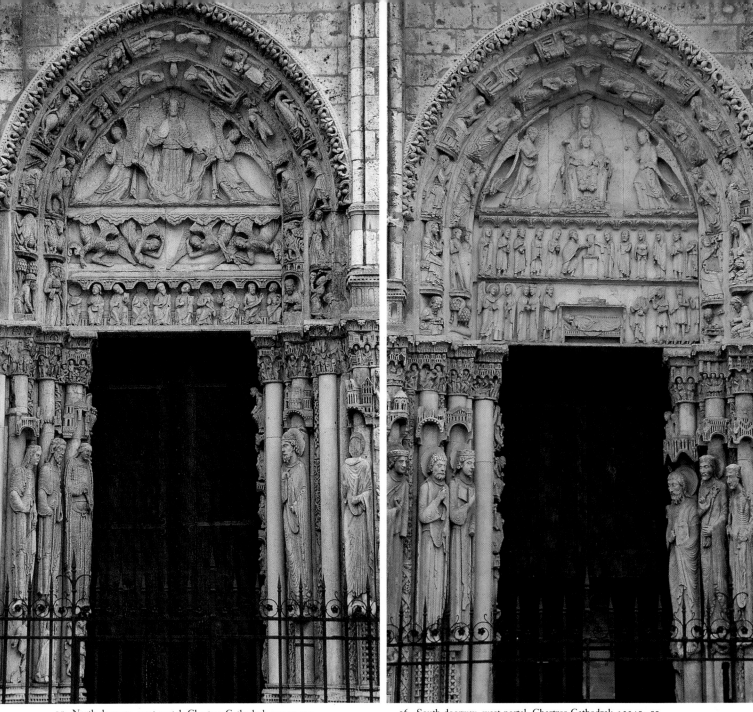

15. North doorway, west portal, Chartres Cathedral; c.1145–50

16. South doorway, west portal, Chartres Cathedral; c.1145–50

angels in the tympanum, while below two lintels illustrate the infancy of Christ from the Annunciation to the Presentation in the Temple [16]; in the two orders of voussoirs are angels and personifications of the seven Liberal Arts (female) and their exponents (male), the *Trivium* and *Quadrivium* dealt with at length in Thierry of Chartres's *Heptateuchon*.[24] The north doorway shows Christ standing in a cloud, flanked by two angels, while below a further four angels swoop down on ten seated figures, presumably the apostles [15]. This has normally been viewed as the Ascension of Christ, but recently an alternative interpretation as the Creation has been put forward, which might logically be more closely linked with the figures in the voussoirs, representing the Signs of the Zodiac and the Labours of the Months associated with them.[25] Numerous other small sculptures complete the decorative repertory of the west front, including forty-eight small figures of angels and prophets on the

doorposts and pilasters, and there is a profusion of purely ornamental carving on the columns between the jamb figures and elsewhere.

Unlike the sculptural programme at Saint-Denis, where Christ occupies only the central doorway, at Chartres the entire decorative scheme is dedicated to him. Shown in the central tympanum as the Great Judge at the Second Coming, on the south doorway he is represented as the ruler and the reason for secular learning, while on the north doorway he is the Lord of Heaven and Earth, and the controller of time. These three separate images are linked visually by Christ's identical gestures of blessing with the right hand. The Incarnation of Christ is highlighted on the south doorway, where the three representations of the Christ-Child are shown one directly above the other, and it has been demonstrated that here especially the doctrines of Thierry of Chartres are clearly manifested. Not only were the beliefs of

those who taught at the cathedral schools under threat at precisely this time, but also other heresies questioning the validity of the Eucharist had to be answered.[26] In addition to creating an elaborate portal decoration of the most up-to-date type, with jamb-figures and decorated voussoirs, the designer of the Chartres Royal Portal took the opportunity to offer a public admonishment in stone to heretical opponents.

As would be expected, the workshop which produced the sculptures of the Royal Portal was of some size. Differences of style within the ensemble have allowed the identification of certain 'masters', and while the cult of the individual has perhaps been embraced too readily by some scholars it is incontestable that several sculptors with distinctive stylistic traits linking them with other buildings were at work on the site. The major 'personality' has since the time of Vöge been known as the *Hauptmeister* or head master, and together with his assistants has been credited with the tympanum, lintel and jamb figures of the central doorway [17] and the inner jamb figures of the side doorways. These figures are elongated and extraordinarily refined; great delight is taken in rendering the finest detail of the crêpe-like draperies, especially on the two queens of the central door, whose plaits, pendulous sleeves and girdles are carved with an attention normally confined to small-scale sculpture. Their stylistic roots have been placed in Burgundy, especially at Vézelay and Autun, but although a similar treatment of draperies is seen at Autun, especially on the Christ of the tympanum there, the Chartres sculptures are far more advanced in their head types and in the proportions of the bodies. A proposal that Gislebertus of Autun should be identified with the head master certainly cannot be sustained.[27]

Three other quite distinctive styles may be recognised. To the right of the south doorway, the three jamb figures (the originals are now in the crypt) have been compared with the Montfaucon engravings of the Saint-Denis column figures and the head of the innermost figure has been paralleled with the fragmentary heads from the voussoirs of the central portal at Saint-Denis. On the north doorway, the three jamb figures on the left side are so clearly similar to those on the south portal at Notre-Dame, Etampes [18, 19], about fifty km to the east of Chartres, that they must have been carved by the same hand. The deeply-excavated circular patterns on the upper bodies and the shawl-like cloaks draped over the shoulders of the two outermost figures at Chartres are seen in exactly the same form at Etampes and the capitals and canopies at both places are extremely close. Unfortunately, because of a lack of reliable documentary evidence to help in the dating of either ensemble, it is impossible to be certain about which came first. The balance of probability is in favour of Etampes, as the single portal composition there does not take over the iconographic formula utilised on the north doorway at Chartres, nor is there any sign of the influence of the style of the head master of Chartres at Etampes. Moreover, the angels in the spandrels above the doorway at Etampes are also close to the great Christ of the Vézelay tympanum, and the distinctive style of the jamb figures is a development from the idiosyncratic manner of Romanesque sculptures at Saint-Maurice, Vienne, of around 1140–50: it may be that the Etampes sculptor came originally

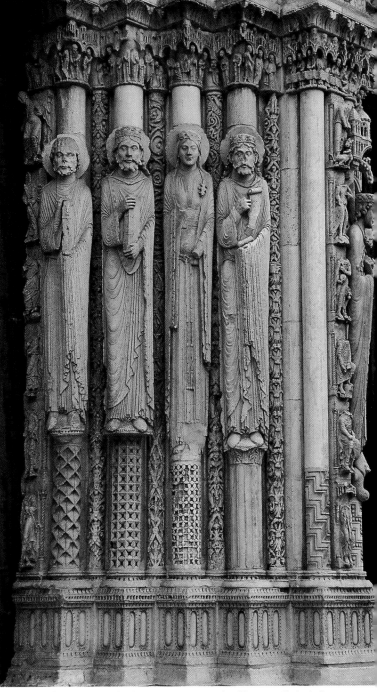

17. Jamb figures; central doorway, west portal, Chartres Cathedral, *c.*1145–50

from that area.[28] The fourth distinctive style on the Royal Portal is that of the sculptor (with an assistant or assistants) named the 'Master of the Angels' by Priest, who was probably responsible for all the voussoir figures and the lateral tympana: his training may well have been in the South-West, as there is a connection between some of the small voussoir figures and sculpture at Moissac.[29]

Both the Royal Portal at Chartres and the west doorways of Saint-Denis were large, prestigious projects, employing a number of sculptors drawn from different regions. In the more modest sculpted portals which followed them in the Ile-de-France and the neighbouring regions one is sometimes able to detect the hand of these sculptors, although it is not always possible to establish the priority of one over the other. Two tall figures of a king and a queen now in the Musée du Louvre, although restored, are the

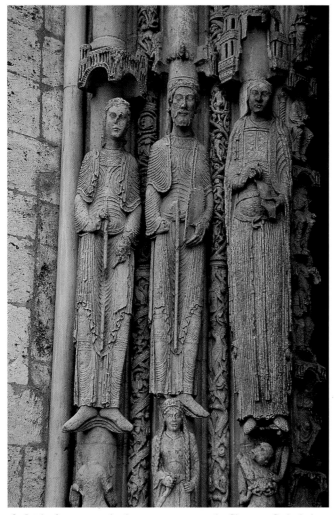

18. Jamb figures; north doorway, west portal, Chartres Cathedral; c. 1145–50

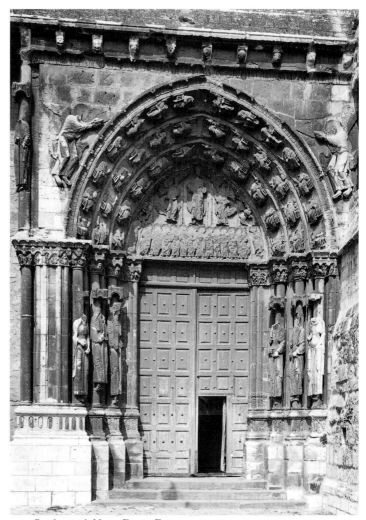

19. South portal, Notre-Dame, Etampes; c.1145

work of the head master of Chartres or one of his assistants [20, 21]. They come from the now-dismantled west portal of Notre-Dame, Corbeil, the remains of which were erected in the grounds of the château at Montgermont in the early nineteenth century: these consist of some of the voussoirs, the lateral parts of the tympanum, the fragmentary remains of a Last Judgement lintel, and the right hand side of the doorway, which includes a frieze of capitals but not the jamb figures. The portal originally had six Old Testament jamb figures, the capitals also showing Old Testament scenes, while the tympanum must have included Christ in Majesty between the Virgin and St John, flanked by angels: below, the lintel showed the Dead rising from their graves. Because of its close stylistic and compositional proximity to Chartres, the sculpture from Corbeil was in all probability executed in the early 1150s.[30] In a similar style is the sole remaining column-figure from the cloister of Saint-Denis, now in the Metropolitan Museum of Art in New York [22]: the Saint-Denis cloister was probably constructed shortly after Suger's death, at some time in the 1150s, and such convincing comparisons have been made between other sculpture from the cloister and capitals in the choir of Saint-Germain-des-Prés in Paris, dedicated in 1163, that it can hardly be

doubted that whoever sculpted the latter must have moved there from the Royal Abbey.[31]

The style of the 'Etampes master' is so distinctive that it should be possible to pick it out instantly, but curiously it does not seem to be found again in any monument in the area.[32] It is seen to best advantage in the two figures of Saints Peter and Paul now inside Notre-Dame, Etampes, which were originally column figures at the far left and right of the portal, but which were displaced when the south transept was added: they are thus unweathered, but seem to have had new heads added [23].[33] Their pristine condition allows a startling comparison to be made which might explain the apparent disappearance from France of the Etampes master. The articulation of the swirling drapery around the knee, with an uncarved circular area in the middle, the decoration of the garments with bands consisting of cross-hatching enhanced with pricked dots, and especially the calligraphically incised wavy lines above and below the bands below the knees, are all to be found on a fragment now in the Devonshire Collection at Chatsworth, which was said to have been brought from 'the mountainous country between the coasts of Tyre and Sidon and the river Jordan' [24].[34] Standing 107 cm high, the fragment would when complete

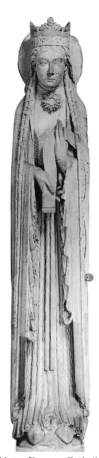
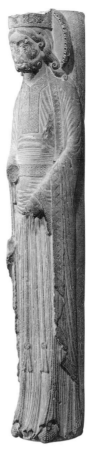
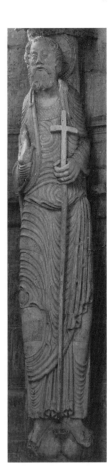

20. King from the west portal of Notre-Dame, Corbeil; c.1150–5 (Musée du Louvre, Paris)

21. Queen from the west portal of Notre-Dame, Corbeil; c.1150–5 (Musée du Louvre, Paris)

22. Column figure of a king from the cloister of the abbey church of Saint-Denis; c.1155–60 (Metropolitan Museum of Art, New York)

23. St Paul; column figure, Notre-Dame, Etampes; c.1145

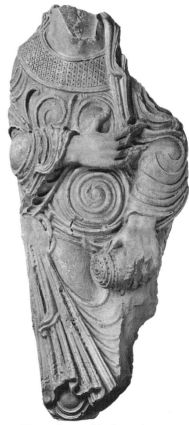

have been almost life-sized, and it is possible that it formed part of one of the jamb figures of the west portal of the Church of the Annunciation at Nazareth. This portal, clearly derived from those of Etampes and Chartres, was either never completed or fell down in an earthquake of 1170, shortly after it had been constructed: this is probably the reason why the many sculptural fragments connected with it, of extraordinarily high quality, are in such good condition. It must have been carved within a decade of the Etampes and Chartres portals.[35] The Nazareth sculpture also illustrates the link between Etampes and the workshop of Vienne, and it is possible that the Etampes master, having travelled north during the 1140s to work at Etampes and Chartres, joined up again with some of his former workshop in the Holy Land in the following decade.[36]

The arrangement of the central doorway at Chartres – with a Christ in Majesty surrounded by the symbols of the evangelists in the tympanum, radiating voussoirs with angels and other figures, a lintel with the apostles, and jamb figures – was repeated in the years following in a number of places.

24. Standing figure with scroll; possibly from the west portal of the Church of the Annunciation, Nazareth; c.1150 (Trustees of the Chatsworth Collection)

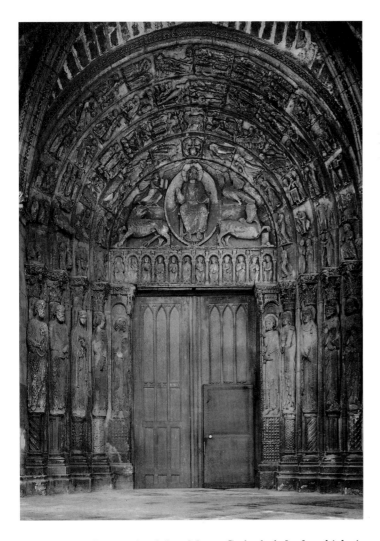

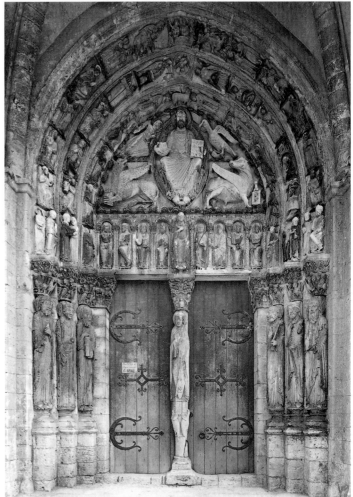

The south portal of Le Mans Cathedral [25], which is generally thought to date before the dedication in 1158, takes the main features of the Chartres central doorway, but introduces narrative scenes from Christ's life into the voussoirs (rather than capitals above the column figures). It also retains certain archaisms, especially notable being the flattened relief figures of Saints Peter and Paul to each side of the doorway, which are reminiscent of much earlier sculptures and ultimately hark back to the reliefs of standing saints in the cloister of Moissac, dating from the very beginning of the century.[37] By contrast, the Old Testament jamb figures alongside these two rather old-fashioned reliefs faithfully reflect the new Chartres type of elongated figure with crinkled draperies.[38] The west portals of the priory church of Saint-Loup-de-Naud (about forty km north of Sens) and Angers Cathedral, and the reset south nave door of Bourges Cathedral all to a greater or lesser extent carry on the Chartres Royal Portal tradition into the 1160s and – in the case of Angers and Bourges – beyond the Ile-de-France.[39] At Saint-Loup-de-Naud [26], local iconographic variations (scenes from the life of the patron saint) are introduced into the voussoirs and the trumeau holds an image of the saint, but the overall scheme remains the same.[40] Further north, at Cambrai, two of three small column figures probably from a cloister or chapter house illustrate the tenacity of the Chartres-Etampes drapery style

as late as 1170. In the third (sometimes described as the '*Cariatide*'), carved by a different sculptor, the folds of the garments are arranged in wild abstract patterns which betray his attachment to an earlier Romanesque mode of representation.[41]

To the south, at La Charité-sur-Loire and Montmorillon, similar versions of the Infancy programme seen on the lintels of the south door of the Royal Portal were carved. The great priory church at La Charité originally had five portals on its west façade: the much reduced building now retains only half its original façade, so that just the two northern doorways survive. The tympanum and lintel from the southernmost of the two have been moved inside the church, to the wall of the south transept, and happily remain in pristine condition [27]. At La Charité the Infancy of Christ ran from north to south on the lintels of the portals, with the Annunciation, Visitation, Nativity and Annunciation to the Shepherds on the north portal, and the Adoration of the Magi and the Presentation in the Temple on the more southerly door. At least two different sculptors were at work on the portals at La Charité, the crisp folds of the draperies in the Adoration and Presentation scenes being closer to the work at Chartres. It is curious that the important scene of the Adoration of the Magi, so prominent at La Charité, is excluded from the lintel at Chartres, where the figure of the Christ-Child at the Presentation is shown at the centre of the composition, and

25. South portal, Le Mans Cathedral; c.1155–8

26. West portal, priory church of Saint-Loup-de-Naud; c.1160

27. Tympanum and lintel from west façade, priory church of La Charité-sur-Loire; probably c.1145

28. North portal, Bourges Cathedral; c.1155–60

this may indicate that La Charité predates Chartres.[42] Other sculptures produced by the La Charité workshop are the reliefs now set into the west wall of Saint-Laurent at Montmorillon in Poitou (presumably intended for the lintel of a doorway), the fine fragments in the north aisle at Saint-Pierre, Souvigny, and finally the north portal sculptures at Bourges Cathedral, probably to be dated in the late 1150s [28]. All show a concern for depicting in detail plant forms, ornamental border designs, and finely drawn small figures.[43]

In Burgundy, the famous abbey church of Saint-Bénigne in Dijon had a large central west portal, the sculpture of which was destroyed in 1794. For its appearance we now have to rely on the engraving in Plancher's *Histoire de Bourgogne*, published in 1739, and for the style on a single head now in the Musée Archéologique in Dijon, which came either from the trumeau figure of St Benignus or more likely from the third jamb figure on the left side of the door. This large portal is now placed on the west front of the thirteenth-century church but was intended for (or actually used on) the earlier building. Two smaller tympana have been associated – not necessarily correctly – with the central portal: one of these, now sadly shorn of its sculpture and mounted in the porch, showed the martyrdom of the patron saint, while the other – in good condition – depicts the Last Supper and is displayed in the Musée Archéologique [29].

Although sometimes connected with Chartres, the style of the existing Last Supper tympanum and the head already mentioned point clearly to connections with sculptures of the third quarter of the century, even anticipating the cloister sculptures at Châlons-sur-Marne of the late 1170s.[44] A fourth tympanum, smaller than the Last Supper one and also displayed in the Musée Archéologique, is carved in a more Romanesque style and comes from a different part of the building, possibly the door linking the church with the cloister, or from a tomb. It shows the *Majestas Domini* [30] and was exactly copied in a small tympanum over the south door of the church at Til-Chatel in the nearby Côte d'Or, the latter signed by a local sculptor, *Petrus Divionensis*.[45] By comparing the heads of Christ from the Dijon *Majestas Domini* and Last Supper tympana one can see, albeit in less extreme form, the same differences that distinguish the sculpture of Senlis from Vézelay, their superficial similarity slightly enhanced by the inscriptions.[46] The Last Supper tympanum derives its style from the new developments in the Ile-de-France and Champagne rather than influencing its northern counterparts. The composition of the grand central portal, with its imposing jamb figures and historiated voussoirs, can hardly predate 1160, and the form of the two lintels relates them to the apostles under arcades at Saint-Loup-de-Naud and the infancy of Christ frieze on the Saint Anne portal at Notre-Dame, Paris.

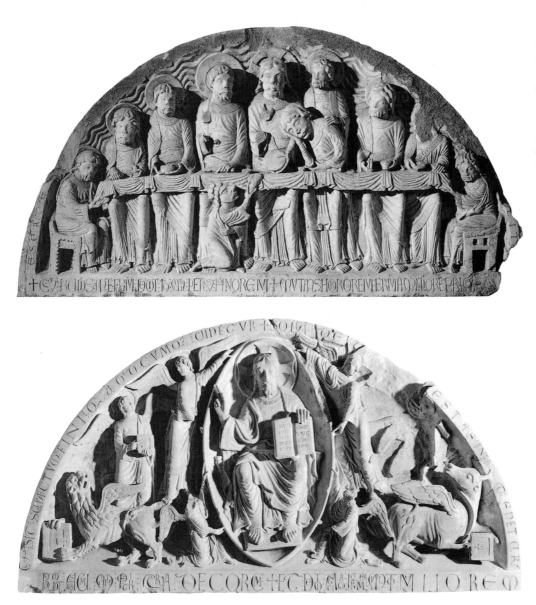

29. Tympanum from Saint-
Bénigne, Dijon; c.1160–70 (Musée
Archéologique, Dijon)

30. Tympanum from Saint-
Bénigne, Dijon; c.1160–70 (Musée
Archéologique, Dijon)

31. Tympanum and lintels, *Portail
Sainte-Anne*, Notre-Dame, Paris;
c.1150–5 and later

THE PORTAIL SAINTE-ANNE AT NOTRE-DAME, PARIS

The so-called *Portail Sainte-Anne*, the southernmost of the three portals of the west façade of Notre-Dame, is now a composite made up of sculptures from more than one twelfth-century portal, with thirteenth-century additions [31]. Rather unsuitably, it takes its name from the scenes on the lower lintel, an addition of the thirteenth century, which are concerned with the story of Joachim and Anna. The portal was placed in its present position probably around the end of the first quarter of the thirteenth century, when the earlier components were augmented by the lower lintel, the upper lintel was extended at both ends, the censing angels and foliate decoration were carved to fill the space between the tympanum and the archivolts, and voussoirs were added at the bottom and top of all the archivolts: new keystones were also provided. There are also nineteenth-century additions, the most notable being the jamb figure of St Marcellus, which replaced the original now in the Musée national du Moyen Age.[47] Before 1977 only four other fragments were associated with the portal: the remains of the jamb figure of

St Peter [32], the head from a jamb figure of King David [33], now in the Metropolitan Museum of Art in New York, and two keystones in the Louvre [34, 35]. But in that year the remarkable discovery took place near the cathedral of over 300 fragments of sculpture from its façade, hidden in 1796 after the revolutionary destruction, which included the substantial remains of a number of other jamb figures from the *Portail Sainte-Anne*, including that of St Paul.[48] The most significant pieces are now displayed in the Musée national du Moyen Age in Paris.

It has long been recognised that the Saint Anne portal must incorporate the remains of at least two – possibly three – doorways which were intended for an earlier façade. The tympanum, showing the Virgin and Child between two censing angels, with a bishop and a scribe on the left and a kneeling king on the right, would not originally have been framed by voussoirs depicting the Elders or with key stones of the type in the Louvre, now reflected by thirteenth-century versions on the doorway itself. These would more properly belong with a tympanum showing Christ in Majesty – a Judgement portal – and although this tympanum seems to

have disappeared just such a relief was recorded by Viollet-le-Duc during his excavations underneath the side chapels at Notre-Dame.[49] It has also been suggested that the upper lintel would originally have supported a tympanum showing the Adoration of the Magi. These iconographic divisions are reinforced by stylistic criteria. Excluding the thirteenth-century additions, three quite distinctive styles can be identified on the portal. The tympanum is probably the work of the so-called 'Master of the Angels' at Chartres, who was responsible for the tympanum of the Virgin [16], while the upper lintel and the head of David in New York are closer to sculptures from Saint-Denis: comparing the head of David with the surviving Saint-Denis heads, the treatment of the eyes is similar but the carving of the hair and beard has become more naturalistic at Notre-Dame. Unfortunately, the elegant flowing drapery of the fragmentary jamb figures cannot now be set beside comparable figures from Saint-Denis, but they appear to have moved a step beyond Saint-

Denis and Chartres and anticipate the jamb figures at Senlis. The tympanum, upper lintel and jamb figures on the Saint Anne portal would thus most comfortably be placed in the 1150s, shortly after the Chartres Royal Portal. A traditional identification of the bishop on the tympanum as Maurice de Sully, who rebuilt the cathedral after 1160, and the king as Louis VII, has recently been convincingly rejected in favour of the historical figures of Saint Germanus and King Childebert, the first benefactor of Paris, with the tympanum recording the royal donation of 528. Once again the chance was not missed to underline the relationship between Church and Monarchy, here as elsewhere showing unequivocally the priority of the former over the latter, this time in the presence of the Virgin and the Son of God, the act of sacred fealty being recorded for posterity by the seated monk on the left.[50] This was especially significant at Notre-Dame, as it was not only the church of the bishop of Paris but also adjacent to the king's palace on the Ile de la Cité.[51]

32. Lower half of a jamb figure of St Peter; *Portail Sainte-Anne*, Notre-Dame, Paris; *c.*1150–5 (Musée national du Moyen Age, Paris)

33. Head from a jamb figure of King David; *Portail Sainte-Anne*, Notre-Dame, Paris; *c.*1150–5 (Metropolitan Museum of Art, New York)

34. Key stone associated with the *Portail Sainte-Anne*, Notre-Dame, Paris; *c.*1165 (Musée du Louvre, Paris)

35. Key stone associated with the *Portail Sainte-Anne*, Notre-Dame, Paris; *c.*1165 (Musée du Louvre, Paris)

While the sculptures in the Chartres and Saint-Denis styles may reasonably be dated between 1150 and 1155, the two keystones in the Louvre – and by extension the elders in the fourth archivolt – must be slightly later. The attention to detail in the hair of Christ and the angels, the round, naturalistic faces of the latter, and their close resemblance to the heads of the angels on the lintel at Senlis [38], do not allow a dating much before 1165.[52] What we have, both *in situ* at Notre-Dame and in the museums of Paris and New York, is the remains of a large project to adorn an earlier western façade, probably of three portals, which was carried out between about 1150 and 1165. Of vital importance for the development of early Gothic sculpture in the Ile-de-France, the Saint Anne portal more than any other monument illustrates the transition from an essentially late Romanesque style of sculpture – as represented at Saint-Denis and Chartres – to the beginnings of a refined naturalism, more often seen in smaller works of art, which is exemplified by the sculptures of the next generation, at Senlis, Mantes, the Porte des Valois at Saint-Denis, and Sens. What prompted this change in approach?

SAINT-DENIS AND GOLDSMITHS' WORK, SENLIS AND RELATED SCULPTURES

In Abbot Suger's account of the ornaments in his church at Saint-Denis, there is an extended reference to a colossal golden candlestick which he had ordered to be made in 1145–7 and placed in the choir. He recalls that he employed goldsmiths from Lorraine (*aurifabros Lotharingos*) to make this cross and goes on to describe it in some detail, mentioning that it had four figures of the evangelists at the base and that the shaft of the cross, below a large capital, was 'enamelled with exquisite workmanship'. Although Suger's cross no longer exists, it is likely that a much smaller cross-foot from the Abbey of Saint-Bertin, now in Saint-Omer, is a modest variant of the former's lower part.[53] Imagined on a monumental scale – Suger's cross has been estimated as more than six metres high – such a piece cannot have failed to impress all who set eyes on it. Just as Suger's importation of sculptors from Languedoc and Burgundy profoundly affected the course of sculpture in the late 1130s it seems likely that the commissioning of such a striking piece of metalwork from goldsmiths from the north-east also played a significant part in shaping the form of Gothic sculpture in the generation after the Saint-Denis west portals. Looking at the Saint-Bertin cross-foot, or a closely related figure of the personification of the Sea in the Victoria and Albert Museum [36], one is aware of how the goldsmith is able to experiment with three-dimensional form more readily than the stone-sculptor, and how the free-flowing forms of the drapery are conditioned by the modelling and lost-wax casting process. Small-scale gilt bronzes of this type – and the larger figures on Suger's cross pedestal – would undoubtedly have impressed the stone sculptors employed in the workshops of the Ile-de-France after the middle of the twelfth century, who would have wished to emulate the naturalism of the facial types, the detailed treatment of the hair, and the relaxed poses. The desire was created to free the figure from the constraints of its architectural setting. The keystones

36. Personification of the Sea (*Mare*); gilt bronze, cast and chased; *c*.1150–60 (Victoria and Albert Museum, London)

from the Saint Anne portal now in the Louvre show the first signs of this increased interest in such concerns – indeed, the heads of the angels especially look like large-scale examples of goldsmiths' work turned into stone, and it should not be forgotten that all stone sculptures were conceived to be painted and even gilded. But the first clear manifestation of this new style is to be seen in the main doorway of the west façade of Senlis Cathedral, a few miles north of Paris in the Ile-de-France.[54]

The façade of Notre-Dame at Senlis shows an immediate debt to Saint-Denis, with its fortress-like appearance divided into three by buttresses, but unlike Saint-Denis only its central doorway is of any size: the lateral portals are diminutive and undecorated. The connection with Saint-Denis, apart from the geographical proximity of one to the other, goes deeper still. The cathedral was started in 1151 – although not dedicated until 1191 – under Bishop Thibault, a friend of Suger, and the chevet may reflect the great abbey's design. But the layout and style of the portal are new, and a novel iconographic programme of far-reaching influence is introduced.[55]

Instead of the customary Christ in Majesty or Virgin and Child, the tympanum shows the Coronation of the Virgin [37]. Below in the lintel two scenes divided by a slim colonnette are devoted to the Death and Assumption of the Virgin, while in the first three archivolts are the precursors of Christ and the Virgin from the Tree of Jesse: the outer archivolt is filled with patriarchs and prophets. The eight

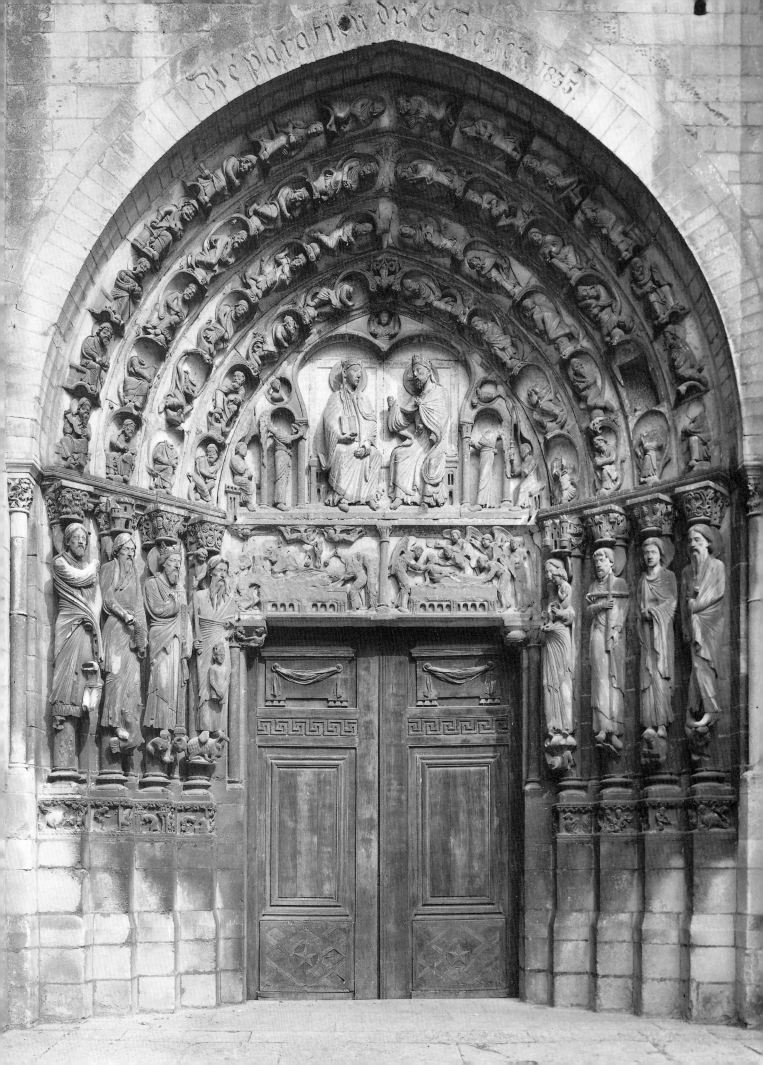

jamb figures, now with nineteenth-century heads and other additions, all allude to Christ's sacrifice and redemption. They are, from the left, John the Baptist, Samuel or Aaron, Moses, Abraham, Simeon, Jeremiah, Jacob and David.[56] Now lost, the trumeau figure represented Saint Rieul, the first Bishop of Senlis.[57] In all, the portal programme demonstrates the redemption of mankind through Christ's sacrifice and his inseparable bond to the Church through the Virgin, 'the Bride of Christ', anticipated in the Old Testament and witnessed by the prophets and patriarchs.[58] Since the late eleventh century a public devotion to the Virgin had been growing, nurtured and increased by St Anselm, St Bernard of Clairvaux, Suger and others. The portal at Senlis was the first major sculptured manifestation of this cult, and provides the perfect illustration of the move away from a hieratic, at times frightening, concern with eschatological themes often seen on Romanesque portals, in favour of a more forgiving, human aspect. The Virgin is seen as an intercessor between the faithful and Christ the Judge, providing an attractive and sympathetic focus for the devotions of the public. It is not coincidental that the cult of the Virgin developed in the way that it did, as the great cathedrals were monuments built for the city and town dweller, not the monk. The audience had changed, and with it the message.[59]

The stylistic filiation of the Senlis sculpture with the latest non-thirteenth-century sculpture of the Saint Anne portal – especially the keystones in the Louvre – has already been pointed out, and there can be no reasonable doubt that they are the products of the same workshop.[60] The portal at Senlis was presumably executed shortly after the completion of the work at Notre-Dame, probably between 1165 and

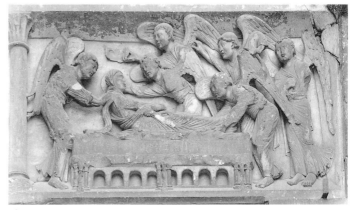

38. Detail of lintel, showing the Assumption of the Virgin; west portal, Senlis Cathedral; c.1165–70

1170: although the angels on the lintel at Senlis [38] and those on the Paris keystones seem to be by the same hand, the column figures at Senlis have advanced a step further than the jamb figures of the Saint Anne portal and show a fuller treatment of the draperies. The corrugated, rigidly parallel lines of the draperies on the figures of the Chartres Royal Portal have gone forever, and there is now a dynamic, free-flowing appearance to the cloth. The cloak of the Baptist at Senlis is pulled across the body in a way that suggests it has been poured from a mould – a fluidity more often seen in drawings and of course metalwork itself.[61]

At about the same time another portal was being constructed at Saint-Denis. The *Porte des Valois* (so called

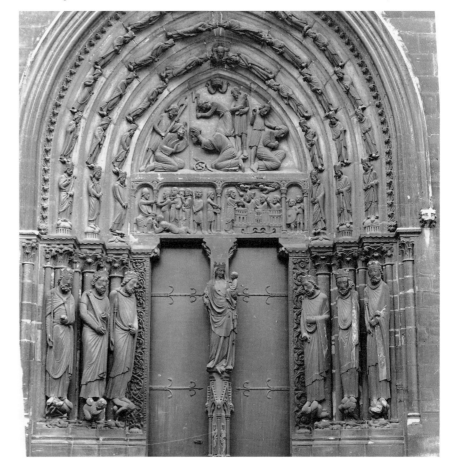

37. West portal, Senlis Cathedral; c.1165–70

39. The *Porte des Valois*, north transept, abbey church of Saint-Denis; c.1170

40. Tympanum, north portal, west façade, Notre-Dame, Mantes; c. 1170–5.

because it faced the now demolished later tomb of the Valois dynasty) was added to the north transept only in the thirteenth century, but it was presumably intended for one of the transepts from the start, as it could not have been made for the west front, which already had Suger's three portals. It was perhaps made for the south transept, facing the cloister, as its subject matter – showing the martyrdom of St Dionysius and his companions – would have offered a salutary instruction in selfless devotion to the monks in the abbey [39]. When the nave was nearing completion in the middle of the thirteenth century a new doorway probably showing the Last Judgement was placed at the south transept.[62] Because of a lack of documentary evidence it is not possible to state with confidence whether the *Porte des Valois* was made before or after the Senlis portal, although the stylistic similarities with the voussoirs of the Saint Anne portal and its close relationship with the north portal of the west front of Mantes (to be discussed below) make a date around 1170 likely.[63] The doorway was badly damaged during the Revolution; although its present form does not depart from the original, new heads were added to the archivolt figures of kings and a good deal of surface cleaning and filling took place in the nineteenth century.[64] Enough unrestored passages and fragments still exist, however, to make meaningful comparisons. Two small heads, originally attached to the *marmouset* figures on which the jamb figures stood, once again can be compared with the Louvre keystones from the Saint Anne portal. The slim standing figures of kings in the voussoirs, however, are still constrained by the block, and look back to the more static voussoir figures on the Saint Anne portal rather than to the expressive and freely-moving voussoir figures of Senlis.[65]

The north portal of the west front of the collegiate church of Notre-Dame at Mantes [40], with the enthroned Christ in the tympanum and the Maries at the Sepulchre in the lintel, shows the same features: the shape of the doorway, the figure style, the construction of the figured voussoirs and the nodding foliate band around the edge of the archivolts all mark it out as a product of the *Porte des Valois* workshop at Saint-Denis, presumably made between 1170 and 1175.

Perhaps working concurrently with or slightly later than this workshop were sculptors from Senlis, who were responsible for the larger central portal showing the same iconographic scheme as at Senlis – the Coronation of the Virgin with scenes of her Death and Assumption below in the lintel [41]. The twisting and turning figures of kings from the Tree of Jesse, patriarchs and prophets in the archivolts – little statuettes in their own right – are almost identical to the voussoir figures of Senlis. Given a date of around 1170 for the latter, the central portal of Mantes must have been carved within the following decade. It now lacks its jamb figures and trumeau (originally a figure of the Virgin) but heads from the jamb figures survive and are preserved in the Dépôt lapidaire of the church, while a small head of a king from one of the voussoirs is in the Brummer Collection at Duke University, North Carolina.[66] The south portal at Mantes was rebuilt after 1300 and now dominates the earlier doorways, but judging by the iconography of the other two and the dedication of the church it is possible that it originally showed the Virgin and Child in the tympanum.

A number of other individual sculptures and larger schemes may be linked with the Paris-Senlis-Mantes workshops after 1170. Notable among these are five figures associated with Noyon Cathedral, which with the exception of a fragmentary Virgin and Child still at Noyon, are now separated between collections in New York, Durham (North Carolina), and Lugano.[67] An attempt has been made to reconstruct their setting as the south transept portal at Noyon, with the Virgin on the trumeau and the prophets as jamb figures; but although the portal is of the right date for the sculptures, it does not appear to provide the appropriate spatial context. A seated Virgin and Child in the trumeau would, in addition, be extremely unusual and is not shown in a watercolour of the portal made just before the Revolution.[68] Notwithstanding the uncertainty over the original placement of the figures, their drapery style and head types are demonstrably close to Senlis and Mantes; they have the appearance of enlarged voussoir figures, albeit slightly more static and frontally posed than most of the examples at those places.[69]

Far more important than the Noyon sculptures are the extensive remains of the cloister decoration of the collegiate church of Notre-Dame-en-Vaux at Châlons-sur-Marne.[70] The cloister was demolished in the years immediately following 1759 and the stone from it used as foundations and building material for walls, fortunately on the site itself. As a result, when excavation and the dismantling of some of the walls took place between 1963 and 1976, one of the biggest and most significant ensembles of early Gothic sculpture came to light; although many of the pieces are abraded or fragmentary, the surface of the stone is in most cases remarkably fresh and in pristine condition, making these sculptures amongst the most rewarding to study in detail.[71] When complete, the cloister at Châlons would have had over fifty column figures, each one with a capital (either foliate or carved with scenes) above it, supporting the arcades.

41. Central portal, west façade, Notre-Dame, Mantes; c.1170–80

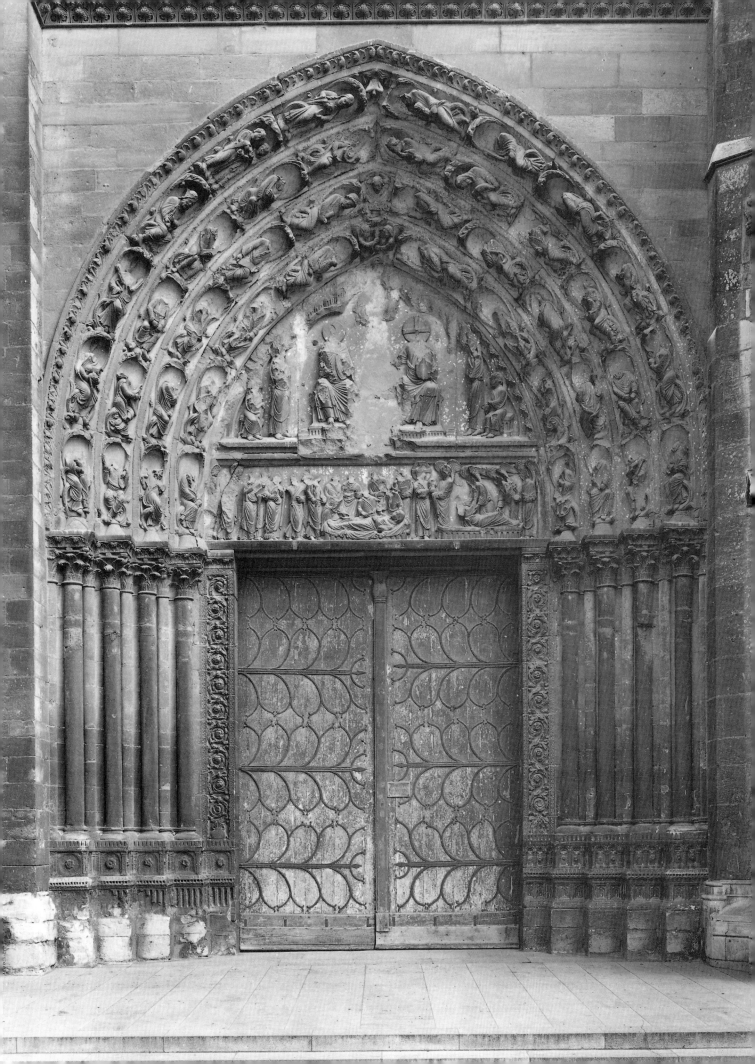

42. St John the Baptist; column figure from the cloister of Notre-Dame-en-Vaux, Châlons-sur-Marne; *c.*1180

43. St Paul; column figure from the cloister of Notre-Dame-en-Vaux, Châlons-sur-Marne; *c.*1180

44. Capital from the cloister of Notre-Dame-en-Vaux, Châlons-sur-Marne; *c.*1180

45. The *Porte romane*, north transept, Reims Cathedral; *c.*1180–5

The decorative programme included Old Testament figures, prophets, apostles, saints, knights probably representing the Virtues, Wise and Foolish Virgins, and scenes from the Life of Christ in the capitals [42–44]: it was thus as rich in typological and allegorical allusions as even the most ambitious portal programme, and paralleled contemporary typological goldsmiths' work. The church at Châlons was partially dedicated in 1183, and given the size of the cloister programme, which was probably finished by that date, it seems likely that the sculpture was made in the five years before the dedication. If the sculpture at Senlis has points of contact with the metalworker, this is even more true at Châlons; it has been suggested that the sculptured surfaces were polished and burnished, highlighting the figures against the rougher surface of the columns behind.[72] This close relationship to Mosan and Lotharingian metalwork should come as no surprise as Châlons is in Champagne, itself an important centre of enamel workshops; there are also connections with slightly earlier sculptures at nearby Reims.[73]

In Reims itself, on the so-called *Porte romane* on the north transept of the cathedral, is an ensemble of sculpture which clearly pre-dates the rebuilding of the cathedral necessitated by the disastrous fire of 1210 [45]. It has been shown by reference to more or less contemporary tombs that the Virgin and Child (looking oddly isolated within the blank arch of the doorway), the archivolt of angels, the angels in the spandrels, and the two deep reliefs of clerics reciting the Office for the Dead – only the foliate sides of which are visible from the front – originally belonged within the previous building and formed part of a canopied wall tomb. On stylistic grounds this must have been made either posthumously for Archbishop Henri de France (d.1175) or for his successor William I de Champagne (d.1202), in the 1180s.[74] The figure style is quite different from contemporary sculpture in the Ile-de-France, but it was ultimately this slightly elongated and austere manner, covered in loose but seemingly damp draperies, that was to be employed at Laon and on the transepts at Chartres, the largest ensemble of sculpture of the first years of the thirteenth century. The Reims workshop which produced the sculptures of the *Porte romane* had already been employed at the church of Saint-Rémi in the same city, where this distinctive style – perhaps inspired again by goldsmiths' work from the Rhine-Meuse region – was first worked out around 1175.[75]

SENS

The sculptures on two of the portals of the west front of the cathedral of Saint-Etienne at Sens may be viewed as both the conclusion of the first Gothic period in the Ile-de-France and the start of the mature style which led to the achievements of the thirteenth century. The earlier of the two, the

46. North portal ('the Baptist's portal'), west façade, Sens Cathedral; c.1180–90

in the clouds is shown between two angels in the apex of the tympanum [46]. In the lower half of the tympanum are the scenes of the Baptism of Christ, Herod's Banquet and the beheading of the Baptist, while in the voussoirs are episodes from his life (rather than single figures), in the manner of the historiated voussoirs at Le Mans and Saint-Loup-de-Naud; there were originally three jamb figures on each side, and below are large roundels with Avaritia on the left and Largitas on the right.[78] While the style is, of course, closely comparable to the Mantes and Senlis sculptures, a number of subtle innovations in the layout anticipate the portal compositions of the next century. Most noticeable in this respect are the medallions on the socles below the jamb figures, which were to be taken up – albeit on a smaller scale – at Notre-Dame in Paris and Amiens, and the fact that the jambs of the portal are slanted rather than stepped, the latter being the norm until this point (while curiously the central portal retains the established arrangement). The merging of the canopies with the capitals above the column figures is also a new development.

The central portal [48] is for stylistic reasons later in date than the Baptist's portal, and was probably executed in the last years of the century. The crisp, taut draperies of the earlier portal have given way in the voussoirs and in the trumeau figure of St Stephen to a softer, more flowing drapery style, the beginnings of which are seen on the north door panels of Avaritia and Largitas.[79] The tympanum, showing the martyrdom of St Stephen, is later still, presumably contemporary with the south portal. Why the tympanum was remodelled in the thirteenth century, only about seventy years after its original construction, is not certain: it is unlikely to have been necessary as a result of the fall of the

47. Head from a jamb figure; central portal, west façade, Sens Cathedral; c.1195–1200 (Musée Synodal, Sens)

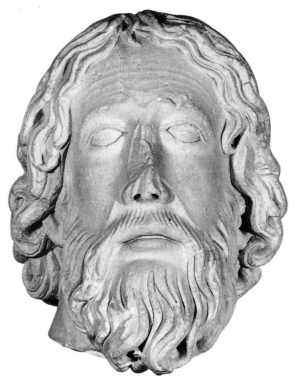

so-called Baptist's portal to the north, could well have been in course of execution when a devastating fire occurred in 1184, the date normally given as the *terminus post quem* for the portal. It was carved by the workshop responsible for the central portal at Mantes, who must have moved directly to Sens, and shows the same predilection for fluid draperies and detailed, minute carving. Unfortunately the portals at Sens suffered badly in 1793, when the jamb figures were pulled down and virtually all the heads were broken off.[76] Long before then, in 1268, the south tower had collapsed and destroyed the portal beneath it: this was rebuilt in the years immediately after the disaster, at which time the tympanum of the central portal was also renewed.[77]

The Baptist's portal is, as the name suggests, devoted to John the Baptist, although the half-length figure of Christ

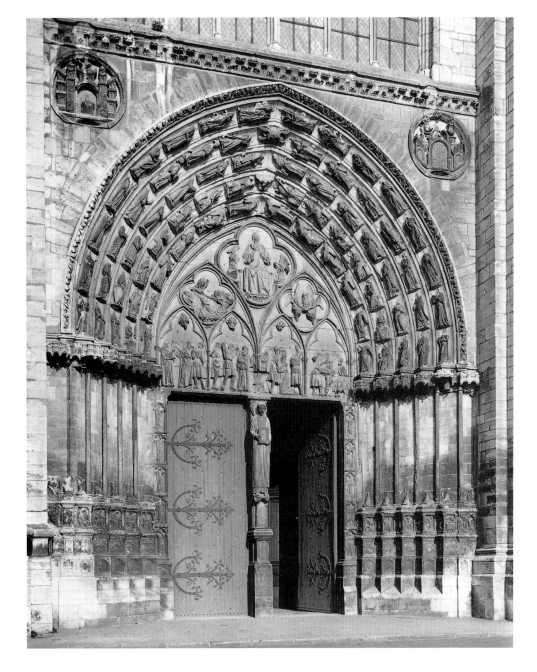

48. Central portal, west façade,
Sens Cathedral; c.1190–1200 and
probably c.1270

south tower in 1268, as the trumeau figure and the voussoirs remained unharmed. Probably it was made to reinforce the cathedral's connection with its patron saint, and that it replaced one showing the more traditional subject of Christ in Majesty. This interpretation is supported by the surrounding iconography. The voussoirs contain angels, deacons, martyrs and Virtues; the socles show the Liberal Arts and the Calendar; the Wise and Foolish Virgins are carved on the doorposts, and the medallions in the spandrels above hold the open and closed gate of Paradise. Nor is it precluded by the presence of St Stephen on the socle.[80] The central portal also included for the first time the twelve apostles on the jambs; these were unfortunately destroyed in 1793, although some heads still survive which may with confidence be connected with the figures.[81] The best preserved of these, now in the Musée Synodal at Sens [47] has been likened to Hellenistic sculpture, and although this

exaggerates the realistic quality of the head it is true that when compared with the detached heads from Mantes – or indeed the small head of Christ from the Baptist's portal – it reveals a greater understanding of physiognomy. This comparison, together with the softer drapery on the figure of Largitas on the Baptist's portal, defining the shape of the figure beneath, and the gracefully rippling folds of St Stephen's robes, provides clear evidence that in a short space of time, between about 1180 and the end of the century, a new, more naturalistic, element had been introduced into the repertory of the cathedral sculptor in the Ile-de-France which finally banished all trace of the Romanesque, fifty years on from Suger's portal at Saint-Denis. The stylistic advances seen in the heads of the jamb figures and that of St Stephen in the trumeau provided the foundation upon which the workshops at Chartres, Notre-Dame in Paris and Strasbourg would build.

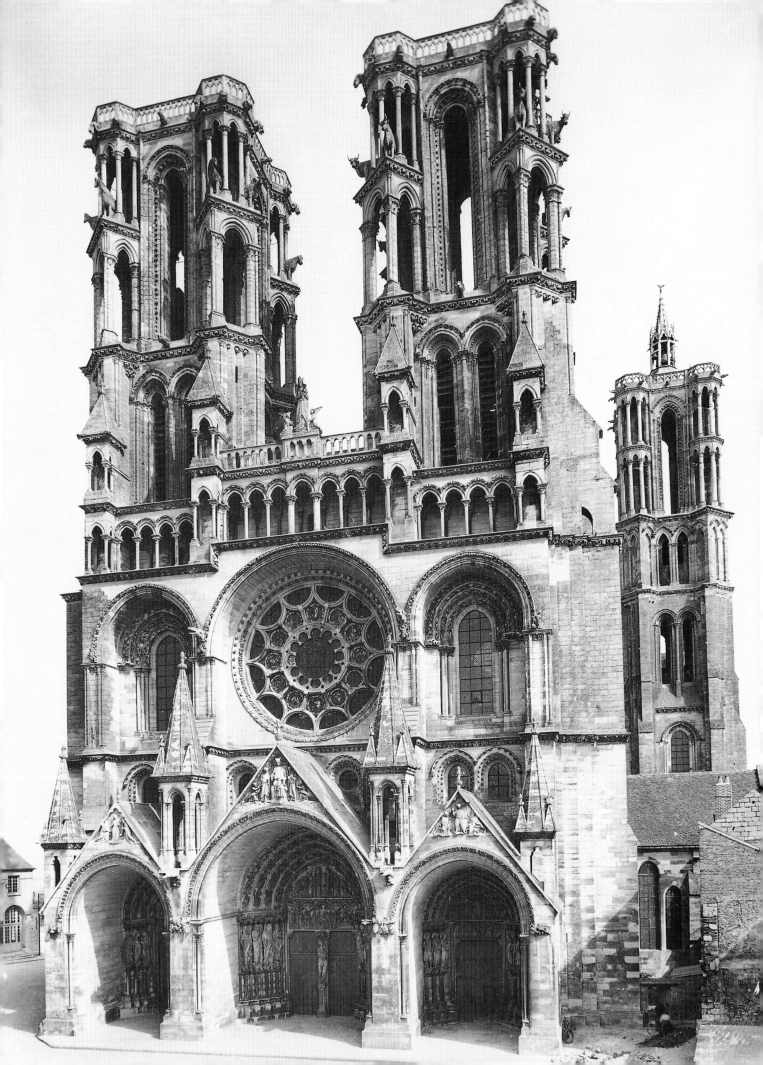

LAON AND BRAINE

Although as at Chartres there are no documents to assist in the dating of the sculptural decoration of the west front of Laon Cathedral [49], it is now generally agreed that, with the exception of the Last Judgement tympanum and the two inner archivolts of the south portal, all the work must have been executed between about 1190 and 1205.[82] At Laon we see for the first time the use of deep gabled porches to encase the sculpted portals, a feature which would be taken up at Chartres, Amiens and Reims, but which was ingeniously employed at Laon largely because the architect of the façade had to incorporate an ambitious decorative and iconographic scheme into the width of a nave designed about thirty years earlier.[83] Originally, there were open passages between the different portals, allowing free movement under the porches as on the transepts at Chartres, but these were blocked up in the middle of the nineteenth century in order to consolidate the subsiding façade. A few years later a thorough-going restoration of the sculptures of the façade – gravely damaged at the Revolution – was carried out: as a result, most recent scholars have chosen to confine their comments on style to the plaster casts taken before the restorations were made, now kept in the Musée des Monuments Français. As they stand today, the portals at Laon tell us almost as much about the stylistic tendencies of the nineteenth-century restorer as the late twelfth-century workshop. This is especially true of the modern jamb statues now *in situ*, which are based on those at Chartres, the lintel of the central portal, and the heads of nearly all the figures: that of the sleeping Nebuchadnezzar on one of the voussoirs of the north portal mysteriously escaped destruction.[84]

The iconographic scheme was not, of course, affected by the restorations. The cathedral being dedicated to the Virgin, it naturally enough celebrated the Mother of God. At its centre is the Coronation of the Virgin with, in the voussoirs, attendant angels, a Tree of Jesse, and prophets, based on the arrangement at Senlis: above, in the gable, is the Virgin enthroned, flanked by angels, further reinforcing her importance. The north portal introduces a new iconographic scheme, showing the three magi alongside the standard depiction of the Virgin and Child under a canopy in the tympanum, complemented below in the lintel by the Annunciation, the Nativity and the Annunciation to the Shepherds. In the voussoirs are angels, Virtues triumphing over Vices, and scenes or individual figures prefiguring Mary's virginity, identified by carved inscriptions [50].[85] In addition to the Marian programme on these two doorways, the earlier Last Judgement portal had its outer archivolts and a lintel showing the separation of the Blessed and the Damned added.

Two larger than life-size column figures of prophets are still preserved in the museum at Laon [51, 52], and although doubts have been expressed over their original location it is highly likely that they belonged to the Coronation portal of the cathedral.[86] They are figures of great elegance, their robes made up of broad folds arranged in parallel curving

49. West façade, Laon Cathedral; *c.*1190–1205

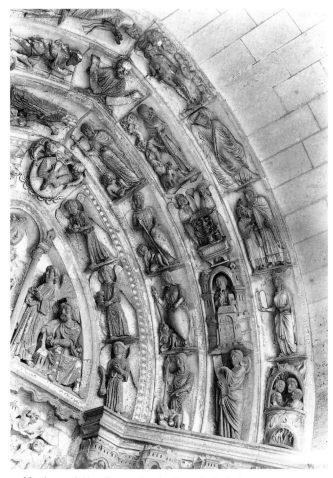

50. North portal (detail), west façade, Laon Cathedral; *c.*1195–1205, with nineteenth-century restorations

lines, pulled in at the waist by broad, rope-like girdles. The heads are characterised by a combination of detailed carving of certain features – such as the almond-shaped eyes – and a freer approach to the beards and hair. They are close in this respect to the heads from Sens already mentioned, and like them they indicate the growing ability of the cathedral workshops to represent the human figure in a realistic, life-like manner. The Laon figures do not actually look like real human beings – they are slightly too elongated and the heads, although naturalistic, follow set types rather than being based on living models. But when set against the ethereal, fragile-looking column figures of the head master at Chartres [17] or the king and queen at Corbeil [20, 21] one can see that the shape of the body is beginning to be understood and that the draperies are now represented approximately as they would fall in nature. The nervous and artificial patterns of the earlier attempts at rendering drapery in stone have passed into history, and the sculptor has joined the metalworker and manuscript illuminator in the quest for a heightened visual effect based on the close observation of nature and classical prototypes.

Because of the size of the portals we may presume that the Laon workshop was comparatively large, and it seems to have consisted of sculptors trained in different centres. In addition to the influence of Sens, clear connections can be seen with Reims, especially when comparing the angels of

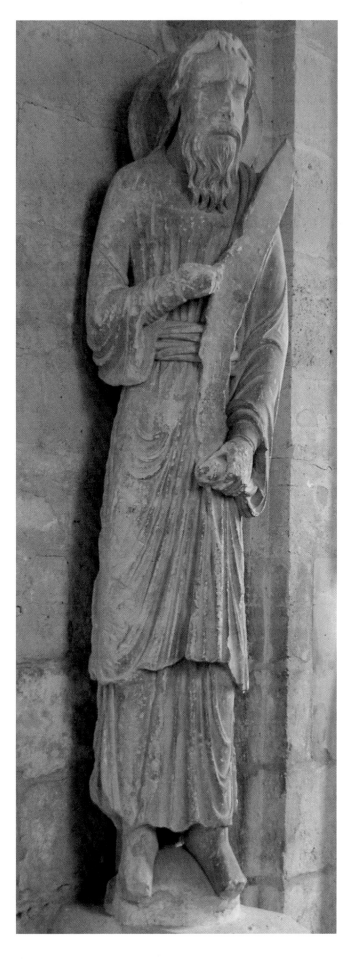

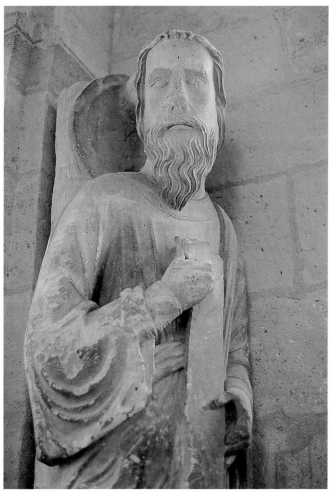

52. Jamb figure of a prophet (detail), probably from the Coronation portal, Laon Cathedral; c.1200 (Musée Municipal, Laon)

51. Jamb figure of a prophet, probably from the Coronation portal, Laon Cathedral; c.1200 (Musée Municipal, Laon)

the voussoirs on the *Porte romane* with their counterparts on the Coronation portal at Laon.[87] Laon appears to have acted as an influential 'melting pot', where stylistic innovations worked out in different centres in the Ile-de-France and Champagne were blended, and there can be no doubt that several members of the workshop were responsible for the sculpture at Saint-Yved at Braine (only thirty km to the south) and some of the earliest work on the transepts at Chartres.

The Gothic west façade of Saint-Yved at Braine was demolished in 1832, but from early plans we know that it originally comprised three deeply recessed doorways, the central portal being much larger than those flanking it. The central portal, like that at Laon (but closer still to Senlis), showed the Coronation of the Virgin with her Death and Assumption in the lintel below and with the Tree of Jesse and prophets in the voussoirs: many surviving fragments were reconstructed in 1970 inside the church, set on to the west wall behind the modern central portal [53].[88] The portal also included eight jamb figures, and a bearded head now in the museum at Soissons probably originally belonged to one of them: it certainly bears a close relationship to the

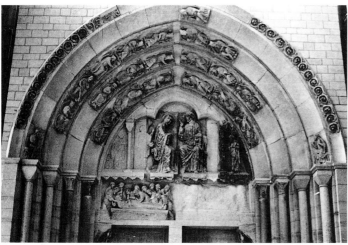

53. Reconstructed Coronation portal, Saint-Yved, Braine; probably c.1205–8

two column figures at Laon, and reinforces the workshop connection.[89] It has been suggested that a large fragment made up of several blocks cemented together, showing Christ in Limbo and scenes of the Damned from the Last Judgement (also now in the museum at Soissons), occupied the tympanum of the north portal, but this is unlikely both from an iconographic and a compositional point of view; the original placement of these pieces remains a mystery, but they may have formed part of a choirscreen, or *jubé*.[90]

Saint-Yved was probably complete by 1208, so the west front was in all likelihood constructed in the immediately preceding years.[91] Certainly, the style of the sculpture is so close to the work at Laon that it can hardly be separated by many years, and we cannot even be sure that it was not made before Laon (building had probably begun at Saint-Yved as early as 1176). It is in small nuances that the composition can be distinguished from those at Laon and Senlis, such as in the way the Virgin turns to face Christ directly, rather than sitting frontally or in a three-quarters pose, but one is more struck by the marked iconographic similarities. The Coronation of the Virgin programme first worked out at Senlis, having been repeated or expanded at Mantes, Laon, Braine, Saint-Nicolas at Amiens, and elsewhere, was to receive its fullest treatment in the next great monument of early Gothic sculpture, the central doorway of the north transept at Chartres Cathedral.[92]

THE CHARTRES TRANSEPTS

On the night of 10 June 1194, a terrible fire consumed much of the town of Chartres and all but the west façade of the cathedral. Contemporary accounts describe the understandable despair of the local populace, who at first imagined that they had not only lost their great church but also their most precious possession – the relic which set Chartres apart from all others in its claim to be the first church of the Virgin. The tunic of the Virgin, which had been preserved in the crypt, was, however, shortly after the fire retrieved unharmed and displayed amid much rejoicing; its recovery seems to have served as a catalyst for generous contributions to the rebuilding of the cathedral, which proceeded almost at once. It was not long before the fire was

seen as a divine intervention from the Virgin herself, who clearly desired a grander church to be built in her honour. Huge sums of money were pledged to the rebuilding by the cathedral chapter and donations started to pour in, from rich and poor alike; it was reported that miracles were often worked on those who contributed, especially the poorer members of the community, who brought cartloads of building materials or goods to sell, the money generated being given towards the building costs.[93] The enthusiasm and commitment of those who funded the rebuilding, driven by a recognition that the economic and spiritual health of the town would not be restored until the work had been finished, ensured that the magnificent Gothic cathedral was largely complete by about 1220, as reported by the contemporary chronicler Guillaume le Breton.[94] At the beginning of the following year the Canons made preparations for the assignment of seats in the choir stalls, which had just been put in place, and in 1224 a wooden porch attached to the south face of the transept was removed, probably so that the present stone porch could be built.[95]

With the exception of the porches – which were added immediately afterwards – the sculptures on the six doorways of the transepts were probably finished by 1220 [54, 55]. The central doorway of the north transept, showing the Coronation of the Virgin in the tympanum, the Death and Assumption of the Virgin in the lintel, angels, prophets and the Tree of Jesse in the archivolts, with solemn jamb figures from the Old and New Testaments and with the figure of St Anne holding the infant Virgin on the trumeau, was probably started in or just after 1204, when the cathedral received the gift of the supposed head of St Anne, taken from Constantinople during the Fourth Crusade [56].[96] The overall message is here just as complex as on the Royal Portal, but is nevertheless clear: the Virgin is shown as the link between the Old and New Testaments, as the Queen of Heaven, while the jamb figures, presented in their chronological sequence from left to right, are unequivocal prefigurations of Christ as priest and sacrifice. Melchizedek, on the far left, is shown as an Old Testament priest with censer and chalice and is juxtaposed with St Peter on the far right, who is presented as the successor of Christ and the High Priest of the New Testament; Abraham, in his sacrifice of Isaac, anticipates the sacrifice of Christ, while opposite John the Baptist points to the Lamb of God; Moses holds the tablets of the Old Law, while Simeon, who foretold Christ's sacrifice, holds the Christ-Child, the maker of the New Law.[97]

Of all the doorways at Chartres the figure style is here closest to Laon, from where the sculptors presumably came, and it appears to have been the first of the transept entrances to be completed, probably by about 1210. The jamb figures share the scale and elongation of the two jamb figures in Laon, but they are covered in more voluminous draperies, which are mostly drawn across their bodies in great sweeping arcs, with deep troughs formed between the ridges of cloth [57]. The head types are remarkably similar to those at Laon, and indeed are close to one another, so that the identities are distinguished not by facial characteristics but by their attributes.[98] Perhaps the most dramatic feature is the way that some of the figures are treated very much

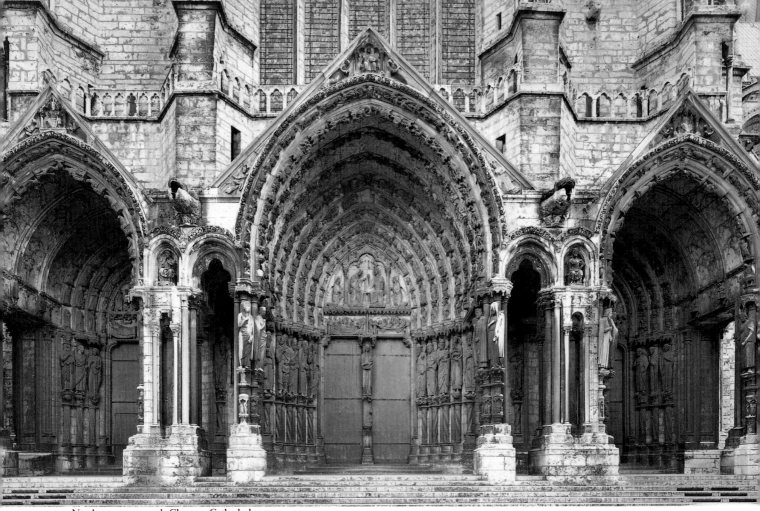

54. North transept portal, Chartres Cathedral; *c.*1204–30

55. South transept portal, Chartres Cathedral; *c.*1210–35

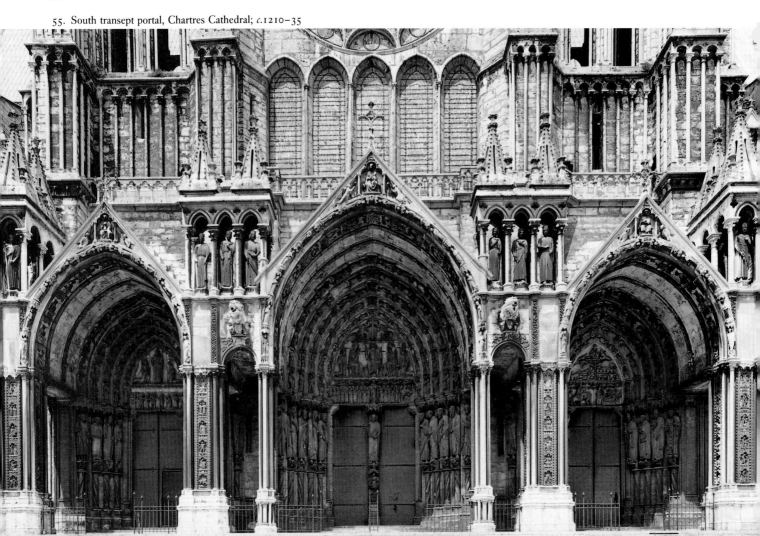

as individuals, making self-contained gestures, while still forming part of a larger unified programme. A conspicuous example of this is Abraham, who, in the act of sacrificing his bound son Isaac, turns away from the portal to look up at the angel flying towards him, which is actually carved amongst the leaves of the adjacent figure's canopy. This independence of action, not previously seen on jamb figures in France, was to be developed further on the eastern doorway of the north transept, where the individual jamb figures would participate in a dramatic dialogue.[99]

It is likely that at first it was the intention to have a single portal on the north transept, but that after the decision was taken to create a three-portal façade on the south transept a similar layout was adopted for the former.[100] To the east was added a portal further stressing the close relationship between the Virgin and Christ: the programme starts unusually in the jambs with the Annunciation on the left and the Visitation on the right, both flanked by prophets – probably Isaiah and Daniel – and continues into the lintel and tympanum with the Nativity, the Annunciation to the Shepherds and the Magi, and the Adoration of the Magi; in the voussoirs are angels, the Wise and Foolish Virgins, the Virtues triumphant over the Vices, and crowned female figures [58]. Its composition derives from the left portal of the west façade at Laon but the sensitive and human communion of the inner four jamb figures, as already mentioned, informs – and in terms of dramatic impact exceeds – the same scenes at Amiens and Reims.[101]

On the west side of the transept the other lateral portal shows a much more unusual iconographic scheme, one in all probability planned at the School of Chartres itself, as the Royal Portal had been [59]. In the tympanum is Job on the dung heap, tormented by a devil while his wife and three male figures look on; above is Christ flanked by angels. Job represents the suffering Church, and the three figures to the left should be interpreted as a Jew, a Moslem and a heretic. The lintel is dedicated to the Judgement of Solomon (a typological reference to Christ as Judge, dismissing the ancient philosophers), while below on the jambs are to the left Balaam, the Queen of Sheba and Solomon himself, and on the right an unidentified Old Testament figure once thought to represent Jesus Sirach, a female figure possibly to be identified as Judith (or perhaps Asenath, the wife of Joseph), and Joseph – recognisable by his youthful looks and by the small figure of Potiphar's wife at his feet, who is shown listening to the whispered entreaties of a coiled serpent. The voussoirs illustrate scenes from the lives of Samson, Gideon, Esther and Judith, all valiant defenders of the Faith. It has been convincingly demonstrated that all the scenes above the portal and the jamb figures around it – a most unusual choice not seen anywhere else – combined to offer a damning refutation of current heresies against the Church and the siren calls of temptation to embrace non-Christian beliefs. The creator of this visual message is likely to have been none other than the chancellor of the School of Chartres between 1208 and 1213, Peter of Roissy, who actually wrote a commentary on the Book of Job, interpreting Job as both Christ and the Church.[102] The two side portals on the north transept were therefore probably sculpted and constructed in the decade between about 1210 and 1220.

Compared to the north transept that on the south presents a more unified appearance both from an iconographic and stylistic point of view. The central portal is dedicated to the Last Judgement, with Christ in Majesty in the tympanum between the Virgin and St John and with angels holding the instruments of the Passion [60]; below in the lintel are the Blessed and the Damned, overflowing into the lowest two orders of voussoirs and separated by the Archangel Michael, who is in the process of weighing souls in a set of scales. Christ is seen again on the trumeau, flanked by the twelve apostles on the jambs, who hold the instruments of their martyrdom and trample on their oppressors to emphasise their relationship to the Passion of Christ. Carved on the trumeau are a number of small figures in two tiers whose identity remains unclear: the kneeling figure distributing loaves of bread may be Louis of Blois, the donor of the cranium of St Anne in 1204.[103] The western doorway is devoted to the famous martyrs [61]. The standing Christ is shown between two kneeling angels in the tympanum, while in the lintel is the martyrdom of the protomartyr St Stephen, who looks up towards the Saviour. Various seated martyrs occupy the archivolts and below in the jambs are six full-length figures which, reading from left to right, may be identified as Stephen, Clement, Laurence, Vincent, Dionysius and Piatus: the flanking figures of the warrior Saints Theodore [63] and George were only added when the porch was constructed after 1224. The third portal, on the east side, is commonly referred to as the Confessors' portal [62]. In the tympanum, below the half-length figure of Christ floating in clouds, are four scenes to do with Saints Martin and Nicholas. At the bottom, on the left, St Martin is seen on horseback in the act of dividing his cloak with the beggar, and on the right St Nicholas drops one of the three gold bags through the window of the house of the impoverished merchant with the dowerless daughters. Above, St Martin sleeps alongside his servant (with the divided cloak hanging above) and dreams of Christ wearing the other half of his garment, while on the right the body of St Nicholas is laid out on his tomb with the small figures of the sick in front of it. A third confessor's life – that of St Giles – is celebrated on the lowest order of the voussoirs. As on the Martyrs' portal, six jamb figures flank the opening, and again the two outermost figures, Saints Laudomarus and Avitus, were added when the porch was constructed; the others, reading from left to right, are likely to be Pope Leo the Great, St Ambrose, St Nicholas, St Martin, St Jerome and St Gregory the Great.[104]

As the transept sculptures – excluding the porches – must have been completed by 1224 at the latest, it seems obvious that a number of separate teams of workmen were employed. In order to finish such an ambitious programme, containing hundreds of figures of different sizes, in the space of about twenty years, it is likely that different teams worked on some of the doorways concurrently. Sculptors from Laon have already been mentioned in connection with the central portal of the north transept, which was probably started first, and the contribution of a workshop from Sens has been recognised in the sculptures of the Confessors' and Solomon portals. After the Coronation portal was finished, or while it was still in the course of execution, the Judgement portal

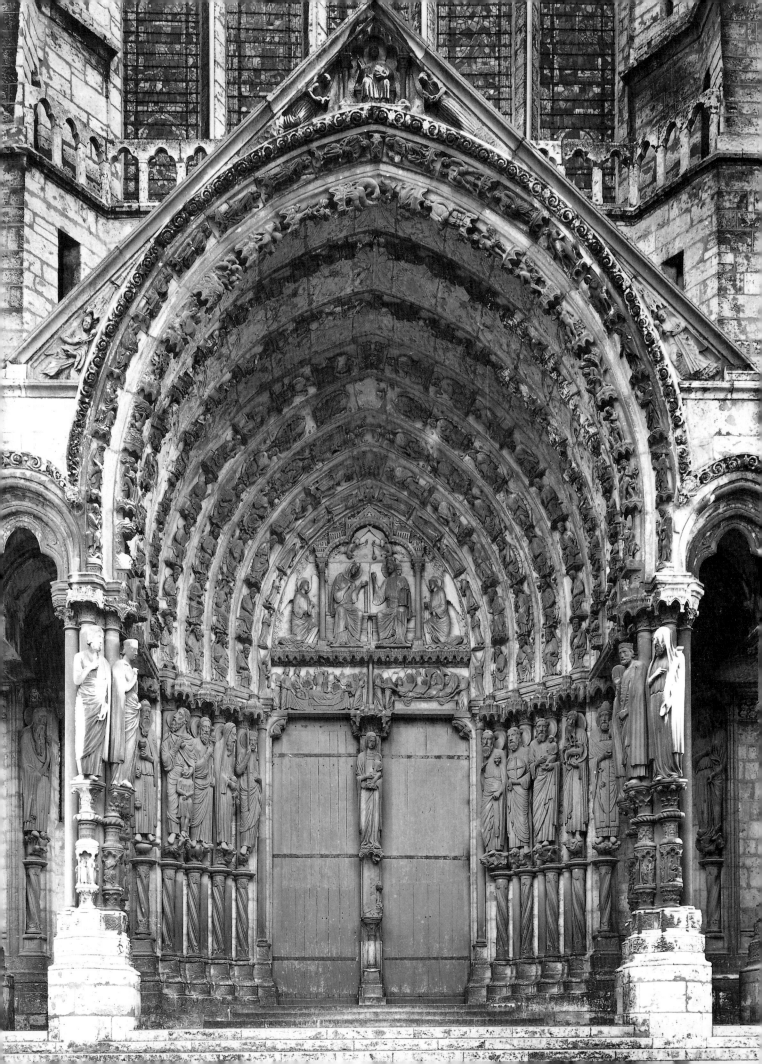

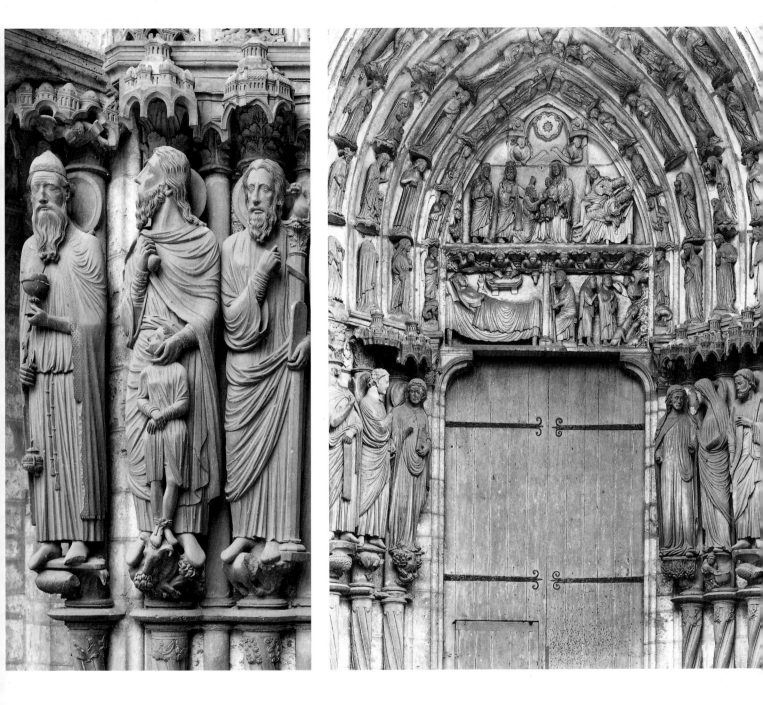

56. Central (Coronation) doorway, north transept, Chartres Cathedral; c.1204–10

57. Central doorway (detail of jambs), north transept, Chartres Cathedral; c.1204–10

58. East (Infancy) doorway, north transept, Chartres Cathedral; c.1215–20

59. (*overleaf, left*) West (Solomon) doorway, north transept, Chartres Cathedral; c.1215–20

60. (*overleaf, right*) Central (Judgement) doorway, south transept, Chartres Cathedral; c.1210–15

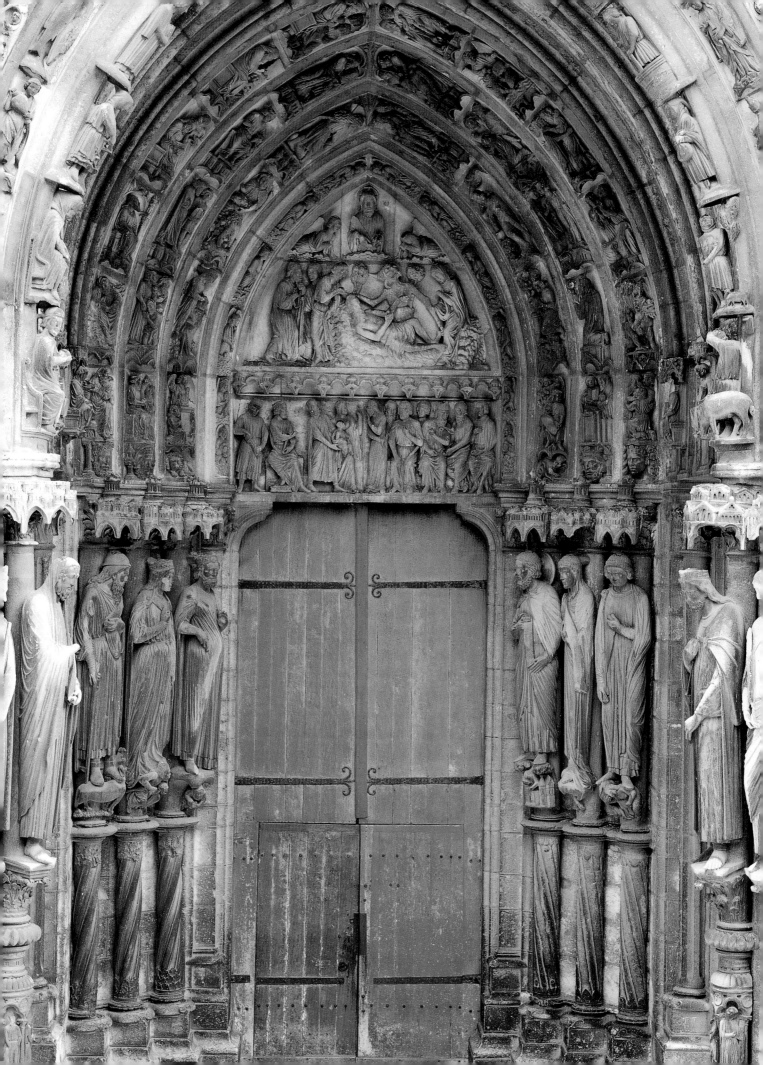

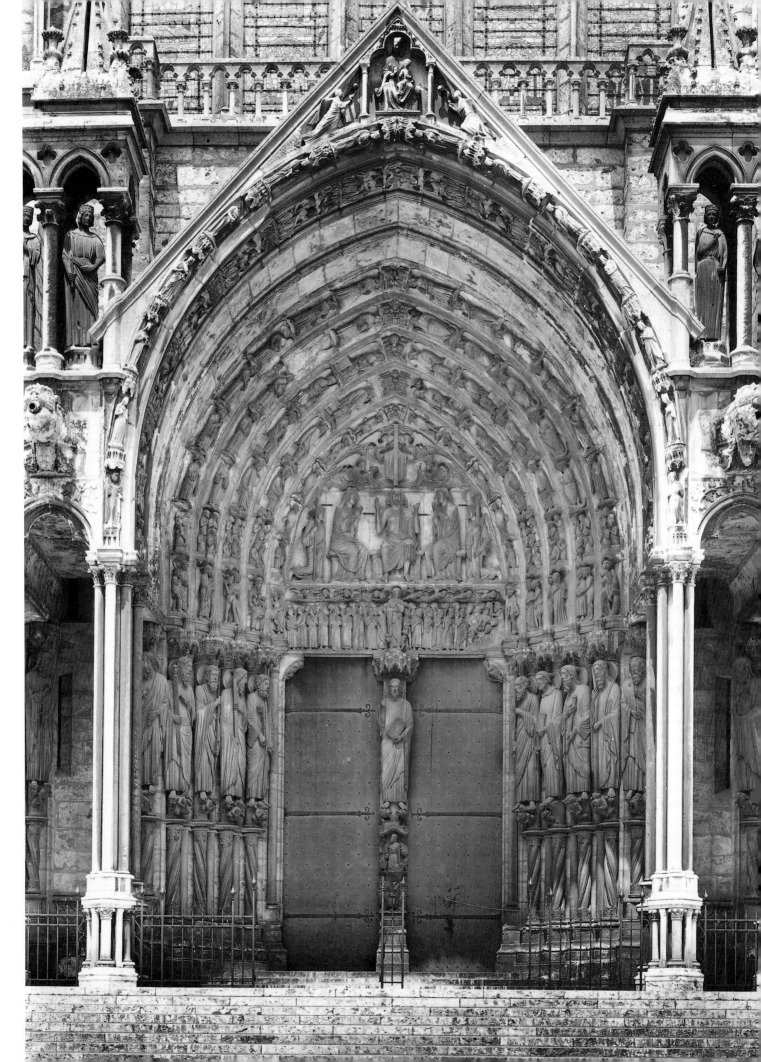

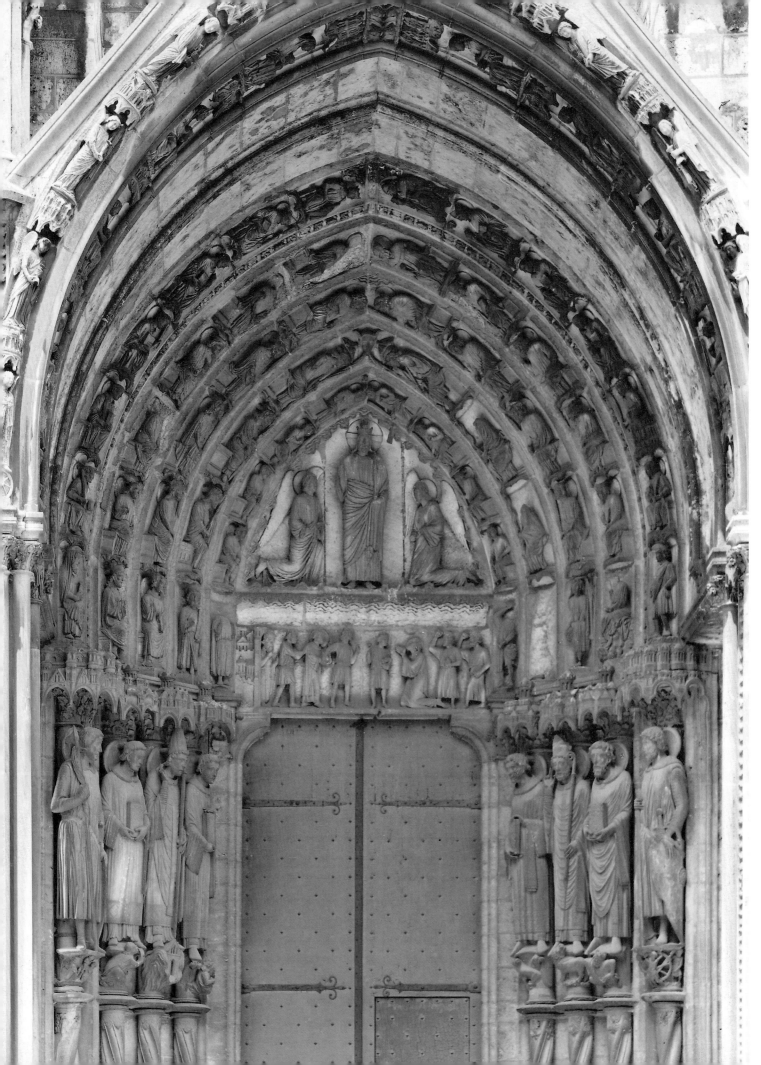

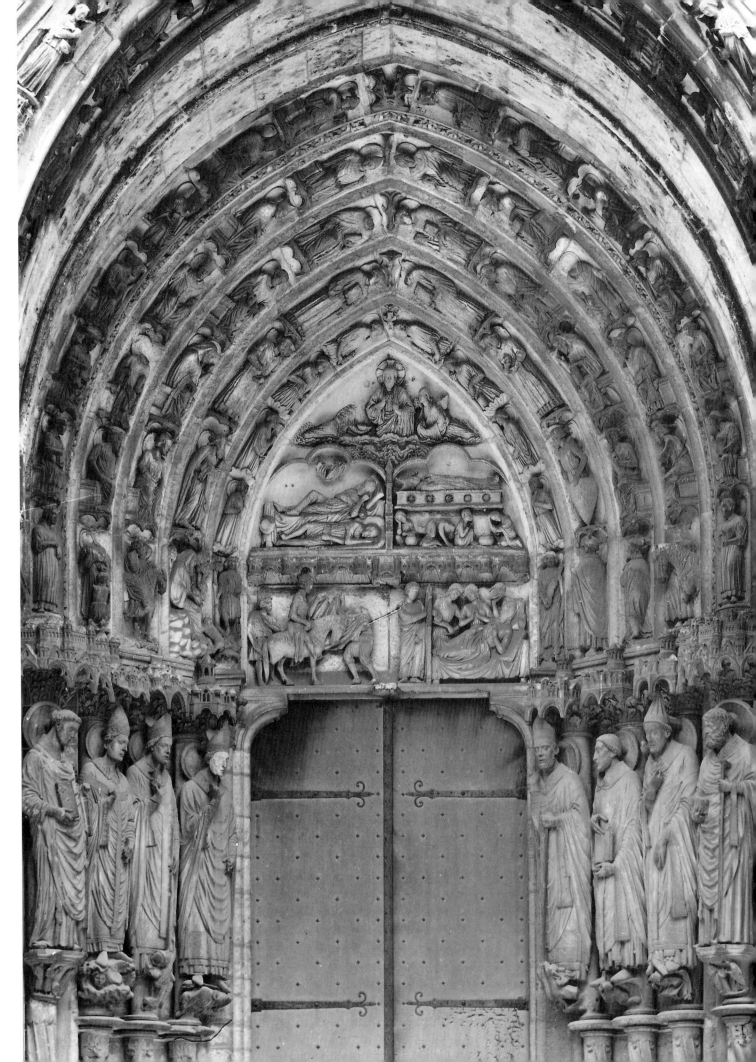

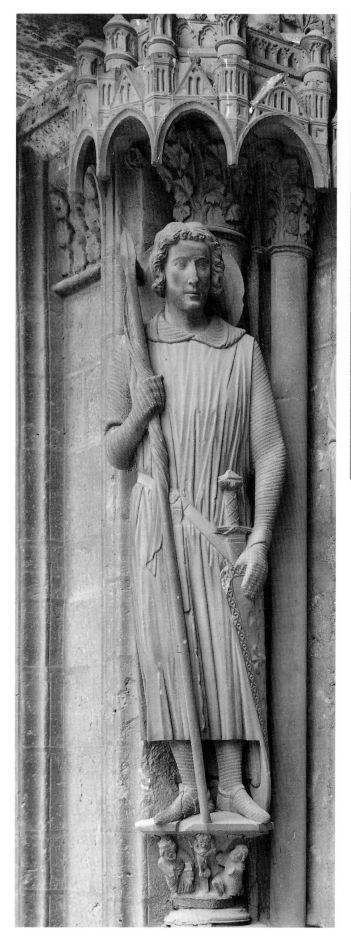

61. (*preceding page, left*) West (Martyrs') doorway, south transept, Chartres Cathedral; *c*.1210-5 and 1230 (outer jamb figures)

62. (*preceding page, right*) East (Confessors') doorway, south transept, Chartres Cathedral; *c*.1215-20 and 1230 (outer jamb figures)

63. St Theodore; west doorway, south transept, Chartres Cathedral; *c*.1230

64. Pride and Humility; south transept porch, Chartres Cathedral; *c*.1230-40

65. The Nativity; relief from the destroyed *jubé*, Chartres Cathedral; *c*.1220-30

would have been started, probably by the same Laon workshop. The Martyrs' portal was probably also executed by this atelier in the years after 1210, while the teams were augmented by sculptors from Sens, who completed the work on the Confessors' portal in all likelihood in the years just before 1220.[105]

The whole monumental ensemble was completed on both transepts by the addition of deep porches, bringing their appearance into line with their prototype, the west façade of Laon cathedral. The north transept porch was built first, presumably directly after work was completed on the side portals, in the 1220s. There were originally twenty column figures, carved by different workshops, and once again we can recognise the style of Laon in a number of the figures flanking the Coronation portal.[106] The identity of the figures remains unclear, with the exception of two local saints, Modesta and Potentianus and the now-missing figures of *Synagoga*, *Ecclesia*, Leah and Rachel (or Martha and Mary).[107] Column figures were done away with on the porches of the south transept, and the sculptures here, including an extraordinarily rich compendium of typological and exegetical reliefs on the piers – the Virtues and Vices [64], scenes of martyrdom and the Elders of the Apocalypse – are in a different style and likely to date from around 1230–40.[108] This style is the one now current in Paris, and it is from the capital that the sculptors must have come.

At the same time as the work on the transepts was being carried out, sculpture was produced for the interior of the building, the most notable ensemble being the choirscreen or *jubé*, which occupied the area between the giant crossing piers, closing off the canons' choir to the east. Although it was dismantled in 1763 fragmentary reliefs still remain at Chartres, while three heads have found their way into American collections; in addition, an engraving of 1697 – albeit indistinct – gives an impression of what the screen looked like.[109] The scenes of Christ's Infancy were placed above those of the Passion on the front and presumably on the sides, and the gables above the seven arches of the open arcade were also decorated with sculpture, the screen being topped by a silver-gilt Cross flanked by the Virgin and St

66. Fragmentary relief from the destroyed *jubé*, Chartres Cathedral; *c.*1220–30

John. Although the choir-stalls had been made by 1221, it seems likely that the screen was not finished until some time later. There is a mixture of different styles in the surviving reliefs, some of which relate to the sculptures outside on the transept doorways, especially those on the Solomon and Confessors' portals, while the style of others has more in common with the flatter drapery to be found at Notre-Dame in Paris and at Amiens, suggesting that they were carved during the course of the 1220s [65]. Perhaps the most remarkable of the reliefs are two large slabs which probably decorated the back of the screen, showing quatrefoils within roundels, inhabited by animals, the symbols of the evangelists and a variety of plant forms [66]. The carving on these particular panels is of a supreme quality, combining and contrasting a high relief treatment inside the roundels with a brilliant low relief technique in the scenes around the edges: in their relation to the roundels at the centre of the composition they recall marginal illustrations in manuscripts, while the exquisite refinement of their execution evokes once again the art of the goldsmith.[110]

SCULPTURE AT THE BEGINNING OF THE THIRTEENTH CENTURY AND THE INFLUENCE OF THE ANTIQUE

The two figures of St Laudomaurus and St Avitus added to the Confessors' portal on the south transept at Chartres in about 1230 are in a markedly different style from the other figures around the same doorway [67, 68]. The fall of their chasubles is delineated by curving ridges separated by deep, wide troughs which in comparison with the neater and more ordered draperies of the adjoining figures look as if they have been roughly gouged out. Likewise, the heads of the two figures stand out from those alongside. There is a classical naturalism in them not yet present in the slightly earlier figures, which follow a set physiognomic pattern and are individualised by the attributes at their feet rather than by different head types. Although this distinctive approach to drapery is seen for the first time at Chartres only in around 1230, and was to reach its most developed form in the sculptures of Reims and Bamberg in the same decade, it had actually first been employed in the last quarter of the twelfth century in a wholly different medium.

Because the 'trough fold' style is so clearly intimately linked with sculptural production it is surprising that its introduction in the medieval period appears to have been through works of art on a small scale and in two dimensions. Be that as it may, there is no twelfth-century sculpture which could have acted as a model for Nicholas of Verdun's enamels on the Klosterneuburg pulpit, which was completed by 1181.[111] As we have seen, this is about the same time as the earliest sculptures at Mantes, Châlons-sur-Marne and Sens, which although reflecting the style of works in metal, refer back to the naturalism of slightly earlier Mosan pieces. At a glance one can see the difference of approach taken by Nicholas from the goldsmiths' works immediately preceding him and the points of contact with the St Avitus at Chartres [69] – the troughs with rounded ends on Abraham's cloak (the so-called *Muldenfaltenstil*) and the liveliness of the rendering of his hair and beard. In his other known works,

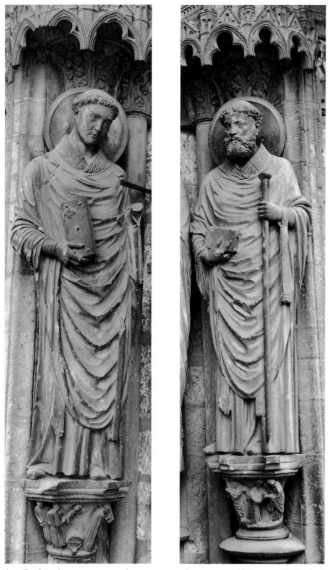

67. St Laudomarus; east doorway, south transept, Chartres Cathedral; c.1230

68. St Avitus; east doorway, south transept, Chartres Cathedral; c.1230

the seated figures of prophets around the Shrine of the Three Kings in Cologne Cathedral and the repoussé reliefs on the Shrine of St Mary in Tournai Cathedral, this formula was transformed into three dimensions, so that the similarity with the larger sculptures is inescapable.[112] Nicholas's early exposure to models which would have helped to create his individual style is not documented, but there can hardly be any doubt that he was profoundly influenced by classical sculpture, either directly or through early Byzantine intermediary sources, such as the sixth-century ivories on the throne of Maximianus in Ravenna.[113] Roman sculpture on both a large and small scale and Late Antique and Byzantine ivories were readily accessible in France in the twelfth and thirteenth centuries, as is proved by some of the drawings of Villard de Honnecourt [70].[114] That they were utilised as stylistic exemplars towards the end of the twelfth century should not perhaps be taken to indicate that artists at that time chose them as models simply because they were aiming for greater naturalism. It has been convincingly suggested

that by appropriating the stylistic vocabulary of classical statuary the Gothic artist was doing more than plagiarising for solely aesthetic reasons.[115] But the fact that Roman sculptures were appreciated in the late twelfth century for their beauty is unequivocally demonstrated by John of Salisbury's famous account of the purchase by Bishop Henry of Blois of Winchester of several classical statues while on a visit to Rome between 1149 and 1151, and by a slightly later detailed and enthusiastic description of the sculptures of the city by another Englishman, Magister Gregorius.[116] Could it be that Nicholas of Verdun was encouraged to adopt this classical *Muldenfaltenstil* by one of his early patrons, who might have wished to establish a link between the authority of the classical past and his own time?

By the beginning of the thirteenth century this distinctive drapery style had spread to manuscript illumination – the Ingeborg Psalter in Chantilly is the most notable example – and was employed by the sculptors of the jamb figures on the central portal of Notre-Dame in Paris.[117] Although the jamb figures of the western portals were taken down and mostly destroyed in 1793, two large fragments have survived from the central doorway (the body of St Andrew in the Musée Carnavalet and an unidentified torso in the Musée national du Moyen Age) which clearly demonstrate this tendency, and indeed the former has been strikingly compared with a fragmentary Roman statue now in Béziers [71, 72].[118]

THE CENTRAL AND NORTH PORTALS OF NOTRE-DAME, PARIS

The rebuilding of the cathedral of Notre-Dame, started at the east end after 1160 by Bishop Maurice de Sully, had by the beginning of the thirteenth century extended as far as the present west façade, when in 1208 houses were demolished in the immediate vicinity. As we have seen, the St Anne portal to the south was composed of twelfth-century pieces intended for an earlier façade, modified to fit the shape of a new portal and with early thirteenth-century fills in the voussoirs and lower lintel. It seems that when the west end was reached work started on the lower parts of the central and north portals first – up to lintel level – and that the socles and jambs were probably complete by about 1215.[119] The fine reliefs of the Virtues and Vices on the socles of the central portal are obviously derived both in style and layout from the Liberal Arts on the socles of the central portal at Sens and the roundels of *Avaritia* and *Largitas* on the Baptist portal of the same church, which begs the question whether the lost jamb figures there were similarly draped in *Muldenfaltenstil*: the surviving classicising heads at Sens may suggest that this was so, although the remaining figure of St Stephen on the trumeau is not of this type.[120]

Like the complicated – but at the same time perspicuous – earlier eschatological portals the central portal at Notre-Dame would have been read as a lesson, reminding visitors of the Judgement on the Last Day [73]. The Virtues and Vices play a vital rôle in this, positioned directly underneath the twelve apostles and continuing the vertical flow downwards of the voussoirs, which show angels, patriarchs, prophets, ecclesiastics, martyrs and virgins, all flanking the

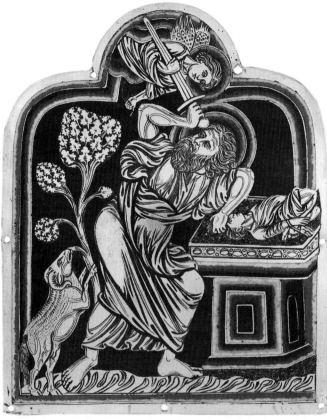

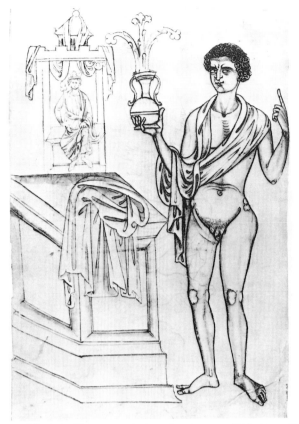

69. Nicholas of Verdun: The Sacrifice of Isaac. Detail of the former pulpit in the Stiftskirche, Klosterneuburg; champlevé enamel on copper, c.1181

70. Villard de Honnecourt: Antique figure; c.1235 (Bibliothèque Nationale, Paris, Ms. fr. 19093)

71. Fragmentary jamb figure of St Andrew from the central portal, west façade, Notre-Dame, Paris; c.1215–20 (Musée Carnavalet, Paris)

72. Roman statue from Roujan (Musée Archéologique, Béziers)

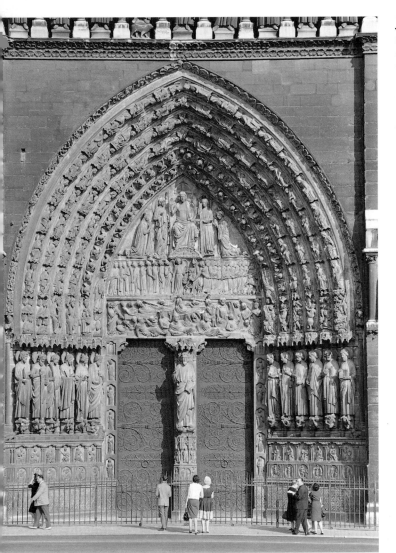

Judging Christ in the tympanum. Below Christ, the Blessed and Damned are separated by the archangel Michael, while on the lintel the Dead rise from their tombs. In the centre of the door is the figure of Christ on the trumeau, with the Last Judgement parable of the Wise and Foolish Virgins on the flanking doorposts.[121] It is significant that the Virtues and Vices should be brought down from the voussoirs, where they had been seen in earlier compositions, to a position at the churchgoer's eye-level, making their message inescapable: the apostles and the heavenly congregation in the voussoirs were out of reach of the public, but the very human vices of cowardice, anger, and so on were plain for all to see. Sitting serenely above each Vice is the Virtue which would triumph over it, offering salvation to those in need of guidance [74]. This *Summa virtutum et vitiorum* served to involve the viewer – through the illustration of human faults and the means by which they could be overcome – more directly than ever before.[122]

The sculptor of the Virtues has portrayed them sitting on thrones under depressed arches, each one holding a disc which encloses a symbolic attribute. It is unlikely to be coincidental that they resemble the gilt copper seated figures around the massive shrines of the Rhineland and Meuse valley, such as those already mentioned on Nicholas of Verdun's shrine of the Three Kings in Cologne Cathedral, and in this connection it should be remembered that they would originally have been fully coloured, perhaps even

73. Central (Judgement) portal, west façade, Notre-Dame, Paris; c.1210–30

74. Pride and Humility; central portal, west façade, Notre-Dame, Paris; c.1215

75. Villard de Honnecourt: Pride and Humility; c.1235 (Bibliothèque Nationale, Paris, Ms. fr. 19093)

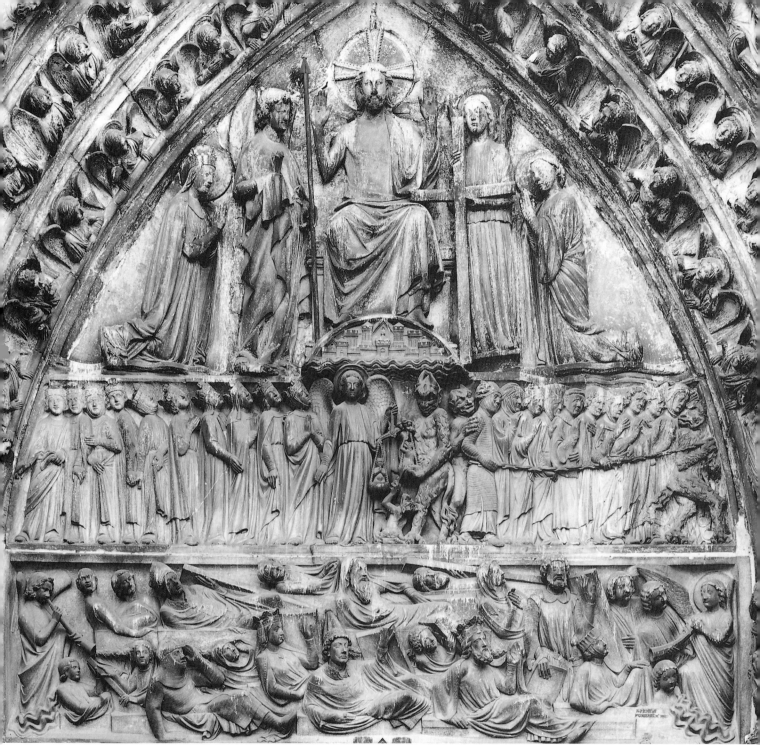

76. Tympanum of the central portal, west façade, Notre-Dame, Paris; *c*.1220–30

gilded. The range of fluid poses, the troughed drapery folds, the circular indentations in the spandrels of the arcades (possibly to hold fake gems, now long gone?) and the decoration of the dado below the Vices in the manner of repoussé gilt copper sheets, all serve to reinforce this association with shrines.

The ethical *Summa* of the Virtues and Vices perfected at Notre-Dame was copied, but not presented as tellingly, on the south porch at Chartres and on the west front of Amiens. Villard de Honnecourt also recorded the images of the Virtue of Humility and the Vice of Pride in his sketchbook [75]. Curiously, the image of Pride falling from his horse is closest to that at Chartres [64], while the figure of Humility most nearly approximates to that at Notre-Dame: both are

drawn in Villard's distinctive *Muldenfaltenstil*, which is so similar to the sculptures at Paris and Reims that one must assume an intimate connection with the sculptors' lodges in the 1220s and 1230s.[123]

The tympana of both the central and north portal – the latter illustrating the Assumption and Coronation of the Virgin – introduce new features into the repertory of the Gothic sculptor. It has been shown that on the central portal the figures of Christ, the angel holding the nails and spear of the Passion, and the figures on the left side of the lintel (the original is now in the Musée national du Moyen Age) are in a more advanced style than the rest of the doorway [76]. It has yet to be proved, however, whether this difference indicates that these parts were inserted into the door in

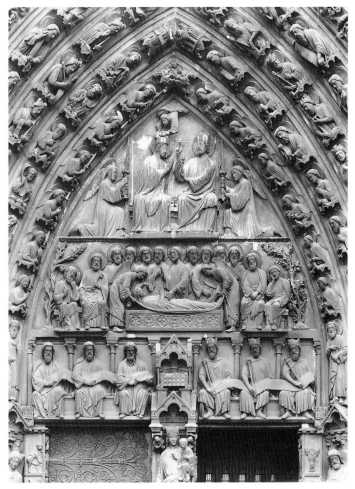

77. Tympanum of the north (Coronation) portal, west façade, Notre-Dame, Paris; c.1220

duced into the lower lintel, flanking the Ark of the Covenant, and locally venerated saints took up position on the jambs, their identities confirmed by small square reliefs at eye level on the socle.[126] Both features were copied at Amiens, while the devotion to local saints was marked again in the portal programmes at Reims and Bourges. The Virgin's place at the centre of the Cosmos was also stressed by a series of reliefs around the opening of the doorway of the type normally only found in portals dedicated to Christ: these show the Signs of the Zodiac, a Calendar, the Six Ages of Man, and images which appear to refer to different temperatures. The whole portal is flanked by two pillars with lush and naturalistic plant ornament, anticipating the closely-observed leaf forms to be found at Reims, Naumburg and Southwell later in the century.[127]

Above the portals on the west front was a gallery of kings, containing twenty-eight over life-size statues of the Kings of Judah, the ancestors of the Virgin. These were pulled down at the Revolution, and although not a single body has been found, twenty-one massive heads were recovered in 1977: together with the fragmentary torsos from the Saint Anne portal these represented a discovery of the greatest importance.[129] Many of the heads retain extensive traces of paint, sensitively and naturalistically applied to the cheeks, eyes and lips, and demonstrate how important colour was to the thirteenth-century audience [78]. From the ground the paint would not have been clearly visible, yet it has been applied as carefully as if the sculptures were of polychromed wood and intended to be seen at close quarters.[128] They were presumably executed immediately after the latest of the sculptures below, in the late 1220s, and show more obviously than any of the other existing sculptures at Notre-Dame the still-strong influence of the Sens heads.[130]

around 1240, as has been suggested, or on the contrary whether they offer evidence of the first contributions of an innovative member of the Notre-Dame workshop in the late 1220s.[124] The latter seems more likely. Certainly, the fine head of Christ has much in common with such works as the trumeau figure of King Childebert from Saint-Germain-des-Prés and the apostles of the Sainte-Chapelle, both of the 1240s, but it should be expected that the Notre-Dame workshop would provide the stylistic impetus for later Parisian sculptures and that the sculptors who disseminated the new 'mature' Gothic style were trained there.

In addition to the influence of the antique on the now mostly missing jamb figures, it has been proposed that Byzantine ivories were used as a stylistic source by one of the sculptors of the north portal [77]. The flattened and angular draperies of the St Peter to the left of the Assumption of the Virgin on the lintel and his severe frontality – staring out from the scene as if oblivious to the action taking place alongside – are sufficiently close to certain tenth- and eleventh-century Byzantine ivory reliefs to suggest knowledge of the latter by the Parisian sculptor, and of course ivory triptychs and bookcovers must have been brought back from the Sack of Constantinople in 1204.[125]

The iconographic programme on the north portal also breaks with the past. Seated prophets and kings were intro-

TOMB SCULPTURE

Because of the close association between architectural form and the beginnings of Gothic sculpture, emphasis has been placed on the development of the portal. But although the entrance to the church provided the framework for the creation of sophisticated iconographic programmes and the growing importance of the three-dimensional figure within those schemes, it should not be forgotten that the sculpted tomb – by its ubiquity – was also a major source of employment. By the beginning of the thirteenth century shallow effigies set into the floors of churches had been superseded by more realistic figures in higher relief resting on a free-standing tomb chest or *tumba*, or recessed into a niche (as was the tomb in Reims Cathedral which provided the sculptures for the *Porte romane*). This development went hand-in-hand with the experiments on the portals and in many instances it can be demonstrated that the cathedral workshops were also responsible for sepulchral effigies: the *gisants* in the abbey church of Notre-Dame-de-Josaphat, the burial place for the bishops of Chartres in the late twelfth and early thirteenth centuries, are perhaps the most striking illustration.[131]

78. Head from the gallery of kings, west façade, Notre-Dame, Paris; c.1230 (Musée national du Moyen Age, Paris)

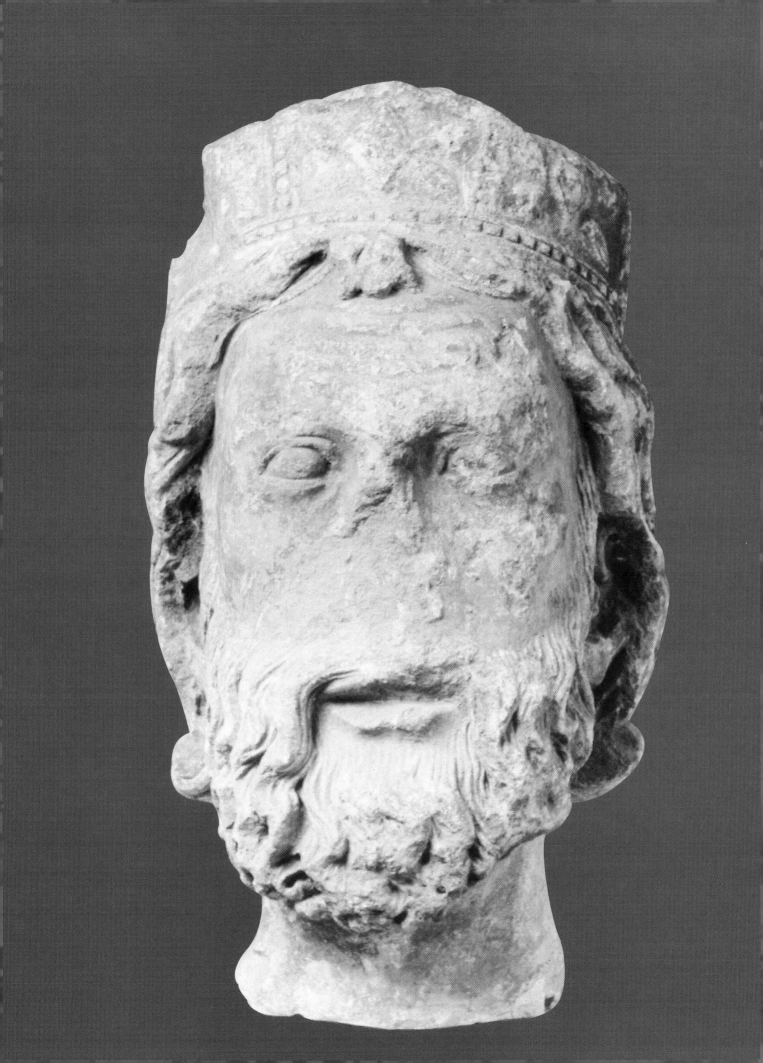

79. Tomb effigy of Eleanor of Aquitaine (d.1204); abbey church, Fontevrault; *c.*1204–10

In addition to making tombs for those recently deceased it became more and more common to honour famous ancestors – and especially founders of monasteries and churches – with retrospective monuments, as was done most notably for the Merovingian, Carolingian and Capetian rulers at Saint-Denis in 1263–4. The practice was not designed to help future historians to date the sculptures; although there can be no question of anyone now considering the effigy of Charles Martel (died 741) in Saint-Denis to be of the eighth century, in the absence of documents it is sometimes difficult to know how many years elapsed between the death of the person commemorated and the erection of their tomb. This is the case with the four famous *gisants* of the Plantagenets at Fontevrault in Anjou. It has been pointed out that the effigies are represented on cloth-covered biers as if lying in state – a ritual introduced in England in the second half of the twelfth century – and this very uniformity obscures our ability to separate them in date. The effigies of Henry II (died 1189) and Richard the Lionheart (died 1199) have been put forward as the earliest, possibly commissioned by Henry's widow Eleanor of Aquitaine before her death in 1204. Her effigy, quite extraordinarily showing the queen with an open book in her hands [79], followed perhaps immediately after her demise. The fourth effigy, carved in wood, is often identified as Isabella of Angoulême, but as she only died in 1246 it is likely to represent a so-far unidentified figure; the theory that it was made in 1254 in the style of the earlier effigy of Eleanor would appear to be contrary to thirteenth-century mores.[132]

From the 1230s onwards the tomb monument would become an increasingly important vehicle not only for the creative ideas of the best sculptors but also for sending out political signals to those who could read them. The employment of retrospective effigies for pressing particular claims had a precedent at Wells Cathedral at the beginning of the century (see p. 105) and would be repeated in a different form at Naumburg in around 1250; but it was taken to an extreme at Saint-Denis, as will be seen later.

STRASBOURG AND FRENCH LINKS WITH THE HOLY ROMAN EMPIRE

It will have become clear that a number of large workshops were working concurrently in different important centres in the first third of the thirteenth century. Work commenced on the transepts at Chartres at the outset of the century and continued until the 1230s; at almost exactly the same time the west façade and most of its sculpture was erected at Notre-Dame in Paris. Also towards the end of this period, as we shall see, the earliest of the many sculptures made to adorn the exterior of Reims Cathedral were made. Inevitably the workshops brought together at Chartres and Paris expanded and contracted as sculptors and stone masons joined and departed. By stylistic analysis it has been possible to distinguish the contribution of sculptors from Laon and Sens at Chartres, for instance, and it has also been shown how influential the Sens model was for the overall design of the Gothic portal. Outside the great cathedrals of Paris, Chartres and Reims the stylistic hallmarks of their sculpture workshops were disseminated by sculptors who had been trained in those centres, but in many instances new elements were added, thus modifying and refining Gothic style from locality to locality. The early thirteenth-century sculptures of Strasbourg and Lausanne are examples of this.

Strasbourg did not, of course, become part of France until the seventeenth century. At the beginning of the thirteenth century its bishop was suffragan to the Archbishop of Mainz and, being situated on the Upper Rhine, its trade links were mostly with other cities of the Holy Roman Empire. However, links established within the Church were as important as political affiliations and Strasbourg, more than any other city of the Empire, often found itself looking westwards. An example of this – perhaps significant in our context – is the fact that in 1207, Henry of Vehringen (Bishop of Strasbourg since 1202) was unable to be consecrated by the Archbishop of Mainz, who was under Papal Interdict, so he went with the approval of the Pope to the Archbishop of Sens instead.[133] As it happens, the Sens workshop seems to have provided the starting point for some of the sculptures at Strasbourg, although Chartres must have acted as the conduit.

The early thirteenth-century sculpture at Strasbourg Cathedral is confined mainly to the south transept.[134] It consists of a double portal, now rather diminished by the destruction of the jamb figures in 1793 and by the replacement of much of the other sculpture by copies or replacements, and the magnificent 'Angels' Pillar' in the interior [80, 85].[135] An idea of the original appearance of the portal can now best be gained by reference to Isaac Brunn's

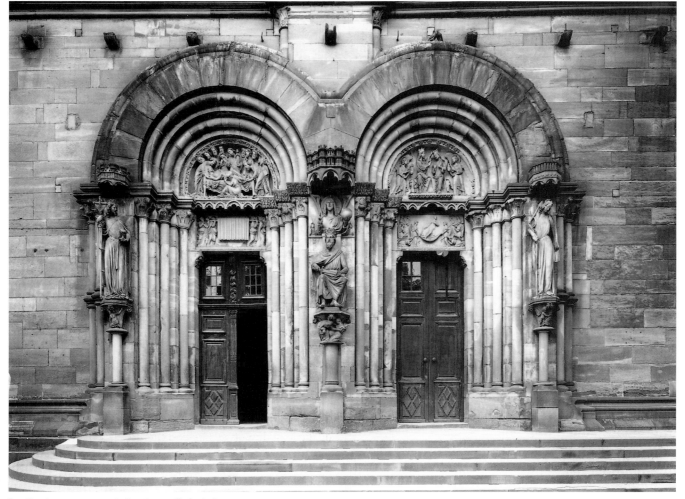

80. South transept portal, Strasbourg Cathedral; c.1225–30

engraving of 1617, which shows the twelve apostles around the doors, six to each doorway; although the figures are now gone, three heads survive in the Musée de l'Œuvre Notre-Dame.[136] Unusually the twelve apostles are disposed around doorways which celebrate the Virgin, rather than Christ, and this has led some to the supposition that they were originally intended for a Judgement portal: this cannot now be proved one way or the other, but the style of the existing heads is close enough to the heads of the apostles on the left-hand tympanum, which shows the Death of the Virgin [81], and so different from the restrained and elegant heads of Paris and Chartres that one is immediately aware of a local and very original contribution. The dramatic action of the scene of the Virgin's Death is accentuated by the crowding of the apostles and Christ around her bed, squashed in by the low curve of the arch above. The carving and composition of the narrative is a virtuoso performance, creating a scene of great pathos in high relief, where one might believe that the apostles are able to step out of the lunette. Each apostle, the solemn figure of Christ holding the Virgin's Soul and the crouching female figure in front of the bed (perhaps Mary Magdalene), registers an individual note of grief using demonstrative gestures or plaintive facial expressions. We see again the heavy, classical *Muldenfaltenstil* of the draperies by this time familiar in the Royal Domain, but what sets the

scene apart is the power of the drama, emphasised by the twisting and turning of the figures and the knitted brows of the participants. It suffices to compare it with the adjoining tympanum of the Coronation of the Virgin, probably carved by a more conservative member of the workshop, to appreciate its very special qualities.

Similarly characteristic and expressionistic heads to those at Strasbourg are to be found at La Madeleine, Besançon, Notre-Dame de Beaune and – to a less marked degree – Notre-Dame de Dijon. Unfortunately, none of the ensembles from which these heads might have come can be dated accurately, leaving open the question of whether sculptors came from Burgundy or travelled on to there after working at Strasbourg. In any case, all these heads share a slightly wild, passionate quality, with unkempt, full beards and with their emotional state etched by fine lines on their foreheads: all in all, they are completely different from the slightly earlier and rather frigid visages of the apostles on the south transept at Chartres. Those at Besançon [82] are probably by the same hand as the Strasbourg jamb apostles.[137]

One can detect a different sculptor's work in the famous figures of *Ecclesia* and *Synagoga* [83, 84], and there cannot be much doubt that this particular sculptor had been trained at Chartres. The treatment of the drapery, the way the cloth falls to the ground, the detailed and aloof head types, can all

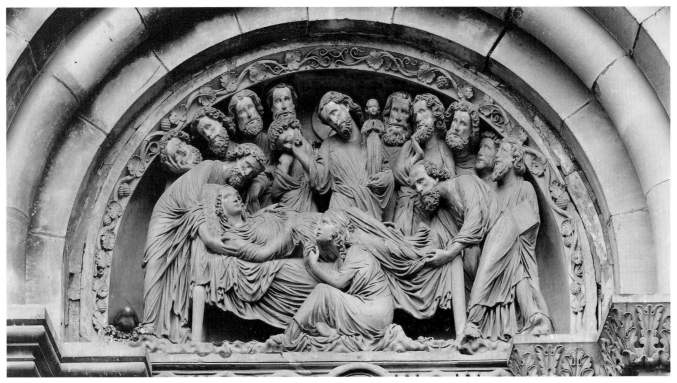

81. Tympanum of the left doorway, south transept portal, Strasbourg Cathedral; *c.*1225–30

82. Head from La Madeleine, Besançon; *c.*1230 (Musée d'Archéologie, Besançon)

83. Personification of *Ecclesia*, from the south transept portal, Strasbourg Cathedral; *c.*1230–5 (Musée de l'Œuvre Notre-Dame, Strasbourg)

84. Personification of *Synagoga*, from the south transept portal, Strasbourg Cathedral; *c.*1230–5 (Musée de l'Œuvre Notre-Dame, Strasbourg)

be matched on the figures of the north porch at Chartres, and *Ecclesia* could almost form a pair with either the St Theodore [63] or St George at Chartres, which were added to the outside of the Martyrs' doorway on the south transept at Chartres in around 1230. It is significant that these figures at Chartres have the same type of historiated consoles beneath their feet and architectural canopies above their heads as *Ecclesia*, *Synagoga* and King Solomon, but a striking development has taken place at Strasbourg, where the three figures have been released from an architectural setting: they are not column figures, but free-standing statues.[138] Like the warrior saints at Chartres it is probable that these three figures at Strasbourg did not form part of the original portal scheme, but were added shortly after, either during or after the work on the Angels' Pillar inside; this speaks for a date in the early 1230s. Be that as it may, it has quite rightly been pointed out that they not only complement and appropriately extend the iconographic programme of the portal but that they are site-specific. It is known that the south portal and the transept itself were used in the thirteenth century as courts of law by the bishop, and in this context the True and False Church (*Ecclesia* and *Synagoga*) and the Wisdom of Solomon would have been constantly referred to. The Angels' Pillar – which is often alternatively described as the Judgement Pillar – was also aptly positioned in this connection, since it stands in the centre of the transept behind the double portal.[139]

The Angels' Pillar is a brilliant decorative response to a structural need. Both transept vaults are supported by massive pillars, but only the south was embellished with sculpture, indicating that it was intended to relate to the sculptures of the south portal and that the area from the beginning was set aside for special use.[140] Placed on an octagonal base, the Angels' Pillar is composed of four large and four smaller attached columns, the remarkable sculptures being attached to the latter [85–87]. They are arranged on three levels, with the four evangelists at the bottom, standing on consoles containing their symbols, four angels in the middle tier blowing trumpets as if on the Day of Judgement, and at the top the Seated Christ, his wound exposed, on a socle composed of small figures rising from the dead, flanked by three angels holding the instruments of the Passion. The bodies were elongated in relation to their position on the pillar, and the drum-like socles gradually increased in height, so that the bottom parts of the figures in the middle and top row could be seen from the ground. It is important to note that Christ faces west, not towards the entrance from the south transept but to address those approaching from the main doorway (which was still at this time in its Romanesque form), and turns his head to look towards the canons' stalls near the crossing. It might be added that although it is often called the Judgement Pillar, the choice of figures and the way they are represented suggest that a more appropriate reading would be to do with Redemption: there is no reference to the Damned and the emphasis is placed strongly on human salvation reached through Christ's sacrifice and the writings of the evangelists.

85. Angels' Pillar; south transept, Strasbourg Cathedral; *c*.1230

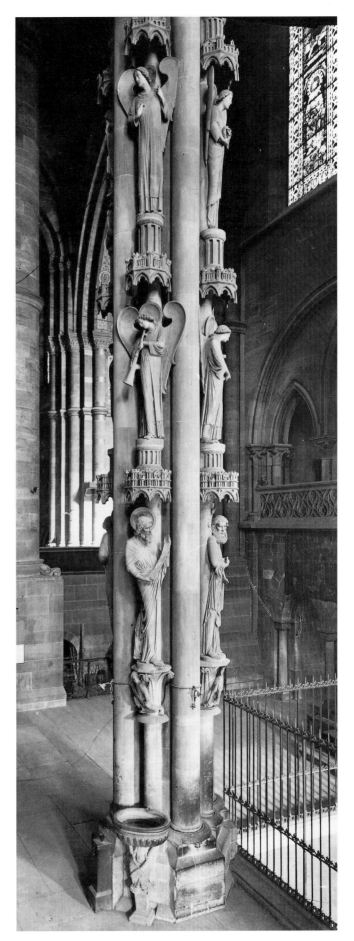

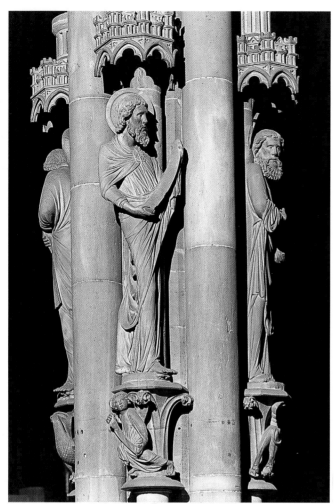

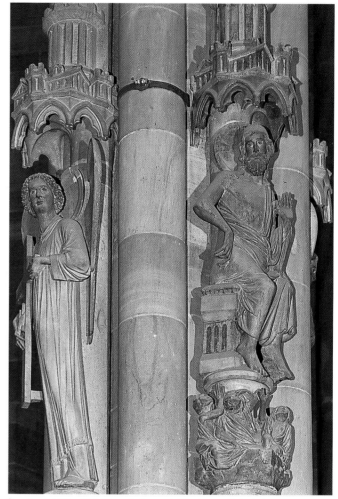

86. Saints Matthew and Luke; Angels' Pillar, south transept, Strasbourg Cathedral; *c.*1230

87. Angels' Pillar (detail), south transept, Strasbourg Cathedral; *c.*1230

For obvious reasons sculpted depictions of the Last Judgement were almost invariably confined to the decoration of portals.

Although the Strasbourg Pillar is unique, there is a formal precedent for the practice of grouping full-size figures around a central core at Chartres. Hardly surprisingly, this is on the north porch [54], which the Strasbourg sculptor not only knew well but possibly even worked on. The figures at Chartres are grouped in pairs, and only on one level, but they represent the intermediary stage between the portal-related jamb figures of the early thirteenth century and the independent figures on the Pillar at Strasbourg, which can be walked around and are not tied to an architectural function. The style is also unequivocally Chartrain, the heads of the angels returning to the roots of the Chartres style, as seen in the figure of St Stephen at Sens of around 1200; the head types of the Evangelists and Christ reveal few of the fiercely individual characteristics of the freer heads from the portals. Being inside, the sculptures have been protected from the elements and still retain a certain amount of their colouring. Their pristine condition allows us to imagine the full impact of the great decorative programmes of Chartres, Paris and Amiens when new; fully painted, they might have appeared as a miraculous celestial vision.

We are even more fortunate with the sculpture of the south portal at Lausanne Cathedral of about 1220–30, the polychrome decoration of which has already been mentioned in the introduction (p. 6).[141] The portal, situated at the second bay of the nave from the crossing, is enclosed within a small square porch [88]. Above the door the tympanum shows the Coronation of the standing Virgin, crowned by the seated figure of Christ in a mandorla, attended by five angels, which clearly harks back to twelfth-century reliefs of Christ in Majesty rather than reflecting the current arrangement of the Virgin seated as an equal alongside Christ; this is all the more surprising as the lintel scenes of the Death and Assumption of the Virgin derive from the post-Senlis type of depiction, which always shows just such an image of the Coronation above. To the left of the door are Moses, John the Baptist and Simeon, to the right Saints Peter, Paul and John the Evangelist; directly opposite are a further six jamb figures – Jeremiah, David and Isaiah face the Old Testament prophets, and Saints Matthew, Luke and Mark complement the New Testament figures on the right. St Michael occupies the trumeau, while above on all four sides of the porch are two orders of voussoirs with the elders of the Apocalypse, prophets and saints.[142]

The curious iconographic type of the tympanum and the

unique choice and arrangement of jamb figures may be explained by the fact that the decorative scheme was planned in accordance with the Homilies of the Blessed Amédée de Lausanne (*c*.1110–59). In one of his homilies he recounted how the soul of the Virgin 'advanced towards the Lord, surrounded by choirs of angels, carried by the respectful devotion of the apostles, immune to all pain, free of any blemish', and in another how the Old and New Testaments were arranged on the left and right of the Virgin, just as the jamb figures are at Lausanne.[143] The effect of entering this heavenly realm would have been increased by the gleaming whiteness of the figures' garments, enhanced by gilded ornamental borders, and by the blue of the vault.

As at Strasbourg, the style is of the Chartres north transept; but again it is informed by the local contribution, which is seen most strikingly in the heads of St Paul and Moses [89], who share the broad bushy beards of the contemporary jamb figures at Strasbourg and Besançon. A connection with the latter is hardly surprising, as Lausanne came within the archdiocese of Besançon, and there are other iconographical similarities between the now-destroyed portal of the collegiate church of La Madeleine and Lausanne, most noticeably the rare choice of the Archangel Michael as trumeau figure. However, the portal at Besançon differed from that at Lausanne in that it appears to have had a standard layout – albeit with seven jamb figures on either side of the doorway – whereas the chapel-like porch at Lausanne, with jamb figures facing one another, brings to mind the earlier arrangement of the Pórtico de la Gloria at Santiago de Compostela.[144]

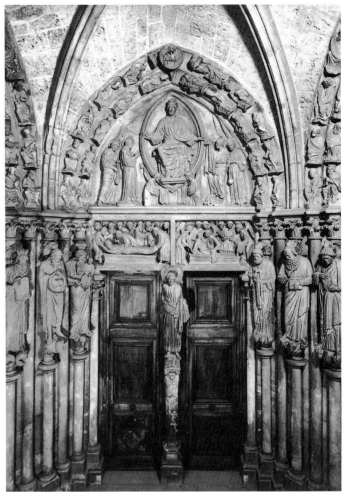

88. South portal, Lausanne Cathedral; *c*.1220–30

89. Moses; jamb figure, south portal, Lausanne Cathedral; *c*.1220–30

THE EARLIEST FIGURES ON THE WEST FAÇADE, THE CHOIR AND THE NORTH TRANSEPT PORTALS OF REIMS CATHEDRAL

As at Chartres sixteen years before, the old cathedral of Notre-Dame at Reims fell victim to fire on 6 May 1210. Work on its reconstruction began at the east end almost at once, so that by 1221 daily masses were being held in the axial chapel of the ambulatory and in 1223 and 1226 the coronations of Louis VIII and Louis IX took place inside the building. Because of its status as the centre of one of the largest archdioceses in Gaul, it was clearly the intention to create the grandest cathedral of all, to compete with and surpass the great buildings going up at Sens, Chartres, Paris, Soissons and elsewhere. In 1241 the chapter took possession of the completed choir and the four eastern bays of the nave, but after that date work must have slowed: the cathedral's west façade (excluding the towers) was not finished until late in the century. The building of a major cathedral was a hugely expensive endeavour and the costs incurred were a heavy burden for any chapter and town to bear, but it seems that at Reims the burghers of the town reached breaking-point in the face of the over-ambitious levies of the ec-

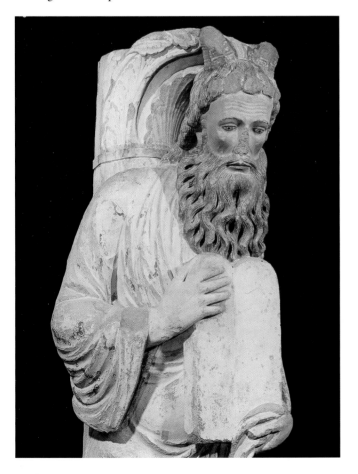

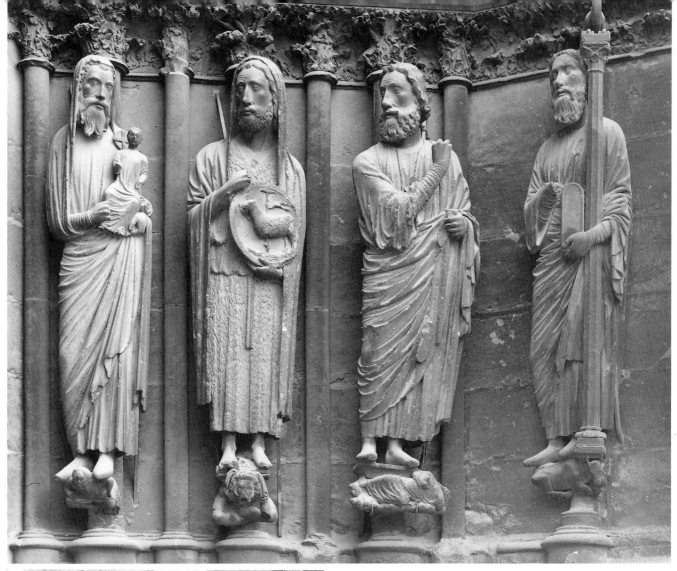

90. Jamb figures, south doorway, west portal, Reims Cathedral; *c*.1215–20

91. Angel; chevet, Reims Cathedral; *c*.1220–5

92. Central (Calixtus) doorway, north transept, Reims Cathedral; *c*.1225–30

clesiastical authorities: the friction created by the constant drain on the town's financial resources sparked open rebellion in 1233, when the clergy were forced to flee and were only able to return in 1236.[145] This cessation of building signalled a break in the sculptural output at Reims, so that it is possible – and because of the size of the programme, preferable – to divide the pre-1233 sculptures from those produced after the re-founding of the workshop. The later sculptures of the west front will be dealt with in the second part of the book.

On the right embrasure of the south doorway on the west front are six jamb figures of patriarchs and prophets, in a style and with socles conspicuously different from the surrounding sculptures [90]. These are the earliest figures from the post-1210 programme of work and it is clear that they do not now occupy the position originally intended for them. From the inside, the figures represent Simeon, John the Baptist, Isaiah, Moses, Abraham and Aaron, and it has been claimed that they were made for a portal of the Coronation of the Virgin, planned for the west front of the cathedral but subsequently abandoned. More recently an

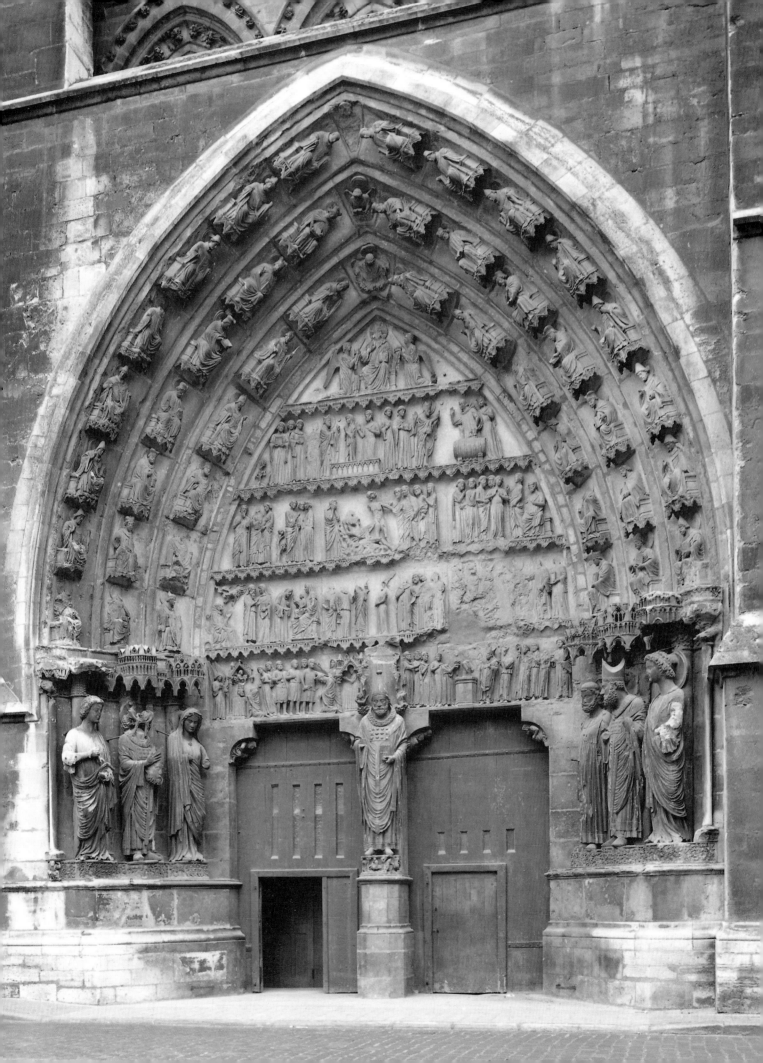

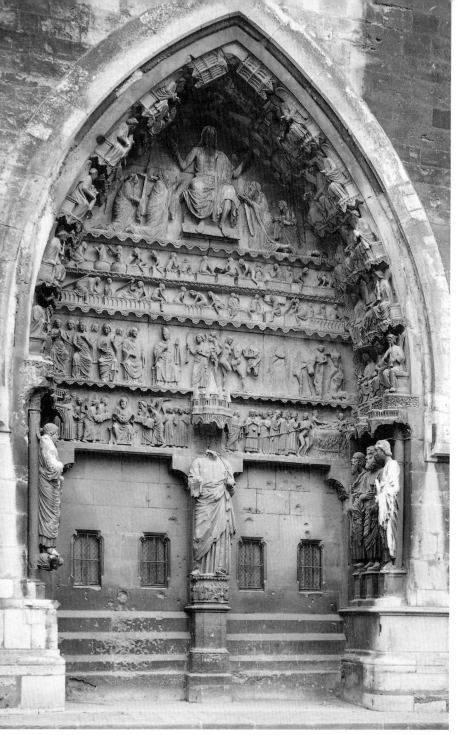

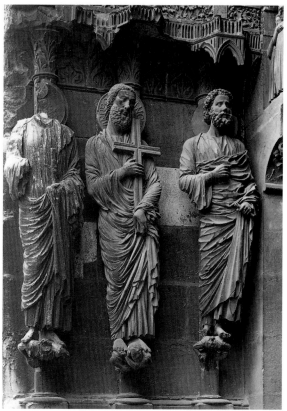

94. Saints Bartholomew, Andrew and Peter; jamb figures, east doorway, north transept, Reims Cathedral; c.1225–30

93. East (Judgement) doorway, north transept, Reims Cathedral; c.1225–30

alternative proposal has been put forward that they were installed on the front of the surviving façade of the previous cathedral, which was presumably not demolished until the middle of the century, in the manner of the statues on the church of Saint-Rémi in Reims.[146] One sees immediately their close similarity to the figures of patriarchs and prophets on the Coronation portal on the Chartres north transept, and there can hardly be any doubt that they were executed within the orbit of the Chartres workshop in the years around 1215. Certain of the figures, such as John the Baptist and Isaiah, are broader than their counterparts at Chartres: this may be to do with the fact that they were not confined to such a narrow space, although the figure of Simeon is no less slim at Reims than at Chartres. The beginnings of the classical trough style seen on the Chartres north transept had not yet been noticeably advanced in the Reims figures, but in the

sculptures which followed them in the next twenty years there would appear to be almost an obsession with this treatment of drapery and a profound interest in the use of classical prototypes.

As already mentioned, by the beginning of the 1220s work was well advanced in the easternmost parts of the cathedral. It therefore follows that the eleven angels and the figure of Christ on the buttress piers and corners of the ambulatory chapels were executed by about 1225.[147] In their broad heads, with rather thick necks and wig-like hairstyles [91], the angels reveal a knowledge of Roman sculpture which could only have been obtained from study of the originals. The use of the drill to produce tightly-bunched curls is proof of this, and the sculptors must have seen Roman female portraits of the Flavian dynasty of the last quarter of the first century AD.[148] They also have the appearance of

Roman caryatid figures in their stiff, upright stance, and their placement – at the tops of the buttresses, appearing to support the roof line – might indicate a reference to their classical antecedents.[149]

At about the same time that the angels of the chevet were being carved, or shortly afterwards, it was decided that the design of the north transept façade should be changed. This was effected by simply – and rather crudely – building a solid masonry wall across the transept between the buttresses, cutting across the three lancets already placed in the centre of the wall, so that portals could be incorporated into its considerable thickness. We have seen how earlier twelfth-century sculpture was set into the so-called *Porte romane* on the west side, but the sculptures of the other two doorways were made specifically for their present position.[150] The north transept originally faced the canons' cloister, and it should be remembered that all three doorways could not have been viewed as they are today, in an uninterrupted sweep: when they were first constructed, the central portal opened into the cloister garth while the lateral doorways seem to have been reached from within the cloister walk.[151] It appears that the central portal, devoted to the locally celebrated saints of Reims, is the earlier of the two grand portals, and from the point of view of its iconography certainly the more interesting [92].

The tympanum is divided into five bands: at the top the seated Christ is offered two crowns by flanking angels, while the four bands below show miracles of St Remigius (in the second, third and fourth tiers), the episode of Job on the dung heap (in the third register), and in the bottom band the coronation of Clovis by Remigius on the right and the martyrdom of St Nicasius on the left.[152] In the voussoirs, bishops, high priests and popes look on; below, St Calixtus, whose body was believed to be preserved in the cathedral, occupies the trumeau, the decapitated St Nicasius is flanked by an angel and his sister St Eutropia on the left, and St Remigius is accompanied by another angel and an unidentified bearded male saint. In addition to celebrating the local saints, the narrative programme serves to confirm the claims of Reims as the place of French royal coronation by emphasising the miracles of Remigius and his legendary coronation of Clovis, the first Frankish king, and it may be that the portal was constructed in time for the coronation of Louis IX in 1226. The draperies of the jamb figures reveal a developing use of the deep trough style, but in comparison with the figures on the Judgement portal alongside they represent only an intermediate stage in the imitation of classical dress.

The Judgement portal is squeezed in between the two eastern buttresses of the north transept, and because of this the jambs are not splayed as is customary but set at right angles to the tympanum: as a result the jamb figures confront one another across the doorway and a porch effect is created, with the trumeau figure of Christ at the centre [93]. Above in the tympanum the Last Judgement is played out in horizontal bands, and in the voussoirs are the Wise and Foolish Virgins, trumpeting and crowning angels, and seated ecclesiastics: as on the Calixtus portal these figures are slightly bigger than usual, and larger than the characters taking part in the narrative of the tympanum. On the jambs

the six apostles are enveloped in voluminous togas of dimpled and creased cloth, creating an exciting visual effect further enhanced by the play of light and shadow on the deep folds [94]. Christ's draperies are noticeably less dramatic, posing the question whether a different sculptor was responsible for this figure or whether the overtly classical dress of the apostles was considered inappropriate for the Saviour. Here we return to the questions of what the early thirteenth-century sculptor and patron sought to achieve by the use of this particular stylistic vocabulary, and how the audience would have responded to it. Judging by contemporary writings such as those of Magister Gregorius, already referred to, which reveal an informed interest in the art of classical antiquity, there can hardly be any doubt that when figures were so obviously dressed in Roman garb it was recognised as such. Have we here simply an attempt to give a 'period accuracy' to the dress of the apostles, or is there more to the appropriation of the style of an earlier era, which might serve to parallel the strength of the Church with a great terrestrial empire? It is worth repeating that both portals faced into the canons' cloister and that the choice of iconographic programme and possibly even the style of the sculptures would have been made by the canons. Whatever the reason for this devotion to Roman style, it is obvious that antique models were close at hand in Reims – the Roman *Durocorotorum* – itself: mention has been made of the close similarity between Flavian portraiture and the angel heads on the chevet, and it has been shown elsewhere that the head of St Peter on the jamb of the Judgement portal is probably derived from a classical head of similar type to that of Antoninus Pius, of which many versions existed.[153]

The pinnacle of 'Reims classicism' is reached in the famous figures of the Visitation group, now to the right of the central doorway of the west front [95]. It has often been pointed out how much both these figures owe to antique prototypes, and the statue of the Virgin has been tellingly compared with a late first-century BC female figure in relief from the *Ara Pacis* in Rome.[154] The movement of the bodies under the draperies is better understood than on the Judgement portal and the Virgin's face is the quintessence of cool Augustan elegance. Two further figures on the west façade show a similar immersion in their classical models, although neither has such strikingly distinctive drapery. These are the prophet on the buttress between the central and left doorways, known as the prophet 'with the head of Odysseus', and the angel to the spectator's left of St Dionysius on the left doorway, which was carved by the workshop responsible for the chevet angels.[155] All four figures were presumably made as part of a portal programme which was abandoned in 1233, and were only incorporated into the present façade when work on it started after 1252. Other figures which also pre-date the construction of the façade and which complement the Marian iconographic programme of which the Visitation group forms part show affinities with work at Amiens and will be discussed in connection with those sculptures.

The work at Reims had progressed with great speed for over twenty years when the inhabitants of the town drove the cathedral chapter out in November 1233. By this time the choir and transepts would have been virtually complete to

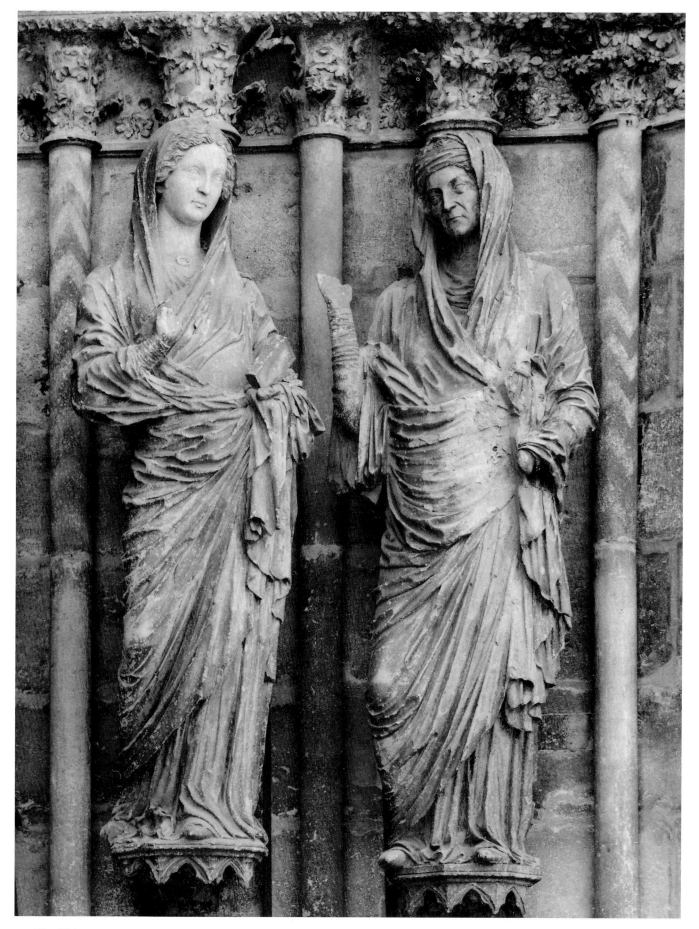

95. The Visitation; central doorway, west portal, Reims Cathedral;
c.1230–3

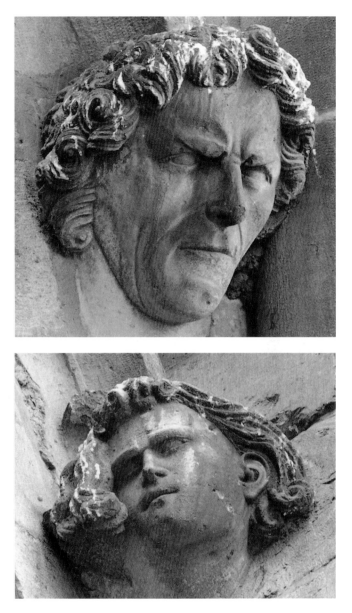

96. 'Philip Augustus'; north transept façade, Reims Cathedral; c.1230–3 (now in Musée du Tau, Reims)

97. Corbel head; choir window, Reims Cathedral; c.1230–3

98. Corbel head; choir window, Reims Cathedral; c.1230–3

roof height, the easternmost bays of the nave were in course of construction, and the first jamb figures were probably being prepared for the proposed western portals. The colossal figures of kings, Adam and Eve, and *Ecclesia* and *Synagoga* high up on the transept façades are likely to have been in position or ready for placement and the numerous corbel heads and archivolt figures around the windows of the choir and transepts must have been in progress.[156] The courtly dignity of some of the former [96] and the remarkable realism and variation in the latter [97, 98] evince a different sensibility from that employed in the jamb figures, although many of the small sculptures would have been indistinct or even invisible from the ground. In their attention to facial expression and heightened characterisation they surpass the apostles of the Death of the Virgin tympanum at Strasbourg, and their influence was to be felt throughout Europe, especially in Germany and England. In contrast to the ascetic classical facial type of the Virgin from the Visitation group – so clearly derived from a sculptural source – they testify to

an entirely new close study of nature, as if the sculptor had been experimenting with expressions in a mirror: indeed, in spirit they are close to the extraordinary character heads of Franz-Xavier Messerschmidt, nearly five hundred years later.[157] Just as Villard de Honnecourt proudly declared on his now-famous sketch of a lion that it was drawn from life ('*contrefais al vif*'), the exactly contemporary heads at Reims proclaim their independence from older models.[158] It was at this point that the work stopped. As a consequence of the sudden and violent civil unrest the workshops employed on the cathedral would have had to look elsewhere for work until building resumed: not only was there no employment but the mob used the stone from the cathedral yard to build their barricades.[159] By great good fortune some of the sculptors were immediately called into service by the Bishop of Bamberg to work at his cathedral, thus introducing a new style which would transform the development of sculpture in Germany and lead to a realism unequalled elsewhere.

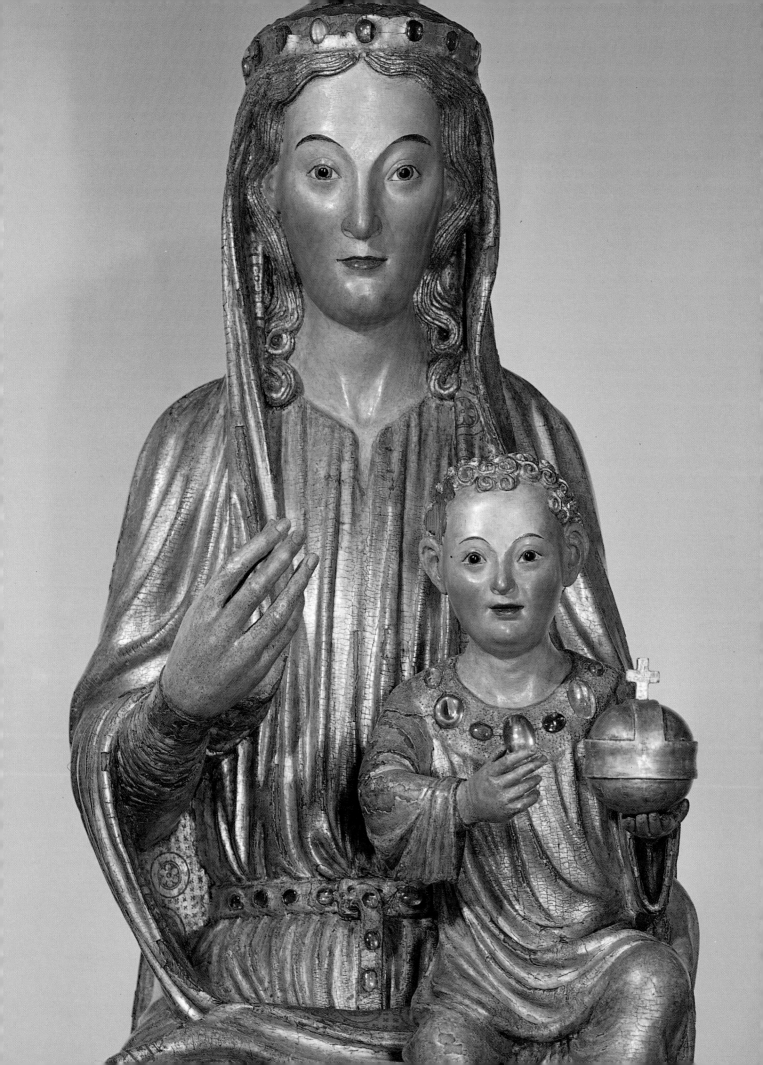

The Holy Roman Empire 1160–1240

Unlike the French Royal Domain in the middle of the twelfth century, the lands of the Holy Roman Empire possessed a building tradition of long standing. The Romanesque ecclesiastical architecture of the Rhineland and elsewhere had evolved out of the great Ottonian churches, developing distinctive German characteristics, the most conspicuous being the adoption of double apses, with east and west choirs. In Cologne – one of the most powerful cities of north-western Europe and at the centre of a vast archdiocese – major churches such as St Aposteln were still being built in the Romanesque style well into the thirteenth century. It was not until 1248, when the rebuilding of Cologne Cathedral started, that Gothic architectural forms would be wholeheartedly embraced: the emerging choir would have stood apart from the other churches only recently built in the city not just because of its size but because it employed a totally new architectural vocabulary. The retention of Romanesque architectural forms in the German lands obviously prevented the application of sculpture in a manner comparable to the contemporary French examples, and it was only in the 1220s that jamb figures were introduced into portal designs. But although the sculptures executed before this date were set within a Romanesque architectural context it is not the case that all of them are carved in a conservative style. It has been shown that one of the major sources for the sculptures at Senlis and Mantes was the art of the Mosan and Lower Rhenish metalworker, so it might be expected that the stylistic innovations worked out on a smaller scale and transmitted to the stone sculptors of the Ile-de-France should also have been taken up locally.

Outside a purely architectural framework, German workshops in this period were also of course exceedingly active in the production of sculptures for the interiors of churches, such as choirscreen reliefs, statues of the Virgin and Child and crucifixes. Because certain parts of Germany escaped the iconoclastic destruction experienced in France and England there is a far higher survival rate for such pieces, and they represent a vitally important aspect of the Gothic sculptor's output. Many of them retain their bright colour schemes and may therefore still be viewed as they were originally intended. Figures of the Virgin and Child and wooden crucifixes were ubiquitous fixtures in all churches, from the most modest *Pfarrkirche* to the largest cathedral; usually free-standing, they offered more scope for the individual expression of emotion and experimentation in the development of form than relief sculpture in stone.

The Holy Roman Empire, although technically ruled by the Emperor with the blessing of the Pope, was throughout the Middle Ages in a constant state of change. Even in settled times the Emperor could not possibly exert control over the whole Empire, from Rome to Lübeck, Burgundy to Moravia; it was to be expected that there would be breakaway kingdoms and independent-minded local dukes, to say nothing of the power struggles between Papacy and Emperor. These were to reach a climax in the ruinous conflict between Frederick II and Innocent IV leading up to the former's death in 1250 and the subsequent eclipse of the Hohenstaufen line. It was an Empire only in name, the link with Rome being manipulated by both parties for political gain on numerous occasions.[1] The centres of artistic production were inevitably distinctly regional, usually clustered around the powerful archbishoprics where most employment was offered, such as Mainz, Cologne, Trier and Magdeburg; alongside these local workshops foreigners were occasionally employed through the international links of certain bishops, as at Bamberg.

COLOGNE AND THE LOWER RHINE

In 1164 Archbishop Reinald von Dassel translated the bones of the Three Kings from Milan to Cologne, where they were to be encased within the precious *Dreikönigenschrein* and displayed behind the high altar of the cathedral. The relics added immeasurably to the celebrity of the city, attracted wealthy pilgrims and strengthened the traditional right of the Archbishop to crown the German King, as it was claimed that 'whoever possessed the relics of the first Christian Kings also possessed the Christian Kingdom and with it had the power to grant the same'.[2] A year later, Frederick I Barbarossa's antipope Paschal III was persuaded to canonise Charlemagne, and thus elevated the Emperor to the same level as himself – both occupied the office of saints. The Archbishop of Cologne, Chancellor to the Emperor, now stood as perhaps the most powerful figure in the Church, and the city was set to transform itself into a great ecclesiastical centre.

From the extant remains, it appears that monumental sculpture did not at first play a major part in the decoration of the churches then being built in Cologne. The portals of these Romanesque churches were of modest size and unambitious, in contrast to their French counterparts, and they were often situated on the north or south sides of the nave. The two most important surviving tympana of the second half of the twelfth century, both now removed from their original setting and displayed in the Schnütgen-Museum, come from the churches of St Cäcilien and St Pantaleon [100, 101]. They are simple, symmetrical compositions and were produced within a few years of one another, in around 1160–70. The St Cäcilien tympanum, which originally decorated the north door of the collegiate church of Augustinian nuns, shows the Roman martyr being crowned from above by an angel swooping down from clouds (the crown now missing) and flanked by her husband Valerian and his brother Tiburtius. The style of drapery and rigid frontality follow local Romanesque tradition, as

100. Tympanum from north door of St Cäcilien, Cologne; c.1160–70 (Schnütgen-Museum, Cologne)

101. Tympanum from St Pantaleon, Cologne; c.1160–70 (Schnütgen-Museum, Cologne)

102. Choirscreen (detail) from St Maria in Gustorf; c.1170 (Rheinisches Landesmuseum, Bonn)

103. Retable; St Nikolaus, Brauweiler; c.1170–80

manifested in the ivories of the so-called '*gestichelte*' (pricked) group, but the arrangement of the figures and certain details call to mind the lateral tympana of the Royal Portal at Chartres [15, 16]. St Cecilia has the long plaits of the head master of Chartres's jamb figure of an Old Testament queen, while the angel above her echoes the angels on the upper lintel of the north doorway. There is nevertheless something small-scale about the Cologne tympanum: each figure is strictly contained within a separate block of stone, rather like an enlarged ivory plaque, and the filling of the eyes with glass-paste pupils further enhances this impression.[3] The same workshop was responsible for the first grave-slab of Plectrudis, the founder of St Maria im Kapitol: here the half-length figure of St Cecilia has been replicated and made full-length, not without some coarsening of effect.[4] The influence of Chartres is also felt in a fragmentary little relief of the Virgin and Child between the evangelist symbols of Saints Mark and Luke found in the Benedictine abbey of St Michael at Siegburg (also now in the Schnütgen-Museum), which was certainly made in a Cologne workshop at about the same time as the St Cäcilien tympanum. Its original function is not known but it was

presumably intended for use inside the abbey church, possibly forming part of a throne or tomb.[5]

The tympanum from St Pantaleon is even more iconic in its frontality than that from St Cäcilien. Christ is shown at the centre of the composition, flanked by the Virgin and St John the Baptist with the patron saint on the left and the founder of the monastery, the tenth-century Bishop Bruno of Cologne, on the right. The draperies on the lower half of Christ's body especially have been carved in the diaphanous or 'damp-fold' style so prevalent in manuscript illuminations around the middle of the century – especially in England – and often attributed to Byzantine influence.[6] Whether the Cologne sculptor had studied Byzantine manuscripts or had taken note of the style through an intermediary source cannot now be established, but it should be remembered that the Ottonian court had had close associations with Constantinople since the late tenth century and that Byzantine books and works of art had long been available; indeed, Bishop Bruno was the brother of Otto I, and the Byzantine princess Theophano (the wife of Otto II) extended St Pantaleon to the west.[7] In its iconography too – with the *Deesis* at the centre – the tympanum reveals Byzantine

inspiration, possibly transmitted through ivory reliefs.[8]

The figures on the choirscreen from the parish church of St Maria in Gustorf (originally from St Maria ad Gradus in Cologne and now in the Rheinisches Landesmuseum in Bonn) share the damp-fold draperies of the St Pantaleon tympanum, while some of the heads may be compared with those on the St Cäcilien tympanum, especially the angel in the scene of the Annunciation to the Shepherds [102].[9] The arrangement of the figures under rounded arches again puts one in mind of smaller reliefs, this time those in ivory from a portable altar associated with Saint-Denis, possibly the work of a Mosan ivory carver, which also have distinctive damp-fold draperies.[10] It may reasonably be asked whether the Gustorf reliefs (and by extension those in Cologne) are not purely Romanesque, and therefore outside the scope of the present book; they are without exception treated as such by German scholars. But they justify inclusion because they represent a very definite stage between the frontality and

stiffness of Rhenish Romanesque and the more naturalistic and French-influenced developments towards the turn of the century, when direct comparisons may be made between certain Rhenish sculptures and contemporaneous work in the Ile-de-France. In the evolution of German medieval sculpture they occupy a position analogous to the relief of around 1150 from Carrières-Saint-Denis (now in the Louvre), which shows the transition from a Burgundian Romanesque style to the early Gothic of the third quarter of the twelfth century, and the Parma sculptures of Benedetto Antelami.[11] There is an increasing three-dimensionality, the damp-fold drapery revealing the shape of the legs underneath the clothes of the figures, and although the head types are not individualised there is an attention to detail in the hair not found previously.

The gradual freeing of relief sculpture from the block is taken a step further in the painted limestone retable from the abbey church of Saints Nicholas and Medardus in

104. Virgin and Child; Kloster Marienborn, Zülpich-Hoven; polychromed poplar (Virgin) and copper beech (Child and throne-posts), c.1170–80

105. Angel from a group of the Maries at the Sepulchre; polychromed poplar, c.1170 (Skulpturensammlung, Staatliche Museen zu Berlin, Preussischer Kulturbesitz)

Brauweiler (now kept in the church of St Nikolaus), which is probably to be dated in the 1170s [103].[12] Here the figures have been carved virtually in the round, giving the impression that each one could be removed from the altar in the manner of wood sculpture. The similarity to wood sculptures is not of course fortuitous, as there were thriving workshops of sculptors in wood in the lower Rhine and Meuse valleys which may well have provided models for individual figures, especially those of the Virgin and Child. Although the wood sculptors were probably regulated by different guilds from those who worked in stone, there was of course a common interest in sculptural prototypes and approaches to form.[13] This is demonstrated by the correspondence between a good number of surviving wood Virgin and Child groups produced in the Cologne region – such as those in Zülpich-Hoven [104], Aachen and Bonn – and the stone figures from Gustorf and Brauweiler.[14] These wood sculptures belong to a long tradition of single cult figures in Ottonian and Romanesque Germany, exemplified by the famous Virgins of Essen and Paderborn, but they too have been affected by the new stimuli emanating from Chartres.[15] This is especially noticeable in a very fine small seated angel now in Berlin [105], probably from the same workshop as the Zülpich-Hoven Virgin and Child, which has been convincingly compared with some of the seated figures on the voussoirs and doorposts of the Royal Portal. It once formed part of a group

of the Maries at the Sepulchre, such as may be seen on the Gustorf choirscreen, and one of the Maries is still preserved in the Keresztény Múzeum in Esztergom.[16]

Wood sculpture in this transitional style continued to be made in Cologne and the surrounding area until the second quarter of the thirteenth century, but occasionally alongside the more traditional sculptures the contribution of individual workshops or sculptors has been recognised. One such is the 'Samson-Master', so-named after a fragmentary figure in the abbey of Maria Laach showing the young Samson struggling with the lion [106]. It has been suggested that the sculpture should be associated with the decoration of a choirscreen in the abbey church, but this cannot be proved.[17] Notwithstanding the uncertainty over its original function and the lack of any documents to help with its dating, the figure provides clear evidence for the reception of the second stage of early Gothic sculpture reached in France by such monuments as Senlis, Mantes, Sens – especially the Baptist's portal – and Châlons-sur-Marne. As we have seen, the style of these French sculptures was informed by a knowledge of Mosan metalwork, a source much closer to Maria Laach than the Ile-de-France, and it is therefore surprising that the Samson has sometimes been dated as late as 1220–30.[18] In the detailed carving of the eyes and in the treatment of the hair, the head of Samson is so similar to the heads at Mantes and that of the baptised

have become heavier, with thicker rounded ridges of cloth bunched around the body, in the manner of goldsmiths' work: this connection is further reinforced by the raised flower patterns in roundels and the rich designs on the hem of the angel's tunic.[22] The workshop associated with the Samson-Master was in all probability based in Cologne itself, perhaps centred around the cathedral: two reliefs of a dancer and a seated musician now in the Schnütgen-Museum, which show the same stylistic traits as the Cologne angel at a less advanced stage, almost certainly came from that building and may have formed part of a now-destroyed choirscreen.[23]

THE MEUSE VALLEY

The Samson-Master, probably trained at Sens or Laon, introduced the new style of the Ile-de-France and Champagne to the Rhine valley between Cologne and Mainz, an area with an already thriving late Romanesque sculptural tradition. On the other great river of north-west Europe, the Meuse, there was also a receptivity to the language of French

106. Samson and the lion; abbey of Maria Laach; *c.*1190–1200

107. Angel of the Annunciation (?), from St Johann Baptist, Cologne; *c.*1210–20 (Schnütgen-Museum, Cologne)

Christ at Sens that, were it not for its provenance, it could be mistaken for a French work. Given these parallels, all of which date from between about 1170 and 1185, it is inconceivable that a gap of forty years should separate the sculptures.[19] A date around 1190 would appear to be more reasonable.

A number of sculptures in a similar style have been grouped around the Maria Laach figure, encouraging the construction of a career for the 'Samson-Master'. Probably by the' same hand are a single detached figure of a young man holding a scroll, possibly an apostle, in the parish church of Lonnig, and the stone terminals of choirstalls now in the Minster at Bonn, which must date to around 1200.[20] Other sculptures almost certainly produced by the workshop, if not by the Samson-Master himself, are the two founders of Brauweiler Abbey seated in tympana above small doors leading into the choir, and fragmentary reliefs showing scenes of Damnation possibly from the *Lettner* (choirscreen) of the Liebfrauenkirche in Andernach (Rheinisches Landesmuseum, Bonn), of around 1200–1210.[21] In the following decade should probably be placed the south portal tympanum at Andernach, containing two angels holding a medallion of the *Agnus Dei*, and a fragmentary figure – likely to be the Angel of the Annunciation [107] – found in the ruins of the church of St Johann Baptist in Cologne in 1947 (now in the Schnütgen-Museum). Here the draperies

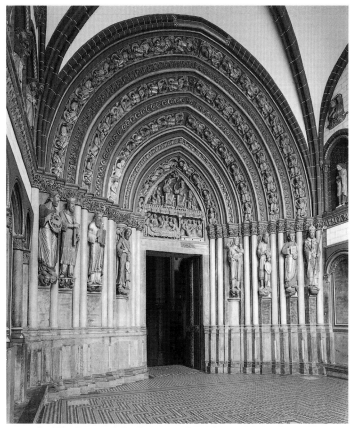

108. The *Bergportaal*, St.-Servatius, Maastricht; *c.*1220–30

sculpture, both in stone and wood. As in the Lower Rhenish area, the latter material seems to have been especially favoured and sculptures were produced in large numbers, to a very high standard, from the twelfth to the sixteenth century. The Meuse ran through Lorraine, an area famed for metalworking throughout the Middle Ages, from Verdun in the South to Liège and Maastricht in the North, so that there is often a direct relation here between the development of cast or repoussé sculpture and its carved counterpart. One needs only to recall Abbot Suger's desire to recruit the *aurifabros Lotharingos* to Saint-Denis, and the effect of Nicholas of Verdun's style on subsequent sculpture to appreciate the importance of the connection.

As in Cologne in the second half of the twelfth century there were isolated instances of influence from the French Royal Domain rather than a wholesale acceptance of its style and iconographic schemes. From the third quarter of the century there survives a single column figure in Nivelles, which is presumed to have formed part of the south portal of the church of St.-Gertrudis and, despite the inscription GERDRUDIS, thought to represent the Virgin of the Annunciation.[24] It would appear, however, to be too small for a portal and if it does indeed represent the Virgin would have been juxtaposed with the Angel, possibly in an interior setting.[25] In southern Lorraine at about the same time, at Metz and Verdun, reliefs in an idiosyncratic local style testify to the longevity of the Romanesque tradition. A rectangular relief of Saint Nicholas rejecting his mother's milk, from the church of St.-Gengoult in Metz (now in the Pitcairn Collection, Pennsylvania) is a provincial product which were

it not a rare survival would hardly be worthy of note;[26] but the four high reliefs now situated on the choir buttresses of Verdun Cathedral are of much more interest both from an iconographic and stylistic point of view. They show the Temptation of Adam and Eve (separated by the Tree of Life, around which the Serpent is coiled), the Offering of Cain and Abel, the Annunciation to the Virgin (as in the Temptation of Adam and Eve they are separated by a luxuriantly flowering tree), and a Bishop holding a book. The present choir at Verdun was only built in the fourteenth century and the original placement of the reliefs is not known, but as it stands the decorative programme does not appear to be complete: the Temptation and Annunciation were obviously meant to complement one another, so it could be presumed that a New Testament scene would have balanced that of Cain and Abel (perhaps the Presentation in the Temple). One might expect that other Old Testament prefigurations and their New Testament counterparts, such as the Slaying of Abel and the Crucifixion, would also have been included in the original scheme, which was probably executed in around 1180–1200.[27] The style of the reliefs is slightly more advanced than on the Metz slab, and other sculptures in the immediate vicinity were produced by the same workshop.[28]

By the beginning of the thirteenth century examples of the fully developed French portal, with jamb figures, tympanum and archivolts were to be found in the area between the Meuse and Moselle. All that remains of a doorway of this type in Metz is the upper half of a jamb figure of King David, probably of about 1210, while a column figure of St Peter indicates that such a portal also existed in Epinal.[29] However, further north, at St.-Servatius in Maastricht there is a complete – albeit savagely renovated – portal which copies many of the features found at Senlis, Mantes, Laon and Chartres: the so-called '*Bergportaal*' on the south side of the cathedral.[30] Because of the political situation at the end of the twelfth century in this part of the Meuse valley it is not surprising that French influence was prevalent. After the murder of Albertus of Louvain in 1192, there was a movement against the Hohenstaufen in neighbouring Liège and from that date the see of St Lambert was usually occupied by French bishops; in Maastricht, Hugues de Pierrepont, a native of Laon, was bishop between 1200 and 1229.[31] It was probably towards the end of Hugues' time that the *Bergportaal* [108] was erected. The arrangement of the tympanum and lintel, showing the Coronation of the Virgin and her Death and Assumption, the archivolts with the Tree of Jesse, and the jamb figures below owe a clear debt to the Ile-de-France, although in details – such as the grouping of the jamb figures and the late Romanesque decoration of the capitals above their heads – the portal is revealed as a regional variant. As at Lausanne, the doorway is enclosed within a deep porch, almost an ante-chapel, and the decorative scheme is extended onto the side walls where a further twelve Old Testament figures, with angels above, are ranged.[32] Unfortunately many of the figures have been badly restored; in one instance even the sex of a figure was changed (Simeon being transformed into the Virgin and Child) and the whole ensemble was repainted in 1883–6, so it is not now possible to assess the style.

In contrast, the baptistery portal of the collegiate church of Notre-Dame in Dinant is well preserved. It has no tympanum, the sculptural decoration being limited to the three orders of archivolts; unusually, the Coronation of the Virgin is shown at the apex of the outer order flanked by prophets [109], and the *Agnus Dei* occupies the centre of the inner archivolt. Executed after 1227, probably in around 1240, the prophets have been related to contemporary Mosan wood sculptures, such as an enthroned figure of Christ from Rausa, now in the Musée d'Art religieux et d'Art mosan in Liège.[33]

Apart from the production of shrines and other metalwork, the most notable achievement of the Mosan artist in the twelfth and thirteenth centuries was in the making of wood sculpture, invariably of oak, and the primary subject – as elsewhere throughout Europe at this time – was the Virgin and Child (the *Sedes sapientiae*). The earliest examples are as frontally-posed and stiff as their well-known equivalents from the Auvergne, but from the middle of the first half of the thirteenth century there survive a number of Virgin and Child sculptures which testify to a close kinship with the metalworker and an increasing interest in naturalistic form. The Virgin and Child in the church of Saint-Jean in Liège has indeed the appearance of a work in precious metal: the Virgin is seated on a bejewelled throne and there is an abundance of gilding on the hair and clothes [99, 110]. The draperies have been carved in the familiar *Muldenfaltenstil* developed by Nicholas of Verdun and his followers, and a telling comparison may be made with the image of the Virgin and Child on the reverse of the phylactery of St Martin in Namur, a work attributed to Hugo d'Oignies and dated to around 1230.[34] The Liège Virgin has all the features which characterise the Mosan wood sculptures of this time – the fluid carving of the draperies, the graceful elongation of the body, the serenity and grave dignity of facial expression – although in terms of quality it is without equal. Parallels with sculpture at Chartres and Amiens have been pointed out, but even if the Mosan sculptor was aware of these figures his work stands apart as a quite distinct contribution. Other Virgin and Child groups of about the same date, such as that in the Metropolitan Museum in New York of about 1220 and a Lower Rhenish example in the Schnütgen-Museum in Cologne, exemplify the wood carving skills in the Rhine-Meuse region but hardly match the excellence of the Liège Virgin.[35]

THE MIDDLE AND UPPER RHINE

The Romanesque style was more persistent in the Upper Rhenish region than further north, and as might be expected the monuments were exposed to different influences. The arrangement and style of the north transept portal at Basel Cathedral (the *Galluspforte*), constructed at the end of the twelfth century, have points of contact with Provençal and North Italian portals, and by no stretch of the imagination could be described as Early Gothic. Its four jamb figures of the evangelists – carved out of square piers – are clearly derived from Italian prototypes, such as at Ferrara and Verona, rather than those of the Kingdom of France.[36] Further up the Rhine at Petershausen on Lake Constance

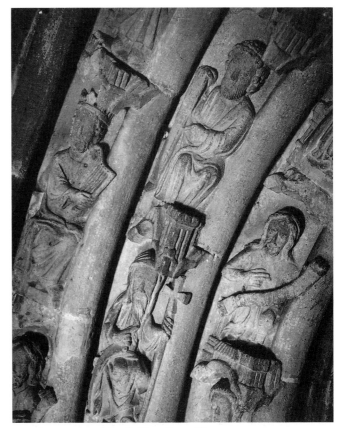

109. Baptistery portal (detail), Notre-Dame, Dinant; *c*.1240

110. Virgin and Child; Saint-Jean, Liège; polychromed oak, *c*.1230–40; see plate 99

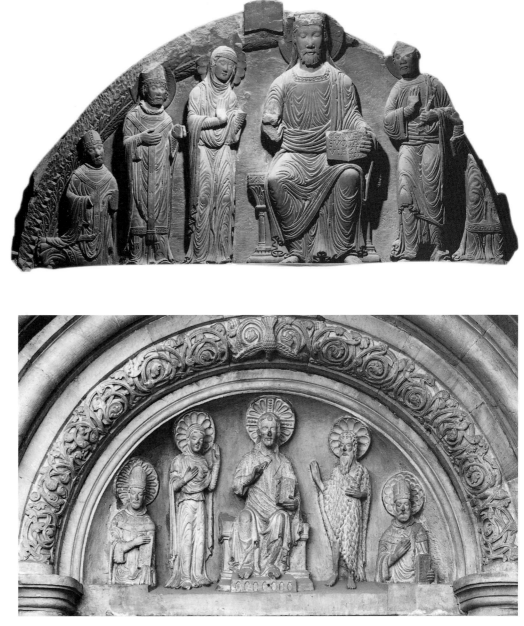

111. Pope Gregory the Great; jamb figure from the portal of the abbey church of Petershausen; 1173–80 (Badisches Landesmuseum, Karlsruhe)

112. Tympanum from the south portal, Worms Cathedral; *c*.1200

113. Tympanum; *Leichhofportal*, Mainz Cathedral; *c*.1210

jamb figures fashioned from the square block in a similar way to those at Basel [111] formed part of the now dismantled portal of the abbey church, which can be dated to 1173–80.[37] However, here the models for the tympanum and lintel are Burgundian (specifically Brionnais), close parallels for the composition being found at Paray-le-Monial, Montceaux-l'Etoile and Anzy-le-Duc.[38] Of course the style of the Petershausen portal is quite different from its models as they are separated by many years, and the jamb figures of Pope Gregory and Bishop Gebhard of Constance are considerably more accomplished than the flatter relief carvings of the lintel. It is likely that the workshop moved north after their completion in around 1180 and worked in the Middle Rhine, as elements of its style are to be found in Worms and Mainz.

The tympanum of the south portal of Worms Cathedral is now detached from its doorway and displayed inside the church [112]. Missing part of its right side, it shows Christ in Majesty flanked by the Virgin and St Peter; to the left of the Virgin is a haloed Bishop, probably St Nicholas (the adjacent chapel was dedicated to him) and the kneeling figure of a donor-bishop, possibly Lupold von Schenfeld, who was in office between 1195–1217. The fragmentary figure next to St Peter appears to be dressed as a deacon (it has been suggested that it represents St Lawrence) and a seventh, kneeling figure probably filled the lower right corner.[39] The tympanum's hieratic composition reflects works in Cologne such as the St Pantaleon tympanum and the Brauweiler retable, although the manner of carving the draperies and the facial types are markedly different. The chasuble of the standing bishop saint is treated very similarly to that of St Gregory at Petershausen, with paired looping V-folds, but alongside this restrained figure the draperies of the Virgin and Christ are broken up into a mass of near abstract patterns.[40] This painterly treatment of the surfaces is nearly contemporary with the *Muldenfaltenstil* of the

Ingeborg Psalter, and like it was also seen in manuscript illumination, in the Speyer Gospels, probably made in Worms in 1197–8.[41]

The influence of Cologne mixed with distinctive local features is seen in the tympanum of the small *Leichhofportal* to the south of the west choir at Mainz Cathedral [113]. Its arrangement is comparable to the Worms tympanum, with the seated Christ flanked by the Virgin, St John the Baptist and two half-length figures of bishop saints, whose form recalls the similarly truncated figure of St Cecilia in Cologne; likewise, the scalloped nimbus is a Cologne convention. Although the figure of Christ is different, the Virgin is clearly derived from the same figure at Worms.[42] The Mainz tympanum was probably executed in about 1210, and presumably provided the model for the inferior portal on the north side of the nave of the Marienkirche at Gelnhausen, about eighty km to the east, which also includes half-length bishop saints at the extremities of the relief. The Marienkirche has two other portals at the north and south ends of the transept, showing the Crucifixion and the Virgin and Child between four female saints, and all three share the same formulaic drapery patterns of incised parallel lines and doll-like, expressionless faces.[43] Another church in Gelnhausen, dedicated to St Peter, has a small tympanum with the single figure of the apostle, which although probably more or less contemporary with the sculptures of the Marienkirche (about 1220), is not by the same workshop. The figure is encased in such bulky folds of drapery, his head characterised by strikingly protruding eyes, that the work of the sculptor may easily be recognised on the tympanum of the collegiate church at Aschaffenburg, a few

miles south of Gelnhausen on the Main, where he carved a seated figure of Christ between the church's patron saints Peter and Alexander.[44] Framed by similarly old-fashioned foliate ornament to that found on the doorposts and around the tympana at Gelnhausen and Mainz, the Aschaffenburg portal represents the last manifestation of the Romanesque tradition in Germany. Elsewhere in the Empire at this time – at Strasbourg to the South, Bamberg to the East, and Hildesheim to the North – new developments were taking place in the representation of the human form and the relationship of sculpture to its architectural surroundings.

SAXONY

The Archbishopric of Mainz was the biggest in the Empire, including most of what is described as Middle Germany. The Bishops of Strasbourg, Speyer, Worms, Augsburg, Paderborn and Hildesheim were all suffragan to the Archbishop of Mainz, but as we have seen in the case of Strasbourg there is not necessarily any stylistic homogeneity between such ecclesiastically linked cities. In the field of sculpture, Mainz itself did not assume pre-eminence until the middle of the thirteenth century, by which time the cities of Hildesheim, Halberstadt and Freiberg in Saxony had all provided commissions of the first importance.

Hildesheim, the city of the famous Ottonian Bishop Bernward (993–1022), had a long history of artistic production. Bernward will be remembered especially for two magnificent works of art he commissioned in the early eleventh century: the great bronze doors and a twelve-foot high column which once supported a crucifix, both now in

114. North side of choirscreen, west choir, St. Michael, Hildesheim; painted stucco, probably 1194–7

115. South side of choirscreen, Liebfrauenkirche, Halberstadt; painted stucco, c.1200

116. Virgin and Child; south side of choirscreen (detail), Liebfrauenkirche, Halberstadt; painted stucco, c.1200

the cathedral.[45] By the end of the twelfth century the Benedictine abbey church of St Michael, which he had founded, had been rebuilt following a fire in 1162, and was reconsecrated in 1186; work certainly continued after this on the fittings within the church, the most significant of which was the screen closing off the west choir from the nave and transepts. Sadly only the north side now survives in situ, the rest having been pulled down in the sixteenth century, but fragments from the front face of the screen still exist which indicate that it included a narrative cycle of Christ's Infancy and Passion.[46] The remaining side [114] shows seven figures standing under elaborate architectural canopies, which from left to right can be identified as the founder of the order, St Benedict, St James, St Peter, the Virgin and Child, St Paul, St John the Evangelist, and the haloed Bishop Bernward, holding a model of the church. As Bernward was canonised in 1193 the screen could clearly only have been made after that date and may have been finished by the time the altar of the Virgin in the newly-extended crypt was re-dedicated in 1197, after the translation of Bernward's remains there in 1194. On the reverse of the spandrels of the arcades running along the screen above the figures are fine seated angels with outstretched wings. The south face would almost certainly have shown Christ among the apostles and might have included St Stephen, who had an altar dedicated to him in the south transept.

The Hildesheim screen is not carved from stone but made of stucco, and it would originally have been brightly painted, although virtually nothing of this colouring survives.[47] The use of stucco here in Lower Saxony – an area well-known for its metalworking – is of some interest, and may indicate the participation of a workshop connected primarily with casting. There is evidence elsewhere in the region of very

accomplished earlier work in this material, in the reliefs set into the Holy Sepulchre chapel in St Cyriacus at Gernrode, which are generally dated to around 1100. Parallels have been drawn between these works and the bronze reliefs on Bernward's bronze doors, and there is certainly a freedom of movement in this medium which was rarely matched at that date in stone carving.[48] Nearly a century later the flowing draperies and pose of the figure of Christ at Gernrode are seen again in the St John of the Hildesheim screen, although by this time the head types are more naturalistic and bear comparison with the repoussé prophets and saints on contemporary shrines; the architectural canopies above are also reminiscent of metalwork, as are the patterned ornaments of the borders and on the piers dividing the figures.[49]

A close connection with metalwork shrines is again apparent in the stucco choirscreen reliefs in the Liebfrauenkirche in Halberstadt [115, 116] and in St Pankratius, Hamersleben. Like the Hildesheim screen that at Halberstadt is now missing its front face, but it retains both its north and south sides intact, and much of its original polychromy remains.[50] The twelve apostles are shown seated under a round-headed arcade, six on each side, with Christ in their midst on the north and the Virgin and Child on the south. A band of plain wind-swept fleshy foliage runs along the bottom edge while above on the south side there is a rich frieze of connected medallions with alternating foliate and inhabited decoration; on the north the frieze consists of a plainer running blossom design. Striking comparisons have been made between the apostles of the screen and extremely similar seated figures on Lower Rhenish shrines, such as that of St Heribert in Cologne-Deutz, the decorative vocabulary of the upper friezes is quoted from the gilt-copper strips running around the edges of the shrines, and the ornate frieze on the south

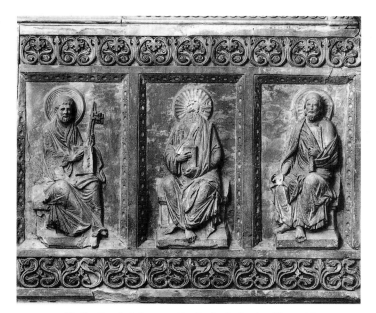

117. North side of choirscreen (detail), St. Pankratius, Hamersleben; stucco, c.1210–20

side has much in common with the ornamental band on the front face of the *Dreikönigenschrein* in Cologne.[51] There is no documentary evidence in connection with the building which would help to date the Halberstadt screen, but on stylistic grounds it is unlikely to be more than a decade later than that at Hildesheim and was therefore probably made in around 1200. By the subtlety and sophistication of its modelling, in the attention to detail in the foliate frieze and the careful marriage of plastic and painted surfaces, the Halberstadt screen represents the high point of Saxon stucco work. Just as the serried ranks of jamb figures on the French portals both guarded the entrance to the church and pointed to the salvation to be found inside, so the Halberstadt and Hildesheim apostles enclosed the Holy of Holies within the church itself. The screens' approximation to the sides of shrines was not simply a consequence of borrowing elements of style but was a conscious reference to the sanctity of the choir. The message was further stressed by the presence of the monumental cross which always faced the nave above the choir screen and which will be discussed below.

The remains of the choirscreen at Hamersleben take the parallels with metalwork to their limit [117]. Only three panels on the north side of the choir still survive, showing St Peter and two other apostles: presumably three more apostles appeared on the south side, while the remaining six flanked Christ on the west face in the manner of the north side of the Halberstadt screen. At Hamersleben it is as if the gilt copper reliefs and fleshy foliate borders associated with shrines have been enlarged for an architectural setting. The palmette frieze has a distinctly metallic, sharp quality, and to increase further the similarity with precious smaller works the borders around the rectangular panels of the apostles are decorated with the settings for fictive gems.[52] However, the drapery has changed from the soft curvilinear style of Hildesheim and Halberstadt to become flatter and slightly more hard-edged, approaching the '*Zackenstil*' (or 'jagged' style) which was to be so widespread in Saxony from the second decade of the thirteenth century, especially in painting. It has been shown how much this local style owed to Byzantine prototypes, probably obtained as part of the booty from the Fourth Crusade (1204), and it enjoyed a remarkably long life in this particular area. It is manifested most clearly in the Wolfenbüttel sketchbook (1230–40), the ceiling paintings of St Michael, Hildesheim (probably 1240–50), the wall-paintings of St Blaise, Brunswick (1240–50), and the Goslar Gospels (1230–40).[53] The *Zackenstil* of the Hamersleben choirscreen is not as extreme as in these paintings, and given its points of contact with the Halberstadt screen it should probably be dated in the second decade of the century.[54]

The closest sculptural equivalent to the paintings in this style is seen in the stucco reliefs in the Neuwerkkirche in Goslar which once formed part of a *Lettner* but since 1950 have been incorporated into an organ loft. Two large panels show Christ and the Virgin [118] and the other surviving figures include Saints Peter and Paul. The draperies are broken up into zigzagging patterns around the hems of the garments, while the gathering of the cloth in the middle of the bodies has a charged energy not seen in the earlier stucco panels. The similarity to the illuminations in the Goslar Gospels and the drawings of the Wolfenbüttel sketchbook, both executed in the 1230s, is so striking that there can hardly be very much difference in date.[55]

118. Reliefs from destroyed *Lettner*, Neuwerkkirche, Goslar; stucco, c.1230–40

119. Tympanum; north nave door, St. Godehard, Hildesheim; stucco, c.1200–10

The durable type of stucco used in these sculptures was also employed for exterior work, as on the tympanum of the door on the north side of the nave at St Godehard in Hildesheim.[56] Christ is shown as a half-length figure, holding a book in his left hand and blessing with the right, flanked by St Godehard on his left (who holds a model of the church) and another nimbed bishop on his right, probably St Epiphanius of Pavia [119].[57] It was suggested long ago that the bust form of Christ was derived from Byzantine images of the Pantocrator, possibly via ivory reliefs; an indication that there was such a model in Hildesheim by the end of the twelfth century is provided by the tomb slab of the presbyter Bruno in the cloister of the Cathedral, of around 1195–1200, where a very similar image of Christ blesses the soul of the deceased, and there are to this day Byzantine ivories in the cathedral treasury at Hildesheim.[58] The bishop saints are placed in the position of the intercessors at the Deesis – usually the Virgin and St John the Baptist – but there is nothing Byzantine in the style of the tympanum, which was probably produced in the first years of the thirteenth century by the same workshop which executed the St Michael choirscreen.

As already mentioned, the area of Lower Saxony, like the Rhine-Meuse region, maintained a thriving metalworking industry throughout the Middle Ages. A wide variety of objects were cast in bronze, ranging from massive items of church furniture, such as those made for Bishop Bernward in the eleventh century and the great seven-branched candlestick in the choir of St Blaise at Brunswick of the late twelfth century, to small objects for both ecclesiastical and domestic use.[59] Many of the latter are now scattered in museums and private collections and lack reliable provenances, so it is sometimes difficult to separate the products of one region from another; such pieces were in any case exported throughout Europe in the twelfth and thirteenth centuries. Nevertheless, a small number of highly important bronzes do still remain in the place for which they were

made and, even more fortunately, two of them bear inscriptions.

The first of these, the magnificent baptismal font in the St George chapel on the north side of the nave of Hildesheim Cathedral, is a *tour-de-force* of compressed narrative and typological exegesis [120, 121]. Supported on kneeling personifications of the four Rivers of Paradise, the main body of the font is separated into four scenes – the Baptism of Christ, flanked by two prefigurations of Baptism, the Parting of the Red Sea and the Crossing of the Jordan, and on the back a dedication panel with the Virgin and Child, Saints Epiphanius and Godehard and the kneeling donor, who is identified in the inscription above as Wilbernus. The kneeling figures of the Rivers of Paradise mark the points between the scenes, and above them three further sets of four – the Cardinal Virtues, prophets and the symbols of the Evangelists – are shown as half-length figures. The message is clear: through the sacrament of Baptism Evil will be overcome. On the lid of the font are four more scenes; Mary Magdalene washing the feet of Christ, a seated personification of Charity (*Misericordia*) dispensing largesse, Aaron's flowering rod, and the Massacre of the Innocents. Like the scenes on the bowl they are divided by small colonnettes which are topped by four prophets – Isaiah, Solomon, Jeremias and David. The visual narrative is consolidated by the numerous inscriptions, either prefiguring the scenes in the case of the quotations on the scrolls of the prophets or referring specifically to the power of Christ through Baptism in those of the symbols of the Evangelists.[60] This extremely sophisticated and coherent iconographic programme is comparable to the carefully conceived portal schemes at Chartres, and must have been created by a biblical scholar of some note. Whether the donor of the font, Wilbernus, was this man cannot be proved, and a second bronze font in Osnabrück which bears his name is of a more modest type.

The Osnabrück font has a simple bucket-shaped bowl set on three lion's feet. It has no lid and the two integrally-

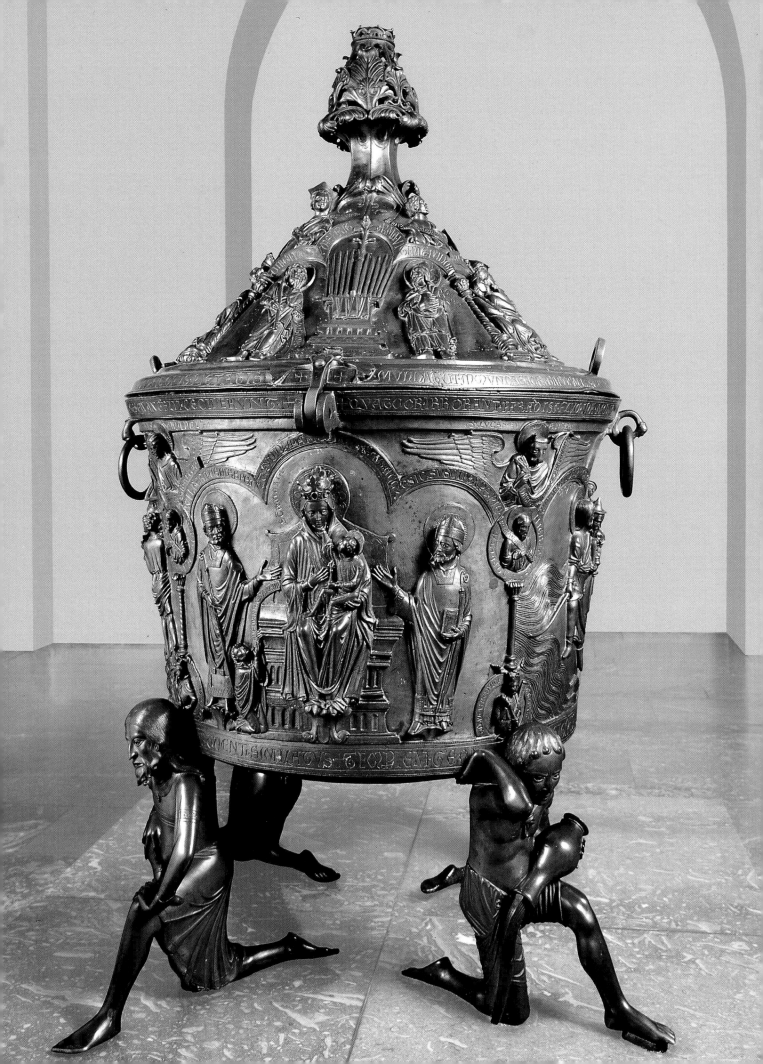

cast loops near the rim suggest that it was intended to be portable. Although it is comparatively plain in relation to the Hildesheim font, the five small figures set in relief around its upper half – the baptised Christ, Sts John the Baptist, Peter, Paul and an angel flying towards Christ with a cloth in his outstretched arms – are of a similar quality to those at Hildesheim and certain details in the heads and elsewhere indicate that it is by the same craftsman. On the Osnabrück font he has signed his work GERARD(US). ME FEC(IT), and Wilbernus is named alongside as the donor.[61] Given the presence of Wilbernus's name on both fonts and the likelihood that they were produced by the same craftsman in Hildesheim it is reasonable to accept the hypothesis that Wilbernus should be identified as Wilbrandus of Oldenburg, cathedral provost at Hildesheim between 1219 and 1225 and archdeacon of both Münster and Osnabrück in 1226–7 before becoming Bishop of Utrecht in 1228.[62] On this basis the Hildesheim font should be dated 1220–5, while that at Osnabrück was probably given in 1226.

Smaller bronze sculptures of about the same date also remain at Hildesheim, including an eagle lectern and a candlestick in the form of a lion, both in the cathedral.[63] The lion figure was especially popular for utensils, and many small *aquamanilia* (bronze water vessels used for washing the hands) took this form, essentially a miniature and functional version of the monumental lion of Duke Henry the Lion, erected in the Burgplatz of Brunswick in 1166.[64] A handsome example in the Victoria and Albert Museum [122] has

been convincingly compared to the lion evangelist symbol on the Hildesheim font and is probably a product of a Hildesheim foundry in around 1220–30.[65]

To the east, Magdeburg was perhaps an even more important centre for bronze-casting until the thirteenth century. The tomb slabs of Archbishops Friedrich von Wettin (died 1152) and Wichmann (died 1192) or Ludolf (died 1205) in the ambulatory of Magdeburg Cathedral illustrate the advanced competence of the workers in bronze on a large scale in the second half of the twelfth century and the beginning of the thirteenth [123]. Compared with the late eleventh-century bronze effigy of Rudolph of Swabia in Merseburg – essentially a low relief – the effigies of the archbishops are far more three-dimensional and without parallel anywhere in Europe at this date. The later of the two, whether identified as Wichmann or Ludolf, was made in the decade either side of 1200 (probably around 1205) and is consequently considerably earlier than the first comparable bronze effigy in France, that of Evrard de Fouilloy in Amiens (after 1222). The shallow looping folds of the drapery, determined to some extent by the technical process of casting, may be compared to the modelled stucco figures on the Hildesheim screen.[66]

As was the case elsewhere, large numbers of Virgin and Child groups and crucifixes in wood were produced in Saxony; these illustrate how local stylistic conventions were not confined to particular media but were equally common in stone, wood and metal. The painted oak Virgin and Child

120. Baptismal font; Hildesheim Cathedral; bronze, *c*.1220–5

121. Personification of the River Geon; detail of pl. 120

122. Lion aquamanile; bronze, probably Hildesheim, *c*.1220–30 (Victoria and Albert Museum, London)

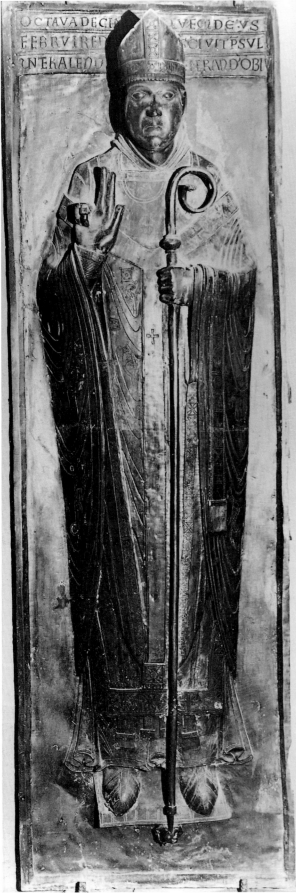

123. Tomb effigy of Archbishop Wichmann (d.1192) or Ludolf (d.1205); Magdeburg Cathedral; bronze, c.1205

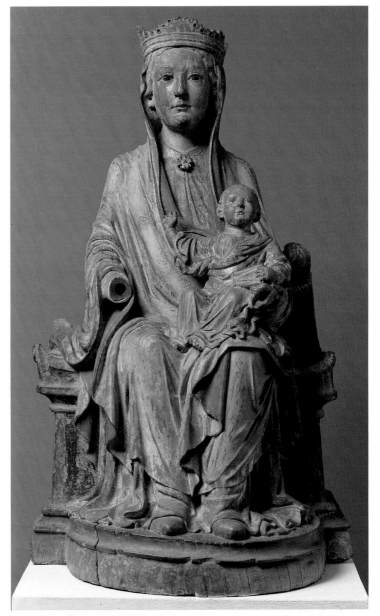

124. Virgin and Child; polychromed oak, c.1220–30 (Cathedral Treasury, Halberstadt)

formerly in the Liebfrauenkirche in Halberstadt [124] has the same frontal pose and solemn staring attitude as the Virgins from Cologne and Liège of about the same date. It reveals its relationship to other works of Lower Saxon origin in the details, such as the surviving lion head terminal on the back of the throne, which is close to the head of the symbol of St Mark on the Hildesheim font, previously mentioned in connection with *aquamanilia*; while its soft and flattened draperies and the pose of the Christ-Child are also seen in small statues in silver and in ivory.[67] On a larger scale it is also particularly close to the Virgin and Child at the centre of the tympanum on the Freiberg *Goldene Pforte*, to be discussed below.

The other major category of wood sculpture – the crucifix – is especially well represented in Saxony and adjoining Westphalia.[68] Numerous single crosses remain in the choirs of the churches of the region, and more ambitious complexes

from the first half of the thirteenth century comprising multi-figure groups – triumphal crosses – still survive at Halberstadt, Freiberg and Wechselburg. The triumphal cross in front of the choir of Halberstadt Cathedral is the earliest of these ensembles, and was probably made in about 1215–20 [125]. Christ is shown crucified on a cross with trefoiled terminals, containing angels and the figure of Adam emerging from his tomb at the bottom. To the left and right are the Virgin and St John and at the extremities two cherubim; these large figures are supported on a rood beam with at its centre two angels and with busts of the twelve apostles under an arcade, while on the back in the centre is the scene of the Maries at the Sepulchre, with half-length figures of prophets on each side. Extensive traces of paint remain.[69] This type of triumphal cross was not new – there is an account of a similar one in Canterbury in the eleventh century – but because the Halberstadt cross is largely intact it gives us a good idea of what the grander examples looked like.[70] A different type of crucifixion ensemble survives – albeit in a fragmentary state – at Freiberg (c.1230). Here the three figures of Christ, the Virgin and St John originally surmounted a stone *Lettner* decorated with narrative scenes.

The principal figures share the graceful elongation of those at Halberstadt, and although parallels have been drawn with Chartrain sculpture for both ensembles it is unlikely that this was due to direct influence. The extant reliefs from the *Lettner*, on the other hand, reveal an approach very close to French sculpture, especially in the figures of a sibyl and prophet; the former has all the elegant bearing of the Modesta at Chartres, with her high-waisted dress and pleated folds, and there is none of the *Zackenstil* seen on the directly comparable reliefs on the slightly later *Lettner* at Wechselburg, to be discussed below, and on the 'Golden portal' at Freiberg, which was made by the same workshop as the sculpture at Wechselburg.[71]

French sources have also been proposed in connection with the earliest sculptures at Magdeburg Cathedral. The massive Ottonian edifice on the site was said to have been grievously damaged in a fire in 1207 and the decision was taken by the Archbishop, Albrecht von Kefernburg, to rebuild rather than repair. The foundation stone of the new building was laid in 1209; by Albrecht's death in 1232 the choir was probably finished up to clerestory level. Albrecht had been schooled in Paris and was obviously keen to build

125. Triumphal Cross; Halberstadt Cathedral; polychromed wood, *c.*1215–20

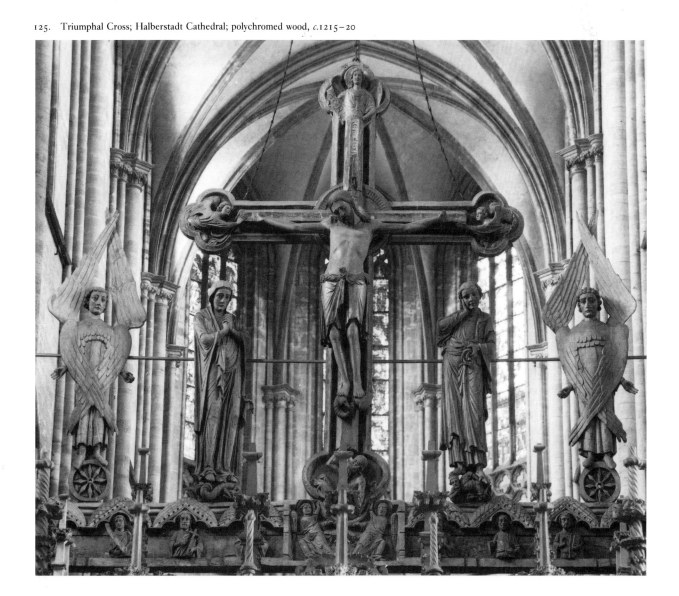

126. Saints Paul and Andrew; Magdeburg Cathedral; *c.*1230

in the modern style current in France: but although the choir of his cathedral shows its formal debt to the choirs at Senlis and Noyon, it departs from French models in many places and also incorporates elements of the earlier building, most notably the four massive columns at its east end. Standing on these columns are four over-life-size figures, and two further figures are positioned alongside at the same level to the north and south [126]. Immured below them and further west in the choir are twenty small figures of Virtues and Vices, ten of the Wise and Foolish Virgins and five angels. Long ago Adolph Goldschmidt postulated that these sculptures were *spolia* from an abandoned plan for a portal and since then a number of different reconstructions have been put forward. All of these place the column figures on the jambs, the angels in the archivolts, and the Virtues and Vices on the socle below the jamb figures, while the reliefs of the Wise and Foolish Virgins must have decorated the doorposts.[72] However, the six standing figures are clearly not all from the same workshop. It seems most likely that the figures of Saints Peter, Paul and Andrew, which are all in the same style, were indeed made for the putative and unfinished portal, probably in around 1230; but the remaining figures of John the Baptist and the warrior saints Maurice and Innocent are completely different, the latter like two large toy soldiers, and these may only have been made when the decision was taken to place the other figures in the choir.[73] The style of the apostles is a reflection of that current in the Ile-de-France, with the saints triumphing over their persecutors, who are shown as diminutive supporting figures crouching under their feet. The iconographic layout of the portal too, with its Virtues and Vices in the socle area and Wise and Foolish Virgins on the doorposts, is a modest echo of such doorways as the central portal at Notre-Dame in Paris.[74] The Magdeburg sculptor of the apostle statues and the smaller reliefs was clearly familiar with the Parisian prototype, but there is little to suggest that he was actually French: on the contrary, the iconographic misunderstandings in the reliefs of the Virtues indicate that these features were taken over – perhaps via sketches made on a journey to the French capital – without being fully understood.[75] The other sculptures in the cathedral just preceding the 'portal' sculptures, the bizarre but extremely fine capitals of the ambulatory which were presumably carved in the decade after 1209, are a strange mixture of teeming Romanesque inhabited ornament and disembodied heads and busts, unthinkable in a French context at this date but comparable to contemporary sculpture not only at nearby Halberstadt but also further south, on the Upper Rhine and at Bamberg.[76]

If the abandoned portal at Magdeburg was intended to follow French lines the same could only be said of the so-called 'Golden portal' at Freiberg in a limited sense [127]. Of course, certain elements such as the figured voussoirs call to mind French archivolts and the subject of the tympanum was earlier seen at Laon, but the overall effect is quite different. The portal was only moved to its present position on the south transept at the beginning of the sixteenth century, after a fire in 1484 had damaged much of

127. The *Goldene Pforte*; Freiberg Cathedral, *c.*1230–40

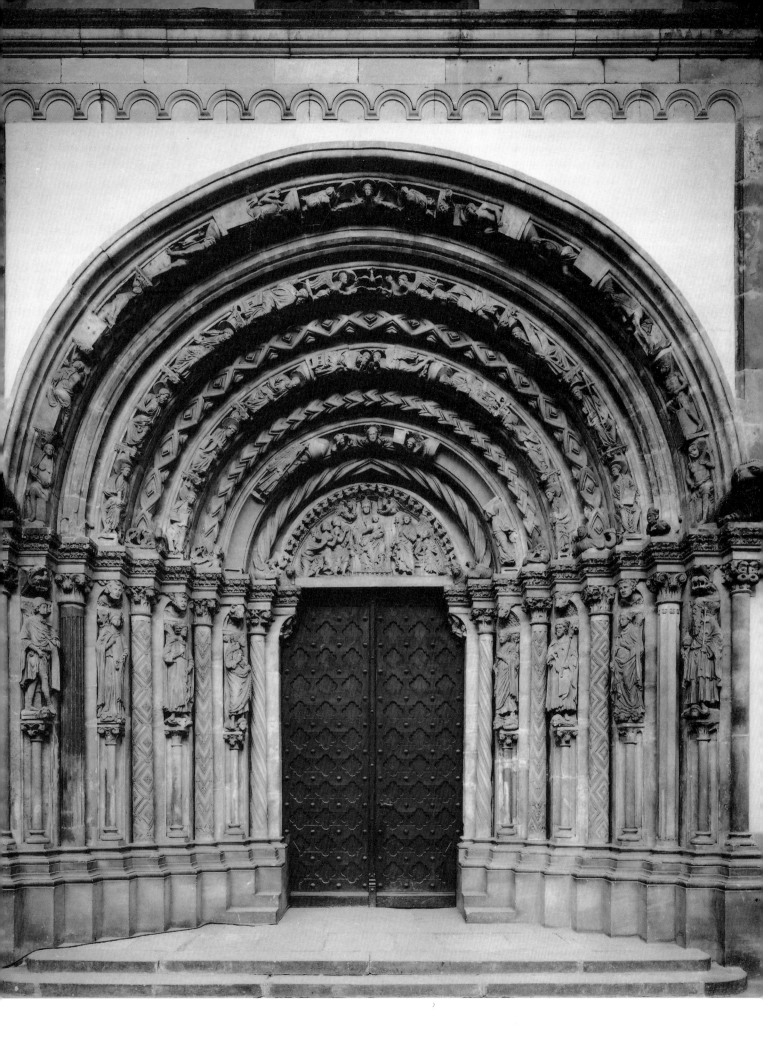

128. Daniel; detail of pl. 127

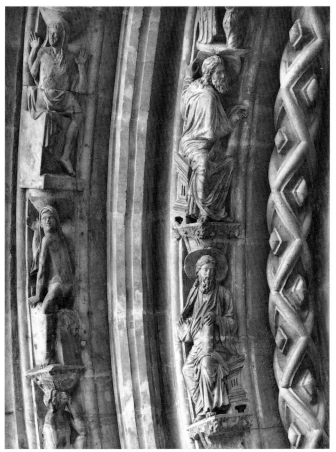

129. Apostles in the voussoirs; detail of pl. 127

the previous church; it was probably originally placed on the west façade. The tympanum is dedicated to the Adoration of the Magi, and the iconographic scheme is extended into the archivolts with the Coronation of the Virgin at the apex of the second order, the apostles [129], the evangelists Mark and Luke, and Abraham offering a soul to an angel in the middle orders, and scenes from the Last Judgement in the outermost band. On the embrasures of the door are eight figures, not carved on columns but set into niches in the manner of the evangelists on the *Galluspforte* at Basel. Standing on colonnettes, they represent Daniel [128], the Queen of Sheba, Solomon, John the Baptist, John the Evangelist, David, Bathsheba and Aaron, while above each figure is either a human head (in the case of the Queen of Sheba, Solomon and Bathsheba), a ram's head (John the Baptist), a lion's head (John the Evangelist and David) or a pair of doves (Daniel and Aaron), the full significance of which remains unclear.[77]

The sculpture is of the highest quality, the apostles in the voussoirs being especially well conceived, turning and twisting on their thrones towards the tympanum, and each head is carved with infinite care. They do not suffer by comparison with their counterparts on the transepts at Chartres, but the animated *Zackenstil* of their draperies sets them apart, and telling comparisons can be made with contemporary paintings on both a small and large scale in Saxony, especially the already-mentioned Goslar Gospels.[78] Although there are no documents to help with its dating, these parallels strongly suggest that the portal was conceived

and constructed in the 1230s. The capital frieze and decor-
ative details indicate that at least some of the workshop
responsible for the portal may have been employed at
Magdeburg in around 1220, and as at Magdeburg there are
links with the earliest works at Bamberg Cathedral, on the
Gnadenpforte and the choirscreen reliefs, also of about 1220
(see below).

On completion of the Golden portal the sculptor or
sculptors responsible for the jamb figures travelled to the
small Augustinian church at Wechselburg, a short distance
to the north-west of Freiberg, where they carved the stone
figures and reliefs on the *Lettner* in front of the choir [130].
After being modified in various ways in the centuries
since its creation the *Lettner* was subjected to a thorough
archaeologically-based reconstruction in the early 1970s.[79]
The pulpitum at the centre has on its front face Christ in
Majesty surrounded by the evangelist symbols and flanked
by the Virgin and St John the Baptist, while below in the
spandrels of the arch Cain and Abel make their offerings.
On the sides of the pulpitum are reliefs showing Moses and
the brazen serpent (the same scene was employed on the
Freiberg *Lettner*) and the Sacrifice of Isaac. To each side
of the central pulpitum are three prophets: Abraham and
Melchizedek stand on the lower level, and on the upper tier
are Daniel, David, Solomon and Isaiah or Ezekiel. The
polychrome wood triumphal cross, the Virgin and St John

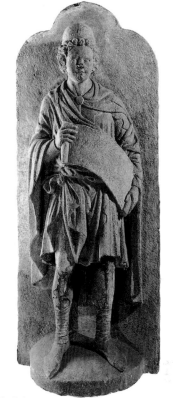

131. Daniel; detail of pl. 130

130. *Lettner*; collegiate church, Wechselburg; c.1240

132. Triumphal Cross; above *Lettner* in pl. 130

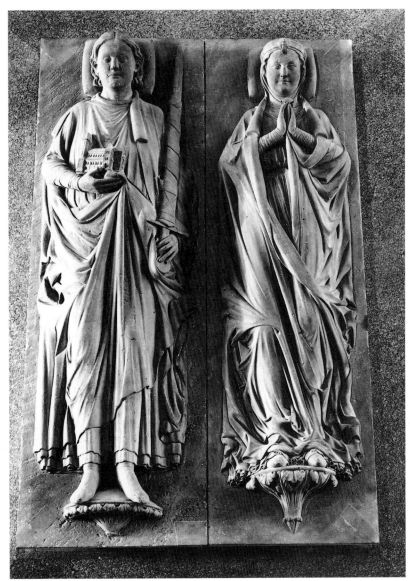

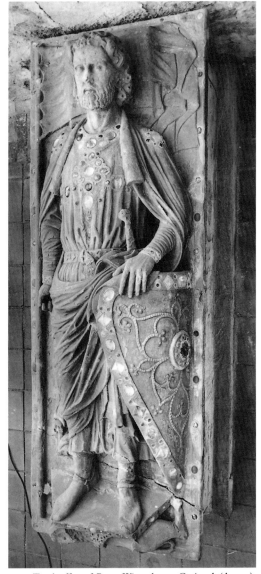

133. Tomb effigies of Henry the Lion (d.1195) and Mathilda (d.1189); collegiate church of St Blaise, Brunswick; *c*.1235–40

134. Tomb effigy of Count Wiprecht von Groitzsch (d.1124); St Laurentius, Pegau; *c*.1240–5

the Evangelist (trampling on two crowned figures, probably Synagogue and Paganism) stand on a platform high above the screen; as on the earlier cross at Halberstadt, the figure of Adam looks up at the crucified Christ and two angels occupy the lateral terminals, but in this case God the Father is shown above Christ's head, holding the Dove of the Holy Ghost [132]. Unlike the Christ in the cathedral at Halberstadt, the Wechselburg Christ has one foot over the other, nailed to the cross with a single nail. This type of crucified Christ (the '*Dreinagelkruzifix*'), extremely rare before the beginning of the thirteenth century, was to become the norm from about 1250.[80]

A comparison of the figures of Daniel or David at Wechselburg [131] with the same prophets on the Golden Portal at Freiberg [128] suffices to demonstrate that one sculptor was responsible for both sets of figures, while the form of the Wechselburg *Lettner* must also have been taken over from that at Freiberg, now sadly dismantled. While both the reliefs and the wood figures of the Crucifixion group at Freiberg have a stillness and classicism which link

them with French works, perhaps through the earliest sculptures at Magdeburg, all the Wechselburg figures – both in stone and wood – are permeated with the energetic *Zackenstil* of the 1230s. The flying angels and the figure of Adam on the terminals of the cross have an exquisite realism, enhanced by the subtle colouring of their draperies and faces, and the movement of the limbs under cloth is rendered with great skill.[81] The Wechselburg *Lettner* represents the peak of the 'Middle German' hybrid style, which mixed elements of French Gothic with Byzantine and local late Romanesque.

This distinctive blend of stylistic sources is also manifested in tomb sculpture. The most celebrated effigies of the first half of the thirteenth century in Saxony are those on the retrospective double tomb of Duke Henry the Lion, the Guelph scourge of the Holy Roman Emperor, and his wife Mathilda, the daughter of the English King Henry II [133]. Mathilda had died in 1189, Henry in 1195, but it was not until about 1235–40 that their tomb monument was executed and placed in front of the high altar of the collegiate church

of St Blaise in Brunswick. Henry is shown holding a model of the church in which he is buried – indicating his pious generosity – and with a sword in his left hand (a reference to his temporal power), while Mathilda alongside simply joins her hands together in a gesture of reposeful prayer. In contrast to the serenity of the figures' poses, the drapery envelops their bodies in agitated swirls; and although the fall of the cloth and the presence of the pillows is consistent with their recumbent position the presence of consoles beneath the feet introduces an ambiguity. Seen from above they have a similar appearance to jamb figures: compare, for instance, Mathilda with Bathsheba on the Golden portal at Freiberg. The Guelph association with the Plantagenets has been put forward as the explanation for the appearance of this type of effigy in Saxony (as for the introduction of the triumphal cross into the German lands), with the tombs of Henry II and Eleanor of Aquitaine at Fontevrault proposed as precursors; these may have provided the inspiration for the juxtaposition of the effigies, but the type of draped bier at Fontevrault was not employed at Brunswick and the style and pose of Mathilda was possibly anticipated in the effigy of an unidentified abbess in Quedlinburg.[82]

The double tomb of Count Dedo von Wettin and his wife Mechthild at Wechselburg was obviously produced in response to that at Brunswick, and must have been made within a few years of the latter. Like Henry the Lion and Mathilda, both of the commemorated figures had died at the end of the twelfth century, and the references to the earlier tomb are apparent at once in the bearing of the figures, the model of the church held by Dedo, and the consoles on which they rest their feet. Notwithstanding the coarser sandstone in which they are carved, the effigies have the same fine fluttering drapery as their models and were evidently carved by a member of the workshop responsible for the Golden portal at Freiberg and the Wechselburg *Lettner*.[83] A third product of this workshop is the effigy of Count Wiprecht von Groitzsch (died 1124), the founder of the Benedictine monastery of St Jakob in Pegau [134]. His effigy, once complemented by his wife Judith's effigy alongside (now destroyed), was moved after the Reformation to the Laurentiuskirche in Pegau, and its condition has suffered.[84] It follows the form of that of Dedo at Wechselburg, with shield and standard unfurled behind his head, but here the draperies, the edges of the shield and tomb chest are enlivened by inset glass jewels.

WESTPHALIA

The lands of Westphalia, split between the archbishoprics of Cologne and Mainz and bordered by the Lower Rhine to the west and Lower Saxony to the east, were receptive to diverse influences. Many wood sculptures of the Virgin and Child and the Crucifixion still survive in this area. As might be expected, several of the early thirteenth-century Virgin and Child sculptures in the western part of Westphalia, notably the well-preserved example of about 1230 in the Marienkirche in Dortmund, reflect the pervasive style of Lower Rhenish or Mosan models, while the crucifixes continued to be made in the late Romanesque manner until the middle of the century.[85] A particularly interesting type of cross which was to be popular in Sweden – the *Scheibenkreuz* (wheel-cross) – is seen for the first time in around 1220 in an example in the Hohnekirche in Soest; now missing its figures of Christ, the Virgin and St John, the four remaining round and four square shallow reliefs of Christ's Passion and Resurrection, and the two censing angels standing on the lateral terminals of the cross have the appearance of goldsmiths' work.[86]

On a monumental scale, the most significant stone sculptures were contained in the 'Paradise' porches at Münster and Paderborn. The Münster 'Paradise' is attached to the south-west transept of the Cathedral of St Paul. Christ in Majesty is contained in the tympanum above a lintel showing the Adoration of the Magi, the Presentation in the Temple and the Conversion of St Paul, and the doorway is flanked by ten apostles, five to each side (the fifth in each case accommodated on the side wall), with the figure of St Paul on the trumeau [135].[87] The foundation stone of Münster Cathedral was laid by Bishop Dietrich von Isenburg in 1225, but it was not until 1264 that it was completed and consecrated under Bishop Gerhard von der Mark. Although there are no more specific dates than these, it is now generally accepted that the apostles and tympanum reliefs were executed in the decade after the laying of the foundation stone. Not all the sculpture is in the same style: the lintels were carved by a sculptor trained in the techniques of the Middle Rhenish workshops, while the apostles show knowledge of the life-size figures on the transept portals at Reims and Chartres.[88] Four other figures, carved in a far more accomplished manner, were added to the side walls of the porch: to the right stand statues of Bishop Dietrich, holding his foundation stone, and St Lawrence, with a small kneeling donor figure at his feet [136]; to the left, St Mary Magdalene, also with a kneeling figure, this time female, and a knight, probably St Gottfried of Cappenberg.[89] These figures had traditionally been dated to the last years before the consecration of the cathedral in 1264, but by drawing parallels with sculpture at Chartres and especially Strasbourg, Sauerländer has convincingly moved their date back into the 1230s.[90] A particularly persuasive comparison has been made between the figure of St Lawrence at Münster and one of the angels on the Judgement Pillar at Strasbourg. It therefore appears that a sculptor outside the main workshop on the 'Paradise' executed these four figures and departed again, because there does not seem to be any further trace of his work in this region. The style of the portal's apostle figures reappears in the four evangelists of the crossing at Münster, where echoes of Reims are manifested in the St Mark, and in the other major portal project of the first half of the thirteenth century in Westphalia, at Paderborn.[91]

The 'Paradise' portal on the south-west transept at Paderborn is composed differently from that at Münster: instead of being ranged along the walls flanking the doorway, the apostles (there are only six) are placed in the conventional French fashion, on the splayed embrasures, and the Virgin and Child occupy the trumeau [137]. Above, in the tympanum, two angels fly towards a wooden crucifix, which appears to be of contemporary date.[92] At the edges of the portal are two further figures – a haloed bishop in a niche on the left and a female saint trampling on a small figure of a king or emperor.[93] It has been proposed that both the Münster and

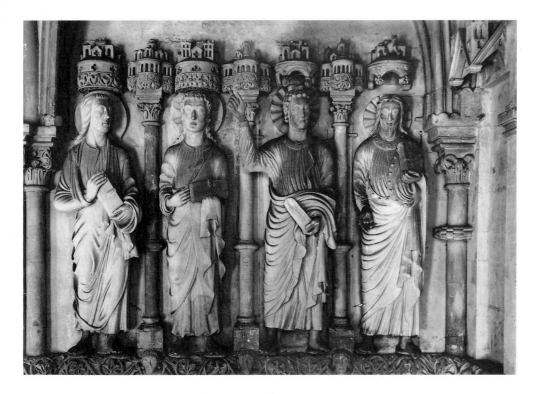

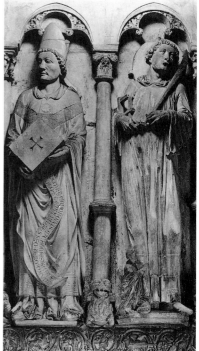

135. Apostles from the 'Paradise porch', south-west transept, Münster Cathedral; c.1225–35

136. Bishop Dietrich von Isenburg and St Lawrence; the 'Paradise porch', south-west transept, Münster Cathedral; c.1235–40

137. The 'Paradise portal', south-west transept, Paderborn Cathedral; c.1240

Paderborn porches owe their layout to western French examples, such as Saint-Seurin at Bordeaux and Saint-Martin at Candes, but although there is clear evidence of links between Paderborn and Le Mans at this date there are objections to hypotheses which would place too much importance on this connection.[94] The style of the figures is unequivocally Middle Rhenish, and given that Paderborn was suffragan to Mainz it is hardly surprising that this should be the case. The *Leichhofportal* in Mainz Cathedral [113] illustrates the genesis of the style of at least one member of the Paderborn workshop – compare the bishop saint with the bishops on the tympanum – although new elements from northern France have been added in the apostle figures. Datable to around 1240, the Paderborn portal shows the tenacity of a local German Romanesque style at a late date, still distinctively regional but increasingly transmogrified by the influence of the dominant French models. By this time sculptors were already working in a completely new manner on the western screen in Mainz Cathedral, a preliminary to one of the greatest ensembles of European sculpture of the thirteenth century, in the west choir of Naumburg Cathedral.[95]

BAMBERG

The cathedral of St Peter and St George at Bamberg was founded by the German King Henry II (Emperor from 1014) and his wife Kunigunde and dedicated in 1012. From this date onwards the founders were held in special reverence at Bamberg: Henry was canonised in 1146, Kunigunde in 1200, and their relics enshrined in the cathedral; and the basic form of their Ottonian building was retained even after fires in 1081 and 1183. Bamberg enjoyed a special status in the Empire as a result of its close association with Henry and after 1020 it was no longer subordinate to the Archbishop of Mainz, being instead a special protectorate of the papacy; its partial dedication to St Peter and the later iconographic programme of two of the portals would draw attention to this bond between Church and Empire. After the second fire, major rebuilding was carried out under the powerful and well-connected Bishop Ekbert von Andechs-Meran which although not radically affecting the groundplan of the church (the elevation changed greatly) included the creation of new portals and considerable amounts of interior sculpture. There are no documents for the beginning of the new work: the cathedral was re-dedicated in 1237 just after Ekbert's death, and there are references in the 1220s to various activities within the building, including the gift of 4000 silver marks from the Emperor Frederick II in 1225, so a start in around 1215 would seem most likely.[96] Contrasting with the measured and gradual reception of the new sculptural styles emanating from the West elsewhere in the Empire, the two decades of sculptural activity at Bamberg can – quite exceptionally – be divided into two: before and after the arrival of a workshop from Reims. The earliest sculptures produced for the new cathedral – the eastern choirscreen and the 'Portal of Mercy' (the *Gnadenpforte*) – do not prepare us for the strikingly different sculptures of the 1230s. The stylistic rupture at Bamberg was due to the unprecedented and seemingly opportunistic importation of a workshop

138. The *Gnadenpforte*; north side, eastern choir, Bamberg Cathedral; *c.*1220

trained in the idiom of the French cathedrals, whose influence would be both profound and far-reaching.

In about 1220, the two portals on each side of the apse of the eastern choir dedicated to St George were constructed. That on the south, the so-called 'Adam's portal', was at first undecorated, save for two bands of chevron ornament running around the doorway, but the northern portal – the *Gnadenpforte* – was filled with a sculpted tympanum and although it remained free of any figural carving in the archivolts and embrasures the capital frieze on each side of the doorway was richly decorated with small figures among foliage, surmounted by half-length figures of martyrs holding a continuous scroll and the instruments of their martyrdom [138]. At the extremities of the frieze angels usher the assembled company of martyrs into the presence of the Virgin and Child, who occupy the centre of the tympanum. They are shown flanked by Saints Peter and George, Henry II and Kunigunde, and smaller figures of two ecclesiastics, in a carefully stepped hierarchical arrangement; a third even more diminutive figure kneels at the feet of the Virgin. Unfortunately the inscriptions on the scrolls the figures are

139. North side of eastern choirscreen, Bamberg Cathedral; c.1225–30

140. Prophets debating; north side of eastern choirscreen, Bamberg Cathedral; c.1225–30

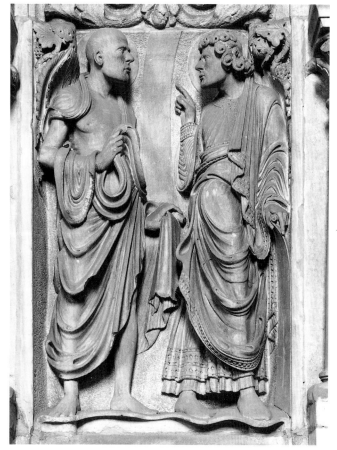

holding are now missing so they can no longer be positively identified, but it is almost certain that the bishop is Ekbert, while the figure on the right is likely to be his cathedral provost Poppo.[97] The relationship between *Sacerdotium* and *Imperium* is here explicitly illustrated, specifically linking the cathedral at Bamberg to the highest authority in the Church through special locally-venerated intercessors. Such an iconography would have appealed to Frederick II, so often in conflict with the Pope.

The symmetrical layout of the tympanum harks back to the Rhenish reliefs illustrated at the beginning of this chapter, at St. Pantaleon in Cologne and at Brauweiler for instance, and the stylistic roots should also be sought in the Rhine-Meuse region. The arrangement of the drapery and the predilection for three-quarters profile in the principal figures on the tympanum recalls the Cologne and Andernach reliefs associated with the Samson-Master, a relationship strengthened by the fine detail of the heads in the Martyrs' frieze.[98]

On its completion, the workshop responsible for the *Gnadenpforte* turned its attention to the eastern choir screen just inside the cathedral. The enclosure walls to the north and south are decorated with twelve prophets and apostles respectively – the same positions as they occupy on the transepts at Chartres – arranged in pairs under arcades [139]. In contrast to the apostles on the slightly earlier choirscreen at Hildesheim, those at Bamberg turn to gesture to one another in a lively *disputatio*, and their scrolls originally contained excerpts from the apostles' creed to underline the debate.[99] They have the animation of the similar figures of disputing apostles on the door posts of the central por-

tal at Vézelay, almost exactly one hundred years earlier, and, although there can be no question of a direct connection, they share the experimental freedom of the early Romanesque.[100] The mannered heads found on the St Peter and the martyrs on the *Gnadenpforte* – with pointed chin and wig-like hair – are developed on the apostles into even more individualistic types. Slightly different styles have been identified among the various apostles and prophets, which is either due to the contribution of a number of sculptors or the stylistic development of one master over a period of about ten years. Either way, the apostles of the western half of the southern choirscreen appear to be the earliest (they are certainly the closest to the *Gnadenpforte*) and are more restrained than the frenetic prophets on the north side, who are enveloped in draperies of extraordinary vitality [140].[101] The swirling tubular folds and bristling dynamism of the figures exhibit perhaps for the first time a particularly *deutsche* quality, and it would not be far-fetched to suggest that their style informed the distinctive work of early sixteenth-century sculptors such as Hans Leinberger.[102]

In company with the Hildesheim and Halberstadt choirscreen reliefs, those at Bamberg were of course originally brightly painted and gilded; faint traces of some of the foliate patterns in the lunettes above the heads of the apostles still exist.[103] An interesting feature here is the roughened background to the prophet reliefs, which may have been treated in this way to receive a coloured paste or other application.[104]

The next work to be executed was the main doorway on the north side of the nave, the so-called Princes' portal (*Fürstenportal*), which was probably started in about 1230.[105] The tympanum is devoted to the Last Judgement, complemented by a highly unusual arrangement in the jambs of the apostles standing on the shoulders of the prophets – interpreting literally the New Law's dependence on the Old, but also indicating that the apostles' vision exceeded that of the prophets [141].[106] Unfortunately the embrasures on the right are now badly weathered, which is especially regrettable given the importance of the sculpture and the differences between the left and right sides. From a style-critical analysis of the doorway it would seem that the jambs on the left-hand side were undertaken first, by a member of the workshop responsible for the *Gnadenpforte* and the choirscreen reliefs; but in the outermost figures on the right one can detect a different hand, working in a style which is most clearly manifested in the better-preserved tympanum relief.

Christ is shown seated in the midst of the Blessed and Damned, involved in the surrounding drama more directly than in any French Judgement portal, while at his feet the Virgin and St John the Baptist intercede for the souls rising from the dead between them [142]. The Damned, to Christ's left, consist of five terrified figures transfixed with fear, their faces contorted into masks of helpless misery, being guided away from the Saviour and towards a monstrous devil who corrals them with a length of chain. The miser is recognisable at the centre of the group holding his bag of money, the contours of the coins pressing against the fabric of the bag, accompanied by a king, a pope and a bishop. On Christ's right, angels turn towards him with the instruments of the Passion, while another king is touchingly led by the hand

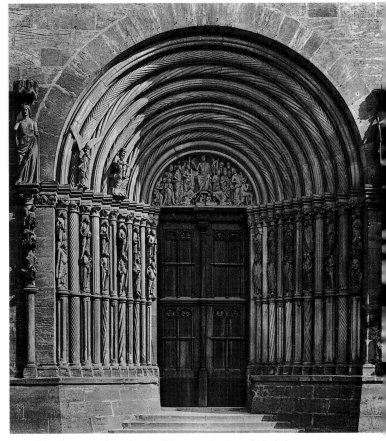

141. The *Fürstenportal*; north side of the nave, Bamberg Cathedral; *c*.1230–5 (photograph taken *c*.1900)

into the Lord's presence; in front of him the personifications of three blessed souls smile with undisguised pleasure at their happy fate.[107] Before 1936, the iconographic programme of the portal was completed by the isolated figures of a trumpeting angel and the seated Abraham with four diminutive blessed souls in his lap at the bottom of the archivolts on the side of the Blessed (these were possibly balanced by another angel and damned souls falling into the mouth of Hell on the other side) and by the figures of *Ecclesia* and *Synagoga* at the sides.[108] *Ecclesia* rested on a column carved with the symbols of the evangelists – confirming the Gospels as the foundation of the Church – and a seated figure below (now headless) which presumably represents Solomon; on the other side of the portal the column supporting Synagogue is carved with the gruesome image of a devil reaching down to blind the standing figure of Judaism.

It is likely that the portal was already well advanced when a second workshop arrived in Bamberg in around 1233–4. As already mentioned, it seems that the prophets and apostles on the left side are the work of the sculptors who had been employed at the cathedral from the beginning. They were joined by a small group from Reims – it is pointless to hypothesise whether there was a German trained at the French cathedral among them – who by the introduction of new carving techniques and in their approach to the depiction of emotion and drama revolutionised the making of sculpture

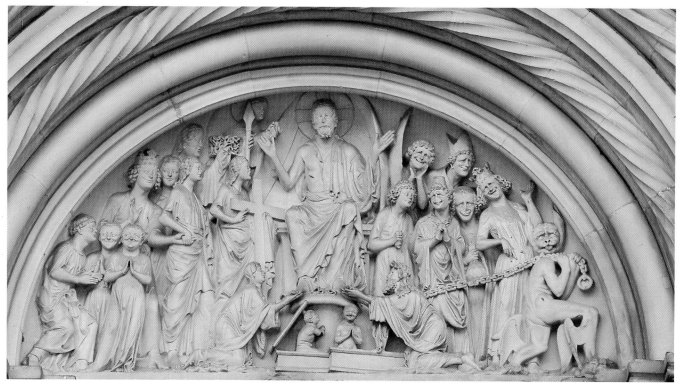

142. Tympanum, the *Fürstenportal*; north side of the nave, Bamberg Cathedral; *c.*1233–5

143. The *Adamspforte*; south side, eastern choir, Bamberg Cathedral; *c.*1220 and 1235–7 (photograph taken *c.*1900)

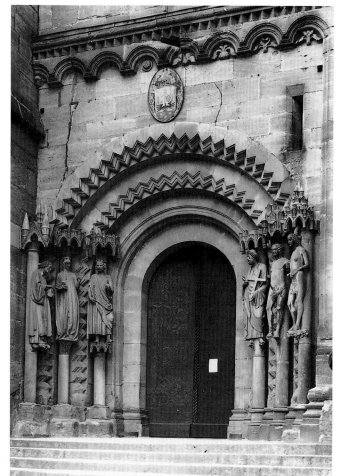

in Germany. Many of the stylistic hallmarks of the Reims workshop are instantly recognisable, and the grinning and grimacing headstops from the choir and transepts [97–8] have often been compared with the remarkably similar heads of the *Fürstenportal*; but there is at Bamberg – and later at Magdeburg – a strained sense of emotion without parallel in France. Indeed the closest comparison to the bustling chaos in the Bamberg tympanum – in spirit if not in form – is found in the more muted pathos of the Death of the Virgin at Strasbourg, of almost the same date. Although this must partly be to do with the generally increasing interest in the study of nature and man's expression of his emotional state (both of which are explored in contemporary writing) it was nevertheless an approach to art which was to appeal particularly to the patrons and sculptors of the Empire.

The Reims-trained workshop completed the right hand jamb figures and carved the tympanum. Because the portal had already been designed they were unable to extend the Last Judgement iconography into the voussoirs, but simply added separate attached figures at the bottom of the arch: the result is a contraction of the Reims north transept Last Judgement tympanum, but in this case the concentration of the scene into a smaller space has greatly increased the dramatic power of the composition. The programme was also expanded by the addition of the figures of *Ecclesia* and *Synagoga*. The latter, while not being copies of the same figures on the south transept at Reims, are sufficiently close in style to prove a common parentage.[109] Six jamb figures were added to the Romanesque 'Adam's portal' on the other side of the east choir from the *Gnadenpforte*, their slightly clumsy positioning betraying the fact that they did not form part of the original conception of the doorway [143].[110] On the left are Henry II and Kunigunde, holding a model of the church, and St Stephen, who clasps the instrument of his

martyrdom – a large rock – in front of him; on the right are St Peter and the naked figures of Adam and Eve. They represent the concept of foundation: Adam and Eve, the 'founders' of mankind, are juxtaposed with the first patrons of the cathedral, St Peter is present as the primary Bishop of Rome and St Stephen as the first martyr.[111] The style of the figures, like the *Ecclesia* and *Synagoga* from the *Fürstenportal*, is unmistakably that of the massive statues on the Reims transepts, and a close comparison may be made between Henry II and the so-called Charlemagne.[112]

Inside the cathedral the Reims workshop was responsible for the four figures of Elizabeth, the Virgin, the Angel with a crown [259] and St Dionysius, now mounted on plain consoles on the piers on the north side of the east choir, and the famous 'Bamberg Rider'. The resemblance of the first two figures [144] to the Visitation group at Reims has often been noted, the most conspicuous similarity being the *Muldenfaltenstil* of the draperies, which is even more pronounced at Bamberg; attention has also been drawn to significant details on the figure of Elizabeth, such as the way the bulky cloth of her robe is gathered up in her right hand in exactly the same way as on the figure of 'Charlemagne' at Reims, and the striking resemblance of her face to one of the console heads.[113] The original placement of these figures is not now known: it was perhaps the intention to position them around a never-completed doorway or they may have been destined for a *Lettner*.[114]

The Bamberg Rider itself [145] has proved to be one of the most enigmatic sculptures in the history of art. It is often the case that the meaning of a work of art can be explained by its position on or in a building, but in this instance (as with the other four figures) we do not know whether its current position – on the pier on the north side of the entrance to the eastern choir – was intended, even though its base seems to be original and the complicated physical structure of the sculpture would discourage moving. As a result of this uncertainty the scholarly imagination has been given full reign and numerous different identifications proposed, including Henry II, Conrad III, Frederick Barbarossa, Philip of Swabia, Frederick II, St George and even one of the Three Magi. Most recently opinion has tended to favour either Constantine the Great or St Stephen of Hungary. In favour of Constantine, it should be pointed out that like the figures on the Adam portal he also represents the concept of foundation, being the first Christian Emperor, and that in his present position at least he appears to be looking towards the crucifix in the west choir (the *Peterschor*), which would of course be entirely appropriate given his legendary vision of the Cross.[115] St Stephen of Hungary, on the other hand, was the brother-in-law of Henry II, and it is perhaps significant that the Rider was identified as such in an early eighteenth-century source.[116] Nor is the image of the Rider of any help in this connection, being a generic king type deriving directly from the Reims transept figures of 'Philip Augustus' and others [96].

In addition to being a work of art of great beauty – a distillation of the Christian chivalric spirit into sculptural form – the Bamberg Rider is also a technical *tour-de-force*. It is constructed of seven pieces of sandstone, including the plinth and the mask console, and the joints are still visible,

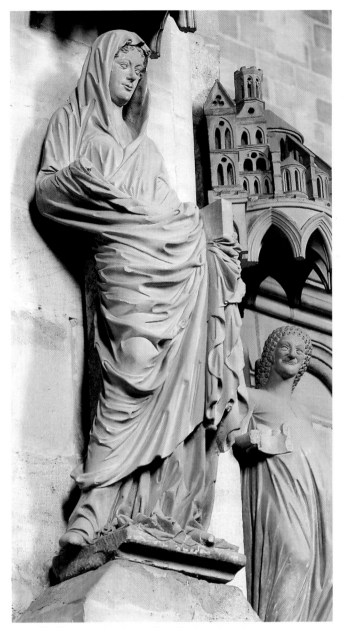

144. The Virgin; north side, east choir, Bamberg Cathedral; *c*.1235–7

so that it is possible to see that the legs and lower part of the horse's body are carved from one block, the main part of the horse's body and the lower part of the Rider from another, while the top of the horse's head and the upper part of the Rider are made from smaller pieces.[117]

The last work to be associated with the Reims-trained workshop in the cathedral is the now incomplete tomb of Pope Clement II, the Bishop Suidger of Bamberg, pontiff for less than a year in 1046–7. His remains were transferred from Rome to Bamberg after his death, and after Ekbert's rebuilding of the cathedral solemnly put back into the western choir of St Peter, where a splendid tomb was made, presumably just before the consecration in 1237. Because it was dismantled in the seventeenth century the major components of the tomb – the tomb-chest and the effigy – were separated, and it is not now possible to reconstruct its appearance with

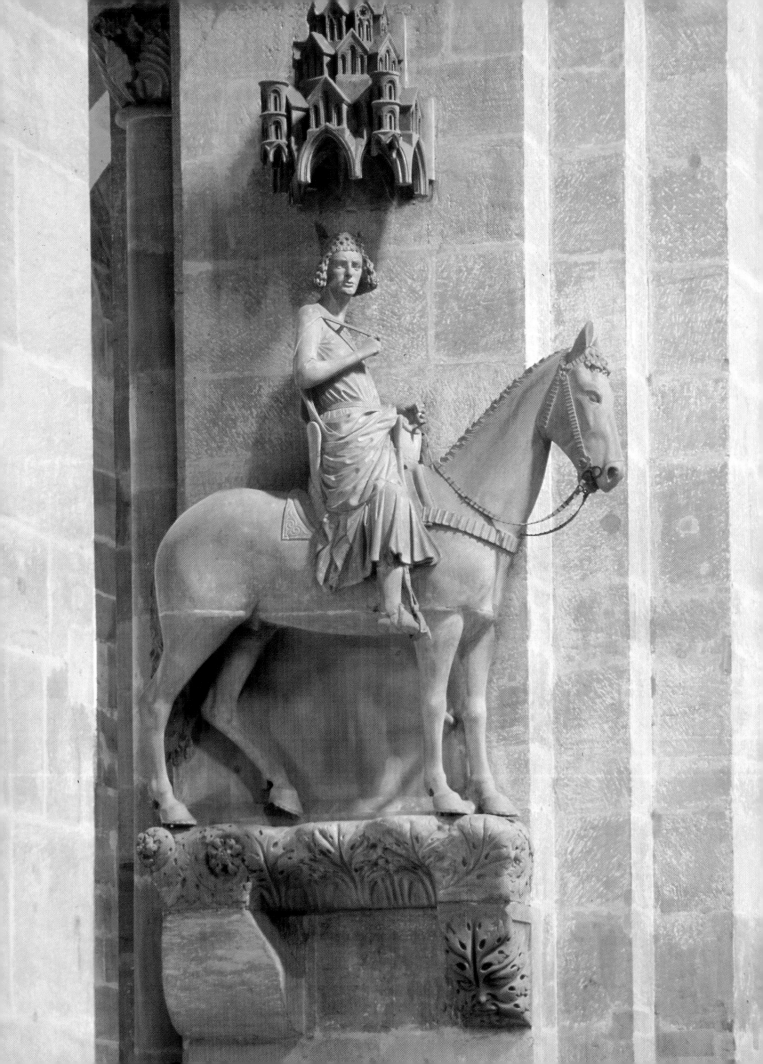

146. Tomb effigy of Pope Clement II (d.1047); north side, east choir, Bamberg Cathedral; c.1235–7

147. Tomb chest of Pope Clement II (d.1047); west choir, Bamberg Cathedral; c.1235–7

like serpent) and a river god, and on the ends the death of the Pope and the figure of St John the Baptist or Christ [147]. Panofsky has pointed out that the depiction of Virtues on the *tumba* echoes the words of Thiofrid of Echternach (d.1110), who had described how the saints had 'entered their graves in an abundance of virtues' (*qui in abundantia virtutum ingrediuntur sepulchrum*), and the position of the tomb at the centre of the *Peterschor* confirms that Clement, like Henry II, was accorded saintly status in his place of birth.[120]

The effect of the Reims workshop was felt far beyond Bamberg. In the twenty years following the consecration of Ekbert's cathedral, other major sculptural schemes at Magdeburg, Mainz and Naumburg would show how the lessons learnt at Bamberg were taken up and transformed into a wholly German style.

To the south, in Bavaria, a single case of a different type of French influence – transmitted through the Upper Rhine – can be seen in the sculptural decoration of the castle chapel of the Wittelsbach dukes in Trausnitz (Landshut). The earliest sculptures are now confined to the east end of the chapel and consist of an arcaded gallery screen in stucco with Christ flanked by the Virgin and St John the Baptist, the twelve apostles, and three unidentified saints, an oak triumphal cross group above, and on the east wall two life-size female saints and an Annunciation group, also in stucco [148]. The chapel was considerably modified and vaulted in the sixteenth century, and fragments that have since come to light indicate that the sculptural scheme has been substantially reduced.[121] The screen figures, like those from Wessobrunn and Reichenbach now in the Bayerisches Nationalmuseum in Munich, share the form of the earlier choirscreen apostles in stucco at Halberstadt, but the style is distinctly that of the Upper Rhine, particularly Strasbourg.[122] This affiliation with the sculpture of Strasbourg, which the Wittelsbachs certainly knew, is demonstrated most clearly in the figures on the east wall. The slender saints (without foundation described as Catherine and Barbara) have the elegant bearing and flowing drapery of the Strasbourg *Ecclesia* and *Synagoga*, while the angel of the

confidence; the tomb-chest and effigy seem to have been surmounted by a canopy, judging by the bases for six slender columns still extant, and these probably supported censing angels, one of which is preserved in a fragmentary state in the Liebieghaus in Frankfurt.[118] The effigy itself [146], now mounted in a vertical position on one of the piers on the north side of the eastern choir, is perhaps the most 'French' of all the Bamberg sculptures, showing the Pope in exactly the attitude – with the right hand raised in blessing and the left holding a book – of so many figures of bishop and pope-saints on the portals of Chartres, Reims and Amiens: indeed, the pillow behind his head is the only feature which betrays his original function.[119] In keeping with the suitable mood for a tomb sculpture, there is here an element of emotional restraint which is absent in the other 'living' figures at Bamberg.

The tomb chest is remarkable not only for its decoration but also for its material, a greyish marble from the Kärnten in Austria. On the sides are highly accomplished reliefs of the personifications of the Cardinal Virtues (Justice holding the scales, Temperance changing wine into water, Fortitude fighting with a lion and Prudence restraining a large dragon-

145. The Bamberg Rider; east choir, Bamberg Cathedral; c.1235–7

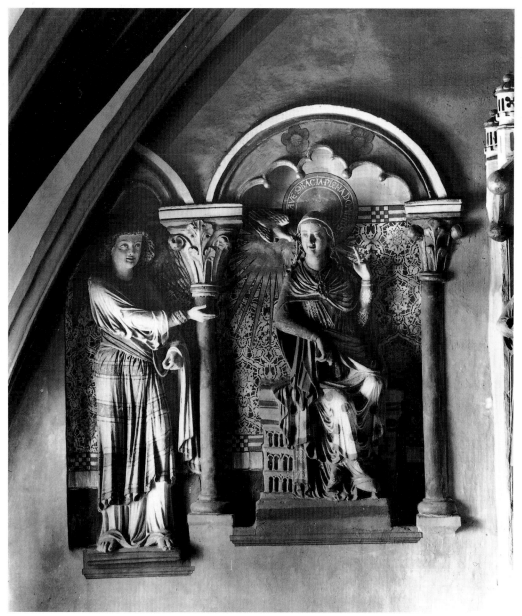

148. The Annunciation; castle chapel, Trausnitz (Landshut); painted stucco, c.1235-40

Annunciation – like the St Lawrence in the porch at Münster – is related to the angels of the Judgement Pillar: even the pose of the Virgin echoes that of Christ on the pillar. The sculptures are thus likely to have been made in around 1235–40.

ON THE FRINGES OF THE EMPIRE

It should come as no surprise to find that outside the larger cities and monastic foundations of the Empire there were few opportunities for building on a significant scale before the middle of the thirteenth century. This was especially the case around the periphery of the Empire, in what is today Poland, the Czech Republic, Slovakia, Eastern Austria and Hungary. There were few towns of any note before the middle of the twelfth century, so that although a rapid expansion did take place in the following century artistic ambition remained modest; the funds needed for commissioning accomplished architects and sculptors were rarely

available and there was only a limited tradition of stone sculpture to draw upon. As a result, the first attempts at monumental sculpture in these areas were usually connected with monasteries and there is little that can be compared with the new styles emerging further west.[123]

In Silesia, the Cistercian abbey of the Virgin and St Bartholomew at Trzebnica (Trebnitz) was founded by Duke Henry the Bearded and his wife Hedwig in 1202. Hedwig, a sister of Bishop Ekbert of Bamberg, was to be canonised in 1267 and as St Hedwig of Silesia became one of the most popular saints of Eastern Europe.[124] She brought the first convent of nuns to Trzebnica from Bamberg in the year of the abbey's foundation and in 1219 a consecration took place: this was probably only for the eastern part of the church, but the building was in all likelihood finished by the end of the 1230s. Unfortunately, the extensive sculptural decoration of the abbey church has been largely dispersed; out of context fragments with narrative scenes survive on the site, but at least some of the sculpture – the tympanum of

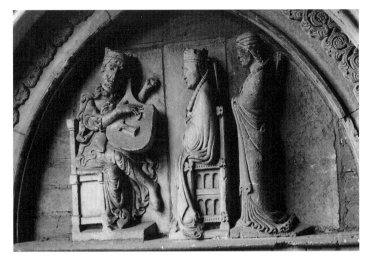

149. King David playing to Bathsheba; tympanum of north door, west façade, abbey of Trzebnica; c.1230–40

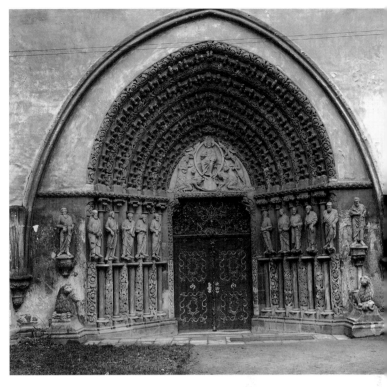

150. The *Porta coeli*, Cistercian nunnery of Tišnov; c.1250

the north door of the west façade – remains in its original position [149].[125] The tympanum shows a simple scene of King David playing to Bathsheba, with a handmaid standing behind her, and it has been suggested that the south portal had a matching composition with Solomon and the Queen of Sheba, and the central portal the Coronation of the Virgin.[126] Despite the well known historical links between Trzebnica and Bamberg there are no signs of stylistic influence from the Bamberg workshops; instead it seems that the patrons of the abbey church called on sculptors nearer to Silesia, at Magdeburg.[127] Two figures of the apostles Thomas and Philip are demonstrably by the same workshop that carved the choir capitals at Magdeburg, of 1210–20: the facial types are similar and the highly distinctive drapery patterns made up of deeply-cut troughs are common to both sets of sculptures.[128] These were probably the earliest of the sculptures at Trzebnica (c.1225–30), and it appears that the tympanum of David and Bathsheba (and another of the Virgin between angels now in the north transept) was made by a different hand, also from the Magdeburg workshop, in the 1230s. The sculpture of Trzebnica therefore provides evidence, like Bamberg, of the importation of a fully trained workshop from elsewhere rather than the contribution of a local school. Examples of indigenous work – at Wroclaw (Breslau), Czerwińsk and Strzelno for example – continue the Romanesque style well into the thirteenth century.[129]

The same situation obtained in Bohemia. The major sculptural commissions were confined to important buildings associated with the Premyslid court in and around Prague and Brno, and only one or two sculptures of note can be distinguished among the provincial late Romanesque output.[130] The first of these, the remains of a tympanum probably from the Virgin's chapel in the Benedictine convent church of St George in Prague Castle (now in the Národní

Galerie), shows the Virgin enthroned with the Christ-Child on her knee, being crowned by two angels and with two kneeling abbesses at her feet; separate segments at the sides contain the additional kneeling figures of Ottokar I, King of the Bohemians (d.1230), and his sister the Abbess Agnes (d.1228).[131] It was probably made in the 1220s and reveals no knowledge of developments elsewhere. By the middle of the century, however, the primary works begin belatedly to show signs of an awareness of the Gothic style. The *Porta coeli* of the Cistercian nunnery at Tišnov [150] reflects the influence of portal design in Saxony, especially the *Goldene Pforte* at Freiberg, while also incorporating elements of Italian derivation – such as the recumbent lions at each side – possibly transmitted through South German or Austrian examples. Ottokar I is shown again, presenting a model of the church with his wife Constance (the founder) under the commanding figure of Christ. Although Christ is shown in the traditional Romanesque manner within a mandorla and surrounded by the symbols of the evangelists, with the Virgin and St John the Baptist at the sides, all the figures of the tympanum show a much more advanced approach to the human form than in the Prague tympanum and the treatment of drapery is far more sophisticated. Jamb figures of the apostles (now restored) and the rich foliate decoration of the archivolts combined to complete an ensemble which must have stood out from the earlier Bohemian portals as a modern work, despite its comparatively late date – in relation to German and French portals – of around 1250.[132]

Further south the city of Salzburg was a magnet for artists, being at the centre of a large and wealthy archdiocese, and was at this time part of the Duchy of Bavaria. Some of the sculpted portals of the first half of the thirteenth century in Salzburg appear to have affiliations with the late Romanesque tympana of the Middle Rhine, such as at Aschaffenburg: the doorways of the Franziskanerkirche

151. Tympanum with the Virgin and Child and angels; marble, probably *c*.1215–30 (Museum Carolino-Augusteum, Salzburg)

(*c*.1220) and that of the abbey church of St Peter, both presumably by the same workshop, show the enthroned Christ flanked by saints in just the way favoured in the Middle Rhenish churches.[133] But the more dominant stylistic influence – for sculpture as well as painting – came from Italy.[134] This Italian strain is most clearly perceived now in fragments from larger schemes, the marble tympanum of the Virgin and Child between angels in the Museum Carolino-Augusteum being the most significant survivor [151]. Although it follows the symmetrical arrangement of the other tympana, the stocky, square-jawed figures are entirely different, linking the sculpture with the so-called 'Madonna degli Annegati' in Trento Cathedral, which is in turn derived from Benedetto Antelami's tympanum of the Virgin and Child on the Parma Baptistery of shortly after 1200 (see p. 127). With these parallels it can hardly have been made much before 1215 and a date in the twelfth century – which it has sometimes been given – is out of the question.[135] Other *disjecta membra*, including a fine marble lion from a portal, further indicate the debt to North Italian prototypes.[136]

In Lower Austria, the earliest portal of the Stephansdom in Vienna (the so-called '*Riesentor*') had different antecedents. Now incorporated into the later Gothic cathedral, the portal is contained within a deep porch on the west façade. Its tympanum shows Christ within a mandorla supported by two angels, the archivolts are decorated with rich non-figural decoration, and above the embrasures runs an inhabited capital frieze. The most striking feature now is the presence of small busts of the apostles above the capital frieze, which in type and style clearly reveal the contribution of a member of the older Bamberg workshop responsible for the *Gnadenpforte* and the apostle reliefs on the south side of the choirscreen, indicating a date of around 1235. This would accord well with the building history of the church, which was not yet a cathedral and which had been remodelled in time for Frederick II's visit in 1237.[137] There are also

parallels to be drawn between the *Riesentor* and the *Goldene Pforte* at Freiberg, especially the animal heads at the top of the embrasures; and as the jambs have been shaved down below these heads it seems possible that the Viennese portal also accommodated standing figures on each side of the doorway, as at Freiberg.

Outside the Empire, to the south-east, little Gothic sculpture of significance seems to have been produced in the Kingdom of Hungary until the fourteenth century. Its exposed eastern flank was vulnerable to attack from barbarian hordes (such as the Mongols in 1241–3), and a buffer-zone is rarely a conducive place for grand church building. In addition, most of the cathedrals and important monastic churches which might have provided the setting for large sculptural projects had been completed in the twelfth century and were in no need of remodelling. There does not appear to have been a taste for elaborate church furnishings, as in Saxony for example, and the sculptural embellishment of the more prominent early thirteenth-century churches – many of which were private foundations – was largely confined to the west façades. The majority of the scattered remains that survive, at Vértesszentkereszt, Esztergom and elsewhere, illustrate the longevity of the Romanesque style – often under Italian influence – far into the thirteenth century.[138] Occasionally an awareness of northern European Gothic may be glimpsed, such as in the fragmentary surviving sculptures of Somogyvár and Pusztaszer, but these are the exception rather than the rule. The sculptures from the cloister of the Benedictine abbey of Somogyvár probably date from about 1210–20, when it is known that French abbots were in residence; those from Pusztaszer, most notably six broken column figures (also probably from a cloister and of about 1210), are even more clearly inspired – both in type and style – by French prototypes, such as the late twelfth-century column figures from Châlons-sur-Marne and Sens.[139] It is nevertheless still surprising to discover a direct intervention from the most celebrated French architect

and designer of the first half of the thirteenth century, Villard de Honnecourt, who we know visited Hungary because he makes two specific references to '*Hongrie*' in his notebook. Until 1971 it was unclear exactly what his work there entailed, but it now seems likely that this included designing the mostly-destroyed tomb of Gertrude of Meran (d.1213) in the Cistercian abbey of Pilis (now Pilisszentkereszt) to the south-east of Esztergom, between 1233 and 1235. Enough fragments survive – including a fine crowned head with the remains of gilding – to effect a reconstruction of the sides of the *tumba*, which probably showed seated figures of kings under arcades.[140]

The tomb appears however to have been a relatively isolated example of a French work in this foreign setting. Unlike the sculpture of the Reims workshop at Bamberg it did not inspire any followers and the course of Hungarian sculpture was apparently unaffected by it. Instead the evolution of sculpture in Hungary was a slow process of gradual change, exemplified by the west portal of the Benedictine abbey church of St George at Ják [152]. Started in around 1220, the church was dedicated in 1256. The west façade was probably finished in about 1240, and the portal does not depart from the rather old-fashioned decorative scheme, consisting of ornamental designs on the archivolts and jamb colonnettes, which is also found at Ipolyság, Lébény and Sopronhorpács.[141] It differs from those portals, however, by adding Christ and the twelve apostles in ascending niches on the gable above the door, a novel alternative to placing them on the jambs to each side of the portal. The idea of the niched gable may have been suggested by the treatment of the exterior of the *Georgenchor* at Bamberg, and both the style of the figures and the decorative carving of the portal indicate a close familiarity with work at the Franconian cathedral before the arrival of the Reims-trained workshop in around 1233–4. It is even likely that members of the earlier Bamberg lodge were employed at Ják in the 1230s: the sculptural friezes elsewhere on the building tally exactly, and there may have been personal reasons why the masons were sent. Bishop Ekbert of Bamberg was the brother of the Gertrude of Meran mentioned above, and because other documented links between Bamberg and Hungary exist

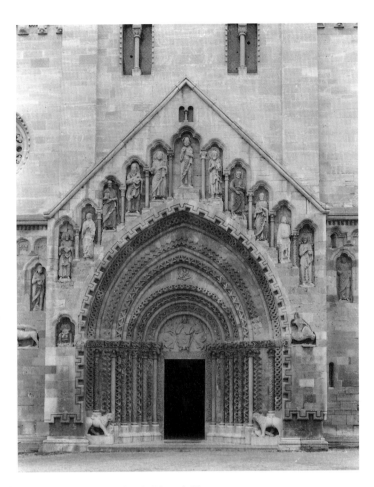

152. West portal, abbey church, Ják; probably *c.*1230–40

a special relationship between the two buildings is less unexpected than might otherwise be assumed.[142] Like the Pilis tomb the Ják figure sculptures did not lead to any more ambitious schemes. They also appear to be a single experiment, but in a style already outmoded in Germany, and they represent the end of the Romanesque rather than the beginning of Gothic.

England 1160–1240

EARLY INFLUENCES FROM FRANCE 1140–80

In the Holy Roman Empire one looks in vain for any sign of a direct transplant of the earliest French Gothic sculpture, as seen at Saint-Denis, the Chartres Royal Portal and elsewhere. But in England the close links between the Crown, the monastic communities and western France ensured that an established connection had already been made, with the result that many twelfth-century Romanesque stone sculptures, ivory carvings and manuscripts have quite rightly been described as 'Anglo-Norman'. The rebuilding of the choir of Canterbury Cathedral from 1174 under the supervision of the French architect, William of Sens, is popularly presented as the first importation of Gothic architectural forms, but there are indications that by then there were already in England sculptures in the new style of the earliest Gothic of the Ile-de-France. This is not to say that sculptures in the Romanesque style were not still being produced until the late twelfth century alongside the French-influenced works: there was a long period of overlap, and the earliest pieces in the transitional style (before about 1190) are mostly isolated, hardly constituting a 'school' of sculpture.

Elements of the Saint-Denis doorways – most notably the inhabited colonnettes – were taken over as early as the 1140s at Bishop Alexander's Lincoln Cathedral, but the portals themselves were more modestly designed. There are no tympana, the archivolts have no figurative work, and if eighteenth-century testimony is to be believed only the central portal had column figures; this appears to have been limited to a single figure on each side but nothing of them now remains.[1] This rejection of narrative sculpture in and around the doorway was to set a pattern for English church façades which would culminate in the famous 'small door' west fronts of Wells and Salisbury in the next century. It has been suggested that at Lincoln the portals could be free from figurative work because the frieze panels and other relief sculptures above carried the scenes of the Old and New Testaments and the Last Judgement which would normally be shown around the doorway; whether the frieze was in place before the doorways were carved, or planned at the same time is at the moment an open question.[2]

Unfortunately, because of the combined effects of wholesale iconoclasm in the sixteenth and seventeenth centuries – which affected most English medieval sculpture – and weathering over a long period, there are only scant remains from some of the most prestigious building schemes of the second half of the twelfth century. We know that Henry of Blois, Bishop of Winchester, imported classical statuary from Rome in around 1151, and there is clear evidence in the sculptural fragments from his palace at Wolvesey that he had also taken note of contemporary sculpture. Henry visited France in 1140, just after work on Wolvesey had begun, and almost certainly visited the newly-consecrated Saint-Denis of Abbot Suger: the pieces of door

jambs excavated on the site, like those at Lincoln, are similar to the colonnettes at Saint-Denis, and a delightful fragment of a head with a small figure clambering in the hair [153] shares the precise carving of the head of a queen from the Saint-Denis central portal [10].[3] The sculpture is inconceivable without knowledge of French models.

The same is true of the top half of a statue of the Virgin and Child in the Yorkshire Museum, which probably comes from St Mary's Abbey in York [154]. Although sadly damaged, enough remains to show the high quality of the carving – note especially the detailed treatment of the clasp – and its close dependence on the jamb figures of the Royal Portal at Chartres. Because it is rough at the back, the York Virgin does not appear to have been a column figure and it is now impossible to be certain whether it was originally standing or seated, but the long plaits and fine horizontal parallel lines of the tunic immediately relate it to the Old Testament queens on the portals at Chartres, Le Mans and Angers. It must have been made in around 1160–70, and thus pre-dates the more well known figures from St Mary's Abbey, to be discussed below, by about thirty years; tantalisingly its original context is not known, but given its stylistic isolation in Yorkshire at this date one is tempted to view it as the work of a sculptor from the Ile-de-France.[4]

At about the same time the west portal of Rochester Cathedral was constructed, and this too was probably executed by a workshop trained in France [155]. Indeed, at this date in the south-east it is hardly worthwhile to attempt to separate the 'English' from the 'French': French was spoken by the educated élite, many of the bishops came from France, and the English King was ruler of Normandy, Poitou, Aquitaine, Gascony and other parts of the country. The Channel actually expedited travel between the two countries and made the transportation of large quantities of Caen stone – the chosen building material for many of the southern English cathedrals – very much easier.[5] It has long been recognised that the Rochester portal incorporates features derived directly from across the Channel. In the tympanum, Christ is shown in Majesty, flanked by the symbols of the evangelists, his mandorla held by two standing angels, and in the lintel are the apostles; the archivolts, capitals and imposts are all decorated with lush foliate, animal and mask designs, while below are two column figures, almost certainly King Solomon and the Queen of Sheba. Earlier studies tended to see two distinct elements in its composition (the radiating voussoirs being associated with Poitevin prototypes, the tympanum and column figures with the Ile-de-France) and went so far as to suggest that two separate sculptural campaigns took place. More recently it has been shown that the portal is the result of one workshop, and that the formal blending of these diverse elements had already taken place in France.[6] The column figures are now rather weathered, but with the help of engravings published in 1840 one can see how closely they resembled the

153. Fragment of a head from Wolvesey Palace; *c.*1145 (Winchester City Museum)

154. Fragment of a Virgin and Child from St Mary's Abbey, York; *c.*1160–70 (Yorkshire Museum, York)

elongated figures of the Chartres Royal Portal and more especially the King and Queen from Corbeil in the Louvre [20, 21].[7]

In the years immediately following the completion of the Rochester portal other related sculptures were made in the south-east. A window in the Moot Hall, Colchester, was decorated with similar radiating voussoirs and with two small column figures – one apparently a bishop, the other female – but it is now destroyed and only known through a nineteenth-century engraving.[8] A column figure of the Virgin and Child from the nunnery of Minster-in-Sheppey in Kent (now in the Victoria and Albert Museum) also shows clear influence from France, although it is fragmentary and in no way comparable to the Virgin and Child in the Yorkshire Museum from a qualitative standpoint. It cannot have belonged to a portal, but may have formed part of a screen or cloister.[9]

As one might expect, and as we know from the detailed account of the work by Gervase of Canterbury, the contribution of William of Sens at Canterbury Cathedral between 1174 and 1179 extended to the design of the architectural sculpture. Because the rebuilding at this time was limited to the choir and the eastern transepts alone the capitals and vault bosses offered the only opportunities for sculptural work associated with the fabric of the building; there were no decorated portals. The earliest of the extremely fine foliate capitals do indeed show a similarity to those at Sens, and close parallels have been drawn with other capitals at Saint-Leu-d'Esserent, Laon, Reims and Arras.[10] Apart from the capitals and bosses it appears that a choir screen was erected in 1180 by William of Sens's successor, William the Englishman, and the suggestion has been made that a number of reliefs in quatrefoils and roundels, most of which were found in 1968–72 built into the cloister and show half-length figures and grotesque masks, decorated this structure [156].[11] Attractive as this hypothesis is, it cannot at present be proved, and there is the possibility that the reliefs originally belonged to the cloister; notwithstanding this doubt

155. West portal, Rochester Cathedral; probably *c.*1160–70

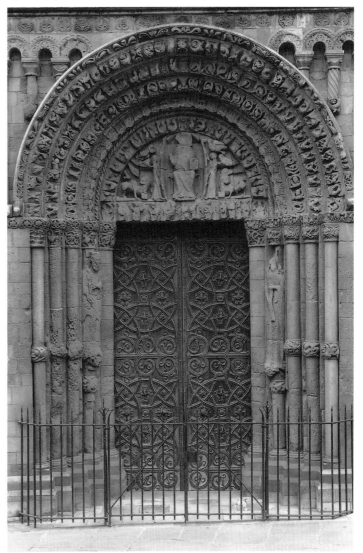

they are surely of about 1180, and like contemporary work in the Ile-de-France and Champagne – such as the cloister sculptures at Châlons-sur-Marne – they reflect the influence of smaller-scale works in metal, an influence emphasised by their scale, the quatrefoils and roundels in which they are contained, and the detailing of some of the frames. Twenty-five years later, on the tomb of Archbishop Hubert Walter (died 1205) in the south ambulatory of the Trinity Chapel, metalwork prototypes still provided the inspiration for the sculptors employed by the cathedral, but by this time the style reflected the increased naturalism emerging throughout Northern France and England in the first years of the thirteenth century. The gabled tomb takes the form of a shrine with arcaded sides and with six heads within quatrefoils on the lid; carved from Purbeck marble, a polishable limestone

156. Quatrefoil with half-length figure, Canterbury Cathedral; probably *c*.1180

157. Moses from St Mary's Abbey, York; probably *c*.1190–1200 (Yorkshire Museum, York)

158. Detail of figure of St John the Evangelist from St Mary's Abbey, York; probably *c*.1190–1200 (Yorkshire Museum, York)

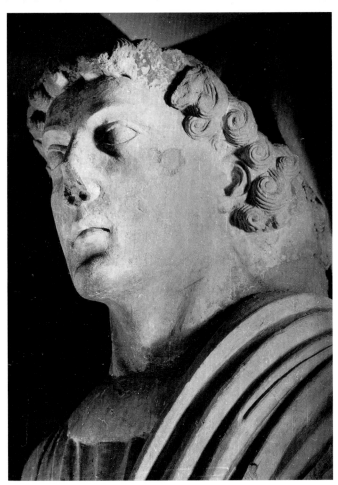

from Dorset, its shiny appearance (possibly enhanced by gilding in places) reinforced the connection with precious metal. The now-damaged tomb of Bishop Gilbert de Glanville (died 1214) in Rochester Cathedral was clearly derived from that at Canterbury, but its relationship with works in metal is further underscored by the surviving sprays of foliate decoration carved under the arcades on its side, which could have been lifted straight from a reliquary shrine.[12]

YORK

As we have seen, by the end of the twelfth century the increased naturalism of the latest French sculptures at Mantes and Sens – achieved by the study of Mosan goldsmiths' work and a growing interest in the human form – was beginning to trickle through to England. The most notable and best preserved sculptures in this transitional style are the eleven life-size figures from St Mary's Abbey, York, seven of which were excavated on the site of the nave in 1829, and seven fragments of archivolts, now in the Yorkshire Museum. Among the figures are Moses and John the Baptist, but the majority would appear to represent apostles [157, 158]; the voussoirs show scenes from the life of Christ. Unfortunately, because so little of the abbey church from this period survives and because there are few relevant documents, the original position of the sculptures is not known. Older studies had understandably assigned the sculptures to a portal, but more recently it has been proposed that there were originally twelve prophets and twelve apostles and that the latter stood above the former on the chapter house vault shafts; in this arrangement the voussoirs would have belonged to the eastern window of the chapter house.[13] There are, however, problems with this reconstruction, not least the fact that the figures seem to have been buried under the foundations of the thirteenth-century church less than a hundred years after they were carved, when the chapter house was still standing.[14] Because the seven excavated figures were fully polychromed when they were recovered (traces of paint still remain) they must have been installed in their intended setting for at least a short time; but whether this was an earlier western portal or an arrangement similar to that found in the porch at Lausanne (perhaps in the chapter house vestibule), where six prophets are juxtaposed with the four evangelists and Saints Peter and Paul, remains unresolved.[15]

The closest stylistic parallels for the figures are the archivolt sculptures on the Baptist's portal at Sens Cathedral – unfortunately the jamb figures are now gone – and some detached column figures from a cloister or conventual building also in Sens, both of the 1180s.[16] Here we find the same heavy loops of tubular drapery and crisp carving of the heads, before the former gives way to the flatter folds seen at Laon and the Chartres north transept. But the St Mary's Abbey figures are not the work of French sculptors; carved in the local Tadcaster limestone, the figures have a block-like quality which sets them apart from their models. There was obviously a number of different workmen, but at least one of the sculptors responsible for the York statues must have had first-hand experience of the Sens workshop and

can hardly have arrived in York before 1185; it is most likely that the work was done in the last decade of the twelfth century.

The St Mary's Abbey workshop went on to execute other sculptures in the immediate vicinity. The biggest scheme by far was for York Minster. Twenty-three life-size figures have survived, now unfortunately extremely weathered after being reused on the western towers and buttresses of the fourteenth-century façade of the Minster. Unlike the St Mary's prophets and apostles they are not column figures; they were presumably originally displayed in niches on the earlier west front, in a manner anticipating the later arrangement at Wells. Among the recognisable figures are prophets, kings, apostles, saints, and a female figure possibly to be identified as the Queen of Sheba.[17] On the less worn statues the style is unmistakeably that of the St Mary's sculptures, while further figures from Cawood Castle (the Palace of the Archbishops of York) and fragments at Guisborough Priory and elsewhere illustrate the extent of the workshop's output around the year 1200.[18]

THE WEST COUNTRY

The largest amount of sculpture remaining on an English church from before the middle of the thirteenth century is at Wells Cathedral. The construction began at the east end in about 1180 and progressed westwards until work on the west front was initiated, probably in the early 1220s.[19] The earliest large-scale sculptures are not actually part of the fabric of the building, but retrospective effigies of the Anglo-Saxon bishops of Wells. These five recumbent figures in the local Doulting stone, now placed around the ambulatory to the north and south of the choir, seem to have been made as part of a campaign to press the claims of Wells alongside Bath to the rights to a bishopric, the position of which had been in dispute and which Wells had lost in the late eleventh century. It was not until 1244 that the Pope re-conferred cathedral status on Wells and allowed the chapter to have an equal say in the election to the joint see of Bath and Wells. The making and placing of the effigies in the new building thus sought to legitimise the construction of what was at the time an extremely large collegiate church in the hope that it would be transformed into a cathedral, and to emphasise the antiquity of the foundation.[20] The effigies themselves, which were probably carved just after the succession of Bishop Jocelin in 1206, were identified by the lead name plates found in the tomb chests underneath because there is nothing in their attributes or head types to tell one from the other [159]. They are simply bishop types – no more than symbols – but are carved in a much higher relief than their twelfth-century effigial predecessors such as the tomb slab of Bishop Roger at Salisbury.[21] The Bishops Giso and Dudoc occupied the positions of honour to the north and south of the high altar and their effigies were made slightly later than the other five, probably in around 1220–30. They are shown almost as horizontal statues, virtually free of the block, and are not constrained by the canopies of the earlier bishops; it is probable that they are early products of the workshop responsible for the statuary of the west front, although the heads are noticeably cruder.

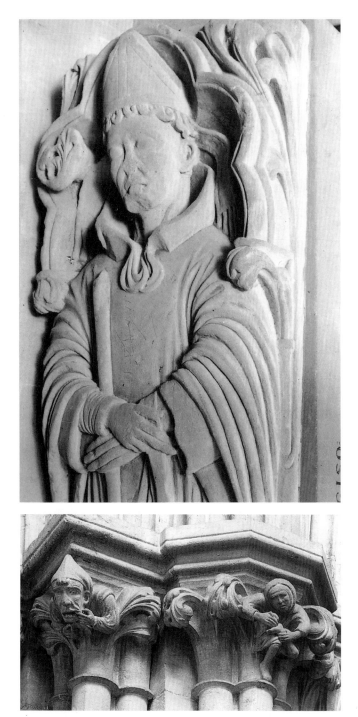

By the beginning of the thirteenth century work was being carried out on the transepts and the easternmost part of the nave. The capitals in these areas mix lush foliate decoration – early examples of the distinctive English thirteenth-century stiff-leaf – with small figures, sometimes on their own (a spinario figure extracting a thorn from his foot, a bust of a man apparently with toothache) or in modest narrative scenes, such as a fox carrying off a goose, pursued by a farmer, and an episode of thieves stealing from a vineyard and being caught.[22] In contrast to the capital frieze by the same workshop on the north porch, which shows scenes from the martyrdom of St Edmund, there does not appear to be a coherent iconographic programme [160, 161]. The capitals and the label stops in the form of heads in the transepts and nave were certainly finished when in 1218–20 the Abbot of St Augustine's, Bristol (now Bristol Cathedral) wrote to the Dean of Wells asking him to 'release your servant L. to hew out the seven pillars of wisdom's house, meaning, of course, our chapel of the blessed Virgin'.[23] That the Dean acceded to the abbot's request is proved by the architectural form of the Bristol Elder Lady Chapel and by the close similarity of certain of the spandrel sculptures and especially the head stops at Bristol to carvings at Wells.[24] Whether this 'servant L' may be identified as Adam Lock, master mason at Wells before 1229, cannot be proved at present but the evidence suggests this to be the case.

A fine label stop of a bearded man at Bristol, which on the basis of the letter referred to above and its obvious relationship to a head of the same type at Wells is presumably of about 1220–5, is in turn very close to a label stop on the north side of the Glastonbury Abbey Lady Chapel [162, 163]. This is an important connection for the dating of the sculptures at Glastonbury, which has been the subject of much scholarly debate. The Benedictine abbey of Glastonbury was one of the richest in England, and benefited particularly from the architectural additions of Henry of Blois, who as well as being Bishop of Winchester was Abbot of Glastonbury between 1126 and 1171. The great monastic complex was totally destroyed by fire on 25 May 1184, but we are told by a late thirteenth-century chronicler, Adam de Domerham, that rebuilding started immediately with the

159. Tomb effigy of Bishop Levericus, Wells Cathedral; probably c.1206–10

160. Capitals; west side, south transept, Wells Cathedral; c.1210

161. Capital frieze; north porch, Wells Cathedral; c.1210–20

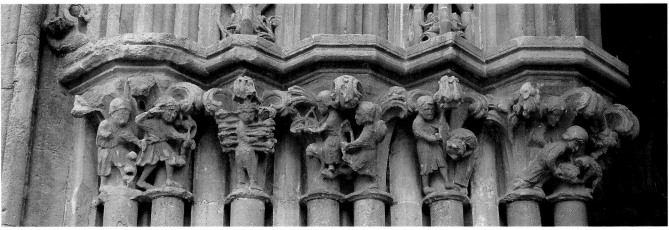

162. Label stop; Elder Lady Chapel, Bristol Cathedral; *c*.1220–5

163. Label stop; interior north side, Lady Chapel, Glastonbury Abbey; *c*.1220

Lady Chapel, which because it occupies the site of the 'vetusta ecclesia' is unusually sited at the west end of the now largely ruined abbey church. Although a later authority, John of Glastonbury (*c*.1390), recounts that the building was dedicated in 'about' 1186 it cannot have been finished by then, and despite Adam's references to Ralph FitzStephen 'omitting no kind of ornamentation' – this is typical medieval hyperbole – in the work on the chapel, the sculptural decoration itself tells a different story. When King Henry II, who had been funding the work, died on 6 July 1189, the work ceased.[25]

The statement of Adam de Domerham that the chapel was complete at this time is contradicted by the physical evidence of the south door, which has only two oval reliefs (showing the Creation of Eve and the Temptation) partially blocked out on the second archivolt, while the fourth order, clearly intended to be decorated with narrative scenes, is entirely blank [4]. In view of the correspondence between these two scenes and the same episodes on the south porch at Malmesbury Abbey, of about 1170, it would seem likely that a start was made on the south door at Glastonbury by a sculptor from Malmesbury but that the work remained unfinished when work stopped in 1189.[26] The north door was not sculpted at all until about 1220, when its archivolts were finally carved *in situ* with foliate decoration alternating with scenes from the Infancy of Christ [164, 165]. The scenes are this time laid out radially along the archivolts rather than vertically as on the earlier door, and the style is markedly different from the Malmesbury sculptures. The

agitated damp-fold draperies and shallow relief of around 1170 have been replaced by full-bodied figures wrapped in heavy looping folds of cloth, and the head of Herod in the scene of his ordering the massacre of the Innocents attests to the new naturalism of the beginning of the thirteenth century. Because of its similarity to the head in the Bristol Elder Lady Chapel the label stop must also have been added at about this time.[27]

The workshop responsible for the Glastonbury Lady Chapel north doorway also seems to have executed the sculpture on the side of the tomb of St Dyfrig in Llandaff Cathedral (Cardiff) and was of course involved in the earliest sculpture on the west front of Wells Cathedral, including the Virgin and Child in a quatrefoil over the central doorway.[28] The design of the Glastonbury Lady Chapel north doorway, with orders of figurative work in medallions mixed with foliate decoration, emerged from a long tradition in Romanesque England of the type of work which had culminated in the Malmesbury south porch. This approach to the doorway was a peculiarly English phenomenon, and in contrast to French examples usually dispensed with the tympanum. It lasted well into the thirteenth century, being employed on the north transept at Lichfield Cathedral in the 1230s, and led in turn to the portal of the Westminster chapter house vestibule in the middle of the century.[29]

By comparison with sculptural programmes of a similar size in contemporary France one would estimate that the erection and filling of the great image-screen at Wells Cathedral – containing over 176 statues, thirty half-length

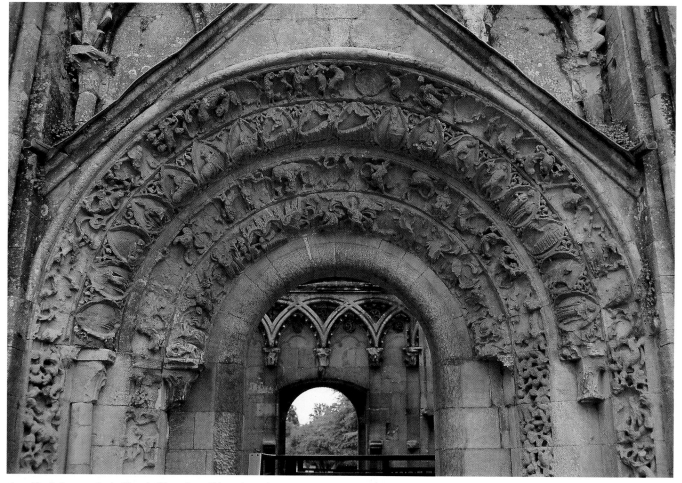

164. North doorway, Lady Chapel, Glastonbury Abbey; the sculpture c.1220

angels, forty-nine reliefs of Old and New Testament scenes and eighty-five reliefs of resurrected souls – took at least fifteen years [166]. It is likely that the work, although possibly planned in the second decade of the thirteenth century by the architect Adam Lock and Bishop Jocelin (1206–42), was not started until about 1225; and the fact that some of the niches on the east face of the south tower seem never to have been filled might indicate that the sculptural programme ceased at the time of the dedication in 1239. The stylistic

165. Detail of pl. 164

homogeneity of the sculptures, excluding the fifteenth-century apostles and angels in the central gable, suggests that the workshop activity was concentrated in a short period of intense endeavour, and we know that large numbers of stonemasons were employed: masons' marks in the western bays of the nave show that at least twenty-three different stonecutters were at work.[30]

In contrast to French cathedrals only the central portal has any sculptural decoration, and this is modestly confined to a single figure of the Virgin and Child in a quatrefoil flanked by two angels in the spandrels: the simple voussoirs of the porch consist of foliate designs and slim figures standing under canopies.[31] But above this austere foundation the dense richness of the sculptural programme – which wraps around the front to the back of the north tower – can hardly be paralleled on any other building. On the first level, above the central portal, is a group of the Coronation of the Virgin, and in the quatrefoils above are scenes from the New and Old Testaments, to the north and south of the centre respectively. The standing figures on the west face of the front at this level are now mostly missing, but many still survive around the east and north faces of the north tower, including deacon saints and female figures [167, 169]. Each pair of niches on this lowest level is contained within its own arcaded bay and, immediately above, a half-length angel floating in clouds looks out from a quatrefoil [168].[32] On the second and third tiers martyrs, confessors, patriarchs and

166. West front, Wells Cathedral; *c.*1225–40 and later

167. Two deacon saints; east face, north tower of the west front, Wells Cathedral; c.1225–30

168. Angel within quatrefoil of west front, Wells Cathedral; c.1225–30

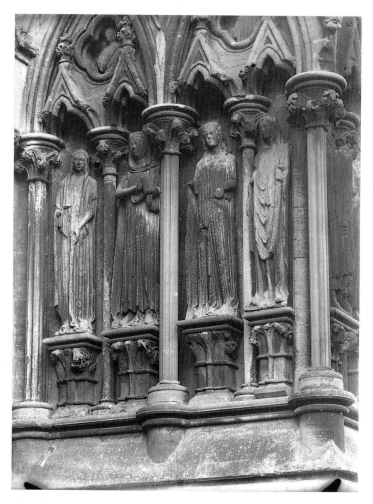

169. 'The four Maries'; east face, north tower of the west front, Wells Cathedral; c.1225–30

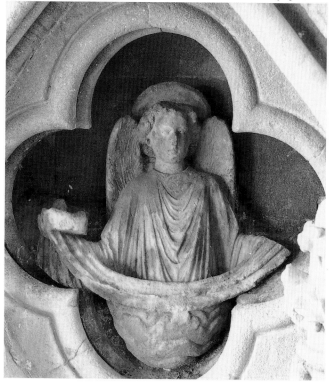

prophets, with King Solomon and the Queen of Sheba just above the Coronation of the Virgin, stand or sit in the niches; to the south of the centre are mostly ecclesiastics (bishops, monks, but also hermits), and to the north secular figures, including kings, queens and knights. Above, running along the entire length of the façade, are reliefs of naked figures rising from their graves. This emphasis on resurrection, without the usual accompaniment of the Blessed and the Damned, is unmatched on French portals, where comparable figures form only a small part of Last Judgement tympana; its iconographic message would have been all the more resonant when the green in front of the cathedral was in its original use as a burial ground for the laity. The whole ensemble – representing the Heavenly Jerusalem – must have been surmounted as it is now by the orders of angels, the apostles and by Christ in Majesty, although all of these (with the possible exception of the figure of Christ) were replaced in the fifteenth century, when the towers were added.[33] The iconographic programme does not have the subtlety and intellectual coherence of the Chartres north transept, for instance, where the juxtaposed figures and reliefs of the portals combine to connect the Old and the New Laws, but it nevertheless presents the single concept of the City of God in a highly impressive display. The Wells

west front was designed specifically as an image screen for the sculpture, in effect as an outdoors reredos, and this impression would have been furthered by its original bright colouring and gilding.[34] Twelve apertures in the wall behind the four angels closest to the Coronation of the Virgin would have allowed choristers to sing the *Gloria, laus et honor* at Palm Sunday – when a re-enactment of the Entry into Jerusalem took place – and on other occasions without being seen, giving the impression that the angels themselves were participating in the liturgy.[35]

The earliest sculptures are undoubtedly those on the lowest level, starting with the Virgin and Child and angels of the central doorway. As already mentioned, the Virgin and Child is close in style to the sculpture of the Glastonbury Lady Chapel north doorway and the Llandaff tomb of St Dyfrig, and furthermore has points of contact with the figure of the seated King Henry III on his first great seal of 1218.[36] The elegant figures of deacons and other saints on the first tier of the north west tower and the surviving half-length angels [168] would seem to be of around 1225–30: the heads of the angels are of the same type as the deacons, with finely-carved detailing of the eyes, mouth and hair. A close comparison can be made between the head of one of the deacon saints and that of St John the Evangelist from St Mary's Abbey, York, the latter showing – as we have seen – a developed naturalism gained through prototypes in the Ile-de-France.[37] The Wells sculptor has copied the double-line upper eyelid, the arched eyebrows and pursed lips of the Sens-inspired York figure, but the draperies show the influence of the more up-to-date models on the Chartres transepts. This is particularly true of the group of four female saints on the north tower (the so-called Maries) whose plain fluted garments, the hems rippling as they meet the floor, seem to reveal a knowledge of the elderly female figure with wimple on the north transept porch at Chartres, which must have been executed only a few years earlier [169]. Likewise, the figure types and method of narrative in the small scenes from the Old and New Testaments in quatrefoils may be compared with the contemporary miniature scenes of martyrdom on the south porch at Chartres.[38]

Because the Wells workshop was of some size, it is to be expected that there should be variations in the quality of the work.[39] Some of the figures higher up on the front do not match the standards set by the best sculptures on the lowest tier, and it is greatly to be regretted that nearly all the figures on this level on the west face are now gone. The figures of kings on the buttresses seem to have caused the sculptors considerable difficulty in the creation of a convincing seated pose, but, although the proportions of these statues are not happy, the heads are invariably well carved; consequently it has been suggested that the sculptors were trained in the carving of effigies and had no experience of sculpting figures in other than recumbent positions.[40] Other figures, especially those of the bishops, also have the appearance of effigies.

Hardly surprisingly, there is evidence of the contribution of the Wells workshop elsewhere in the south-west in the second quarter of the century. A now headless and damaged life-size seated figure of the Virgin and Child, until recently set into a wall at St Bartholomew's hospital in Bristol, is

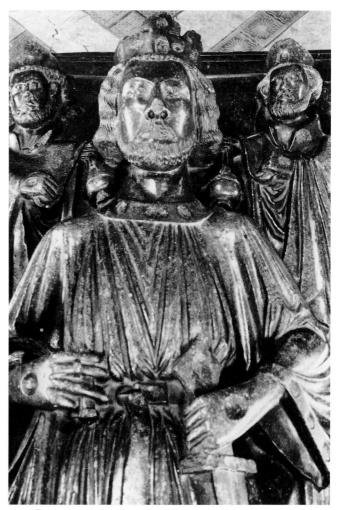

170. Tomb effigy of King John (d.1216); Worcester Cathedral; Purbeck marble, c.1230–2

demonstrably by a member of the Wells team, and the important knightly effigy of William Longespée (died 1226) in Salisbury Cathedral – the earliest non-ecclesiastical effigy in the West Country – is also likely to be Wells work.[41] The head of one of the kings at Wells has been convincingly related to that of King John on his Purbeck marble effigy in Worcester Cathedral [170]. Although John died in 1216, his effigy was only made and placed between the shrines of Saints Oswald and Wulfstan in front of the high altar in the new choir in 1232; the small mitred figures of the local saints are shown swinging censers to each side of the king's head.[42] The similarity to the Wells king underlines the fact that at this date even royal effigies were not intended as portraits, but rather as idealised noble types: in England it was not until the end of the following century – in the effigies of Philippa of Hainault and Edward III at Westminster Abbey – that royal portraiture even in a limited sense was first seen. King John's effigy has often been put forward as an early work of the London Purbeck marblers, but in view of its resemblance to the Wells king and other sculpture at Worcester, and the lack of any directly comparable pieces in the capital, it is more likely that it was produced in Worcester by a sculptor trained at Wells.[43]

Much sculptural work was done at Worcester between

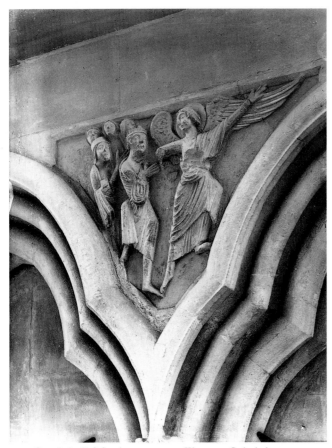

171. Spandrel relief; South-east transept, Worcester Cathedral; 1224–32

1224 and 1232, when the choir was extended to create a Lady Chapel to the east. In the spandrels of the wall arcades here and in the eastern transepts were carved small scenes from the Old and New Testaments, the Last Judgement, and various foliate and animal designs [171]. Many of the carvings were reworked in 1857, and although the remaining thirteenth-century sculptures are cruder than the contemporary narrative reliefs in quatrefoils on the Wells west front they stand as the earliest spandrel carvings of this sort, the later spandrel reliefs at Westminster Abbey and in the Salisbury chapter house deriving from them.[44] Prior to this only single figures had occupied wall arcades, the most significant examples being the half-length angels and prophets in St Hugh's choir at Lincoln Cathedral, of around 1200–10, which introduced the decorative language of the reliquary shrine to the interior of the church in much the same way as the contemporary choirscreens at Hildesheim, Halberstadt and Hamersleben. The Lincoln spandrel figures' resemblance to the apostles in the spandrels of the Anno shrine in Siegburg (c.1183) has been pointed out elsewhere, and angels in particular would continue to be popular in this context until late in the century, most notably on the Salisbury choirscreen and in the Lincoln Angel choir.[45]

Another relief at Worcester, probably carved at about the same time as the spandrel reliefs inside the cathedral, is of a different class altogether from those rather squat and unattractive figures. Now set into the middle of a fourteenth-century reredos constructed in the east wall of the refectory

and badly damaged when the whole composition was abraded and boarded up, presumably at the Reformation, it is still a survival of great importance and beauty [172]. Christ is shown seated in Majesty within an elongated quatrefoil, enclosed by two colonnettes, with the symbols of the evangelists at the corners: he presumably held a book in his left hand and blessed with his right.[46] As the figure of Christ is seated within the frame of the quatrefoil and thus set back from the front face of the reredos it was not necessary for the iconoclasts to eradicate the draperies above his knees; we should be grateful for this small mercy because what remains comes closest of any sculpture in England to the mature Chartres style of the Solomon portal, of about 1220 [59].[47] Although stylistically absolutely up-to-date, in its quatrefoil setting and flanked by the Evangelist symbols it also looks back to late Romanesque pictorial types in the same way as

172. Christ in Majesty with the symbols of the evangelists; refectory, Worcester Cathedral; c.1220–30

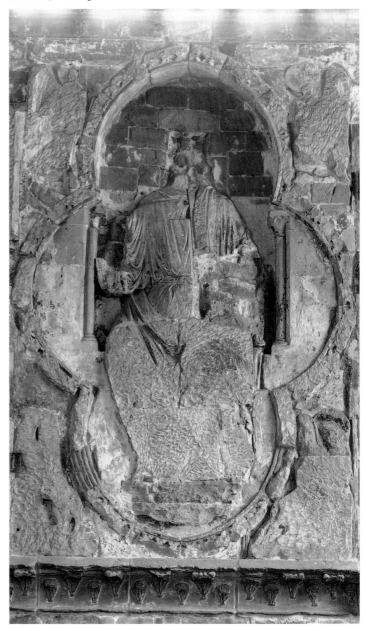

the contemporary *Christ in Majesty* pages of certain English psalters.[48]

Earlier it was shown how classicising form was introduced into sculpture at Chartres, Paris and Reims both through the influence of metalwork – specifically that of Nicholas of Verdun and his followers – and the study of antique originals towards the end of the first quarter of the thirteenth century. It should therefore come as no surprise that in this general climate of awakened interest in the classical past there should be evidence of the same trend in England. That the most significant and outstanding example of classically-inspired sculpture should remain in Winchester, the seat of the twelfth-century Bishop Henry of Blois, is probably not fortuitous. Now lacking its head and lower arms – and with them any attributes which would have aided in its identifi-

173. Female figure, probably *Ecclesia*; south retrochoir aisle, Winchester Cathedral (*ex situ*); *c*.1230–40

cation – this solitary female figure has been divorced from its original setting and is presently displayed at the east end of the south retrochoir aisle in Winchester Cathedral [173]. It almost certainly came from one of the niches above the porch of the prior's house, but may not have been there originally: if correctly identified as *Ecclesia* – an interpretation supported by the figure's similarity to the eponymous figure at Strasbourg and the position of the upper arms – it could not have been shown in that position.[49] As she steps forward with her right foot planted firmly in front of her, the figure's almost weightless robe defines the shape of the body beneath and is swept away at the sides. Although the convention of the draperies fluttering to the ground and covering the feet is followed (as on the contemporary figures of St Modesta and the Queen of Sheba at Chartres and the Strasbourg *Ecclesia*), the Winchester figure surpasses its French counterparts in its understanding of the human form in movement. The fine rippling draperies would have been enhanced by metal fittings, the position of which is indicated by pinholes, including a belt and a brooch at the neck. As with the French classically-inspired figures it is unlikely that the sculpture was copied directly from a classical source, but rather that the sculptor was drawing on the stylistic repertory of an antique work and transforming it to his needs. It is significant in this respect that the Winchester figure displays an altogether different drapery style – but no less classical – than the Paris and Reims figures, suggesting that one of Henry of Blois's *veteres statuas* had provided the model for it.[50] An isolated sculpture of this excellence surviving from the 1230s, with which there is nothing comparable in England, highlights the great losses sustained in the extended periods of iconoclasm in the sixteenth and seventeenth centuries. It is not only enigmatic because its identity remains unclear but also because we are unable to place it satisfactorily in the sequence of early thirteenth-century sculpture in the South of England; there is the possibility that its sculptor received his training with the workshop responsible for the earliest figures at Wells, but nothing of his work after Winchester appears to have survived.

WOOD SCULPTURE

Perhaps the most serious loss occasioned by the iconoclasm of the Reformation in England was to sculpture in wood. By way of references in inventories, contemporary descriptions and illustrations we know that nearly every church would have contained a rood screen, with a crucifix and the Virgin and St John above, and that figures of the Virgin and Child – usually displayed within a winged tabernacle – were commonplace by the middle of the thirteenth century.[51] The famous chronicler Matthew Paris related in his *Deeds of the Abbots of Saint Albans* that a certain Walter of Colchester, 'an incomparable painter and sculptor', was commissioned by the Abbot William of Trumpington (1214–35) to carve among other things a 'screen in the middle of the church with its great cross, also Mary and John' and 'a most elegant figure of Our Lady'.[52] In connection with the refurbishment of the chapel of St Peter ad Vincula in the Tower of London in December 1240 it was instructed that 'the small figure of St Mary with her tabernacle, the images of St Peter, St

174. Virgin and Child; polychromed oak, *c*.1220–30 (Victoria and Albert Museum, London)

175. Virgin and Child; high vault boss, Lady Chapel, Worcester Cathedral; 1224–32

Nicholas, and St Katherine, the beam above the altar of St Peter, and the small cross with its images are to be repainted and refreshed with good colours', and there are no less than sixteen references to an *ymago beate Marie cum tabernaculo* (or such like) in churches in the diocese of London in an inventory of 1297.[53] Sadly all of these figures have now gone, mostly consigned to the flames of the reformers' bonfires in the sixteenth century, or defaced beyond repair by government order in 1643.[54] Not a single wooden crucifix figure survives in England from the thirteenth century, and only one Virgin and Child, now in the Victoria and Albert Museum, remains [174].

This oak Virgin and Child, supposedly from Langham church in Essex, has the looping, thick folds of drapery between the knees, similar dress and the same frontal pose as the Virgin over the central portal at Wells and the same figure on a boss in the Lady Chapel at Worcester [175], giving it a probable date-bracket of 1220–30.[55] It still retains a good deal of its original colouring and by reference to the inventories cited above and to comparable Virgins in

Norway [179] it was in all likelihood enclosed within a painted winged tabernacle.[56] Given its extreme rarity and its consequent isolation in the history of English medieval sculpture it would be easy to allocate it an undue importance; it is, however, doubtless no more than a typical product of the early thirteenth century, the kind of sculpture which would have been made in large numbers. Master Walter of Colchester's 'most carefully carved' Virgin and Child for St Albans Abbey would certainly have been more impressive, possibly comparable in size and splendour to the nearly contemporary Mosan Virgin and Child in Liège [110].

Because of the almost total destruction of English wood sculpture it is particularly fortunate that close ties existed between England and Norway in the twelfth and especially the thirteenth century. It has been shown that not only were sculptures probably exported to Norway but also that English workshops seem to have worked there, and it is therefore possible to fill some of the gaps in our knowledge with the help of the well-preserved and comparatively numerous Norwegian figures with distinctively English traits.

Scandinavia 1170–1240

The seafaring nations of Norway, Sweden and Denmark had forged trade links with the surrounding countries of north-west Europe from the early middle ages onwards. Before the middle of the eleventh century much of the trade was carried out under the shadow of aggressive plundering, but as their neighbours gradually became stronger the 'Northmen' had to confine themselves to more peaceful activities. Naturally, the most significant contacts were made with those countries either in closest proximity or within easy reach by boat, so that Norway – facing the Atlantic Ocean and the North Sea – maintained a special relationship with Britain from an early date, while the Swedes and Danes, on the Baltic, associated themselves more with Lower Saxony and the Rhineland. These commercial and political alliances inevitably led to the importation of works of art and in a few instances to the employment of foreign workshops. Christianity came to Scandinavia relatively late – Norway and western Sweden were only converted in around 1000 and Uppsala in eastern Sweden was still pagan in around 1100 – so the first Christian images had to be brought from outside.[1]

At the end of the twelfth century, Norway's three major cities were Bergen on the west coast (already a wealthy trading centre), Trondheim – known as Nidaros – further up the coast to the north, and Oslo in the east. Trondheim greatly increased its importance in the eleventh century, after St Olaf – who introduced Christianity to Norway – was killed in battle at Stiklestad, north of the city, in 1030; the cathedral was later built to house his remains and his shrine became the most important pilgrimage centre in Scandinavia. As a result of the increasing number of pilgrims and the wealth generated by the cult Trondheim became the seat of a new archbishopric in 1153, and the cathedral was extended a number of times throughout the Middle Ages: architecturally and decoratively it was the most ambitious church building in Scandinavia. The choir of the first pilgrims' church was expanded by Archbishop Eystein (1161–88), returning after a short period of exile in England between 1180 and 1183, when he had stayed at Lincoln and Bury St Edmunds. He built a richly-ornamented octagon at the east end of the cathedral to house the shrine of St Olaf, possibly inspired by the new choir then being built for the display of St Thomas Becket's shrine at Canterbury; and when in 1208 building continued on the long choir east of the crossing, the work was carried out by workmen familiar with the contemporary St Hugh's choir at Lincoln. A series of fires and reconstructions have destroyed much of the sculpture which must have decorated the building, but a number of striking heads sprouting from circles on the exterior string course of the octagon and other detached examples testify to the high quality of the work.[2] There was, however, no tradition of stone sculpture in Scandinavia and the earliest work appears to have been executed by foreigners. Stone as a material for free-standing sculpture does not seem ever to have been as popular as wood, and the

most notable works of the twelfth and thirteenth centuries were carved in the softer and more readily available material.

The influence of Lower Rhenish models is apparent in many of the earliest Swedish and Norwegian wood sculptures. Of the numerous comparable Marian sculptures, the seated Virgin – once holding the Christ-Child on her lap – from Viklau church on the island of Gotland in the Baltic shows this derivation most clearly [176]; its similarity to certain Virgin and Child sculptures from the region of Cologne, such as that from Zülpich-Hoven [104], would suggest that it is either an imported work or made by a Cologne craftsman who had settled in Visby.[3] Some indication of purely local work may be seen in the naïve imitation of this type of Virgin in an example from Mosjö church, which perhaps betrays its pagan roots underneath the Christian veneer and completely lacks the serenity and quiet beauty of the Viklau Virgin.[4] As we have seen, the foundations of the style of the Cologne wood sculptures were provided by the mid-century Virgin and Child at Chartres. This new style, carried by the Lower Rhenish intermediaries into Scandinavia, spread remarkably quickly from about 1170: the detached head of a monk or deacon saint from the stave church at Urnes, now in the Historisk Museum at Bergen, shows the dissemination of the style into Norway and may be compared with the polychromed wood angel in Berlin, a Cologne sculpture of about 1170 [177, 105].[5]

The other major categories of wood sculpture before about 1220, the crucifixes and figures of seated bishop saints, also either show the influence of Lower Rhenish, Westphalian and Lower Saxon prototypes or are actually imported works. The fine polychromed crucifixes on Gotland, at Hemse and Väte (both of around 1170–80), belong to the established tradition of German Romanesque crucifixes ultimately deriving from the late tenth-century Gero Cross in Cologne Cathedral, and it is likely that the former was made in the same workshop as the Viklau Virgin.[6] The seated bishop saints at Eskilstuna, Furuby, Näsby, Hemmesjö and elsewhere in southern Sweden are the earliest examples of a type of cult image which would be particularly popular in Scandinavia and appear to be regional variations on a Lower Rhenish type exemplified by the figure of St Nicholas (c.1170) now in the Rheinisches Landesmuseum in Bonn.[7] A final example of North German influence in the early thirteenth century is provided by the figure of St Michael trampling on the Dragon in the church at Haverö in eastern Sweden.[8]

If the examples of sculpture produced in Scandinavia up to this point have unequivocally pointed to the overwhelming influence of the Rhineland, we should remind ourselves that virtually all the wood sculpture of England and France from this period has disappeared. We do not know, for instance, how closely the wood sculptures of England resembled those of the Meuse valley and the Lower Rhine, although the only fragments of a crucifix figure surviving from England

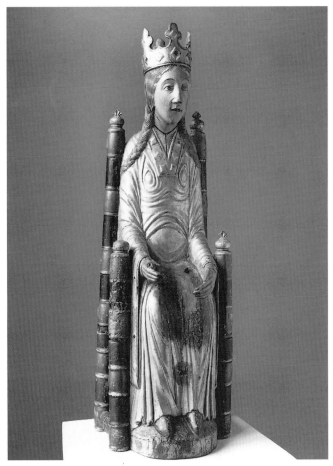

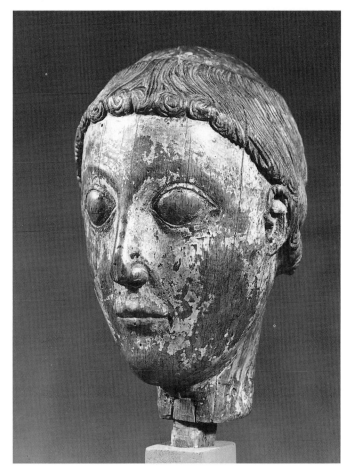

176. Virgin and Child from Viklau, Gotland; polychromed wood (the Virgin aspen, hands and backboard beech, posts of throne oak), c.1170–90 (Museum of National Antiquities, Stockholm)

177. Head of a monk or deacon saint from Urnes; polychromed wood, c.1180 (Historisk Museum, Bergen)

178. Christ in Majesty (or St Olaf?), possibly from the choirscreen of Trondheim Cathedral; soapstone, c.1230–5 (Nidaros Domkirkes Restaureringsarbeider, Trondheim)

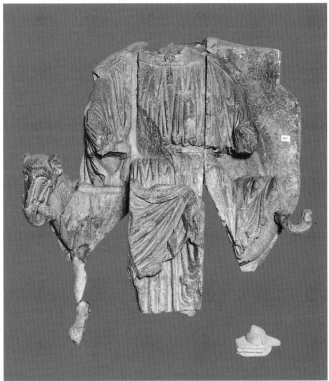

in the twelfth century – the head and foot found in the church of South Cerney in Gloucestershire and now in the British Museum – suggest that there were indeed stylistic connections.[9]

With the accession of King Håkon Håkonsson to the throne in 1217 the bond between Norway and England was strengthened still further. He has been compared to King Henry III because of his interest in building and ostentation – his royal hall in Bergen was the most splendid secular building in Norway – and gifts were exchanged between the two rulers almost every year until Håkon's death in 1263.[10] It was to be expected therefore that from about 1220 the influence of English sculpture in Norway was felt much more strongly than before, becoming as dominant as that of the Lower Rhine in the previous century in Sweden. The indebtedness of the form of Trondheim Cathedral to English architectural precedents has already been pointed out, and a fragmentary relief of Christ in Majesty or St Olaf, possibly from the screen enclosing the new choir which was finished in about 1235, further illustrates how closely the new forms worked out in the third decade of the thirteenth century in England – following French models – were copied [178]. Disregarding the fact that both reliefs are severely damaged, a condition which might suggest a spurious similarity, the resemblance of the Trondheim figure to the Christ in Majesty on the refectory wall at Worcester

180. Crucifix figure from Fresvik; polychromed oak, c.1230–40 (Historisk Museum, Bergen)

179. Virgin and Child from Hove; polychromed oak, c.1230 (Historisk Museum, Bergen)

[172] is nevertheless striking. Both figures are dressed in comparable draperies with deep folds, drawn in at the waist in the classicising style of the 1220s–30s, and share the same air of solemn *gravitas*. If it is not the work of an English sculptor, the Trondheim relief testifies to the rapid absorption of the latest models of high quality from England.[11]

The earliest wood sculptures produced in Norway in the English manner must have been made at about the same time, and also show connections with Worcester. They all come from the vicinity of Bergen, and were probably made in that city by sculptors from England attracted by the chance of royal and ecclesiastical patronage in a burgeoning

market. The most important of these is the Virgin and Child from Hove church (now in the Historisk Museum in Bergen) which still retains its gilding and other colouring [179]. Its similarity to the Langham Virgin and Child and more particularly the Madonna on the boss in the Worcester Lady Chapel of about 1230 [175] is unmistakeable – note especially the elongated U-folds above the Virgin's girdle.[12] A half-size crucified Christ from Fresvik (also now in the museum at Bergen) must be of about the same date as the Hove Virgin and Child and has been attributed – perhaps optimistically – to the same sculptor [180]; in the absence of any surviving crucifix figures in England its head has also been compared, again not altogether convincingly, to the effigy of King John in Worcester Cathedral.[13] It is hardly likely that such accomplished sculptures could be produced by a local workshop at this date; only later, around the middle of the century, are there clear signs that Norwegian sculptors had learnt from the imported works and had started to produce variants in their own style. This is true in the north and east of the country and in Sweden as well, where the distinctive stylistic vocabulary of the Wells sculptures would be taken up after 1240: early examples of this different current are to be seen in the seated figures of St Olaf made in the region of Trondheim and the Virgin and Child from Enebakk, now in the Universitetets Oldsaksamlingen in Oslo.[14]

Spain 1170–1230

Like the southern part of Italy the Iberian peninsula provided a bridgehead between Europe and Africa, and in common with the former it was the scene of numerous territorial struggles after the break-up of the Roman Empire. The Visigoths at first occupied primarily the north-west part of the country, but their church building was modest and the relief sculpture on capitals and screens unambitious. They were supplanted by the Muslim drive north in 711: after this time only small Christian settlements still survived, mostly in the Asturias region north of the Picos mountains, which provided a natural barrier between the two civilisations, and in the 'Frankish March' of Catalonia. But the Muslim centres were concentrated in the south (known to them as *al-Andalus*), at Cordoba, Granada, Jaén and elsewhere, and by the following century the Reconquest – the Christian advance in their direction – had tentatively begun. The discovery of the body of St James in the ninth century and the subsequent growth of Santiago de Compostela as a great pilgrimage centre supplied an additional impetus to the urge to reclaim the lands further south, the pilgrims conveniently providing much of the funds, and occasionally manpower, to repel the infidel. The *Reconquista* was a slow process and it was not until 1085, when Toledo was taken by Alfonso VI of Castile, that the north of Spain – with the exception of a wide strip in the east – was finally secured. The hostilities continued into the thirteenth century, when the Almohads were defeated at the battle of Las Navas de Tolosa in 1212, and shortly after the Muslims were left with only the area around Granada. They were driven out of Spain altogether two and a half centuries later, in 1492, by King Ferdinand and Queen Isabella. This image of pious aggression over a long period should however be seen in the light of the many years of fruitful relations between the two societies, bringing material benefits to both parties.[1]

The influx of foreigners travelling to Santiago de Compostela began to have cultural repercussions before the end of the eleventh century. Entering Spain at the western end of the Pyrenees, the four main routes through France converged at Puente-la-Reina, and continued through Estella, Logroño, Burgos, Carrión de los Condes, Sahagún, and León. This route became known as the *camino francés*, and it acted as an artery for the transmission of new artistic ideas into Spain. Much has been written on the close connections between the earliest Romanesque sculptures at Toulouse, Conques, Jaca, León, Santiago de Compostela, and at other sites on both sides of the Pyrenees, and on the part played by the pilgrimage route in the dissemination of their style in about 1100.[2] Contacts between French and Spanish architects and sculptors would continue throughout the twelfth and thirteenth centuries, the points of direct influence changing from time to time during the period. In the major monuments made between about 1160 and 1230, those that show an awareness of French sculpture usually reveal a knowledge of the novel Gothic style of the North

through the intermediary of buildings in northern Burgundy. This connection with Burgundy, and more specifically with the great Benedictine abbey of Cluny, had been established long before by Ferdinand I of Castile, who by his marriage to Doña Sancha of León in 1032 created what was to become the massively powerful and rich kingdom of León and Castile. His annual financial contributions to the Burgundian abbey, realised by the levying of *parias* (effectively protection money) on the Muslim cities of the South, outshone all the other gifts to Cluny; these were carried on by his son Alfonso VI – who not only married Constance, daughter of Duke Robert of Burgundy, but also had his two daughters married to Burgundian princes – and although they diminished by the end of the century the firm links forged at that time were to remain.[3]

THE PÓRTICO DE LA GLORIA AT SANTIAGO DE COMPOSTELA AND CONTEMPORARY SCULPTURE

Around the middle of the twelfth century, the cloister of the monastery of Santo Domingo de Silos, south of Burgos, was nearing completion. Many of the famous capitals and six of the reliefs at three corners of the cloister had been executed in an earlier campaign, but the pier on the south-west corner remained undecorated; when this was done, by adding two reliefs of the Annunciation [181] and the Tree of Jesse, the difference in style between the old and new must have been striking. In place of the flattened draperies of the earlier figures, delineated with simple pleat-like folds, the Virgin and angel are wrapped in heavy garments gathered up in thick loops around their arms; beautiful as the earlier reliefs undoubtedly are, they lack the three-dimensionality and proximity to reality of the new reliefs. The date of the two reliefs has not been fixed by documentary evidence, but good reasons have been put forward for viewing them as pre-dating the Pórtico de la Gloria, which was largely complete by 1188.[4] Despite the increased corporeality of the later Silos reliefs they nevertheless stand in the unbroken line of development of Spanish Romanesque sculpture, sharing the full draperies of the Christ in Majesty at the centre of the frieze above the north portal of the cathedral at Carrión de los Condes, of about 1170.[5]

Other work at Silos was connected with the abbey church, which was pulled down in the eighteenth century. A tympanum survives, showing the Presentation in the Temple, the Adoration of the Magi and the Nativity, which is in a different style from the cloister reliefs and may be slightly later, possibly of about 1180. The manner of defining the draperies, in softer, flowing lines associates the figures of the tympanum with a different strand of the Romanesque tradition in Spain, linking them with the elegant standing column figures of the paired apostles in the Cámara Santa of Oviedo Cathedral (probably *c*.1165–75).[6] This style is also seen in a

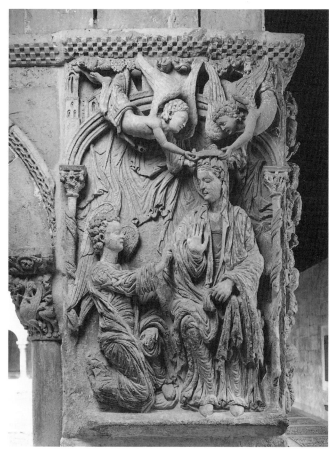

181. The Annunciation; south-west corner pier, cloister, Santo Domingo de Silos; *c*.1170

of which it forms a part – is demonstrably north Burgundian in inspiration, the portal at Saint-Lazare, Avallon (*c*.1160) providing the closest parallel.[8] The apostles are grouped in pairs, turning towards one another in conversation; this dynamism, possibly influenced by the apostles on the central portal at Vézelay is here developed more fully than anywhere in Burgundy, the subtle interaction of the figures prompting comparison with the later groups on the north transept at Chartres and the choir screen at Bamberg. The Annunciation group [183] placed to the left of the south doorway, while not attached to columns, creates the same effect of communication across an unpromising architectural background. Unfortunately the building history of S. Vicente at Ávila is not clarified by documentation: although cons-

182. West portal, S. Vicente, Ávila; *c*.1180

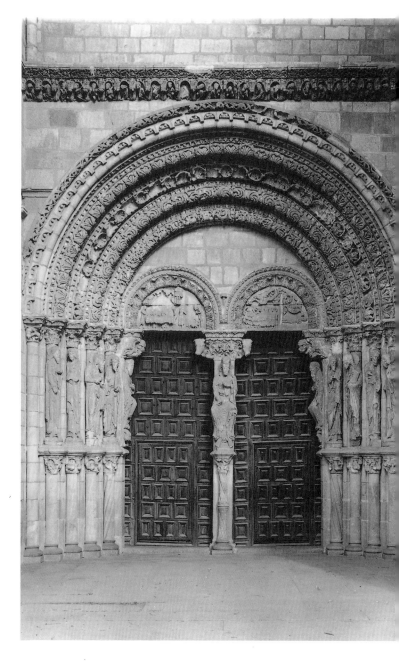

more advanced form in the frieze of apostles (probably *c*.1170–80) on either side of the Christ at Carrión de los Condes, and at S. Vicente, Ávila, in the jamb figures of the Annunciation on the south portal in around 1180, and most notably in the figures of the west portal of about the same date. This complex web of connected sculptures also includes three fragmentary figures in the crypt beneath the Pórtico de la Gloria, which provide a link between Santiago de Compostela, the apostles of Carrión de los Condes and Ávila.[7]

The Ávila west portal is, with the exception of the Pórtico de la Gloria, the most important surviving proto-Gothic Spanish portal of the second half of the twelfth century [182]. Ten apostles occupy the jambs – the earliest example of so complete a showing – and the seated figure of Christ (or St Vincent?) is shown on the trumeau. The tympanum is decorated with two lunettes which illustrate the parable of Lazarus and the rich man, Dives: on the left is the Feast of Dives, with the figure of Lazarus excluded, the sores on his legs licked by dogs, while the lunette on the right shows the deaths of the respective figures, the rich man's soul being carried to Hell, Lazarus's to Heaven. The archivolts are filled with rich plant decoration in the outer orders, only the innermost voussoirs being carved with small animals and monsters amidst the foliage. While the figure style of the apostles reveals them to be the work of a Castilian sculptor, the form and arrangement of the door – and the architecture

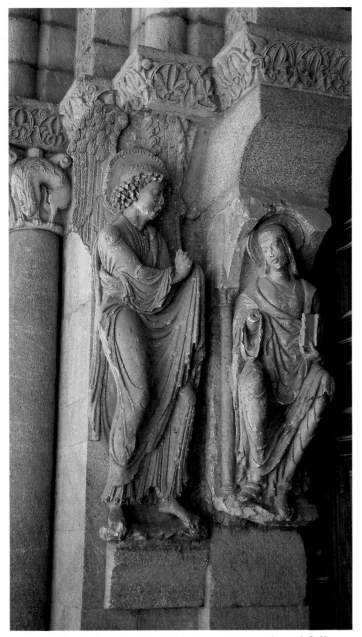

183. The Virgin and the Angel of the Annunciation; south portal, S. Vicente, Ávila; *c.*1180

truction continued over a long period it is probable that the master of works, Fruchel, who died in 1192, was responsible for the design of the west portal and the insertion of the sculptures into the earlier south doorway.[9]

To the east, in Navarre, two buildings of this period are worthy of note. The façade of the first, S. María la Real at Sangüesa, although an untidy conglomeration of sculptures of different dates in the second half of the twelfth century, is of interest because of its derivation – probably through an intermediary source – from the central doorway of the Chartres Royal Portal. The most immediately striking features in this respect are the frieze of apostles under arcades below the Last Judgement in the tympanum and the three slender jamb figures on each side [184]: on the left are the three Maries, while on the right are Saints Peter and Paul and, unusually – although appropriately in relation to

the Last Judgement above – the figure of Judas is shown hanging on the outermost jamb.[10] Unlike the more realistic jamb figures at Ávila they are close to the earliest type of Gothic column figures, still cylindrical and constrained by the width of the column behind. While the similarity to the elongated figures from the tomb of Saint-Lazare at Autun has been pointed out, the remains of inhabited colonnettes between the figures indicates the ultimate debt to Saint-Denis and Chartres and a date of around 1170. The most significant sculpture of the main portal of the second building, S. Miguel in Estella, is not on the jambs but on the reliefs on each side of the doorway, which show St Michael slaying the Dragon, weighing the souls at the Last Judgement and greeting the Maries at the Sepulchre. Probably executed in about 1180–90, they too seem to reflect the style of the Ile-de-France at a distance, the fine detail of the angel heads calling to mind the metallic quality of the angels on the lintel at Senlis a decade or two earlier.[11]

At the same time as most of these sculptures were being made, work was progressing on the most celebrated portal of the period, the so-called Pórtico de la Gloria in the Cathedral of Santiago de Compostela. By good fortune we know the name of the architect or master of works and the dates between which most of the sculpture was executed. There is a charter of Ferdinand II in 1168, which establishes the salary of 'Magistro Matheo' for work on the

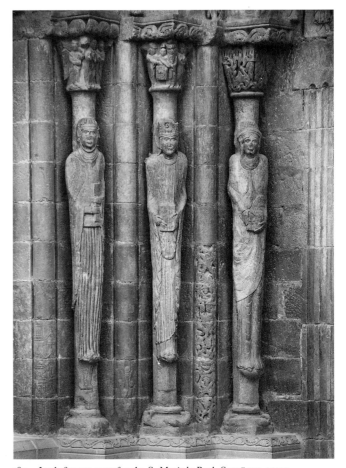

184. Jamb figures; west façade, S. María la Real, Sangüesa; *c.*1170

185. Jamb figures of prophets; central door, Pórtico de la Gloria, Santiago de Compostela Cathedral; probably *c.*1180–90

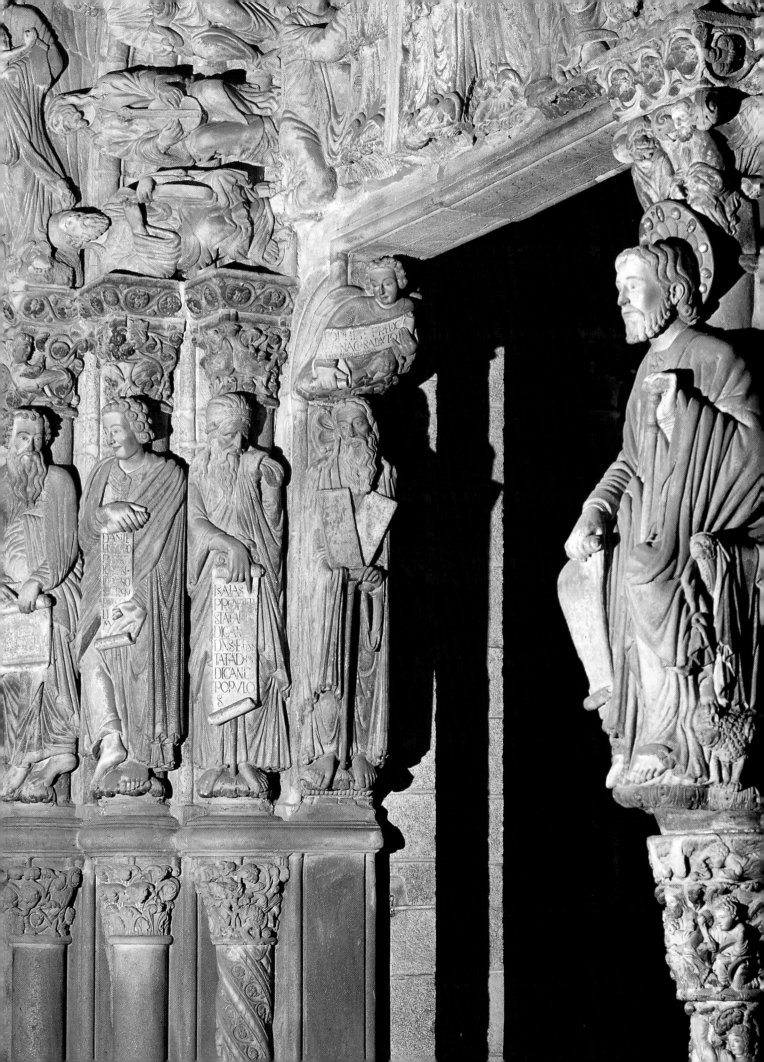

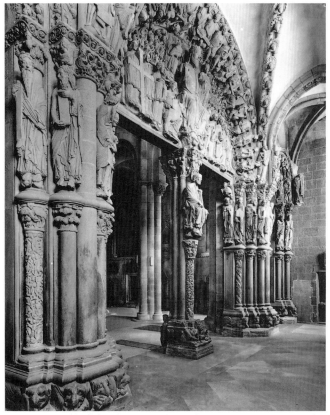

187. Detail of pl. 185

186. Central door, Pórtico de la Gloria, Santiago de Compostela Cathedral; probably c.1180–90

church, and more importantly a long inscription on the underside of the lintel of the central doorway, recording its completion in the year 1188: AN(N)O AB INCARNACIONE D(OMI) NI MCLXXXVIII ERA ICCXXVI DIE K(A)L / APRILIS SVPER LIMINARIA PRINCIPALIVM PORTALIVM / ECCLESIE BEATI JACOBI SVNT COLLOCATA PER MAGISTRVM MATHEVM / QUI A FVNDAMENTIS IPSORVM PORTALIVM GESSIT MAGISTERIVM.[12] We can conclude from this evidence that Master Mateo was employed specifically to complete the building of the cathedral, sweeping away the older western façade of the early twelfth century and replacing it with the present portal, the work being carried out between 1168 and 1188. It is likely that not all the work on the portal was finished by 1188, however, and Mateo's name is mentioned in further documents in the years immediately after.[13]

The three doorways of the Pórtico de la Gloria are enclosed within a porch, the outside of which was completely rebuilt in the first half of the eighteenth century, the sculptured doors opening directly into the body of the church, as at Vézelay.[14] Only the central portal has a tympanum, containing Christ in Majesty, the four evangelists, eight angels holding the instruments of the Passion, and on each side of Christ two rows of the Blessed [186]. A single order of radiating voussoirs above is made up of the twenty-four Elders of the Apocalypse playing musical instruments, each instrument carved with considerable accuracy. The archivolts of the left portal are decorated with figures among foliage, which have sometimes been identified as Old Testament figures; those on the right doorway are devoted to blessed souls held by angels on the side closest to Christ and with scenes of damnation on the right. Trumpeting angels flank the whole composition. On the jambs below are apostles to the right of centre, prophets to the left [185],

with St James seated in the middle, occupying the position of honour between Moses and St Peter: beneath him, the pilaster of the trumeau is carved from marble rather than the Galician granite of the rest of the portal, and shows the Tree of Jesse, topped with a capital of the Trinity. Most unusually, all three doorways are supported by – or perhaps more accurately are crushing – a variety of fabulous and real beasts pressed below the column bases. On the reverse of the trumeau, facing into the church towards the high altar, is a kneeling figure holding a scroll in his left hand which has quite plausibly been identified as Master Mateo himself. Column figures, including Saints John the Baptist, Mark and Luke on the left, and Esther, Judith and Job on the right, face the south and north lateral portals on the east face of the porch's external wall.[15] Iconographically, the tympanum, voussoirs and jamb figures follow the form laid down at Saint-Denis, although the theme of the innermost archivolt of the French prototype – the salvation of the blessed souls and the damnation of the sinners – was transferred to the right doorway at Compostela.[16]

Despite our knowledge of Mateo's name and the dates between which he was employed on the Pórtico, we do not know his exact rôle vis-à-vis the sculpture of the portal. Opinions differ over whether he was actually the master sculptor or the architect and master of works, although it seems hardly likely that he would have been employed specifically to redesign the west portal of the cathedral if he had not been an experienced master mason with a reputation for excellence in sculpture. Some clues as to the background of Mateo and his workshop may be gained from the more modest sculptures of the crypt – on capitals and bosses – which must have been made before work on the Pórtico could commence.[17] Connections with northern Burgundy,

already mentioned in relation to S. Vicente in Ávila, are also apparent at Compostela in the crypt and the structure above, but apart from a few capitals in the former the stylistic vocabulary appears to be predominantly Spanish. The angel vault bosses in the crypt are closest to their counterparts in the Silos Annunciation relief and to the small figures of prophets on the Tree of Jesse relief alongside it, while other comparisons also point to Silos as a possible training ground for at least one member of Mateo's workshop.[18]

The style of the Pórtico de la Gloria is truly a transitional one between Romanesque and Gothic. While the decorative forms of the inhabited capitals and the scenes of the Damned in the archivolts of the right doorway have much in common with earlier twelfth-century sculptures, the naturalism and vitality of the jamb figures and the Elders of the Apocalypse is in no way inferior to the contemporary developments in the Ile-de-France, at Senlis and Mantes: indeed, it has been observed that the draperies of the archivolt figures at Compostela and Mantes share the same looping treatment of rounded folds.[19] This is probably due to a new common interest in the rendering of form as it appeared in life rather than evidence of a direct link between the two monuments. The contribution of Master Mateo – if indeed he was the chief sculptor – is of the greatest originality, and in certain respects is in advance of work in France. The relationship between the jamb figures and the characterisation of the facial types on the central portal anticipates the statues of the north transept at Chartres by roughly two decades, and the smiling countenance of the figure of Daniel is a precursor of the same type of joyful face seen only later in the thirteenth century at Reims and Bamberg. The grave realism of some of the heads of the prophets [187] is closely comparable to the byzantinising classicism apparent in other European centres at this time, such as is found in the roughly contemporary Winchester Bible and the Morgan Leaf in New York, and it is significant that Winchester painters were responsible for the frescoes in the chapter house of the royal convent of Sigena in Aragon at precisely the same time as the Pórtico de la Gloria was being completed; the convent was dedicated in 1188.[20]

No other sculpture at Compostela attained the same level of artistic originality and quality after this date. Certain members of the workshop brought together by Master Mateo were also employed on the construction of the granite choir screen inside the cathedral, which was presumably in place by the time of the consecration of the building in 1211. It was pulled down at the beginning of the seventeenth century, but enough fragments have been discovered in various parts of the cathedral to allow a reconstruction to be made with some confidence. The screen appears to have extended four bays westwards from the crossing; on the exterior of the north side were sixteen prophets, on the south side the twelve apostles and the four evangelists, echoing their position on the Pórtico de la Gloria. Twenty-four of these seated figures were re-used almost immediately after the dismantling of the screen, on each side of the *Puerta Santa* on the east side of the cathedral, where they can still be seen, and a number of other figures are in the museum of the cathedral and elsewhere. The end of the screen contained the Adoration of the Magi, of which only a

relief showing the three horses of the magi survives. Inside the screen, the stalls were capped with intricate architectural canopies decorated with lunettes containing fantastic and real animals, divided by standing figures of children holding scrolls.[21] The prophets and apostles of the choirscreen have suffered as a result of being stripped of their original colouring and the carving has been rendered less distinct because of weathering to the coarse-grained granite; this notwithstanding, there is nowhere any sign of the sculptural genius who carved most of the jamb figures on the Pórtico. The majority of the figures follow the form of the seated St James on the trumeau of the portal, and likewise show an affinity with certain late twelfth-century sculptures of the Ile-de-France, this time with a group of seated figures associated with Noyon.[22] At the same time the form of the canopies above the choirstalls fits into the Spanish Romanesque tradition, being especially close to the slightly earlier canopy over the tomb of an unknown lady in Santa María Magdalena in Zamora.[23]

THE TÚY PORTAL AND SCULPTURE IN THE FIRST THIRD OF THE THIRTEENTH CENTURY

The influence of the Pórtico de la Gloria made itself felt in Galicia and the surrounding areas until well into the thirteenth century, becoming increasingly old-fashioned in the light of new developments elsewhere. Sometimes this influence is limited to isolated features taken from the original, such as on the north portal of the Collegiata at Toro – which has the twenty-four music-playing Elders of the Apocalypse on the outer archivolt – but in the case of the west doorway of the cathedral of Orense (the *Pórtico del Paraíso*) the whole scheme was copied with only minor changes. Constructed in the second quarter of the thirteenth century it provides the clearest evidence of the esteem in which the Pórtico de la Gloria was held and an illustration of the beginning of the decline of sculpture in Galicia.[24]

The last sculptural programme of real importance in Galicia is the portal of the cathedral of Túy, situated on the border with Portugal. Although begun in about 1145 it was not dedicated until 1224 or 1225, and it appears that minor works still needed to be carried out on the doorway in the latter year.[25] The portal is contained within a deep porch on the west side of the cathedral, a rather forbidding fortress-like edifice with crenellated towers. It is immediately apparent that a different model from the Pórtico de la Gloria has provided the inspiration for its design, banishing Romanesque elements altogether. The choice of subjects for the decoration of the tympanum and lintel – the Adoration of the Magi, the Annunciation to the Shepherds, the Nativity and the Annunciation to the Virgin – is based on that of the north doorway of the west front at Laon, and the types of jamb figures are equally informed by the early thirteenth-century figures on the north transept at Chartres [188].[26] The eight jamb figures, comprising John the Baptist, St Peter, a prophet and Moses on the left, a young prophet (or possibly St John the Evangelist), Jeremiah, the Queen of Sheba and King Solomon on the right, are unthinkable without a knowledge of their counterparts at Laon and Chartres but there can equally be no question of considering

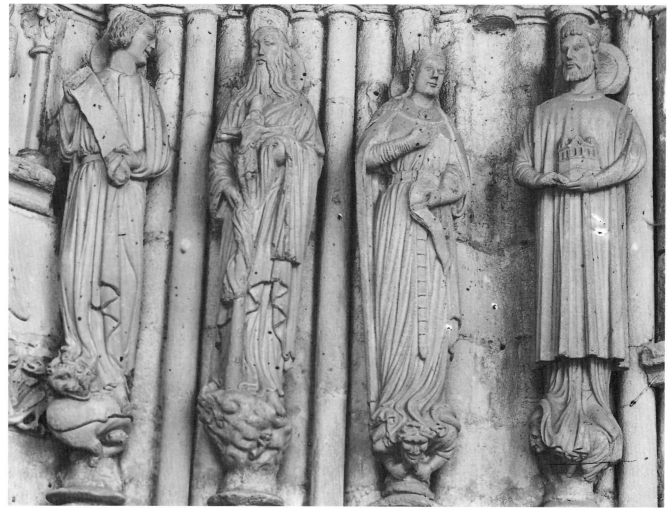

188. Jamb figures; west portal, Túy Cathedral; c.1215–25

the contribution of French sculptors in their execution. Although they follow the form of their models in the Ile-de-France – especially the type of high-waisted dress worn by the Queen of Sheba and the way it and the robe of King Solomon cascade down over their supporting grotesque consoles – the head types are those of the Master Mateo workshop: this is even more noticeable in the tympanum and lintel. A sculptor probably trained at Compostela may have travelled to Laon and Chartres, recorded the newly built portals, and created his own version of the Gothic portal.

The Laon-Chartrain style does not appear to have become popular in Spain, although the voussoirs of the south portal of Santa María la Mayor in Tudela (Navarre), with scenes of the Blessed and the Damned, do show a form

and narrative method which is comparable to the historiated archivolts of the Ile-de-France at the beginning of the thirteenth century.[27] Another portal of about the same date as the Túy doorway, that at Ciudad Rodrigo (province of Salamanca), is also devoted to the Virgin, and shows the Coronation of the Virgin in the tympanum with her death in the lintel below; a second lintel has scenes from the Passion of Christ, and the twelve apostles occupy the jambs. The sculpture throughout is in a crude late Romanesque style and despite the ambitious richness of the portal is only of passing interest.[28] But by this time the building of Burgos Cathedral was already underway and fresh inspiration from a different source was about to revitalise the course of Spanish sculpture.

Italy 1180–1250

It has sometimes been proposed that Italian Gothic sculpture was the invention of Nicola Pisano in the 1260s.[1] There can be no doubt that in sculpture, as in architecture, Gothic forms were slow in gaining acceptance south of the Alps; and it has often been pointed out that apart from the churches of Fossanova, Casamari and San Galgano – all Cistercian – and Sant'Andrea at Vercelli, French architectural innovations were virtually ignored outside the mendicant foundations.[2] This resistance to change is usually explained by the tenacity of the classical tradition and the presence everywhere of Early Christian and Early Medieval basilicas which continued to serve the needs of their congregations. Another major factor which inhibited the progress of the Gothic style was the country's fragmented political geography. In contrast to the established Papal territories around Rome and the lands of the Holy Roman Empire in the South, the cities of Tuscany and Northern Italy acted as independent communes, some with Guelph sympathies (against the Empire), others Ghibelline. In these circumstances one would not expect the easy movement of individuals and ideas from one locality to another, and only rarely did sculptors find employment in different areas before the middle of the thirteenth century.

Nevertheless, there are compelling reasons for including the most significant developments in the period between about 1180 and 1250 in a survey of Gothic sculpture. Although sculpture in a wholly Romanesque style – virtually indistinguishable from twelfth-century work – was still being made in Central and Southern Italy late in the thirteenth century, it is undoubtedly productive to compare the Italian with contemporary sculpture in Northern Europe. It will be seen that there was actually a considerable interest in French Gothic sculpture before 1200 and that both iconographic and stylistic traits were adopted. At the same time, it is clear that the Italian sculptor's approach differed from his counterpart in France and Germany, and that opportunities to work on a monumental scale were limited by less ambitious portal schemes. Other influences than French are apparent throughout the period: the inspiration of antique prototypes is everywhere evident and Byzantine models played an important part in the formation of Pisan and Venetian sculpture. There is also a marked tendency for the sculptors to announce their identity by inscription in a manner rarely found further north, and every indication that the workshops were generally smaller. The genesis of the cult of the individual artist is to be found in these careful and usually taciturn inscriptions; but by 1301, in the extended lines of fulsome praise for Giovanni Pisano on the Pistoia pulpit, we are on the verge of biography. It is noteworthy that in contrast to the anonymous sculptors responsible for the Sens, Laon and Chartres transept portals the most important sculptor of Northern Italy in the same years is known to us by name.

BENEDETTO ANTELAMI AND FOLLOWERS

Two sculptures in Parma bearing the name Benedictus provide the basis for the study of Benedetto Antelami and his workshop. The first, a marble relief of the Deposition now mounted on the wall of the south transept of Parma Cathedral [189], has an intrusive but beautifully carved inscription which tells us that it was completed by the sculptor in 1178.[3] The second inscription is on the lintel below the tympanum of the north door of the Baptistery opposite, and records that the work was started by Benedetto in 1196.[4] Taking these sculptures as a starting point in the reconstruction of his œuvre most authorities have also attributed to the sculptor the central portal of the Duomo at Fidenza (formerly Borgo San Donnino) and the other tympana and reliefs of the Seasons and Labours of the Months inside the Baptistery. As might be expected, this core group of works has been expanded with varying degrees of success.[5]

The Deposition relief formed part of a pulpit or *pontile* inside Parma Cathedral. Other fragments also survive from this ensemble, most notably a planed-down relief which once showed Christ in Majesty, the four Fathers of the Church and the symbols of the evangelists.[6] The distribution of the figures in orderly queues to each side of the cross and their elegantly arranged pleated draperies reveal a familiarity with the Royal Portal of Chartres, specifically with the lintel reliefs on the right doorway [16]. A pictorial effect is created which is quite different from that on roughly contemporary Romanesque reliefs, such as those on the *pontile* in the Duomo at Modena.[7] Although nothing is known about Benedetto's activity before the Parma Deposition, he is likely to have made a journey to the Ile-de-France in the 1170s. He was also very much aware of the late Romanesque sculptural programmes in Provence. Both currents are present in the sculpture which his workshop produced for the façade and interior of the cathedral at Fidenza, probably made in the decade between 1185 and 1195.

The west portals at Fidenza were made and added to at different times throughout the twelfth century. The lateral portals are largely the work of mid-century sculptors, of no great distinction, so that it appears that the Antelami workshop was brought in to unify and complete the façade.[8] It was not entirely successful in this, and no overall iconographic scheme has been created. As has often been noted, there is a general similarity to the portal constructions of Saint-Gilles-du-Gard and Saint-Trophime at Arles, both of which employ the deep porticos of the central doorway at Fidenza, although there was of course a tradition of west façades of this type in Northern Italy by this date, as may be seen at Modena, Piacenza, Ferrara and Verona.[9] Moreover, the small personifications of the Commandments and the figures of apostles arranged along the outer edge of the arch

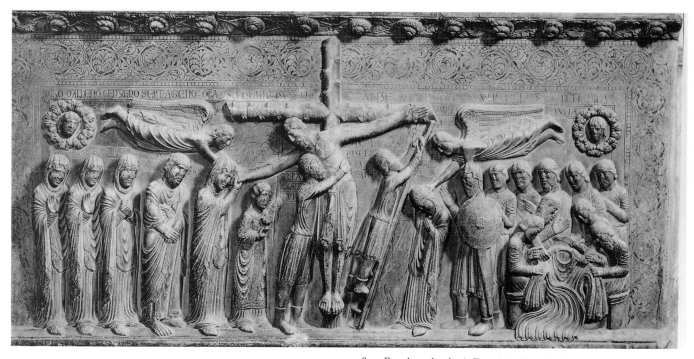

189. Benedetto Antelami: Deposition from the Cross; south transept, Parma Cathedral; 1178

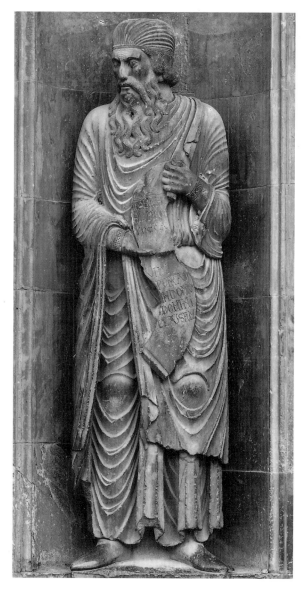

190. Antelami workshop: the prophet Ezekiel; west façade, Fidenza (Borgo San Donnino) Cathedral; c.1185–95

follow the archivolt type of the Ile-de-France. However, the connection with Provence is strengthened by the style of certain of the sculptures. Most striking in this respect are the figures of the prophets David and Ezekiel standing in niches on each side of the central portal [190], which may be compared with the closely similar life-size figures at Saint-Gilles-du-Gard, likewise positioned between the central and side portals.[10] There is no way of knowing whether these figures were the work of Benedetto or not, although they differ sufficiently from the sculptures which bear his signature to suggest that they should be attributed to another member of his workshop. It cannot be doubted, however, that the same style is to be found on the Baptistery at Parma after 1196, as two figures of prophets which are clearly from this hand until recently adorned the outside of the building. One work at Fidenza which may with confidence be assigned to Benedetto is the Virgin and Child now in the crypt, which resembles the Virgin and Child on the signed north door of the Baptistery closely enough to allow a common attribution. Probably made in the early 1190s, it again reflects Chartrain and Parisian prototypes.[11]

In the decoration of the Parma Baptistery we can see for the first time in Italy an attempt at a coherent iconographic programme akin to those on the French cathedrals. The three doors on the north, west and south faces of the Baptistery are sculpted inside and out with an ambitious narrative scheme which fills the tympana, lintels, arches and doorposts. On the north side the tympanum of the portal is devoted to the Adoration of the Magi, with on the right side Joseph receiving the warning from an angel to flee [191]; the story is continued on the inside tympanum, which shows the Flight into Egypt. Around the outside of the typanum are

191. Benedetto Antelami and workshop: tympanum, north portal, Parma Cathedral Baptistery; 1196–1216

twelve prophets, each one holding a medallion within which is a bust of an apostle, representing, as on the Bamberg *Fürstenportal*, the New Law's derivation from the Old. The prophets are seated among the branches of a tree, which links them with the figures of the Tree of Jesse and the twelve sons of Jacob on the doorposts below. On the lintel are scenes from the Life of St John the Baptist.

The west portal has Christ of the Last Judgement flanked by angels holding the instruments of the Passion in the tympanum and the twelve apostles around the arch. The Resurrection of the Dead is shown below in the lintel and on the doorposts are reliefs of the Acts of Mercy and the Parable of the Labourers in the Vineyard. The interior tympanum, which shows the figure of King David – the prefiguration of Christ – playing his harp among other musicians, echoes the composition of the exterior. The tympanum of the third portal, on the south side, is dedicated to the unusual scene of the Legend of St Barlaam at its centre, a vivid allegory of the passing of Life further dramatised by the addition of the personifications of Night and Day, hurtling towards the centre of the relief from each side.[12] Below on the lintel are three roundels with the *Agnus Dei*, a half-length figure of Christ blessing in the centre, and St John the Baptist. The tympanum on the other side of the wall shows the Presentation in the Temple. Finally, facing the west entrance and above the altar is another tympanum with Christ in Majesty flanked by the symbols of the evangelists and two standing angels.

Following the inscription above the north door we can be sure that work started on the Baptistery in 1196, and because baptisms were already taking place in 1216 the building had clearly advanced above the level of the doorways by that date. The Baptistery must have been covered by a temporary roof as the building which we see today was not completed until the beginning of the fourteenth century.[13] The work that Benedetto and his workshop were able to complete in the twenty years of their activity also took in the frieze of animals which runs virtually all around the building at just above eye level. This frieze and other sculptures once mounted on the outside and inside of the Baptistery were probably originally intended for a western portal of the cathedral but were subsequently utilised for the decoration of the upper parts of the Baptistery. These included two large standing angels, two seated prophets and King Solomon and the Queen of Sheba on the outside and the famous reliefs of the Labours of the Months and the Seasons, angels and the tympanum of Christ in Majesty inside. This work was presumably carried out concurrently with the building of the Baptistery in the second and third decades of the thirteenth century.[14]

Contrasting with the Deposition relief and the tympana of the Baptistery many of these loose sculptures and the frieze of animals show an awareness of contemporary developments in the Ile-de-France, suggesting that Antelami made another trip north while work was in progress. The high-waisted fashionable dress of the Queen of Sheba [192] and the figure representing Spring–Summer is that of Chartres and Paris in the early thirteenth century, the angels are wrapped in draperies conceived in an exaggerated classical *Muldenfaltenstil*, while King Solomon is a more restrained figure comparable to his counterpart at Amiens. It should also be remembered that the doorposts of the north portal of the west front at Notre-Dame in Paris, of around 1210–15, are also decorated with reliefs showing the Months. On the

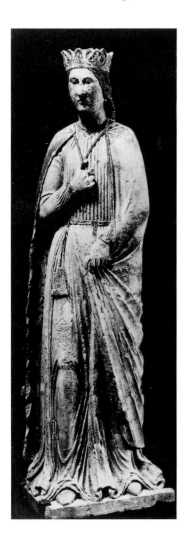

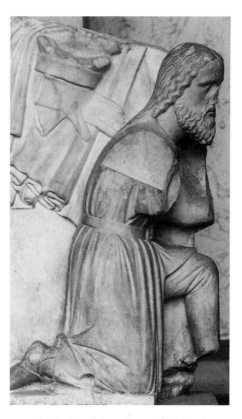

192. Antelami workshop: Queen of Sheba; Parma Cathedral Baptistery; *c.* 1210–20 (Galleria Nazionale, Parma)

193. King from the *Adoration of the Magi*, formerly part of a pulpit in Vercelli Cathedral; *c.*1235–40 (Museo Leone, Vercelli)

194. The Tree of Jesse (detail); right doorpost, central portal, S. Lorenzo, Genoa; *c.*1215–20

other hand the two seated prophets, like those from the contemporary choir of Santiago de Compostela, appear to reflect late twelfth-century prototypes exemplified in surviving figures from Noyon, and the animal frieze can also be paralleled at Sens in around 1200.

Given an estimated birth date of around 1150, it is unlikely that Benedetto Antelami would have lived much beyond 1215. However, there is clear evidence that his workshop – or sculptors who had received their training in it – exercised a considerable influence throughout Northern Italy for another twenty or thirty years. The so-called 'Maestro dei Mesi' who sculpted the series of reliefs of the Months for the south portal of the Cathedral at Ferrara in around 1225–30 was presumably involved in the making of the sculptures of the same subject at Parma, and appears to have gone on to execute the tympanum of San Mercuriale in Forlì.[15] This shows the Dream and Adoration of the Magi, and because of the similarity between the first of the Magi at Forlì and the same figure from a now-destroyed pulpit in Vercelli (1235–40) there are grounds for seeing the activity of one workshop in both commissions.[16] The Forlì and Vercelli sculptures [193] are the result of an ever-increasing understanding and digestion of French models, the points of inspiration here appearing to be the *jubé* at Chartres and the heads of the apostles on the north portal of the west front at

Notre-Dame. Elsewhere in Vercelli, at Sant'Andrea, the tympanum showing the martyrdom of St Andrew of the late 1230s likewise reveals an evolved post-Antelami softening of forms.[17]

FRENCH INFLUENCE AT GENOA, VEZZOLANO AND PADUA

Other workshops were also responsible for French-inspired sculptural programmes in North Italy at this time. The central portal of the cathedral of San Lorenzo, Genoa (*c.*1215–20), with Christ in Majesty and the four evangelist symbols in the tympanum and the martyrdom of St Lawrence on the lintel, is based on a French iconographic type of the third quarter of the twelfth century; and the so-called 'Arrotino' at the south-west corner is clearly derived from the angel with the weather-vane once in the same position at Chartres. The superb figured doorposts, on the other hand, which show scenes from the Infancy of Christ on the left and the Tree of Jesse on the right [194], can be related to contemporary French sculptures, such as the voussoirs of the Chartres north transept central doorway. They are excellent examples of the so-called 'Style 1200', exemplified in metal by the contemporary Trivulzio candlestick in Milan Cathedral.[18]

A more unusual ensemble is to be found in the isolated Augustinian priory at Vezzolano, between Turin and Asti. Here, on the arcaded choirscreen within the church a two-tiered carved strip stetching across the width of the nave is devoted to the Glorification of the Virgin, to whom the building was dedicated [195]. The upper band has at its centre the Virgin being blessed by Christ, with censing angels to each side and the Death of the Virgin and her Assumption to the left and right respectively; the symbols of the evangelists are shown at each end. Below, a densely packed row of seated kings and prophets holding scrolls – the Virgin's ancestors – converse with one another. It has been observed that the iconographic scheme owes its form to the tympanum, lintel and archivolts of the portal at Senlis, somewhat unsatisfactorily adapted to a completely different space.[19] Unlike the earlier sculpture of Antelami that at Vezzolano shows little sign of the Italian late Romanesque style, nor can any other work of this type be traced in North Italy. The date sometimes accepted for the frieze is 1189, apparently given in a now almost illegible painted inscription below, but this may not refer to the carving and would seem to be at least twenty years too early on the application of stylistic criteria. The capitals below are certainly unlikely before about 1200, and follow the form of Northern French examples. The connection with French sculpture is even more marked in the cloister, where a capital showing the Annunciation, Visitation and Nativity is inhabited by figures with the poses, slender proportions and pleated draperies of

196. Doorpost relief showing *Ecclesia* from now-dismantled portal, S. Giustina, Padua; *c.*1230

195. Choirscreen; S. Maria, Vezzolano; probably *c.*1220–30

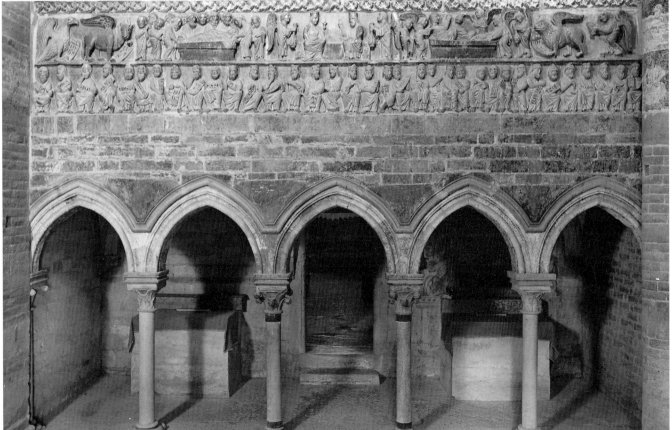

the same figures on the Chartres Royal Portal south doorway lintel.[20]

The now dismantled doorway of S. Giustina in Padua (c.1230) is no less eloquent of French inspiration, although in this case the Italian training of the sculptors is more evident. The tympanum, showing the extremely unusual image of the personification of the Church distributing the eucharistic wine, has obvious stylistic parallels with the late Antelami workshop, but the lintel and doorposts are directly derived from French models. The former, with scenes from the Infancy of Christ, is reminiscent of the upper lintel on the St Anne portal of Notre-Dame. The figures on the doorposts, including personifications of Church and Synagogue [196], are even more indebted to French prototypes.[21] These particular sculptures fall completely outside the Italian tradition, but even here the figures are still no more than reliefs constrained within the confines of the block. It remains a mystery why column figures of the type so popular on French Gothic portals were not adopted in Italy also. This is all the more surprising in view of the presence of embryonic jamb figures on a number of Italian Romanesque doorways in the middle of the twelfth century, as for instance on Niccolò's portals at Ferrara and Verona; although the S. Giustina figures are stylistically close to certain sculptures on the Chartres transepts they are applied to their architectural setting in the same way as the earlier Italian examples.[22]

VENICE AND TROGIR

In many ways Venice stands apart from other Italian cities, with a different tradition and with its eyes turned to the East. From its earliest days the influence of Byzantium was overwhelmingly present and there was a constant exposure to traded goods from Constantinople and imported works of art. The Fourth Crusade of 1204, and with it the sacking of Constantinople, brought a flood of Classical, Early Christian, Islamic and Byzantine antiquities to Venice, many of which remain there to this day. Stone sculptures and architectural components were set into the walls of San Marco, but alongside these *spolia* new sculptures were also incorporated into the fabric when the west portals were remodelled in the years after the Crusade.[23] Most relevant here is the central portal of San Marco, which was constructed by a team of sculptors conversant with the achievements of the workshop of Benedetto Antelami.

Above the central doorway are three arches in Greek marble decorated on both their underside and front face. The innermost shows animals and humans, some in combat, among a dense framework of foliate shoots. The second decorated order has personifications of the Months on the inside and figures of the Virtues on the outer face [197, 198], and the inner side of the third arch is made up of illustrations of the Trades, including shipbuilding, fishing and the making of wine, bread, milk and cheese. The outer face is composed of lush swirls of vegetal decoration among which are Christ and prophets, and the iconographic programme as a whole was completed by a mosaic – rather than a sculpture – of the Last Judgement. The basic form of the doorway is derived from earlier Romanesque portal designs further south on the Adriatic coast, in Apulia, and their

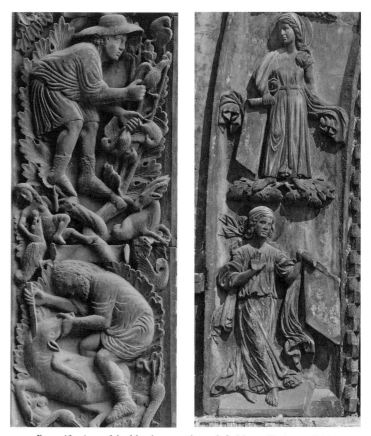

197. Personifications of the Months; central portal, S. Marco, Venice; probably c.1230–5

198. Personifications of the Virtues; central portal, S. Marco, Venice; probably c.1230–5

Dalmatian offshoots. This derivation is most clearly seen in the first archivolt to be executed, the innermost of the three, which compositionally is not very far from the late twelfth-century portals of San Nicola at Bari, and Trani and Troia cathedrals. In the second arch a different and more accomplished sculptor or workshop is in evidence. Here the stumpy figures of the first order have been replaced by more animated and naturalistic figures: especially fine are the Virtues on the outer face, whose draperies billow out around them as their dancing shapes fill the voussoirs. The heads have the delicacy of their peers on the voussoirs of the north transept at Chartres, but they are also informed by a byzantinising classicism unique to Venice. The sculptors responsible for both the first and second arches were probably trained within the Antelami workshop or by sculptors who had worked at Parma, but they added elements peculiar to Venice to these Emilian foundations. Although documentary evidence is lacking, the first two arches must have been made before 1240, the date of the portal at Trogir (see below), which presupposes a knowledge of the Venetian work. The third arch is probably slightly later, but there do not appear to be any compelling reasons for placing it much after the middle of the century.[24]

The mixture of Emilian Romanesque, French Gothic and Byzantine classicism that crystallised on the central portal of San Marco was carried across the Adriatic to the Dalmatian port of Trogir (Traù), where in 1240 the sculptor Radovan (Raduanus) left his name on the tympanum of the west

199. Radovan: tympanum, west portal, Trogir (Traù) Cathedral; before 1240

portal. The bishop of Trogir at this time was a certain Treguanus of Florence, who is also mentioned in the inscription, and it may well be that it was he who was responsible for drawing up the iconographic programme of the portal, which contains the Nativity in the tympanum and the Labours of the Months on the door jambs [199]. The portal has been dismantled and reconstructed on more than one occasion and has had sculptures added to it, but the contributions of the Master Radovan are readily recognisable. The style of the figures in the tympanum and the door jambs, and the way the latter are depicted, point to the inspiration of Venice, and the distinctive physiognomic types of Benedetto Antelami are still employed, albeit modified.[25] The long journey of Antelami's innovative style, moving outwards from Parma and mutating as it was passed down from sculptor to sculptor, came to an end outside the Italian mainstream. From the middle of the thirteenth century the most advanced sculptural activity would take place not in Emilia or Lombardy but in Tuscany.

TUSCANY

Like Venice, the city of Pisa had from an early date served as a stepping-off point for visitors to Europe from all parts of the Mediterranean basin. As a port it regularly received exotic imports of all sorts and its position on the coast, at the mouth of the River Arno, enabled the free passage of bulky and heavy goods and ensured its prosperity throughout the Middle Ages. One of the most important raw materials which passed through the city from the eleventh century onwards was marble from the Apuan Alps near Carrara, the gulf of La Spezia, and the hills behind Pisa itself, and it at once became the preferred medium for sculpture. The almost exclusive use of marble from this date encouraged a different approach to sculptural technique from that employed in the North, where limestone and sandstone were the dominant materials for external sculpture. There are also signs that from the twelfth century Tuscan sculptors studied and attempted to emulate the Roman sculptures which still remained visible in many cities, creating a tradition of classicism in details if not in overall appearance. The major technical difference is the extensive and visible use of the drill, punch and point, while another distinctive feature of Tuscan relief sculpture is the love of inlay in different coloured marbles, employed not only on the outsides of buildings but also on fonts, pulpits, choirscreens and other church furniture.[26]

The many Romanesque sculptures in Pisa and the neighbouring cities, often signed and of great interest, will not be discussed here. In contrast to the output of the Antelami workshop on the other side of the Appenines there does not appear to be any indication of an interest in the developing Gothic of Northern Europe; instead there is an evolution based on an increasing virtuosity in the carving of marble and the translation of an essentially small-scale approach to larger projects. At the end of the twelfth and beginning of the thirteenth century an overwhelming interest in Byzantine prototypes – fuelled no doubt by the Sack of Constantinople in 1204 – ensured that this style was chosen for the reliefs of the east portal of the Pisa Baptistery

200. Detail, lintel of east portal, Pisa Cathedral Baptistery; c.1200

[200]. In the same year a marble relief of Christ Pantocrator, now in the Museo Nazionale di S. Matteo, was set up above the doorway of S. Michele degli Scalzi in Pisa, which shows exactly the same stylistic traits and an identical use of the drill in the hair and beard as the reliefs of the Baptistery.[27]

The function of the building is reflected in the choice of scenes in the lintel above the portal, which show the Life of John the Baptist. The Baptist's head especially reveals a study of the antique, resembling as it does a classical tragic mask of the type still preserved at Pompeii, with steeply arched eyebrows and downturned mouth. This may, of course, have been transmitted through Byzantine sources, as it is has been shown that classical prototypes such as this were utilised as models for the expression of human emotion from the early Byzantine period onwards.[28] We know virtually nothing about the training of this 'Byzantine' workshop, and although its work is of the finest quality its influence in Tuscany does not appear to have been widespread. Instead, the interest in the antique and a proclivity for carving marble in the most detailed fashion led to a blossoming of the production of interior sculpture, and it is in the making of fonts and pulpits that the Tuscan *magistri marmorum* excelled in the first half of the thirteenth century. The panels that make up the large fonts in the baptisteries of Pistoia and Pisa, which are signed and dated 1226 and 1246 respectively, are products of the so-called *Guidi* workshop of Lucca. They reward close inspection for the astonishing precision of the carving and undercutting of foliate details, for the remarkable small heads at the corners, and for the technical mastery of their layout.[29] This attention to detail and the extensive use of the drill to delineate the tresses of the hair is also seen on the signed and dated panels (1239 and 1250) of the rectangular pulpit of Guido da Como in S. Bartolomeo in Pantano in Pistoia, which provides an illustration of the form – albeit reconstructed – of the typical Tuscan pulpit before the arrival of Nicola Pisano [201].[30]

In Lucca itself, the major project of this time was the decoration of the three portals inside the portico of the arcaded façade of San Martino. Work on the façade had carried on throughout the late twelfth century and into the

thirteenth, the addition of sculpted portals being the final stage of the project: this part was started – so an inscription tells us – in 1233.[31] The central doorway shows the Ascension of Christ in the tympanum with the Virgin and apostles in the lintel; that on the right the martyrdom of St Regulus, whose relics had been venerated at Lucca since the eighth century, in the tympanum and the saint's meeting with the Arians in the lintel; and on the left door is shown the Deposition from the Cross with the Nativity and Adoration of the Magi below. There is general agreement that the

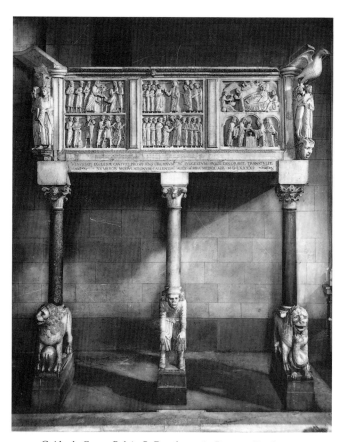

201. Guido da Como: Pulpit, S. Bartolomeo in Pantano, Pistoia; c.1235–50

sculptural decoration of the left door was completed last, and an attribution to Nicola Pisano has plausibly been proposed; it will thus be set aside and discussed later. Between the central and side portals two registers of reliefs are devoted to the Life of St Martin and the Labours of the Months.[32] All these sculptures, with the exception of those on the left doorway, appear to have been carved by the workshop of Guido da Como which was responsible for the pulpit in S. Bartolomeo in Pantano in Pistoia.[33]

Slightly different in style and showing a greater understanding of sculptural form than the reliefs is a life-size equestrian statue of St Martin dividing his cloak for the beggar, which once stood on two decorated brackets above the entrance to the portico [202].[34] In its frozen dignity and scale, and its presentation as an isolated object of veneration, it inevitably calls to mind the Bamberg Rider of about the same date [145] rather than the also contemporary St Martin at Bassenheim, which lacks the *gravitas* of the larger groups.[35] Although it would be misguided to postulate a direct relationship between the Lucca and Bamberg sculptures they speak of a common concern for the three-dimensional depiction of natural form, perhaps both stimulated by knowledge of antique equestrian prototypes. It has already been shown how an awakened interest in classical models, followed by the observation of nature itself, spread throughout Europe at precisely this time. A few years later, under the leadership of Nicola Pisano, this 'Christian classicism' was to reach new heights.

WOOD SCULPTURE IN CENTRAL ITALY

The main subjects of wood sculpture, as elsewhere in Europe, were the Virgin and Child and Crucified Christ figures which adorned every church.[36] In addition to these categories a popular devotional type emerged in Umbria and Northern Latium in the second quarter of the thirteenth century, showing the Dead Christ being lowered from the Cross. A complete and early example of this Deposition type is still preserved in the Duomo at Tivoli [203], and parts of similar ensembles may be seen in the Musée du Louvre in Paris, the Galleria Nazionale dell'Umbria in Perugia and the Castello Sforzesco in Milan.[37] By reference to the analogous Deposition group at Las Huelgas in Burgos (p. 238) it is likely that such ensembles were usually mounted on a beam over the choir, although some may have been installed at a lower level, perhaps above an altar (as in the Duomo at Volterra). They relied on lifelike colouring for their effect and in contrast to the many static Virgin and Child sculptures in the same churches they must have appeared as almost breathing tableaux of religious drama. It seems likely that the Holy Week processions incorporating scenes from Christ's Passion which are still common practice in certain towns in Italy and Spain were initiated at the time and that wood sculptures of this type played a vital part in the ritual.[38] Here sculpture was taken to the edge of the fine line which divides the image made as an aid to devotion from the venerated object adored by the faithful in its own right.

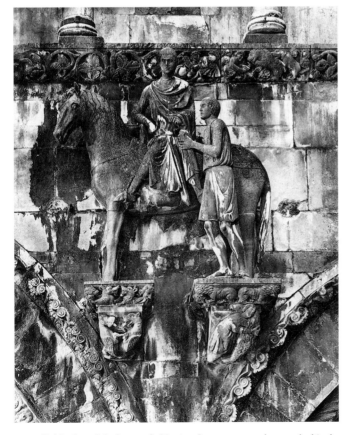

202. St Martin and the beggar; S. Martino, Lucca; *c.*1235; photographed in the original location

203. Deposition from the Cross; Tivoli Cathedral; group in polychromed poplar, *c.*1220–30

204. Virgin and Child; Chiesa del Crocifisso, Brindisi; polychromed wood, c.1240–50

No comprehensive study of the Virgin and Child groups of Central Italy has so far been attempted, but in the present incomplete state of knowledge it would appear that the large numbers of essentially late Romanesque Marian sculptures were produced in small workshops in the larger towns and purchased to order. Most of the Umbrian-Tuscan examples from the first half of the thirteenth century followed a set pattern, showing the Virgin sitting stiffly on a cushioned throne with the Christ-Child placed centrally on her lap facing the viewer, in the manner of the late twelfth-century Virgin and Child groups of the Auvergne, usually enclosed within a winged tabernacle.[39] They followed a path of slow internal stylistic evolution common to craft tradition and impervious to developments elsewhere, but occasionally an isolated case of importation would introduce new ideas into this rather backward milieu. In the second quarter of the thirteenth century the influence of French, Mosan and Lower Rhenish models gradually made itself felt even as far afield as Brindisi [204].[40]

ROME, SOUTHERN ITALY AND THE EMPEROR FREDERICK II

The city of Rome, the fountain-head of classical inspiration for so many artists and patrons throughout the Middle Ages, was ironically one of the most conservative centres of art production between 1150 and 1250. The stimulus which the antique remains both in Rome and elsewhere gave to northern sculptors was vital to the development of Gothic art in the early thirteenth century precisely because it added a new vocabulary to the stylistic vernacular. But this introduction of classical motifs and style into the art of the North was not reciprocated by any interest in the new forms being worked out in France. This has sometimes been viewed as a conscious rejection of Gothic art by the papacy and the people of Rome with a concomitant defiant embracing of classical forms, as if a clear choice between the two had been made. Notwithstanding the fact that the late twelfth and early thirteenth centuries were not in any case marked in Rome by ambitious building programmes, this again raises the question of whether in the eye of the medieval observer the style and form of classical sculpture – and conversely those of northern Gothic sculpture – were loaded with socio-political meaning. In this case however it is more likely that the classical traditions of marble working were adhered to in Rome because of the existence of a close-knit network of families who from the beginning of the twelfth century controlled what amounted to a monopoly in the making of architectural sculpture and fittings for the interiors of churches.[41]

The Roman marble workers (generally known as the Cosmati although this particular family were only one of the dynastic workshops involved in the trade) were extremely busy in these years, building the cloisters at S. Giovanni in Laterano and S. Paolo fuori le mura and providing such outstanding works as the great paschal candlestick now in the south transept of the latter; it is carved with scenes from the Passion of Christ and signed by Nicolaus de Angelo and Petrus Vassallettus. They also operated a business which sometimes prefabricated and transported ensembles of their work to sites further afield in Latium and Umbria, such as the cloister of the abbey at Sassovivo, and executed numerous inlaid pavements. Most of the architectural work – although by no means all of it – is enlivened with patterns of glass and cut stone applied to a decorative grid.[42] Hardly surprisingly, the figurative sculptures – recumbent lions, caryatid figures and expressive isolated masks – are usually modelled on classical originals, while other antique fragments would have made a more physical contribution to the later works by being used as the raw materials of the medieval workshop.[43]

As we have seen, Rome's greatest gift to the development of Gothic sculpture before the time of Arnolfo di Cambio was its provision of models from the distant past. The sheer wonder of the northern European visitor to the city is memorably captured in the English Master Gregorius's *Narracio de mirabilibus urbis Romae*, written probably in the early thirteenth century, which has already been mentioned in the context of French sculpture of the time. Gregory was clearly a knowledgeable spectator, recounting stories – both

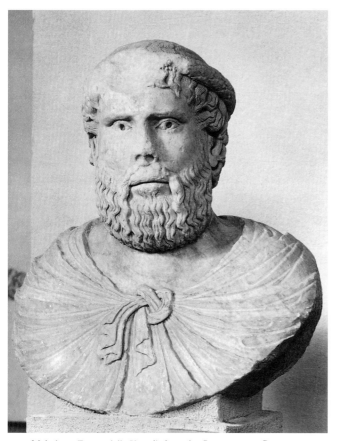

205. Male bust (Petrus della Vigna?) from the *Porta romana*, Capua; 1234–40 (Museo Campano, Capua)

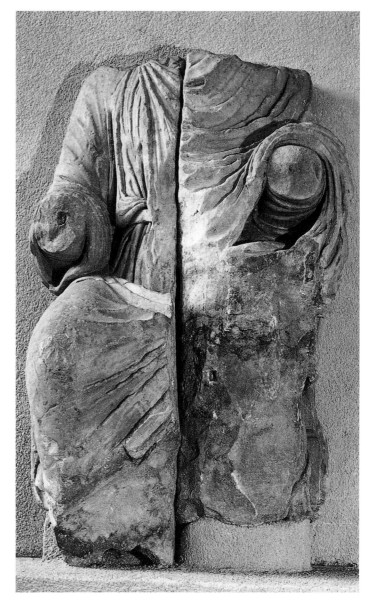

206. Fragmentary figure of the Emperor Frederick II from the *Porta romana*, Capua; 1234–40 (Museo Campano, Capua)

apocryphal and based on fact – about the many statues and buildings he saw. Although he was transparent in his admiration for the sculptures which surrounded him on all sides, he nevertheless found it necessary to temper his enthusiasm by drawing attention to the inevitable fate of pagan works of art:

> After I had spent some time admiring this stunningly picturesque sight, I thanked God, mighty throughout the entire world, who had here rendered the works of man wondrously and indescribably beautiful. For although all of Rome lies in ruins, nothing intact can be compared to this. And thus someone has said: 'Rome, although you are almost a total ruin, you have no equal; Shattered you can teach us, whole how greatly you would speak!' I believe this ruin teaches us clearly that all temporal things will soon pass away, especially as Rome, the epitome of earthly glory, languishes and declines so much every day.[44]

If it is debatable what the classical appearance of certain cathedral sculptures in northern Europe meant to the clergy, their sculptors and the general audience in the first half of the thirteenth century, there can be no room for doubt that the choice of an *all'antica* scheme of decoration in a secular setting was a clear allusion to the temporal power of the patron. Such was the case with the Hohenstaufen Emperor Frederick II's gateway at Capua.

Frederick II (1194–1250), praised as *Stupor Mundi* by his followers, has enjoyed a posthumous fame even he could not have imagined. Presented as a brilliant maecenas, he is often credited with the creation of a proto-renaissance and a direct and informed interest in art and architecture to set beside the Medici of fifteenth- and sixteenth-century Florence. Although this view is probably wide of the mark and not supported by the existing buildings – significantly these are mostly castles – and the cultural remains he left behind,

it is nevertheless clear that he understood the value of architectural propaganda and consciously employed the artistic language of the caesars to buttress his claims to supreme power.[45] Shortly after his coronation as Holy Roman Emperor in Rome in 1220 he set about strengthening the Norman castles he had inherited in southern Italy and Sicily and where necessary building new fortifications. The majority of these were severely functional and undecorated buildings, but the edifice for which he is now best remembered was embellished with sculpture for very specific reasons.

At the northern entrance to Capua, the nearest of the Kingdom's cities to Rome, a large gateway faced visitors approaching along the via Appia. Compressed between two massive cylindrical towers, the entrance wall was pierced by a gate above which an ensemble of sculpture was intended to convey as clear a message as that found in the iconographic programmes of contemporary cathedral portals in France. The gateway was built between 1234 and 1240 but was unfortunately devastated by the Spanish in 1557, so that now only the largely stripped towers and the striking sculptural fragments still survive, the latter displayed in the Museo Campano. On the basis of early drawings, the remains of the gateway and the sculptures themselves, we know that directly above the entrance was a large female head flanked at a slightly lower level by two male busts [205], all three sculptures set in circular niches.[46] Directly above the female head was the seated figure of the Emperor [206], with standing figures – probably classical *spolia* – on each side, and on a third level further smaller sculptures were placed in a double arcade; additionally, other heads and decorative finials were set at intervals around the towers. Encircling the niche containing the female head was an inscription with the words CESARIS IMPERIO REGNI CUSTODIA FIO (By command of Caesar I am the guardian of the Kingdom), which suggests an identification as *Justitia* rather than the personification of Capua sometimes proposed.[47] The traditional reading of the bearded male busts as Frederick's counsellors Petrus della Vigna and Thaddeus de Suessa cannot be ruled out, but it is perhaps more likely that they too simply represented the concept of delegated legal strength, shown in the guise of Roman judges. As has been observed, the whole decorative scheme was nothing less than a visual manifestation of the heart of the *Constitutions of Melfi*, drawn up by Frederick and his advisors in 1231, just after their greatest triumphs over the papacy. Here at Capua, writ large in stone, was a declaration of the authority of the Emperor, a three-dimensional statement presenting him – rather than the Pope – as the divinely appointed giver of laws on Earth.[48]

In these circumstances it was of course entirely appropriate that the sculptures should be carved in a style that approximated as closely as possible to classical originals. But where did the workshop that was called upon to do the work come from? Not Campania, where there does not appear to have been any experience of carving human figures of this scale, nor Apulia, where the pulpit in Bitonto Cathedral of 1229 gives an indication of typical late Romanesque sculpture in that region.[49] Of course, in both these areas a conspicuous classicism prevailed – the pulpits in the cathedrals of Salerno and Sessa Aurunca are especially accomplished in this

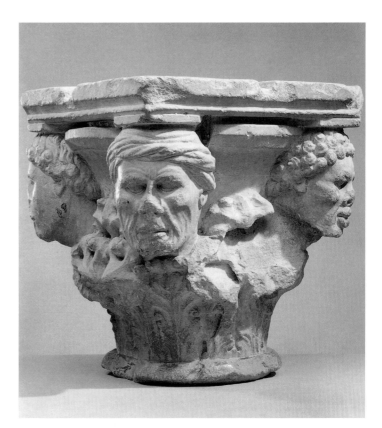

207. Capital, probably from Troia Cathedral; *c*.1240 (Metropolitan Museum of Art, New York)

respect – but nothing approaching the ambition of the Capua sculptures is to be found.

Two capitals associated with the Cathedral of Troia, one now in the Metropolitan Museum of Art in New York [207], the other still in Troia, may shed some light on the origins of the new style. Possibly originally forming part of a ciborium, the capitals have been dated in the years immediately before 1229, when Frederick turned against the city, although it is perhaps more likely that they are slightly later, possibly from around 1240. Both show four human heads equally spaced around the bell of the capital, the gaps in between being filled by luxuriant curly leaves. Compared with contemporary south Italian sculptures they are immediately striking in their realism, in the attempt to depict the faces as if they were imbued with life rather than as staring masks. The head of the man with a turban on the New York capital is particularly noteworthy, the sculptor taking great care to carve the sunken cheeks and knitted brow of a weather-beaten old man. In this interest in facial types he is not far from his near contemporaries in the Ile-de-France and Mainz, and convincing parallels have been drawn between the heads on the capitals and those of the console figures on the transepts at Chartres.[50] It has also been shown that the draperies of the seated figure of the Emperor from the Capua arch are closer to those of Chartrain and Parisian sculptures than to the antique.[51] In the light of these comparisons it is highly likely that French or German sculptors were working under imperial patronage in the South, just as the former travelled to Strasbourg and Bamberg in the same years. They presumably trained local

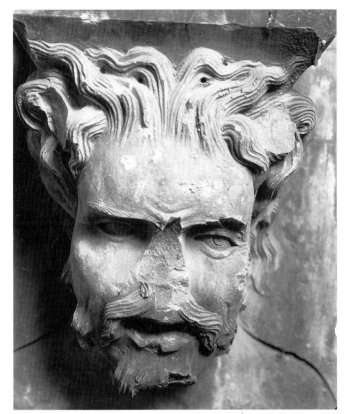

208. Vault console, Castel del Monte; c.1240–50

Frederician workshops, outstanding among them being a bust (of Frederick II?) in Barletta which shares some of the stylistic features of the heads on the Troia capitals.[52] While not one of these can be definitively associated with Frederick's patronage – indeed some of them are probably not even of thirteenth-century date – no such uncertainty exists in connection with the sculptures inside his hunting lodge near Andria in Apulia, the Castel del Monte. Started in 1240, Castel del Monte was first and foremost a fortified residence, although its octagonal structure and use of classical ornament around the doorways mark it out from other small castles of the time. Inside, the rooms were never excessively decorated but inside one of the towers the vault consoles were carved with remarkably animated heads [208]. In another of the towers the consoles consist of squatting naked caryatid or *telamone* figures. None of the sculptures can be seen effectively from below, and in this respect they bring to mind the same type of small-scale detailed carving high up on the south transept at Reims, of the early 1230s. Here are found the same expressive faces, even similar naked figures, so that the likely employment of French sculptors (or French-trained Germans) in Apulia is more than mere conjecture.[53]

Frederick II's quest for an imperial *Regno* to be set beside that of ancient Rome was gradually undermined by the papacy and his enemies in North Italy and elsewhere. His relations with Rome went from bad to worse during the 1240s and his death in 1250 was greeted with undisguised glee by Pope Innocent IV and his Guelph allies. With the demise of the Hohenstaufen dynasty in the years after, the sculptors who had been working in the style of classical naturalism so suitable for imperial propaganda must have dispersed, as nothing of this type of work appears to exist in the South from after 1250. Some of them, including it seems Nicola Pisano, moved north and were to plant the seeds of artistic revolution in the fertile soil of Pisa and Siena in the second half of the century.

sculptors skilled in the art of marble carving, as is suggested by the different styles apparent in the sculptures of the Capua arch, and the influence of classical prototypes remained as a dominating component of the native sculptors' repertory.

A good number of quasi-classical marble heads in various museums and private collections have been ascribed to

PART TWO

Mature Gothic

. . . leurs mestiers n'apartient à nule ame, fors que à sainte Yglise, et aus princes et aus barons, et aus riches homes et nobles (their craft belongs to no one but the Holy Church, the princes and barons, rich men and nobles)

(Chapter LXI of the *Livre des Métiers* of Etienne Boileau, referring to the *Ymagiers-Tailleurs* of Paris, *c.*1268)

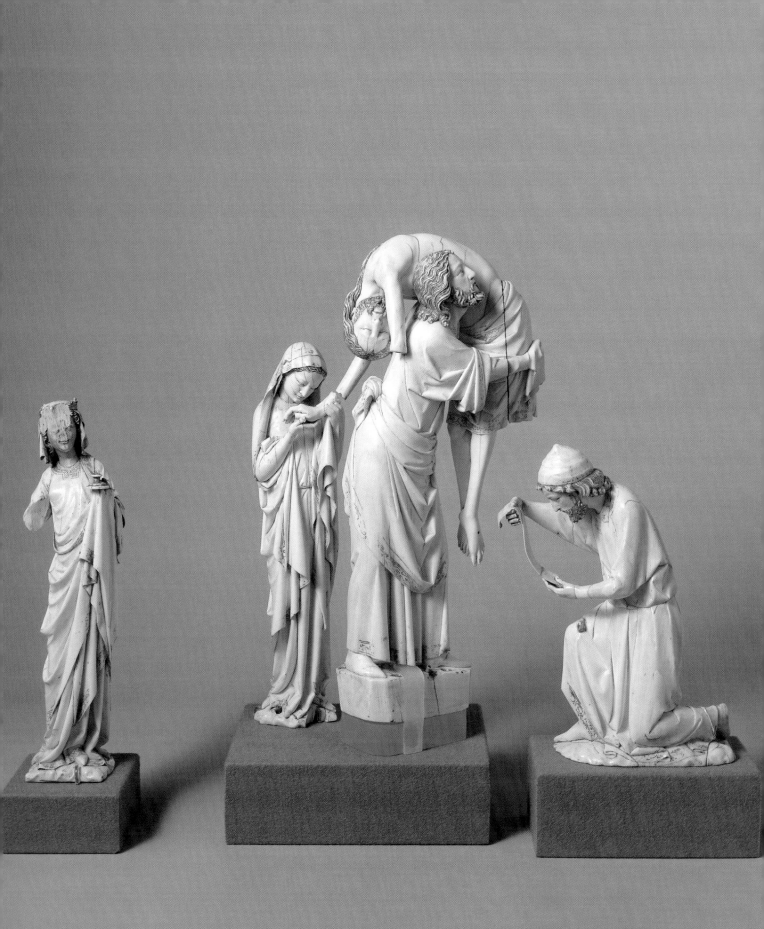

France 1230–1300

THE AMIENS WEST PORTALS AND RELATED SCULPTURES

The cathedrals of Chartres, Reims and Amiens are often considered the Holy Trinity of Gothic architecture, and of the three it is at Amiens that one can see the purest demonstration of sculpture complementing architecture in a unified statement of High Gothic design. Because Chartres retains its twelfth-century west portal and the Reims west façade is made up of sculptures of different campaigns, only Amiens presents a thirteenth-century western entrance as intended from the outset by master mason and ecclesiastical patron [211]. As we have seen, the other great early thirteenth-century façade, at Notre-Dame in Paris, incorporates the earlier *Portail Sainte-Anne* and thus also has a more piecemeal appearance than the Amiens west front. Like so many Romanesque cathedrals standing in the way of architectural progress and pious ambition, the previous building had burnt down in 1218, although curiously the treasury (containing the cathedral's relics) was spared. No time was wasted in clearing the site and by 1220 the first stone was laid by Bishop Evrard de Fouilloy, whose fine bronze effigy remains in the nave [210]: in 1222, when the Bishop died, the foundations were apparently in place and work on the nave was progressing.[1] In contrast to many other cathedrals the construction did not proceed as normal from east to west. Thanks to a reference to bells in the south-west tower in 1243 we are entitled to conclude that by that time the west front was complete up to the level of the rose window and that most if not all of the sculpture must have been in position. The large amount of figure and relief sculpture clustered around the three doorways was therefore made in a relatively short and concentrated burst of activity between about 1225 and 1240 and as no changes have been made to the original programme it stands as the primary example of the Gothic façade.[2]

In overall appearance the design of the three doorways is clearly based on that of Laon [49], the major difference being that the buttresses dividing the deep porches at Amiens were not pierced and could consequently serve as supports for further figures. The Amiens portals also differ from those at Laon in their choice of subjects. The central portal is devoted to the Last Judgement, with the blessing Christ on the trumeau [212] and the apostles on the jambs; the south portal shows the Coronation, Death and Assumption of the Virgin in the tympanum and the Ark of the Covenant flanked by Moses, Aaron and four Jewish priests on the lintel, with the Virgin and Child on the trumeau [213] and groups of the Annunciation, Visitation, Presentation, King Herod and the Magi, and Solomon and the Queen of Sheba

209. Deposition from the Cross; ivory group, painted and gilded, *c*.1250–60 (Musée du Louvre, Paris). See p. 150

210. Tomb effigy of Bishop Evrard de Fouilloy (d.1222); Amiens Cathedral; gilt bronze, probably *c*.1240

211. West façade, Amiens Cathedral; c.1225–40

on the jambs [214]. The north portal is dedicated to the first bishop of Amiens, St Firmin, who is shown on the trumeau, flanked on the jambs by figures of local saints and accompanying angels, and in the tympanum above are scenes showing the translation of the saint's body. The lintel echoes that on the south portal, this time showing three seated bishops to each side of the canopy above St Firmin's head. Iconographically and stylistically the doorways derive principally from Notre-Dame, Paris, and the Chartres transepts. The Judgement portal is only a slightly modified copy of its Parisian model, and many of the distinctive details found in the latter – such as the blindfolded and disembowelled naked riders of the Apocalypse in the voussoirs – are taken over exactly.[3] Likewise, the six seated figures and the Ark of the Covenant appear on the Virgin portals at both places, and local saints grace the jambs.[4]

However, the iconographic programme of Notre-Dame has been greatly expanded and unified with the architectural frame. The personifications of the Virtues and Vices carved on the socle of the central portal in Paris are also included at

Amiens – this time in quatrefoils – but the use of small reliefs to complement the figures above is here extended right across the façade, with signs of the Zodiac and Calendar on the left doorway [215] and scenes relating to the Infancy of Christ [216] and to King Solomon on the right. The three portals are linked together by the application of figures of the twelve minor prophets on the buttress piers and the four major prophets, two on each side, alongside the apostles of the central doorway; and the quatrefoils on the buttresses to each side of the central portal literally reinforce

212. The *Beau Dieu*; trumeau of the central portal, west façade, Amiens Cathedral; probably c.1230–5

213. Virgin and Child; trumeau of the south portal, west façade, Amiens Cathedral; probably c.1230–5

214. The Annunciation, the Visitation and Presentation in the Temple; right side, south portal, west façade, Amiens Cathedral; probably c.1230–5

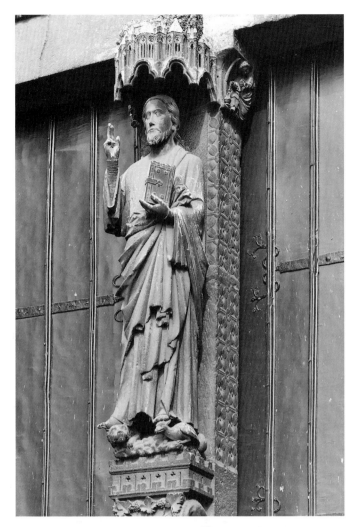

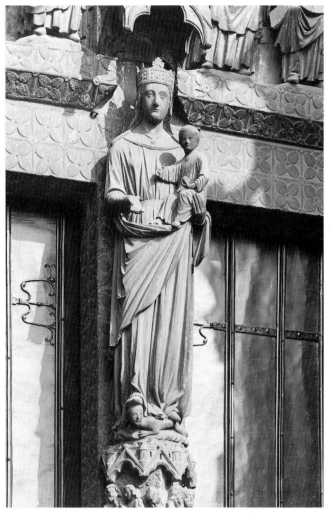

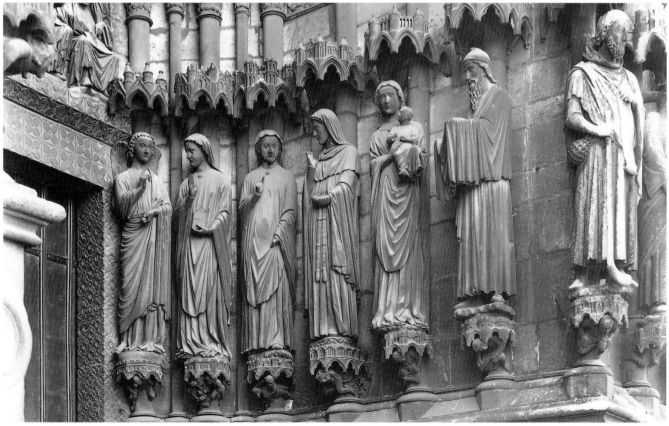

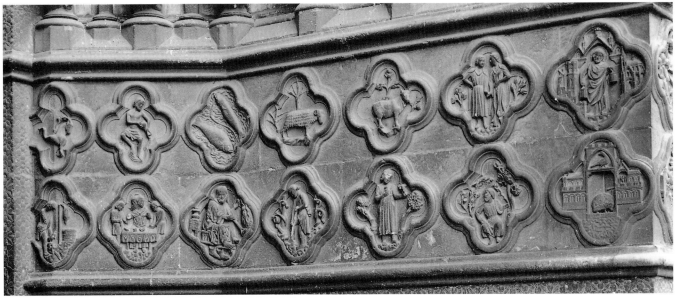

215. Signs of the Zodiac and Calendar; socle of right jamb, north portal, west façade, Amiens Cathedral; probably *c*.1225–30

216. The story of the Magi; socle of left jamb, south portal, west façade, Amiens Cathedral; probably *c*.1225–30

this impression of binding together the iconographic programme.[5] Leafy shoots grow out of the sides of the quatrefoil borders and become entwined. High above the portals the façade is further unified by the gallery of kings, following the example of Notre-Dame again.[6]

The sculpture at Amiens is sometimes criticised as lifeless and inert. Because the extensive programme was completed in a short space of time it is possible that the sculptures were worked up into a semi-finished state by less experienced masons and completed more rapidly than usual by the senior members of the workshop, so that the resulting statues have a uniformity of expression and gesture unappealing to the modern eye.[7] It should also be remembered that the apostle statues especially were considerably restored in 1844–7, when their attributes were renewed, and that painting would have greatly enlivened the sculpted surfaces. However, it seems that the most important consideration here was to create an overwhelmingly complete *schema* of Christian doctrine – an aim which was clearly achieved – and the iconographic novelties should not be overlooked.

The most striking innovation is in the arrangement of the jamb figures on the Virgin's portal. Although the Annunciation and Visitation had already been shown on the jambs of the left portal of the north transept at Chartres here the Infancy cycle has been expanded to include the Magi (who were included in the tympanum at Chartres) and the Presentation in the Temple, and the figures of Herod, King Solomon and the Queen of Sheba complete the ensemble. This has the effect of converting the jamb area – normally taken up by predominantly static, frontal figures – into a zone of drama and gentle movement to complement the narrative scenes above and below. The jamb figures are now almost free from the columns behind.[8]

There is, by and large, a uniformity of style in the jamb figures throughout the west front, and few of them assert any marked individuality. One that does is the female saint to the extreme left of the St Firmin portal, usually identified as St Ulphia, whose draperies still retain the deep trough style of the Reims north transept.[9] The others are mostly dressed in heavy garments which conceal the bodies beneath, and the heads lack the vitality of their predecessors at Chartres and Reims.[10] As the iconography would lead us to expect, and in the fact that the first architect at Amiens – Robert de Luzarches – came from near Paris, it is likely that the majority of the sculptors had previously worked in the capital, at Notre-Dame and elsewhere. The sculptures at Saint-Germain-l'Auxerrois and from Sainte-Geneviève in Paris, especially the effigy of Clovis I now at Saint-Denis, belong to the same stylistic group.[11] In many ways the most accomplished sculpture at Amiens is on a small scale, in the quatrefoils at eye level. These reliefs are not only beautifully carved in all their details but in the narrative scenes especially the compositions have been brilliantly worked out to make the most of the potentially awkward shape of the quatrefoil [216].[12] It is not coincidental that in their simple but effective approach to story telling they resemble the coeval enclosed miniatures of the *Bibles moralisées*.[13]

When work came to a close on the west portals the large numbers of sculptors employed in the workshops either returned to Paris, which as we will see was enjoying unprecedented prosperity, or took their skills to smaller churches outside the capital. Some went further afield – even to León Cathedral in Northern Spain – and others found work at Reims. Although the construction of the west façade of Reims Cathedral was not started until after 1252, it has already been shown that some of the sculptures installed there were actually made considerably earlier. The six jamb figures of patriarchs and prophets on the south portal are the oldest of these [90], and a start had been made by the sculptors of the north transept workshop on figures for a Virgin portal, including the famous Visitation group [95]. To this were added several figures by a sculptor from Amiens – most notably the Virgin of the Annunciation [217] and the Virgin and Child and Simeon performing the Presentation in the Temple – which were probably made in the early 1240s and were thus not utilised until at least a decade later. Indeed, the Amiens-type Virgin was probably originally intended to face the angel to the left of St Dionysius on the north portal, but was ultimately juxtaposed with an angel by a different sculptor during the final campaign.[14]

217. Virgin of the Annunciation; central portal, west façade, Reims Cathedral; probably *c.*1240–5

PARISIAN SCULPTURE 1240–65

At the same time as the western doorways at Amiens were being constructed a different, 'younger' workshop was engaged on the south transept portal [218]. This is dedicated to the local bishop-saint Honoratus, scenes from his life being shown in the lower two registers of the tympanum; the third and fourth combine an episode after the saint's death – when his relics were processed in front of a cross on which the figure of Christ bowed its head towards the reliquary chest – with the image of the Crucifixion itself. On the lintel below are the twelve apostles, and in the archivolts are angels and a full complement of Old Testament figures, prophets and New Testament figures. The jambs are occupied by two angels with censers and six other so far unidentified clerical saints, and the trumeau holds the celebrated *Vierge dorée*. Judging by the figures on the socle below and the general context it is likely that it was originally the intention to place a statue of St Honoratus on the trumeau and that the Virgin and angels were added only at a late stage – perhaps in around 1250 – after the rest of the sculpture had been completed.[15]

218. South transept portal, Amiens Cathedral; possibly *c.*1233–5 and later (the Virgin and Child probably *c.*1250)

It is generally agreed that the jamb figures and the socle of the trumeau were made by the workshop responsible for the sculptures of the west front. The rest of the portal's sculptural decoration, however, is in a different style, the small heads of the figures being imbued with a liveliness and animation previously missing in all but the best of the quatrefoil reliefs. It has been demonstrated by detailed study of the building that this upper part of the doorway was not carved in a second campaign after 1259, as was previously thought, but that the whole portal was completed at the same time, possibly in 1233–5 or slightly later.[16] The design of the doorway is taken over from another hagiographic portal, the so-called Calixtus portal at Reims [92], where the narrative method of stacked strips is seen for the first time, but the finely carved heads with rather pointed features are

related to those of the most advanced figures of the central portal at Notre-Dame in Paris, the seated Christ and the nail-holding angel of the Last Judgement.[17] This new style, which became something akin to a Parisian 'Court style', held sway in the years around the middle of the thirteenth century in Paris and would provide the model for numerous derivations elsewhere.

By 1240 Paris had assumed a position of eminence unchallenged throughout Europe. Already recognised as the leading intellectual centre, it was also experiencing unprecedented economic prosperity – followed by its natural corollary, a building boom – and enjoying the patronage of Louis IX (1226–70), the greatest of the medieval kings of France, and his mother Blanche of Castile. No foreign ruler could visit Paris without being impressed by the fine churches and domestic buildings to be seen everywhere, and Matthew Paris's account of the English King Henry III's visit in 1254 provides a perfect illustration of the city's international reputation in the middle of the thirteenth century.[18] The cathedral of Notre-Dame was naturally at the centre of all this, and work continued on the building throughout most of the century. Evidence for the widespread influence of the cathedral workshop has already been seen at Amiens, and in the years leading up to the middle of the century smaller

219. 'King Childebert'; from the trumeau of the refectory portal of Saint-Germain-des-Prés, Paris; 1239–44 (Musée du Louvre, Paris)

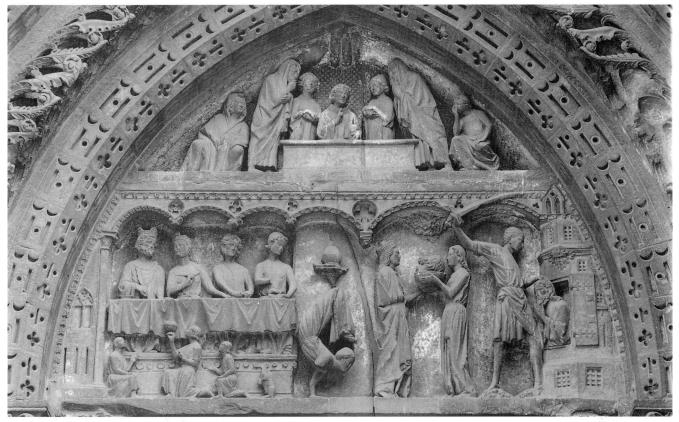

220. Tympanum with scenes from the story of St John the Baptist; north portal, west façade, Rouen Cathedral; c.1240

'satellite' workshops, either trained at Notre-Dame or basing their style on that found in Paris, executed sculptures on more modest portals at Longpont, Villeneuve-l'Archevêque and Rampillon.[19]

A typical and accurately dated example of the Parisian style at this time is the figure traditionally known as King Childebert, which once adorned the trumeau of the refectory portal of Saint-Germain-des-Prés, built between 1239 and 1244 [219]. The well preserved head, with its curly beard, flowing locks and sharp nose, shows a more advanced stage of the transformation of facial features first noticed in the Christ of the Judgement portal at Notre-Dame in the late 1220s.[20] Figures of this kind appear elsewhere in Northern France in the decades on each side of 1250, but the tympanum of the St John portal on the west front of Rouen Cathedral – the work of a Paris atelier in around 1240 – shows a special attention to detail in the carving of the facial types and an overall quality of the first rank [220].

The quintessence of Gothic is reached in the architecture, stained glass and sculptural decoration of the Sainte-Chapelle [221]. Built to house the most important relics to come to France in the Middle Ages, it represents to many the perfect embodiment of medieval royal patronage in the service of God. In 1239 Louis IX – later to be St Louis (he was canonised in 1297) – received in Paris the Crown of Thorns acquired from the Latin Emperor of Constantinople, Baldwin II. This most precious and symbolically significant relic was joined two years later by part of the True Cross and other sacred items, and the King determined to house these treasures in a setting appropriate to their importance. Rather than having them displayed at Notre-Dame or Saint-Denis he decided to commission a new chapel next to, and connected with, the Royal Palace in the heart of the Ile de la Cité. The great two-storey chapel was built remarkably quickly and was probably finished by 1246, when guardians were appointed; it would certainly have been complete at the time of its dedication in 1248. Branner has demonstrated that the architect responsible for the design of the building probably came from Amiens, and he proposed the second architect of that cathedral, Thomas de Cormont, as the master of the works.[21]

The figurative sculpture was confined to the upper main chapel and consisted primarily of the twelve apostles, mounted on the columns between the windows, and legions of censing and crown-holding angels in the spandrels of the wall arcades at socle level. At head height the many small capitals topping the colonnettes of the blind arcades were carved with a stunning variety of naturalistic leaf ornament.[22] The apostles were taken down at the end of the eighteenth century and dispersed, and when the chapel was restored in the middle of the following century the reinstallation was effected with a mixture of three or possibly four original figures, two extensively restored fragments, four copies of original fragments now in the Musée national du Moyen Age, and two modern inventions. In addition to the four damaged figures – one is headless – the Musée national du Moyen Age owns the lower halves of two apostles damaged at the dismantling of the chapel in 1797.[23]

The interior of the Sainte-Chapelle has been aptly described as like 'a contemporary gold and enamel reliquary

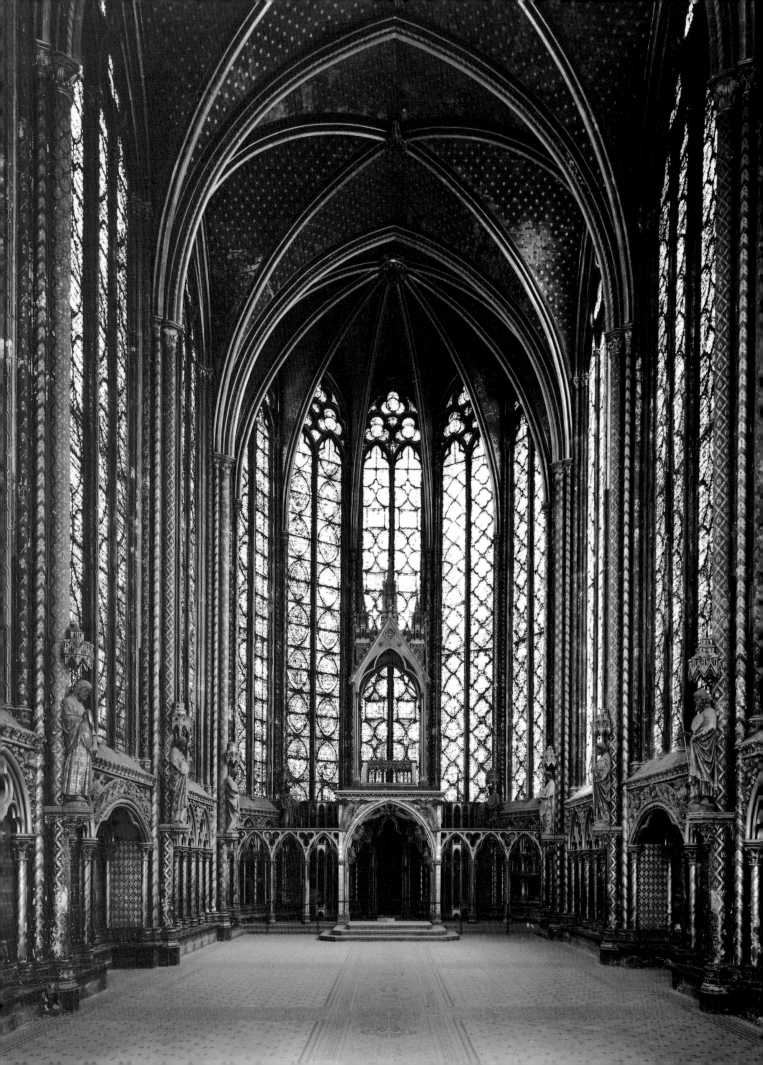

turned outside-in'.[24] This was of course the intention, to provide a monumental showcase for the relics enclosed within their great *châsse* in the choir. Although the interior has been much restored and repainted it is obvious that the original polychrome and sculpted decoration was meant to echo on a large scale the sumptuous appearance of the reliquary-chest itself, which sadly no longer exists.[25] But contrary to what some scholars have thought, the style of the apostles does not reflect that of metalwork. Unlike the sculpture in the last third of the twelfth century, which has been shown in some cases to have taken metalwork as its model, there is no evidence that Parisian sculptors in 1240 looked in the same direction. The few pieces of goldsmiths' work which still exist from the first half of the thirteenth century do not show the elegant draperies and curly locks of the Sainte-Chapelle apostles, but rather indicate an adherence to a post-Nicholas of Verdun style. It should more reasonably be concluded therefore that in this case sculpture provided the lead, and that the gilt-copper figures on the great metalwork *châsses* of the second half of the thirteenth century, as at Rouen and Nivelles, were based on monumental prototypes such as the Sainte-Chapelle apostles themselves.[26]

The three damaged but almost complete apostles in the Musée national du Moyen Age have been stripped of their polychrome decoration, but even in an unpainted state their quality is evident [222]. Although following the form of jamb figures, their placement along the walls of the Sainte-Chapelle allowed the sculptors the freedom to treat each figure individually, almost as separate cult statues. Unlike the Amiens figures, each apostle's draperies were arranged in a different manner and the heads were carefully personalised. Great attention was paid to the carving of the hair and the beards, which are made up of tight curls, and although there appear to be slight stylistic differences it is quite possible that a single master 'imager' was responsible for all the apostles. That he was a Parisian, almost certainly trained in the Notre-Dame workshop, seems beyond doubt when comparing the head types with the King Childebert in the Louvre and the Christ of the cathedral Last Judgement portal.[27]

In addition to the Crown of Thorns and the other precious relics displayed in the Sainte-Chapelle, works of art in many materials must have been donated – by visiting foreign dignitaries as well as the French Royal Court – in the years immediately after the chapel's dedication. A rare survival, mentioned in an inventory of the treasury drawn up between 1265 and 1279, is the magnificent ivory Virgin and Child now in the Musée du Louvre [223]. Standing 41 cm high, it possesses a monumentality which belies its actual size, and represents a perfect miniaturisation of the currents present in Parisian mid-century sculpture.[28] The deep furrows created by the sweep of the Virgin's mantle are comparable to those on the *Vierge dorée* at Amiens and the trumeau Virgin of the north transept at Notre-Dame (to be discussed below), although the natural curve of the elephant tusk has here been maximised by the great skill of the carver. He has

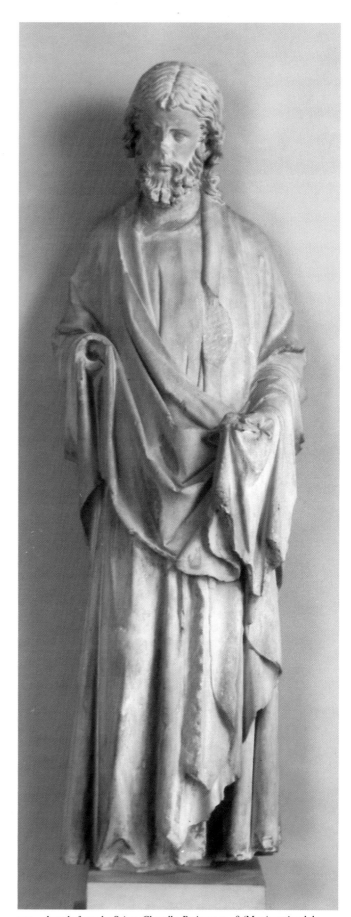

221. Interior of the upper chamber, Sainte-Chapelle, Paris; 1241-8

222. Apostle from the Sainte-Chapelle, Paris; 1241-8 (Musée national du Moyen Age, Paris)

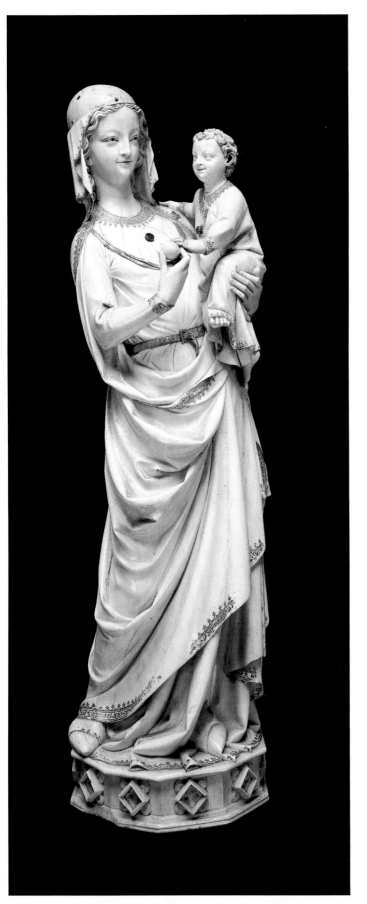

223. Virgin and Child from the Sainte-Chapelle; ivory, painted and gilded, c.1250–60 (Musée du Louvre, Paris)

created a courtly figure of supreme elegance, swaying in a gentle *contrapposto* onto her front foot, a pose which would permeate numerous representations of the Virgin in a variety of media in the second half of the century.[29]

Carvings in elephant ivory had only rarely been made in Northern Europe during the twelfth and early thirteenth century. In France and England the ivory used by the Romanesque workshops was that of the walrus, which although of similar appearance came in smaller tusks, and its use for statuettes was therefore limited. In the twelfth century the vast majority of ivory carvings were produced for ecclesiastical use, either for the monastery or the cathedral, but by about 1250 – when the first carvings in a mature Gothic style were produced – the market for such pieces had changed and ivory was employed predominantly for objects of private devotion. By the middle of the thirteenth century elephant ivory was being imported in some quantity, and by the beginning of the following century the production of ivory carvings of all sorts – statuettes, triptychs, diptychs, combs, mirror backs, boxes – was burgeoning, especially in Paris. The Sainte-Chapelle Virgin is of course hardly typical, as it was made under royal patronage, possibly for Louis IX himself, but many other more modest Virgin and Child groups were carved in these years. Because they were portable and especially suitable as gifts from the rich they were often exported and thus became prime transmitters of the modern style.

Particularly notable examples of the ivory carver's art from this time are the Virgin and Child and angels from the treasury of Saint-Denis (now divided between the Taft Museum, Cincinnati, and Rouen Cathedral), which again show marked affinities with monumental sculpture, and the contemporary Deposition from the Cross group in the Louvre [209].[30] The latter is not only one of the most beautiful and touching small sculptures ever made but is also a brilliantly-conceived piece of workmanship made up out of a number of pieces of ivory dowelled together and carved across the joins. Like the Sainte-Chapelle Virgin it must have been made within the Court circle, but unfortunately in this case nothing is known of its provenance before the nineteenth century. Both the Sainte-Chapelle Virgin and the Louvre Deposition group retain much of their original colouring and it is of interest to note that this seems to have been confined largely to the edges of the garments, to certain features such as the Virgin's girdle, and the hair, which was invariably gilded.[31] The natural colour of the ivory sufficed for the flesh areas and it is likely that colour was used selectively rather than employed to cover the whole carved surface. There is thus a correlation between the ivories and some of the surviving polychromed monumental sculpture at Lausanne, for instance, where the draperies were predominantly white [88, 89].

As mentioned above, the Virgin and Child of the north transept portal at Notre-Dame acted as an influential model for the carvers of both ivory and wood statuettes, and it has been shown that these small-scale versions carried the style of the Ile-de-France into Italy and elsewhere in the second half of the thirteenth century.[32] The doorway to which it belongs forms part of the remodelling of the cathedral that took place in the second and third quarters of the century.

The whole transept was probably designed by Jean de Chelles, whose name appears on the south transept portal with the date of February 1257 (= 1258),[33] and although the north doorway is not dated by documentary evidence it has been convincingly demonstrated that it was executed first, probably in around 1245–50. The Virgin occupies the trumeau, but the figures which originally flanked her in three niches to each side are now missing [224]. Fortunately a pre-revolutionary account of the doorway refers to the three kings on the left and the three Theological Virtues – Faith, Hope and Charity – on the right, and three heads have come to light in recent years which almost certainly belonged to this ensemble.[34] The identity of the figures which filled the further three niches to each side of the door is unclear.[35] The subject matter of the three-register tympanum is connected with the Virgin, and while the scenes on the lowest tier follow traditional lines (the Nativity, Presentation in the Temple, Massacre of the Innocents and Flight into Egypt) the episodes in the second and third band are unusual for portal decoration: they show scenes from the legend of Theophilus [225]. The *Golden Legend* described his story as follows:

> There was in Sicily [*sic*] a man named Theophilus, who was the vicar of a certain bishop; and so prudently did he manage the affairs of the Church, that when the bishop died the whole populace proclaimed Theophilus worthy to succeed him. But he was content with his office, and desired rather that another be made bishop. But soon afterward, the new bishop dismissed Theophilus, who thereupon fell into such choler that, in order to recover

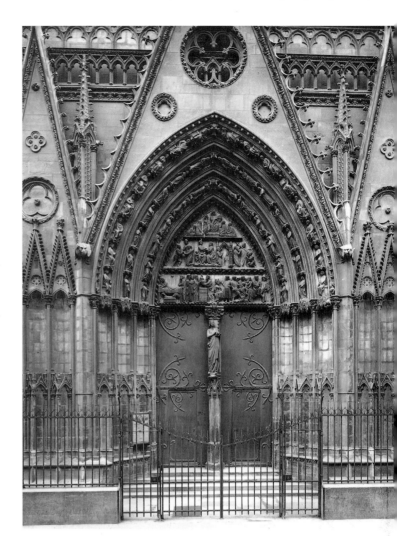

224. North transept portal, Notre-Dame, Paris; *c*.1245–50

225. Tympanum showing scenes from the Infancy of Christ and the legend of Theophilus; north transept portal, Notre-Dame, Paris; *c*.1245–50

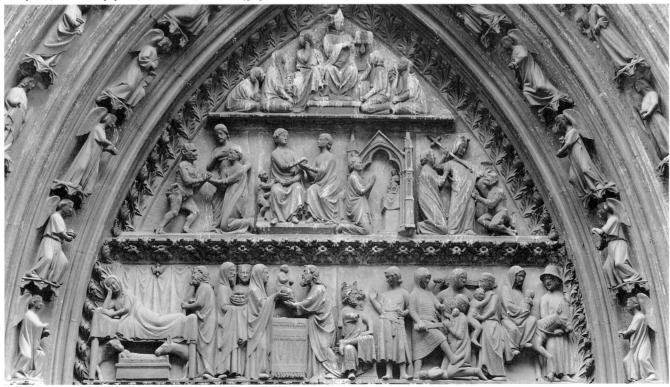

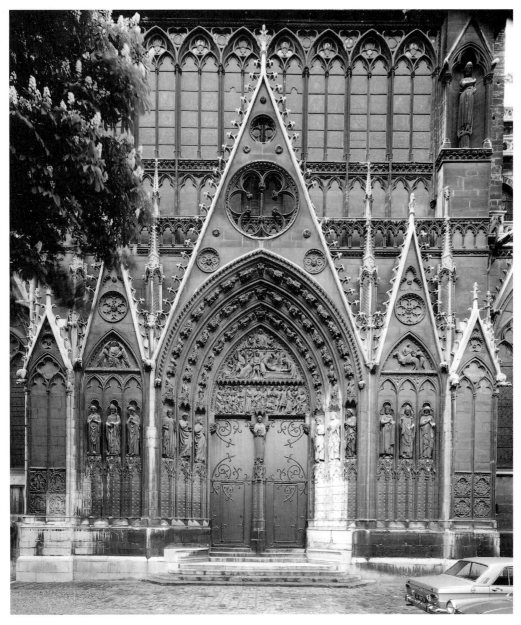

226. South transept portal, Notre-Dame, Paris; c.1258–65

227. Reliefs on buttress pier, south transept, Notre-Dame, Paris; c.1258–65

his dignities, he sought the assistance of a certain Jewish sorcerer. The Jew therefore summoned the Devil, who appeared with all speed. At the Devil's command, Theophilus renounced Christ and His mother, foreswore the Christian faith, and wrote down his abjuration in his own blood, sealing the paper with his ring, and giving it to the demon. Thus he gave himself over to the service of the Devil. On the morrow, by Satan's machinations, Theophilus was taken back into the bishop's favour, and restored to his honourable post. But at length, returning to himself, he bitterly lamented what he had done, and with all the devotion of his soul had recourse to the glorious Virgin, that she might come to his aid. Some time later, therefore, the Blessed Mary, appearing to him in a vision, rebuked him for his impiety, and commanded him to renounce the Devil, and to profess Christ the Son of God and the whole Christian faith. Thus she restored him to her favour and to the grace of her Son; and in token of his pardon she appeared to him again, and returned to

him the paper which he had given to the Devil, placing it upon his breast, that he might no longer fear the bondage of Satan, and might rejoice at his deliverance by the Virgin. Receiving this, Theophilus was filled with joy, and recounted all that had taken place, before the bishop and all the people. They too were moved to admiration, and gave praise to the glorious Virgin; and Theophilus, after three days, departed this life in peace.[36]

The legend is shown in all its essentials at Notre-Dame, emphasising the victory of the Virgin over the Devil and the humbling of Theophilus in the presence of the bishop at the apex of the tympanum; the bishop holds up Theophilus's contract with the Devil – inscribed *Carta Theophili* – while the penitent vicar crouches at his side. But why was this particular legend selected for the north transept portal? Although the story of Theophilus was by this time well known and is illustrated in a number of stained glass windows it is not found on any other thirteenth-century tympana, so one

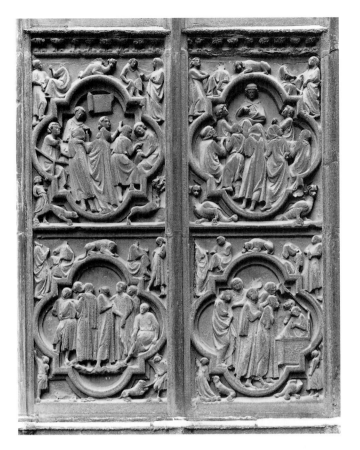

needs to look into the specific context of this doorway to explain the idiosyncratic choice. The north transept portal faced the canons' cloister at Notre-Dame, giving it the name *Porte du Cloître*, and as a result it was the principal entrance to the cathedral for the governing body. In addition to paying homage to the Virgin, the tympanum served to deliver a striking lesson on the perils of hypocrisy and the corrupting power of ambition and envy to the important churchmen passing beneath, who would have been well aware of the parallels which could be drawn between their own positions and that of Theophilus. That this legend had a particular resonance for the canons of Notre-Dame is underlined by the presence of a further relief of the early fourteenth century nearby on the exterior north side of the choir, which shows the central scenes of the pact with the Devil, Theophilus praying to the Virgin, and her recovery of the contract.[37] The cloister portal at Notre-Dame was therefore site-specific, like the south transept at Strasbourg, but in this case its iconography was aimed at an élite audience.

The design of Jean de Chelles also departed from what had gone before and was to prove very influential. The jamb figures, now completely free from columns, were placed in canopied niches rather than on consoles, an innovation widely followed in the second half of the century.[38] The idea of bringing the Virtues down into the jambs and transforming them into life-sized figures – thus further increasing the moralising aspect of the doorway – also appears to have been a novelty, and was to be expanded at the end of the century on the left portal of the west façade of Strasbourg Cathedral. Perhaps most important of all, the overall appearance of the portal, with its tall pointed gables standing free from

the mass of the transept behind, heralded the arrival of the Rayonnant 'applied' architectural feature – probably introduced for the first time on the façade of Saint-Nicaise at Reims – which was to become widespread in the following years.[39]

Kimpel has divided the sculpture of the north transept portal between two major sculptors who he has named the 'Master of the Virgin' and the 'Master of the Childhood scenes'. The latter's hand has been recognised not only in some of the figures of the lintel of the central portal of the west front but also in the small tympana in the flanking gables of the south transept, predicating a career of over thirty years in one workshop and a consequent consistency of artistic approach.[40] Although Jean de Chelles probably drew up the original design for the south transept façade it must have been seen to completion and in all likelihood modified by his successor, Pierre de Montreuil, as it is usually accepted that the relationship between the gabled portal and the building behind is more harmonious than on the north side [226]. There is likewise a continuity in the style of the sculptures, while at the same time new elements appear.[41]

The tympanum shows scenes from the life and martyrdom of St Stephen, the second patron of the cathedral after the Virgin, with the archivolt figures of angels, martyrs and confessors forming a celestial guard of honour. Small tympana showing St Martin dividing his cloak for the beggar (right) and the seated Christ being presented with the cloak by two angels (left) flank the central opening. Below, all the jamb figures and the trumeau figure of St Stephen are of the nineteenth century, but the fragmentary original torsos still survive and are preserved in the Musée national du Moyen Age. A single head of a bishop in the same museum undoubtedly comes from one of these figures, reflecting as it does on a large scale some of the heads on the archivolts of the same portal.[42] It seems that the six figures on the inside were apostles, those on the lateral walls local saints, including Dionysius, Rusticus, Eleutherius, Marcellus and Germanus. More difficult to interpret are the four small reliefs above the socles of both the flanking buttresses [227]. Like the Theophilus scenes on the opposite transept they should presumably be linked with their physical setting, which in this case faced a courtyard of the bishop's palace, but no convincing explanation of their imagery has so far been offered. In most of the reliefs, clusters of robed figures dispute with one another or listen attentively to a speaker, and it has been proposed that they show scenes from student life, as the university came under the jurisdiction of the bishop. It is perhaps more likely that they refer to the application of justice through the illustration of events of which we now have no knowledge, but which would have been of significance to visitors to the bishop's court.[43]

Probably immediately after the exterior sculptures on the south transept were made, in around 1270, the interior wall was furnished with a number of sculptures of varying size, including Christ of the Last Judgement and angels. To each side of the entrance, placed in canopied niches above the door, were larger figures of Adam and Eve. Only the former still survives, now displayed in the Musée national du Moyen Age, and this was considerably restored in the nineteenth

228. Tomb effigy of Robert the Pious (d.1031); abbey church of Saint-Denis; 1263–4

century.[44] These interior transept sculptures formed part of a larger programme of decoration in the area of the choir, the first part of which – the *jubé* separating the sanctuary from the nave – was also in course of construction in these years. This choirscreen, now destroyed, was surmounted by the Crucifixion and showed scenes from Christ's Passion in the manner of that at Bourges; later, in about 1300, the christological cycle was expanded still further when work began on the narrative reliefs for the *clôture* (the choir enclosure) to the north and south of the sanctuary.[45]

In architectural history the redevelopment of the nave and transepts of Saint-Denis after 1231 stands out as an epoch-making juncture.[46] As we have seen, an earlier portal was incorporated into the north transept façade, but on the south side a new doorway was constructed. Unfortunately this was grievously damaged in the eighteenth century, but enough remains to show the original form and suggest the high quality of the work, carried out by Parisian sculptors in the 1240s.[47] Like a number of other portals of this time in Paris it did not include any jamb figures and, although now missing, it is probable that the Last Judgement was contained in the tympanum, with the Infancy of Christ in the lintel: this is suggested by the presence of groups of the Blessed and Damned and the scenes of the Annunciation and

Visitation in the surviving archivolts to the left and right of the doorway.[48]

The thirteenth-century sculpture for which Saint-Denis is best known was carried out for the interior of the church. The royal abbey church had for a long time been the primary burial place of the kings of France, but in 1263–4 it was decided to celebrate this special rôle by having sixteen limestone *gisants* carved for the tombs of the Merovingian, Carolingian and Capetian kings already interred around the choir. Now surrounded at Saint-Denis by medieval effigies brought from other burial sites – most notably the Cistercian abbey of Royaumont – after the French Revolution, the sixteen tombs were originally laid out with the Merovingian and Carolingians to the south and the Capetians to the north of the crossing.[49] Given the importance of the building and the significance of the commission it is surprising that they do not appear to be of the same high quality as the Sainte-Chapelle apostles. Obviously carried out quickly and to a fixed pattern, the sculptures have been made even more difficult to appreciate by surface abrasion and numerous repairs, and once again it should be remembered that they would have been painted and perhaps further embellished with applied ornament. The head types of the kings and queens are of uniform appearance throughout the series, following the current idiom for royal personages found on contemporary portals, and the male figures are mostly bearded, with hair curling into neat balls on each side. As would be expected, the closest comparisons for the style of the best figures, such as that of Robert the Pious [228], is with the surviving sculptures of the south transept of Notre-Dame, which was at that time nearing completion: Pierre de Montreuil was architect at both sites.[50]

Special treatment was reserved for the funerary monument of Dagobert I (d.639), considered to be the founder of the abbey and well known for his generosity to it.[51] Erected in the choir, to the right of the high altar, it is appropriately far more elaborate than the other commemorative monuments. Comprehensively restored in the nineteenth century, it consisted of a free-standing large gabled niche with Dagobert's *gisant* lying across the base, flanked by the standing figures of his son Clovis and his wife Nanthilde.[52] On the wall of the niche behind Dagobert are scenes from the legend recounted by John the Hermit of the saving of Dagobert's soul by Saints Dionysius, Martin and Maurice, and in the gable above two of the bishop saints are shown kneeling to each side of the standing Christ. The impression of miniature architecture is reinforced by the presence of six censing angels in the archivolt of the niche and the spiky finials sprouting from the corners, and although a roughly similar type of arrangement had already been used on the tomb of Ogier the Dane in Saint-Faron in Meaux in the twelfth century, the narrative method and sculptural details – taken over from the Notre-Dame transepts – create an altogether more sophisticated ensemble. It is not clear whether Dagobert's cenotaph pre-dates the tombs of 1263–4, as has been proposed by some scholars, or forms part of the same programme, but in any case the difference would amount to no more than a decade.[53] Perhaps a more interesting problem than that of mere chronology is the question of the extent of St Louis's direct involvement in the

229. The Blessed; tympanum of the central portal, west façade, Bourges
Cathedral; c.1245–50

construction of this new mausoleum. Was the decision to underscore the royal abbey's traditional right to be the burial place of the kings of France taken by Louis himself, as is commonly supposed, or was it a politic response by the abbot Odo of Clément to the potential challenge of Royaumont, where Louis had buried his brother Philip and son Louis? If the latter, it was manifestly successful: the bones of Saint Louis himself were in due course buried at Saint-Denis.[54]

BOURGES CATHEDRAL

The ripples of the Parisian style were soon felt outside the Ile-de-France. The magnificent Gothic cathedral at Bourges, although started in around 1195, was still in course of construction by the middle of the thirteenth century. As we have seen, two twelfth-century portals which were presumably intended for an earlier west façade were incorporated into the nave walls, leaving the designer of the thirteenth-century frontispiece with a free hand.[55] The resulting five-portal layout allowed for the inclusion of two extra portals dedicated to local saints, William (north) and Ursinus (south), in addition to the normal choice of the Last Judgement, a Virgin portal (inner north) and another devoted to the patron saint, in this case St Stephen (inner south). When the north tower collapsed in 1506 the two portals on that side were destroyed and replaced shortly after. Sadly, the façade in its present state reflects the harsh treatment it has received since then: the jamb figures have either been destroyed or dispersed around the building, many piecemeal restorations

have been carried out, and regrettably the sculptures have been neglected in recent times.

The two portals on the south side, executed in a homogeneous style probably in the early 1240s, reflect the working methods if not the quality of the Amiens and earlier Parisian sculptors employed on the Judgement portal at Notre-Dame. It seems likely that they were sculpted a few years before the erection of the actual façade, as certain modifications have been made to enable them to be installed, and they are quite clearly in a different style from the great central tympanum of the Last Judgement, which must have been executed by another workshop.[56] This last, justly famous for its dramatic middle register of the division of the Blessed from the Damned [229], reveals the contribution of sculptors conversant with the north transept at Reims. Not only are distinctive elements of the iconographic scheme based on the Last Judgement portal there, but the smiling faces of the Blessed are unthinkable without knowledge of the naturalistic head studies higher up on the towers. They may be seen as the French counterpart of the Blessed on the *Fürstenportal* at Bamberg or the Wise and Foolish Virgins of the Paradise porch at Magdeburg, where the exaggerated glee of the figures verges on smugness, and there is no reason to suppose that they are much later than the lateral western portals.[57]

While the portals were being executed for the west façade at Bourges, yet another workshop was engaged on the making of a splendid *jubé* inside the cathedral. Although this was pulled down in the eighteenth century, many of the reliefs of which it was made up have survived, albeit in a battered state.[58] The choirscreen consisted of a series of

230. The Crucifixion; relief from the *jubé* of Bourges Cathedral; *c*.1240–50 (Musée du Berry, Bourges)

financial difficulties and the strained relations between the chapter and town – this contract was called up only on 8 April 1252, so that even if a start on the foundations of the new façade had been made immediately afterwards one would hardly expect the production of sculpture before about 1255.[60] This re-dating of the bulk of the west front sculpture to the third quarter of the thirteenth century inevitably forces a re-appraisal of the place of the later Reims workshops in relationship to developments elsewhere, especially Paris.[61]

The form of the doorways, and the west front generally, owes a clear debt to Amiens, although the arrangement at Reims introduces many new features, some of which indicate the influence of the Notre-Dame transepts. Most striking of these is the abandoning of sculpted tympana for glazed tracery, so that the Crucifixion, Coronation of the Virgin and Christ in Majesty appear instead in the gables above the doorways [232]. Likewise, the narrative content of the façade is boosted by the introduction of figured tympana on the buttress piers to the north and south. Contrasting with the unity of the Amiens façade, fifteen of the embrasure figures at Reims were made before the beginning of work on the west front, creating a patchwork of different styles scattered between the other twenty figures executed after 1252.

No more than a summary of the decorative scheme can be attempted here.[62] The central portal is dedicated to the

reliefs dedicated to the Passion of Christ and the Harrowing of Hell which, starting on the short north side, continued across the west face of the screen – with the Crucifixion at the centre [230] – and finished on the south. Below this single register the spandrels between the pointed arches of the open arcade were occupied by standing figures of the apostles. One can now only gain a limited impression of the original appearance of the choirscreen. It was more than usually elaborate, and in addition to the painted figures the backgrounds throughout were encrusted with medallions and small squares of coloured glass (some of which remain) so that it must once have sparkled with reflected light like an enamelled altarpiece. Its stylistic proximity – both in the figural work and foliate carving – to Parisian sculpture of the 1240s such as at the Sainte-Chapelle and Saint-Denis indicates that it too was complete by the middle of the century.[59]

THE WEST FAÇADE OF REIMS CATHEDRAL

Following the publication by Ravaux of two hitherto-overlooked documents the chronological sequence of sculpture at Reims has been very much clarified. It was revealed that in June 1230 a lease was drawn up between the cathedral chapter and the Hôtel-Dieu concerning two or possibly three houses situated in front of the façade existing at that time, giving the former the right to demolish them when the cathedral was extended to the west. For reasons which remain obscure – but which probably had to do with

231. Joseph; left jamb, central portal, west façade, Reims Cathedral; *c*.1255–65

232. West façade, Reims Cathedral; *c*.1255–75 (some figures earlier) (photograph taken before 1914)

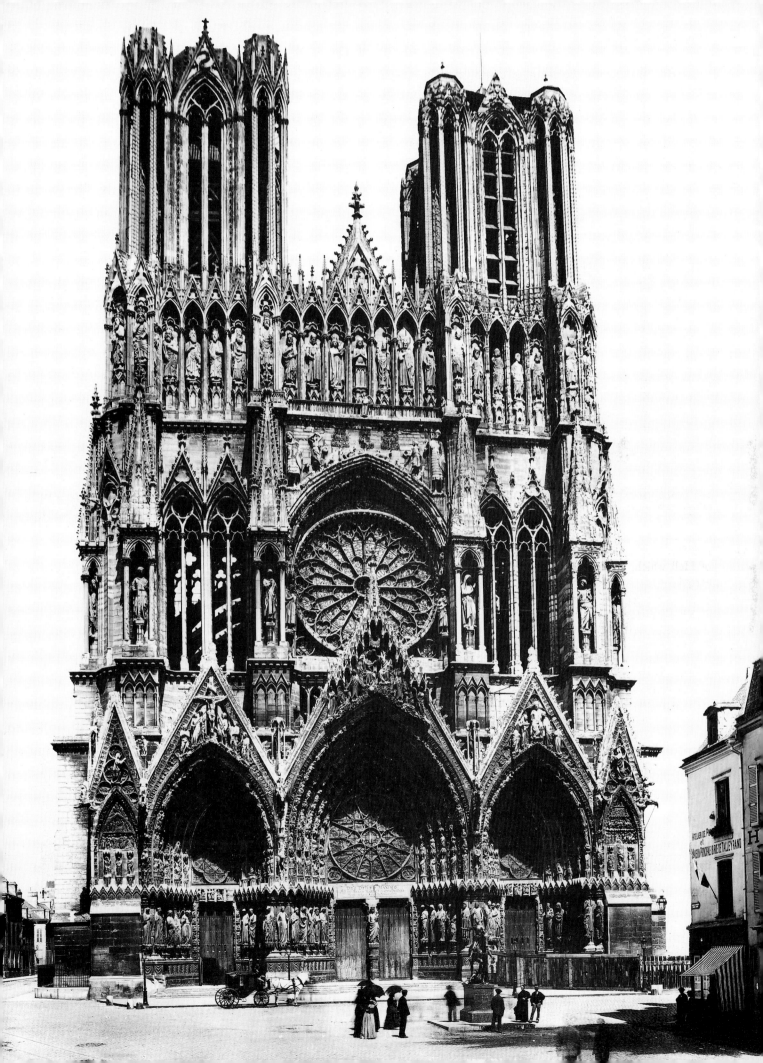

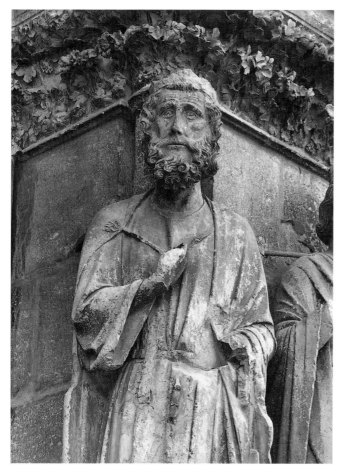

233. Prophet (David?); buttress between central and south portals, west façade, Reims Cathedral; c.1255–65

234. Queen of Sheba; buttress between central and north portals, Reims Cathedral; c.1255–65 (photograph taken before 1914)

Virgin, with her Coronation in the gable above and the Virgin and Child on the trumeau.[63] The jamb figures, arranged in groups in the manner of Amiens, show the Annunciation and Visitation [95] on the right and the Presentation in the Temple, with the flanking figures of Joseph [231] and Mary's maidservant on the left; presumably the lintel, which was shaved off at the end of the eighteenth century, once showed other scenes from the Life of the Virgin. In the archivolts are the Tree of Jesse and angels. The groups of jamb figures are complemented by a prophet on each side [233], and standing next to them, in the middle of the buttress piers, are the Queen of Sheba to the north [234] and Solomon to the south. The left doorway, with the Crucifixion in the gable, has christological scenes in the archivolts, the conversion of Saul on the lintel, and saints on the jambs: these include a figure that is probably St Dionysius flanked by angels, St John the Evangelist and a crowned female figure who may be identified as St Helena, Constantine's mother. This last is made more plausible by the fact that the field immediately to the north on the outer buttress pier is carved with scenes from the legend of the Finding of the Cross; on its north face it shows the Preaching of St Paul.[64] The north doorway was particularly badly damaged by fire in 1914, when the Queen of Sheba, the angel to the right of St Dionysius, St Helena, and other figures were all hideously disfigured.[65] Finally, on the south portal, Christ of the Last Judgement is seated on the gable

accompanied by Apocalyptic scenes in the voussoirs; in the lintel is the Baptism of St Paul, while on the jambs are the Chartrain prophets on the right side and other male figures, including Pope Calixtus on the left.[66] The relief on the outer buttress adjacent to this door shows scenes from the Apocalypse, that on the south face being dedicated to episodes from the Life of St John the Evangelist. Completing this extraordinarily rich façade are hundreds of smaller sculptures clustered around the doorways and countless beautiful leaf carvings in the capital frieze above the jamb figures' heads; and above, in the buttress aedicules, massive figures tell the story of Christ's resurrection.

With the exception of the earlier insertions all the sculptures up to the level of the rose window were executed in about twenty years, between 1255 and 1274.[67] In comparison with the layout of the contemporary Notre-Dame transept portals they are therefore old-fashioned, retaining the traditional jamb figure with column behind instead of having almost free-standing figures in canopied niches; this was, of course, the price to pay for incorporating the older figures. It has been shown that there is a consistency between the smaller sculptures actually attached to the building (on the archivolts, the doorposts, lintels, etc) and the post-1255 jamb figures, and many exhibit the precious style seen on the upper part of the Honoratus portal at Amiens and in Parisian sculpture after the Sainte-Chapelle apostles. This is illustrated in the heads of the prophet (David?) and Joseph

235. Magister Fromundus: tomb effigy of Blanche of Navarre; completed 1252 (Musée municipal, Châlons-sur-Marne)

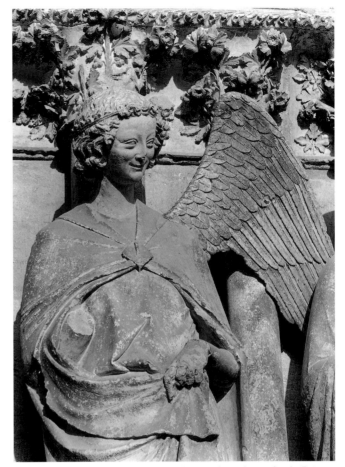

236. Angel of the Annunciation; right jamb, central portal, west façade, Reims Cathedral; c.1255–65

[232, 233], both of whom have the narrow face, curly beard and thin-lipped mouth of the King Childebert of Saint-Germain-des-Prés and the large folds of drapery current in mid-century Paris. Even more striking are the close similarities between the reliefs of the buttress piers at Reims and the tympanum of the south transept portal at Notre-Dame, proving the direct intervention of Parisian workshops after the resumption of works and pointing to a *terminus post quem* of c.1260 for these particular sculptures at least.[68]

But alongside these sculptors from the capital, other workmen with different backgrounds were also providing figures for the façade. The Queen of Sheba [234] belongs to an older Reims tradition, emanating ultimately from the female figures on the Chartres north porch.[69] That this graceful style of rendering drapery, in long curving folds falling over the feet, retained an attraction past the middle of the century in Champagne is proved not only by this figure at Reims but also by a less well-known sculpture not far to the south. By good fortune records of payment exist for the effigy of Blanche of Navarre [235], which was completed and installed in the Cistercian nunnery of Argensolles (near Epernay) by a certain Magister Fromundus in 1252. Nothing more of his work is documented, and although it would be presumptuous to postulate his involvement in the cathedral's workshops in the years just after the making of the effigy, the close similarities are undeniable.[70] There is still very little known about the composition of the great cathedral yards

and how the individual 'masters' were brought together, but in this instance it is of interest to note that Fromundus appears to have been employed for two years to execute the tomb at Argensolles. By extension, the twenty life-size figures made for Reims after 1255, possibly employing four master sculptors, could have been completed by 1265 if they were contracted out separately. This must remain as speculation, as we know nothing of the involvement of apprentices and the more junior masons who would have prepared the freestone blocks for carving, nor how the work was allocated.[71] Notwithstanding our ignorance of the interaction between different teams of workmen present at a major site such as Reims, it is clear that the cathedral must have acted as a magnet for peripatetic masons and sculptors in addition to providing long-term employment to local workers. The contributions of Paris and Amiens workshops attest to the former, while such figures as the famous 'smiling angels' [236] speak of a process of local stylistic evolution developing out of the innovations in facial expression pioneered at Reims in the early 1230s.[72] The Last Judgement tympanum at Bourges is part of this same strand.

At the same time as the immense sculptural programme was being created for the exterior of the façade it was decided to invent an equally ambitious scheme for the interior west wall. In many ways this sculptural decoration is more remarkable than that on the outside as it appears to be unique in scope and placement and has been protected from

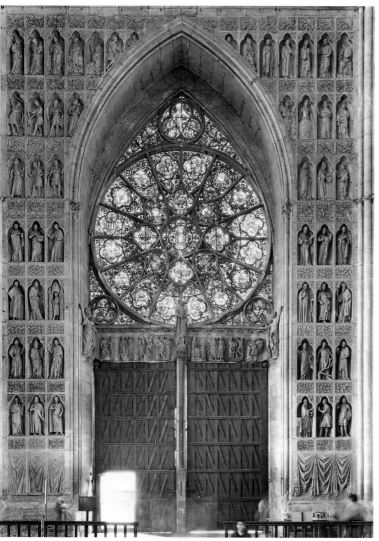

237. Interior west wall, central portal, Reims Cathedral; c.1260–70

the elements.[73] Less constrained by the broken wall surfaces of the exterior, the architect has arranged standing figures in rows of individual niches to each side of the doorways and glazed tympana, each tier separated from the next by panels of exquisite naturalistic leaf ornament [237].[74] Broadly speaking, the iconographic scheme relates to that on the other side of the wall. The central portal thus shows scenes from the Life of the Virgin on the left and from that of John the Baptist on the right: his beheading and the burning of his bones are on the lintel. The beheaded St Nicasius is placed on the trumeau, flanked on the side walls of the portal by his executioners and two angels. Pairs of prophets occupy the niches to each side of the side portals (sixteen to each doorway), the Life and martyrdom of St Stephen are recounted on the lintels, and the niches around the arches contain apocalyptic figures (to the south), typological scenes relating to the Passion of Christ and scenes from the New Testament.[75]

The style throughout is again that of Paris. Although there are minor differences between some of the upper panels – which are carved in shallower relief – and those of the lower four registers it is clear that the whole project must have

been completed in a concerted attack on the work, probably between 1260 and 1270. Most of the fifty-six figures standing below the level of the springing of the arches of the nave arcade are sculptures of the utmost elegance, turning towards one another to converse across the enclosing space of their niches with frozen gestures [238]. They were carved as separate panels in most cases, on the ground, and mortared together with the help of installation marks: complete, *en masse*, ranged around the glazed tympana of the entrances, the grid-like mass of rectangular compartments puts one in mind of wall-paintings or stained glass panels rather than sculptures. As far as is known this type of rich sculptural interior decoration was never tried again in France, although a modified version is to be seen at York Minster in the early fourteenth century. Perhaps there was a particular reason for its presence at Reims, possibly connected with the pageant of royal processions leaving the church after coronation ceremonies. Or it might have been realised that the interior west wall of a northern cathedral was not an ideal place for sculpture: then as now it would have spent much of the day shrouded in gloom. The prohibitive cost of such an undertaking – which had of course earlier provoked rebellion in Reims itself – would also have weighed against its imitation elsewhere, and by 1270 the great cathedral workshops were being wound up. The grandest of the cathedrals in the French Royal Domain were now in most cases nearly complete, so that after the middle of the thirteenth century the most lucrative employment prospects were offered primarily by cathedrals to the south, belatedly embracing the mature Gothic style, and by the ubiquitous sculpted tomb or funerary monument.

BURGUNDY

From the 1240s onwards the type of portal decoration which had first been seen at the entrances to the most important cathedrals had been adapted for use on smaller buildings in the Ile-de-France and elsewhere in the north, such as at Villeneuve-l'Archevêque, Rampillon and Thérouanne.[76] The most common arrangements – with the Last Judgement or the Coronation of the Virgin in the tympanum and jamb figures below – were of course popular elsewhere when Gothic portals were constructed further afield, as at Notre-Dame-de-la-Couture at Le Mans, Saint-Thibault-en-Auxois, Moutiers-Saint-Jean and in the south (see below), but in Burgundy iconographic and compositional variations are sometimes to be found.[77] Thus the tympanum of the north transept portal of the priory church at Semur-en-Auxois, of about 1250, is dedicated to the legend of the apostle Thomas while the single archivolt is decorated with scenes from the Calendar, and the contemporary west façade of La Madeleine at Vézelay has single figures disposed around the lancet windows above the twelfth-century portal.[78] Likewise, the major monument of the second half of the thirteenth century in the region, the triple west portal of Auxerre Cathedral, includes scenes in the lower parts of its doorways which do not appear elsewhere.

The building of the Gothic cathedral of Saint-Etienne at Auxerre, started in about 1215, seems to have progressed slowly after the completion of the choir about ten years later.

238. Detail of pl. 237

Unfortunately there are no surviving documents relating to the fabric to help with the dating of the western doorways, so that all studies up to now have had to rely on style-critical judgements or informed guesses about the likely patrons in order to separate the different phases of the work. There is, however, general agreement that the earliest part is the south portal and the lower sections of the central doorway; the north portal is probably to be dated to the final years of the century, while the Last Judgement tympanum and voussoirs of the central doorway were only added (possibly replacing a thirteenth-century ensemble?) in the early fifteenth century. In addition to this halting advance – presumably due to lack of money – it is clear that in the end the work remained unfinished, as indicated by the blank tympanum on the north portal and other unfilled spaces in the same area.[79]

The south portal is concerned with the Life of John the Baptist and the Infancy of Christ in the tympanum and archivolts – an updated and expanded version of the earlier Baptist's portal at Sens, to which Auxerre was suffragan [239]. The six jamb figures are now missing, but below on the socles are extremely fine reliefs illustrating the story of David and Bathsheba in six arcaded panels, with personifications of the seven Liberal Arts and Philosophy in the

spandrels between the gables. On the wall to the right is a large-scale group of the Judgement of Solomon, and at socle level a low-relief panel with episodes from the youth of King David. Because of the additionally highly unusual choice of scenes in the socle zone of the central portal, including the story of Joseph and the parable of the Prodigal Son, a number of ingenious suggestions have been put forward as to the likely patron of the earliest sculptural programme, all explaining the iconography as driven by motives personal to a specific donor. These include Bishop Guy de Mello in around 1260, Count Jean de Châlon (c.1270) and even Bishop Pierre de Morney (1295–1306): for various reasons the first is the most plausible, although a reading of the decorative scheme as a commentary on his political affiliations and life story is *prima facie* unconvincing.[80] What is undeniable, however, is the extremely rich and classicising character of the socle reliefs, calling to mind a remarkable stone fragment in Chartres of half a century earlier.[81] Both clearly derive their hard, jewel-like appearance from prototypes in precious metal, in the case of Auxerre probably from the antique and medieval silver which is known to have been kept in the cathedral treasury. The decorative repertoire of the borders, the flowing draperies of the graceful figures,

239. South portal, west façade, Auxerre Cathedral; probably c.1260

240. Socle of left jamb, central portal, west façade, Auxerre Cathedral; probably c.1260–70

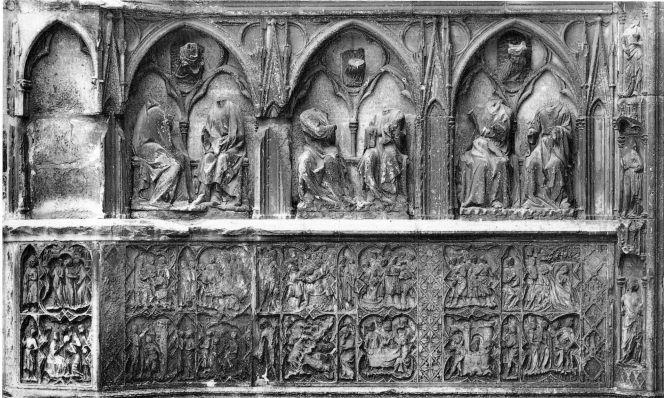

and the actual insertion of classical types (Hercules, a satyr and a sleeping fawn) into the narrative sequence indicate that the treasury was being utilised as a library of forms [240].[82]

Two artistic currents are present in the earliest of the Auxerre sculptures. The elegant figures of the Liberal Arts, those in the reliefs illustrating the story of David and Bathsheba, and the three seated prophets and a sibyl to the right of the central portal [241] are surprisingly late examples of the Chartres-Reims north transept style, and were presumably executed by a workshop trained in that now rather old-fashioned manner.[83] The heavy, deep folds of the seated figures – more typical of 1220–30 – contrast strikingly with the newer large, flat draperies of the six prophets on the left side of the same doorway, which should be attributed to sculptors familiar with Parisian work. If it were not for the architectural framework in which the figures are enclosed one could be forgiven for thinking they were twenty years earlier than the date in the 1260s now usually assigned to them.

At about the same time as the west façade at Auxerre was in course of construction, the south portal of Sens Cathedral had to be rebuilt following the fall of the tower above it in 1268. It is likely that the present doorway, presumably executed immediately after the disaster, replicated the subject of the late twelfth-century tympanum – the Coronation of the Virgin – although the form in which it is shown now follows works in the orbit of Paris, such as the west portal of Notre-Dame at Longpont.[84] The opportunity was also taken to remodel the tympanum of the central portal, which had probably previously shown the Last Judgement (pp. 32–3).

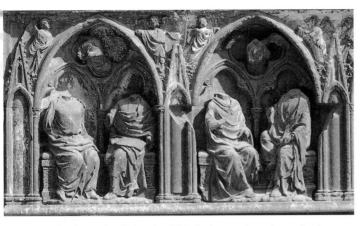

241. Prophets and a sibyl; socle of right jamb, central portal, west façade, Auxerre Cathedral; probably c.1260–70

242. Tympanum of west portal, Saint-Urbain, Troyes; probably c.1280–90 (plaster cast)

In honour of the cathedral's patron saint, St Stephen, it shows his preaching, martyrdom and the carrying of his soul to heaven, with Christ in Majesty at the apex [48]. The dedication of a central portal to a locally-venerated saint is unusual in itself, but here at Sens in about 1270 the design of the tympanum is also radically different from the standard layout, showing the scenes set within blind tracery in the manner of stained glass. The only known French precedent – the west portal of Saint-Nicaise at Reims designed by Hugues Libergier – is now destroyed, but its form is known through a seventeenth-century engraving.[85] Attractive as it is, this way of dividing the narrative on the tympanum was not imitated widely, although it was utilised nearby on the Last Judgement west portal of Saint-Urbain at Troyes [242], and even found its way to England.[86]

POITIERS, THE SOUTH WEST AND CARCASSONNE

Both the cathedral of Saint-Pierre at Poitiers and the abbey church of Saint-Sauveur at Charroux (about forty km to the south) had triple portals attached to their western façades in the years immediately after the middle of the thirteenth century. In the by-now customary manner further north the

doorways at Poitiers were devoted to the Coronation and Death of the Virgin (north), the Last Judgement (central) and a saint, in this case St Thomas (south). The effect of the portal is lessened by the complete loss of the standing figures which originally spread across the entire width of the façade between the two western towers, in emulation of Amiens; it should be noted however that at Poitiers the figures must have been free-standing under the canopied niches, rather than column figures, thus showing a knowledge on the part of the architect of the latest Parisian developments. Stylistic parallels have also been drawn between the sculpture at Poitiers and that at Amiens and Paris of the second quarter of the century, but it is not possible to state with any degree of confidence that northern sculptors were actually involved in the making of the Poitevin portal. The forms have become coarsened, the compositions crowded and chaotic, so that it is difficult to escape the conclusion that what we have here is a weak copy of an already outmoded prototype, executed by sculptors of mixed ability.[87]

The Charroux portal was simply added to the west end of the existing Romanesque abbey church. It was demolished in the early nineteenth century, but a lithograph of 1823 shows its form in some detail, revealing deep porches and elaborate canopied niches between the doorways.[88] Only the central portal appears to have had any figurative content, comprising the Last Judgement in the tympanum and in-

243. Bishop; voussoir from central portal, west façade, Saint-Sauveur, Charroux; c.1250–60 (Chapter House, Saint-Sauveur, Charroux)

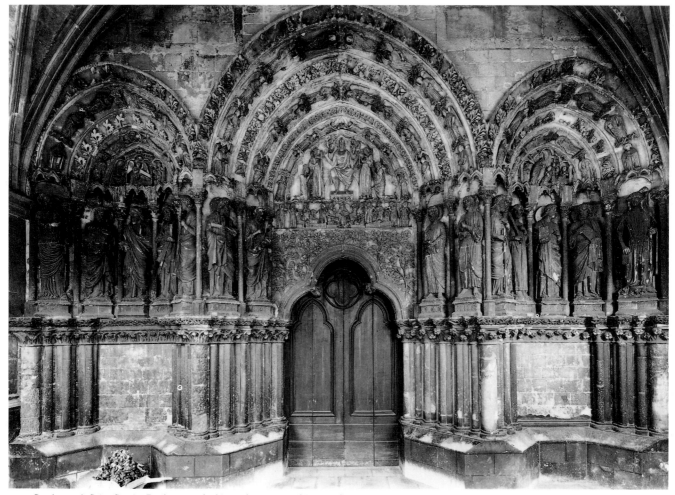

244. South portal, Saint-Seurin, Bordeaux; early thirteenth-century and c.1250–60

habited archivolts containing kings, prophets, apostles, bishops, abbots, and the Wise and Foolish Virgins, above empty niches within which once stood life-size figures; the upper parts of the lateral doorways seem to have been decorated with foliate ornament in the voussoirs. Over fifty reliefs, including the Christ in Majesty from the tympanum and a more than representative sample of the archivolt figures, have survived and are still preserved at Charroux.[89] Paradoxically these are in better condition than the Poitiers doorways, which have suffered from weathering, and they reveal even more clearly than the latter a kinship with the archivolt figures at Amiens in the broad folds of their drapery and in their animated round faces [243]. There can be no doubt that both are products of the same workshop, active probably in around 1250–60, but there is little sign of other comparable work in the area and one cannot therefore speak in this context of a regional style.

Farther south, in Bordeaux, there are clearer indications of a distinctive local contribution. The south portal of the collegiate church of Saint-Seurin follows the format of late Romanesque doorways in Aquitaine, with a central opening and blind niches at the sides, but has expanded to include jamb figures of the twelve apostles, the Church and Synagogue, sculpted archivolts and a Gothic iconographic scheme in the tympana [244]. There are signs that the portal was subject to a change in layout during the course of its con-

struction and the small lateral tympana are in a noticeably earlier style – more to do with the early thirteenth century – than the rest of the work, which was probably completed in around 1260. But even among the jamb figures there are differences. While most of the apostles have the large fold draperies of the middle of the century the figures of Paul, John and *Ecclesia* are encased in deep folds reminiscent of Chartres and the 1220s, and are possibly the work of a local sculptor who had earlier executed the Virgin and Child now in the parish church at Créon: this was probably originally made for the abbey of La Sauve-Majeure.[90] The so-called *Portail Royal* on the north side of the cathedral at Bordeaux, also constructed just after the middle of the century, has none of the internal inconsistencies of the Saint-Seurin portal and is a more accomplished and refined composition, possibly reflecting the influence of the Bourges central portal and *jubé* in its stylistic and decorative vocabulary [245].[91] Especially striking is the sumptuous appearance of the socle zone, carved to give the impression of embossed goldsmiths' work, and the ornamental patterning on the jambs which, like that on the Bourges *jubé* reliefs, was probably originally filled with inlaid glass.[92] Derivations from these two Bordeaux doorways appeared locally in the years immediately following, most notably on the north portal of the collegiate church and the portal of the subterranean church at Saint-Emilion.[93]

Elsewhere in the South-West minor variations were being introduced to the imported form of the Gothic portal, as for instance at Bazas, where the triple portal of the cathedral was probably executed in the third quarter of the thirteenth century.[94] With the Last Judgement in the tympanum of the central portal, the Coronation of the Virgin to the right and a saint's portal – dedicated here to St Peter – to the left, it follows the conventional form transmitted to the south by way of Bourges and Poitiers cathedrals, but the height of the doorways has been increased to such an extent that the tympana float far above the heads of any spectator. The double tiered arcade, seen for the first time on the socle and jamb zones of the Coronation portal at Notre-Dame in Paris, exaggerated at Bourges and Poitiers, is here stretched to such an extent that the jamb figures – when extant – would no longer have been within reach of the congregation entering the church. This may have had the effect, ultimately unsuccessful, of protecting the statues when *in situ*, but the scale of the portals now appears at odds with the height of the façade. This curious elongation is accentuated still further on the more modest west portal of the small church of Saint-Sauveur at Saint-Macaire, a few miles to the north of Bazas.[95]

Two other portals in the deep south-west of Aquitaine are worthy of mention. The first, now restored and reconstructed inside the north transept of Dax Cathedral, originally belonged on the west façade of the church. Once again the tympanum and lowest tier of voussoirs are dedicated to the Last Judgement, the twelve apostles are shown on the jambs

246. West bay of cloister portal, Bayonne Cathedral; probably *c*.1260

245. The *Portail Royal*, Bordeaux Cathedral; *c*.1255–60

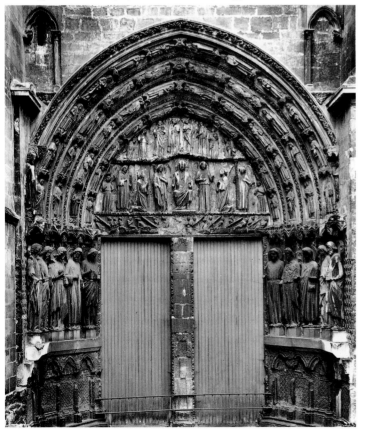

and a standing figure of Christ occupies the trumeau.[96] Although almost certainly made in the third quarter of the thirteenth century the disposition of the jamb figures and their attachment to columns hark back – as does the contemporary Reims west façade – to a composition already at least thirty years old: in this case primarily to that most influential model, the Last Judgement portal at Notre-Dame in Paris. A more idiosyncratic arrangement, forced on the designer by its unusual setting, is to be found on the double portal leading from the cloister into the south transept of Bayonne Cathedral. Because the two doorways have had to be incorporated into adjoining bays of the vaulted cloister, separated by a pierced load-bearing wall, both tympana are asymmetrically placed. In each case the voussoirs on one side have been curtailed by this wall, the sculptural decoration being continued onto the adjoining masonry, and by way of compensation a further three kneeling angels holding candles have been inserted into the wedge between the outer voussoirs and the beginning of the vault [246]. The choice of subject for the two tympana is common enough – the Virgin and Child flanked by angels and Christ in Majesty with angels and the four evangelist symbols – and six of the apostles are positioned around the doorways.[97] While there are no firm dates connected with the construction of the portal it too would seem most appropriately placed in around 1260. Of all the Gothic monuments of the South-West it is the closest to contemporary Spanish sculpture. This is hardly surprising given its geographical proximity to Spain and it is

247. General view of the choir, Carcassonne Cathedral; the sculpture probably c.1280–90

248. South transept portal, Bayeux Cathedral; probably c.1270–80

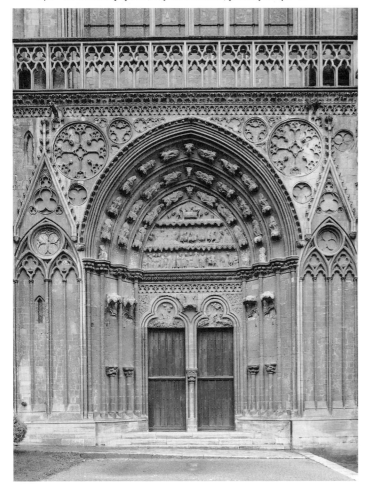

possible that the workshop responsible for the Bayonne portal went on to play a minor part in the development of Spanish sculpture; we should beware, however, of assuming a 'French' primacy at this date, and more properly view both the Bayonne and northern Spanish sculptures as parts of a common Southern response to the High Gothic. In the absence of evidence one way or the other it is not now possible to postulate a direct relationship, but the rounded face and heavy drapery of the seated Virgin and the foliate border running around the edge of the tympanum also appear in sculpture at both Burgos and León.[98]

Towards the end of the century the major sculptural programme in the South was the decoration of the choir of Carcassonne Cathedral (Saint-Nazaire). Because it was decided to retain the Romanesque nave when the rebuilding of the choir and transepts started after 1269 there was not the usual opportunity to incorporate figure sculpture into a western portal; instead the architect devised an ingenious way of including three-dimensional decoration in the cathedral's interior layout. Twenty-two life-sized standing figures are placed on the eastern crossing piers and around the choir in distinct groups, about six metres above ground level. The apostles are arranged around the choir, an Annunciation group and St Helena are displayed on the piers at the entrance, and the crossing piers show Christ, the Virgin and local saints [247]. This type of arrangement calls to mind the placement of the apostles on the walls of the Sainte-Chapelle, and although standing figures had also been positioned in this way – albeit just below the springing of the vaults – inside the choirs of late twelfth-century Angevin churches, other architectural features of the Carcassonne choir and transepts point unequivocally in the direction of Rayonnant Paris.[99] Extraordinarily, the Carcassonne figures were carved out of the same stone blocks as the columns themselves, so they must have been completed during the first phase of work some time before 1300. Although there has been some recarving and restoration and there were at least three different sculptors at work, most of the apostles have the long beards and spiral curls of the latest Reims figures on the west front and interior wall, and the angels and certain of the local saints show the sweet and smiling *Rémois* countenances which by this time were spreading throughout Europe.[100]

NORMANDY

To the west of Paris the imposing sculpted doorways at Bayeux and Rouen were the largest projects of the second half of the century. The Romanesque cathedral of Bayeux was seriously damaged by a fire in 1160 but it was not until about 1230 that work started on the new Gothic choir; the nave was renewed between 1245 and 1255, and the transepts were completed last, in about 1280. In the final phase of work new portals were added to the west façade and south transept which unfortunately have suffered from general neglect over the centuries: the cathedral was nearly demolished in the nineteenth century, and even after its reprieve the sculptures were subjected to a particularly rough cleaning which further damaged their surfaces. Of the three west doorways only the lateral entrances retain their sculptural

decoration in the tympanum and archivolts. These are devoted to scenes from the Passion of Christ (left) and the Last Judgement (right), so it is likely that the central portal, which was remodelled at the end of the eighteenth century, originally showed the Glorification of the Virgin and other Marian scenes, especially as the cathedral is dedicated to Our Lady.[101] Like the nearly contemporary doorways at Poitiers, and even taking into account the sorry condition of the sculptures, they would appear to offer clear evidence of how the creation of an ambitious decorative programme was sometimes beyond the means of a workshop of limited talent. This is particularly noticeable in the unsatisfactory arrangement – and the consequent loss of dramatic force – of the scenes of the Resurrection and the Separation of the Blessed and Damned in the Last Judgement tympanum, where the small seated figure of Christ is almost reduced to insignificance. On the south transept portal, the tympanum of which is given over to scenes from the Life of St Thomas Becket, the narrative flow is better organised [248]. As on the western doorways, the designer of the portal has dispensed with the usual series of jamb figures and instead placed four statues on slim columns with canopies above, in a manner closer to the English approach to portal decoration.

The two transept portals of Rouen Cathedral are of far greater importance. In 1280 Archbishop Guillaume de Flavacourt was persuaded by his canons to construct a grand entrance for their use on the north side of the transept, which involved demolishing the Chapel of the Virgin then abutting the transept wall. At the same time it must have been decided similarly to enlarge the south transept doorway and it is likely that both portals were complete by 1306, when the archbishop died and was buried at the entrance to his newly-constructed Lady Chapel. The north transept portal, known as the *Portail des Libraires* since the fifteenth century because booksellers' stalls occupied the courtyard outside, was probably built first and finished by 1290, being followed immediately by the *Portail de la Calende* (named after the ecclesiastical assembly held periodically in a house next to the portal) to the south in the final decade of the century.[102] The architect entrusted with the task of designing the transept façades, Jean Davy, was faced with the problem of a narrow frontage on the north side which he overcame brilliantly by extending the decorative programme on to the flanking walls of the courtyard buildings [249]. At the heart of the scheme is of course the portal itself, which gives the appearance of never having been finished. The tympanum

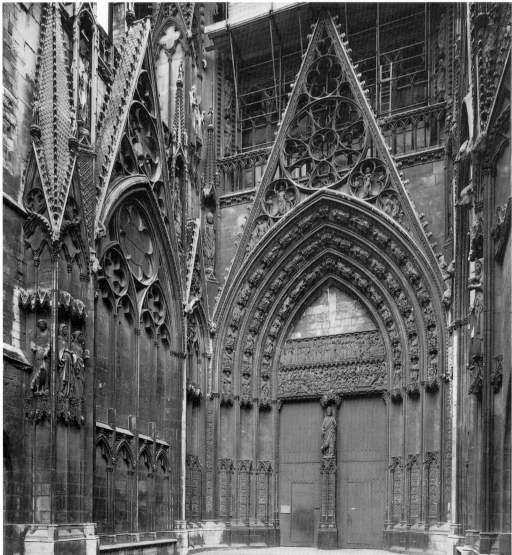

249. The *Portail des Libraires*, north transept, Rouen Cathedral; *c.*1280–90

250. Grotesque quatrefoils; *Portail des Libraires*, Rouen Cathedral; *c*.1280–90

shows in its two completed registers a seething mass of resurrected souls with dense crowds of the Blessed and Damned above, all presumably intended to be crowned at the apex by Christ in Judgement flanked by the interceding figures of the Virgin and St John. No satisfactory explanation for its odd incomplete state has yet been put forward, and, given the amount of work which was carried on into the following century, it does not appear that money was in short supply: in any case, if sacrifices had to be made one might think that less important sculptures would have been the first to go.[103] Complementing the theme of the Last Judgement, angels, apostles and martyrs occupy the three orders of voussoirs, the Wise and Foolish Virgins flank the window above the portal and amongst the fine tracery of the gable are sculptures of the Trinity, a standing Christ in Majesty and angels leading the Blessed towards the Saviour. Life-size standing figures, including bishops, the Three Magi, female saints and King Solomon, are grouped around the doorway on the side walls. Ten figures – possibly prophets (?) – would originally have filled the niches to each side of the door, and a statue of the Virgin and Child was placed on the trumeau.[104]

The most celebrated feature of this portal is the series of 154 quatrefoil reliefs on the faces of the square piers below the niches and on the thin strips dividing the side walls from the doorway proper. Scenes from Genesis top an extraordinary array of grotesques [250] – pointing perhaps to the establishment of order over chaos through divine intervention and punishment – and the Judgement of Solomon appears again, with four of the Liberal Arts, on the socle of the trumeau. As at Strasbourg and León, the court in front of the portal was probably a place of legal judgement, an interpretation strengthened by the presence nearby of the bishop's prison.[105] The idea of decorating the socle area in this way was not new of course: the narrative quatrefoils on the west façade of Amiens Cathedral are about fifty years earlier, although the density and coverage of the sculpture – amounting almost to a *horror vacui* – is closer to the reliefs

on the same parts of the central and south doors at Auxerre.

The system of filling the plinth pedestals with quatrefoil reliefs was also employed on the south transept portal. This time scenes from the Old Testament stories of Jacob, Joseph, Job and Judith were illustrated, interspersed with the New Testament parable of the rich man and with scenes from the lives of the great archbishops of Rouen, Saints Romanus and Audoenus. Even more ambitious than the *Portail des Libraires*, with an increased verticality and a more open prospect, the *Portail de la Calende* stands as the masterpiece of Norman Rayonnant architecture [251]. The derivation of the whole transept façade from the south transept of Notre-Dame is obvious, but Jean Davy has here lightened the buttress piers by adding more figures and blind tracery, the great gable over the portal has a pierced delicacy surpassing even its counterpart on the north transept, and the two buttresses are drawn together audaciously by the insertion of a crowning gable with the Coronation of the Virgin, in the manner of Reims, over the rose window. Although many of the life-sized figures have been replaced and the Christ of the trumeau is a copy of the *Beau-Dieu* of the Reims north transept, the magnificent general decorative effect is unimpaired.[106]

The tympanum of the *Portail de la Calende* [252] is perhaps the most successful of the many tympana arranged in stacked narrative bands. Dedicated to scenes from the Passion of Christ, the atmosphere here is less frantic than on the tympanum of the north transept, so that although the narrative is bound together in a continuous flow the different episodes are separated by the careful turning of individual figures away from those in the adjoining scenes. Such an approach to narrative and the placing of figures in comparable architectural settings recommended itself to carvers of small-scale reliefs, especially in ivory, in the second half of the thirteenth century [253], and it may well be that portable carvings of this type in turn occasionally provided the iconographic models for monumental sculptures further afield.[107] Well ordered as the Rouen reliefs are, the designer of the tympanum was confronted with compositional difficulties arising out of the desire to show scenes from both before and after Christ's crucifixion and to reconcile this with the position of the latter at the apex of the tympanum. His answer was to start the narrative at the left of the second tier with the scene of the Betrayal, following it with the Flagellation and the Carrying of the Cross; at this point the narrative flow is broken by the necessity to give greater prominence to the Crucifixion, but continues with the Deposition as the final scene on the right of the second tier. The bottom band concludes with the triumph of Christ over death, showing the Maries at the Sepulchre, Christ's appearance to Mary Magdalene, the Harrowing of Hell, the Ascension and Pentecost.

As elsewhere on the transepts, the style is of Paris and the Paris-trained workshops of Reims, some of whom may have come to Rouen at the completion of work in Champagne.[108] However, the elongated, willowy bodies with finely-featured heads on the tympanum of the *Portail de la Calende*, when

251. The *Portail de la Calende*, south transept, Rouen Cathedral; *c*.1290–1305 and later

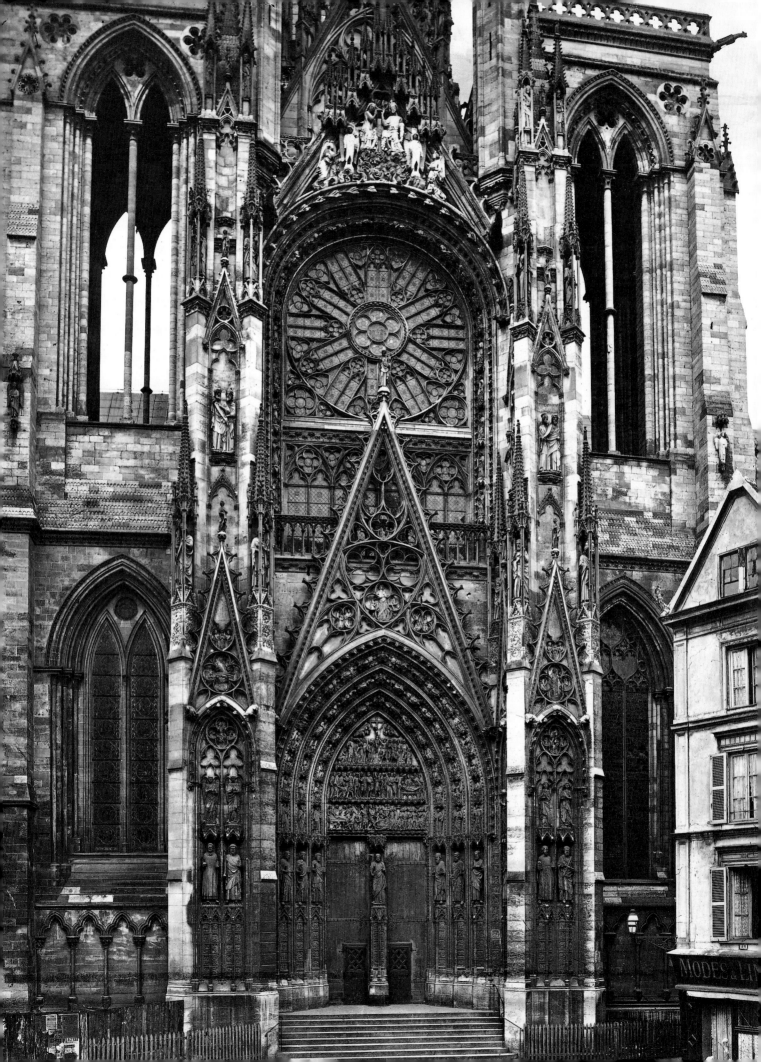

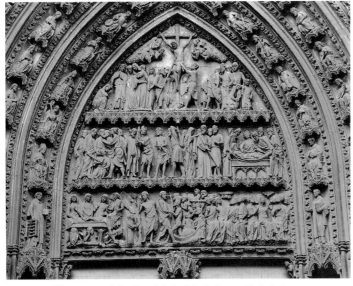

252. Tympanum of the *Portail de la Calende*, Rouen Cathedral; *c.*1290–1305

compared with the sculpture of the Paris transepts, show a kinship more with figures carved for interior schemes of decoration, such as choirscreens and retables; while the larger free-standing statues both on the exterior and interior of the transepts likewise testify to the increasing and widespread rôle of the *imagier* as a provider of independent statues which were no longer physically attached to the fabric of a building.

253. Diptych ('the Soissons diptych'); ivory, painted and gilded; French (Paris), *c.*1280–1300 (Victoria and Albert Museum, London)

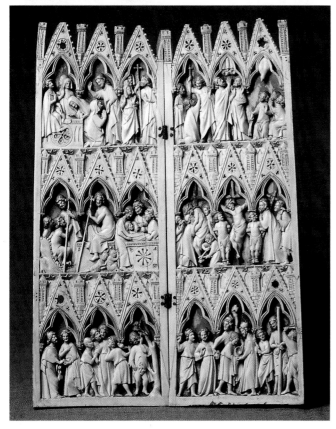

SCULPTURE UP TO 1300

It has been shown that the great age of the Gothic portal in France lasted in essence for just over a hundred years, roughly speaking between the middle of the twelfth and thirteenth centuries. Even the most splendid examples from the late thirteenth century – such as the *Portail de la Calende*, which took its basic arrangement from innovations worked out in Paris in the late 1250s – did not provide any major new approaches to the layout of iconographic programmes, and in overall effect few of the later ensembles approach the achievements of before 1260. The south transept portal at Meaux (after 1282) is a case in point, reflecting once again the appearance of the influential south transept portal of Notre-Dame in Paris.[109] As we have seen, other portals, such as at Bayeux, and that on the west front of Sées Cathedral in Normandy (which has the Death, Assumption and Coronation of the Virgin in the tympanum) carried the form of around 1250 into the second half of the century, while that on the south side of the west façade of the collegiate church at Mantes was remodelled in the years immediately after 1300 in the manner of the *Portail de la Calende*, almost certainly by members of the Rouen atelier.[110]

As noted above, workshops had for the most part been reduced in size from the large teams engaged at Chartres, Notre-Dame, Amiens and Reims in the first half of the century to smaller groups of sculptors who moved from one commission to the next. The patterns of training and employment of sculptors working predominantly in wood, revealed in Etienne Boileau's *Livre des Métiers* – written in Paris in the 1260s – had probably extended to those sculpting in stone by the end of the century: this is evinced not only by the increasing documentation surrounding sculptural production and our concomitant awareness of the names of many more sculptors but also by a diversification in their output. If the design and execution of monumental architectural sculpture – most notably portal decoration – had in the majority of cases reached a creative impasse, the same could certainly not be said for smaller-scale sculpture produced for interiors, tombs and single cult figures. It was in these categories that the new compact workshops of the fourteenth century, often consisting of no more than one sculptor and an apprentice, were to excel.

The foundations for much of what was to come in these areas of activity were laid in the third quarter of the thirteenth century. Three stone retables in the choir chapels of Saint-Denis and a fourth from the royal abbey now in the Musée national du Moyen Age (the so-called Benedict retable) anticipated in style and narrative method the Rouen south transept tympanum and acted as prototypes for the marble altarpieces of the following century. That showing scenes from the legend of St Eustace and with the Crucifixion at the centre [254] is a work of especially high quality, as is another, now sadly mutilated, from the abbey church of Saint-Germer-de-Fly, which was probably made in around 1266 (also now in the Musée national du Moyen Age).[111] Church furnishings were unfortunately vulnerable to damage or destruction by iconoclasts and revolutionary vandals or by those simply wishing to improve their church's interior. As a result, thirteenth-century examples have not survived in large

254. Retable with scenes from the legend of St Eustace; abbey church of Saint-Denis; c.1260–70

255. Tomb effigy of Isabella of Aragon (d.1271); abbey church of Saint-Denis; marble, 1272–5

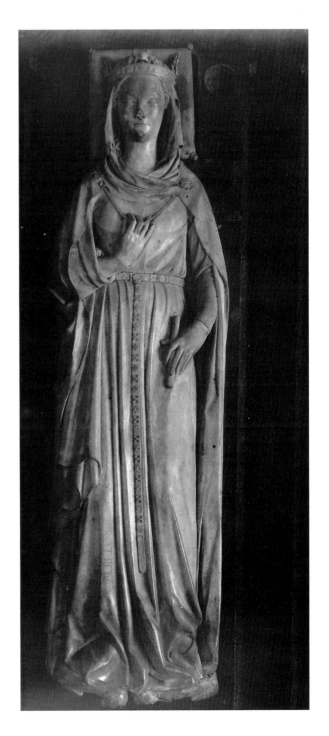

numbers and the existing evidence is often fragmentary or very much restored: such was the fate of the three *jubés* constructed at Amiens, Saint-Denis and Notre-Dame. That at Amiens Cathedral (*c.*1300), showing scenes from the Passion and Resurrection of Christ, was destroyed in 1755, but illustrations made before then show it to have followed the form of earlier choirscreens, as at Chartres. A few surviving sculptures – most notably a figure of Mary Magdalene from the *Noli me tangere* scene, one of Christ's torturers from the Flagellation and a large fragment from the Entry into Jerusalem – attest to the beauty of the sculpture, and the extensive remains of paint and gilding on the Magdalene give some impression of the original richness of the ensemble.[112] Even less survives of the *jubé* of Saint-Denis, also probably executed in the last years of the thirteenth century but destroyed between 1641 and 1705: only an imposing square relief, containing a quatrefoil showing St Dionysius carrying his head to the place of his burial between Sts Rusticus and Eleutherius.[113] At Notre-Dame it is likely that the *jubé* itself, demolished in around 1700, was constructed in about 1270, although the surviving choir enclosure (the *clôture*) on the north and south sides – which added scenes from the Infancy and Resurrection of Christ – was only completed in the second quarter of the fourteenth century. Again, only a few fragments in the Louvre speak for the style of the earlier work.[114]

After the series of sixteen royal effigies commissioned in 1263–4, single tombs were constructed as necessary at Saint-Denis when the Capetian kings and queens died. Louis IX's tomb, originally a plain stone slab (as requested by the King himself), was subsequently enlarged due to popular demand but nothing now remains of it.[115] As a result the only *gisants* from before the end of the century still to be found in the royal abbey are those of Isabella of Aragon, the first queen of Philippe III le Hardi, and of the king himself [255]. Isabella died in Cosenza in 1271, on the way back from the ill-fated crusade on which Louis IX also lost his life.[116] On the return of the royal entourage to Paris arrangements were made for the burial of her bones at Saint-Denis, although the tomb was probably not completed

256. Isabella, daughter of Louis IX; 1297–1304 (Notre-Dame, Poissy)

to the nearly contemporary *Virgen Blanca* in Toledo Cathedral [359]. Perhaps the idea of using marble for the queen's effigy had been planted in the minds of those responsible for its commissioning while in Italy, where its use in a funeral context was just beginning to be exploited.[118] Whatever the reason for the choice, this combination of white and black marble was to become immensely popular for French tomb sculpture in the fourteenth century. The effigy of Isabella also acted as an influential stylistic model. Although the pose of the right hand on the mantle-cord and the left holding a sceptre follows the common courtly form of the earlier effigies at Saint-Denis, the flattening-out of the draperies and the physical shallowness of the marble slab anticipates the style and working methods of the image-makers of the following century.[119] In addition, it could be argued that an attempt has been made to present a likeness – if not a portrait – of the deceased; in contrast to the stereotyped queens of the earlier series, the effigy of Isabella does appear to represent a young woman of twenty-four years rather than an idealised monarch. The atmosphere of sweetness and restful nobility is further reinforced by the presence of the two small dogs at the Queen's feet, counterbalancing the diminutive angels which once held the cushion beneath her head.

The existing documentation in connection with the tomb of Isabella is silent on the authorship of the work. But after this date references in account books to *imagiers* become more frequent; although this might be explained by the better survival rate of documents from the late thirteenth century onwards, it is likely that individual sculptors were increasingly allying themselves if possible with specific patrons, preferably at the royal courts. This appears to be borne out in the commissioning of the next effigy to be installed at Saint-Denis. Isabella's husband Philippe III died in 1285, but his tomb was still not in place by the end of the century. The royal accounts of 1308 record retrospective payments made both to Pierre de Chelles (referred to in other documents as the master of works at Notre-Dame) and to the widow of a certain Jean d'Arras. It is clear from these and other accounts that Jean (described in a document of 1298 as *mestre Jehan d'Arraz ymagier*) had died in 1298–9, possibly leaving the effigy unfinished, and that it was not until 1307 that the complete tomb was taken to Saint-Denis and erected under the supervision of Pierre de Chelles. Jean d'Arras was one of the first of an increasing number of sculptors drawn from Flanders and the Netherlands to the wealthy patronage of Paris, taking advantage of the increased mobility this type of work offered and enjoying a different status from that of the *tailleurs de pierre* of the cathedral workshops.[120]

The effigy itself, all that remains of the tomb, was, like that of Isabella, carved from white marble and set on a black marble *tumba*. It also shares with the earlier effigy the mixture of adherence to an older tradition of pose and arrangement of drapery with the introduction of an increased naturalism. Philippe IV le Bel (1285–1314), the son of the deceased, was probably personally involved in the choice of tomb. Like his grandfather Saint Louis he seems to have been passionately interested in the patronage of architecture and the arts, especially in the way that it might be used for the

until 1275, when payment is recorded.[117] A number of new features mark it out as a monument of the first importance. The most immediately striking is the material from which it is carved, white Italian marble, its ghostly sheen heightened by the black marble slab on which it is set, which in turn was inlaid with a white inscription. It is likely that parts of the effigy – the crown, sceptre and girdle – were highlighted with gilding and that colouring was applied selectively elsewhere, so that its original appearance would have been close

aggrandisement of the royal family and its historic line. Two monuments commissioned by him, one just before 1300, the other in the first years of the fourteenth century, speak eloquently of these concerns and provide telling examples of the changing rôle of sculpture in these years.

Immediately after Saint Louis's canonisation in 1297, Philippe IV set about establishing a Dominican convent at Poissy, the saint's birthplace. Dedicated to the memory of his illustrious grandfather, it was obviously intended to emulate the foundations instituted under Louis himself, at Royaumont and elsewhere. The priory church of Saint-Louis was built extremely quickly and seems to have been occupied by 1304; although it no longer stands, part of the interior decoration was recorded in drawings made at the behest of the antiquary Roger de Gaignières (1642–1715), who also did so much to preserve the memory of the numerous sepulchral monuments existing in France before the Revolution.[121] These drawings show that Philippe installed standing figures not only of St Louis and his Queen, Margaret of Provence, on the piers at the entrance to the choir, but also of six of his children – Louis, Philippe III, Jean Tristan, Isabella, Pierre d'Alençon and the still-alive Robert de Clermont – on consoles on the inner face of the south transept. In addition, standing figures of angels were arranged around the choir.[122] Of this sculptural cycle, only the statues of Isabella [256] and Pierre d'Alençon (now headless) and some of the angels and their heads, have been preserved at Poissy (Notre-Dame), the Musée national du Moyen Age and the Louvre.[123] No less than the apostles of the Sainte-Chapelle fifty years earlier, these sculptures exemplify the Parisian court style: elegant and serene, the figure of Isabella displays all the qualities of the very best royal tomb sculpture at this time, combining an aristocratic *gravitas* with attention to the minutest detail of carving. Every button on her tight sleeves has been picked out, each stitch around the edge of her garments and the jewels on her diadem have been carved with obsessive care, in defiance of the hardness of the stone and regardless of the fact that such precision might be covered with paint. Her face – and those of the angels – is likewise the product of a man of great skill, and is sufficiently close to that from an effigy of Jeanne de Toulouse (now in the Musée national du Moyen Age) in all its details to suggest that it is actually the work of the same court sculptor [257].[124]

257. Head from the tomb effigy of Jeanne de Toulouse (d.1271), formerly in the abbey of Gercy (Essonne); probably *c*.1280–5 (Musée national du Moyen Age, Paris)

The positioning of both dead and living secular figures, rather than founders, inside a church in this way was seemingly unprecedented, an exceptional arrangement prompted by Philippe's desire not only to honour his grandfather but also to memorialise the later Capetian line of which he formed part. He was to go further still in this direction in the decoration of the Grand'Salle of the Palais de la Cité, where statues of past kings of France lined the walls, forming a three-dimensional portrait gallery.[125] By this time life-size figures were more often than not intended to be viewed as completely independent from their architectural setting. The fourteenth century was to be the age of the *imagier*, when the single devotional image – especially the Virgin and Child – and the tomb became the primary vehicles for sculptural experimentation.

The Holy Roman Empire 1240–1300

When the Hohenstaufen Holy Roman Emperor Frederick II died on 13 December 1250 at Castel Fiorentino near Foggia the idea of a unified Empire, already under severe threat from many sides, disappeared for ever. The Hohenstaufen dynasty struggled on without real power until 1268, when the unfortunate Conradin, Frederick II's grandson, was put to death by Charles of Anjou in Naples. Opposition had been mounting throughout the 1240s, both in Italy and Germany, and support for the Papacy against the Emperor was already being given by the powerful archbishops of Cologne and Mainz in 1241. This was to lead to the election of alternative kings in 1246 and 1247 and to reinforce further the importance of the ecclesiastical princes. The so-called 'Interregnum' between 1250 and 1273, when the Habsburg Count Rudolph was crowned King of Germany, saw the occupation of the throne by foreigners – William of Holland and Richard of Cornwall – elected by the archbishops of Cologne, Mainz and Trier and several of the most powerful princes, but increasing power now lay in the hands of strong groupings of geographically close cities. In 1254 the most influential of these Leagues, the *Confoederatio pacis rhenana*, was formed by the affiliation of the wealthy cities of Mainz, Cologne, Worms, Speyer, Strasbourg, Basel and others, and soon spread outwards from the Rhenish heartland. Elsewhere, the Hanseatic League in North Germany strengthened the trading position of its members, especially the cities of Hamburg and Lübeck, in the increasingly prosperous markets around the Baltic. One of the results of this fragmentation of the Empire was an increase in construction, as the newly-emerging rich merchant classes were now in a position to finance the building of large churches. In addition to contributing substantial sums of money in the time-honoured fashion towards the great cathedrals, as at Strasbourg, the burghers also occasionally funded the erection of parish churches of comparable ambition. Such was the case at Freiburg im Breisgau and the Marienkirche at Lübeck, while the building of the Elisabethkirche in Marburg was largely paid for by the Order of the Teutonic Knights. The architectural language of these new buildings, from the second quarter of the thirteenth century onwards, is almost invariably derived from French Gothic. The importance of this source, and the status it held in Germany in the second half of the century, is perfectly illustrated in the famous account of the rebuilding of the collegiate church of St Peter in Wimpfen im Tal, written in about 1280 by the chronicler Burckhardt of Hall. He tells how Richard of Deidesheim, having

> summoned the master mason most skilled in architecture, who had then recently come from the city of Paris in the land of France, ordered the church to be built of ashlar stone in the French manner [*opere francigeno*]. Truly, then, this master built a church of marvellous workmanship, elaborately adorned within and without with images of the saints, with

moulded window frames and piers, a work that caused much toil and large expenditure. . . .[1]

Although in many cases the sculpture of the German lands, especially in the Rhine valley, was equally indebted to French prototypes there was by the middle of the thirteenth century an established cultural identity of great distinction. This ensured that influence from abroad would be absorbed into the existing matrix but was never imported without change.

THE MAGDEBURG RIDER AND SCULPTURE IN THE CATHEDRAL

Earlier it was shown how a workshop trained at Reims introduced a new method of representing the human form at Bamberg Cathedral between 1233 and 1237. The advanced technical skill of the sculptors allied with an increasing interest in the depiction of emotion through facial expression and the ability to experiment with the application of sculpture to a number of different tasks provided the basis for the pioneering figures of the tympanum of the Princes' portal and the Bamberg Rider [142 and 145]. These important sculptures immediately gave rise to imitations elsewhere and some members of the workshop, rather than returning to France, appear to have moved to other sites or trained younger native sculptors in their methods. Two ensembles of sculpture made in the years around the middle of the century at Magdeburg provide clear evidence for the influence of the Bamberg workshop.

The first of these is the life-size equestrian monument in the Alte Markt [258]. The surviving original parts – the Rider and two standing female figures – have been replaced by copies and are now displayed in the entrance hall of the Kulturhistorisches Museum, while the present form of the monument is only very loosely based on its sixteenth-century appearance. Comparison with the Bamberg Rider springs to mind, although the Magdeburg horseman, being entirely free-standing, is closer to antique prototypes (such as the Marcus Aurelius in Rome) and is the only remaining post-classical example of the genre before the fourteenth century. Like the Bamberg Rider, its identity has been much debated; there are, however, good reasons for accepting the traditional identification as the Emperor Otto I, the founder of the archbishopric of Magdeburg, although details of the monument's original appearance are not known. The two flanking female figures, one holding a banner in her left hand (now broken off), the other a shield, perhaps represented Church and State, and thus may have emphasised the rôle of the Emperor as ruler of both at a time when the relationship between the Empire and the Papacy was extremely strained. In common with Frederick II's *Porta romana* at Capua, constructed a few years earlier, the Magdeburg Rider seems deliberately to have been given the

258. The Magdeburg Rider; *c.*1240–5 (Kulturhistorisches Museum, Magdeburg)

259. Crown-holding angel; north side, east choir, Bamberg Cathedral; *c.*1235–7

260. The Wise Virgins; north transept porch, Magdeburg Cathedral; *c.*1245

261. A Foolish Virgin; north transept porch, Magdeburg Cathedral; *c.*1245

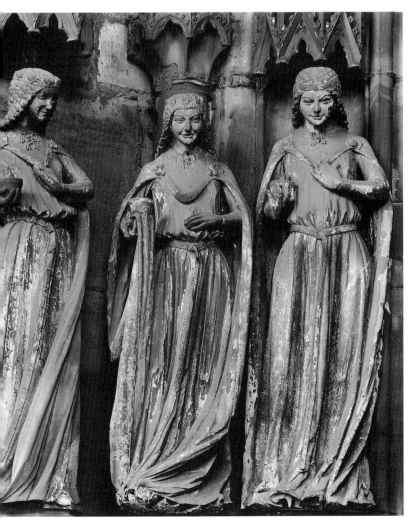

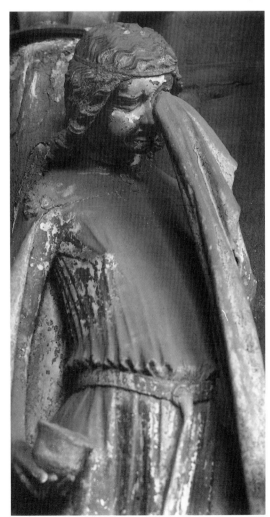

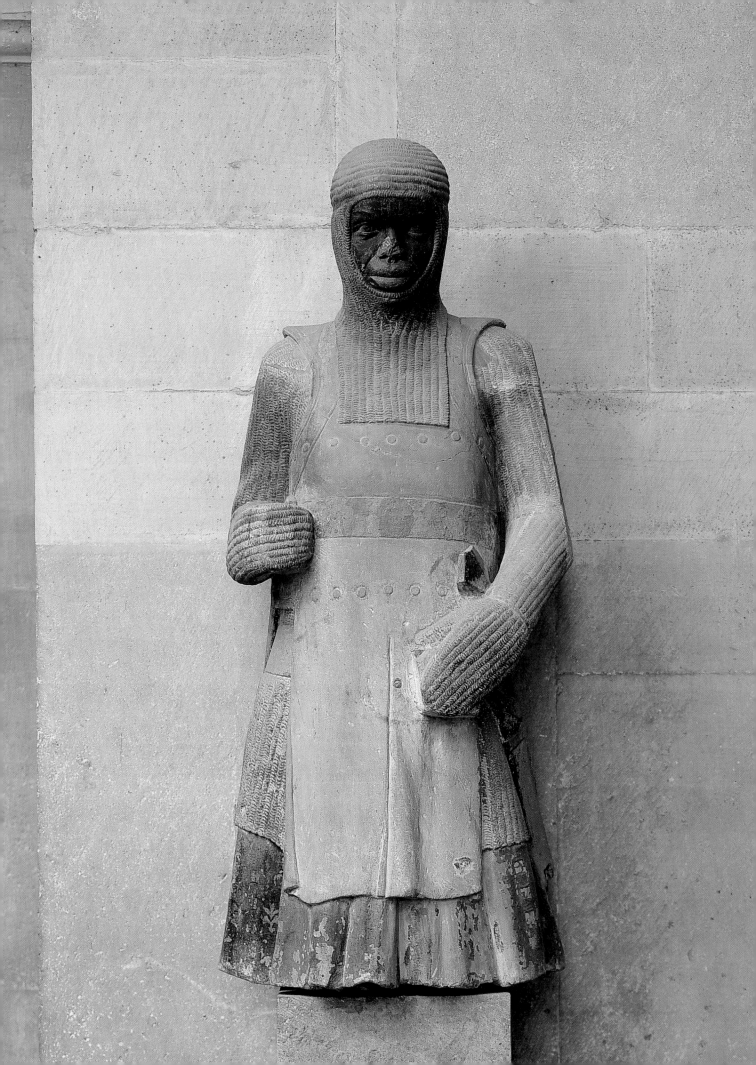

visual language of Imperial Rome, not least in the manner in which it was displayed atop a column.[2] The head of the figure, with its wavy hair at the sides and small spiral curls spilling from under the crown at the front, is close indeed to that of the Bamberg Rider and its model, the so-called Philip Augustus at Reims [96, 145], but the features have been exaggerated and slightly coarsened: the eyes are more bulbous and the face less refined.[3]

The same metamorphosis took place in the sculptures of the second major ensemble. As in the case of some of the interior figures at Bamberg, these sculptures, scattered about the east end of the cathedral and placed around the four-teenth-century 'Paradise' porch on the north transept, are not in their intended positions.[4] The greater number are in the porch, which contains five Wise and five Foolish Virgins to either side of the doorway [260, 261], and the personi-fications of Church and Synagogue in the northern corners, while inside the cathedral are individual figures of the patrons St Maurice [262] and St Catherine, the Virgin and annunciatory Angel, and a seated pair interpreted either as Christ and Mary-*Ecclesia* or Otto I and his first wife Edith.[5] As it is obvious that the Wise and Foolish Virgins and the figures of *Ecclesia* and *Synagoga* pre-date the porch in which they stand it was thought that, like the earlier figures high up in the choir, they had originally been destined for a portal on the north or west façade which was either never erected or actually built but subsequently dismantled. An alternative theory, based on a drawing of the now-destroyed *Lettner* of Hamburg Cathedral, accommodates all the above-mentioned figures on the west face of a similar choirscreen, with the seated pair – necessarily Christ and Mary in this context – at the centre, the Wise Virgins to the north and the Foolish Virgins to the south; below, the figures of the Church and Synagogue would have flanked the central arch, with the Annunciation to the north and Saints Maurice and Catherine to the south.[6] This is a persuasive suggestion, but archaeological excavation has failed to locate any foundations for such a structure and the Wise and Foolish Virgins are more usually found on Last Judgement portals.[7] Prior to Magdeburg they were represented on a smaller scale than the jamb figures, often occupying the doorposts, but towards the end of the thirteenth century, at Strasbourg and else-where, they are given a similar position, on the jambs. It seems likely that Magdeburg provided the first example of this type of portal.[8]

As with the Magdeburg Rider the most immediately strik-ing link with the sculpture of Bamberg is in the facial type. The heads of the grinning Wise Virgins, especially the second and fourth from the left, are so similar to those of the crown-holding angel at Bamberg and some of the figures in the tympanum of the Princes' portal that a close relationship seems certain [259, 142]. The stylistic signature of this particular sculptor is revealed in the way he carves the eyes, with heavy lids above and deeply-incised lines below, while the pupils are set back in the head; likewise, the smiling

mouths force the puffy cheeks up at the sides in what almost amounts to a grimace. If we accept a date of about 1237 for the Bamberg angel, the Magdeburg Virgins must surely have been executed in the next ten years, probably in the second half of the 1240s. The same goes for the figures of *Ecclesia* and *Synagoga*, which are also derived from their counterparts at Bamberg. However, in these figures – and in some of the Wise Virgins – the draperies seem to have taken on a life of their own, billowing out, as if air-filled, in Baroque waves of cloth [263]. It is as if the sculptor was experimenting, Bernini-like, with the physical limitations of the stone. The Bamberg connection is strengthened still further by the existence of a Virgin and Child now mounted in the north aisle of the Franconian cathedral, which displays the same looping outer mantle as two of the Wise Virgins at Magdeburg. It was presumably made some time after the pre-1237 sculptures and provides an extra bridge – if any were needed – between the two ensembles.[9]

The statue of the joint patron saint of the cathedral, St Maurice, is among the finest of the Magdeburg sculptures and by a different sculptor. Faithful to the saint's origins and his position as *primicerius* of the Theban legion the figure is shown for the first time as a black soldier, dressed in accurately-depicted mail and breast plate – evidence perhaps of both an increasing awareness of Africans in the Hohenstaufen era and the growing interest in realistic portrayal.[10] Now divorced from its original setting it may be viewed singly as one of the most impressive statues of the thirteenth century, the embodiment of Wolfram von Eschenbach's black knight Isenhart in *Parzival*:

> Fine qualities burgeoned on him like blossoms on a spray. This knight was brave and discerning. Loyalty bore fruit in him nourished from deep roots. His breeding excelled all breeding. He was more modest than a woman. He was brave and daring. No hand more liberal ever grew on knight in any land before.[11]

Seen in a wider context it also forms part of a remarkable efflorescence of sculpted figures in Germany between 1235 and 1260 which reached a peak in the *fundatores* of Naumburg and the slightly later statues in the choir of Meissen Cathedral. Nowhere else in Europe did sculpture more closely resemble life.

THE WORKSHOP OF THE SO-CALLED NAUMBURG MASTER AT MAINZ, NAUMBURG AND MEISSEN

The relationship of the Magdeburg sculptures to the Reims-Bamberg tradition is seemingly straightforward. Because a number of the figures not only share the emotional strength of the earlier sculptures but also follow the very individual approach to physiognomical detail it is likely that the same sculptor or sculptors were active at both places. Although the Reims background to the training of the other major work-shop of the mid-thirteenth century – active at Mainz, Naumburg and Meissen – is also assured, a more subtle transformation takes place. In the space of about twenty years almost every trace of the French foundation of its style had been eradicated.

There is widespread scholarly agreement that the frag-mentary remains of the *Westlettner* in Mainz Cathedral

262. St Maurice; choir, Magdeburg Cathedral; *c.*1245

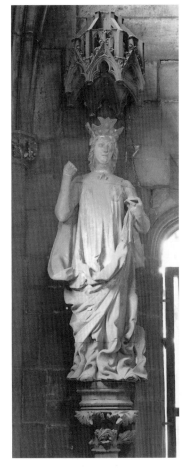

represent the earliest work of a master sculptor (more accurately a workshop) named after the location of a still extant second choirscreen – the 'Naumburg Master'. Because the style of the sculpture is so recognisable, making it possible to chart the progress of the workshop from one site to another, this discrete group of works – of sublime quality – has during the course of the late nineteenth and twentieth centuries attained an almost mythic status, seeming to encapsulate the German medieval spirit.[12] While some of the motives behind the construction of a great German artistic personality by earlier writers were possibly of dubious merit, there can nevertheless be little doubt that the sculptures at Mainz, Naumburg and Meissen are predominantly homogeneous in style and decorative intention. It would be a mistake to veer too far in the opposite direction from the interpretations of older writers and to forget that the chisel was wielded by living human beings with distinct characteristics. Gothic sculpture, no different in this respect from that of any other age, was not conceived and executed by committee. We might not know any names, but the existence of a workshop made up of at least one sculptor of

263. Personification of *Ecclesia*; north transept porch, Magdeburg Cathedral; *c*.1245

264. The Blessed; relief from the *Westlettner*, Mainz Cathedral; *c*.1237–9 (Bischöfliches Diözesan- und Dommuseum, Mainz)

surpassing talent at these three sites is inescapable, no more an 'art-historical fiction' than such fully-documented figures as Claus Sluter in the following centuries.[13] In the case of the Naumburg workshop the sculptures themselves are the most eloquent documents.

The *Westlettner* at Mainz Cathedral was probably complete by the time of the consecration of the new western choir under Archbishop Siegfried III von Eppstein in 1239. Although it was dismantled in 1683, the extensive remains allow a confident reconstruction of its appearance and provide a firm basis for an analysis of the sculptural style. The largest surviving fragments are two reliefs showing groups of the Blessed and the Damned [264, 265] and a third of the Deesis. It is likely that the former were positioned to each side of the Deesis at the centre of the choirscreen, above an open arcade, and that the iconographic scheme of the Last Judgement on the front face was completed by reliefs showing the Dead rising from their graves and the torments of Hell.[14] It thus borrowed certain key elements from the fuller Last Judgement programme on the north transept at Reims, of around 1230, adapting them to the more awkward spaces available on the choirscreen. As on the Bamberg Princes' portal the drama is heightened by the exaggerated facial expressions of fear or joy, and once again heavy chains seal off any chance of escape for the hapless Damned.

A number of sculptors must have been involved in the execution of the reliefs. That responsible for the procession of the Blessed – especially the smiling child perched on the gable at the right – was possibly trained in the Bamberg workshop by the Reims masters, while another may have come from Amiens.[15] The influence of Reims at Mainz is underlined a few years later – probably in around 1250 – in the eastern choir: the only surviving figure from this ensemble, a caryatid Atlas figure, was clearly modelled on similar figures high up on the outside of the French cathedral's choir.[16] Other suggestions have been made in connection with the early French training of a putative Naumburg Master, postulating his presence at Noyon, Metz and elsewhere, but these hypotheses have not been accepted in all quarters, and the general similarity of the sculptures is more likely to be due to shared sources; the comparison between the Noyon console figure and one of the Mainz figures is the most compelling.[17]

What we have then at Mainz is probably a workshop made up of a small number of sculptors, at least one of them having been trained at Reims (or Bamberg), another possibly at Amiens. Perhaps the most accomplished is the sculptor of the fine head which once probably belonged to a figure (Adam?) in the vault inside the *Westlettner* [266].[18] Here the vivid characterisation of the heads of the Blessed and Damned has been further advanced and the full potential for psychological expression realised. The deep-set eyes shaded by bony eyebrows, beautifully rendered undulation of the flesh on the cheeks, slightly parted lips and dishevelled hair

265. The Damned; relief from the *Westlettner*, Mainz Cathedral; c.1237–9 (Bischöfliches Diözesan- und Dommuseum, Mainz)

266. Head, probably from the *Westlettner*, Mainz Cathedral; *c.*1237–9 (Bischöfliches Diözesan- und Dommuseum, Mainz)

267. St Martin and the beggar; St Martin, Bassenheim; *c.*1240

impart a brooding intensity to the head within the power of only the most talented sculptors. This particular sculptor also executed the celebrated relief of St Martin dividing his cloak with the beggar in the parish church of St Martin in Bassenheim, near Koblenz [267], considered by several scholars to have come originally from Mainz Cathedral.[19] Once again the stylistic foundations of this art are to be found in the acutely observed corbel heads of Reims.[20]

In 1249 Bishop Dietrich II issued an appeal for funds in connection with the building of the west choir of Naumburg Cathedral, to honour the *primi fundatores*, the eleventh-century benefactors, and to celebrate the confirmation by Pope Gregory IX in 1230 of Naumburg's right to a bishopric. As at Wells, Naumburg had been in dispute with a close neighbour – in this case Zeitz – since 1028 over the position of the See. When the conflict was finally settled in its favour, the Bishop must have wished to commemorate the earlier donors and to illustrate the history of the cathedral in three-dimensional form, in a comparable way to his English counterparts. But here the similarity ends. The Naumburg benefactors are not presented as horizontal effigies: in a stroke of genius – although perhaps inspired by the comparable positioning of the apostles of the Sainte-Chapelle in Paris – the architect decided to show them as standing figures around the choir. The 1249 document promises the usual indulgences for those who would contribute to the work, but unfortunately it is unclear from the wording how far the choir had progressed by this date, and no mention is made of the statues themselves.[21] The choir had presumably been started shortly after the consecration of the nave in 1242 and may well have been nearly finished, although the completion of the Parisian royal chapel in 1248 might be used as a possible *terminus post quem* for the figures. All things considered, a date bracket of 1249–55 for the sculpture is probable, and as most of the statues are attached to the fabric of the building they were presumably made immediately before the choirscreen.

The twelve life-sized *fundatores* (eight men and four women) stand under canopies in front of the passage running around the west end at window level, as if they have just taken their place in the choir [268, 269]. Identified either by the painted inscriptions on their shields or by mention in the 1249 document, the figures *en masse* constitute a unique display at this time of secular power in an ecclesiastical setting. They are not, however, shown as lifeless representations in a solemn pantheon. On the contrary, the Naumburg statues have long been recognised as the highpoint of realistic portrayal in thirteenth-century Germany. They cannot of course be viewed as true portraits of the eleventh-century members of the Billung and Wettin dynasties, but in the astonishing attention to detail in the carving of the clothes and faces, and most of all in the subtle nuances of pose and gesture the figures have been invested with a genuine human quality.[22]

Pride of place in the choir is occupied by the two brothers, the Margraves Ekkehard II and Hermann of Meissen, and their wives Uta and Reglindis [270], who face one another in front of the altar. There is a sense of arrested movement never attempted before, as the full-faced Ekkehard fiddles with his shield-strap and Uta, seemingly feeling the cold,

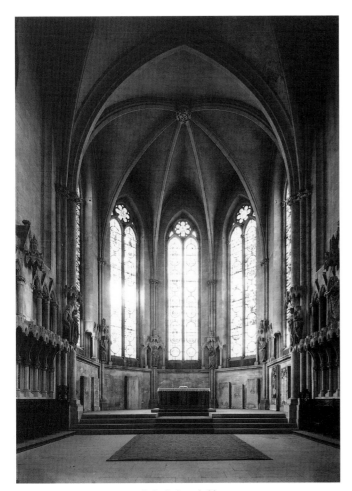

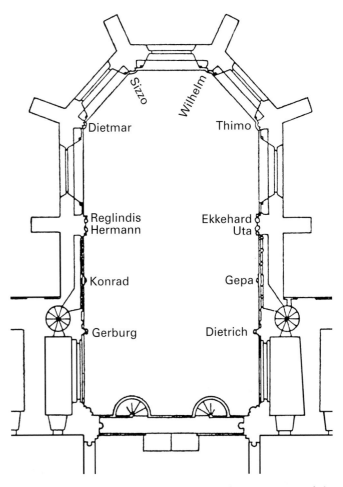

268. West choir, Naumburg Cathedral; probably c.1245–55

269. Plan of west choir, Naumburg Cathedral, showing positions of the *fundatores*

pulls her heavy ermine cloak up to her face. A distinctive leitmotiv of the master sculptor responsible for most of the Naumburg figures is his fascination with hands. These are rarely inert: especially noteworthy are Uta's left hand, gathering her cloak into a thick bundle, the fingers spread out, and Ekkehard's right hand, where each finger is treated individually. These aristocratic pairs are at ease with themselves – Reglindis smiles sweetly as she looks towards the entrance to the choir – but there is a more strained and threatening atmosphere in the demeanour of the four male figures further west.[23] Count Dietmar, accused of treason and killed in combat in 1048, raises his shield and fingers his sword as if in renewed danger from the glowering figure of Count Sizzo von Käfernburg alongside him [271, 272], while the uneasy poses of the other Counts Wilhelm von Camburg and Thimo von Kistritz do nothing to defuse the dramatic tension.[24]

Enclosing the choir, a *Westlettner* was erected in a form roughly following that at Mainz [273]. Instead of scenes connected with the Last Judgement, eight reliefs showing the Passion of Christ (the Last Supper, the giving of the pieces of silver to Judas, the Betrayal, Mary Magdalene and Peter, two of Caiphas's watchmen, Christ before Pilate, the Flagellation and the Carrying of the Cross) were placed above the blind arcades flanking the entrance to the choir.[25]

Extraordinarily, rather than setting the Cruxifixion, Virgin and St John above the choirscreen they were grouped inside the entrance porch of the *Lettner*, in a magnificent *coup de théâtre* [274]. The crucified Christ occupies the trumeau, so that anyone passing into the choir had to walk under his outstretched arms in unprecedented proximity to his sagging body, unavoidably entering into the dramatic and grief-stricken atmosphere created by the mourning figures at the sides. The execution of the individual figures, including the two censing angels above the cross, matches the brilliance of the arrangement: by looking out towards the main body of the church with imploring gestures both the Virgin and St John involve the spectator directly in Christ's suffering. This unflinching and lifelike atmosphere is also present in the little *tableaux* of Christ's Passion above [275]. It has been pointed out how these scenes – like the poses of the figures in the choir – are shown as if frozen from a dramatic performance, where every small gesture intensifies the narrative content. There is a similar fondness on the part of the sculptor for the pointing or grasping hand, the whispered aside and snatched glance which lifts these reliefs above the formulaic depictions of the same episodes so often seen elsewhere.[26] Almost overlooked in the midst of this extensive narrative programme, but also worthy of note, are the remarkable capitals and friezes densely decorated with a rich

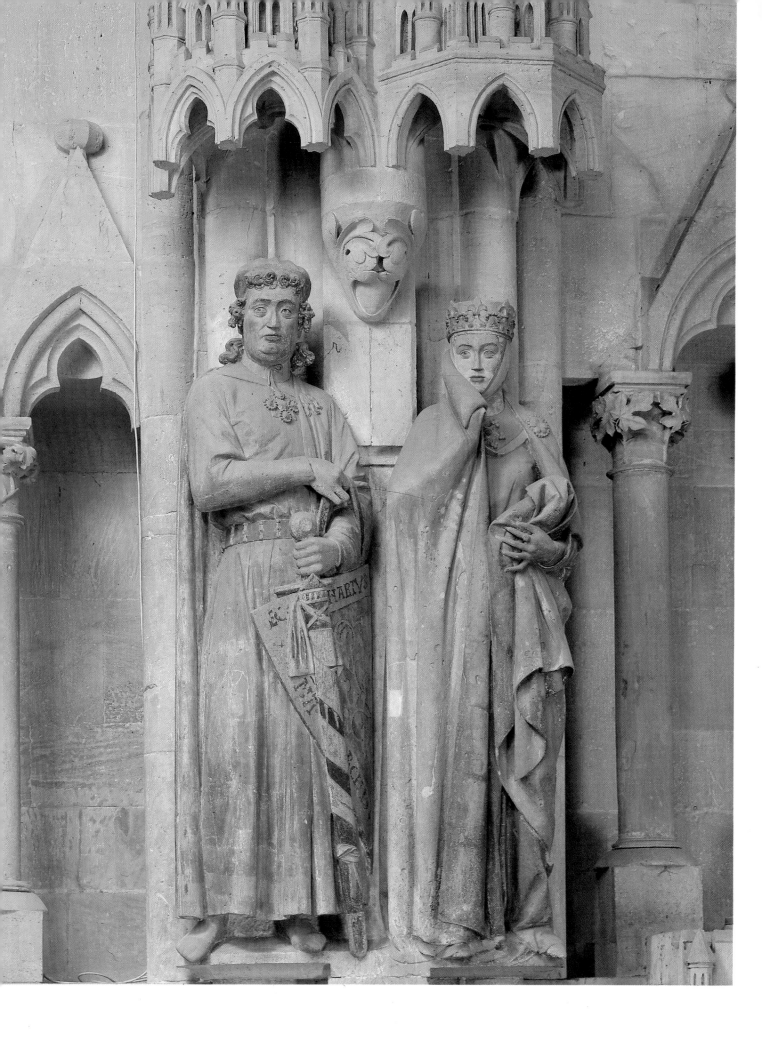

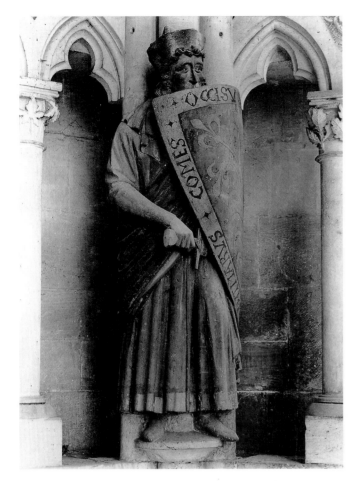

270. The Margrave Ekkehard II and Uta; west choir, Naumburg Cathedral; *c*.1249–55

271. Count Dietmar; west choir, Naumburg Cathedral; *c*.1249–55

272. Count Sizzo von Käfernburg; west choir, Naumburg Cathedral; *c*.1249–55

273. *Westlettner*, Naumburg Cathedral; *c*.1255

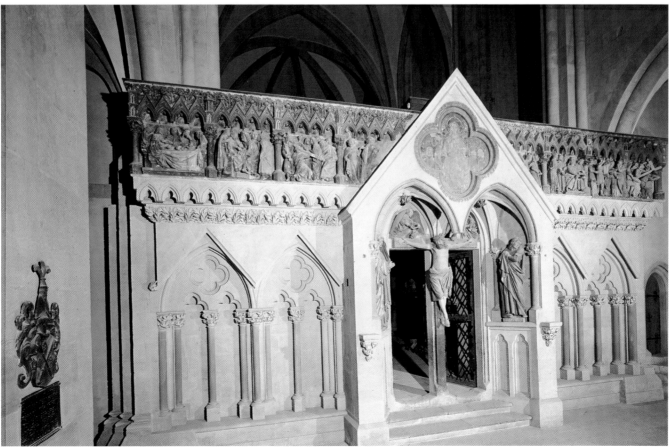

274. The Crucifixion with the Virgin and St John; *Westlettner*, Naumburg Cathedral; *c*.1255

275. Christ before Pilate; *Westlettner*, Naumburg Cathedral; *c*.1255

276. Otto I and Adelheid; north wall of choir, Meissen Cathedral; *c*.1255–60

variety of leaves, fruit and flowers, and it should not be forgotten that the whole iconographic scheme was completed by a cycle of stained glass in the choir showing Christ, the apostles standing on their heathen adversaries and the Virtues vanquishing the Vices, representing the triumphant Church.[27]

By any standards the Naumburg ensemble represents the supreme achievement of German thirteenth-century sculpture. It is more than probable that the great sculptor who executed the statues of the Margrave Ekkehard and Uta received his training in the Reims workshop at Bamberg in the middle of the 1230s, judging by his approach to the carving of crumpled cloth, while the smiling face of Reglindis, undoubtedly by the same sculptor, also follows the conventions of facial expression brought to Bamberg by the French.[28] However, the lessons learnt in apprenticeship have now been thoroughly absorbed and transformed into a unique artistic language of enormous dramatic strength and super-realism, quite surpassing the efforts of the earlier teachers. It is frustrating that there are no records to illuminate the contributions of the various members of the workshop and to allow a confident division of their work, but it is surely the case that the management of the sculptural programme was entrusted to one master mason-sculptor (was he also the architect?), who would have carved many of the figures himself and supervised work on others.[29] The

workshop need not have been large – witness the size of Jean de Marville and Claus Sluter's teams at the Chartreuse de Champmol in Dijon at the end of the following century – and might have consisted of only two senior sculptors and up to half a dozen juniors and stone cutters.[30] About five years would have sufficed for the completion of work.

The Naumburg workshop, possibly reduced in size, next travelled to Meissen, where seven life-size figures remain in the cathedral, four in the choir, three in the exterior octagonal chapel wedged between the nave and the south transept. Standing on (later) socles beneath architectural canopies on the north wall of the choir are the Emperor Otto I and his second wife Adelheid, the founders of the cathedral [276], faced by John the Evangelist and Donatus, the joint patron saints [277, 278]. In the porch-chapel outside a censing figure (a deacon?) and St John the Baptist flank the Virgin and Child. Opinions vary on the original location of the seven figures, earlier writers tending to favour the theory that all the statues were intended for a Virgin portal. Against this the four figures in the choir appear to be tailor-made for their present positions: the windows in that part of the choir are considerably shorter than those further east, the canopies above the figures' heads are bonded into the masonry, and no tympanum or archivolts from the putative doorway have come to light. There was in any case the recent precedent of the Naumburg west choir, which the

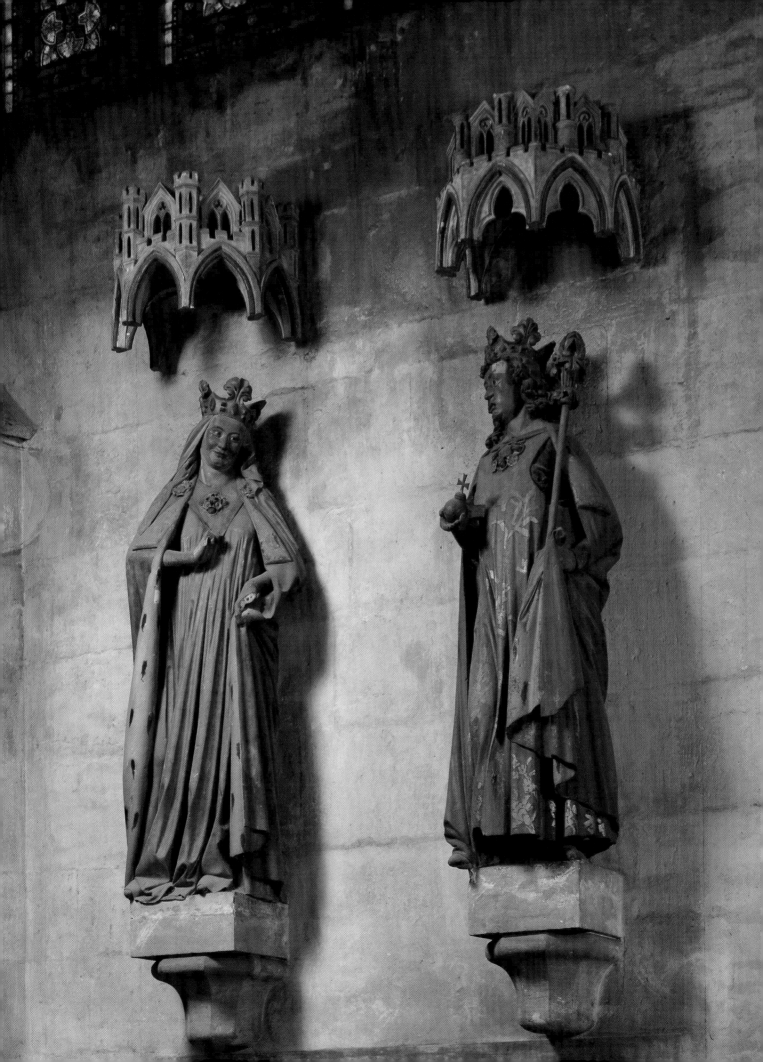

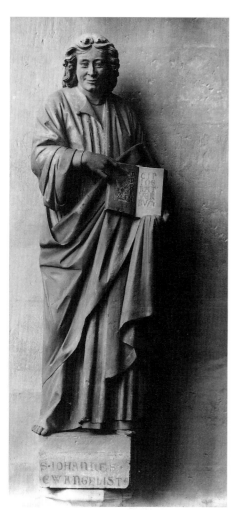

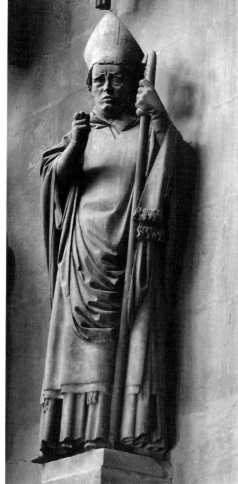

277. St John the Evangelist; south wall of choir, Meissen Cathedral; *c*.1255–60

278. St Donatus; south wall of choir, Meissen Cathedral; *c*.1255–60

Bishop of Meissen may have wished to emulate: he had after all employed the same sculptors.[31]

The hand of the Naumburg master is apparent at once. Not only do the figures in the choir share the general bearing and impressive range of gestures of the Naumburg *fundatores* but certain features are taken over virtually unchanged, suggesting that only a very short period had elapsed since the completion of the earlier work. One needs only to compare the head of Otto I with that of Pilate at Naumburg [276, 275], or that of St John the Evangelist at both places [277, 274] to be struck by the close family resemblance. The choir figures are finer than the three in the octagon outside, but all testify to the workshop's mastery of the draped human form. As on the figures of Ekkehard and Uta at Naumburg, the clothes and especially the jewellery of the royal couple have been reproduced with such verisimilitude – albeit anachronistic – that they have been used by specialists as evidence for the courtly fashions of the mid-thirteenth century.[32]

By the time the Meissen figures were executed, probably around 1255–60, more than twenty years had passed since the first exposure to French Gothic had taken place at Bamberg and Mainz. The hugely influential workshops of Reims before 1233 had provided the fertile testing-ground for sculptural innovation, but the three-dimensional depiction of the human condition was taken up with such unexpected enthusiasm by these German sculptors that by the middle of the century their best work for a moment had no equal in Europe. Reims Cathedral was by this time burdened by its over-ambitious plans and stuck with a retardataire scheme on its west façade, and, impressive as they are, the sculptures produced in Paris during the reign of Louis IX lack the immediacy and emotional appeal of their Teutonic counterparts. Nonetheless, even after the 1240s France continued to provide German sculptors with fresh ideas, so that alongside the process of internal evolution seen at Mainz, Naumburg and Meissen, inspiration from the West never ceased entirely. This was of course to be expected in those places in the Empire closest to the French sources, such as Trier and Strasbourg.

LORRAINE AND THE UPPER RHINE AROUND THE MIDDLE OF THE THIRTEENTH CENTURY

The influence of the Reims transept workshop, of such fundamental importance at Bamberg, Magdeburg and Mainz, was not surprisingly also carried into the adjoining archdiocese of Trier. Modest portals at Metz, Mont-devant-Sassey and Epinal, all of about 1240–50, followed the typical French type, with jamb figures, tympanum and figured archivolts. Whereas the sculptures at Mont-devant-Sassey are poor-quality imitations of prototypes found in the

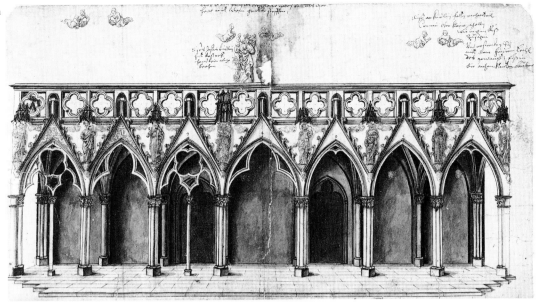

279. Drawing of the choirscreen in Strasbourg Cathedral (*c.*1660) before its demolition in 1682 (Landesbibliothek, Stuttgart)

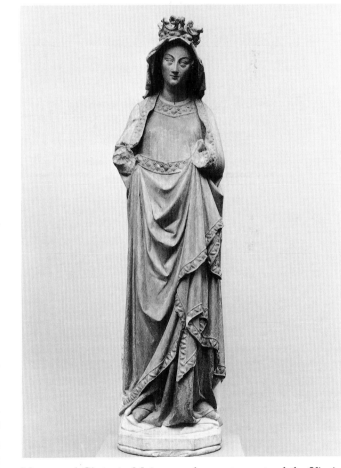

280. The Virgin; from the choirscreen, Strasbourg Cathedral; *c.*1255–60 (Metropolitan Museum of Art, New York)

French Royal Domain, the remaining original work from the much-restored Virgin portal at Metz Cathedral, especially the right-hand side of the lintel (now in the crypt), has a vitality of pose and understanding of the draped form which has led some scholars to propose a link with sculpture at Mainz and Naumburg.[33] In Trier itself, the single west and north doorways of the Liebfrauenkirche next to the cathedral also provide a clear illustration of the pervasive eastern march of *opus francigenum*. The western portal had six jamb figures, including *Ecclesia* and *Synagoga*, and a tympanum with the Virgin and Child and scenes from the Infancy of Christ; above, six life-size figures (Noah and Abraham below pairs of prophets) were placed under canopies on the piers to each side of the door, and the Angel of the Annunciation and the Virgin faced each other across the west window. The Crucifixion completed the programme in the gable.[34] Despite their weathered and reworked condition it can be seen that the Trier figures, especially those of Church and Synagogue, reproduce faithfully the mannerisms of the figures on the Reims transepts, and they were presumably executed about a decade later, in the 1240s.[35]

In Alsace, the sculptures on the north portal of the collegiate church of Sts Peter and Paul in Neuweiler show an even more marked debt to Reims. The distinctive use of the drill on the hair and beard of St Paul calls to mind the same feature on the classically-inspired heads of the chevet angels at Reims, and like the Trier figures this portal should also be dated to around 1240–50.[36] Nearby at Strasbourg, however, in the major local sculptural project of the mid-thirteenth century, other stylistic currents come into play.

The choirscreen of Strasbourg Cathedral was demolished in 1682, but, on the basis of drawings and engravings made before its destruction, it is known that it consisted of an arcade of seven gabled arches [279]. In between the gables – which unusually were filled with reliefs showing the Acts of Mercy and Christ in Majesty at the centre – stood the Virgin and Child with the rose bush and eleven apostles under canopies, while the parapet above was constructed of open-work quatrefoils.[37] Fortunately eight of the apostles, a figure of a deacon which may have acted as a lectern and fragments of the gable reliefs still survive, some of them displayed in a partial reconstruction in the Musée de l'Œuvre Notre-Dame in Strasbourg. The Virgin [280], missing the Child and any traces of the rose bush, is now in the Metropolitan Museum

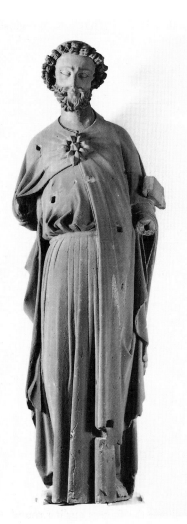

this restoration the support of the faithful is known to be extremely useful, we ask, advise and urge your whole community in the name of the Lord, adding remission of your sins to the extent that you bestow from the gifts given you by God, righteous alms and the pleasing gifts of charity, so that thus, by your aid, the building can be completed, and you, because of these and other good deeds, which you have done under the Lord's inspiration, can arrive at the joys of eternal blessedness.[39]

A date of about 1255–60 tallies well with the style of the remaining sculptures.[40] But instead of Reims, the apostles take their lead from developments in Paris, adopting the sharp folds of drapery and the metallic 'precious' style of the Sainte-Chapelle apostles. This is enhanced by the presence on several of the figures of ostentatious foliate clasps [281], and by the borders of the Virgin's clothes, which are carved with imitation precious stones. In view of the fact that the Reims west front programme only commenced after 1252 (see p. 156), the correspondence noted between the Strasbourg apostles and some of the voussoir figures on the left portal at Reims is probably due to a shared Parisian source, although it is possible that the Strasbourg sculptors travelled to Champagne on completion of the choirscreen.[41]

282. Tomb effigy of Archbishop Siegfried III von Eppstein (d.1249); Mainz Cathedral; *c*.1249–50

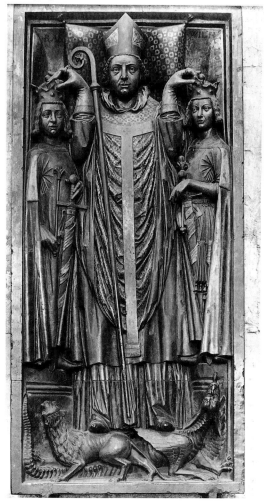

281. An Apostle; from the choirscreen, Strasbourg Cathedral; *c*.1255–60 (Musée de L'Œuvre Notre-Dame, Strasbourg)

of Art in New York, and an apostle in the Toledo Museum of Art (Ohio) may also be associated with the ensemble.[38]

It is likely that the choirscreen was complete by 1261, when a document issued by Bishop Walter of Strasbourg refers to a *lettenere*, and it may be that the exceptional choice of the Acts of Mercy for the decoration of the spandrels was a response to an open letter of indulgence issued by the Cardinal Legate Hugo in 1253. In order to encourage donations towards the completion of the cathedral, the cardinal appealed to the congregation's charity and promised remission:

Since, as the apostle says, we shall all stand before Christ's tribunal to receive good or evil according as we have acted in the flesh, we should anticipate the day of the Last Judgement by works of mercy, and, looking to things eternal, sow on earth what we shall reap with interest multiplied on the Master's giving it, holding firm our hope and faith; even as he who sows sparingly shall reap sparingly, and for him who sows with almsgiving shall alms reap eternal life. Therefore, as the venerable Bishop of Strasbourg, the Prior, the Dean and the chapter of the church of the Blessed Mary in Strasbourg have taken pains to make known to me that for

FIVE GERMAN EFFIGIES, *c.*1250-75

It has been demonstrated how the Naumburg *fundatores* fulfilled a similar rôle to the early thirteenth-century effigies of Anglo-Saxon bishops at Wells, celebrating the founders of the see and underlining the antiquity and importance of the cathedral. We have also seen in earlier chapters how a similar effect was sometimes achieved through the erection of single or double tombs, constructed in memory of the illustrious dead – as in the case of the tomb of Henry the Lion and Mathilda in Brunswick, made about forty years after the Duke's death. By the middle of the thirteenth century this practice was a common one, but of course numerous tombs with sculpted images were also made every year simply to commemorate the more recently deceased, wealthier members of society. Only a sample of these funerary sculptures can be discussed here; nevertheless, by choosing no more than five tombs it is possible to gain an impression of the approaches to different types of commission – albeit all made for a cultured and élite market – and to recognise the contributions of the major workshops.

The tomb slab of Archbishop Siegfried III von Eppstein in Mainz Cathedral, now mounted on the first pier from the

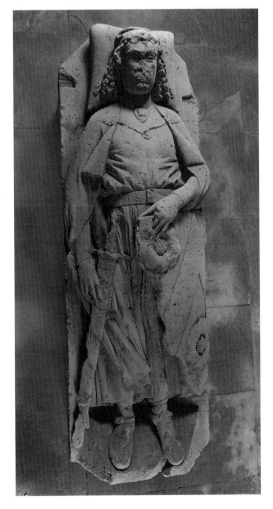

283. Tomb effigy of a knight, probably Hermann von Hagen; Merseburg Cathedral; probably *c.*1256

east on the south side of the nave, was originally placed in the eastern choir, probably over a stone chest [282]. It was almost certainly made immediately after his death in 1249, and much more than simply depicting the likeness of the archbishop it also stridently proclaims his considerable political power. He is shown crowning two pointedly smaller figures, the 'anti-kings' put on the German throne by the Rhenish archbishops in opposition to the Hohenstaufen Emperor Frederick II. On the left is the Landgrave Heinrich Raspe of Thuringia, elected in 1246, on the right Count William of Holland (who succeeded him in 1247), while Siegfried himself stands Christ-like, trampling the young lion and dragon underfoot (Psalms 90, 13). It is an image of astonishing confidence, even arrogance, ordered presumably by the archbishop's successor Werner von Eppstein and vividly illustrating not only the position of the Mainz archbishop as one of the principal 'king-makers' but also the broken hold of the Hohenstaufen dynasty on the Empire.[42] The formula appealed, for obvious reasons, to later archbishops at Mainz: unfortunately the tomb slabs of the two followers of Siegfried have been destroyed, but that of Archbishop Peter von Aspelt, who died in 1320, shows a remarkably similar composition to that of his predecessor – given a gap of seventy years – except that the later archbishop crowns three kings, John of Bohemia, Henry VII of Luxembourg and Louis of Bavaria.[43]

The style of the sculpture is slightly different from that employed on the *Westlettner* about a decade earlier. The heads of the two kings can instead be compared with that of the Magdeburg Rider, while the carving of draperies, swords, accoutrements and hands is close to the contemporary work at Naumburg: note especially the left hand of William of Holland, the fingers curling round the hilt of his sword. It has already been suggested that only a relatively small number of sculptors were involved in the execution of works at Mainz, Naumburg and Meissen around the middle of the century, but the relationship of the sculptor of the Siegfried tomb slab to that workshop still remains unclear. One would of course expect individual sculptors of the Naumburg workshop to have carried out commissions of this sort, and a simpler tomb in Merseburg Cathedral may reasonably be claimed as a product of their craft.

The effigy represents a knight of the Hagen family, the arms of which are shown in relief on the figure's shield [283]. There is nothing unconventional about the pose, which follows the typical recumbent attitude of the knightly effigies of the second quarter of the century in Saxony. What distinguishes the figure from the earlier effigies, such as that of Count Wiprecht von Groitzsch in Pegau [134], is the same degree of realism which separates the Naumburg statues from the figures of the Freiberg Golden Portal. Although the Pegau effigy is a work of fine quality the sculptor has made no concessions in his treatment of the drapery to the placement of the figure; at Merseburg, the knight's tunic is pulled tight across his chest, the short deep folds at the sides highlighting the constriction of the cloth, while lower down his cloak folds back on itself above his right knee, emphasising the horizontality of the composition. Similarly, the life-like quality of the fleshy face framed with falling curls – so close to Wilhelm von Camburg

284. Tomb effigy of Archbishop Konrad von Hochstaden (d.1261); *Johanneskapelle*, Cologne Cathedral; bronze, *c*.1261–5

285. Tomb effigy of the Count Palatine Henry II (d.1095); abbey church, Maria Laach; polychromed walnut, probably *c*.1270–80

and Thimo von Kistritz at Naumburg – and the sensitively rendered hands of the young knight contribute to the illusion that one is in the presence of a real person rather than a three-dimensional symbol, an illusion which would have been heightened by the original colouring.[44]

The third effigy falls into another category, and being bronze – originally gilt – can only ever have been intended as an impressive memorial rather than as an attempt to imitate nature. It represents Archbishop Konrad von Hochstaden of Cologne, the founder of the new Gothic cathedral in 1248, who died in 1261 [284]. He was buried in the recently completed axial chapel, but by the time of the consecration of the cathedral in 1322 his tomb had been moved into the next chapel to the north, dedicated to St John, to make room for the shrine of the Three Kings. This was not to be the last change to the monument: following serious damage the arcaded *tumba* was replaced in 1845 by the present stone chest and in 1847 the effigy was restored (the feet, right hand and staff are of this date) and the gabled trefoil arch remade.[45]

The image of the archbishop could hardly be more different from that of his contemporary Siegfried in Mainz. Konrad's status is announced not by aggressive propaganda but in the choice of material, which was costly and required enormous skill to cast, work up and gild. Even allowing for the depredations of time there can never have been a large number of gilt-bronze effigies made in the thirteenth century, so the selection of this particular material evinces a knowing sophistication and a desire to match the most expensive tombs elsewhere. It can hardly be coincidence that the most celebrated gilt-bronze effigy in France – that of Evrard de Fouilloy at Amiens [210] – also commemorated the founder of a cathedral, moreover a building which partly provided the architectural model for Cologne. Given the difference in dates, Konrad's effigy is in many ways comparable to the earlier figure of Evrard, although in detail and overall design it perhaps more closely resembles that of his successor Geoffroi d'Eu.[46] There can in any case be no doubt that its designer had looked in the direction of France for inspiration, and parallels have been drawn with the tombs from Royaumont now at Saint-Denis. The French comparisons and the similarity the tomb bears to the Cologne city seal of 1268–9 suggest that it was made immediately after the archbishop's demise.[47] It is of interest to note in this connection that a similar cast-bronze effigy was made for the now-lost tomb of the Savoyard Peter de Aquablanca, Bishop of Hereford (died 1268), in the collegiate church of St Catherine which he had founded at Aiguebelle. Before it was destroyed in 1792 the antiquary Thomas Kerrich had recorded the appearance of the crosier-holding effigy, that its feet were resting 'upon a Living Lion, not asleep' (*vide* Konrad), and that it had a Lombardic inscription running around the edge of the slab which included the name of the artist: *Hoc opus fecit Magister Henricus de Colonia*.[48] Considering the distance between Aiguebelle and the Lower Rhine, the fact that Master Henry of Cologne was chosen for this prestigious commission was a tribute to the reputation of metalworkers from the area and a measure of the esteem in which they were held.

A Cologne wood sculptor was responsible for the execu-tion of the posthumous tomb of the Count Palatine Henry II in the abbey at Maria Laach [285]. Recently conserved, it provides a splendid example of the original appearance of polychromed effigies in general while also illustrating the Lower Rhenish style of the second half of the thirteenth century.[49] Henry II was the founder of Maria Laach in 1093, and the building of the church had started before his death two years later. But it was not until the time of Abbot Theoderich (1256–95) that a suitably grand tomb was raised to the memory of the founder, after his remains had been transferred from the cloister to the nave in 1255–6. Rather than stone or bronze, the effigy was fashioned from wood (walnut), a decision that might have been made because of the recognised expertise of Cologne sculptors in this medium. By this date the Cologne workshops were not only making statues of the Virgin and Child and Crucifixion groups but also the first of the head reliquaries – many of them supposedly containing the relics of the 11,000 virgin martyrs of St Ursula – which are now their most recognisable product.

The tomb of Henry II was in a sense a large reliquary, albeit not of a saint, and the approach of the sculptor and painter to the figure did not differ from their method of carving and painting the smaller sculptures. The effigy has quite rightly been compared with the so-called 'stylised' reliquary bust in the *Goldene Kammer* in St Ursula in Cologne, of about 1270, and the contemporary Virgins from Ollesheim and Kendenich, now in the Schnütgen-Museum, which have similar facial features and naturalistic colouring.[50] Like the Naumburg figures, Henry has been dressed in the attire of the mid-thirteenth century, the fine-grained quality of the wood allowing the sculptor to carve in great detail the foliate decoration of the mantle-cord and the model of the abbey church (made separately) in the founder's right hand, while the rich and lustrous garments – silk and ermine – are convincingly simulated in paint and gold leaf.

The final example forms part of one of the most important series of tombs from medieval Germany. When Elizabeth, the daughter of the King of Hungary and wife of the Landgrave Ludwig IV of Thuringia, died in 1231 she was famous throughout the Empire for her piety and charitable deeds. Only four years passed before her canonisation by Pope Gregory IX and in the same year the foundation stone for a church in her honour was laid in Marburg. In 1236, in the presence of the Emperor Frederick II, Hermann of Salza (the Grand Master of the Order of the Teutonic Knights), the archbishops of Cologne, Mainz, Trier and Bremen, and many other ecclesiastical and secular dignitaries, her remains were solemnly translated to the site; and by 1249, when the choir and transepts were complete, the great reliquary shrine had probably been made, embellished with gilt copper figures of Christ and the apostles and panels showing scenes from the saint's life.[51]

The building was from the outset not only the resting place of St Elizabeth but also the church of the Teutonic Knights, so that almost immediately the Grand Masters of the Order and the Langraves of Hesse and Thuringia – the saint's descendants – chose to be buried in close proximity to the patron.[52] The earliest effigy is that of Konrad of

286. Tomb effigy of the Landgravine Alheidis of Hesse (d.1274); *Elisabethkirche*, Marburg; *c*.1275

287. Tomb effigy of the Blessed Erminoldus (d.1121); abbey of Prüfening (Regensburg); 1283

Thuringia (died 1240), but from the point of view of style and typology a later tomb is perhaps of more interest. It shows the Landgravine Alheidis of Hesse, who died in 1274 [286]. As is so often the case she appears to be standing rather than lying down, and in a tender gesture presents her small son, who joins his hands in prayer and smiles broadly. One is instantly put in mind of the equally delighted blessed souls to the left of the *Fürstenportal* tympanum at Bamberg [142], of about 1235, and it would seem that it was also the intention at Marburg to show the mother and child as if entering Paradise: above, two angels fly out from the canopy holding the figures' souls. If the style of the figures is old-fashioned, possibly consciously so, the type of effigy with child is unusual for this date. As far as is known, the first juxtaposition of parent and child in a funerary context is on the wooden effigy of Count Henry III of Sayn with his daughter (Germanisches Nationalmuseum, Nuremberg), of 1247–8, while another notable example in Basel Minster shows Queen Anna (died 1281), wife of Rudolph of Habsburg, with her son Charles, who predeceased her in 1276.[53]

THE 'ERMINOLDMEISTER' AND SCULPTURE IN SOUTH GERMANY AROUND 1280

Another effigy, slightly later than the group just discussed, serves as an introduction to the work of a sculptor known as the *Erminoldmeister*, so named after the subject represented

on the tomb. Following in the tradition of celebrating notable figures many years after their death, the effigy of the Blessed Erminoldus (died 1121), the first abbot of the Benedictine monastery of Prüfening – just outside Regensburg – was only made in 1283 [287].[54] Because the date of the sculpture is securely documented it acts as the starting point for this sculptor or workshop's *œuvre*, as distinctive in its own way as that of the Naumburg atelier, but it was not the earliest work.

It has been proposed that the genesis of this particular style is to be found in the Upper Rhine, in the archivolt figures of the west portal of the Basel Minster (probably *c*.1275). There the mannered angels and half-length prophets and kings with narrow faces, curly beards and squeezed eyes are carved in an unmistakeably similar manner, and although possibly influenced by developments in Strasbourg they reveal a marked individuality. Other Upper Rhenish sculptures of about the same date, such as the figures on the Holy Sepulchre in Constance Cathedral, the effigy of the eighth-century Eberhard in the abbey church at Murbach near Colmar, and a standing angel in the Musée d'Unterlinden in Colmar show a comparable local style informed by metropolitan impulses.[55]

Sometime before 1283, probably in the late 1270s, the workshop moved to Regensburg, where the cathedral was being rebuilt. Evidence of their early work in the cathedral is a small gable-stop carved with an animated smiling monk

recently discovered in the upper polygonal choir when the organ was moved, which provides a clear link with the voussoir figures at Basel.[56] But it is the life-size Annunciation group set on the western crossing piers – the Virgin to the north, the angel to the south – and the seated figure of St Peter, probably formerly in the cathedral, now in the Regensburg Stadtmuseum, which together with the effigy of Erminoldus constitute the core of the principal sculptor's output. The style of all four figures is decidedly quirky: there is a love of all-enveloping heavy draperies, while the faces are characterised by pinched smiles and framed by baroque curls. In the heads of Erminoldus and St Peter there is a very distant echo of Paris and Reims in the third quarter of the century, and Troyes has also been suggested as a source of inspiration; but in the final analysis the figures can only be viewed as a personal, regional response to what was by now a pan-European style.[57]

It is possible that this master stayed in Regensburg for the rest of his life. In the same year as he executed the Erminoldus tomb (1283) there is a reference for the first time in the Regensburg records to a *Magister Ludwicus lapicida*, and in 1306 a will drawn up by his widow describes the same person as the *magister operis sancti Petri Rat(isponensis)*.[58] Although it is tempting to think of this Master Ludwig as one and the same person as the *Erminoldmeister* the lack of further evidence would make it incautious to press the point; it should be noted, however, that such a rôle, combining the skills of chief sculptor with master of works (*Baumeister*), would not be unusual at this date.[59] In support of this hypothesis there do not appear to be any works – excluding the early Basel archivolts – in this sculptor's style outside Regensburg; the Virgin and Child of around 1280 in the Lorenzkirche in Nuremberg, sometimes associated with the *Erminoldmeister*, actually seems instead to reflect the influence of mid-century models in Mainz and Bamberg.[60]

THE STRASBOURG WEST FAÇADE AND UPPER RHENISH SCULPTURE, 1280–1300

By the 1280s work was in progress on the west façade of Strasbourg Cathedral, the most ambitious portal programme of the end of the thirteenth century. The Gothic nave had been completed in 1275 and the foundation stone of the new west front was laid two years later on 25 May 1277 by Bishop Konrad von Lichtenberg. Several drawings of the façade still exist which are usually interpreted as illustrations of the evolution of the design from a straightforward version of the Rayonnant of the Paris transepts (Scheme A, *c*.1260) to a more complex arrangement specifically suited to the building (Scheme B, *c*.1275–7). Although the façade as a whole was not completed until the fifteenth century the three doorways appear to have been in place within twenty years, and by 1318, when the architect Erwin von Steinbach died, building had progressed up to the level of the rose window.[61] The form of the doorways follows the standard French pattern but the absence of any saints in the jambs sets them apart from their predecessors. The three tympana were designed to be read together from left to right: that on the north side shows the Infancy of Christ, the central portal

has the Passion, and the south is dedicated to the Last Judgement.[62] Although the central portal [288] has prophets in the jambs and the Virgin and Child on the trumeau (nineteenth-century), the lateral portals depart from usual practice by placing figures of Virtues triumphing over the Vices on the north and the Wise and Foolish Virgins, with the accompanying figures of Christ and the 'Prince of the World' or Tempter, on the south [289, 290]. Several of these have been replaced by copies, so that two Virtues, four Wise Virgins, two Foolish Virgins, the Tempter, and two prophets are now in the Musée de l'Œuvre Notre-Dame.[63]

The only known precedent for setting figures of the Virtues on the jambs of a portal was on the north transept at Notre-Dame, Paris, but there only the three theological Virtues occupied the right side of the doorway. The Wise and Foolish Virgins, on the other hand, do not appear to have been utilised on a monumental scale, as free-standing figures, on French portals, but as we have seen they seem to make their début at Magdeburg at around the middle of the century. Their rôle as symbols of the Blessed and Damned, as vital living elements of the Last Judgement iconography,

288. Central portal, west façade, Strasbourg Cathedral (detail); *c*.1280–1300

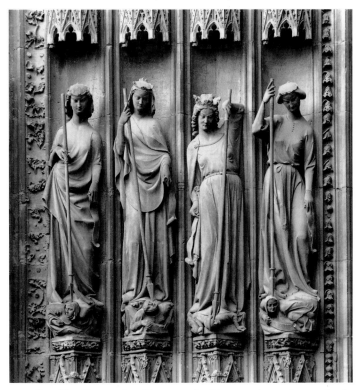

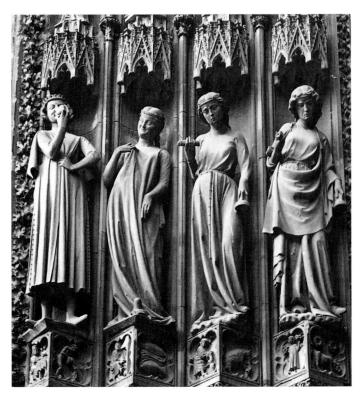

289. The Virtues triumphing over the Vices; north portal, west façade, Strasbourg Cathedral; c.1280–1300

290. The Foolish Virgins; south portal, west façade, Strasbourg Cathedral; c.1280–90 (and nineteenth-century copies)

291. 'The Prince of the World'; from the south portal, west façade, Strasbourg Cathedral; c.1280–90 (Musée de l'Œuvre Notre-Dame, Strasbourg)

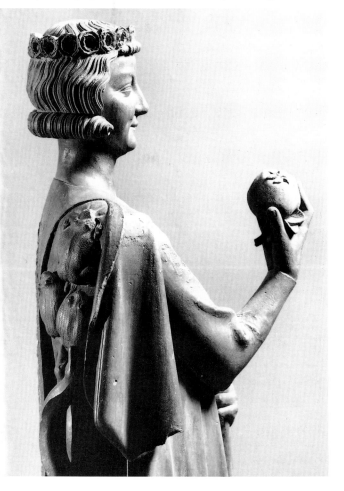

is enhanced by the novel addition to the jambs of the standing Christ, blessing the Wise Virgins to the right of the entrance, and the introduction of the memorable figure of the devilish but handsome young prince, who with a smile seductively offers an apple – in an obvious reference to the Temptation of Eve – to one of the Foolish Virgins. What she cannot see, but clearly visible to the spectator, is the revolting sight of the prince's decomposing back, crawling with snakes, toads and lizards, and anticipating the gruesome treatment of the dead body in the *transi* tombs of the end of the fourteenth century and later [291].[64] As might be expected, this arresting figure captured the imagination of the public and ecclesiastical patrons, and is seen again in almost identical form at Freiburg im Breisgau, Basel and St Sebaldus in Nuremberg.[65]

Given the self-evident architectural and iconographic connection with the Paris transepts it is hardly surprising that at least some of the sculptures are also derived stylistically from the same source. It has long been recognised that the reliefs of the central tympanum depend from those of the south transept at Notre-Dame and that the Wise and Foolish Virgins have much in common with contemporary Parisian sculptures.[66] However, we have seen that sculptural activity continued almost without interruption throughout the thirteenth century in the Strasbourg lodge, punctuated by the major works of the south transept at the beginning, the choirscreen in the middle and the west front at the end of the century. The jamb figures at Strasbourg, be they Virgins, Virtues or Prophets, are not slavish copies of developments in Paris, but are products of a mature Upper Rhenish workshop of some size, constantly assimilating new influences from outside. The Virtues are linked with the

earlier figures of the choirscreen in their slim and metallic appearance, while the rather wild and mystical bearded prophets – probably the latest of the jamb figures – take to extremes the mannered appearance of the figures on the interior west wall at Reims.[67]

Some of the sculptors, most obviously those responsible for the Wise and Foolish Virgins, moved on to the minster of Freiburg im Breisgau, where the deep western porch was embellished with sculpture. There was room for only one large portal at Freiburg, but the long lateral walls of the porch and those facing the portal were used to create a comprehensive decorative scheme made up of single free-standing figures: although not of the same scale as Strasbourg it covered similar themes. The tympanum is devoted to the Infancy and Passion of Christ and the Last Judgement, while below the Virgin and Child, close in style to the Strasbourg Virtues, stands on the trumeau above the sleeping figure of Jesse. On the jambs, to the left are the Three Magi and *Ecclesia*, on the right the Angel of the Annunciation, the Virgin, the Visitation and *Synagoga*. These figures are smaller than the Virgin, about two-thirds life size, and of the same dimensions as the further twenty-eight figures standing above the blind arcading which runs around the walls of the porch [292]. The latter, including the Wise and Foolish Virgins (with Christ and the Devil-Prince), personifications of the seven Liberal Arts, four female saints (Margaret, Catherine, Mary Magdalene and Elizabeth (?)), three Old Testament figures (Abraham, Zacharias and John the Baptist), an angel and the semi-naked single figure of *Voluptas* – draped only in a revealing goat's skin – are almost certainly not all now in their original places; in addition, all the sculptures were repainted in 1888–9.[68] The major changes to the present arrangement would bring the Prince and *Voluptas* into positions flanking the Foolish Virgins on the south wall and would group all the Liberal Arts together in the southwest corner, in effect creating three linked and juxtaposed groups.[69]

It is of interest to note that the Freiburg porch was from the beginning more than simply the covered entrance to the church. Standing in the heart of the market, the minster[70] was at the centre of the town's life and the porch was utilised not only as a meeting place but also for the holding of trials: tiered stone benches still indicate this function. On the exterior, officially scored into the red sandstone of the fabric over the centuries, are numerous measuring marks (including outlines of loaves of bread) which set the standards for the traders outside.[71] Any dispute would have to be settled within sight of the Virgin and Child.

A comparable scheme was probably created in the western porch at Basel Cathedral, but was largely destroyed in an earthquake in 1356. Only four figures – Henry II and Kunigunde, the Tempter and one of the Foolish Virgins – and two detached heads have survived, the former mounted on piers to each side of the slightly earlier portal.[72] It is not now possible to judge whether the Freiburg porch preceded the Basel ensemble or *vice versa*, and while arguments put forward in favour of dating the Basel figures before 1289 and those in Freiburg before 1301 are not wholly conclusive it is likely that both sets of sculptures were indeed made in the last fifteen years of the century.[73]

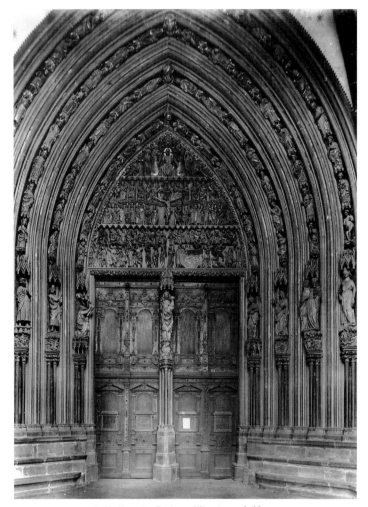

292. Western porch, Freiburg im Breisgau Minster; probably *c.*1290–5

COLOGNE AND MARBURG AT THE END OF THE THIRTEENTH CENTURY

From 1248, when Archbishop Konrad von Hochstaden [284] laid the foundation stone for the new cathedral at Cologne, the great city on the Lower Rhine was at the height of its power. The tradition of sculpture in stone and especially wood has already been noted, and we have seen that a workshop from the city was called to execute the polychrome-wood founder effigy in the abbey of Maria Laach to the south in around 1270–80. Other sculptors travelled to the suffragan see of Liège in 1279, where it was recorded that John of Cologne, Peter the German and Enguerrand the Bohemian, 'who had no equal in the world', completed *le Beau Portail* of the now-destroyed cathedral of Saint-Lambert.[74] French influence was by this time prevalent in the Meuse valley, but little remains to show the monumental output in stone in the second half of the century. The suggestive remnants of a Last Judgement programme on the west portal of Notre-Dame at Dinant now have to suffice to show this side of sculptural production, while the more numerous wood sculptures continued in the conservative style of the mid-century.[75] Further north, in Westphalia, the most significant surviving sculptures are also in wood, although the Wise and Foolish Virgins in the

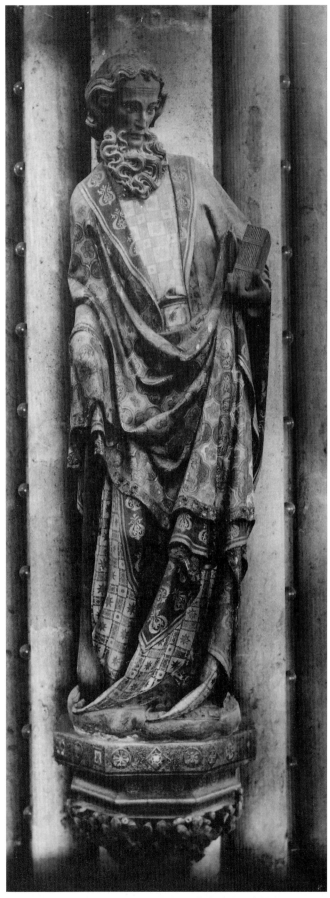

293. St James the Less; choir pier, Cologne Cathedral; probably *c.*1290

294. Angel on canopy above the Apostle Philip; choir pier, Cologne Cathedral; probably *c.*1290

voussoirs of the south portal of Minden Cathedral are worthy of note for their fine quality; in spite of a date of 1270–80 they have their stylistic roots in the very much earlier Freiberg *Goldene Pforte* and some of the figures of the Münster Paradise porch.[76]

Work on the chevet of Cologne Cathedral carried on throughout the second half of the thirteenth century, and from about 1280 a large sculpture lodge was extremely active on a decorative scheme of great splendour. Although the choir was only formally consecrated in 1322 it was structurally complete by 1304, when the wall closing it off from the west was finished: this was not to be removed until 1863. The superb wooden choirstalls remained to be made in 1308–11, the glazing was only put in place in about 1310, and the magnificent marble high altar was left until last, probably being executed in around 1315–22.[77] Before these extraordinarily rich furnishings were installed all the stone sculpture must have been in place. Twelve over-life-size apostles [293] and figures of Christ and the Virgin, standing on foliate consoles on the choir piers six metres above the ground, are the most conspicuous survivals. Each of the apostles has an elaborate canopy upon which perches a small angel playing a musical instrument [294], and although all the figures were repainted in 1840–2 it is likely that their appearance closely approximates to the original. The placing of the apostles inevitably recalls the interior decoration of the Sainte-Chapelle in Paris, and it must have been the intention of the Cologne cathedral chapter – led by Konrad von Hochstaden – to emulate the famous Parisian chapel

295. The 'Mailander Madonna'; Sakramentskapelle, Cologne Cathedral; polychromed walnut, probably c.1290–1300

296. St Elizabeth between St Catherine and St Mary Magdalene; high altar, Elisabethkirche, Marburg; c.1290

from the beginning. Branner has shown that it is unlikely to be a coincidence that the rebuilding at Cologne started in precisely the same year as the dedication of the Sainte-Chapelle, and that the architectural form of the cathedral's east end would not have been possible without the example of Amiens and the royal chapel. Like the Sainte-Chapelle, it was meant to be seen as a huge and sumptuous container for the city's most highly venerated relics, encased behind the high altar in Nicholas of Verdun's *Dreikönigenschrein*.[78]

Not only the spatial concept was taken over from the Sainte-Chapelle. The style of the swaying apostles and the richness of their garments, inset in places with fictive gems, are clearly modelled on the Parisian figures, although it appears that at least thirty years separates the models from the later versions. Opinions differ over when the Cologne apostles were executed, but a date in around 1290 seems most plausible.[79] Immediately afterwards the same workshop carved the so-called *Mailänder Madonna* (traditionally considered to have been made to replace a statue of the Virgin brought from Milan in 1164 by Reinald von Dassel) which is no less eloquent of French inspiration [295]. Now placed on the central pier of the Holy Sacrament chapel, the polychromed walnut figure was originally displayed on the high altar of the *Marienkapelle* on the south side of the choir, within an elaborate pinnacled stone tabernacle carved with extraordinary attention to detail and carefully painted.[80]

The sanctuary was separated from the ambulatory to the north and south by an enclosing screen in about 1300, the inner sides of which were decorated by the still extant cycle

of paintings in 1330–40. This enclosure was originally embellished with brightly coloured stone sculpture, especially around the north and south entrances, but this was all demolished in the modernisation of the choir in the years after 1760. At the same time the impressive stone furnishings of the choir, including the archbishop's throne, the sedilia and pulpit, were swept away. Fortunately many fragments of this decoration were discovered in excavations in the choir in 1966–7, including several torsos, and together with four fine small heads in the Rheinisches Landesmuseum in Bonn and the Schnütgen-Museum in Cologne they provide important additional information for a reconstruction of the original splendid appearance of the choir as a whole.[81]

At the same time as the Cologne choir was being built and furnished the *Elisabethkirche* in Marburg was completed. The high altar was dedicated in 1290, so it is likely that the west portal, which in its tympanum has the Virgin and Child attended by angels, all set against a dense background of naturalistic leaves and flowers, was executed in the previous decade. The Virgin gives the appearance of a trumeau figure – including the canopy and sculpted socle – lifted up into the tympanum area, and its close similarity to the *Vierge dorée* of Amiens attests to the widespread influence of that particular model.[82] Inside the church a shrine-like high altar in stone was placed in the choir in time for the dedication, with nine figures set into three gabled niches. Those on the left side were renewed in the nineteenth century, but the central and right hand niches still retain their original, if

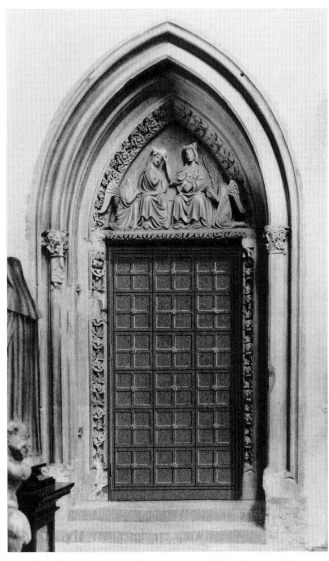

297. The Coronation of the Virgin; tympanum on south side, St Hedwig's chapel, abbey of Trzebnica; after 1267

298. Princess Salomea; from the destroyed collegiate church at Głogów; probably *c.*1290 (National Museum, Poznań)

overpainted, statuettes: the Virgin and Child flanked by two crown-carrying angels (centre) and St Elizabeth between St Catherine and St Mary Magdalene [296]. The style of the figures is unlike that of both the Virgin and Child on the west portal and the tomb of Alheidis, which hark back to considerably earlier types, and instead it reveals the contribution of sculptors schooled in the latest manner of the Upper Rhenish workshops at Strasbourg and Freiburg im Breisgau.[83] It was probably partly through the activities and crusades of the Teutonic Knights that this type of sculpture was disseminated eastwards, and although much has undoubtedly now disappeared there are still traces of such work as far afield as Silesia.

CENTRAL EUROPE

By the middle of the thirteenth century the Kingdom of Poland had split into a loosely-bound agglomeration of independent duchies. Silesia, the closest of these to the Holy Roman Empire, had already separated into Upper and Lower Silesia in 1163, and in 1248 the latter divided again

into the duchies of Wroclaw (Breslau), Legnica (Liegnitz) and Głogów (Glogau). The German colonisation that occurred from about this time would suggest that the area was receptive to artistic impulses from the west, but because so little has survived one can gain only a limited impression of the extent of sculptural production. In the second chapter it was shown how the earliest sculptures at Trzebnica (Trebnitz) were closely related to work at Magdeburg; and after 1267, when the founder Hedwig was canonised and a chapel constructed in her honour, the sculptural decoration seems also to have been derived from German sources. This consisted principally of a double-sided tympanum on the door between the saint's chapel and the presbytery, with the Coronation of the Virgin on the south side [297] and the Crucifixion between the Virgin and St John on the north.[84] From a qualitative standpoint it is no way comparable, but the repertoire of naturalistic leaf forms and facial expression point to it as being an offspring of developments at Naumburg and Meissen. That sculptors from Saxony were employed in Lower Silesia, or possibly sent finished works, would appear to be confirmed by a now-destroyed tomb. If

the eighteenth-century drawings of the effigies of Count Peter Wlostowic and his wife Maria (probably *c.*1270–80) once in the church of St Vincent in Wroclaw are taken as credible evidence, the link with Naumburg is clear. The pose and dress of the figures – especially that of Count Peter – are very similar to those of Ekkehard and Uta, and like the Naumburg founders they had died more than a century before the creation of their monument.[85]

A chance find in the walls of the destroyed collegiate church of Głogów in 1945 provided the best surviving example of sculpture of the second half of the thirteenth century in Poland. The over life-size statue of the Princess Salomea [298], now in the National Museum in Poznań, was originally mounted in the choir alongside that of her husband, Prince Konrad, who had died in 1274.[86] Both were benefactors of the church, and they were thus also honoured in a comparable way to the founders at Naumburg and Meissen. The style of the figure, however, has more to do with that of the St Elizabeth at Marburg, and it has even been proposed that the sculptor came from Hesse to Głogów in about 1290 to carry out the work. This must remain as conjecture, but the lack of anything similar in Polish art of this time, and the presence of the aforementioned tombs seemingly by Naumburg sculptors, adds weight to the claim.[87]

Elsewhere in eastern Europe, in Bohemia and Hungary, the period 1250–1300 was not marked by sculptural production of any significance. Perhaps shaken by the incursions of the Mongols in 1241–3, and only very gradually embracing the Gothic architectural style, the commissioning of new work seems to have gone through a temporary lull. In Bohemia a few wooden Virgins and minor architectural sculptures are all there is to show, and in Hungary only the church of Our Lady in Buda indicates a familiarity with the repertoire of sculptural forms current throughout western Europe.[88] But this was not to last. The fourteenth century was to witness an extraordinary artistic awakening in central Europe, galvanised by the patronage of the Luxembourg dynasty and financed with the huge natural resources of these open lands. Within a hundred years Prague had taken its place alongside Paris, Cologne and London as one of the great centres of European civilisation, and the *Schöne Stil* held sway from Innsbruck to Lübeck and from Buda to the Rhine.[89]

CHAPTER 9
England 1240–1300

WESTMINSTER ABBEY, 1246–59

If in the years before 1240 Wells Cathedral was the principal magnet for southern sculptors, after 1246 Westminster Abbey supplanted it as indubitably the most important centre of sculptural activity in England. The monks of Westminster had already started to make changes to the abbey church in 1220, when they began construction of a Lady Chapel at the east end of the eleventh-century building, but they faced increasing difficulty in meeting the cost of the improvements. Fortunately the young King Henry III, who was crowned there in 1220, took a growing interest in the abbey and gradually assumed financial responsibility for much of the work.[1] From this early time his attachment to the abbey and to the figure of the royal Saint Edward never waned until his death in 1272, and the amount of money he devoted to the building of the new church from 1246 was unparalleled in Europe. As a patron of architectural projects on a grand scale, prepared to spend a large proportion of his annual income on commissioning works of art of great beauty, he stands comparison with the rulers of any age. The most obvious parallel is to be drawn with his exact contemporary and brother-in-law Louis IX, and as we shall see Henry himself often felt the need to compete with the French king. In political acumen and military expansion he came a poor second to St Louis; but in the building of Westminster Abbey he may be said to have surpassed him.

Although Henry had not yet been to France he would undoubtedly have been aware of the important buildings being constructed in the orbit of Louis's court. By 1245 the Sainte-Chapelle was nearly complete and the abbey church at Royaumont, the new Capetian necropolis, had been dedicated in 1236. Henry decided formally to establish the Benedictine abbey church at Westminster – because it contained the body of the Confessor – as not only the Coronation church of the English monarchs (a rôle it already fulfilled, comparable to Reims Cathedral) but also as a family and dynastic mausoleum, a combination of Royaumont and Saint-Denis. Before work on the new church had begun he had employed goldsmiths in 1241 to start work on the extraordinarily expensive shrine of St Edward, which would only be finished in 1269; and in 1247, when building was in progress, the King was able to set beside the relics of his sainted predecessor a newly-acquired rock-crystal phial containing the Blood of Christ. The vessel was processed through London on the Feast of St Edward, held aloft by the King from St Paul's to Westminster, and from the beginning it was seen as complementary to the saint, specially venerated on his Feast day. Its acquisition was quite clearly viewed as an emulation of the bringing of the Crown of Thorns and the relic of the True Cross to Paris by Louis IX in 1239 and 1241, and was part of a determined attempt to present Henry as the French king's equal.[2]

After the eastern part of the old church had been demolished in 1245 the foundations of the new were laid probably in spring the following year. It appears that the choir, transepts and chapter house were raised in the remarkably short time of fourteen years, because in 1259 orders were given to pull down the eastern parts of the old nave; and by 1269, when the Confessor's remains were translated to his shrine behind the high altar, the nave had been extended by five bays to the west, accommodating the monk's choir. Consonant with the idea that the church's internal decoration should be viewed as a response to the jewel-like appearance of the Sainte-Chapelle, it is probable that the basic design and surface decoration of the shrine of St Edward, begun in 1241, was already known and that the dense diaper patterns in the spandrels of the main arcade and gallery of the choir and transepts, once probably gold and red, were intended to magnify its effect.[3] The first architect of the new church was Master Henry 'de Reyns': whether he was French – from Reims – or English is unknown, and it has been shown by architectural historians that despite its overwhelmingly French appearance the design also incorporates a number of distinctively English features.[4] It is certainly the case, however, that Reims Cathedral provided the architect not only with many of the most important architectural elements of the abbey church but also with the inspiration for his designs for the chapel of St Edward the Confessor in Windsor Castle in 1240.[5] In sculpture too the influence of Reims is evident, but ironically it is most conspicuous in the least visible places, notably in the corbel figures and heads of the presbytery triforium, and in St Faith's chapel off the south transept.

The style of these crouching figures and grimacing heads, combined with the positioning of many of them high up in the triforium, immediately recalls the naturalistic heads and figures in the Reims transepts [299]. As at Reims (p. 65), the masons have taken the opportunity to experiment with the depiction of facial expression in a manner that was rarely possible in historiated compositions, and have treated each corbel individually. They hardly qualify as portraits, despite the efforts of some to identify them as such, but are instead lively and rather irreverent studies.[6] There was already by this time in England the beginning of a tradition of carving characterful head stops, and unlike the case of Bamberg, for instance, where Reims-trained sculptors travelled to work in the mid-1230s, there is little sign of a direct foreign contribution. It may well be that one or more of the Westminster sculptors had been to Reims, or that the architect encouraged them to copy the *Rémois* work, but the heads belong firmly in an English milieu. The earlier examples, at Wells, Oxford and Salisbury cathedrals, lack the range of expression manifested in the Westminster heads, and although the corbel heads of bishops at Salisbury are accomplished pieces of sculpture they fulfil a more public rôle in the nave, equating more closely to the solemn countenances found on effigies.[7] The semi-hidden and more emotionally-charged character of the Westminster corbels is paralleled outside

London by an exactly contemporary single head stop found in excavations at Henry III's Clarendon Palace, near Salisbury [300]. In this rare piece of secular architectural sculpture, probably made to face a complementary label stop on the other side of a door or window hood-mould, the sculptor has created a penetrating observation of great pain or anguish by wrinkling the brow and showing the eyes squeezed tight shut. It is difficult now to be sure how such a head would have been perceived at the time of its installation at Clarendon: would it have had a moralising aspect, paired with a head exemplifying happiness? It was of course more visible – albeit to a small audience – than its analogues in the triforium at Westminster Abbey (although no more so than the heads in St Faith's chapel), but in the absence of any knowledge of its original context in the royal palace it would be unwise to posit a too sophisticated reading.[8]

It is likely that many of the sculptors and masons gathered together at Westminster emanated from the West Country. This is suggested not only by common sense – as major building projects had been carried out in the previous years or were still continuing at Wells, Salisbury and elsewhere – but also by the names of some of the master masons, such as John of Gloucester, and by the migration of sculptural types. The method of decorating the spandrels above the blind arcades in the transepts and radiating chapels at Westminster with narrative scenes was, as we have seen, probably first employed at Worcester, although the standard of the earlier work does not come close to the best sculpture in London. Unfortunately, much of the spandrel sculpture *in situ* in the Abbey has been damaged or destroyed by the insertion of later monuments, but some detached pieces give an idea of its marvellous quality.[9] The crispness and precision of the

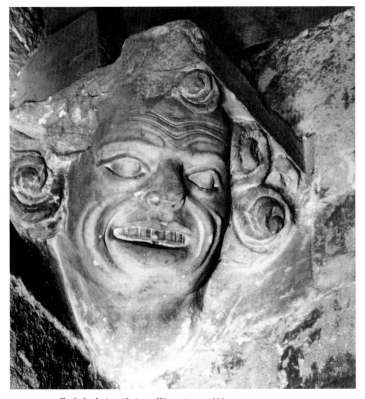

299. Corbel, choir triforium, Westminster Abbey; *c*.1245–55

300. Headstop from Clarendon Palace; *c*.1245–50 (Salisbury and South Wiltshire Museum)

301. Head of an angel, probably from a wall arcade of one of the radiating chapels, Westminster Abbey; *c*.1245–50 (Dean and Chapter of Westminster)

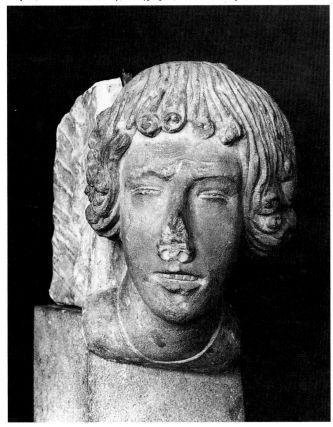

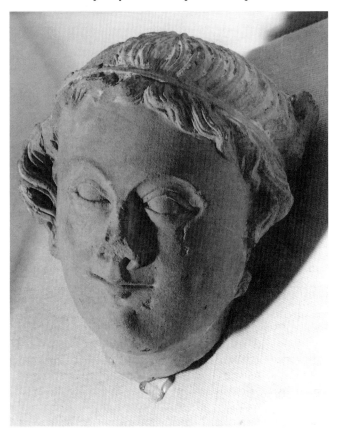

302. Section of choirscreen, Salisbury Cathedral; probably c.1240

carving is best exemplified in a superb head of an angel, probably from a hood-mould of the wall arcade in one of the radiating chapels [301], which shows the cool classical elegance and the self-contained smile of the best of the Wells angels [168]. Indeed, the distinctive treatment of particular facial features, such as the sharply-defined arcs of the eyebrows, the almond-shaped eyes with double lids and the slightly pinched thin mouths, even indicate that a member of the Wells workshop was employed at Westminster in the late 1240s.[10] This is reinforced by the compositional similarities between the Westminster spandrel reliefs still *in situ* and the small narrative quatrefoil sculptures and certain of the larger figures at Wells; in both places the figures are cleverly fitted into awkward spaces with angled sides by reducing the size of the flanking figures and seating them with one knee raised along the slope of the arch.[11] Furthermore, the close relationship between a crown-holding demi-angel in one of the Westminster spandrels and the same figures at Wells, and between the lush foliage above the former and that in the spandrels above the resurrected souls at Wells, leaves little room for doubt that the sculptors responsible for these particular reliefs at Westminster had previously worked at the cathedral in Somerset.[12]

The placing of angels in the spandrels of wall arcades, consciously reminiscent of the decoration of metalwork shrines and suggestive of heavenly space, had been seen at the beginning of the thirteenth century in St Hugh's choir in Lincoln Cathedral and would continue throughout the century to be a particularly popular form of architectural decoration in England. At about the same time as the Westminster spandrels were being carved another workshop was executing what must have been one of the most impressive choirscreens of the thirteenth century, using an angelic choir to enliven the surfaces above the niched arcade on its front [302]. Unlike the more or less contemporary French examples at Chartres and Bourges, the Salisbury screen was not open under its arcades and set with altars, but was decorated with fourteen niches filled with figures thought to be kings, which were destroyed at the Reformation; rectangular panels above probably originally held narrative reliefs.[13] What remains of the screen – ten niches from the lower section – was removed to the north-east transept as a result of Wyatt's restorations in the late eighteenth century, but the fine quality of the surviving head stops and angels, with their wings spread to fill the space of the spandrels in a manner strikingly similar to the angels in the spandrels of the wall arcade of the Sainte-Chapelle, is still apparent.

The presence of angels at Westminster extends to the upper walls of the transepts, where some of the most beautiful sculpture of the abbey is to be found. On the soffits of the lancet windows above the north transept doorway are twenty-four half-length angels in foliate roundels and lobed squares, some playing musical instruments, others holding censers or other objects, while at the sides are two standing kings, usually identified as St Edward and either St Edmund or Henry III.[14] Above these, just below the rose window, two full-length angels swing censers in the direction of two now-missing figures which would originally have stood on corbels in the central spandrels.[15] Because the two figures in the facing positions on the south transept appear to represent the legend of Edward the Confessor giving his ring to St John in the guise of the poor Pilgrim, it is possible that here the Confessor was receiving the ring back from St John in immediate anticipation of the former's death and salvation. If this interpretation is accepted, the choir of angels immediately below would thus have welcomed the royal saint into Paradise. The story was a particular favourite of Henry III, and as a fable demonstrating the divine outcome of charitable deeds it was probably chosen by the king himself, who must have hoped for a similar reward for sponsoring the building of the abbey church.[16]

The two censing angels in the half-spandrels on the south transept [303] are even finer than their counterparts to the north and are often said to represent the high point of Westminster sculpture in around 1255. Carved almost in the round, their outstretched arms and wings once again perfectly fill the potentially barren space between the triforium arches and the transept walls, creating a harmonious marriage of sculpture and architecture. This unity would have been further underscored when the entire south wall – as elsewhere – was ablaze with colour. The polychromed sculpture, gilded and painted architecture and brilliant stained glass would all have combined to persuade the visitors entering through the main north transept portal that they had temporarily moved from earth-bound to heavenly surroundings.[17] Some impression of this effect can of course still be gained in the much-restored but suggestive interior of the Sainte-Chapelle, where similar censing angels occupy the spandrels of the wall arcades and the corners of the

303. Censing angel; south transept, Westminster Abbey; *c.*1255

304. Boss with combat between lion centaur and man; muniments room (south transept, west gallery), Westminster Abbey; *c.*1250–9

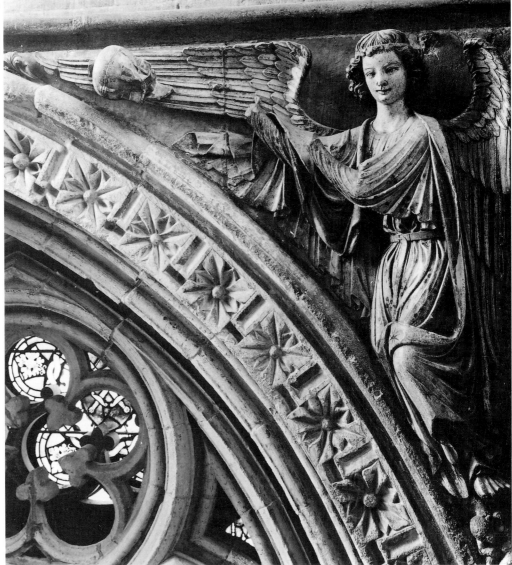

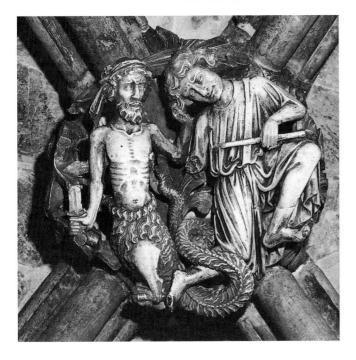

Tribune aux reliques, and it may well be that the introduction of large-scale angels of this type into a shrine-like setting was derived from the newly-built Parisian royal chapel.[18] Because of the perceived superiority of the south transept angels they have sometimes been associated with a certain John of St Albans, named as sculptor of the king's images in 1257, but this is no more than hypothesis: his activities and even his origins (was he Flemish, from St Omer?) remain unclear.[19] Nevertheless it is worth mentioning in this connection that from the accounts it can be seen that the work at Westminster was contracted out as taskwork, so that the masons and imagers were paid either by the week or for particular jobs at fixed rates. Rather than suggesting that a large 'Court' workshop executed the majority of the sculptural work at the abbey it seems to have been the case that small freelance teams, supervised by the Master Masons and clerks of work, were employed instead.[20] The stylistic homogeneity of much of the sculpture must partly be to do with the overall control exerted by these Masters, and also with the extremely short space of time in which the work was carried out.

The style of the south transept angels has been identified in other sculptures of the highest quality at Westminster, most notably in the three famous bosses showing scenes of combat (between a centaur and a man [304], a centaur and a dragon, and a man and a dragon) in the recess of the chamber in the adjacent gallery, now the muniments room. This probably originally housed the royal pew, and the bosses, set above the lancets on the south side of the chamber, may allude to the dangers lurking outside the House of God; by contrast, the two decayed bosses in the main vault of the chamber, above the heads of the royal congregation, show Abraham with two souls of the Blessed and the Coronation of the Virgin. Looking up, they might optimistically have linked the fate of the king and queen with the first and the sanctity of royal coronation with the latter.[21] It is of interest to note that Robert of Beverley, later to be King's Master Mason at Westminster, was paid 32s in 1253 for carving four bosses; and although it is unlikely that this payment was connected with the muniment room sculptures it further confirms what has already been said about the division of work and the contribution of single, named, masons to the programme of decoration.[22]

Other bosses, in the western aisle of the north transept, are devoted to King David harping, the Annunciation and Aaron and Moses. But west of the crossing, further from the shrine and high altar, the iconography of the sculpture in the nave aisles turns from the religious to the secular. In a fascinating and unique display of heraldic decoration, the spandrels of the wall-arcades were carved with shields showing the arms of the royal houses to which the king was connected by marriage and of his principal vassals, starting at the east with the most important (the Empire and France on the north side, Edward the Confessor, England, Provence and Scotland on the south) and continuing with the arms of the major English barons (Clare, Bigod, Montfort, Warenne, Bohun and Albermarle to the north, de Quincy, de Lacy, Richard, Earl of Cornwall, and Richard, Earl of Ross to the south). These must have been carved between 1259 and 1264, before Simon de Montfort's revolt, and it has quite plausibly been suggested that this novel idea was sown in Henry III's mind on the occasion of his visit to Paris in 1254. The way the shields are shown at Westminster, hanging on their straps from exquisite little heads, must indeed have been intended to evoke the sort of heraldic display seen by the king when he dined with Louis IX in the great hall of the Old Temple; Matthew Paris recounted how on that occasion, numerous shields were hung up, in the continental fashion (*secundum consuetudinem ultramarinam*), around the four walls of the hall.[23] If the monks of St Peter's Westminster had been unaware of it before, they could now hardly fail to recognise that their abbey church had been appropriated by the Crown.

Outside the main body of the church, and excluding the

305. The Archangel Gabriel; Chapter House, Westminster Abbey (*ex situ*); c.1253

north transept portal (which will be discussed shortly), the other principal area of sculptural endeavour at this time was around the portals of the chapter house. Entrance to the chapter house was obtained through the east walk of the cloister to the south of the church by means of a double vestibule. At each end of this vestibule was a decorated doorway. That to the west, opening into the cloister, is now extremely decomposed, its condition exacerbated by the use – here and elsewhere at Westminster – of different stones set alongside one another and the application of shellac to the sculptures in the nineteenth century.[24] But from what remains and from earlier descriptions and illustrations it may be seen that the tympanum, cut into by a two-centred arch on a trumeau, once contained three figures standing on stiff-leaf corbels, all set against a background of swirling foliage, painted and gilded: the central figure, now lost, was almost certainly the Virgin and Child, while those flanking her are angels, that on the right the better preserved. The tympanum is enclosed by two orders of voussoirs, the inner foliate, the outer filled with the small seated figures of the Tree of Jesse.[25] The affiliation with West-Country sculptures detected inside the church is again apparent here in the design of the doorway. At Westminster the area of the tympanum has been greatly enlarged and the number of archivolts reduced to fit the particular shape of the vaulted bay of the cloister, but the distinctive double pointed arch and the Tree of Jesse in the outer voussoirs would seem to point in the direction of the north transept doorway of Lichfield Cathedral, completed in 1241, as the source of inspiration.[26]

The inner doorway has received more attention from both the historian and the restorer. Like that on the cloister side it has extremely fine small seated figures amongst foliage – this time mostly prophets – in the archivolt and on the southern jambs, inside and out.[27] But when standing inside the chapter house, the eye is drawn first to the large-scale sculpture above the entrance. Unfortunately, the obtrusive figure of Christ in Majesty that fills the tracery is an insertion of 1866–72 by Sir Gilbert Scott based on the later, also restored, inner chapter house doorway at Salisbury: originally it would have had an open aspect with a cusped circle, as at Southwell, admitting more light into the vestibule. Ignoring this distraction, the rest of the sculpture is all original, if not in perfect condition, and has long been considered to be among the most important in the abbey. In the spandrels to each side of the arch a trefoil contains a full-length censing angel with another, shown three-quarter length and floating in clouds, behind. They face away from the centre of the doorway and are clearly paired with the slightly over life-size figures of the Archangel Gabriel and the Virgin Annunciate, placed in niches to the left and right respectively [305, 306].[28] The Annunciation group is of special interest for a number of reasons, but particularly because it is likely that the Angel

306. The Virgin of the Annunciation; Chapter House, Westminster Abbey (*ex situ*); *c.*1253

and the Virgin are the two figures for which a William Yxewerth was paid 53s. 4d. in 1253.[29] If this is the case – and the date of payment would tally perfectly with the chronology of the chapter house building programme – it would seem that William either delegated the carving to two others in his workshop or that he sculpted one of the figures and left the other to a colleague: it should be remembered that the name on an account of payment is not necessarily that of the person who actually did the work.[30] The style of the Archangel differs from that of the Virgin and belongs to the 'modern' group of sculptures inside the abbey church, being close to the eastern angel of the south transept spandrels; the Virgin, on the other hand, is perhaps the work of an older sculptor with a background at Wells.[31] These differences would have been less noticeable when both figures were fully painted, and it is of interest to note that they are carved from different stones, the Angel from Caen limestone, the Virgin from Reigate sandstone.[32] One should also imagine the Angel Gabriel with two large wings, probably of gilded wood (the slots remain); his rather mannered backward lean would then be balanced by the wing rising above his left shoulder and the space now empty in the niche would be filled as satisfactorily as those in the transept spandrels.[33]

Before leaving the interior spaces of the abbey it would be a mistake to overlook the purely decorative architectural sculpture, both in the chapter house and church. Lack of space precludes more than a mention of the numerous foliate and inhabited bosses in the main body of the church, less striking perhaps than those already discussed but nevertheless of great beauty. Much use was made of Purbeck marble, in the chapter house especially, for bases, shafts and capitals, with the ubiquitous stiff-leaf dominating the decoration of the latter around the middle of the century.[34] Those capitals that have not been restored by Scott, particularly in the vicinity of the inner doorway, are worthy of inspection, the polished and shining surface of the stone giving them the appearance of burnished copper.[35]

Wide-ranging and erroneous eighteenth- and nineteenth-century 'improvements' to what had served as the major entrance into Henry III's church have removed all trace of the original façade from the north transept face. Only through reference to early drawings, engravings and descriptions, and by judging from what are taken to be reflections of the London work can the original appearance of this most important document of English thirteenth-century sculpture be retrieved. Unfortunately the evidence is not unequivocal. However, what emerges from the early sources – especially from the 1654 etching by Wenceslaus Hollar and a drawing of 1713 by William Dickinson – is that the façade as a whole appears to have been derived from the Amiens west front, but with the design of the portals being very different.[36] Instead of incorporating jamb figures, the life-size statues around the three doorways, apparently the apostles, were placed on corbels;[37] and the tympana were divided not into the horizontal strips common by this time in France but by blind tracery [307]. The only earlier instance of this type of tympanum was on the west façade at Saint-Nicaise at Reims (c.1240), but this alas has also been destroyed and is only known through another engraving.[38] There can be little

room for doubt that the central doorway at Westminster was devoted to the Last Judgement, with a figure probably of the *Beau Dieu* on the trumeau, and by reference to the slightly later Judgement porch at Lincoln (to be discussed below) and to that at Saint-Urbain, Troyes [242], it may confidently be surmised that Christ was shown seated between two angels holding the Instruments of the Passion in the large quatrefoil. If the composition at Troyes is judged to be canonical it is likely that the two large pointed arches at Westminster contained the Virgin and St John kneeling in intercession; immediately below the former the two sub arches would have been filled with the Blessed, those under St John with the Damned; and the Archangel Michael, holding the scales, might have occupied the central arch. By further reference to Troyes the six arches at the level of the lintel were probably given over to the Resurrection of the Dead.[39] Purbeck columns would have flanked the double opening and inhabited voussoirs – perhaps containing the Wise and Foolish Virgins and other seated figures as in the archivolts of the chapter house doorways – completed the iconographic scheme.

The original decoration of the lateral tympana is less clearcut. In both cases the field of the tympanum was broken up into circles of blind tracery within which were cinquefoil cusps.[40] In the absence of any further documentation it is not now possible to be absolutely sure whether these circles were filled with sculpture, although the relationship sometimes mooted between the provincial tympanum at Higham Ferrers in Northamptonshire and the Westminster side doors, if accepted, would suggest that they were.[41] It would be surprising indeed if such a prestigious model had not been imitated elsewhere, in a modified form at least, in the years after 1260, but it was perhaps always more likely that costly large-scale imitations would be found in important centres rather than minor parish churches. It was therefore

307. Reconstruction of form of central north transept doorway, Westminster Abbey (from W. R. Lethaby, *Westminster Abbey and the King's Craftsmen*, London, 1906)

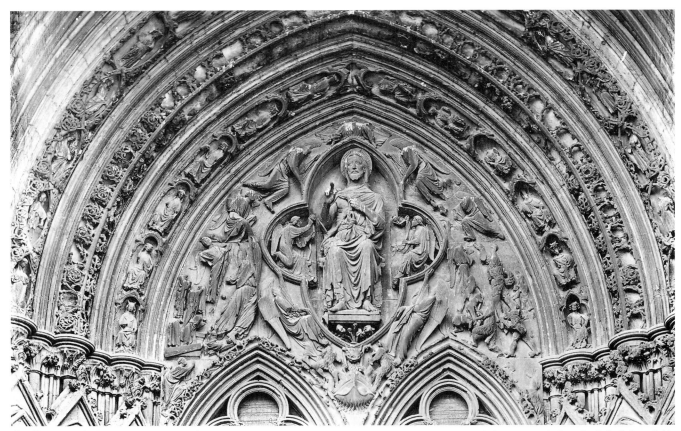

308. Tympanum, Judgement porch, Lincoln Cathedral; probably *c.*1260–70

309. Seated queen; voussoir, Judgement porch, Lincoln Cathedral; probably *c.*1260–70

almost inevitable that in the other major building project of the third quarter of the thirteenth century, the construction of the Angel choir at Lincoln Cathedral, the influence of Westminster would be apparent; and that slightly later, when the lower part of the west front of Lichfield Cathedral was erected, the north transept portal continued to provide elements worthy of incorporation.

THE JUDGEMENT PORCH AND ANGEL CHOIR AT LINCOLN CATHEDRAL

The building of the Angel choir of Lincoln took a quarter of a century, between 1255 – when permission was sought from Henry III to extend the cathedral – and 1280, when the mortal remains of St Hugh (Bishop of Lincoln from 1186 to 1200) were translated to his splendid new shrine in the presence of King Edward I and Queen Eleanor.[42] The new choir which had been built specifically to accommodate the shrine was no less magnificent, and like the choir and transepts at Westminster was liberally embellished with sculpture, both inside and out. It must always have been seen very much as a northern reaction to the rebuilding of Westminster Abbey, a reading borne out by the Lincoln choir's architectural and decorative similarities to Henry's church and the way in which sculpture is used at both places to enhance the sacred ambience around the saints' shrines. It is also highly likely that at least some of the masons and sculptors previously employed at Westminster moved to Lincoln on completion of their work in London, as both the design and carving of the great door to the south of the choir

– the principal entrance to the area around the shrine from the Bishop's Palace – are inextricably bound up with the sculpture of the royal abbey.

In its essentials the Judgement porch at Lincoln appears to reflect what is known of the central doorway of the north transept at Westminster. All the main distinguishing characteristics of the latter – the large quatrefoil of the tympanum, the inhabited voussoirs, the trumeau and the life-size statues standing on figured brackets rather than on the jambs – are present at Lincoln, and the style of the sculpture is similar to sculpture elsewhere in the Abbey [308]. Christ is seated at the centre of the quatrefoil, exposing the wound in his side, and is flanked by two angels, now shown censing but probably originally holding the Instruments of the Passion.[43] Flying angels flutter around the quatrefoil, below which is the Mouth of Hell in the spandrel between the double arches of the door, while the Blessed rise from their graves on the left and the Damned are harried by devils on the right. The inner order of voussoirs contains twelve little canopied niches within which are six seated queens [309] and six kings (on the left and right respectively); the middle order is an openwork cage of vegetation; and the outer voussoirs hold eight Wise and Foolish Virgins (on the left, the Wise above the Foolish) and eight male figures, possibly apostles (right), all standing in stiff-leaf bowers.[44] Below, on each side of the doorway are two now-headless figures: nearest the entrance are the personifications of Synagogue (unusually, in this case, to Christ's right, on the side of the Elect) and the Church, but the identity of the two outer figures is still unclear.[45]

Apart from the distracting restoration in the quatrefoil the sculpture of the Judgement portal is in remarkably good condition, sheltered from the elements by its deep gabled porch, and only the outer figures have suffered from weathering. An assessment of the style of the external Lincoln sculptures is therefore possible, but detailed comparisons with Westminster are difficult to make. It has been pointed out how the sharp ridges of drapery of the seated Christ, for instance, can be found at Westminster, but it has to be admitted that convincing parallels are hard to come by and that most comparisons have to be made between sculptures of quite different scale.[46] The magnificent small figures of the archivolts at Lincoln – little statuettes with the precious and crisp appearance of ivory carvings or goldsmiths' work – seem to surpass those in the voussoirs of the Westminster chapter house doorways, but again it must be appreciated that the latter are but shadows of their former selves. The greatest drawback is of course the loss of all the large-scale sculpture which once decorated the north transept portal at Westminster, so that it is now out of the question to ascertain whether the remaining statues at Lincoln are by the same workshop. There is in fact a considerable variety in the treatment of the draperies of the large figures at Lincoln, but this may have as much to do with the different types of garments worn by the respective figures as the contributions of different sculptors. Hence the broad curving folds of *Ecclesia*'s cloak [311], so conspicuously different from the deep, pleated undulations of *Synagoga*'s robe [310], do not in this case necessarily signify the work of more than one man. What cannot be doubted is the exceedingly high quality of

310. Personification of *Synagoga*; left side, Judgement porch, Lincoln Cathedral; probably c.1260-70

311. Personification of *Ecclesia*; right side, Judgement porch, Lincoln Cathedral; probably c.1260-70

all the sculpture in and around the Judgement porch, ranging from the static *gravitas* of the large-scale figures to the remarkable fluency of movement captured in the smaller flying angels of the tympanum. The best sculptors available must have been employed, and only Westminster Abbey could have provided their training ground.

Several other sculptures, at Lincoln and Crowland Abbey, seem to have been executed by the same workshop. It is now far from clear whether all the many canopied niches on the outside of the Angel choir were originally filled with figures. It is quite possible that the amount of statuary needed proved beyond the means of the cathedral authorities and that in 1280 only the niches at the lower level had been filled.[47] Even without statues the exterior is extremely richly decorated, with lush foliate capitals, countless headstops and many figured brackets. Only three life-size figures remain, to the east of the Judgement porch. The two at the south-east corner of the building, romantically known as 'Edward and Eleanor', had new heads attached in the restorations of J. C. Buckler in the 1850s, and it is probable that the former was originally St Michael trampling on the devil.[48] The third, female, figure now partly immured behind the chantry chapel of Bishop Russell, adjacent to the Judgement porch, is swathed in the same swinging baggy drapery as the *Ecclesia*

and St Michael, and despite claims to the contrary, also has a mid-nineteenth-century head.[49] It is not known at what point between 1255 and 1280 the Judgement porch and the other large-scale sculptures outside were produced, but given the similarities with Westminster and the likely order

of construction it is probable that these were among the first works to be executed, perhaps in around 1260–70. Precise documentary evidence is also lacking for the work executed by the Westminster-Lincoln team on the west portal at Crowland Abbey in the South Lincolnshire Fens. The form of the portal, with a large quatrefoil in the tympanum, the latter bitten into by the double-headed arch of the doorway, is close to the plainer north portal of the Angel choir. Five scenes from the Life of St Guthlac fill the quatrefoil, which is set against a background of curling stiff-leaf foliage of precisely the same type as was once found on the tympanum of the Westminster chapter house vestibule doorway.[50] To each side of the door, standing on figured corbels, were personifications of the Church and Synagogue, as at Lincoln, but only the latter still survives. It is now a weathered wreck, but old photographs show that it was identical to the same figure on the Judgement porch.[51]

Walking through the Judgement portal into the Angel choir one gains a purer impression of the intended thirteenth-century effect than at Westminster Abbey, where the interior of the east end is now cluttered with post-medieval monuments. In addition the decorative scheme has been almost completely preserved, because the figurative sculptural work is confined to the spandrels of the choir gallery and the aisle vaults, rather than occupying spaces at a lower level.[52] The major loss is of course the shrine of St Hugh itself, the central focus of the whole eastern extension, but knowledge of its original position allows an understanding of how the sculpture was used to sanctify the surrounding area. This was achieved by placing a joyous orchestra of seventeen angels [313] and King David playing the harp in the spandrels of the three bays to the east of the shrine, while the twelve spandrels of the two bays to the west – above the high altar – were principally devoted to Judgement and Salvation, and included figures of Christ showing his wound, angels with the Instruments of the Passion,

312. The Virgin and Child; spandrel in triforium of Angel choir, Lincoln Cathedral; probably c.1270–80

313. Angel with pipe and tabor; spandrel in triforium of Angel choir, Lincoln Cathedral; probably c.1270–80

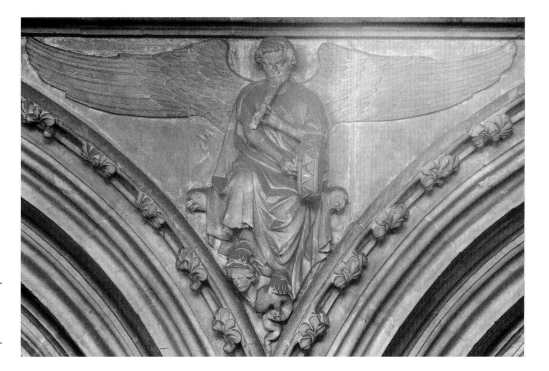

314. Bathsheba and servant (?); vault boss in south aisle, Angel choir, Lincoln Cathedral; probably c.1270–80

direction of a master from Westminster, and indicate a process of slow internal evolution.[56]

TOMBS IN THE THIRD QUARTER OF THE THIRTEENTH CENTURY

Mention has been made of other work on which Lincoln sculptors were engaged, the west portal at Crowland Abbey providing the clearest example. The documentary evidence from Westminster suggests that by this date the concept of 'taskwork' was widespread, and that once major projects of the type seen at Westminster and Lincoln were completed the individuals and small workshops employed there dispersed and moved on (or possibly settled in a major centre like London), often being engaged on works on a smaller scale, such as tombs. It is likely that the fine canopied tomb made for Archbishop Walter de Gray (died 1255) and installed in the south transept of York Minster was executed by a workshop in the ambit of Westminster Abbey, so close are the Purbeck marble stiff-leaf capitals to those in the Westminster chapter house, and the wonderful little head stops on the canopy are the equal of anything in the capital [315].[57] The effigy itself is encased in the metallic drapery

315. Canopy tomb of Archbishop Walter de Gray (d.1255); south transept, York Minster; c.1255–6

St Michael weighing the Souls of the Dead, the Angel of the Expulsion, and the Virgin and Child [312], to whom the adjoining angel offers a Blessed Soul.[53] The vault of the south choir aisle is likewise punctuated by figured bosses [314], and again there seems to be an iconographic distinction between those to the east of the entrance bay – which start with one featuring two bearded scholars disputing, possibly a prophet and an evangelist, and continue with the Coronation of the Virgin – and those to the west, where the first boss shows combat between a man and a monster.[54]

The similarity between the interior scheme at Lincoln and that at Westminster has often been remarked upon, and the angels compared with the larger censing transept angels in London. In view of what has already been said a close connection can hardly be doubted, although it should be remembered that there was already at Lincoln an earlier group of spandrel angels in St Hugh's choir, and that those in the Angel choir fulfill a different rôle from their Westminster counterparts. A closer comparison can be made between the Lincoln angels, especially those that are fitted into the half-spandrels, and the surviving small figures in the same positions in the radiating chapels at Westminster, but in the quarter of a century that separates the two programmes the draperies have been softened and given broader folds.[55] The slight differences of style – almost a question of nuance – that have been detected among the relief figures of the Angel choir point to the contributions of a small number of sculptors trained in the same workshop tradition, under the

316. Censing angel, probably from the canopy tomb of Ralph de Chaddesdon (d.probably 1275–6); from All Saints, Sawley; c.1275–80 (on loan to the Victoria and Albert Museum, London)

folds of much of the Westminster sculpture and the two small censing angels in the spandrels to each side of the gable above the archbishop's head recall on a reduced scale the transept angels in the Abbey. The serious losses sustained in the intervening centuries rule out an accurate assessment of the extent of the London-Lincoln workshops' activities in other places, but certain effigies and tombs are sufficiently close in style to allow a common ascription. Into this category fall a particularly handsome stone effigy of a knight in Pershore Abbey in Worcestershire, of about 1270, and the fragments from a canopy tomb, probably that of Ralph de Chaddesdon, from All Saints, Sawley, in Derbyshire (the effigy still *in situ*, the remains of the canopy on loan to the Victoria and Albert Museum).[58] The censing angels from the canopy of the Sawley tomb are carvings of the highest quality [316] and are almost certainly the products of one of the Lincoln Angel choir workshops from the end of the 1270s. Their parish church provenance provides salutary evidence that sculptures of excellent workmanship were to be found not only in the most important centres, although unfortunately very few monuments of comparable type still survive outside the cathedrals.

The Purbeck marble effigy of Bishop Hugh de Northwold (died 1254) in Ely Cathedral, like that of his near contemporary Bishop William de Kilkenny (died 1256, also at Ely), is slightly old-fashioned, despite its splendid appearance. The figure of the bishop is not very different from that of Archbishop Walter de Gray in York, although the Ely effigy

was never surmounted by a canopy. Its style harks back to the Wells west front bishops, showing nothing of the new approach to draped form worked out at Westminster, but the conservative nature of the effigy is easily overlooked because of the extraordinarily rich setting in which it lies. The usual censing angels flank the cinquecusped arch in which the bishop's head is framed, but they are joined by a further two angels at the apex of the arch, who carry the bishop's soul to heaven. On each side of the tomb slab, below luxuriant foliate colonnettes, three small standing figures are contained within niches like flattened voussoirs (a king, a bishop and a monk to the effigy's right, an abbess, a queen and a nun on the left), and the foot is carved with a relief of the Martyrdom of St Edmund, as Hugh was also Abbot of Bury St Edmunds.[59] Although this was a tomb of some splendour it belongs firmly in the tradition of the bishops' tombs of the first half of the thirteenth century, and being intended for a position close to the shrine of St Etheldreda it would have been inappropriate to emphasise its vertical presence. But from about 1255 an increasing number of tombs of important persons followed the lead of that of Walter de Gray and were given a miniature architectural setting, either placed between the columns of the sanctuary or standing free like a shrine.[60] The grandest early example is the tomb of Bishop Giles de Bridport (died 1262) in the south choir aisle of Salisbury Cathedral, where the effigy is contained in an extremely elaborate construction – almost a small chantry chapel. In the spandrels on the north and south sides of the tomb canopy are reliefs showing scenes from the life and career of the bishop, an unusual feature for the tomb of one uncanonised but perhaps explained by the special rôle that Giles de Bridport played in the establishment of a college at Salisbury.[61] In the slightly later tomb of Bishop Peter de Aquablanca (died 1268) in the north transept of Hereford Cathedral the solid upper section of the canopy seen on both the de Gray and de Bridport tombs is done away with in favour of a lighter open tracery with tall gables, prefiguring in its general effect the great ciborium tomb of Edmund Crouchback in Westminster Abbey at the end of the century.[62]

SCULPTURE FOR EXTERIORS – SALISBURY AND LICHFIELD

Like the north transept façade of Westminster Abbey the west fronts of Salisbury and Lichfield cathedrals have suffered greatly at the hands of iconoclasts and restorers. Salisbury's west façade, the earlier of the two, was probably largely complete by 1266, although the few remaining much weathered and restored medieval figures are later than this and were in all likelihood added at the end of the century. The design of the screen-like façade was clearly derived from Wells, and also incorporates the small openings, hidden by the statues in front, which allowed the singing voices of the *pueri*, standing in an interior passage above the central doorway, to be heard outside.[63] The three tripartite gabled porches, however, are cognisant of French portals and make more of an impression than the tiny doors at Wells.[64] As at Westminster, jamb figures were eschewed and the only sculptural decoration in the immediate vicinity of

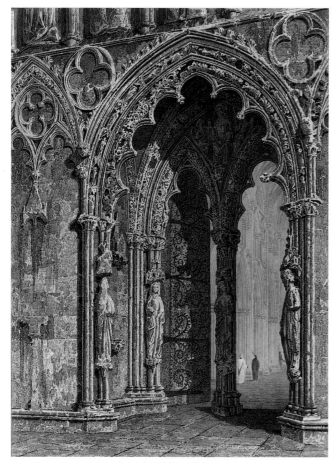

317. Central portal, west façade, Lichfield Cathedral, in the early nineteenth-century; c.1280-90 (engraving in J. Britton, *Cathedral Antiquities*, III, London, 1836)

the porches appears to have been in the tympanum of the central doorway, which may have shown the Virgin and Child set under a trefoiled arch and flanked by two other figures, probably angels. Although the numerous nineteenth-century statues which fill the niches on the buttresses and above the central doorway give an idea of the density of the original sculptural programme it is not now possible to reconstruct in detail the thirteenth-century iconographic scheme.[65]

The west front of Lichfield Cathedral was also planned as an immense image-screen, with most of the statuary concentrated on the middle section of the façade rather than around the portals. This part of the cathedral was probably started in around 1280, with work continuing until the beginning of the fourteenth century.[66] Once again, most of the life-sized figures around the doorways were placed not in a group on the jambs but individually, as at Westminster and Lincoln. The majority of these sculptures had gone by the middle of the nineteeenth century and because of the subsequent restorations it is as well to rely not on the present appearance of the façade but on the engravings of Hollar, Carter and Britton. Hollar's seventeenth-century engraving, made before the Civil War, shows twelve life-sized statues ranged across the blind arcading of the façade at portal height, those flanking the doorways standing on the capitals of slender attached colonnettes; above was a row of seated figures in niches, probably a gallery of Kings, with further

tiers of standing figures higher up.[67] Six further figures were placed within the central porch around a trumeau figure of the Virgin (four of them actually on the jambs), while above in the spandrel of the double arched doorway was the seated Christ of the Last Judgement flanked by two angels holding the Instruments of the Passion [317]; around the outer arch was a single archivolt with fourteen standing figures.[68] As far as one can judge from Britton's engraving, the Virgin of the Lichfield trumeau was close in style to the same figure on the contemporary trumeau of the doorway to the York Minster chapter house of about 1285-95, and this link with York would seem to be confirmed by one of the few surviving medieval figures still at Lichfield.[69] Unfortunately the form of the pre-fourteenth-century west front at York Minster is not now known, although there are grounds for supposing that it too had numerous life-sized figures spread across the façade in a comparable fashion, before the similar arrangement at Wells.[70]

SCULPTURE FOR INTERIORS – THE CHAPTER
HOUSES AT SALISBURY, YORK AND SOUTHWELL

The Salisbury chapter house, possibly begun in the 1260s and certainly by 1280, is unique among the surviving English buildings of this type in having a sculptured cycle running around its interior walls. Fifty-five Old Testament scenes from Genesis and five from Exodus, starting with the Creation and concluding with the Giving of the Ten Commandments to Moses, were chosen to decorate the octagonal room. The only available space for the sculpture was once again the spandrels above the blind arcade and below the tall lancets, so that it was inevitable that the narrative methods employed and the use of the awkard shapes would have something in common with the earlier schemes at the east ends of Worcester Cathedral and Westminster Abbey. Despite the comprehensive restoration of the reliefs in the 1850s the integrity of this extremely full and important iconographic scheme remains unspoilt, although caution is needed in any assessment of the figure style.[71] It is easy to see why the Salisbury chapter house has often been compared with that at Westminster in plan and elevation, and it is of interest to compare the interior entrances. As we have seen, that at Westminster almost certainly had open tracery in the tympanum, but at Salisbury the central quatrefoil was filled with a figure of the seated Christ surrounded by the signs of the evangelists, and it is probable that large angels occupied the spandrels to each side.[72] The arch of the doorway pierces an upper arcade of eight shallow niches, but whether the outer pairs contained figures like the Westminster Annunciation group is a moot point.[73] On the west side of the entrance, facing the vestibule, the tympanum was possibly dedicated to the Coronation of the Virgin, placed under a stunted cinquecusped arch, and the single order of voussoirs is given over to fourteen standing figures of Virtues triumphing over Vices.[74]

In a sense the sculpture of the Salisbury chapter house represents the last stage of an approach to three-dimensional decoration first worked out in the early thirteenth century at Wells and Worcester and passed on through the vastly influential conduit of Westminster Abbey. The lively dis-

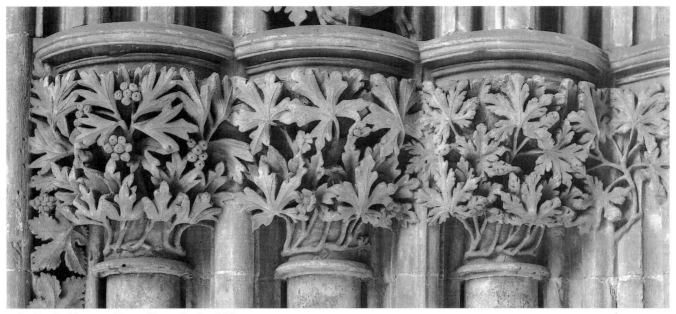

318. Detail of doorway, Chapter House, Southwell Minster; c.1290–5

course between the many Old Testament figures in relief, the legion of extraordinarily fine head stops and stiff-leaf capitals, the relationship between the large sculptures of the tympana and the small figures of the voussoirs, all echo the repertory of the mid-century and would not influence late thirteenth- or early fourteenth-century developments. In the two most significant chapter houses of the years 1285–1300, at York and Southwell Minsters, figural sculpture – apart from head stops – was largely rejected. Instead the energies of the sculptors were channelled into carving leaf forms of astonishing naturalism on the arches of the doorways (at Southwell) and on the capitals and pendants (the latter only at York) running around the buildings and in the vestibules just above head height [318]. At Southwell especially there is a remarkable variety of leaf forms accurately depicted – including maple, oak, vine, hawthorn, rose and ivy – and when originally painted the effect must have been even truer to life than today.[75] The attention to detail in this type of foliage, seen earlier at Paris, Reims and Naumburg around the middle of the century, should be viewed as a late reflection of an interest in the observation of nature manifested in the figure sculpture of the same places. Although naturalistic carving of this kind was a relatively short-lived phenomenon in England, its emergence was a sign that here, as throughout Europe, an atmosphere of experimentation and objective curiosity was prevalent in all artistic spheres.

A KNIGHT IN DORCHESTER

It is a sad fact that much of the English thirteenth-century monumental sculpture which escaped destruction at the Reformation or in the Civil War eventually succumbed to misguided Victorian restoration. The prime targets of the iconoclasts in the sixteenth and seventeenth centuries were of course sculptures of a religious or 'superstitious' nature,

but it would seem that secular works were usually spared, in contrast to their treatment in France at the time of the Revolution.[76] As a result, the existing number of sepulchral effigies of knights, ladies and civilians is comparatively large, but because many of them are undocumented and formulaic it is often difficult to be sure of their date or place of manufacture.[77] The evolution of the knightly effigy, although not a paradigm for the general development of the sculpted effigy through the thirteenth century, does show how the most gifted English sculptors were able to overcome the inherent problem of repetition of stock types. The first examples, notably the effigy of William Longespée in Salisbury Cathedral mentioned earlier, have the appearance of standing figures in the horizontal, and in their straight-legged pose differ little from their counterparts in France and Germany. But after about the middle of the century the sculptors of the English knights invented a brilliant alternative to this rather static convention. The recumbent figure was made to cross one leg over the other, while at the same time his right arm reached across his body to draw his sword from its scabbard. In the best examples this exciting pose set up a dynamic torsion of unparalleled energy, as in the justly famous knight in Dorchester Abbey in Oxfordshire [319].

Elsewhere it has been pointed out how compositional, iconographic or even sculptural innovations were more often than not the result of the stated wishes or the intervention of the patron, rather than a direct contribution from the sculptor. However in this case it is difficult to deny that what separates the Dorchester effigy from other cross-legged knights of the same type is not only the startling originality of the squirming figure and the highly accomplished fluidity of the carving but the slight but telling adjustments which an inspired sculptor of great vision has introduced. Instead of simply placing his hand on his sword, in the manner of the majority of the effigies, the Dorchester knight bends his

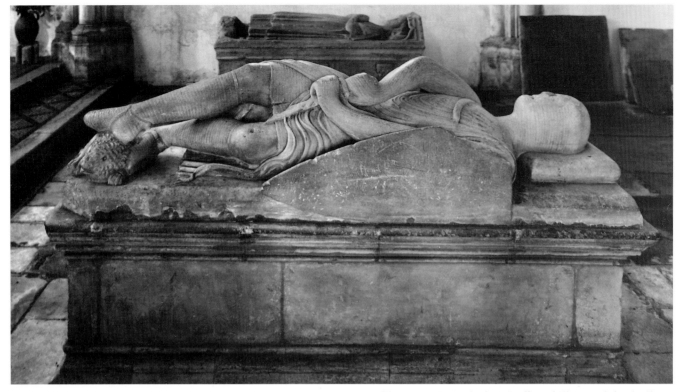

319. Tomb effigy of unidentified knight; Dorchester Abbey (Oxfordshire); probably c.1280–5

320. William Torel: detail of tomb effigy of Eleanor of Castile (d.1290); Confessor's Chapel, Westminster Abbey; gilt bronze, 1291–3

right wrist to curl his fingers round the hilt, while his left hand firmly grasps the scabbard, now broken. The violence of this gesture is set off against the swirling movement of the surcoat, and even the lion under the knight's feet – poised as if ready to spring rather than lying patiently – contrives to give the impression that the tomb-slab is about to be vacated.[78] It is perhaps somewhat ironic that the commemoration of death – when mortal man is stilled forever 'to rest in peace' – should have provided the opportunity for a sculptor to create one of the most vivacious works of art of the Middle Ages;[79] but it is unlikely to be merely coincidental that the first distinct signs of creative expression should occur at the same time as written accounts begin to testify the existence of the individual 'imager'.

The Dorchester knight was carved from limestone and was originally painted. By the end of the thirteenth century the harder-to-carve Purbeck marble effigies were in decline, and as it increasingly became the fashion to embellish the surface of effigies not just with paint but also sometimes with moulded or stamped gesso, inlaid glass and paste, so the natural appearance of the more expensive material became superfluous. Good-quality building stones and wood were more frequently used, but alabaster – the English alternative to marble – did not become widely available until the following century. Only very rarely was bronze employed for effigies, and as might be expected its use was reserved for those in the highest tier of the church and the royal family.[80] The earliest surviving examples are those of Henry III and Queen Eleanor of Castile in Westminster Abbey, and fortunately the circumstances of their production have been fully recorded.

THE PATRONAGE OF EDWARD I AT WESTMINSTER AND THE ELEANOR CROSSES

When Edward I was crowned with his Queen Eleanor in Westminster Abbey in August 1274, building on the church had ceased. Henry III had been the prime motivator of this work, but after the translation of the Confessor's remains into his shrine in 1269 the impetus behind the project seems to have slowed, due principally to a lack of funds. After his death in November 1272 Henry was at first buried before the high altar, in the tomb recently left vacant by the transfer of St Edward to the east, but Edward's apparent indifference to the architectural project, and his greater interest in castle building in Wales, meant that new work on the nave of the abbey church would not take place until late in the following century. The King's attitude to the royal abbey was to change dramatically at the death of his beloved wife at Harby near Lincoln on 28 November 1290, an event that plunged Edward into a long period of grief and determined him to commemorate the Queen with a lavish display of memorials. The first of these was of course her tomb in Westminster Abbey, which he had placed to the north-east of the Confessor's shrine. The decision to position her tomb there, alongside that of his father, appears to have been the first step towards creating in this part of the abbey a Plantagenet *Valhalla*, and the two effigies are appropriately splendid. Both were cast in bronze and gilded by William Torel, a goldsmith (*aurifaber*) of London, who also cast a second effigy of the Queen for the tomb containing her entrails in Lincoln Cathedral, which was destroyed in 1641.[81] Records of payments made by Eleanor's executors between 1291 and

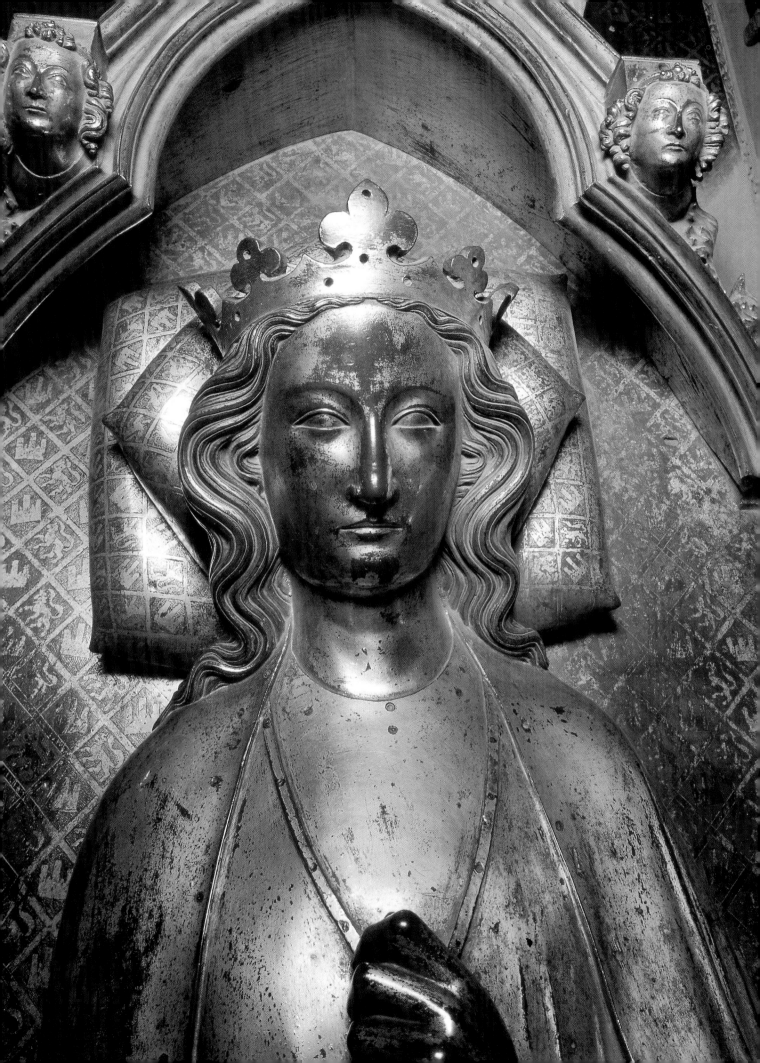

1293 illustrate the progress of the work and reveal such details as the fact that gold florins were bought from merchants of Lucca for the gilding of the effigies.[82] Eleanor's effigy [320], completed by the spring of 1293, was placed on a Purbeck marble tomb-chest commissioned from Richard of Crundale, Master-mason at the royal court, while above a wooden tester made by Master Thomas of Houghton and painted by Master Walter of Durham served as a canopy. This is now lost, but the wrought iron grille on the ambulatory side of the tomb, made by Master Thomas of Leighton, still exists.[83]

The effigies of Eleanor and Henry III were not the first cast bronze effigies to be made in England. The Dean of York Minster, William de Langton (died 1279), had been memorialised with such an effigy, and the fact that an earlier, unsuccessful, attempt had been made to cast a bronze effigy for Henry III's daughter Katherine at Westminster, by a Master Simon of Wells in 1257, suggests that there were others which have since been destroyed.[84] But as elsewhere in Europe it is unlikely that there were more than a small number – hence their special cachet and royal connotations – and it appears that Torel, being a goldsmith, was unused to working on such a large scale. The thickness of the *cire-perdue* casts is a testimony to this, but once the figures had been chased and gilded and laid into their opulent settings such minor shortcomings were artfully disguised.[85] The type of tomb-chest on which Eleanor's effigy was placed – an arcaded Purbeck marble box with shields of arms suspended under the arches – and the fine canopy above her head were not unusual in a northern European context, but the same could not be said of the elaborate Cosmati base on which the effigy of Henry III was put. It is not clear exactly when the body of the King was moved from its first resting-place before the high altar to a new tomb directly adjacent to the Confessor's shrine. It is certain, however, that this tomb was in place before Eleanor's death in 1290 and the subsequent

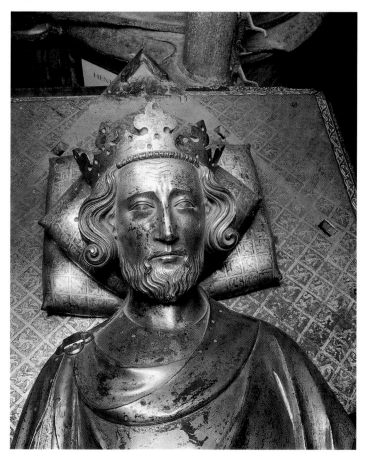

322. William Torel: detail of tomb effigy of King Henry III (d.1272); Confessor's Chapel, Westminster Abbey; gilt bronze, 1291–3

ordering of the effigies and was not part of the same commission, especially as the costly gilt-bronze figure of the King is hardly visible from the ground.[86] The unusual form of the double base on which the effigy lies [321], with the tomb-chest above a shrine-like base pierced by three large apertures, strongly suggests that hope was harboured that Henry would eventually be canonised, and indeed miracles were reported at his tomb.[87] The Cosmati tomb-base completed the remarkable ensemble of Roman works of inlaid marble and coloured stones in the east end of the church initiated in Henry III's time, which included the sanctuary pavement and the base of the Confessor's shrine, signed by Odoricus and a *Petrus civis Romanus* respectively. The stylistic language of thirteenth-century Roman work, itself intensely conservative and old-fashioned, must have been introduced at Westminster for specific reasons, but its appearance was fleeting and its influence – from a sculptural point of view – was negligible.[88]

Torel's background as a goldsmith of pre-eminence is evident in the finely worked surfaces of the two effigies and the detailed finishing, especially on the face, hair and beard of the King [322]. The pillows and metal base plates underneath the effigies were minutely decorated with countless small squares and lozenges, imitating richly-

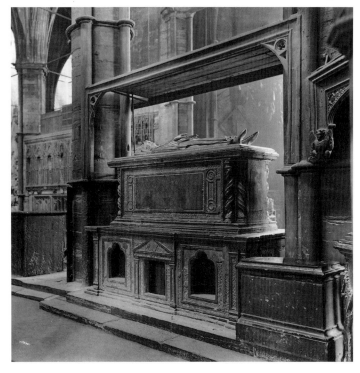

321. Tomb of King Henry III (d.1272); Confessor's Chapel, Westminster Abbey

patterned silks and containing the arms of León and Castile on the Queen's tomb and the lions of England on Henry's. In addition, either real or fictive jewels, of which only the pin-holes remain, enlivened the borders of the draperies and the crowns, and separately made sceptres were held by the King. The figures lie gracefully in state, their long gowns falling in simple folds: that of the Queen is made up of a series of long parallel ridges, while the King's drapery falls from his shoulders in deep curves. This quiet refinement, created in some degree by the material in which they are made, and their surpassing quality sets them apart from other sculptures of the same date, although their figure types were imitated on subsequent tombs in the Abbey. The absence of any large-scale metalwork from this period in England – or even similar small goldsmiths' work – forces us to compare them unfairly with stone sculpture, and in this connection it is especially to be regretted that a further tomb erected in Eleanor's memory, in the Dominican church of the Black Friars in London, has been lost. The form of this third tomb, containing the Queen's heart, is not known, but the executors' accounts refer to three small metal images made by William of Suffolk, possibly based on wax models supplied by Master Alexander of Abingdon; another reference to the tomb is to be found in the Issue Roll for 1290–1, mentioning a figure of an angel, made to hold the Queen's heart, for which Adam the Goldsmith was paid £6 13s 4d.[89] The key person here is Alexander of Abingdon, who was also responsible for the tomb-chest of the Lincoln memorial. His involvement with both the Lincoln and Blackfriars tombs, and his considerable contribution to at least one of the Eleanor Crosses, points clearly to his position at the centre of royal patronage and as a result it has been suggested, not implausibly, that he provided the wax models for the Westminster effigies.[90]

The Eleanor Crosses were a more public manifestation of Edward's sorrow than the three tombs. Between 1291 and about 1295 twelve stone crosses with images of the late Queen were set up at the orders of Edward I at the resting places along the route taken by Eleanor's funeral cortège in 1290. Starting at Lincoln, these included Grantham, Stamford, Geddington, Northampton (Hardingstone), Stony Stratford, Woburn, Dunstable, St Albans, Waltham, Cheapside and Charing, but only the crosses at Geddington, Hardingstone and Waltham, and fragments of that at Cheapside survive.[91] Their erection was not, however, a spontaneous and novel expression of the King's grief, the idea having been planted in his mind – as was so often the case – by recent precedent in France. After Louis IX's death in Tunis in 1270 his bones were brought back to Saint-Denis *via* Aigues-Mortes, and he too had a series of stone memorials (*Montjoies*) placed in his honour along the route of his funeral procession. These were undoubtedly known to Edward, so there must have been more than an element of competitive emulation in his choice of an identical scheme for his deceased wife; the value of the crosses as splendid symbols of Plantagenet piety and prestige might not have

occurred to the king in the midst of his mourning, but this aspect would not have eluded his advisors.[92] Accordingly, the best masons and sculptors were employed in their construction, and with the exception of the crosses at Grantham, Stamford and Geddington we know the names of most of those responsible for the work and how much they were paid.

The memorials in London were by far the most expensive, and of the two the Charing Cross cost over twice as much as that at Cheapside. This was partly to do with the fact that they both used considerable amounts of Purbeck marble in their construction, although it is also likely that they were larger than the others. At the other end of the scale it is possible that the Geddington Cross, which is a slender triangular construction with comparatively poor-quality sculpture, was intentionally diminished in size because money was running out towards the end of the project. Together with those at Grantham and Stamford it was probably completed in 1295–6 as it does not appear in the records of payments made up until 1294.[93] Given that the master mason responsible for the surviving Hardingstone Cross, John of Battle, was in charge of the construction of no less than five of the crosses it would not be unreasonable to assume that its more elaborate polygonal form was typical of the others. This surmise is strengthened by the very similar overall design of the still-standing Waltham Cross, contracted to Roger of Crundale and Nicholas Dymenge [323]. The statues of Eleanor on the Hardingstone cross were entrusted to William of Ireland, those at Waltham to Alexander of Abingdon, who were both described as imagers.

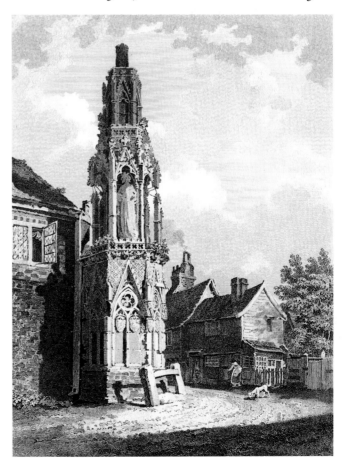

323. The Eleanor Cross at Waltham in the early nineteenth century; 1291–4 (engraving in J. Britton, *The Architectural Antiquities of Great Britain*, I, London, 1835)

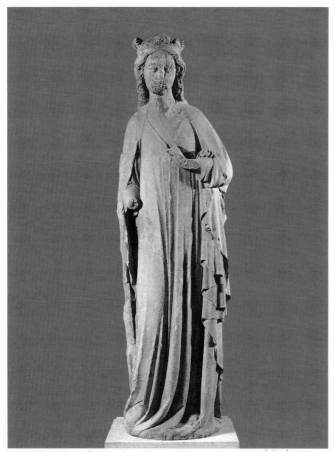

324. Alexander of Abingdon: Queen Eleanor from the Waltham Cross; 1291–2 (Hertfordshire County Council, on loan to the Victoria and Albert Museum, London)

Unfortunately, only one of the latter (now on loan to the Victoria and Albert Museum) is even moderately well-preserved, but it is immediately apparent that the bearing of the Queen, with her left hand reaching up to hold the cord of her gown, is close to the effigy at Westminster [324].[94] The standing, rather than lying, pose of the figure and the different material from which it is made have allowed Alexander the chance to excavate the drapery more deeply and to incorporate the motif of the fluttering bunched drapery caught under the Queen's left forearm. This type was followed by William of Ireland on the comparable figure on the Hardingstone Cross, and the differences often stressed between the styles of these two sculptors would seem instead to be the result of a failure to compare like with like and to take into account the variety within each group of statues.[95]

Both Alexander of Abingdon and William of Ireland must have been well-established imagers for some time before being called upon to work on these royal commissions, but it is not possible at present to construct any sort of career progression in the way feasible for some of their Italian counterparts.[96] Because the documentation connected with the ordering of the Eleanor crosses and the Queen's tombs is so complete, revealing for a moment in full the names of masons and sculptors so often shrouded in anonymity, it serves to highlight our frustrating lack of knowledge elsewhere. No doubt both sculptors were previously employed on the sort of taskwork already described in connection with the earlier building programme at Westminster Abbey,

perhaps carving images of the Virgin and Child and individual tombs to order. One of these may be the fine effigy of a lady in Chichester Cathedral, which shows the same deep parallel folds of drapery as the best preserved Eleanor from the Waltham Cross.[97] In the absence of any documentation for two of the most important tombs from the end of the thirteenth century, those of Edmund Crouchback (died 1296) and his first wife Aveline of Lancaster (died 1273, but her tomb probably early 1290s), there is every reason also for attributing at least the making of the effigies and weepers on these to Alexander.

Edmund Crouchback, Earl of Lancaster, was Edward I's younger brother, and it can only have been the King that ordered and paid for his magnificent tomb on the north side of the presbytery in Westminster Abbey [325]. The design of the tomb has traditionally been ascribed to Michael of Canterbury, who was also responsible for the Cheapside Eleanor Cross and the architect of Edward I's great palatine chapel in the Palace of Westminster, St Stephen's Chapel (begun in 1292). In the same way that the Eleanor crosses were a direct response to the *Montjoies* erected for Louis IX, St Stephen's Chapel was self-evidently a conscious emulation, but assuredly not a copy, of Louis's Sainte-Chapelle of fifty years before. The developed Rayonnant of the Eleanor crosses, anglicised by the addition of numerous peculiarly English decorative details, reached its apogée in the Crouchback tomb in a glorious marriage of architecture, sculpture and polychromed ornament.[98] Crouchback lies with hands joined in prayer, his head turned towards the high altar. Two small angels support the pillow on which he rests his head, a feature that would be widely popular in the fourteenth century. Another extremely important innovation in an English context is seen below, on the tomb-chest, where a row of ten elegantly-clad weepers on each side stand under a deep arcade. The tripartite gabled canopy – so reminiscent of that most influential model, the south transept portal of Notre-Dame in Paris [226] – is encrusted with ornament which echoes that of the Abbey; and in the trefoil of the central gable, on both sides, Crouchback is shown on horseback, the very epitome of the medieval noble knight.[99] Every inch of the surface was originally brightly coloured, either through the application of coloured glass, raised and punched gilded gesso or simply paint, and the standard of workmanship throughout is breathtaking.

The tomb of Aveline of Lancaster is a simpler design, a unifaced canopied niche, now damaged and rather dwarfed by the tomb of Aymer de Valence (died 1324) alongside.[100] Its more modest scale, comparable to the contemporary 'ciborium' tomb of Archbishop Pecham (died 1292) in Canterbury Cathedral, meant that it would be more widely imitated than Crouchback's tomb.[101] In the following century – as in France – the elaborate wall tomb would become commonplace not only in cathedrals but also in parish churches, and the building of shrines, inspired ultimately by the example of the Confessor's shrine at Westminster, would spread across the Country.[102]

325. Tomb of Edmund Crouchback, Earl of Lancaster (d.1296); Westminster Abbey; *c.*1296–7

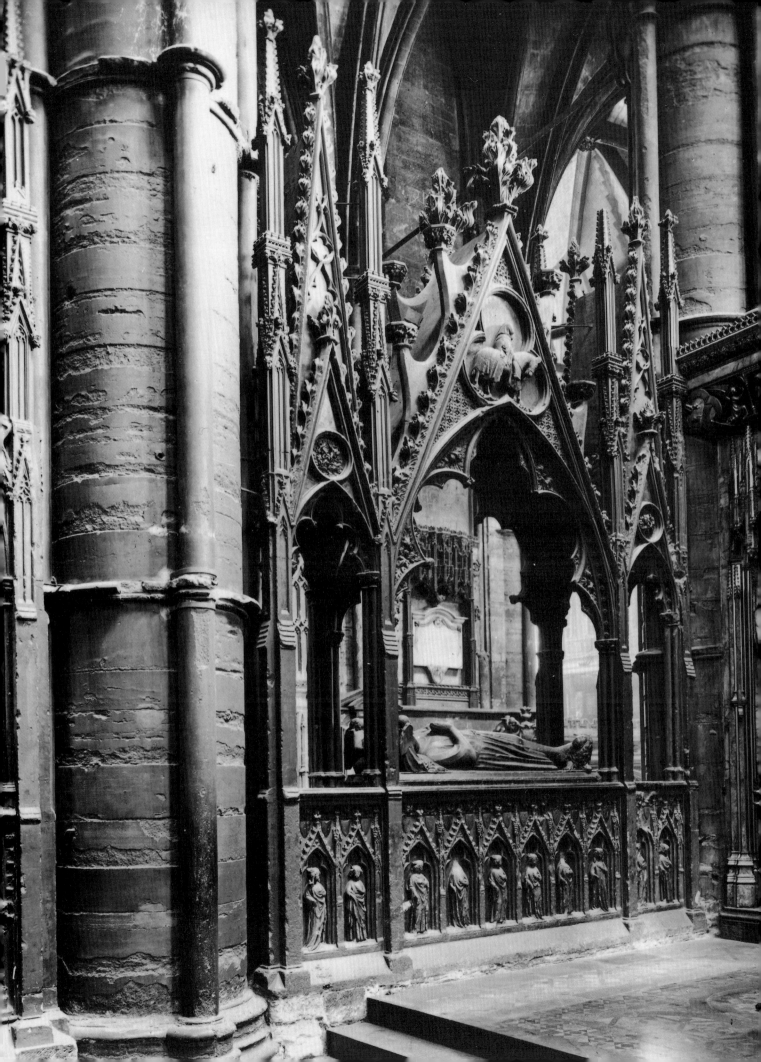

Scandinavia 1240–1300

Louis by the grace of God king of the French, to all his friends and loyal subjects, bailiffs, mayors and provosts, who receive these presents, greeting. Since our dearest friend the illustrious King Haakon of Norway proposes to sail to the assistance of the Holy Land, as he has informed us by letter, we command you, if the said king or his fleet should happen to pass by our shores at sea or to land in territory of ours or dependent on us, to receive him and his people with kindness and honour, allowing them to buy provisions on our territory and lawfully to obtain necessaries. Done at Saint-Germain-en-Laye, in the year of our Lord 1247.[1]

This letter, written by Louis IX at the request of Håkon Håkonsson and delivered to the Norwegian King in Bergen by the influential English Benedictine monk Matthew Paris, might be said to encapsulate the profound change in Norway's European standing that took place in the thirteenth century. Earlier we saw that there already existed close ties between Norway and England, and in Denmark and Sweden too the trading links forged in the first part of the century were strengthened and extended. Where trade leads the way art is rarely far behind, and in all three countries there was a great expansion of building activity and the production of sculpture. In Denmark and Gotland the overriding influence continued to be the art of Westphalia and Saxony, although the most astonishing sculpture from around the middle of the century reveals distinctively English traits.

The colossal ivory figure of the crucified Christ in the abbey church of Herlufsholm on Zealand is extraordinary not only for its size – at 72 cm it is the largest medieval ivory carving in existence – but also because it stands alone, without parallel [326]. Its unique quality, amplified by the loss of similar examples, has led to a divergence of opinion as to its probable place of origin and date.[2] The pathos of the head of the Dead Christ [327], turned to the side and with eyes closed, brings to mind the large tinted drawing of the same subject by Matthew Paris in the first part of his *Chronica Maiora* (Corpus Christi College, Cambridge, Ms. 26), probably of the 1240s, and the flat pleats of the loincloth with the large knot at the side may be compared with the Westminster-inspired sculptures of Synagogue and the seated Christ of the Judgement porch at Lincoln.[3] This does not of course make it English, but the fact that the body is carved from elephant ivory – giving it a noticeable curve to the left – might indicate that it was an import from a centre with access to what at this date was still a comparatively rare commodity.[4] On the other hand, there are also similarities to wood crucifix figures in Schleswig (Fjelstrup) and Scania (Gualöf), so it cannot be discounted that an especially talented Danish sculptor, probably trained in England or

326. The Crucified Christ; abbey church, Herlufsholm; ivory, probably *c*.1250

327. Detail of pl. 326

France, was provided with an elephant tusk, allowing him to carve one of the most striking images of the Scandinavian Middle Ages. Other groups in walrus ivory – notably an *Adoration of the Magi* and the Horne bookcover, both now in the Danish National Museum in Copenhagen – give further evidence of a penchant for carving on a small scale in Denmark at this time, although they do not approach the Herlufsholm Christ in terms of quality.[5]

Monumental sculpture in Sweden and Norway in the second half of the thirteenth century shows an even clearer debt to English and French prototypes. In Sweden, the cathedrals of Skara and Linköping embraced English models in the design of choir and nave respectively, and Uppsala Cathedral was constructed to a French plan with the aid of Parisian masons.[6] In Norway, the major building project continued to be the cathedral at Trondheim, and this too demonstrates a mixture of English and French stylistic features in its later stages. In 1248 Archbishop Sigurd laid the foundation stone of the new west front, which was probably complete up to third-storey level by 1282. This is now largely a work of the present century, but because the façade was still standing in the nineteenth century – albeit in a ruined and truncated condition – and five fragmentary figures survive from the original programme, it is possible to reconstruct the basic design. This took the form of a screen in the English manner, with life-sized standing figures in niches in the second tier and relatively small, undecorated doorways with blind arcading between.[7] Because Matthew Paris actually visited Trondheim in 1248, ostensibly to act as troubleshooter in a dispute between the Benedictine abbey of Nidarholm and the Archbishop of Trondheim, it has sometimes been proposed that the distinguished English monk played a part in the design of the cathedral's façade, especially as it had been the intention to create just such a west front at St Albans, from whence he came.[8] There is, however, no need to conflate these two events, especially as the artistic connections between the Norwegian city and England have already been demonstrated and the internal evolution of the cathedral shows a contemporary awareness of English architectural developments over a long period. In view of the obvious links with England it is perhaps surprising that the remaining statues from the façade show not English features but those of mid-century Paris. This can be seen in the figure of St John the Evangelist [328], whose baggy draperies are extremely close to those of the headless jamb figures from the transept portals of Notre-Dame in Paris and whose head with curly locks may likewise be compared with the fragmentary heads of Virtues from the Parisian north transept.[9] These were presumably the work of a French sculptor or a Norwegian trained in Paris, but elsewhere on the cathedral – in the corbels and head stops – the filiation is most often with Westminster.[10]

In the first part of the book it was shown how the wood sculptures of Norway and parts of Sweden provide an important illustration of the appearance of English wood sculpture in the first half of the thirteenth century. This is even more so for the third quarter of the century. The celebrated polychromed oak figure of the Archangel Michael spearing the dragon from Mosvik Old Church, near Trondheim [329], has often been compared with the Angel

328. St John the Evangelist; from the west front of Trondheim Cathedral; probably *c.*1260–70 (Nidaros Domkirkes Restaureringsarbeider, Trondheim)

of the Annunciation from the Westminster chapter house of around 1253, and it may even have been imported from England [305].[11] Other wood sculptures from the same area, such as the seated Virgin and Child from Austråt, are also so close to English models – in this case the statuary of Wells – that they too have been attributed to English sculptors, while the similarity between the Crucifix figure from Mosvik and the painted crucified Christ in the English Amesbury Psalter of about 1250–5 points to an equally strong relationship.[12] The most marked English influence is naturally enough to be found on the west coast of the country, around Trondheim and Bergen; after the middle of the thirteenth century, however, native sculptors started to develop a characteristic style of their own, and different workshops of accomplished wood carvers can be identified further East.

Foremost among these were the so-called 'Balke School', named after the triumphal cross group from Balke Church in the diocese of Hamar, north of Oslo, of around 1260. The Balke group, originally made up of seven figures (only five survive) set on a rood-beam, represents a stage beyond the Mosvik crucifix in the creation of an indigenous style,

329. The Archangel Michael; from Mosvik Old Church; polychromed oak, *c.*1250–60 (UNIT-Vitenskapsmuseet Archaeological Department, Trondheim)

330. St Paul; from V. Gausdal, Oppland; polychromed oak, *c.*1260 (Universitetets Oldsaksamlingen, Oslo)

although still ultimately deriving from English prototypes.[13] A good number of other sculptures in the Gudbrandsdal valley are related to the Balke Crucifixion, but a life-sized oak figure of St Paul from the church of Vestre Gausdal in Oppland (now on loan to the Universitetets Oldsaksamlingen in Oslo from the Nordiska Museet, Stockholm) may be singled out as a paradigm, not least because it is the most perfectly preserved of the group [330]. The importance of polychromy is here plain to see, transforming the wood into what is in effect a three-dimensional enlarged manuscript illumination: the face especially is enlivened by the painting of the eyes, lips and flesh, and gold is reserved for the beard and hair, contriving to create not a realistic human figure but a vision-like image of striking power.[14]

In Sweden there is more evidence of direct French influence than in Norway, although often with a considerable time-lag. The most extreme case is the stone effigy from Gudhem Abbey in Västergötland (now in the Statens

331. Crucifix; Öja Church, Gotland; polychromed wood, probably *c*.1275–90

Historiska Museet in Stockholm), possibly that of Queen Katarina (died 1252), which reflects at a great distance the style of the Chartres Royal Portal jamb figures and the comparable figure of a queen at Corbeil. This, however, is a *unicum*, and the norm is represented by several wood sculptures which show a more up-to-date admission of French stylistic developments.[15] On Gotland, as in the first half of the thirteenth century, the accent is German. Two wheel-crosses, presumably inspired by earlier Westphalian models as at Soest but far exceeding them in intricacy and ambition, are the most remarkable survivals. The Öja and Fröjel crosses, appropriately described as 'flabellum-crosses' by Andersson, do indeed have the quality of work in precious metal, the earlier crucifix at Öja being especially lavish [331]. Within the ring encircling the cross, painted reliefs of

mourning angels occupy the upper segments while in the lower half two scenes from the Fall of Man – the committing of Original Sin for which Christ died on the Cross (1 Corinthians 15: 3) – are played out below Christ's out-stretched arms. The figures of Christ, the Virgin and St John follow closely the form of Westphalian and Saxon precedents.[16]

With the growth in power of the Hanseatic League Sweden and southern Norway increasingly looked to their Baltic neighbours for trade. Lübeck was to become the principal centre for this maritime business, and in the fourteenth and fifteenth centuries its sculpture workshops would assume a dominance in the Scandinavian market comparable to that held by England between 1220 and 1270 in Norway.

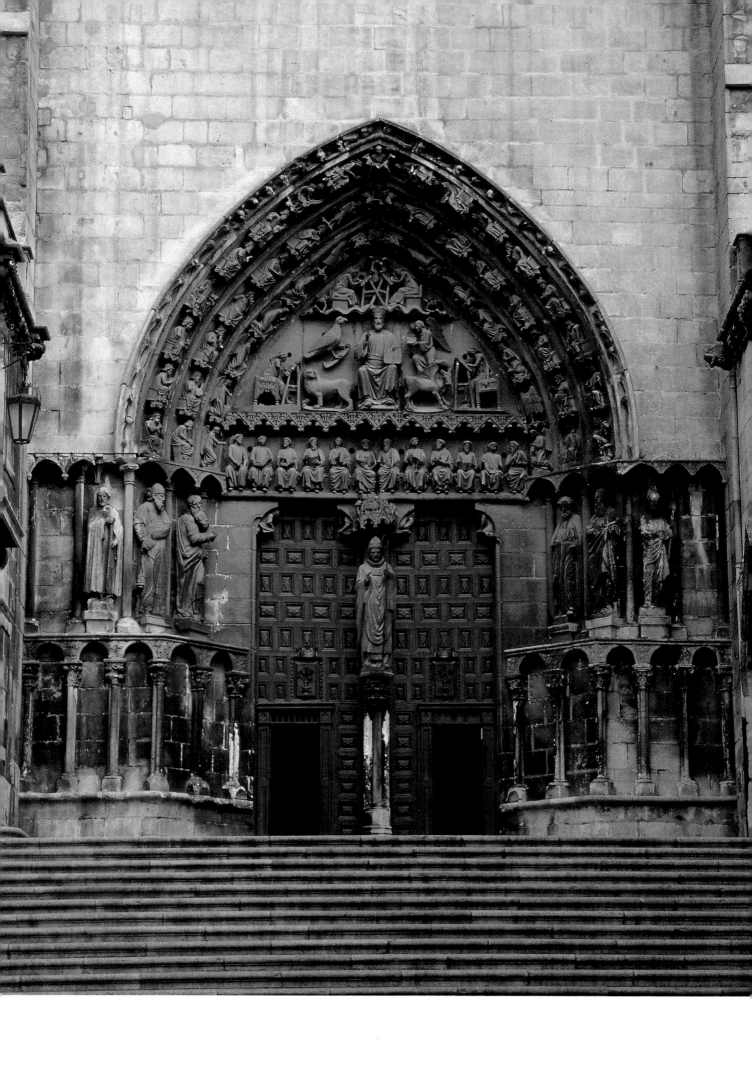

Spain 1230–1300

The history of sculpture in Spain in this period is essentially a history of Castilian sculpture. King Ferdinand III (1217–52) finally reunited the kingdoms of León and Castile after internecine struggles throughout the twelfth century, and after the Muslims had been confined to Andalucia following the battle of Las Navas de Tolosa in 1212 the King of Castile was considerably more powerful than those of Aragon and Navarre. The two most important centres for sculpture in the thirteenth century, the cathedrals of Burgos and León, not only occupied key positions on the pilgrimage route but were also favoured with royal patronage. Burgos was especially privileged in this way, and the Gothic cathedral was from its beginning blessed with the support of the King. Although Toledo was the seat of the archbishop it did not enjoy the same level of support from the crown, and it was presumably for this reason that Burgos was recognised by the Pope as exempt from the rule of the archbishop and administered directly from Rome. Its cathedral's sculptural decoration would reflect this importance and introduce the mature Gothic style of northern France into Spain.

BURGOS

The first stone of the new cathedral of Burgos was laid on 20 July 1221, in the presence of King Ferdinand III. Bishop Maurice of Burgos was especially close to Ferdinand, having been personally chosen to bring back from Germany the King's bride, Beatrice of Swabia, and the royal couple were married in the old cathedral in 1219. He was a well-educated man, schooled in Paris, and there can be no doubt that he travelled widely. It was probably Maurice who decided to employ a French architect and masons on his own church after having seen work in progress on the cathedrals in Paris and Chartres, and the similarity of its architectural form to the French cathedrals of Bourges, Reims and Coutances has often been pointed out.[1] The earliest sculpture of the new building, made for the portal of the south transept – the *Puerta del Sarmental* – reveals the participation of workmen from a different quarter: Amiens.

Work progressed quickly, and it is recorded that in 1230 the choirmaster Pedro Díaz de Villahoz bequeathed funds for the completion of the chapel of St Nicholas, on the east side of the north transept, and that in 1238 Bishop Maurice died and was buried in the choir. The building continued westwards until 1260, when the consecration took place, and by this time the main body of the church must have been complete; the construction of the cloister followed immediately afterwards.[2] In the light of how much sculpture was made for the cathedral before 1260 it is likely that the earliest work was in course of execution in around 1240, a

dating supported by its striking similarity to certain sculptures on the west front of Amiens Cathedral.[3]

The single *Puerta del Sarmental* terminates the south transept, and is reached by a broad flight of steps necessitated by the cathedral's particular position on a hill above the river Arlanzon [332–4]. In the tympanum sits Christ in Majesty surrounded not only by the symbols of the evangelists but also by the evangelists themselves, busily writing at their desks. On the lintel below are the twelve apostles and in the archivolts are angels, the elders of the Apocalypse and representations of the Liberal Arts. The six figures alongside the door are not of the thirteenth century, and the trumeau figure of a bishop is a modern copy of the original, which is now displayed in the cloister: its identity is unclear, although it is possible that it represents St Indalecio, the first bishop of the see of Oca, the Visigothic forerunner of the Burgos diocese.[4]

Although the iconographic theme of the tympanum and lintel was by this time no longer current in France, certain other features of the portal prove that the master of the workshop was fully conversant with the latest developments. The way the figures to each side of the doorway were positioned in niches, rather than on consoles or shafts, was possibly the first instance of this innovation, seeming to predate its appearance in Paris, on the north transept portal at Notre-Dame. But it is in the style of the principal figures that the origin of the chief sculptor is most clearly revealed. A comparison between the head and draperies of the seated Christ at Burgos and the *Beau Dieu* of Amiens [333, 212] leaves little room for doubt that the same sculptor was responsible for both figures. As Deknatel showed as long ago as 1935, there can be no question of one being based on the other: what we have at Amiens and Burgos is the stylistic signature of one man, an exact correspondence in form and detail which cannot be explained by model books or a distant general inspiration. He was presumably responsible for the whole tympanum, while the apostles of the lintel [334] and the bishop saint below seem to have been executed by another sculptor, also from Amiens. These sculptors must have taken on local assistants, and evidence of the indigenous style of northern Spain – the last flickerings of the late Romanesque style which had spread outwards from the Pórtico de la Gloria – may be seen in some of the figures in the voussoirs.[5]

This close correspondence with Amiens was not repeated at Burgos, although the lessons learnt by Spanish sculptors employed in the workshop of the *Puerta del Sarmental* were carried on to the work which followed it. The portal of the north transept (the *Puerta de los Apóstoles* or *Puerta de la Coronería*) was probably constructed in around 1245–55, its iconography complementing that of the south transept. It shows the type of Last Judgement scheme worked out on the south transept at Chartres, with the Virgin and St John interceding for the souls of the dead and with the twelve

332. The *Puerta del Sarmental*, south transept, Burgos Cathedral; c.1240–5

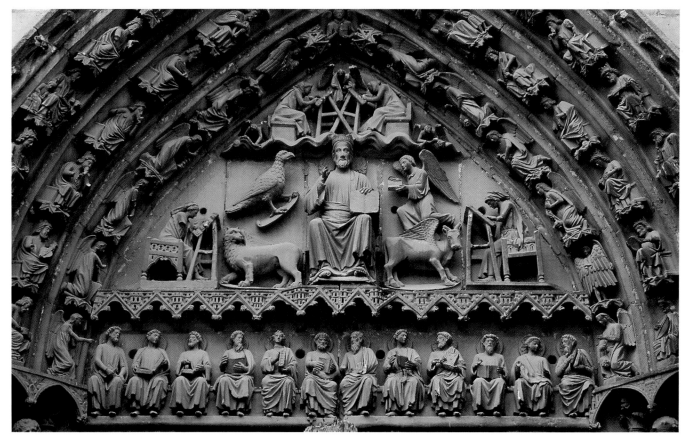

333. Tympanum of the *Puerta del Sarmental*, south transept, Burgos Cathedral; *c.*1240–5

334. Detail of pl. 333

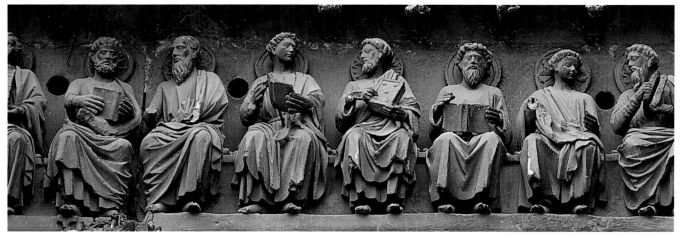

apostles on the jambs below [335]. The lintel is divided into two by the figure of St Michael weighing the small figure of a soul in his scales; on the right three devils attempt to tip the scales in their favour, a miser is being pulled by the hair and his money bag towards damnation, and another devil pitches a naked figure into the jaws of Hell. On the left, an angel holding a soul stands in front of the Gates of Paradise while within a king and queen receive two hooded friars, presented by a now-headless figure in pontificals. It is likely that the king and queen should be identified as King Ferdinand III and Queen Beatrice, and that the friars are Saints Dominic – a Castilian saint – and Francis. The figure

between them could be either a symbol of papal approval for the new orders or Bishop Maurice, the founder of the cathedral.[6] Nothing could illustrate more graphically the growing importance of the mendicant orders at this date, being used here pointedly to espouse the virtue of saintly poverty over the vice of the miser.

As on the *Puerta del Sarmental*, sculptors of differing ability were engaged on the north transept portal. Again, the most accomplished work is on the tympanum and lintel, the figures of the apostles being much less successful. By this time the sculptural workshop at the cathedral must have been greatly expanded to complete the vast amount of work

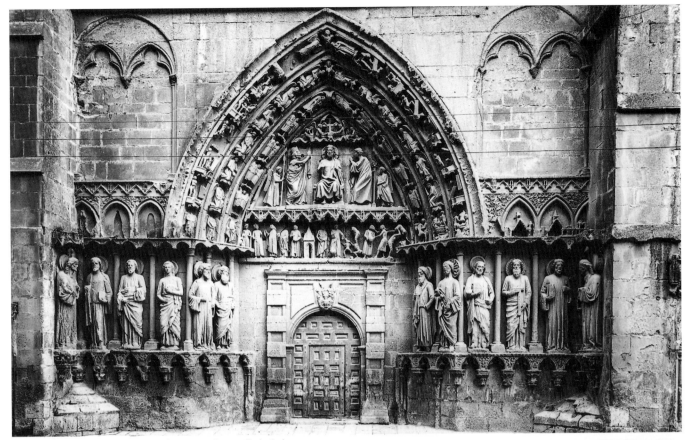

335. The *Puerta de la Coronería*, north transept, Burgos Cathedral; *c.*1245−55

336. Cloister portal, south transept, Burgos Cathedral; *c.*1265

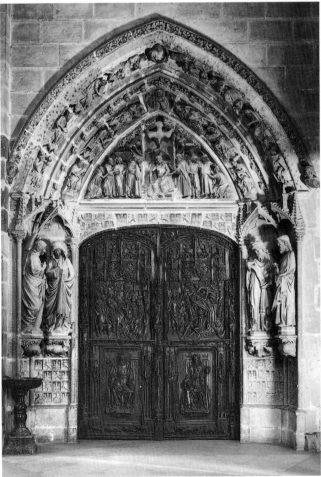

which was in place by 1260, but it is nevertheless odd that inferior sculptors should have been entrusted with such important figures as the jamb apostles. This is even more surprising in view of the fact that the many contemporary standing figures on the towers and façades of the west front and transepts are of distinction, and the numerous fine head studies around the arcades of the triforium are comparable to the naturalistic corbels at Reims.[7] In addition to all this, the west façade was decorated with three portals devoted to the Virgin, although it is not now possible to be certain whether these were in place at the time of the dedication. They were in bad condition by 1663, when the lateral tympana were replaced by new reliefs, and the central portal was completely remodelled in the following century.[8]

After the dedication of the cathedral in 1260 it must have been decided straightaway to replace the old Romanesque cloister to the south of the nave with a new one east of the south transept. Because of the lie of the land this had to be a two-tier construction, access from the cathedral being onto the higher level. The primary entrance to the cloister was through a new portal broken through the south transept on its eastern side, entering the cloister at its north-west corner [336]. The sculpture of this portal and the many figures inside the upper level of the cloister are of great importance not only because of their good condition but also because of their high quality. They represent the mature contribution of a Burgos workshop which had been refining a characteristic style of its own over a period of at least twenty years. While

337. Annunciation group; cloister portal, south transept, Burgos Cathedral; c.1265

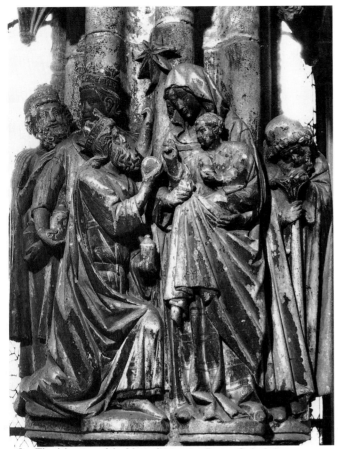

338. The Adoration of the Magi; cloister pier, Burgos Cathedral; *c.*1270

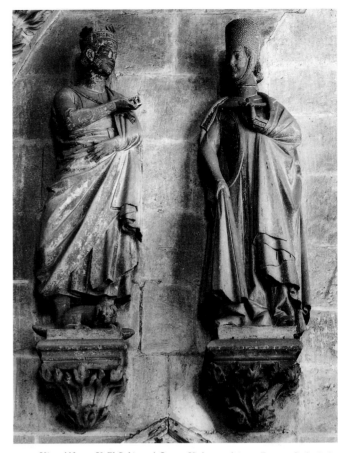

339. King Alfonso X *El Sabio* and Queen Violante; cloister, Burgos Cathedral; *c.*1270

the initial stimulus had come directly from northern France, and new inspiration from that source continued to inform its workshop, the end result is as distinctively Castilian as the Magdeburg Wise and Foolish Virgins are German.

The best sculptors of the large workshop responsible for the *Puerta de la Coronería*, the west front portals and the figures on the towers were retained for work on the cloister, which was probably finished by about 1280, although two doorways on the east side were constructed in the fourteenth century when the chapels of St Catherine and Corpus Christi were built.[9] The portal was in all likelihood among the first work to be done once the building of the cloister on the other side of the transept east wall had reached the second level, probably in about 1265. The Baptism of Christ is shown at the middle of the tympanum, an angel holding Christ's clothes while John the Baptist pours water from a dish over his back; three figures, their identity uncertain, extend the central scene on each side.[10] In the voussoirs are the prophets and kings of the Tree of Jesse, and below two figures stand on consoles on each side of the door: the Annunciation is shown on the left and King David and the prophet Isaiah, who foretold Christ's coming, are on the right. The strong connection between the cathedral and the rulers of Castile and León, to be confirmed in a number of the sculptures within the cloister, is emphasised by the conspicuous display of the arms of the kingdom on the lintel and on the jambs, and even between the pairs of standing figures. The relationship between the figures is strengthened by the fact that the door is built into the

thickness of the transept wall, so that the outer figures in both cases are almost at right angles to those nearer the centre. This is especially effective in the case of the Annunciation group [337], where the Virgin and the Angel are brought into a close contact rarely achieved when the same figures are forced to turn towards one another, as at Amiens and Reims. The style of both the tympanum and the Annunciation group is a development of that on the tympanum of the *Puerta de la Coronería*, where the figures of the Virgin and St John are wrapped in similar broad folds of heavy drapery. The advance is perhaps more marked in the figures of David and Isaiah, which show knowledge of recent French works such as the apostles of the Sainte-Chapelle and their later reflections at Reims.

Inside the cloister the sculpture is best dealt with in three separate groups. The first consists of the sculptures ranged around the columns of the four corners of the cloister garth. Facing the entrance, in the north-west corner, are four crowned figures (one has lost his head) traditionally identified as four of the five sons of Alphonso X the Learned and Queen Violante, and the other three corners show the Annunciation, the Adoration of the Magi [338], and a group of a king and a bishop with two attendants, probably the founders of the present cathedral, King Ferdinand III and Bishop Maurice.[11] Secondly, twenty-three life-sized figures stand on consoles in the outer arcades of the cloister: there are seven Bishops (not including that from the trumeau of the *Puerta del Sarmental*), six apostles (including Saints Peter, Paul, James and Bartholomew), three prophets (including

340. Central portal, south transept, León Cathedral; c.1260–5

341. Isaiah, the Virgin of the Annunciation and one of the Magi; left side of the central portal, south transept, León Cathedral; c.1260–5

the prophetess Anna), St Catherine, Abraham sacrificing Isaac, King Alfonso X (1252–84) and Queen Violante [339], a Prince (probably their eldest son), and two so-far unidentified figures who appear to be connected in some way with pilgrimage. The figures may not now all be in their original positions, although there is no reason to doubt that they were from the outset intended for the cloister, especially as many of the contemporary consoles were specifically made for them.[12] The bishops are presumably all connected with the diocese of Burgos and, as Deknatel has pointed out, there were many local sainted prelates who could have been commemorated in this manner. They should perhaps be viewed in the same way as the effigies of the Anglo-Saxon bishops at Wells and the *fundatores* at Naumburg, as status-minded declarations of the illustrious tradition of this particularly important See. The additional presence of Alfonso and Violante and their sons, of King Ferdinand and Bishop Maurice, and the choice of the Adoration of the Magi on one of the four corners, increase the impression that the cloister should be viewed as an aristocratic and sacred pantheon, and it did, of course, act as the burial place of the most important ecclesiastics. The third major sculptural contribution of this time is the Deesis at the south end of the west wall, formed into a tympanum by the pointed arch of the cloister arcade, in the manner of the *Puerta de la Coronería*. It was presumably completed by a now-missing effigy below, as in the similar fourteenth-century tombs in the cloister at León.[13]

All the sculptures of the cloister have stylistic points of contact with the work carried out on the cathedral immediately before, and a number of different hands have been picked out. The princes of the north-west corner and the figure of King Alfonso are sufficiently close to certain figures on the towers to assume a common authorship, the Magi of the south-west pier may be compared with the figures of David and Isaiah on the cloister portal, and the Queen Violante is related to the Annunciation of the cloister portal and the sculptures of the tympanum of the *Puerta de la Coronería*. Deknatel investigated the different stylistic traits with great thoroughness, an analysis which unsurprisingly indicated a process of internal development by a small number of master sculptors who had probably spent their entire working lives in the cathedral workshop at Burgos.[14] But as was the case elsewhere, other sculptors must have received their training and moved on. The position of the cathedral as the centre of an important diocese ensured that the workshop was extremely influential, so that there were many other sources of employment not only in smaller churches which sought to emulate Burgos but also at the largest site of existing thirteenth-century sculpture in Spain, the cathedral of León.

LEÓN

The Gothic cathedral at León was begun more than thirty years after Burgos, in around 1255, and was presumably finished in 1302, when the Bishop returned to the chapter money which had been set aside for its construction.[15] The

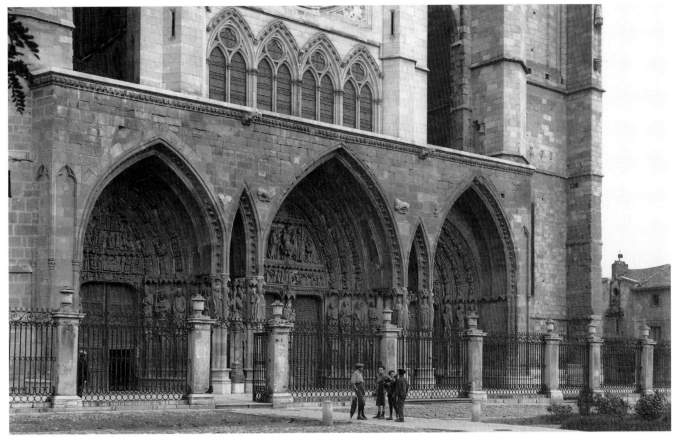

342. West façade, León Cathedral; c.1270–1300

groundplan of the cathedral is clearly based on that at Reims, and it has been convincingly argued that the first architect was the same Maestro Enrique, a Frenchman, who was responsible for the *Rémois* later work at Burgos.[16] Unlike the clear progression of sculptural work at Burgos, the order of construction at León is complicated by insertions of sculpture at later dates, the movement of certain pieces from one part of the cathedral to another, and the presence of carvings of very different quality side by side.[17] It seems likely that the layout of the south and west portals was known from the beginning and that the creation of sculptures for them was carried out concurrently. There are six sculpted doorways of the thirteenth century at León; the three on the west façade are devoted to the Last Judgement and scenes from the life of the Virgin, the two on the south transept to Christ in Majesty and the death and translation of the body of St Froilán, while the north transept doorway again shows Christ in Majesty, standing in a mandorla held by four angels; there are also several tombs of high quality inside the cathedral and in the cloister.[18]

The central portal of the south transept was probably erected first, as it is known that chapels in the apse were already in the course of construction by 1258, and a doorway would have been needed for access into the choir before the nave had been extended to its full length [340]. Its iconography is based on the *Puerta del Sarmental* at Burgos, although it departs from its model in details and the style is of course quite different, the best work in the tympanum and outer voussoirs being closer to the *Puerta de la Coronería*.

Although the positioning of the figure of St Froilán on the trumeau echoes that of the bishop saint on the *Puerta del Sarmental* it appears to be later than the other sculptures and may be a fourteenth-century insertion. The figures of the Three Magi, the Virgin and Child, the Virgin of the Annunciation and the prophet Isaiah in the jambs are now obviously not in their original positions, and it has been suggested that they were moved when St Froilán was placed on the trumeau. A possible reconstruction has the Virgin and Child on the trumeau, looking towards the Three Magi on the right side, while on the left would have been Isaiah, the Virgin, and the Angel of the Annunciation now displayed in the museum in the cloister.[19] Against this, the jamb figures do not relate to the iconographical scheme of the tympanum, and they would make more sense on either the north or south portal of the west façade, where Marian scenes are shown in the tympanum; the present arrangement of the jamb figures there is clearly not as intended (three of the figures are post-medieval and two others are too small).[20] Whatever their original position, these seven figures are among the finest at León [341]. From an iconographic and, to a lesser extent, stylistic point of view they reflect the influence of the jamb figures of the south doorway of the Amiens west front, possibly transmitted through the Amiens-inspired sculptures at Reims.

The west portal is also designed on the French model, incorporating an open porch with figure-decorated piers in imitation of the north transept at Chartres [342]. The central doorway is a more ambitious version of the Coronería portal

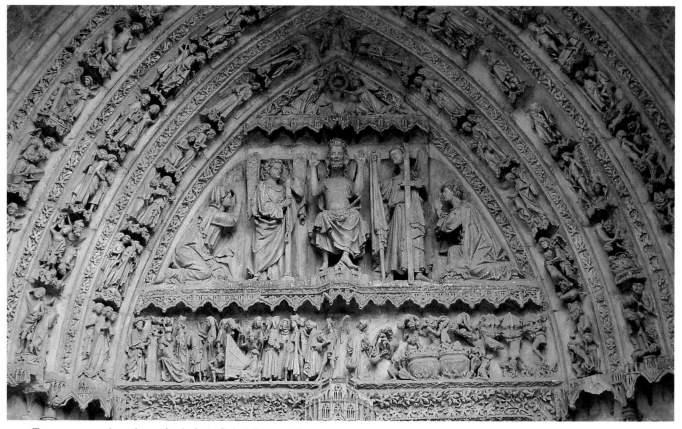

343. Tympanum, central portal, west façade, León Cathedral; c.1275-80

at Burgos, with the twelve apostles in the jambs and – unusually in this context – the Virgin and Child on the trumeau.[21] But the most striking and idiosyncratic feature of this doorway is the lintel showing the separation of the Blessed from the Damned, which one might justifiably claim as the most extraordinary depiction of this particular scene in medieval art [343]. As at Burgos and elsewhere, St Michael stands at the centre of the composition weighing the souls of the deceased. To the right, as usual, the Damned are consigned to the terrors of Hell; here the naked figures are being thrown into boiling vats and devoured by monstrous heads. The naked female figure at the centre being tipped head first into the pot is clearly associated with the sin of lust (*luxuria*), while alongside the miser (the personification of *avaritia*) is about to follow his money bag into the bubbling cauldron. The picture on the other side of the lintel could hardly be more different and is indeed presented as a counterpoint to the happenings on the right [344]. St Peter stands to the extreme left of the scene, welcoming the Blessed through the gates of Paradise. A pope stoops to enter, while behind him a bishop and a hooded figure, presumably a mendicant, are greeted by an angel. The rest of the figures seem in no hurry to move on – they are not even looking in the direction of Heaven – preferring instead to listen to the music played by a small organist, while a child-like angel appears to be conducting. The contrast between the fate of the Damned and the Blessed is here heightened by the inclusion of a small figure using a pair of bellows to pump the organ, while on the other side a demonic hairy figure in a hood also employs bellows to fan the flames of Hell. To

the right of the organ a spirited conversation appears to be taking place between a Franciscan, a hooded female figure and an elegantly attired king, sometimes identified as St Francis himself, St Clare and King Alfonso X. There is an atmosphere of bonhomie, of great happiness, unmatched in the thirteenth century with the possible exception of the same scene at Bourges [229], which shares some of the features found at León. This is all charmingly underlined by the relaxed poses of the figures and the use of touching gestures – literally in some cases as many of the figures have placed their hands on the shoulders or around the necks of their fellows.

The sculptor's distinctive style helps to consolidate this exquisitely refined air. All the figures have delicate rounded faces, their eyes and hair delineated with great sensitivity, their ethereal bodies supported on spindly legs. They are the work of a sculptor familiar with working on a small scale, and it is perhaps for this reason that apart from the seated figure of Christ and the angel to his left in the tympanum and some of the voussoirs of the central portal we do not see any more of his sculpture on the outside of the cathedral. The only other work by him in León is the tomb of the Dean Martín Fernández (d.1250) in the cloister, which shows the Adoration of the Magi and Crucifixion above the now-destroyed effigy of the deceased.[22] The tomb was presumably commissioned some time after the Dean's death, and a date around 1275-80 would suit both the tomb and the execution of the sculptor's work for the west portal. There is nothing remotely like this sculpture anywhere else in Spain, but curiously the figure style resembles the almost

344. The Blessed; left side of lintel, central portal, west façade, León Cathedral; c.1275–80

345. Simeon; detail of jamb figure, south portal, west façade, León Cathedral; c.1280–1300

exactly contemporary Wise and Foolish Virgins and queens in the voussoirs of the Judgement portal at Lincoln [309]. A direct connection is unlikely, but as both sculptures have points of contact with ivory and wood carvings it is possible that small-scale sculptures provided a common inspiration.[23]

In addition to the contributions of the masters responsible for the jamb figures on the south transept doorway and the Last Judgement lintel, the work of other sculptors with different styles may be recognised on the western doorways. The sculptor responsible for the *Virgen Blanca* on the central portal also seems to have carved the figures of the Virgin and St John on the tympanum above, and is likely to have come from the Burgos workshop which made the tympanum of the Coronería portal and the Annunciation group of the cloister portal. The apostles on the jambs of the central portal have a consistency of approach which would be taken over in around 1300 at Vitoria, while the figures on the porch piers facing them are informed by a knowledge of French work of the first half of the century and are probably products of the workshop responsible for the south transept jamb figures. The production of the jamb figures for the west portals clearly carried on spasmodically from about 1270 to 1300. Ignoring the later insertions, the last to be made were probably the Simeon [345] and Sibyl alongside one another on the right jamb of the south doorway and the related figure of a prophet on the outside of the opposite jamb. The heads of Simeon and the prophet have the mannered elongation and the curly beards seen in northern Europe at this time, as for example on some of the later figures of the Reims west façade and their derivatives at Strasbourg [233, 288].

346. North transept portal, León Cathedral; c.1290–1300

The north transept portal, enclosed in a vestibule to the south of the cloister and consequently in good condition, is an attempt to match the cloister portal at Burgos [346]. Although the theme of the tympanum is different – that at León being extremely archaic for the late thirteenth century – the overall design of the portal and the incorporation of such details as the arms of Castile and León on the jamb socles and doorposts is clearly derived from the earlier doorway. Likewise the Annunciation group to the right is virtually a copy of the same group at Burgos, although in the hands of the later sculptor the intimate relationship between the two figures is missing. The other figures on the jambs (Saints Paul, Peter and James on the left, St Matthew on the right) are by an inferior sculptor, while the Virgin on the trumeau is probably an early fourteenth-century work.

Finally, something should be said of the thirteenth-century tombs inside the cathedral which, like the architecture of the church itself and much of the exterior sculpture, reflect the influence of French models. The earliest of these, that of Bishop Rodrigo II Alvarez (died 1232), is in the Capilla del Carmen on the south side of the cathedral and was probably made before the building started on the new cathedral at mid-century. Its decorative arrangement was taken over from the late twelfth-century French enfeu tomb, of the type which provided the now out-of-context sculptures of the *Porte romane* on the north transept at Reims Cathedral,

although its narrative programme is fuller than any surviving French examples. This scheme was to be repeated in two other tombs in the transept at León.[24] That of Bishop Martín II Rodríguez (died 1242) in the west wall of the north transept is especially worthy of note [347], and is likely to date to around 1260.[25] The effigy of the bishop lies in a niche excavated from the wall. In front of the tomb chest a relief showing the distribution of bread to the needy alludes to the charitable deeds of the deceased, while above and adjacent to the effigy a second relief shows a procession of clerics engaged in the Office of the Dead with, to the right, a group of grieving mourners. Above this the lunette was carved with the Crucifixion, now defaced, and around the arch two orders of angels escort the small naked figure of the bishop's soul heavenwards. As well as being fine examples of high-quality sculpture in their own right, the León tombs are extremely valuable as reflected records of their models; as such they shed much light not only on French prototypes but also on derivatives elsewhere, such as the Annibaldi tomb in Rome.[26]

THE SPREAD OF THE BURGOS AND LEÓN STYLES IN THE SECOND HALF OF THE THIRTEENTH CENTURY

As we have seen, the cathedrals of Burgos and León acted as the points of entry for the importation of the mature French Gothic style of architecture and sculpture into Spain. They in turn provided training for masons – we know for instance that in 1277 King Alfonso X exempted as many as twenty stone cutters from paying taxes at León – and the inspiration for a number of more modest sculptural programmes in the surrounding countryside.[27] The most conspicuous display of imitation at this time is provided by the south portal of Santa María la Real at Sasamón [348], about thirty km west of Burgos and just off the road to León.[28] Here the form of the *Puerta del Sarmental* has been copied almost exactly, but the style in which the figures have been carved is not that of the Sarmental masters. It is instead closer to the archivolt figures of the south transept portals at León, a parallel which suggests that the Sasamón portal was made in around 1280, almost half a century after its model was conceived.[29]

The west doorway of the church of San Esteban at Burgos, a short walk from the *Puerta de la Coronería* on the north transept of the cathedral, takes its lead from this other most influential portal, albeit not as slavishly as the Sasamón portal followed the Sarmental tympanum. The upper part of the tympanum shows the Deesis in the form of that on the Coronería portal, and although the lower frieze has adopted the same uncrowded and clearly-structured narrative method it is dedicated to scenes from the martyrdom of the patron saint rather than the separation of the Blessed from the Damned, while the jambs are occupied by saints and martyrs, including Stephen and Lawrence, instead of apostles [349]. Despite the absence of any documentary evidence to help date the portal it is likely to have been made by secondary sculptors who had been employed at the cathedral up until its consecration in 1260, and was probably executed in about 1270–80.[30]

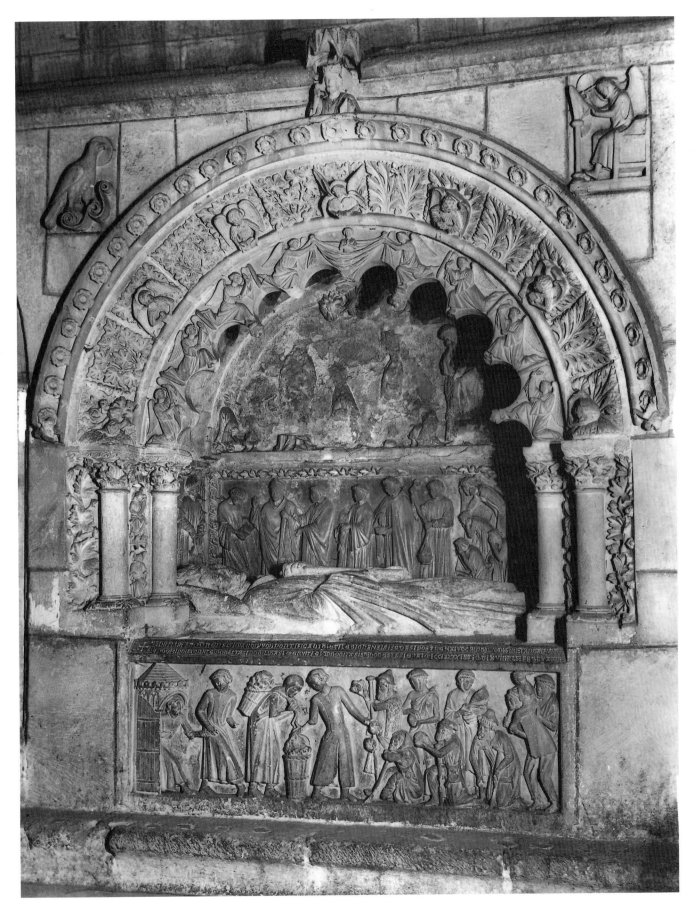

347. Tomb of Bishop Martín II Rodríguez (d.1242); north transept, León Cathedral; c.1260

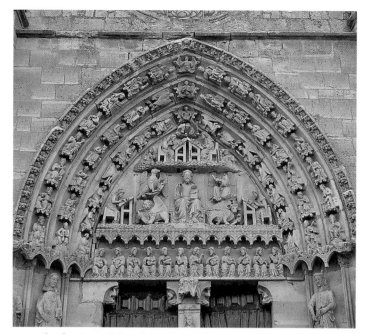

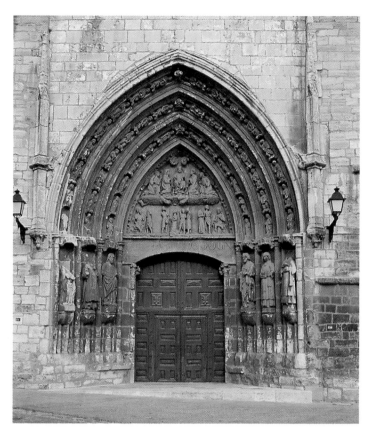

348. South portal, Santa María la Real, Sasamón; *c*.1280

349. West portal, San Esteban, Burgos; *c*.1270–80

350. The Virgin of the Annunciation; south portal, El Burgo de Osma Cathedral; *c*.1270–80

351. The Queen of Sheba; south portal, El Burgo de Osma Cathedral; *c*.1270–80

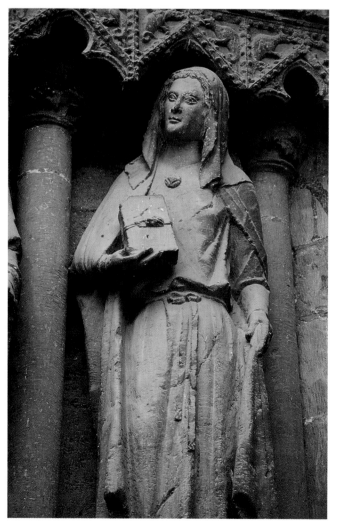

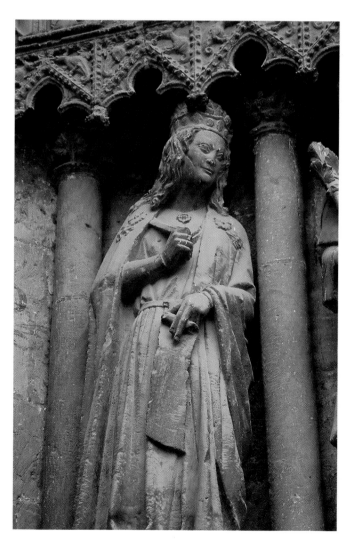

352. West portal, Santa María la Mayor, Toro; c.1270–80

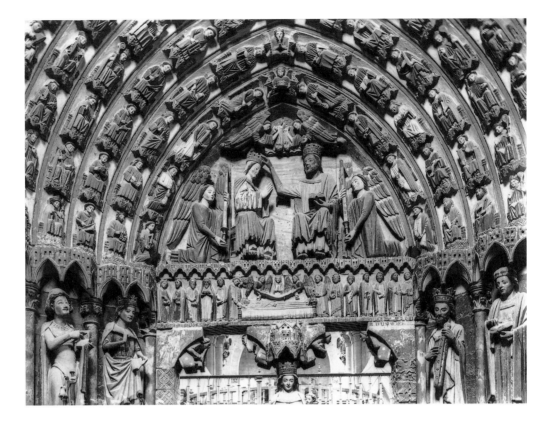

The principal portal of the cathedral of El Burgo de Osma in the province of Soria is on the south side of the building, giving access to the transept. Although the Gothic cathedral was begun in 1232 the doorway was probably not constructed until about forty years later.[31] It was not completed at that time, however, as the tympanum remained uncarved and the figure of Christ as the Man of Sorrows which now stands on the trumeau was only added in the fifteenth century. The lintel shows the Death of the Virgin, so the tympanum was almost certainly intended to contain her Coronation, and the trumeau should more properly show the Virgin and Child.[32] The carving of the lintel and the figures in the voussoirs is routine work and were it not for the jamb figures below, the portal would remain as no more than a footnote in the history of Spanish Gothic sculpture. On the left side is the Annunciation [350] and Moses, on the right the Queen of Sheba [351] and King Solomon, with a poor block-like female figure on the outer face. These five figures are of comparable quality to the best work at León, and it is to that centre rather than Burgos that one should look for their inspiration. But it is unlikely that they could have been carved without knowledge of sculpture in France, in this case the latest figures at Reims on the inside of the west front; the poses of the Queen of Sheba and King Solomon especially, and the way they hold the cords of their cloaks at their necks, recall the figures of Herodias and Herod, and the facial types reveal an effort to emulate the Reims statues.[33]

The Death of the Virgin is depicted in a similar way on the probably contemporary lintel of the enclosed west portal of the collegiate church of Santa María la Mayor at Toro (Zamora), and in this case the tympanum showing the Coronation and the Virgin and Child of the trumeau are present [352]. The six orders of voussoirs are unusually enclosed within an outer radiating archivolt dedicated to the Last Judgement, while below eight figures, including two angels and King David, occupy the jambs. The carving is uninspired, but is informed nevertheless by the advances worked out at Burgos and León, separating it from the earlier portal at Ciudad Rodrigo.[34]

Although the French Gothic style had completely penetrated Castile by the middle of the thirteenth century, traces of the Romanesque tradition persisted in certain places for specific reasons. Just as the *Puerta del Sarmental* had been chosen as the model for the doorway at nearby Sasamón, the arrangement of the porch of Santa María la Blanca at Villálcazar de Sirga was based on the even earlier north entrance wall of the cathedral at Carrión de los Condes five km to the northwest. At Villálcazar de Sirga two friezes extend the width of the porch above the portal; the higher of the two has Christ in Majesty flanked by the apostles, echoing the arrangement at Carrión de los Condes, while the lower has the Virgin and Child in the centre, with the Magi on the left and Joseph and the Annunciation to the right. The portal has five orders of figured archivolts but no tympanum.[35] Here the gap between model and later version was nearly a hundred years, producing a strange hybrid of Gothic figures quite close to those at El Burgo de Osma standing in a Romanesque architectural framework. Examples of this type of 'Romanesque revival' obviously became less and less common, although modified replicas of particularly celebrated sculptures were made as late as the fifteenth century in impoverished and out of the way places.[36]

In León and Burgos themselves the cathedral workshops may also have produced sculptures for monastic and aristocratic patrons. Two fine marble column figures of the

353. Virgin and Child; said to be from San Benito, Sahagún; marble, probably c.1250 (Museo Arqueológico, León)

354. Deposition from the Cross; Las Huelgas, Burgos; polychromed wood, c.1265

standing Christ and the Virgin and Child [353], now in the Museo Arqueológico at León but supposedly from the monastery of San Benito at Sahagún, possibly formed part of an altar, screen or cloister. The Virgin is similar to the *Virgen Blanca* at León, but in its slender elongation it approaches even more closely the type of French Virgin and Child on which the latter was modelled, such as that on the trumeau of the right doorway of the west portal at Amiens [213].[37] At Burgos it is likely that members of the cathedral workshop were employed at the royal convent of Las Huelgas. A number of tombs of the late thirteenth century can be related to work at the cathedral, and the beautiful painted wood Deposition from the Cross above the altar [354] should probably be attributed to the atelier of the cloister portal. Freed from architectural constraints, the sculptors were able to create a masterpiece of great pathos worthy of its royal setting. In its treatment of the subject it remains unsurpassed, anticipating the emotionally charged and technically excellent polychrome wood sculptures of the following centuries for which Spain would become famous.

ÁVILA, TOLEDO AND VITORIA: SCULPTURE AT THE END OF THE THIRTEENTH CENTURY

By the final years of the thirteenth century the great cathedral workshops at Burgos and León were bringing their work to a close. In the first half of the fourteenth century Toledo and Vitoria were to become the primary centres of sculptural production in Castile, and from the second quarter of the century the most innovative and creative sculptors would be found in Aragón. It has been seen that there was a gradual dilution of the Burgos-Amiens-León style in the north of Spain, which only on rare occasions produced original contributions by sculptors worthy of comparison with the best of the cathedral workshops. A slow process of evolution took place, where an initially French-inspired style was transformed into what might be called Franco-Hispanic.

One of the most noticeable changes which took place at the end of the thirteenth century was to the arrangement of the tympanum. As in France, there was a tendency to develop its narrative content by dividing it up into an increasing number of horizontal strips. A tentative experiment with this form is seen on the north portal at Ávila Cathedral [355]. In most respects it is no different from earlier portals, with the twelve apostles on the jambs and a mixture of single-figure and historiated voussoirs above.[38] But here the tympanum is arranged in four clearly separated bands, even though the second and third ranks are broken by the figure of the seated Christ in a mandorla, an archaic feature found in a similar form on the north transept portal at León Cathedral. Despite this different way of dividing the tympanum the sculptor is still tied to the older narrative tradition, where major scenes such as the Coronation of the Virgin and Christ in Majesty take centre stage. The two bands at the level of Christ in Majesty simply contain standing figures of angels – some holding Instruments of the Passion – so that the only narrative scenes are contained in the bottom band, in the manner of a lintel.[39]

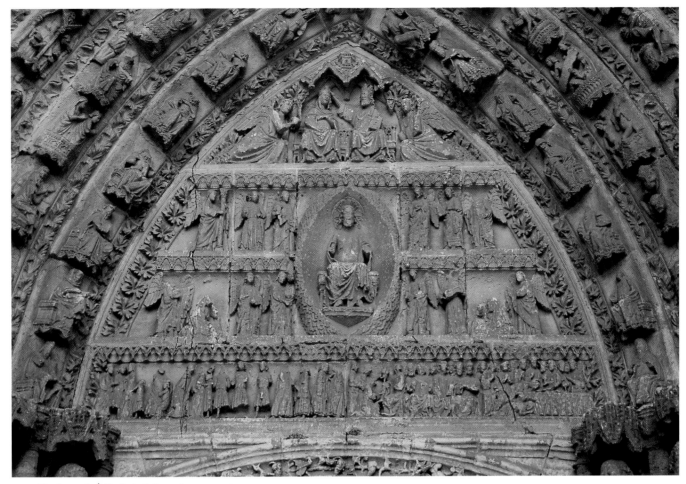

355. North portal, Ávila Cathedral; c.1280–90

The new method of dividing the tympanum is taken to its extreme on the first of the portals of Toledo Cathedral, the *Puerta del Reloj* (the clock portal) on the north side. Although the foundation stone of the cathedral was laid as early as 1226 by King Ferdinand III, work progressed comparatively slowly and it does not appear to have received any sculptured doorways before the turn of the century, in contrast to Burgos and León; its west portals are later still. Here, the narrative of the Infancy of Christ starts at the far left of the bottom register and is read left to right until it reaches the second register, where the order is reversed [356]. The same happens at the end of the second register, the story continuing until the extreme right of the third band, and the Death of the Virgin occupies the apex of the composition.[40] It thus reads like an ivory diptych – compare the narrative order of the contemporary Soissons diptych in the Victoria and Albert Museum [253] – and perhaps such a portable piece of sculpture, itself inspired by architectural models, suggested this method. The Toledo doorway is completed by the Virgin and Child on the trumeau and the Adoration of the Magi on the left jamb, including a further figure of a servant holding the Magi's horses; while on the right are Joseph, Elizabeth and the Virgin of the Visitation, and the Annunciation to St Anne. Because of the Magi's similarity to the figures of kings decorating the *Capilla Mayor* inside the

cathedral, which were made between 1289 and 1308, the construction of the *Puerta del Reloj* must have taken place at about the same time.[41]

Of similar date is the west portal of S. Pedro in Vitoria, which repeats the tiered narrative structure of the Toledo portal [357]. Here the figures are larger and the scenes – devoted to the Infancy of Christ and the Life of St Peter – are consequently easier to read, so that the overall effect is closer to the French tympana of about the same date at Rouen and Mantes. The quality of the carving is also better than that at Toledo, representing the last gasp of the Burgos-León tradition. This is most marked in the jamb figures, which are closely related to the apostles of the León west façade, and in the trumeau figure of the Virgin, based on the *Virgen Blanca*.[42]

The devotion to the Virgin, manifested in the iconographic programmes of so many of the churches already discussed, had for a long time provided the impetus for the production of numerous single statues for display on altars and elsewhere. Throughout the period with which this book deals both seated and standing Virgin and Child groups were made, predominantly in wood. The vast majority of these devotional statues were of mediocre quality, and examples in a provincial Romanesque style continued to be made into the fourteenth century.[43] Alongside the best locally-produced

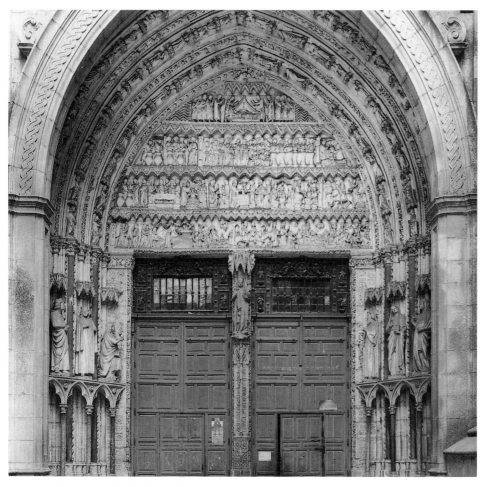

356. The *Puerta del Reloj*, Toledo Cathedral; probably *c.*1290–1305

357. Tympanum, west portal, S. Pedro, Vitoria; *c.*1290–1300

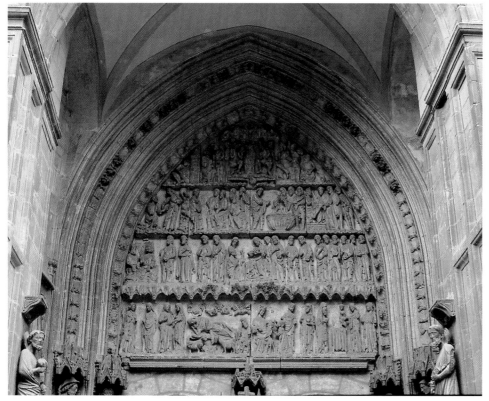

examples in the Gothic style, such as the *Virgen de la Esperanza* in León Cathedral (actually part of a now-separated Annunciation group) and Annunciation groups in León (San Isidoro), Toro, La Hiniesta and Tarazona, foreign works were also imported.[44] The most famous of these is the polychromed marble (or alabaster?) Virgin and Child in Toledo Cathedral, also known as *La Virgen Blanca*, which is traditionally said to have been a gift from King Louis IX [359]. This particular statue, probably a Parisian work of the third quarter of the thirteenth century, does not appear to have acted as an influential prototype in Toledo, but there are signs elsewhere that comparable works provided the models for monumental sculptures.[45] The elegant marble Virgin and Child on the trumeau of the central doorway of the west portal of Tarragona Cathedral in Catalonia [358], probably carved in the last years of the century, is certainly indebted to a French Virgin of the type of that from Saint-Corneille in Compiègne.[46] As was the case in Italy, it is likely that knowledge of these sculptures was actually transmitted through such intermediaries as small-scale statuettes in ivory and wood.

358. Virgin and Child; trumeau figure, central portal, west façade, Tarragona Cathedral; *c.*1290–1300

359. Virgin and Child (the *Virgen Blanca*); Toledo Cathedral; marble or alabaster, *c.*1250–70

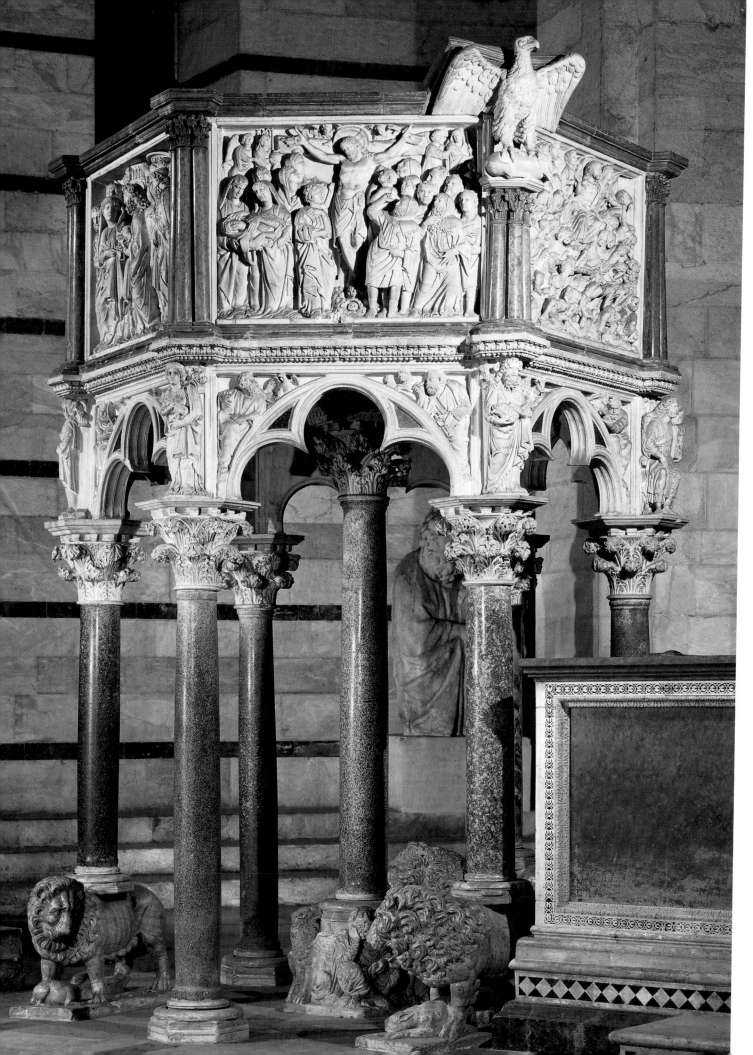

Italy 1250–1300

In the second half of the thirteenth century the achievements of Nicola and Giovanni Pisano and Arnolfo di Cambio overshadow the sculptural output elsewhere in Italy. They were encouraged by the ambitious patronage of competing communes and cathedral chapters in Tuscany and Umbria, and in Arnolfo's case additionally by the Papal Curia. Outside Central Italy the opportunities for sculptural endeavour were more limited. In the South the termination of Hohenstaufen rule also signalled the end of distinguished three-dimensional work until Angevin commissions revived the art in the following century, while in the North only isolated surviving sculptural programmes give an idea of the activities of local workshops. Earlier it was shown how Gothic style and Northern iconographic novelties had begun to percolate into Italy from the end of the twelfth century onwards. A continuation of this French-influenced trend exemplified in the first half of the century by the sculptures at Vezzolano and Santa Giustina in Padua is evinced by the Last Judgement in the gable above the central portal of the west façade of Ferrara Cathedral [361], where the influence of Notre-Dame in Paris is manifest. The Ferrara composition is a slight abbreviation of the tympanum and archivolt programme of the Paris central portal [76], containing all the canonical elements of French Last Judgement iconography: Christ between angels holding the Instruments of the Passion, the Virgin and St John, the Elders of the Apocalypse, the Blessed and Damned with trumpeting angels and St Michael weighing souls, the resurrection of the Dead, and in the adjacent lunettes the Blessed souls in Abraham's bosom (left) and the Damned in the Mouth of Hell. The style likewise is a late example of the long-lived post-Antelamesque manner, inspired by French prototypes of about 1220–40 but adding nothing new.[1] By now the important position occupied by the sculptors of the Po valley in the twelfth and early thirteenth centuries was demonstrably on the wane, and the axis of sculptural invention had shifted to Tuscany.

NICOLA PISANO, THE PISA BAPTISTERY PULPIT AND THE PORTAL AT SAN MARTINO, LUCCA

The circumstances which produced the right conditions for the production of sculpture of the highest quality for Frederick II in South Italy – the desire for self-aggrandisement, the employment of talented sculptors with a knowledge of the Gothic sculpture of the North, and the utilisation of a classical style for both political and artistic reasons – also existed in the Tuscan city states in the second half of the thirteenth century. It was the good fortune of Pisa and Siena, both Ghibelline, that they were in a position to take advantage of the cessation of patronage in South Italy

360. Nicola Pisano: pulpit, Pisa Baptistery; c.1257–9

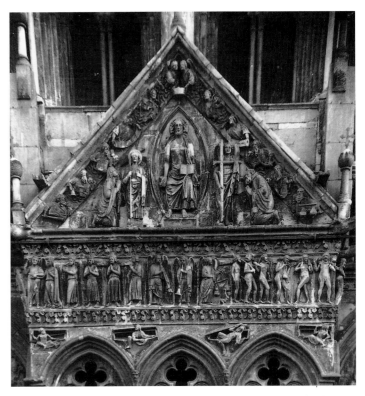

361. The Last Judgement; gable above the central portal of the west façade, Ferrara Cathedral; probably c.1250

and to entice the most influential sculptor of the mid-century, Nicola Pisano, to work for them. In the space of thirty years Nicola, with the foremost members of his workshop – his son Giovanni and Arnolfo di Cambio – totally transformed the appearance of Italian sculpture, extinguishing the embers of the Romanesque style and attaining an unmatched level of technical expertise. The student of Italian Gothic sculpture has the benefit of knowing more about the individual sculptors than in northern Europe, but one should nevertheless be wary of creating artistic personalities in the Renaissance mould. The numerous inscriptions, wills and accounts of payment which save the Italian sculptors from the anonymity of most of their peers in the North do not indicate that their conditions and method of work differed greatly from their French and German counterparts, and should not blind us to the fact that at this date there was an established workshop structure. A sobering antidote to the idea of the great individual master with a clearly identifiable style is provided by the sculptures on the façade of Orvieto Cathedral, which although slightly later (c.1310–30), provide a good example of how the carving of different parts of the same composition was sometimes executed by a number of sculptors.[2] That said, it can hardly be denied that the individual celebrity of the three sculptors mentioned above, even allowing for the loss of documents,

362. Hippolytus sarcophagus; Camposanto, Pisa; 2nd century AD

was unparalleled elsewhere in the thirteenth century and that by the time of his death Giovanni Pisano had a reputation – partly self-proclaimed – as the greatest of all. Nowhere in the North could one match the inscription on the Pisa Duomo pulpit, describing him thus: 'There are many sculptors, but to Giovanni remain the honours of praise'.[3]

The first signed and dated work by Nicola Pisano is the hexagonal pulpit in the Pisa Baptistery [360]. Five rectangular marble panels carry the narrative of Christ's Infancy and Passion around the body of the pulpit, showing scenes of the Nativity (also including the Annunciation and the Annunciation to the Shepherds), the Adoration of the Magi, the Presentation in the Temple, the Crucifixion and the Last Judgement. The reliefs are set in a frame of red marble (*rosso ammonnitico*) with triple colonnettes dividing one from the next, the whole being supported by seven columns with foliate capitals. Three of these rest on the backs of marble lions, while the base of the central column is made up of three squatting figures and three fierce animals. The intermediary zone, between the box of the pulpit and the supporting columns, consists of trilobed arches with figures of prophets and the four evangelists in the spandrels (the latter beneath the reliefs of the Crucifixion and Last Judgement) and at the corners six standing figures, probably to be identified as Charity, Fortitude (or Hercules), Temperance, Prudence, St John the Baptist and Faith (or St Michael).[4]

The inscription, running underneath the scene of the Last Judgement, extols the virtues of the sculptor in a manner to become commonplace: 'In the year 1260 [the Pisan year, therefore probably 1259] Nicola Pisano carved this noble work. May so greatly gifted a hand be praised as it deserves'.[5] The nomenclature employed for the sculptor in the inscription – *Nicola Pisanus* – gives no indication that he was not a native of the city, which after all had a proud tradition of marble sculpture. It is only in two documents drawn up in Siena in 1266 that clear written evidence of his origins is provided: both describe him as 'de Apulia'.[6] Even without the aid of the Siena documents Nicola's connections with South Italy are apparent in the design and details of the

pulpit. Its shape owes more to Campanian than to Tuscan prototypes, and the placing of scroll-holding prophets and Evangelist symbols in the spandrels was anticipated on pulpits at Salerno, Ravello, Sessa Aurunca, Teano and elsewhere, which also retain the coloured glass backgrounds now missing at Pisa.[7] The polychromatic effect of the clustered colonnettes at the corners is reminiscent of similar architectural features at Castel del Monte in Apulia, and more striking still is the closeness of pose and figure type of the squatting naked *telamone* at the base of the central column to the figured corbel stops at Castel del Monte.[8]

Other scattered pieces testify to the activity of South Italian – more specifically Hohenstaufen – sculptors in Tuscany in the years just after the middle of the thirteenth century. The few decorative architectural sculptures on Frederick II's castle at Prato were obviously the work of sculptors employed in the imperial entourage in the 1240s and are again extremely close to those at Castel del Monte, and it may be that Nicola was among these sculptors and masons from the South. Although he is first recorded in 1258 in a will drawn up in Lucca he had clearly been in Pisa for some time before then, and as it is likely that the Baptistery pulpit took at least two years to complete he presumably started it in around 1257. He was certainly employed on the architectural embellishment of the Baptistery, although attempts to identify his output before the execution of the Pisa pulpit – on the fountain at Piombino and in the heads of the cupola of Siena Cathedral – have met with only limited success.[9] It should be noted, however, that a capital now in the Museo dell'Opera del Duomo in Pisa, with four expressive heads emerging from the foliage at the base, is so close to the Troia capitals discussed earlier that it is likely to be a product of the same atelier: it thus furnishes us with further proof of the Apulian background to Nicola's workshop.[10]

It has been demonstrated how important the artistic language of classical Rome was for the official secular sculpture of Frederick II, for the figures of the *Porta romana* at Capua and for the portraits of the Emperor. If it is less clear-cut why a classical style was employed for the religious reliefs and figures of the Pisa pulpit it is certainly the case

363. Nicola Pisano: the Presentation in the Temple; detail of pulpit, Pisa Baptistery; *c.*1257–9

364. Nicola Pisano: Fortitude/Hercules; detail of pulpit, Pisa Baptistery; *c.*1257–9

that this was a style which Nicola Pisano was particularly well-equipped to imitate and which Pisa had good reasons for embracing. Seidel has shown in the most convincing manner how Nicola chose – or had chosen for him by the patron, Archbishop Federico Visconti – significant classical sources which were close at hand to enrich his repertory.[11] These models were of course not taken over wholesale: they were incorporated into the pulpit almost as quotations, transferred out of the context in which Nicola found them into an appropriate setting. This was not in every case simply a matter of 'christianising' certain characters of pagan antiquity, the so-called *interpretatio christiana*: the Hippolytus sarcophagus now in the Camposanto – one of the principal quarries for Nicola's figure types – had served as the tomb of the Countess Matilda's mother and was inserted into the side wall of the cathedral [362]. It was therefore likely to have been viewed as a particularly charged piece of Pisa's heritage. The figure of Phaedra seated to the left of the sarcophagus and her attendant nurse were adapted only slightly before being inserted as the standing Virgin, St

Elizabeth and Hannah (reversed) into the scene of the Presentation in the Temple [363], and the horse in the background at the left centre was used as a model for the second of the Magi's steeds. No less successful was the use of certain figures from the Neo-Attic crater which stood outside the Porta San Ranieri of the cathedral in the later Middle Ages, which were also transferred to the scene of the Presentation in the Temple, while the close similarity of many of the head types to classical models reveals Nicola's wide-ranging search for the realistic.

An instructive illustration of Nicola's use of the classical prototype is the naked figure of Fortitude/Hercules which graces one of the angles in the intermediate stage of the pulpit [364]. The physical exemplar was provided by the figure of Hippolytus on the eponymous sarcophagus, and Hercules himself was presented in almost identical pose on a sarcophagus in the Museo delle Terme in Rome. It is unlikely that Nicola Pisano saw the latter, but similar examples undoubtedly still existed in Tuscany in the thirteenth century and it is clear that he had made a special study of some of these.[12] As elsewhere on the pulpit Nicola was unable or unwilling to copy the classical prototype exactly; and like the arrangement of the drapery on the relief figures above, which shows a familiarity with northern Gothic, so the treatment of the naked form departs from the classical canon, presenting a more full-bodied, muscular depiction of strength.[13]

It has been suggested that the reliefs were executed in the same order as the narrative, so that the Nativity was carved first, the Last Judgement last. Certainly, the first three reliefs show an identical approach to the presentation of figures in three-dimensional space, with monumental forms and no perceptible depth of field, but it is likely that the design of all the plaques was worked out from the beginning and that the crowding and reduction in size of the figures in the Crucifixion and Last Judgement scenes was determined by the pictorial requirements of those episodes. It is probable, however, that at least the Last Judgement was executed with contributions from other members of the workshop. Some of the heads of the Blessed in the top left corner anticipate those on the Arca of S. Domenico in Bologna and may therefore represent the earliest work of the young Arnolfo di Cambio. Unfortunately this relief is the most damaged of all those on the pulpit: many of the small, under-cut heads, carved with great delicacy, were either knocked off accidentally or proved too great a temptation for souvenir hunters (including Lorenzo de' Medici), especially as the panel was situated next to the staircase. As one can see from the dowel holes in the necks, most of these must have been refixed or replaced by copies which were subsequently lost.[14]

Probably on completion of the Baptistery pulpit the workshop executed the undocumented tympanum and lintel of the left portal on the west façade of the Duomo at Lucca [365]. Were it not for the shape of the tympanum, showing the Deposition from the Cross, it could almost be placed alongside the Crucifixion of the pulpit as a continuation of the Passion narrative. The style is indistinguishable, especially in the draperies of the principal figures, which show the angular broken v-folds of the pulpit reliefs. Identical too is the packed density of the drama, and the manner in which the comparatively large and bulky figures jostle together in shallow space, a feature which would be discarded by the middle of the 1260s. The lintel below, dedicated to the Annunciation, the Nativity and the Adoration of the Magi, perhaps because of its elongated shape and narrative flow puts one in mind of the sarcophagi which so inspired Nicola in the Baptistery pulpit reliefs. There is, however, less of the marked and slightly stilted classicism so apparent in the Pisa reliefs; instead the three scenes are merged into one another in a brilliant pictorial composition which combines clarity of story-telling with finely-rendered detail, the latter especially notable in the architectural background.[15]

THE ARCA DI SAN DOMENICO IN BOLOGNA AND THE SIENA PULPIT

The striking novelty and great beauty of the Pisa pulpit ensured that similar commissions were soon offered to Nicola's workshop. The two most significant of these, the Arca di San Domenico and the Siena pulpit, were actually carried out concurrently, in the middle of the 1260s, and were to exert an enormous influence on the form of later shrines and pulpits respectively.

St Dominic died in Bologna in 1221, by which time the mendicant Order of Preachers that would come to be named after him was established alongside the Franciscans as a force of great power. He was canonised in 1234, and although glorification of the saint's remains was not consistent with the beliefs of the Order it was only a matter of time before the cult surrounding the saint demanded a tomb commensurate with his importance. That this was entrusted to the Pisan workshop of Nicola Pisano must have been

365. Nicola Pisano and workshop: Tympanum (before 1945), left portal, west façade, S. Martino, Lucca; c.1260–5

366. Workshop of Nicola Pisano: the Arca di San Domenico, detail of front; S. Domenico, Bologna; 1264–7 with later additions

367. Workshop of Nicola Pisano (Arnolfo di Cambio?): Caryatid group from the Arca di San Domenico; 1264–7 (Museum of Fine Arts, Boston)

partly to do with the lack of sufficiently skilled sculptors in Bologna, but the reputation that Nicola had made for himself by the execution of the Pisa pulpit would have stood him in good stead when the Dominicans decided to honour their founder. Documentary evidence for the start of the work is scanty, but because requests were made for funds to finish the monument in 1265 it is likely that work had begun in the previous year; the body of the saint was transferred to the completed Arca in the church of San Domenico Maggiore in 1267.[16]

The tomb is now radically different from its original appearance. Only the rectangular chest survives from the thirteenth-century plan, major changes being made at the end of the fifteenth century (by Niccolò del Arca and the young Michelangelo) and later.[17] The sarcophagus is given over to six scenes from the Life of St Dominic, including a mixture of miracles and historical episodes concerning the sanctioning of the Order by papal approval [366]. The authority vested in the saint by Popes Innocent III and Honorius III is further emphasised by the scene on one of the short sides of the tomb showing Saints Peter and Paul issuing Dominic with the symbols of his mission, and his spiritual line of descent is indicated by the four statuettes

of the Fathers of the Church – Saints Augustine, Ambrose, Jerome and Gregory – standing at the corners. In the middle of the long sides are the Virgin and Child and Christ the Redeemer. The overall appearance of the reliefs would have been enlivened by the extensive use of reverse-painted glass encrustation (*verre églomisé*) in the backgrounds, now mostly lost or restored, and selective painting and gilding of the figures.[18] There can be little doubt that the sarcophagus was supported by caryatid figures, but their form and number remain controversial. From an ambiguous description of the Cappella delle reliquie in 1620 it is known that *dodici Angeli* were at that time kept there, but it is uncertain whether these were correctly described and how they related to the Arca. There is scholarly unanimity that two three-figured caryatid groups, actually showing young tonsured friars, now in Boston [367] and Florence, formed part of the lower section of the Arca, and it is possible that two other groups of the same type, now lost, helped support the shrine at the four corners.[19]

It seems that Nicola Pisano played primarily a planning and supervisory rôle in the execution of the Arca. The tomb would almost certainly have been carved in the workshop at Pisa and constructed on site, but by September 1265 Nicola had agreed a contract with the *operarius* of Siena Cathedral, Fra Melano, to create another pulpit, and from that point it is likely that he devoted his energies in that direction. In the 1265 Sienese contract mention is made of Nicola's two principal assistants (his *discipulos*), Arnolfo and Lapo, and his son Giovanni, but it is clear that by May the following year Arnolfo had not yet arrived in Siena, presumably because he was still at work on the Arca di San Domenico.[20] This appears to be confirmed by the style of much of the sculpture, which departs from the manner of the Pisa and Lucca reliefs. Only the panel with the scene of the Raising of Napoleone Orsini shows traces of Nicola's style, with tubular v-folds in the drapery and classically-inspired heads on the left side [366]. Any attempt to distinguish different hands at work on the Arca should once again be tempered by an awareness of collaborative workshop procedures, but by reference to later works undoubtedly by Arnolfo it is probable that he was one of the two primary sculptors. Apart from Nicola Pisano himself only one sculptor has been connected specifically with the Arca in medieval documents: this is Fra Guglielmo, who in a fourteenth-century necrology of the convent of St Catherine in Pisa was associated with the theft of a bone of St Dominic.[21] Fra Guglielmo was later responsible for the old-fashioned historiated pulpit of 1270 in San Giovanni Fuorcivitas in Pistoia, which shares the narrative method and Nicola-inspired drapery folds of the Arca, so it is likely that the majority of the work on the tomb was executed by Arnolfo and Fra Guglielmo.[22]

Although the shape and design of the Arca was loosely derived from late Romanesque Tuscan pulpits with narrative scenes, such as those in Pisa Cathedral (now in Cagliari) and San Bartolomeo in Pantano in Pistoia, the idea of a free-standing tomb with episodes from the Life of a Saint which could be walked around was a novel one. Evidence of its great popularity are the many variants on the same lines which followed in the fourteenth century, most notably Giovanni di Balduccio's Arca di San Pietro Martire in

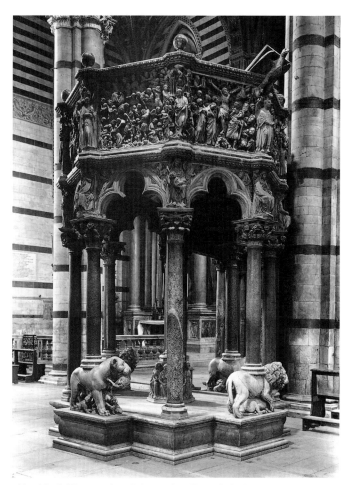

368. Nicola Pisano and workshop: pulpit, Siena Cathedral; *c*.1265–8

369. Nicola Pisano and workshop: Christ of the Last Judgement above the personification of Justice; pulpit, Siena Cathedral; *c*.1265–8

Sant'Eustorgio in Milan of 1339.[23] The grouping of the small figures in the reliefs, usually arranged in two rows one above the other as in a school photograph, is but a slight development of the experimental use of space in the Crucifixion and Last Judgement scenes of the Pisa Baptistery pulpit. At the same time, in Siena, an altogether more ambitious division of the sculpted surface was being undertaken.

Reference has already been made to the start of work on the pulpit in the Siena Duomo in 1265–6. In addition to Arnolfo, Lapo, and Giovanni Pisano, Nicola employed another sculptor, Donato, who is mentioned in a notice of payment in 1267, and by November 1268 the pulpit had been finished.[24] Because of its form and function it immediately begs comparison with the Pisa Baptistery pulpit. Octagonal rather than hexagonal, it retains virtually unchanged the design of the lower part, with lions supporting the columns and with a group of figures clustered around the base of the central column: but instead of grotesques, as at Pisa, these represent the seven Liberal Arts and the personification of Philosophy [368]. Prophets and other sprawling figures still occupy the spandrels, and statuettes of the Virtues mark the corners above the columns. It is in the upper zone, the main body of the pulpit, where the major

370. Nicola Pisano and workshop: the Massacre of the Innocents; pulpit, Siena Cathedral; *c.*1265–8

371. Battle sarcophagus; 2nd century AD (Museo delle Terme, Rome)

changes have been made. The box-like appearance of the Pisa pulpit, with the pictorial units separated by triple colonnettes and framed by different coloured marble, has been diminished by doing away with architectural divisions in favour of further figural work. These figures not only complement the subject matter of the seven reliefs and create a horizontal narrative flow previously missing but they also combine with the figures below to bind the whole pro-gramme together, both visually and iconographically. This is seen most tellingly in the juxtaposition of the Christ of the Last Judgement, seated between the Blessed and the Damned, and the seated figure of Justice below [369].

Because Nicola now had at his disposal seven rather than five panels, he was able to expand the Infancy of Christ to take in the Flight into Egypt and to devote an entire scene to the Massacre of the Innocents [370]. As noted above, the figures at the angles were also used to full effect, so that the Annunciation was acted out not in the first narrative panel but alongside it.[25] Likewise, the Last Judgement was also increased in size, occupying two panels divided by the separately-carved group of the Judging Christ and angels with the Instruments of the Passion. The newly inserted

scene of the Massacre of the Innocents allowed the sculptors (Nicola and the young Giovanni Pisano?) free reign to create an astonishing *tour-de-force* of violent drama, where the soldiers and horrified mothers turn and twist in space in a churning mass of bodies. The terrible consequences of Herod's orders are emphasised by the stillness of the small group in the top left corner, the single gesture with the right hand speaking eloquently of his responsibility for the carnage below. The virtuosity of the carving is manifested in the dazzling ease with which the sculptors have manipulated the marble with drill and chisel, but there are signs – in the way the heads of the uppermost figures overlap the field of the relief and are squashed below the cornice – that the planning of complicated compositions of this type still presented problems. As with the Pisa Baptistery pulpit, the inspiration for this extraordinary composition came from the study of an antique sarcophagus – in this case the type showing a battle scene, an example of which is in the Museo delle Terme in Rome [371].

The fullness of the iconographic programme, showing the Infancy and Passion of Christ, the Last Judgement, Prophets, Virtues and the Liberal Arts, has led to speculation that French Gothic portal schemes provided the lead, possibly through the mediation of the Cistercians of San Galgano, to which order the *operarius* of the Duomo, Fra Melano, belonged. Furthermore, some scholars have explained the move away from classically-derived forms towards a more 'Gothic' style as a reaction to exposure to French small-scale models, such as ivory statuettes. There is no absolutely direct proof of this, although in the figures dividing the narrative – in the Christ of the Apocalypse and the Virgin and Child especially – a kinship with the sculpture of Amiens and Reims is detectable, and the Damned of the Last Judgement may be compared with the same scene at Bourges of a few years earlier.[26] This should come as no surprise, given the dissemination of French work throughout Europe at this time; but unlike the sculptures of Burgos, Bamberg or Cologne, which have recognisably French characteristics, here at Siena the Italian artistic personality is unassailably dominant.

The detailed division of hands on the Siena pulpit, a subject on which much has been written, is ultimately a futile exercise.[27] We know nothing of the stylistic traits of Lapo or Donato, and the identification of the putative contribution of the young Giovanni Pisano – then probably in his late teens – is particularly fraught. The documents are silent on the contributions of the different sculptors, and the homogeneity of the finished work, keenly supervised and probably finished by Nicola, masks any noticeable individual touches. The base of the central column, with the personifications of the Liberal Arts and Philosophy, has sometimes been ascribed to Lapo. This is presumably because of its perceived inferiority to the sculpture above, but the excessive wear the base has sustained, the surface having been rubbed away in many places, makes any comparison with the other figures and reliefs hazardous.

The workshop brought together by Nicola for the execution of the Siena pulpit was presumably dispersed on completion of the work in November 1268. Lapo appears to have stayed on in Siena, being mentioned in a number of documents up until 1289, but Arnolfo was shortly to set his sights towards Rome and to enter the employ of Charles of Anjou. Nicola and Giovanni Pisano remained in Tuscany, probably returning to Pisa to continue with the external decoration of the Baptistery until being called to Perugia to create the sculptures for Nicola's last important commission, the great fountain in the Piazza Maggiore.[28]

THE FONTANA MAGGIORE IN PERUGIA

Monumental fountains, such conspicuous features of Italian Renaissance and Baroque city squares, were extremely rare before the end of the thirteenth century. This was as much to do with the history of hydraulic engineering as with sculpture, and it is undoubtedly significant that in the long inscription on the Fontana Maggiore in Perugia the engineer Boninsegna is mentioned – and praised – alongside the sculptors Nicola (*Flos Sculptorum*) and Giovanni Pisano. A fountain had been planned for the Piazza Maggiore from the middle of the thirteenth century, but it was not until 1278 (the date in the long inscription) that the aqueduct had been put in place and the present structure completed; it is probable that the fourth person mentioned in the inscription, Fra Bevignate, was the designer of the intellectual content of the fountain and acted as the intermediary between the sculptors, engineer and Perugian authorities.[29] That such a person was necessary is evident when one turns to the dense iconographic scheme of the fountain, which combined elements, in relief and in the round, from the Old Testament, Roman legend and contemporary Perugia. In a manner analogous to the wholly religious programmes of the French Gothic portals, it proclaims the power of the City of Perugia through divine support and historical tradition and provides perhaps the most notable surviving thirteenth-century example of civic pride manifested in marble. That the leading sculptural workshop in Tuscany was chosen for the work, even though it hailed from the rival city of Pisa, is a measure of Perugia's ambition and aspirations.

Although the subject matter to be incorporated into the fountain was totally different, the approach that Nicola Pisano took to its overall design was not dissimilar from that employed for the Pisa Baptistery and Siena pulpits. There is a comparable spatial relationship between the fifty reliefs of the twenty-five-sided basin below and the figures of the twelve-sided upper basin, and the polychrome effect of different coloured marbles set against one another – so effective at Pisa – is repeated in pink and white [372]. However, the setting of the fountain, in an exposed and sloping piazza, precluded the use of applied colour and the shallow relief of the lower sculpted panels took into account the fact that a more flamboyant undercutting (as on the Siena pulpit) would have invited damage and weathering. In a further concession to the elements, the second basin was topped by another in a more durable material – bronze – and a bronze three-figured caryatid group, signed on the basin by the founder: *Rubeus me fecit*.

The reliefs on the lowest basin, grouped in pairs, show the Labours of the Months, the Liberal Arts and the personification of Philosophy, scenes from Roman history and the Old Testament, and heraldic beasts. Above, in the middle

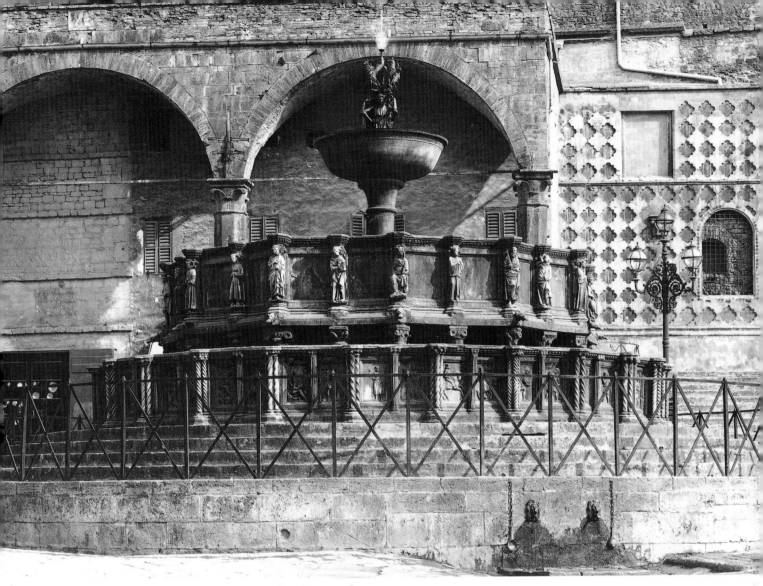

372. Nicola and Giovanni Pisano: the Fontana Maggiore, Perugia; c.1277–8

tier, the single figures in the centre and at the angles of the blank panels have a more specifically Perugian connection. Hence the living Matteo da Correggio, the *Podestà*, and Ermanno da Sassoferrato, the *Capitano del Popolo*, are shown alongside saints, Old Testament figures, personifications of Perugia, allied cities and important local places (*Roma Caput Mundi, Augusta Perugia*, etc). Just as the antiquity of Perugia is stressed by the inclusion of the personification of the city alongside that of Rome, so its Guelph affiliation and the recent victory over the Ghibellines is given body by the presence of *Ecclesia Romana* and *Victoria Magna*.[30]

It appears that the sculptural work on the fountain was completed extremely quickly, possibly within a year; the workshop must have been of some size to execute so many reliefs and figures in such a short time, and this seems to be confirmed by the moderate quality of some of the sculptures, especially the statuettes on the second basin. Once again, the individual contributions of Nicola and Giovanni Pisano are difficult to pinpoint, especially since weathering and cleaning have removed much of the sculpted surfaces. A double relief with two eagles has the name of Giovanni above it in a short inscription, but the extent of his work on the other reliefs remains unclear.[31] The simple compositions of the reliefs seem to represent a step back in the direction of the *Months*

of Antelami and the Pisa Baptistery portal, although it should be admitted that room for invention was presumably strictly limited both by the desires of the patrons and the aforementioned physical constraints of the site.[32]

By 1278 Nicola was almost ready to hand over the reins to his son. They are described together in the Perugia inscription, but while the sun was setting on Nicola's career, Giovanni was approaching maturity. After the completion of the Perugia fountain both sculptors travelled back to Pisa, but Nicola – probably now about sixty – did not have long to live. He was dead by 1284, by which time Giovanni, in his mid-thirties, was a master in his own right, on the threshold of taking control of work on the Siena Cathedral façade. If Nicola is rightly credited with bringing to Tuscany the advanced naturalism of Northern Gothic forms married to a fresh study of the antique, in his two major works between 1285 and 1301 Giovanni far surpassed his father's efforts in the transformation of the marble block into three-dimensional form. But before moving to the achievements of the Siena façade and the Pistoia pulpit, at this point it makes sense to follow the progress of the other pre-eminent sculptor of the last quarter of the thirteenth century, Arnolfo di Cambio, and to assess his equally influential rôle in the development of Italian Gothic sculpture.

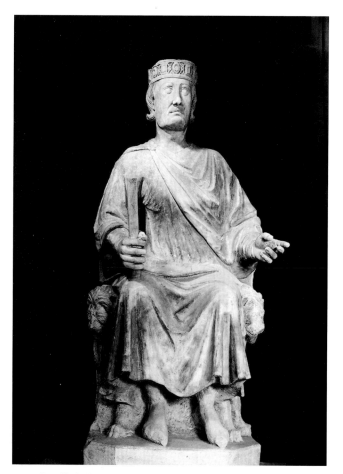

373. Arnolfo di Cambio: Charles of Anjou; probably c.1275 (Musei Capitolini, Rome)

ARNOLFO DI CAMBIO IN ROME, PERUGIA AND ORVIETO

Arnolfo di Cambio appears to have left the workshop of Nicola Pisano shortly after the completion of the Siena pulpit in 1268. He is not mentioned again in writing until 1277, when his services were requested by the same Perugian authorities who were at that moment employing Nicola and Giovanni Pisano on the Fontana Maggiore. He was by then working seemingly exclusively for Charles of Anjou in Rome, who wrote from his castle in Lagopesole to grant the necessary permission.[33] There are no signed or documented works from this period, but on the grounds of style and historical plausibility it is likely that he was responsible for the seated statue of Charles now in the Capitoline Museum in Rome [373]. The original location of the statue, which has been associated with a fragmentary trumpeting figure, is not now known, nor indeed is it clear whether the sculptures were ever finished and installed. In addition, appreciation of the statue has been severely diminished by a reworking of the surface probably carried out in the sixteenth century, and the nose, the baton – perhaps originally a scroll – and left hand have been restored.[34] It remains, nevertheless, a monument of some importance for the light it sheds on Charles of Anjou's self-image and on the re-use and carving of marble.

Notwithstanding our ignorance of the placement of the statue it seems likely that it was the intention to install it in a monumental setting – a doorway has been suggested – on the Capitoline Hill in the vicinity of the church of the Aracoeli.[35] Like the seated statue of Frederick II on the *Porta romana* at Capua it too presents Charles as an heir to the Caesars – an imperial law-giver, seated on a lion throne with a jewelled crown on his head.[36] In this respect Charles would have bettered Frederick in placing his statue at the heart of the First City, an act the Hohenstaufen Emperor could only have dreamt about. Although the Angevin statue is not as obviously classicising in its style as the figure of Frederick at Capua, its very fabric depended on the architectural heritage of classical Rome.[37] Unlike the Tuscan marble-workers, who could rely on freshly-quarried marble from the nearby Apuan Alps, Roman sculptors invariably availed themselves of the copious amounts of marble *spolia* to be had in the city. The statue of Charles of Anjou is an especially instructive example of this practice because, being unfinished, the evidence for the original use of the material is still visible at the back of the figure. It can be seen that the sculpture was fashioned from a colossal fragment of a moulded architrave, the dimensions of which may have limited the depth of the figure.[38]

Although Charles acceded to the Perugian application to borrow Arnolfo in 1277, it is unlikely that the sculptor left Rome immediately. The project for which he was wanted was the construction of a second sculpted fountain in the Piazza Maggiore in Perugia, and he is recorded as still being engaged on the work in February 1281.[39] This fountain was constructed lower down the piazza (*in pedis platee*) than the Fontana Maggiore and would have had a very different form and function. Demolished as long ago as 1308, only five sculptures have survived which can be associated securely with the commission. Now in the Galleria Nazionale dell'Umbria in Perugia, the group consists of two reclining figures (one female, one male), one kneeling female figure, reaching forward as if to slake her thirst, and two seated scribes, one headless [374]. The number of figures in the original plan, the arrangement of the sculptures relative to one another and the form of the fountain have been the subject of some scholarly debate, but it is probable that unlike the Fontana Maggiore, which occupied a free-standing position and which was more symbolic than functional, Arnolfo's was a large wall fountain and was very much intended to be used.[40] This is of course suggested by the attitude of the thirsting figure, indicating the life-giving properties of the water which had so recently been piped to the square.

We cannot be sure whether the sculpture was executed in Rome and constructed on site or whether Arnolfo set up a workshop in Perugia; there is evidence that he spent a good deal of time in Rome during the making of the fountain and the material itself came from there. Not in doubt is the profound study of classical sources made by Arnolfo, comparable to that of Nicola Pisano in Pisa, which conditioned all the works he executed in his Roman years between 1275 and 1295. The two reclining figures have the poses of antique river gods, but they have been transformed by Arnolfo from deities into very human and vulnerable types,

the male figure shown as a cripple resting on a short crutch. It is likely that viewed together, and taking the missing figures into account, the fountain allegorised the charitable work of the *Comune* in providing a new facility for the common good. The seated figures are no less indebted to the classical prototypes which must have been readily available in Rome at this time, while the model for the kneeling old woman appears to have been provided by Early Christian sculpture.[41] In Arnolfo's next major commission, the tomb of Cardinal Guillaume de Bray in San Domenico in Orvieto, the antique spirit was equally apparent, but new elements – some derived from France, others possibly invented by Arnolfo himself – combined to create a monument of great originality and enduring influence.

The French Cardinal Guillaume de Bray died in Orvieto on 29 April 1282, and although there is no documentary evidence concerning his tomb nor a date on the monument itself it is generally accepted that it was started almost immediately after his death.[42] The sculptor responsible is announced in unequivocal terms at the end of the long inscription (HOC OPUS FECIT ARNOLFUS), making it the first surviving example of a signed work by the artist. Unfortunately the monument has been dismantled, parts lost, and the whole incorrectly re-erected. As it stands now, the major components are undoubtedly still present and their positions relative to one another are probably faithful in large part to the original disposition [375]. The effigy of the cardinal lies on a cloth-covered mattress above his mosaic-encrusted *tumba*, which in turn sits on an elaborate base with mosaic panels. A dramatic and innovative feature is intro-

duced at the level of the effigy: two small acolytes are shown in the act of drawing curtains across the front of the space in which the cardinal rests, signalling the close of his mortal existence.[43] Above, on the left, de Bray is shown again, this time in the celestial realm, kneeling in prayer before the enthroned Virgin and Child. His intermediary and personal intercessor, St Mark, stands at his shoulder and the patron saint of the church, St Dominic, looks up at the Virgin from the other side of the inscribed tablet.

By reference to the earlier tomb of Pope Clement IV in Viterbo and to the surviving fragments in the Museo dell'Opera del Duomo in Orvieto, the basic architectural form – if not the exact appearance – of the de Bray monument can be established with some degree of confidence. The figural work described above was contained within a Gothic canopy further encrusted with mosaic inlay, underlining the monument's Roman pedigree, but the way in which Arnolfo combined the effigy of the deceased with the figures in the upper part of the tomb to create a *tableau* of Redemption is without precedent in Italy and paved the way for the more complicated tombs of the fourteenth century. It may be that the design of French tombs, such as the now-destroyed example once in Saint-Père in Chartres or the tomb which provided the sculptures for the *Porte romane* at Reims [45], informed the decision to juxtapose the Virgin and Child with the effigy. Central to the development of Roman tomb design, after all, was the nationality of the patrons. Both Guillaume de Bray and Clement IV – whose tomb of 1271–4 by Pietro di Oderisio incorporated an effigy apparently for the first time in Italy – were French, and Arnolfo must have

374. Arnolfo di Cambio: reclining figure (the '*Assetata*') from the Fontana *in pedis platee*, Piazza Maggiore, Perugia; c.1280 (Galleria Nazionale dell'Umbria, Perugia)

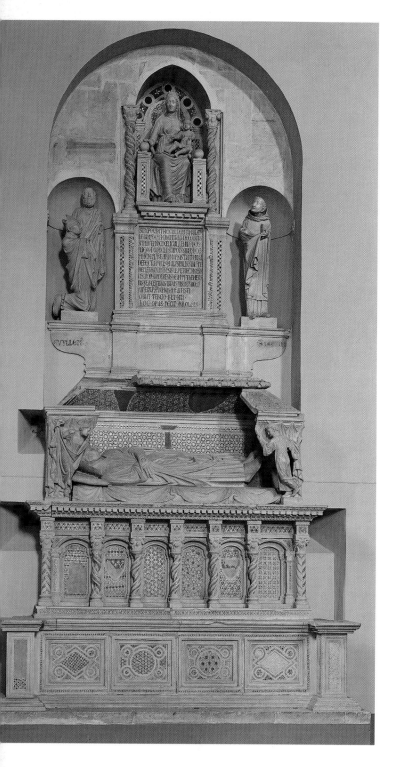

benefited from exposure to new French ideas brought to Italy by the artists of the Angevin court.[44]

While certain elements of the tomb, most notably the effigy, indicate that Arnolfo shared with his French counterparts a growing interest in naturalistic forms drawn directly from life, other features point once again to the decisive rôle of ancient Rome as a source of inspiration. This is most evident in the Virgin at the apex of the monument, which is strikingly similar to a figure of Abundance or Fortune in the Capitoline Museum, while the head of the Christ-Child has been persuasively compared with a type of small second-century chalcedony bust, examples of which are in the Dumbarton Oaks Collection, Washington, D.C., the Louvre in Paris (formerly in the Saint-Denis treasury), San Marco in Venice, and elsewhere.[45] It is precisely this mixture of the ancient and modern – Roman and Gothic – which characterises Arnolfo's most complete and well preserved works in Rome, the two ciboria of San Paolo fuori le mura and Santa Cecilia in Trastevere, both of which are signed and dated.

The erection of elaborate ciboria or baldachins over high altars had been common practice in Rome throughout the Early Middle Ages. The figurative element of these constructions was mostly limited to the carving of capitals, so that the principal decorative effect was gained through the application of glass mosaic to the surfaces of the architectural features. Although Arnolfo's first ciborium, for San Paolo fuori le mura, belongs to this tradition it departs quite radically from the earlier ciboria in both embracing the Gothic forms of France and creating a programme of sculpture which complemented the decorative scheme of the basilica's interior and referred specifically to its setting [376]. The spiky architectural form of the ciborium has been related to that of Rayonnant Paris, more particularly to the similar structure containing the Crown of Thorns in the Sainte-Chapelle, and it may be that such forms were introduced through reduced versions in metalwork. Four freestanding figures – Saints Paul, Peter, Timothy and Benedict – occupy the niches at the corners, and in the spandrels between are shown the Abbot Bartholomeus offering a model of the ciborium to St Paul (front), the Sacrifices of Cain and Abel (side), two prophets (back), the Temptation of Eve and the Admonishment of Adam (side). Above, flying angels appear to support the oculi of the gables, and the angelic presence continues inside the ciborium, where four angels float around the boss of the vault and a further four at the corners hold censers and a candlestick.[46]

On the front face of the ciborium, in the gable and at the base of the pinnacles, three inscriptions record that Bartholomeus had had the ciborium made in 1285, and that Arnolfo *cvm svo socio Petro* had been responsible for the work. The identity of Pietro, Arnolfo's associate on the ciborium, has been much debated and not surprisingly both Pietro di Oderisio and Pietro Cavallini, who was at this time

375. Arnolfo di Cambio: tomb of Cardinal Guillaume de Bray (d.1282); S. Domenico, Orvieto; *c*.1282–4

376. Arnolfo di Cambio and 'Pietro': ciborium, S. Paolo fuori le mura, Rome; 1285

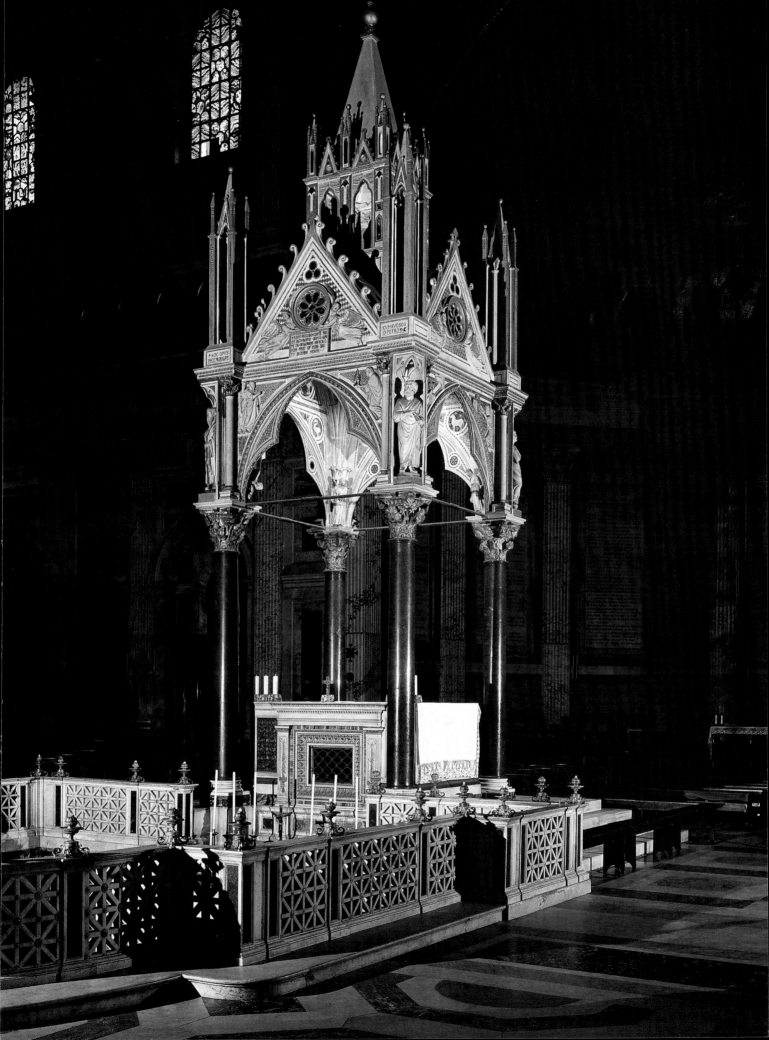

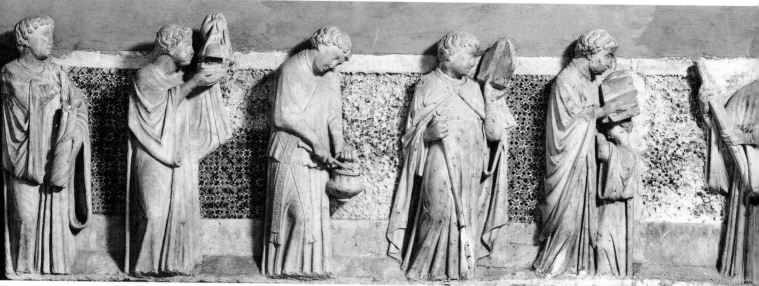

377. Arnolfo di Cambio: frieze of clerics, possibly from the tomb of Cardinal Riccardo Annibaldi della Molara (d.1276); cloister, S. Giovanni in Laterano, Rome

engaged on the frescoes of the nave at San Paolo, have been associated with the work. There is nothing in the ciborium however to encourage a joint attribution to either, and it is perhaps more likely that this Pietro was Arnolfo's otherwise anonymous principal workshop assistant. The workshop brought together by Arnolfo for the de Bray tomb probably moved immediately to work on the San Paolo ciborium; the head of St Dominic on the former, with its summarily-carved locks, has been translated to serve for St Benedict on the latter, and the use of classical and Early Christian models is still evident in some of the reliefs, most notably the figure of Eve, which seems to be drawn from a fourth-century sarcophagus.[47]

In the more modest ciborium in Santa Cecilia in Trastevere, signed and dated 1293 on the base of one of the columns, the decorative programme has again been drawn up as part of a larger scheme to honour the patron saint of the church.[48] As on the San Paolo ciborium, four figures stand at the corners, this time St Cecilia and the most important characters from her *Vita*, Saints Valerian, Tiburtius and Urban.[49] Alluding to the source of St Cecilia's inspiration, the spandrels to each side of the archivolts show the four evangelists and two prophets, while her purity and sagacity is underlined by the presence of two of the Wise Virgins.[50] In the flatter gables above, the flying angels of the earlier ciborium have been replaced by more solid kneeling angels, and there is evidence that Arnolfo was by now limiting his direct involvement in the actual carving of the sculptures. Other commissions in Rome of about this date would appear to confirm the general impression that much of the work associated with Arnolfo's name must have been carried out under his supervision by less gifted masons, and there is the likelihood that some sculptors, having received their initial training in his workshop, left to set up on their own.

A number of other sculptures can be assigned to Arnolfo's workshop in Rome. First among these is the now fragmentary and partially reconstructed tomb in the cloister of San Giovanni in Laterano, until recently described as that of Cardinal Riccardo Annibaldi della Molara (died 1276) but now assigned to his nephew, the papal notary Riccardo Annibaldi, who died in 1289.[51] The most interesting part is the frieze now set up behind the effigy, showing six small clerics in various actions from the *Missa pro Defunctis* [377]; those at each end hold long candles, one blows into a censer while his companion dips an aspergillum into a situla, another holds the deceased's mitre and crozier (now broken), and the sixth reads from an open book held by a young acolyte. It is possible, however, that the effigy and relief did not originally belong together; the former is almost certainly that of the papal notary, and although the latter would probably have been juxtaposed in a similar way, above an effigy, it may have belonged to the tomb of a bishop or cardinal, quite possibly that of Riccardo Annibaldi della Molara mentioned above.[52] From a stylistic point of view both relief and effigy are demonstrably of the Arnolfo workshop, and a chronological separation of just over a decade is not implausible. It is particularly unfortunate that the tomb from which the frieze emanated no longer exists in its entirety, as it would almost certainly have offered the clearest evidence for the transference of a northern Gothic tomb type into Rome. This was the *enfeu* or wall niche tomb, of a type created in France in the late twelfth century (see the fragments mounted on the *Porte romane* at Reims), and reflected in complete mid-thirteenth-century examples in León Cathedral [347].[53] The choice of such a tomb would probably have been made in the will of the deceased or by one of the executors who might have seen similar examples abroad, rather than by Arnolfo, and it is as well to remember, here as elsewhere, that the workshops of the thirteenth century were usually directed in this way. Although outstandingly original sculptors such as Nicola Pisano and Arnolfo di Cambio were obviously able to contribute considerably to the creation of epoch-making monuments, complete artistic freedom was still in the future.

Towards the end of Arnolfo's twenty years of activity in

Rome his workshop executed the tombs of Pope Honorius IV (1285–7) and the unfortunate Pope Boniface VIII (1295–1303). Both have since been dismantled, but the surviving effigies – the former in Santa Maria in Aracoeli, the latter in the grottoes beneath St Peter's – testify to the high quality of the work.[54] The latter was commissioned by the Pope himself, probably immediately after his consecration, and installed above the altar of the ciborium-like chapel of Boniface IV in an arcosolium on the interior wall of the west façade of St Peter's; to the sides were two angels and above the effigy was a mosaic by Jacopo Torriti.[55] In the seventeenth-century Grimaldi drawings, executed before the demolition of the old basilica, it can be seen that this mosaic showed Boniface being presented to the Virgin and Child by St Peter, while St Paul looked on from the other side.[56] The iconography thus echoes the scheme first worked out in the de Bray tomb, and the combination of mosaic and sculpture would prove to be especially influential for the other Roman workshops, such as that of Giovanni di Cosma, in around 1300.[57]

Before leaving Arnolfo's output in Rome mention should be made of two very different commissions. The first is the *Presepio* group, consisting of the Adoration of the Magi, in the Cappella del Sacramento of Santa Maria Maggiore, which was executed in around 1290–1. Like the tombs, it has been dismantled and falsely reconstructed, but with the exception of the Virgin and Child – which was replaced in the sixteenth century – all the original pieces appear to exist.[58] Although the ensemble was designed by Arnolfo, the carving of the squat figures relates to the corner figures on the Santa Cecilia ciborium and seems to have been done entirely by members of his workshop. The final work to be discussed is by contrast a *unicum*, a work so unusual that some writers have viewed it as Late Antique. This is the bronze seated figure of St Peter now displayed at the southeastern end of the nave of St Peter's but previously in the oratory of the monastery of San Martino adjacent to the apse of the Constantinian basilica [378]. Because scientific analysis of the statue has conclusively established its date somewhere between 1265 and 1379, its attribution to an Early Christian artist can now be seen as a compliment to the ability of the later sculptor to capture the essence of Late Roman style.[59] That this sculptor – or perhaps one should amend this to craftsmen, as it is likely that the model was prepared by the sculptor but that the bronze was cast by a foundryman – was Arnolfo himself or another in his circle is confirmed by a comparison with his work in marble; and by the knowledge that Arnolfo was particularly deeply influenced by the classical and Early Christian sculptures which surrounded him in his Roman years. The form of the St Peter is close indeed to a marble seated philosopher once on the façade of St Peter's but now in the Grotte Vaticane, which was in all probability transformed by the provision of a new head into a figure of the apostle by Arnolfo's workshop itself.[60] This may have provided the inspiration for the bronze, but again the model has been significantly altered to include crisp deep v-folds of drapery between the knees – accentuated by the material from which it is made – and a liveliness of approach to the beard and hair reminiscent of the heads of the Magi on Nicola Pisano's Pisa Baptistery

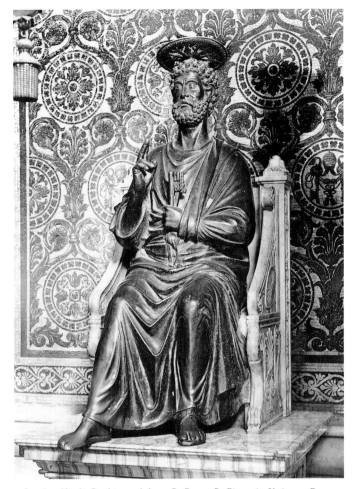

378. Arnolfo di Cambio workshop: St Peter; S. Pietro in Vaticano, Rome; bronze, probably *c*.1290–5

pulpit. When the sculpture was brightly coloured its appearance must have been even more strikingly different.[61]

THE FAÇADE SCULPTURE OF FLORENCE CATHEDRAL

To move from the singular and isolated figure of St Peter to the sculptural programme Arnolfo composed for the façade of the Florence Duomo is to recognise the diverse requirements of his patrons. We know nothing of the original setting of the bronze statue within the oratory of San Martino, but by the middle of the sixteenth century – when it had been moved to St Peter's – its status was such that pilgrims received fifty days of indulgence every time they kissed its right foot. The same iconic quality is to be found in the image of the Virgin and Child from the Florence central portal [379], but here the statue was subsumed into the decorative whole, playing a part – albeit axial – in the iconographic scheme.

The exact date of Arnolfo's departure from Rome for Florence is not known. He had certainly been in Florence for some time by 1300, when he was described in a document as *magistrum Arnulphum...capudmagister laborerii et*

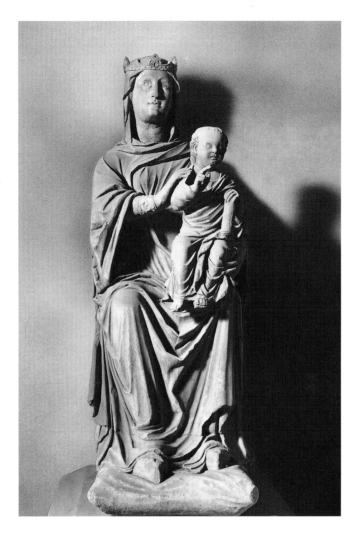

379. Arnolfo di Cambio: Virgin and Child from the central portal, west façade, Florence Cathedral; probably *c*.1300 (Museo dell'Opera del Duomo, Florence)

380. Arnolfo di Cambio: the Dead Virgin and mourning apostle, from the south portal, west façade, Florence Cathedral; probably *c*.1300 (Skulpturen-sammlung, Staatliche Museen zu Berlin, Preussischer Kulturbesitz: photograph before 1945)

operis ecclesie Beate Reparate maioris ecclesie Florentine, and it is likely that he was involved with the work as early as 1296 (perhaps after finishing the tomb of Pope Boniface VIII), when the foundation stone was laid. Because Arnolfo died between the years 1302 and 1310 his sculpted frontispiece was left incomplete at his death, and work continued intermittently throughout the fourteenth and fifteenth centuries, latterly involving such luminaries as Nanni di Banco and Donatello. There is still some doubt about the exact sculptural contribution of his workshop to the façade, but existing sculptures in the Museo dell'Opera del Duomo in Florence, in Berlin and in the Fogg Art Museum of Harvard University, a drawing of the façade made by Bernardino Poccetti before its demolition in 1587, and a sixteenth-century written description provide a firm foundation of fact.[62]

It is certain that Arnolfo and his workshop planned and executed the sculptures placed in the tympana of the three doorways, and although at this date the cathedral was dedicated to St Reparata, the programme chosen for the portal decoration was entirely devoted to the Virgin. The north door contained the Nativity, the south the Death of the Virgin, and the central tympanum the Virgin and Child mentioned above, flanked by standing figures of St Reparata and St Zenobius and two angels holding open curtains. Judging by Poccetti's drawing the tympanum of the north doorway was incomplete at that time, showing only the reclining figure of the Virgin and above her the ox and ass and the Christ-Child in the manger.[63] The south doorway, of which the figure of the Dead Virgin and mourning apostle (probably St John) are now in Berlin [380], was shown only obscurely in the drawing but the detailed description of about the same date furnishes vital additional information for its appearance, referring to 'il Transito di Maria, la quale si vedeva morta giacere, e Cristo, che l'Anima di lei strettamente teneva in braccio, e tutti gli Apostoli, che circondavano il corpo morto'.[64] In view of the connection with Northern Gothic often put forward for this Marian cycle, and because of its rarity in Italy, it is of interest to note that this account of the Florence Dormition would also perfectly

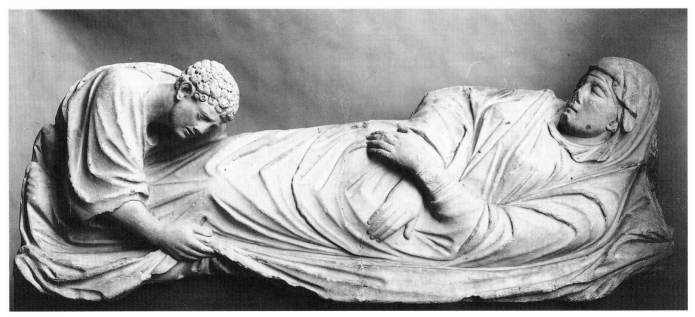

describe the comparable and still complete tympanum on the Strasbourg south transept [81]. The other surviving fragments from the Dormition, two apostle busts in Berlin and the head of Christ with that of the Virgin's Soul in Florence, confirm that Arnolfo's composition was in many respects extremely close to the earlier treatment of the subject at Strasbourg.[65]

By comparison with the contemporary but revolutionary sculpture of Giovanni Pisano at Siena and Pistoia, which will be covered shortly, Arnolfo's figure style adheres securely to the traditions worked out by Nicola Pisano and Arnolfo himself thirty years previously. The drapery on the Virgin of the Dormition and Nativity, for instance, has none of the variety and soft realism to be found in Giovanni's Pistoia pulpit, but simply follows the formula of angular v-folds laid down in the Pisa Baptistery and Siena pulpits; and the classicism of the figure of St Reparata is a repetition of the process of recycling antique prototypes seen most impressively in the Virgin and Child of the de Bray tomb in Orvieto. For all its imposing power, the Virgin and Child of the central portal is essentially old-fashioned in its hieratic immobility, and rather than imbuing the figure with life, the unusual feature of glass eyes set into the head puts one in mind of a staring Early Medieval cult figure, of the type exemplified by the late tenth-century *Goldene Madonna* in the Essen Minster treasury.[66] It is of course impossible now to judge what Arnolfo and his patrons had in mind for the upper parts of the Florence façade, and because the cathedral architects of the fourteenth and fifteenth centuries must have adjusted his work in the lower section before the sixteenth-century demolition we are unable even to assess this portion accurately. But like Benedetto Antelami in his design for the Parma Baptistery about a century before, Arnolfo must have intended to use a combination of localised narrative high relief and standing figures in niches to create a total effect – apart from the absence of jamb figures – not unlike that on the French cathedrals. As a result, his design for the lower part of the façade and the style of the sculptures represent the end of an era rather than the dawn of something new. By the time Arnolfo's workshop started to execute the sculptures in Florence a very different approach had been followed by the other principal sculptor of the day, Giovanni Pisano, on the façade of Siena Cathedral.

LARGE AND SMALL: THE SIENA DUOMO FAÇADE, GIOVANNI PISANO'S WORK IN IVORY AND WOOD, AND THE PISTOIA PULPIT

Giovanni Pisano was employed at Siena Cathedral probably from 1285 until 1297. He became a Sienese citizen in 1285 and in 1290 is referred to as the *caput magistrorum*, ten years before Arnolfo had the same appellation attached to him in Florence. Like Arnolfo's façade at Florence that at Siena was unfinished in 1297, when Giovanni left the works in some disarray to return to Pisa, and the upper part of the west front of the cathedral as we see it today – above the gables of the portals and including the sculptures around the large oculus – was not completed until later in the fourteenth century.[67] There seem to have been problems

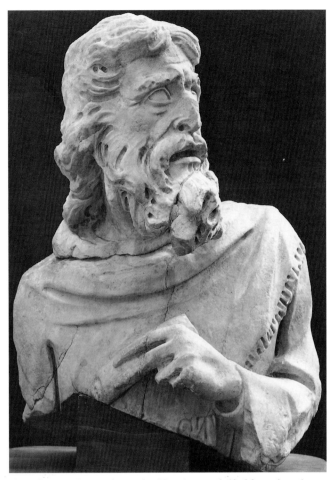

381. Giovanni Pisano: the prophet Haggai; upper half of figure from the west façade, Siena Cathedral; 1285–97 (Victoria and Albert Museum, London)

connected with the funding of the building works so that the sculpture executed by Giovanni and his workshop was only put in place after his departure. This consisted primarily of fourteen life-size figures of prophets and wise men and women from antiquity arranged around a central figure of the Virgin originally placed over the central doorway, following the early thirteenth-century *Ordo Officiorum Ecclesiae Senensis* of the Canon Odericus.[68] These figures, now replaced by copies, stood in front of shallow niches at the level of the portal lunettes, and continued around the north and south corners of the façade: the sequence from north to south was Haggai [381], Isaiah, Balaam, Plato, Daniel, Sibyl, David, Solomon, Moses, Jesus Sirach, Habakkuk, Aristotle, Mary, sister of Moses (Miriam), and Simeon.[69]

The fourteen statues served the same didactic purpose as the French jamb figures of prophets which adorned portals dedicated to the Virgin, such as the central portal of the north transept at Chartres [56]. But because the Siena figures were placed higher on the façade and were separated from one another by greater distances Giovanni Pisano adjusted their proportions (most noticeably in the top-heavy *Solomon*), exaggerated their poses and carved deeply-incised inscriptions – their prophecies and praise of the Virgin – into their scrolls; extensive use was made of the drill in the hair and beards so that the bright sunlight falling on the façade would create dramatic expressions of light and shade,

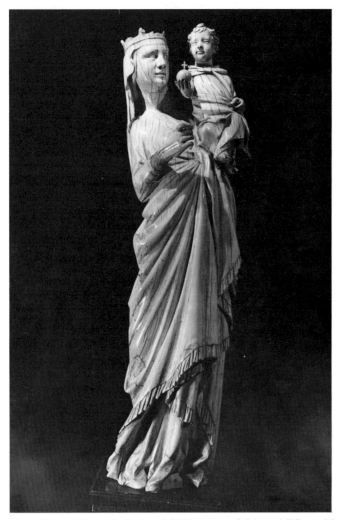

382. Giovanni Pisano: the Virgin and Child; ivory, 1298 (Museo dell'Opera del Duomo, Pisa)

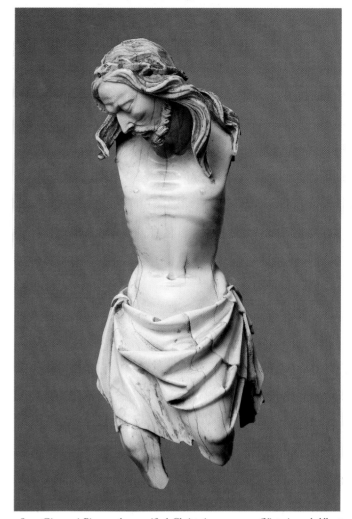

383. Giovanni Pisano: the crucified Christ; ivory, c.1300 (Victoria and Albert Museum, London)

making the heads more legible from below. Craggy fore-heads and parted lips were the means by which the pools of darkness were conjured up in the areas of the eyes and mouth, and although extremely weathered, the heads of Isaiah and Haggai (now in the Victoria and Albert Museum) still show Giovanni's mastery of approach in this regard [381].[70] Although parallels can be found with the figure style of the prophets on the interior west wall of Reims Cathedral [237], an audacious scheme which was probably famous throughout Europe at the end of the thirteenth century, the antique was once again the primary source of inspiration for the head types.[71] Firmer evidence for Giovanni's connection with Northern Gothic sculpture at this time is provided in his experiments with sculpture on a much smaller scale, and in his unexpected use of ivory, a material very rarely used in thirteenth-century Italy.

It has been shown how ivory carving was revived in France around the middle of the century, and that the ivory statuettes produced in Paris acted as vehicles for the trans-mission of the Gothic style to Spain, Italy and elsewhere. But although a large number of ivory carvings were pro-duced throughout Italy in the eleventh and twelfth centuries it seems that the renewed output experienced in Northern

Europe in the thirteenth century did not extend to Italy until the fourteenth century; even then, it is often extremely dif-ficult to separate locally-produced carvings from the French imports which they undoubtedly copied.[72] No such dif-ficulty exists with the two ivory carvings which bear the unmistakeable stylistic hallmark of Giovanni Pisano: the Virgin and Child in the Museo dell'Opera del Duomo in Pisa and a fragmentary figure of Christ from a Crucifixion now in the Victoria and Albert Museum. The Virgin, excep-tionally large for an ivory carving (53 cm high), was being made in June 1298, when Giovanni was ordered by the Pisa Cathedral chapter to complete it by Christmas or face a fine for late delivery [382]. Further documents reveal that it was originally flanked by two ivory angels with metal wings and was enclosed within a gilt wood tabernacle, and that the ensemble was completed by *duo petia* – probably reliefs on the base of the tabernacle – showing scenes from the Passion.[73] The whole therefore probably resembled the slightly earlier type of French ensemble in Saint-Denis of which the Cincinnati Virgin and Rouen angels formed part, and stylistically it also takes its lead from Parisian prototypes of the third quarter of the century.[74] It is quite possible that Giovanni had been to Paris, Reims and elsewhere in France

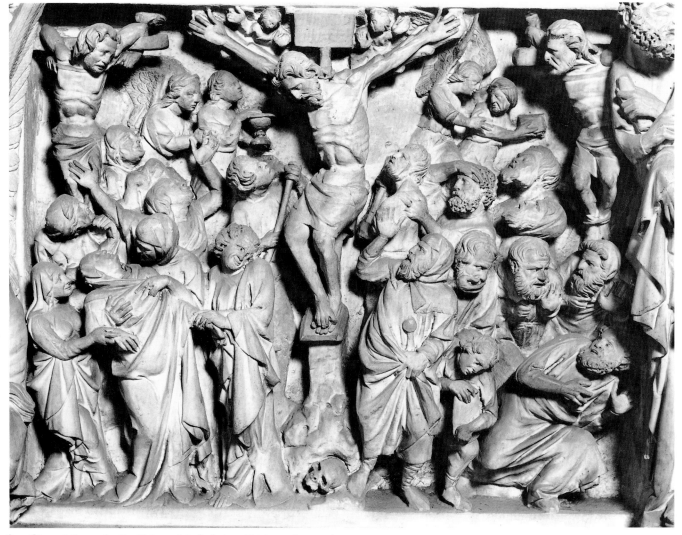

384. Giovanni Pisano: the Crucifixion; pulpit, S. Andrea, Pistoia; 1298–1301

to visit the new cathedrals and talk to his French counterparts, but the availability of small-scale sculptures in Italy at an early date did not make such a journey essential: furthermore the decision to create the *opus heburneum* for Pisa Cathedral did not, in the final analysis, come from the sculptor but from the cathedral authorities, who were presumably seeking to imitate an altar tabernacle they themselves had seen. As a result, the ability of Giovanni to impress his own artistic personality on the figure was limited to relatively minor modifications of certain features, such as the addition of the typical tasselled hems of the Siena pulpit to the Virgin's robe.[75]

The ivory crucified Christ in London [383] has been tentatively associated with the Pisan commission of which the Virgin and Child formed the centrepiece, but because of its size and the likelihood that the Passion scenes in the lower part of the tabernacle were in high relief it is more probable that it was made as an independent, free-standing figure comparable in type but slightly smaller than the examples in wood to be discussed below. Although not a documented work, the authorship of Giovanni Pisano has been persuasively demonstrated by Pope-Hennessy: indeed, so compelling is the exact similarity of the naked back of

Christ to that of Hercules on the Pisa Cathedral pulpit (1302–10) that no alternative attribution can reasonably be admitted.[76] The detailed carving of the head and the astonishingly realistic rendering of Christ's skin, stretched tight across the rib-cage, show how the sculptor took full advantage of the particular qualities of the material, the ample folds of Christ's loincloth serving to highlight the painful emaciation of the upper body. In the years around 1300 Giovanni was further drawn to the softer qualities of organic materials, an attraction borne out by a small number of closely related polychrome wood crucifix figures, in the Museo dell'Opera del Duomo in Siena, in Sant'Andrea in Pistoia, in Prato and Pisa cathedrals and in Berlin.[77] These ivory and wood figures far surpass their French counterparts in their great realism and in the unflinching depiction of physical suffering; and it is possible that Giovanni used the more easily and quickly carved materials to experiment with carving the human form, so that in a sense they might be said to represent *bozzetti* for the same figures in his later Pistoia and Pisa pulpits. Just how far he transformed the treatment of the crucified Christ in sculpture is proved by a comparison of the Crucifixion scenes on the Pisa Baptistery pulpit, the Siena pulpit and that at Sant'Andrea in

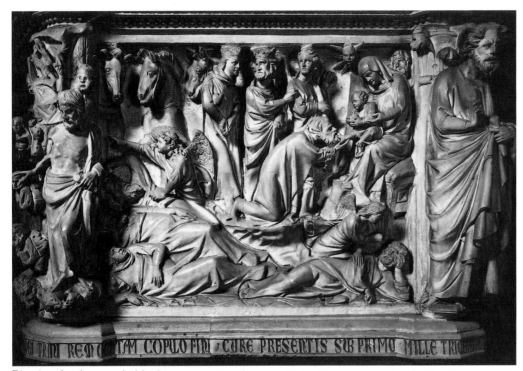

386. Giovanni Pisano and Tino di Camaino (?): the Dream and Adoration of the Magi; pulpit, S. Andrea, Pistoia; 1298–1301

Pistoia, the last probably his greatest and most distinctive masterpiece.[78] Whereas the Christ figures on the Pisa and Siena pulpits are statically posed, the Pistoia Christ is racked with pain, his knees bent and stomach drawn in [384]. As on the wood sculptures the rib cage defines a great arc echoed below by the curve of the loin cloth about the waist, the sinews of his arms are defined with an accuracy comparable to that on later *écorché* figures, and his head slumps forward onto his chest with great and poignant realism, the mouth open in a dying gasp.

Thanks to the inscription on the Pistoia pulpit it is known that Giovanni, 'the son of Nicola and blessed with higher skill', carved it in 1301, that it was commissioned by the canon Arnoldus, and that Andrea (son?) of Vitello, and Tino, son of Vitale, were responsible for paying for it.[79] Vasari recorded that work on the pulpit took Giovanni four years to complete, and this would of course tally with his return from Siena in about 1297. In size and scope the Pistoia pulpit [385] is closer to the Pisa Baptistery pulpit [360] than that at Siena [368]; it is hexagonal, like the former, but incorporates features found in the latter, such as the fuller iconographic scheme and the angle-figures dividing the scenes.[80] Innovatory are the Adam-Atlas figure supporting one of the columns and the introduction of six sibyls alongside the prophets at the level of the archivolt, listening carefully to the messages of divination brought to them by the angels at their shoulders. As is so often the case, it is as well to be aware of the changes that have taken place. The pulpit was originally sited further east in the church, on the opposite side of the nave; it has also lost nearly all of its coloured decoration, which consisted principally of *verre églomisé* inlay in the backgrounds, and there is evidence in the summary finishing of sections of the reliefs – most noticeably in the area above Christ's head in the Crucifixion scene – that these would have been painted at least in part.[81]

The stylistic unity of the sculpture suggests that Giovanni carried out most of the work single-handedly; but unfor-

tunately, unlike the case of the Siena pulpit, there are no surviving documents to chart the progress of the commission. The remarkable vitality of the carving of the reliefs, seemingly executed at speed and with a vigour unparalleled in Italy at this date, supports an image of the sculptor at the height of his powers. In places – in the panels of the Nativity and Massacre of the Innocents for instance – it is as if the sculpted surfaces have been modelled from clay rather than hacked from hard marble, and the range of attack that Giovanni brings to bear on the material allows him to capture the momentary gesture with astonishing effect. The only hint of a contribution from an assistant is in the panel showing the Dream and Adoration of the Magi [386], where the square-jawed figures so characteristic of the work of Tino di Camaino might betray his presence as a young man in Giovanni's studio.[82]

Here, on the threshold of the fourteenth century the old sits side-by-side with the new. In the angle-figures and in the sibyls below, Giovanni acknowledges his debt to French Gothic prototypes of the second half of the thirteenth century and the earlier pulpits in Pisa and Siena. In the reliefs, however, there is a fresh and independent spontaneity which was by now lacking in French sculpture, whatever its other qualities. His workshop, the most influential in Tuscany at the beginning of the century, was to create a further pulpit in the Pisa Duomo, and later – in 1323 – the modern style would be carried South to the Angevin court in Naples by Tino di Camaino.[83] There is a pleasing symmetry in this, as over sixty years earlier Nicola Pisano, 'de Apulia', had used his southern training in the milieu of a Hohenstaufen court workshop to transform the Tuscan artistic landscape. The pendulum had finally swung back.

385. Giovanni Pisano: pulpit, S. Andrea, Pistoia; 1298–1301

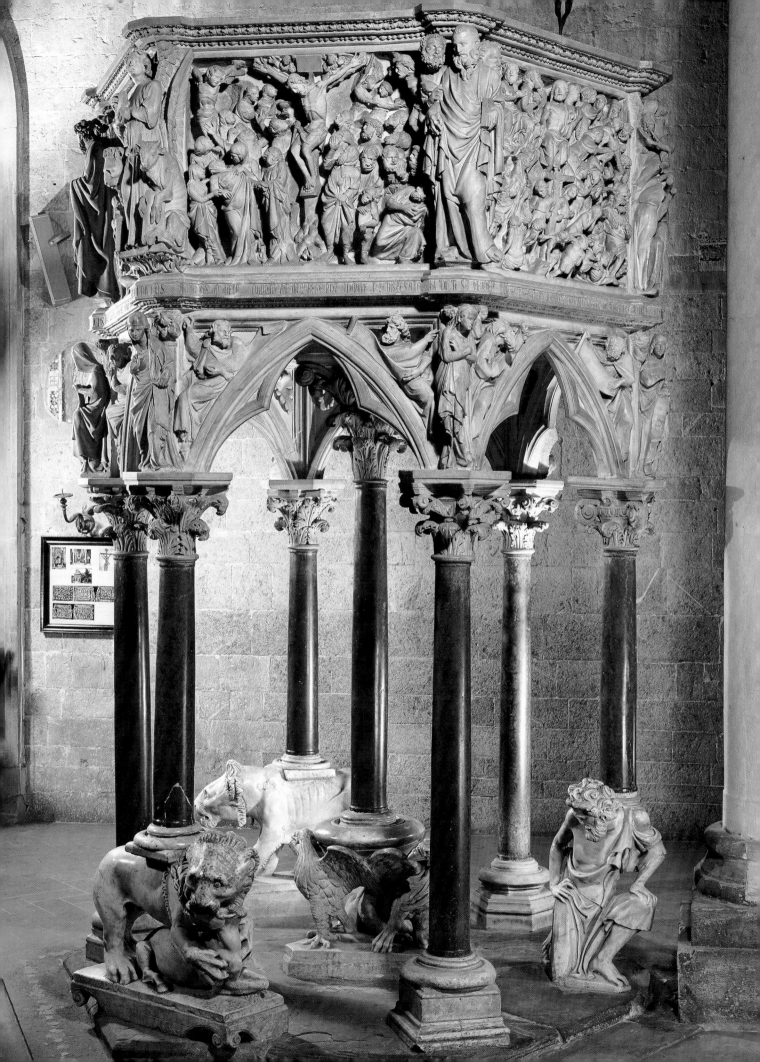

Glossary

archivolt — the continuous moulding on the face of an arch, following its contour

blocking out — the action of reducing the stone block to the stage before detailed carving

boss — an ornamental knob or projection covering the intersection of ribs in a vault or ceiling, often carved with foliage or figurative work

canopy — a projection or hood over a door, window, tomb, altar, pulpit, niche, etc.

chevet — the French term for the east end of a church, consisting of apse and ambulatory with or without radiating chapels

ciborium — a canopy (*q.v.*) on columns, usually over an altar

console — an ornamental bracket

embrasure — the slanting side of an opening, usually a doorway

freestone — any stone that cuts well in all directions, especially fine-grained limestone or sandstone

gisant — funeral effigy

head stop — projecting stones carved into heads at the ends of hood-moulds (*q.v.*), string courses, etc., againstv which the mouldings finish

heartwood — the wood at the centre of the trunk, older and drier than that nearer the outside

hood mould — a projecting moulding to throw off the rain, on the face of a wall above an arch, doorway, or window

jamb — the straight side of an archway, doorway or window

keystone — the central stone of an arch or a rib vault, sometimes carved

label stop — an ornamental or figural boss at the beginning and end of a hood-mould (*q.v.*)

Lettner — German choirscreen

lintel — a horizontal stone beam bridging an opening, supporting the tympanum (*q.v.*)

marmouset — a grotesque figure, usually forming the decoration of a console (*q.v.*)

phylactery — an inscribed scroll

portal — a large doorway

pulpitum — a stone screen erected to shut off the choir from the nave

Rayonnant — literally 'radiating' (this in relation to the tracery of rose windows), but used as a description of French Gothic cathedral architecture in the period *c.*1230–1300

repoussé — a relief pattern formed by hammering out a thin metal from the reverse side

socle — a base or pedestal

spandrel — the triangular space between the side of an arch, the horizontal drawn from the level of its apex, and the vertical of its springing; also applied to the surface between two arches in an arcade

spaly — A sloping, chamfered surface cut into the walls. The term usually refers to the widening of doorways, windows, or other wall-openings by slanting the sides

tumba — a tomb chest

tympanum — the area between the lintel (*q.v.*) of a doorway and the arch above it

voussoir — the wedge-shaped blocks of stone used in arch construction, forming the archivolt (*q.v.*)

Notes

PREFACE

1. R. Krautheimer, 'And gladly did he learn and gladly teach', in C. M. Brown, J. Osborne and W. C. Kirwin (eds.), *Rome: tradition, innovation and renewal* (Victoria, B.C., 1991), 95.

INTRODUCTION

1. R. and C. Brooke, *Popular Religion in the Middle Ages: Western Europe 1000–1300* (London, 1984), 153–5. A succinct account of the rise of the mendicant orders and their relationship to the Papacy is to be found in G. Barraclough, *The Medieval Papacy* (London, 1968), 127–40.

2. For the 'cult of carts' see T. G. Frisch, *Gothic Art 1140 – c.1450. Sources and Documents* (Englewood Cliffs, N.J., 1971), 23–30, and B. Ward, *Miracles and the Medieval Mind: theory, record and event 1000–1215* (London, 1982), 150–3. The importance of Chartres Cathedral for the generation of income for the townspeople is laid out in O. von Simson, *The Gothic Cathedral: Origins of gothic architecture and the medieval concept of order* (3rd ed., Princeton, 1988), 166–9. For Reims see B. Abou-el-Haj, 'The urban setting for late medieval church building: Reims and its cathedral between 1210 and 1240', *Art History*, XI (1988), 17–41.

3. There is of course a vast literature on the development of learning and philosophy in the twelfth and early thirteenth centuries but the essays contained in R. L. Benson and G. Constable, with C. D. Lanham (eds), *Renaissance and Renewal in the Twelfth Century* (Oxford, 1982), the brilliant selective observations by R. W. Southern, *Medieval Humanism and other studies* (Oxford, 1970), and a percipient article by G. B. Ladner, 'The life of the mind in the Christian West around the year 1200', in *The Year 1200: A Symposium* (New York, 1975), 1–23, provide an introduction to the field. A more general survey is given by J. H. Mundy, *Europe in the High Middle Ages 1150–1309* (London and New York, 1973).

4. See M. H. Caviness, '"The simple perception of matter" and the representation of narrative, ca.1180–1280', *Gesta*, XXX (1991), 48–64, esp. 48–9, who, by pointing out the similarities between such exemplars, demonstrates the dangers of a too facile approach to the separation of 'Gothic' from 'Romanesque'.

5. P. Verdier, *Le Couronnement de la Vierge. Les origines et les premiers développements d'un thème iconographique* (Montreal, 1980); P. Schine Gold, *The Lady and the Virgin. Image, attitude and experience in twelfth-century France* (Chicago and London, 1985), 43–75.

6. See the illuminating discussions in T. A. Heslop, 'Attitudes to the visual arts: the evidence from the written sources', in J. Alexander and P. Binski (eds), *Age of Chivalry: Art in Plantagenet England 1200–1400* (exh. cat., London, 1987), 26–32, and M. Camille, *The Gothic Idol: Ideology and Image-making in Medieval Art* (Cambridge, 1989), 197–241.

7. V. F. Koenig (ed.), *Gautier de Coincy, Les miracles de la Sainte-Vierge* (4 vols, Geneva, 1955–66); J. Guerrero Lovillo: *Las Cántigas: Estudio arqueológico des sus miniaturas* (Madrid, 1949), 266–82. The precise interpretation of the Reims trumeau socle remains unclear (W. Sauerländer, *Gothic Sculpture in France 1140–1270* (London, 1972), 482).

8. See p. 39. A note of caution in regarding certain Romanesque schemes as responses to current heresies is sounded by W. Cahn, 'Heresy and the interpretation of Romanesque art', in *Romanesque and Gothic. Essays for George Zarnecki* (Woodbridge, 1987), I, 27–33.

9. See p. 153. Again, for a judicious commentary on the twelfth-century spectator, see W. Cahn, 'Romanesque sculpture and the spectator', in D. Kahn (ed.), *The Romanesque Frieze and its Spectator (The Lincoln Symposium Papers)* (London, 1992), 45–60.

10. F. B. Deknatel, 'The thirteenth century Gothic sculpture of the cathedrals of Burgos and Leon', *Art Bulletin*, XVII (1935), 339–40.

11. See pp. 57 and 195. A similar function can also be traced as far away as Stary Zamek in Lower Silesia in around 1260 (P. Crossley, 'Kasimir the Great at Wiślica', in *Romanesque and Gothic, op. cit.*, 46–7).

12. See D. Knoop and G. P. Jones, *The Mediaeval Mason* (2nd edition, Manchester, 1966); R. Recht (ed.), *Les bâtisseurs des cathédrales gothiques* (exh. cat., Strasbourg, 1989); and the individual case studies of different French cathedrals in D. Kimpel and R. Suckale, *L'architecture gothique en France 1130–1270* (Paris, 1990). An excellent study by C. R. Dodwell, 'The meaning of "Sculptor" in the Romanesque period', in *Romanesque and Gothic, op. cit.*, 49–61, is of use for the earlier part of the thirteenth century.

13. Knoop and Jones, *op. cit.*, 74–5; for the case of Exeter Cathedral around 1300 see J. A. Givens, 'The fabric accounts of Exeter Cathedral as a record of medieval sculptural practice', *Gesta*, XXX (1991), 112–18.

14. Von Simson, *op. cit.*, 228–29.

15. E. Farrell and R. Newman, 'The materials of Gothic sculpture' in D. Gillerman (ed.), *Gothic Sculpture in America. I. The New England Museums* (New York and London, 1989), ix–xxi.

16. For Rochester and Wells see W. H. St John Hope and W. R. Lethaby, 'The imagery and sculptures on the west front of Wells cathedral church', *Archaeologia*, LIX (1904), pls XXXVI (Rochester), XXVII (N.78), XLII (S.22), XLVII (N.44), XLIX (N.74).

17. P. Williamson, 'The Westminster Chapter House Annunciation group', *Burlington Magazine*, CXXX (1988), 123–4, and *idem.*, 928.

18. *Idem.*, *Northern Gothic Sculpture 1200–1450* (Victoria and Albert Museum, London, 1988), 43 (cat. nos 5–8).

19. The drawings by Villard de Honnecourt are more likely to be records of sculptures he had seen than working sketches: for these see H. R. Hahnloser, *Villard de Honnecourt. Kritische Gesamtausgabe des Bauhüttenbuches ms.fr 19093 der Pariser Nationalbibliothek* (2nd ed., Graz, 1972).

20. P. Plagnieux, 'Le portail du XIIe siècle de Saint-Germain-des-Prés à Paris: état de la question et nouvelles recherches', *Gesta*, XXVIII (1989), 21–9. For an analysis of the tool-marks on certain sculptures in Regensburg Cathedral see F. Fuchs, 'Beobachtungen zur Bildhauertechnik an den mittelalterlichen Skulpturen des Regensburger Domes', in *Der Dom zu Regensburg. Ausgrabung – Restaurierung – Forschung* (Munich and Zürich, 1990), 237–47. On tools see P. Rockwell, *The art of stoneworking: a reference guide* (Cambridge, 1993), 31–68 and pls 1–10.

21. In the case of Reims see H. Deneux, 'Signes lapidaires et épures du XIIIe siècle à la cathédrale de Reims', *Bulletin Monumental*, LXXXIV (1925), 99–131, and now, most comprehensively, R. Hamann-MacLean and I. Schüssler, *Die Kathedrale von Reims, Die Architektur* (Stuttgart, 1993), I/1, 261–94; I/2, figs 349–77; I/3, pls 167–8.

22. See, for instance, the tympanum from St Cäcilien in Cologne [100]. These prefabricated blocks were not always installed correctly (or did not always fit together accurately *in situ*), as may be seen in one of the angels in the Lincoln Angel choir (A. Gardner, *The Lincoln Angels* (Lincoln Minster Pamphlet (First Series), 6, 1952), fig. S.5).

23. See p. 107 and pl. 164.

24. L. Schreiner, *Die frühgotische Plastik Südwestfrankreichs* (Cologne-Graz, 1963), 106–12, 162–4.

25. H.-B. Depping (ed.), *Réglemens sur les arts et métiers de Paris, rédigés au XIIIe siècle, et connus sous le nom du Livre des Métiers d'Etienne Boileau* (Paris, 1837), 157–9 (see also the comments of M. Blindheim, *Main trends of East-Norwegian wooden figure sculpture in the second half of the thirteenth century* (Oslo, 1952), 92). A later edition may also be consulted: R. de Lespinasse and F. Bonnardot (eds), *Histoire Générale de Paris. Les métiers et corporations de la ville de Paris. XIIIe siècle. Le Livre des Métiers d'Etienne Boileau* (Paris, 1879). It should be noted that a separate guild existed for *Maçons, Tailleurs de pierre, Plastriers* and *Morteliers* (for its regulations see Depping, *op. cit.*, 107–12). For the Westminster reference see H. M. Colvin (ed.), *Building Accounts of King Henry III* (Oxford, 1971), 228–9.

26. A. Brodrick, 'Painting techniques of Early Medieval sculpture', in *Romanesque: stone sculpture from medieval England* (exh. cat., Leeds, 1993), 18–27.

27. E. Deuber-Pauli and T. A. Hermanès, 'Le portail peint de la Cathédrale de Lausanne: histoire, iconographie, sculpture et polychromie', *Nos monuments d'art et d'histoire*, XXXII (1981), 262–74; V. Furlan, R. Pancella and T. A. Hermanès, *Portail peint de la Cathédrale de Lausanne: analyses pour une restauration* (Lausanne, n.d. [1982]); T. A. Hermanès and E. Deuber-Pauli, 'La couleur gothique', *Connaissance des Arts*, no. 367 (September 1982), 36–45.

28. O. Nonfarmale and R. Rossi Manaresi, 'Il restauro del "Portail Royal" della cattedrale di Chartres', *Arte Medievale*, 2nd series, I (1987), 259–75; C. di Matteo and P.-A. Lablaude, 'Le portail polychrome de Notre-Dame d'Etampes', *Monuments historiques*, 161 (January-February 1989), 86–90; R. Rossi-Manaresi and A. Tucci, 'The polychromy of the portals of the Gothic cathedral of Bourges', *Preprints of the ICOM Committee for Conservation 7th Triennial Meeting, Copenhagen, 10–14 September 1984*, 84.5.1–4; M. Chataignère, 'Etude technique de la polychromie', in A. Erlande-Brandenburg and D. Thibaudat, *Les sculptures de Notre-Dame de Paris au musée de Cluny* (Paris, 1982), 121–3; R. Rossi Manaresi and O. Nonfarmale, *Notizie sul restauro del protiro della cattedrale di Ferrara* (Bologna, 1981). For an overview see R. Rossi Manaresi, 'Considerazioni tecniche sulla scultura monumentale policromata, romanica e gotica', *Bollettino d'Arte*, XLI (1987), 173–86.

29. Translated from Depping, *op. cit.*, 156–7.

30. *Ibid.*, 158–9.

31. For a typical Central Italian example of around 1230–50 see P. Williamson, *The Thyssen-Bornemisza Collection: Medieval sculpture and works of art* (London, 1987), cat. no. 13.

32. See Williamson, *op. cit.*, note 18 (1988), 14–16.

33. For an exemplary investigation into a Mosan Virgin and Child of about 1270, with a coloured illustration showing its evolution through eight different paint schemes, see R. Didier, L. Kockaert, M. Serck-Dewaide and J. Vynckier, 'La Sedes Sapientiae de Vivegnis: étude et traitement', *Bulletin de l'Institut royal du Patrimoine artistique*, XXII (1988/89), 51–77.

34. Frisch, *op. cit.*, 56–7.

CHAPTER I

1. This lack of reference has been explained by some authorities with the assertion that, in contrast to his lavish expenditure on the treasury, Suger needed no *apologia* for the work on the façade (see, for example, C. Wilson, *The Gothic Cathedral. The Architecture of the Great Church 1130–1530* (London, 1990), 34: 'Suger wrote nothing about the portal sculptures, perhaps because their didactic value was too obvious to need any defence'). Others have interpreted Suger's silence on the portals as evidence for their completion *after* his death, a theory now discredited (C. Goldscheider, 'Les Origines du portail à statues colonnes', *Bulletin des Musées de France*, II/6–7 (1946), 22–5). As long ago as 1922, Emile Mâle convincingly demonstrated that Suger did refer to the Last Judgement iconography of the central tympanum in the inscription he set up below it (see E. Mâle, *Religious Art in France: the Twelfth Century. A Study of the Origins of Medieval Iconography*, ed. H. Bober (Princeton, 1978), 179).

2. For the life of Suger see P. Panofsky (ed.), *Abbot Suger on the Abbey Church of St.-Denis and its art treasures* (2nd edition by G. Panofsky-Soergel, Princeton, 1979), 1–37; and articles by J. F. Benton and others in P. L. Gerson (ed.), *Abbot Suger and Saint-Denis: A Symposium* (New York, 1986). An interesting alternative view to Panofsky's portrait of Suger is provided by P. Kidson, 'Panofsky, Suger and Saint-Denis', *Journal of the Warburg and Courtauld Institutes*, L (1987), 1–17.

3. For the most convenient and detailed account of the restorations to the central doorway see P. Z. Blum, *Early Gothic Saint-Denis: Restorations and Survivals* (Berkeley and Los Angeles, 1992); for the style and iconography see W. Sauerländer *Gothic Sculpture in France 1140–1270* (London, 1972), 379–81; C. T. Little, 'Monumental sculpture at Saint-Denis under the patronage of Abbot Suger: the west façade and the cloister', in *The Royal Abbey of Saint-Denis in the time of Abbot Suger (1122–1151)* (exh. cat., Metropolitan Museum of Art, New York, 1981), 25–43; P. L. Gerson, 'Suger as iconographer: the central portal of the west façade of Saint-Denis', and P. Z. Blum, 'The lateral portals of the west façade of the abbey church of Saint-Denis: archaeological and iconographic considerations', in Gerson, *op. cit.*, 183–98, 199–227; S. M. Crosby and P. Z. Blum, *The Royal Abbey of Saint-Denis from its beginnings to the death of Suger, 475–1151* (New Haven and London, 1987), 167–213. For the heads see F. Joubert, 'La tête de Moïse du portail sud de la façade occidentale de Saint-Denis', *Monuments et Mémoires. Fondation Eugène Piot*, LXXI (1990), 83–96 (with older literature), and the useful summary of A. Erlande-Brandenburg, 'Une tête de prophète provenant de l'abbatiale de Saint-Denis, portail de droite de la façade occidentale', *Académie des Inscriptions & Belles-Lettres, Comptes rendus des séances de l'année 1992* (Paris, 1992), 515–42. The most recently found head bears a stylistic relationship to the detached head of King Lothaire from Saint-Rémi, Reims (see Sauerländer, *op. cit.*, pl. 28).

4. Panofsky, *op. cit.*, 47.

5. All six heads, and the drawings of them, are illustrated in Erlande-Brandenburg, *op. cit.* The drawing of the figure of Dionysius is illustrated in Crosby and Blum, *op. cit.*, fig. 84a, its position on the trumeau postulated on p. 195, but this interpretation has rightly been rejected by Erlande-Brandenburg (*op. cit.*, 520, 529).

6. For Suger's relation to Hugh of Saint-Victor see C. Rudolph, *Artistic change at St-Denis: Abbot Suger's program and the early twelfth-century controversy over art* (Princeton, 1990), 32–47.

7. For the relationship of Saint-Denis to Romanesque Last Judgement tympana see P. K. Klein, 'Programmes eschatologiques, fonction et réception historiques des portails du XIIe s: Moissac – Beaulieu – Saint–Denis', *Cahiers de Civilisation Médiévale*, XXXIII (1990), 317–49.

8. Paula Gerson has proposed that their jamb figures in addition complement the iconographic programmes found in the tympana above, and should not simply be read horizontally across the façade (P. Gerson, *The west façade of St.-Denis: an iconographic study* (Ph.D. thesis, Columbia University, 1970), 149.

9. For the early development of the jamb figure see A. Katzenellenbogen, *The sculptural programs of Chartres Cathedral* (Baltimore, 1959), 120–2. For Saint-Denis specifically see K. Hoffman, 'Zur Entstehung des Königsportals in Saint-Denis', *Zeitschrift für Kunstgeschichte*, XLVIII (1985), 29–38.

10. For Leo of Ostia's chronicle see E. G. Holt (ed.), *A Documentary History of Art, Volume I, The Middle Ages and Renaissance* (2nd ed., New York, 1957), 13,

and H. Bloch, *Monte Cassino in the Middle Ages* (Rome, 1986), *passim*; the iconography of the north portal tympanum is fully discussed by Blum in Gerson, *op. cit.* (1986), 209–18.

11. Panofsky, *op. cit.*, 91.

12. The supposition that the sculpture at Saint-Denis developed out of 'indigenous styles characteristic of the Ile-de-France region' (Little, *op. cit.*, 39, following L. Pressouyre, 'Une Tête de reine du portail central de Saint-Denis', *Gesta*, XV (1976), 151–60) seems to me not to be sustainable. Recently, numerous fragments of Romanesque sculpture, including several figured capitals, have been excavated just to the north of Suger's basilica: they probably come from the church of Saint-Michel-du-Degré and date from the early 1130s (M. Wyss, 'Saint-Denis. I. Sculptures romanes découvertes lors des fouilles urbaines', *Bulletin Monumental*, CL (1992), 309–54). Rather than providing a stylistic foundation for Suger's sculptures they would seem instead to show how different the indigenous sculpture of the Ile-de-France was from the work at Saint-Denis. For a general view of Romanesque sculpture in the Ile-de-France see A. Prache, *Ile-de-France Romane* (La Pierre-qui-vire, 1983), 411–78.

13. For the dating of the *Eve*, see D. Grivot and G. Zarnecki, *Gislebertus: Sculptor of Autun* (New York, 1961), 162; Sauerländer's opinion that 'at Saint-Denis, there is, as far as I can see, no trace of any Burgundian inspiration' was given before the discovery of the Musée national du Moyen Age head of a queen; the latter provides the intermediary link between Burgundy and Chartres which Sauerländer thought was lacking (W. Sauerländer, 'Sculpture on Early Gothic churches: the state of research and open questions', *Gesta*, IX (1970), 34–5).

14. Its provenance from the west portal of the abbey church is uncertain, indeed unlikely. It was excavated by Conant near the fourth pier from the west on the south side of the nave of Cluny III (information kindly supplied by Neil Stratford).

15. On this point see W. S. Stoddard, *Sculptors of the West Portals of Chartres Cathedral* (New York and London, 1987), 48–54, 178, 183–209 (see also the review of the earlier edition of the first half of this book by L. Grodecki in *Bulletin Monumental*, CXI (1953), 312–15); B. Kerber, *Burgund und die Entwicklung der französischen Kathedralskulptur im 12. Jh.* (Recklinghausen, 1966).

16. From a stylistic point of view the connection sometimes put forward with western France does not seem tenable (see Stoddard, *op. cit.*, 46–8, 178).

17. *Ibid.*, 44–6, 179–83; see also L. Seidel, 'A Romantic forgery: the Romanesque "portal" of Saint-Etienne in Toulouse', *Art Bulletin*, L (1968), 33–42, and K. Horste, *Cloister design and monastic reform in Toulouse: the Romanesque sculpture of La Daurade* (Oxford, 1992), 153.

18. W. Vöge, *Die Anfänge des monumentalen Stiles im Mittelalter* (Strasbourg, 1894), 80–90; Mâle, *op. cit.*, 179–81.

19. Gerson, *op. cit.* (1986), 183–98.

20. Stoddard, *op. cit.*, 158–69, considers the sculpture of the Royal Portal to have been carried out in 1143–8. For a view of the construction of the lateral portals see J. James, 'An examination of some anomalies in the Ascension and Incarnation portals of Chartres Cathedral', *Gesta*, XXV (1986), 101–8. The vexed archaeological evidence is discussed in M. Aubert, 'Le portail royal et la façade occidentale de la cathédrale de Chartres, essai sur la date et leur exécution', *Bulletin Monumental*, C (1941), 177–218, and E. Fels, 'Die Grabung an der Fassade der Kathedrale von Chartres', *Kunstchronik*, VIII (1955), 149–51.

21. The quote is from R. W. Southern, 'Humanism and the School of Chartres', in *Medieval Humanism and other studies* (Oxford, 1970), 61–85. Southern's careful corrective to the idea of a hugely influential 'School of Chartres', so often put forward, advances the theory that it was Paris which was the dominant intellectual force in the twelfth century; and that although a school existed at Chartres, as at many other cathedral towns, its ideas were informed from the metropolis. See further *idem*, 'The Schools of Paris and the School of Chartres', in R. L. Benson and G. Constable (eds), *Renaissance and renewal in the twelfth century* (Oxford, 1982), 113–37.

22. There was apparently also originally a trumeau figure of St John the Baptist on the central doorway (J. Villette, 'Le portail royal de Chartres a-t-il été modifié depuis sa construction?', *Bulletin des Sociétés Archéologiques d'Eure-et-Loir*, CXV (1971), 255–64).

23. A. Heimann, 'The capital frieze and pilasters of the portail royal, Chartres', *Journal of the Warburg and Courtauld Institutes*, XXXI (1968), 73–102, K. Nolan, 'Ritual and visual experience in the capital frieze at Chartres', *Gazette des Beaux-Arts*, 6th series, CXXIII (1994), 53–71, and L. Spitzer, 'The cult of the Virgin and Gothic sculpture: evaluating opposition in the Chartres west façade capital frieze', *Gesta*, XXXIII (1994), 132–50. For contemporary related sculpture at Dreux see W. Cahn, 'A King from Dreux', *Yale University Art Gallery Bulletin*, XXXIV/3 (1974), 14–29.

24. The voussoirs containing the symbols for Gemini and Pisces should belong to the north doorway (see P. Kidson, *Sculpture at Chartres* (London, 1974), 23–4).

25. J. van der Meulen and N. Price, *The West Portals of Chartres Cathedral, Vol.*

1, The Iconology of the Creation (Washington, D.C., 1981); J. van der Meulen and J. Hohmeyer, *Chartres: Biographie der Kathedrale* (Cologne, 1984), 237–43; for a rebuttal of van der Meulen's views see W. Sauerländer, *Das Königsportal in Chartres: Heilsgeschichte und Lebenswirklichkeit* (Frankfurt am Main, 1984), 44–7.

26. Katzenellenbogen, *op. cit.*, 22–4.

27. Stoddard, *op. cit.*, 209. A different view of the head master, postulating a background at La Charité-sur-Loire and Souvigny, is in my opinion no more acceptable: see C. E. Armi, *The 'Headmaster' of Chartres and the origins of 'Gothic' sculpture* (University Park, Penn., 1994), *passim*. A general discussion of the Royal Portal is to be found in G. Henderson, *Chartres* (Harmondsworth, 1968), 39–60.

28. Sauerländer, *op. cit.* (1970), 38–9; the argument for the priority of Etampes over Chartres is presented most lucidly by A. Priest, 'The Masters of the West Façade at Chartres', *Art Studies*, I (1923), 28–44 (reprinted in R. Branner (ed.), *Chartres Cathedral* (London, 1969), 149–68), while A. Lapeyre (*Des façades occidentales de Saint-Denis et de Chartres aux portails de Laon* (Mâcon, 1960), 53–66) prefers to see Chartres as first. Stoddard, *op. cit.*, 170–7, gives a rebuttal of Lapeyre's theories and provides a useful summary of the state of research up to 1987; see also K. Nolan, 'Narrative in the capital frieze of Notre-Dame at Etampes', *Art Bulletin*, LXXI (1989), 166–84. The connection with Vienne is strengthened by the sculptures of Nazareth (see below, p. 19).

29. Sauerländer, *op. cit.* (1970), 35–6.

30. F. Salet, 'Notre-Dame de Corbeil', *Bulletin Monumental*, C (1941), 81–118; Sauerländer, *op. cit.* (1972), 397–8; W. Cahn, 'Observations on Corbeil', *Art Bulletin*, LV (1973), 321–7 (for the identification of the scenes on the capitals); idem, 'Nouvelles observations sur Corbeil', *Bulletin Monumental*, CXXXIII (1975), 63–77; Stoddard, *op. cit.*, 222–9. A closely comparable statue-column of a queen from Saint-Thibaut, Provins, (now in the Glencairn Museum, Bryn Athyn, Pennsylvania) and the column figures still *in situ* at Saint-Ayoul, Provins, must be of about the same date or slightly later (P. Z. Blum, 'The statue-column of a queen from Saint-Thibaut, Provins, in the Glencairn Museum', *Gesta*, XXIX (1990), 214–33).

31. L. Pressouyre, 'Did Suger build the cloister at Saint-Denis?', in Gerson, *op. cit.* (1986), 229–44; see also D. V. Johnson and M. Wyss, 'Saint-Denis. II. Sculptures gothiques récemment découvertes', *Bulletin Monumental*, CL (1992), 355–81.

32. But see S. Baratte-Bévillard, 'La sculpture monumentale de la Madeleine de Châteaudun', *Bulletin archéologique du comité des travaux historiques et scientifiques*, VIII (1972), 105–25.

33. Stoddard, *op. cit.*, 177, figs 77–9, pl. XXIII/1; see also Prache, *op. cit.*, pls 107–9.

34. *Medieval and Renaissance Treasures in the North West* (exh. cat., Whitworth Art Gallery, University of Manchester, 1976), cat. no. 112, pl. 21.

35. J. Folda, *The Nazareth Capitals and the Crusader Shrine of the Annunciation* (Monographs on the Fine Arts sponsored by the College Art Association of America, XLII, University Park and London, 1986), summarises the previously proposed connections between the sculpture of Etampes and Crusader sculptures, but this is largely confined to the five well-known capitals from Nazareth. Contrary to Folda's hypothesis that they were intended for a shrine within the church, the portal theory has more to recommend it (cf. Z. Jacoby, 'Le portail de l'église de l'Annonciation de Nazareth au XIIe siècle', *Monuments et Mémoires. Fondation Eugène Piot*, LXIV (1981), 141–94; see also A. Borg, 'Romanesque Sculpture from the Rhône Valley to the Jordan Valley', in J. Folda (ed.), *Crusader Art in the twelfth century* (BAR International Series, CLII, Oxford, 1982), 97–119. The rough backgrounds to the capitals and some of the voussoirs at Nazareth (for mastic?) suggest that the carving was finished but not put in position: if this had been done it probably would have been painted, and traces of this would still remain.

36. Compare, for instance, the capital of the Liberal Arts (?) in the nave of Saint-André-le-Bas at Vienne with the Nazareth capitals (N. Stratford, 'Autun and Vienne', in *Romanesque and Gothic: Essays for George Zarnecki* (Woodbridge, 1987), vol. II, pl. 23, and Folda, *op. cit.* (1986), *passim*, and especially the figure of St John the Evangelist in Saint-Maurice, Vienne, with the Chatsworth fragment (J. Lacoste, 'La sculpture romane du Sud de la France à l'époque de Maître Mathieu', in *Actas simposio internacional sobre 'O Pórtico da Gloria e a Arte do seu Tempo'* (La Coruña, 1991), 223–8, pl. VI).

37. The style is, of course, quite different; for the St Peter and Paul reliefs at Moissac see M. F. Hearn, *Romanesque Sculpture: the revival of monumental stone sculpture in the eleventh and twelfth centuries* (Oxford, 1981), pl. 85. Saints Peter and Paul also appear to each side of the portal at Moissac (*ibid.*, pls 131, 133).

38. An attempt to place the Le Mans portal earlier than the late 1150s, between Saint-Denis and Chartres and possibly as early as the late 1130s, has been put forward by Thomas E. Polk II ('The south portal of the cathedral at Le Mans: its place in the development of the early Gothic portal composition', *Gesta*, XXIV (1985), 47–60), but refuted by Whitney Stoddard (*op. cit.*, 212–13).

39. M. Beaulieu, 'Essai sur l'iconographie des statues-colonnes de quelques portails du premier art gothique', *Bulletin Monumental*, CXLII (1984), 273–307.

40. It appears that the Bourges lateral portals were moved into their present positions only in the thirteenth century and were probably originally intended for the west façade (Sauerländer, *op. cit.* (1972), 399–400, and R. Branner, *The Cathedral of Bourges and its place in Gothic architecture* (Cambridge, Mass. and London, 1989), 136–40; for a different view see A. New-Smith, *Twelfth-century sculpture at the Cathedral of Bourges* (Doctoral dissertation, Boston University, 1975)). Clark Maines has argued that the Saint-Loup-de-Naud portal is also largely made up from *spolia* originally designed for another site (probably Saint-Pierre-le-Vif in Sens), with the exception of the sculptures specifically to do with St Lupus (C. Maines, *The Western Portal of Saint-Loup-de-Naud* (New York and London, 1979), *passim*. It is interesting to note that the now-destroyed lintel below the tympanum at Angers only held eight apostles – the same number as at Saint-Loup-de-Naud – and that the remaining four have been placed two to each side in the lowermost voussoirs (Sauerländer, *op. cit.* (1972), pl. 32): in this connection it is therefore possible that the Saint-Loup-de-Naud lintel was not cut down (Maines, *op. cit.*, 85, 149–51; for a discussion of Maines's findings see Stoddard, *op. cit.*, 213–18).

41. J. Vanuxem, 'La sculpture du XIIe siècle à Cambrai et à Arras', *Bulletin Monumental*, CXIII (1955), 7–35 (17–19); *Sculptures romanes et gothiques du Nord de la France* (exh. cat., Lille, 1978), cat. nos 31–2.

42. Sauerländer, *op. cit.* (1972), 388; Stoddard, *op. cit.*, 242–4, considers La Charité to post-date Chartres; for the priority of La Charité, and for the supposed early contribution of the Chartres head master at that site, see Armi, *op. cit. passim*.

43. Sauerländer, *op. cit.* (1972), 389 and ill.7 (Montmorillon), 394 and pl. 26 (Souvigny), 399–400 and pls 34–5 (Bourges). For Montmorillon see also R. Crozet, 'La frise de la Maison-Dieu de Montmorillon et ses rapports avec la sculpture chartraine, bourguignonne et bourbonnaise', *Bulletin de la Société des Antiquaires de l'Ouest*, 4th series, VIII (1965), 83–7, and Y. Blomme, *Poitou gothique* (Paris, 1993), 202–6. The theories of Armi (*op. cit.*, *passim*) are not without difficulties.

44. P. Quarré, 'La sculpture des anciens portails de Saint-Bénigne de Dijon', *Gazette des Beaux-Arts*, L (1957), 177–94; Sauerländer, *op. cit.* (1970), 36–40; idem. (1972), 389–91; Stoddard, *op. cit.*, 239–41.

45. This is most conveniently illustrated and discussed in M. Beaulieu and V. Beyer, *Dictionnaire des sculpteurs français du Moyen Age* (Paris, 1992), 177–8.

46. They are commemorative, and refer to a certain Petrus, not a sculptor but one of the abbots who had made improvements to the church in the second quarter of the twelfth century (see Quarré, *op. cit.*, and for a useful summary, Sauerländer, *op. cit.* (1972), 391).

47. J. Thirion, 'Les plus anciennes sculptures de Notre-Dame de Paris', *Comptes-rendus de l'Académie des inscriptions et belles-lettres*, (1970), 85–112; Sauerländer (1972), 404–6; W. W. Clark and F. M. Ludden, 'Notes on the archivolts of the Saint-Anne Portal of Notre-Dame de Paris', *Gesta*, XXV (1986), 109–18; Stoddard, *op. cit.*, 229–35; J. Taralon, 'Observations sur le portail central et sur la façade occidentale de Notre-Dame de Paris', *Bulletin Monumental*, CXLIX (1991), 384–9.

48. F. Giscard d'Estaing, M. Fleury, A. Erlande-Brandenburg, *Les rois retrouvés. Notre-Dame de Paris* (Paris, 1977); C. Gómez-Moreno, *Sculpture from Notre-Dame, Paris: A Dramatic Discovery* (Metropolitan Museum of Art, New York, 1979); A. Erlande-Brandenburg and D. Thibaudat, *Les sculptures de Notre-Dame de Paris au musée de Cluny* (Paris, 1982), 5–27.

49. For a summary of Viollet-le-Duc's three references to the figure of Christ in his *Dictionnaire*, see Clark and Ludden, *op. cit.*, 117, n. 22.

50. Thirion, *op. cit.*, 92–7; see also W. Cahn, 'The tympanum of the portal of Saint-Anne at Notre Dame de Paris and the iconography of the division of powers in the early middle ages', *Journal of the Warburg and Courtauld Institutes*, XXXII (1969), 55–72, and K. Horste, '"A Child is born": the iconography of the Portail Ste.-Anne at Paris', *Art Bulletin*, LXIX (1987), 187–210.

51. D. Kimpel and R. Suckale, *L'architecture gothique en France 1130–1270* (Paris, 1990), 148–51.

52. *Senlis: un moment de la sculpture gothique* (La Sauvegarde de Senlis, XLV–XLVI, 1977), cat. no. 26; Taralon, *op. cit.*, 386–7.

53. Panofsky, *op. cit.*, 57–61; for a reconstruction of Suger's cross and a discussion of the Saint-Bertin cross-foot see P. Lasko, *Ars Sacra: 800–1200* (Pelican History of Art, 2nd ed., New Haven and London, 1994), 196–7, pl. 270 (see also the comments of N. Stratford, *Catalogue of Medieval Enamels in the British Museum, Vol. II, Northern Romanesque Enamel* (London, 1993), 67).

54. See the telling comparison made by Sauerländer, *op. cit.* (1970), figs 17–18.

55. Sauerländer, *op. cit.* (1972), 406–7; *Senlis: un moment de la sculpture gothique, op. cit.*; D. Brouillette, *The Early Gothic Sculpture of Senlis Cathedral* (Doctoral dissertation, University of California at Berkeley, 1981). See M. Bideault and C. Lautier, *Ile-de-France gothique, I, Les églises de la vallée de l'Oise et du Beauvaisis* (Paris, 1987), 348–67, and D. Vermand, *La Cathédrale Notre-Dame de Senlis au XIIe siècle. Etude historique et monumentale* (Société d'Histoire et

d'Archéologie de Senlis, 1987) for the building history.

56. For the identification of Jacob, rather than Isaiah, see R. J. Adams, 'Isaiah or Jacob? The iconographic question on the Coronation portals of Senlis, Chartres, and Reims', *Gesta*, XXIII (1984), 119–30.

57. Brouillette, *op. cit.*, p. 148.

58. M.-L. Thérel, *A l'origine du décor du portail occidental de Notre-Dame de Senlis: le triomphe de la Vierge Eglise* (Paris, 1984); see also the review article by P. Skubiszewski, 'Les impondérables de la recherche iconographique. A propos d'un livre récent sur le thème de la glorification de l'Eglise et de la Vierge dans l'art médiéval', *Cahiers de Civilisation Médiévale*, XXX (1987), 145–53.

59. See P. Verdier, *Le Couronnement de la Vierge. Les origines et les premiers développements d'un thème iconographique* (Montreal, 1980), esp. 113–52; for a succinct summary see X. Barral i Altet, 'The triumph of Senlis and the new Marian cult', in G. Duby, X. Barral i Altet and S. Guillot de Suduiraut, *Sculpture: the great art of the Middle Ages from the fifth to the fifteenth century* (Geneva, 1990), 117–20. See also L. Pressouyre, 'La "Mactatio Agni" au portail des cathédrales gothiques et l'exégèse contemporaine', *Bulletin Monumental*, CXXXII (1974), 49–65, for an interesting study of one of the column figures and its meaning.

60. Still the most persuasive analysis of the stylistic context of Senlis is the cogent article by W. Sauerländer, 'Die Marienkrönungsportale von Senlis und Mantes', *Wallraf-Richartz-Jahrbuch*, XX (1958), 115–62 (esp. 121–35); see also Brouillette, *op. cit.*; *Senlis: un moment de la sculpture gothique*, 13–29; and Taralon, *op. cit.*, 386, figs 56–7.

61. Mention should be made of the related column figure of Senlis style, probably from Paris, now in the Musée national du Moyen Age: see L. Pressouyre, 'Une statue-colonne complétée au musée de Cluny', in *Etudes d'art médiéval offertes à Louis Grodecki* (Paris, 1981), 155–66.

62. See below, p. 154.

63. Sauerländer, *op. cit.* (1972), 410; for an earlier dating see Blum, *op. cit.* (1990), 232, n. 42, and *idem*, 'Fingerprinting the stone at Saint-Denis: a pilot study', *Gesta*, XXXIII (1994), 19–28, esp. 24.

64. For the trumeau, added when the portal was installed in its present position, see F. Baron, 'Remarques sur le décor sculpté de Saint-Denis. A propos d'une exposition', *La Revue du Louvre et des Musées de France*, X/5–6 (1985), 350–2; this is judged to be of nineteenth-century date by Blum (*op. cit.* (1994), 21–3).

65. For the small heads see *Senlis: un moment de la sculpture gothique*, cat. nos 35–6.

66. Sauerländer, *op. cit.* (1972), 408–9, pls 46–8 and 50; *Senlis: un moment de la sculpture gothique*, cat. nos 42–5; C. Bruzelius and J. Meredith, *The Brummer Collection of Medieval Art, The Duke University Museum of Art* (Durham and London, 1991), cat. no. 11; the identification of the trumeau figure as the Virgin is found in Brouillette, *op. cit.*, 164, n. 30.

67. P. Williamson, *The Thyssen-Bornemisza Collection: Medieval sculpture and works of art* (London, 1987), cat. no. 1; Bruzelius and Meredith, *op. cit.*, cat. no. 9.

68. C. T. Little, '*Resurrexit*: A rediscovered monumental sculptural program from Noyon Cathedral', in E. C. Parker (ed.), *The Cloisters: Studies in honor of the fiftieth anniversary* (New York, 1992), 235–59 (a detail of the drawing is illustrated in fig. 19).

69. A similar difficulty exists in establishing the original setting of the contemporary figures of saints and the Virgin from Saint-Martin, Angers, now in the Yale University Art Gallery, which have been used as evidence for the context of the Noyon figures. Blum has argued for their position around a portal, with the Virgin as a trumeau figure, while Sauerländer accepts the traditional setting around the inside of the choir, just below the vault ribs: this arrangment is also seen at Levroux (P. Z. Blum, 'A Madonna and four saints from Angers: an archaeological approach to an iconographical problem', *Yale University Art Gallery Bulletin*, XXXIV/3 (1974), 30–57; Sauerländer, *op. cit.* (1972), 413–15).

70. Sauerländer, *op. cit.* (1972), 411–12 (lists several important earlier articles by L. Pressouyre in bibliography); S. Pressouyre, *Images d'un cloître disparu: Notre-Dame-en-Vaux à Châlons-sur-Marne* (Châlons-sur-Marne, 1976); S. and L. Pressouyre, *The Cloister of Notre-Dame-en-Vaux at Châlons-sur-Marne* (trans. D. V. Johnson, Nancy, 1981); *idem*, *Le Cloître de Notre-Dame-en-Vaux* (Paris, n.d.).

71. Several column figures had found their way into foreign museums (Cleveland, Antwerp and Riggisberg) before the excavations took place: see W. Wixom, *Treasures from Medieval France*, exh. cat. (Cleveland, 1967), 98–9 and 356–7, J. de Coo, *Museum Mayer van den Bergh, Catalogus 2, Beeldhouwkunst, Plaketten, Antiek* (Antwerp, 1969), 76–9, and L. Pressouyre, *Un apôtre de Châlons-sur-Marne* (Monographien der Abegg-Stiftung Bern, 3, Bern, 1970).

72. W. D. Wixom, 'Romanesque Sculpture in American Collections. XVIII. The Cleveland Museum of Art', *Gesta*, XVIII/2 (1979), 44.

73. Compare, for instance, the capitals at Châlons (Pressouyre, *op. cit.* (1976), 20–9) with the large fragment of an enthroned bishop on one side and inhabited scrolls on the other in the Musée Saint-Rémi in Reims, which is probably a

product of the 1160s (W. Sauerländer, 'Chefs d'oeuvre romans des musées de province', *Kunstchronik*, II (1958), pls 2–4).

74. W. Sauerländer, 'Beiträge zur Geschichte der "frühgotischen" Skulptur', *Zeitschrift für Kunstgeschichte*, XIX (1956), 1–9; *idem.*, (1972), 415–16; E. Panofsky, *Tomb Sculpture* (2nd ed., London, 1992), 61.

75. Sauerländer, *op. cit.* (1956), 1–9.

76. The head of Christ from the Baptism scene on the Baptist's portal was recently identified at Sens and a cast of it placed on the portal: the original is in the Musée Synodal (for a photograph of the cast *in situ* see W. Sauerländer and J. Henriet, *Le Monde Gothique: le siècle des cathédrales 1140–1260* (Paris, 1989), pl. 76). The exact provenance of the head was not recognised when it was included in the *Cathédrales* exhibition at the Louvre in 1962 (cat. no. 39).

77. The thirteenth-century south portal, showing the Coronation, Death, Entombment and Assumption of the Virgin, is illustrated in E. Mâle, *Religious Art in France: the thirteenth century* (ed. H. Bober, Princeton, 1984), fig. 168. See also p. 162.

78. For a full description of the iconography see Sauerländer, *op. cit.* (1972), 416–17.

79. A closely related trumeau figure of St Stephen of about the same date is to be found on the north transept portal of Meaux Cathedral (*ibid.*, ill.40; see also P. Kurmann, *La Cathédrale Saint-Etienne de Meaux* (Geneva, 1971), 87, pl. LIX/73, for the whole door).

80. Sauerländer (*op. cit.* (1972), 418) presumed that the Majestas was not originally shown on the tympanum of the central portal, and preferred a Last Judgement programme running across the façade higher up.

81. L. Pressouyre, 'Sculptures retrouvées de la cathédrale de Sens', *Bulletin Monumental*, CXXVII (1969), 107–18. Ten apostles are grouped on the jambs around the west doorway at San Vicente, Ávila, in around 1180 (see page 119 and P. de Palol and M. Hirmer, *Early Medieval Art in Spain* (London, 1967), pls 204–5).

82. The tympanum and two inner voussoirs of the south portal are clearly earlier in date, and were probably made in about 1160, when a simpler portal layout, with the Last Judgement at its centre, may have been envisaged. For a summary of the dating arguments see Sauerländer, *op. cit.* (1956), 9–27; *idem.* (1970), 43–4, 48; *idem.* (1972), 425–8.

83. Wilson, *op. cit.*, 70. The place of Laon in the development of the porch is treated in detail in P. C. Claussen, *Chartres-Studien: zu Vorgeschichte, Funktion und Skulptur der Vorhallen* (Wiesbaden, 1975), 41–61.

84. The jamb figures were made under the direction of Alfred Geoffrey-Dechaume between 1873 and 1886 (A. Bouxin, *Notre-Dame de Laon* (Laon, 1902), 59–60). For the various nineteenth-century restorations to the west façade at Laon see Claussen, *op. cit.*, 41–7.

85. M.-L. Thérel, 'Étude iconographique des voussures du portail de la Vierge-Mère à la cathédrale de Laon', *Cahiers de Civilisation Médiévale*, XV (1972), 41–51. The Adoration of the Magi and Joseph's Dream are seen in almost identical form on the mid-twelfth-century tympanum of the left portal of the façade of Saint-Gilles-du-Gard, but there the Entry into Jerusalem occupies the lintel (W. S. Stoddard, *The façade of Saint-Gilles-du-Gard: its influence on French sculpture* (Middletown (Conn.), 1973), fig. 75).

86. Sauerländer (*op. cit.* (1972), 428) was circumspect on the matter, but drew attention to their stylistic similarities with the sculptures of the west doorways. Boeswillwald, the architect-restorer of Laon, thought they could have come from Saint-Yved at Braine, but this has recently been disproved (J. McClain,'A modern reconstruction of the west portals of Saint-Yved at Braine', *Gesta*, XXIV (1985), 110, 118, n. 33). A detached head, also in the museum at Laon, would seem likewise to have come from the cathedral's west doorways (W. Sauerländer, *Von Sens bis Strassburg*, (Berlin, 1966) fig. 91)

87. Sauerländer, *op. cit.* (1956), figs 13–18.

88. McClain, *op. cit.*, 108–10, fig. 8a.

89. *Ibid.*, 110, fig. 12.

90. The north portal hypothesis was put forward by McClain, *op. cit.*, 113–15: there is no precedent or parallel for such scenes shown alone on a tympanum.

91. The traditional date of consecration given for Saint-Yved (1216) does not appear to be supported by the documents: see M. H. Caviness, 'Saint-Yved of Braine: the primary sources for dating the Gothic church', *Speculum*, LIX (1984), 524–48.

92. For Saint-Nicolas at Amiens, unfortunately destroyed at the Revolution, see the engraving by Millin illustrated in Sauerländer, *op. cit.* (1972), 430: the tympanum, which must have shown the Coronation of the Virgin, had been pulled down by the time the engraving was made, but the subject matter of the lintel leaves no doubt that such a scene existed.

93. B. Ward, *Miracles and the Medieval Mind: theory, record and event, 1000–1215* (London, 1982), 150–7.

94. For the fire of 1194 and the events immediately afterwards see the brilliant account in O. von Simson, *The Gothic Cathedral: Origins of gothic architecture and the medieval concept of order* (3rd ed., Princeton, 1988), 160–82.

95. L. Grodecki, 'The transept portals of Chartres Cathedral: the date of their construction according to archaeological data', *Art Bulletin*, XXIII (1951), 156–7. The vast literature on the building history of Chartres is listed and commented on (occasionally with passionate subjectivity) by J. van der Meulen, R. Hoyer and D. Cole, *Chartres: sources and literary interpretation. A critical bibliography* (Boston, 1989).

96. It is of course not inconceivable that the portal had been started before 1204 and that the trumeau figure of St Anne was added after receipt of the head; or equally that the gift followed the erection of the trumeau figure. Chartres was, after all, dedicated to the Virgin, and a trumeau figure of her mother would have been perfectly appropriate in the context of a Marian portal, whether or not the cathedral possessed a relevant relic.

97. Katzenellenbogen, *op. cit.*, 61–5. Adams (*op. cit.*, 119–30) interprets the figure on the inside of the right embrasure, traditionally seen as Isaiah, as Jacob.

98. Further close parallels with Laon and Braine can be seen in the archivolt figures and the Coronation tympanum. Although slight stylistic differences may be discerned among the sculptures of the doorway there is no reason to ascribe these differences to numerous individual hands, as has G. Schlag ('Die Skulpturen des Querhauses der Kathedrale von Chartres', *Wallraf-Richartz-Jahrbuch*, XII–XIII (1943), 115–64).

99. There was an earlier independence of movement on certain late twelfth-century column figures in Northern Spain, at Santiago de Compostela, Ávila and Oviedo.

100. Grodecki, *op. cit.* (1951), 163–4. See the following note for an alternative interpretation.

101. It has been proposed by van der Meulen that this portal was originally intended for the south portal of a new west front, with the Last Judgement portal at the centre and the Martyrs' portal to the north; when they were not used in this position, because of the decision to retain the Royal Portal, the latter two were moved to the south transept, displacing to the east the Confessors' portal which had previously served as the only portal to the south (J. van der Meulen, 'Sculpture and its architectural context at Chartres around 1200', *The Year 1200: A Symposium* (Metropolitan Museum of Art, New York, 1975), 509–39, esp. 521; this is repeated in J. van der Meulen and J. Hohmeyer, *Chartres: Biographie der Kathedrale* (Cologne, 1984), diagrams on pp. 142–3). It is not possible, however, despite van der Meulen's objections to style-critical analysis, to regard the Infancy portal as anything other than later than the Coronation portal of the north transept, while the iconographic programme of the south transept has a homogeneity which strongly suggests that the lateral portals were planned expressly to complement the Last Judgement portal. In addition, the Confessors' portal would hardly be likely to stand alone as the termination of the huge transept at Chartres, both because of its size – contrasting with the Coronation portal to the north – and its subject matter. Its style also links it with the *jubé* inside the cathedral, which was probably carved by the same workshop in the 1220s. For the iconographic programme see R.J. Adams, *The Eastern portal of the north transept at Chartres: "Christocentric" rather than "Mariological"* (Frankfurt am Main and Bern, 1982), following van der Meulen's methodology.

102. Katzenellenbogen, *op. cit.*, 76–8, and N. Levis-Godechot, 'Essai d'interprétation de l'iconographie des sculptures du portail nord de la cathédrale de Chartres', *Comptes-rendus et mémoires de la Société d'histoire et d'archéologie de Senlis, 1977* (1978), 31–47. For comments on the style of the sculpture see M. Büchsel, 'Das Hiob-Salomo-Portal. Stilistische Typologie – Typologischer Stil', in H. Beck and K. Hengevoss-Dürkop (eds), *Studien zur Geschichte der europäischen Skulptur im 12/13. Jahrhundert* (Frankfurt am Main, 1994), I, 413–29.

103. See van der Meulen, *op. cit.* (1975), 523 and 537 (notes 84–5); a recent summary of this subject, discussing the identity of the principal figure on the trumeau in the context of other donor representations at Chartres, is to be found in J. Welch Williams, *Bread, Wine, & Money: the Windows of the Trades at Chartres Cathedral* (Chicago and London, 1993), 48–51.

104. For these identifications see Kidson, *op. cit.*, 44–6, and Sauerländer (1972), 434; Maines prefers to see the figure of St Jerome as St Thomas Becket (C. Maines, 'A figure of St Thomas Becket at Chartres', *Zeitschrift für Kunstgeschichte*, XXXVI (1973), 163–73).

105. The Chartres workshop was also responsible for the execution of tomb effigies in the abbey of Notre-Dame-de-Josaphat at Lèves, just outside Chartres (Sauerländer (1972), 441, pl. 122).

106. Sauerländer (1972), pls 96–7.

107. These were destroyed in 1793, but were described fully before then. For the iconographic programme of the northern porches see Sauerländer (1972), 436–48; R. J. Adams, 'The column figures of the Chartres northern foreportal and a monumental representation of Saint Louis', *Zeitschrift für Kunstgeschichte*, XXXVI (1973), 153–62 (his interpretation may be dismissed on stylistic grounds); Claussen, *op. cit.*, *passim*; L. Kalinowski, 'L'idée de l'homme dans l'esprit divin à Chartres', *Études d'art médiéval offertes à Louis Grodecki, op. cit.*, 219–28.

108. Sauerländer (1972), 434–5; J. Villette, 'Quatre identifications nouvelles

de martyrs au porche sud de la cathédrale de Chartres: Saint-Pantaléon, Saint-Sébastien, Saint-Poppon et Saint-Cyprien', *Mémoires de la Soc. archéol. d'Eure-et-Loir*, XXV (1971), 239–54.

109. H. Bunjes, 'Der gotische Lettner der Kathedrale von Chartres', *Wallraf-Richartz-Jahrbuch*, XII–XIII (1943), 70–114; J. Mallion, *Le jubé de la cathédrale de Chartres* (Chartres, 1964); L. Pressouyre, 'Pour une reconstitution du jubé de Chartres', *Bulletin Monumental*, CXXV (1967), 419–29; Sauerländer (1972), 438–40; C. Bruzelius and J. Meredith, *The Brummer Collection of Medieval Art, The Duke University Museum of Art* (Durham, N.C., and London, 1991), cat. no. 14.

110. M. Camille, *Image on the Edge: the margins of medieval art* (London, 1992), 35–6.

111. Lasko, *op. cit.*, 260–3.

112. *Ibid.*, pls 365–7; P. C. Claussen, 'Nikolaus von Verdun. Über Antiken- und Naturstudium am Dreikönigenschrein', *Ornamenta Ecclesiae* (exh. cat., Cologne, 1985), II, 447–56. There is of course the possibility that Nicholas first employed his *Muldenfaltenstil* in three dimensions, but that the evidence is now lost.

113. O. Demus, *Byzantine Art and the West* (London, 1970), 182–5.

114. J. Adhémar, *Influences antiques dans l'art du moyen age français: recherches sur les sources et les thèmes d'inspiration* (London, 1939), pls XXXIV–XXXV.

115. M. Camille, *The Gothic Idol: Ideology and image-making in Medieval Art* (Cambridge, 1989), 73–87; see also W. Sauerländer, 'Architecture and the figurative arts: the North', in Benson and Constable, *op. cit.*, 671–710.

116. Camille, *op. cit.*, 79–87; see also M. Chibnall (ed.), *The Historia Pontificalis of John of Salisbury* (revised ed., Oxford, 1986), 79, and J. Osborne (trans.), *Master Gregorius: the Marvels of Rome* (Toronto, 1987). For the wider context see H. Bloch, 'The new fascination with Ancient Rome', in Benson and Constable, *op. cit.*, 615–36.

117. F. Deuchler, *Der Ingeborgpsalter* (Berlin, 1967).

118. P. C. Claussen, 'Antike und gotische Skulptur in Frankreich um 1200', *Wallraf-Richartz-Jahrbuch*, XXXV (1973), figs 15–16; see also Erlande-Brandenburg and Thibaudat, *op. cit.*, fig. 19 and cat. no. 42.

119. Sauerländer (1972), 450–7; A. Erlande-Brandenburg, 'Les remaniements du portail central à Notre-Dame de Paris', *Bulletin Monumental*, CXXIX (1971), 241–8; *idem.*, *Notre-Dame de Paris* (Paris, 1991), 105–45; Taralon, *op. cit.*, 341–432.

120. The best discussion of the stylistic position of the west portals at Notre-Dame remains W. Sauerländer, 'Die kunstgeschichtliche Stellung der Westportale von Notre-Dame in Paris. Ein Beitrag zur Genesis des hochgotischen Stiles in der französischen Skulptur', *Marburger Jahrbuch für Kunstwissenschaft*, XVII (1959), 1–56.

121. All the jamb figures, and the trumeau figure of Christ, are nineteenth-century restorations by Lassus and Viollet-le-Duc, as are much of the lintels.

122. The expression is Adolf Katzenellenbogen's, from the excellent summary in his *Allegories of the Virtues and Vices in Medieval Art* (London, 1939; reprinted Toronto, 1989), 75–84; see also Michael Camille's illuminating discussion of the depiction of the Virtues and Vices in the light of the Fourth Lateran Council (*op. cit.* (1989), 9–18).

123. H. R. Hahnloser, *Villard de Honnecourt. Kritische Gesamtausgabe des Bauhüttenbuches ms.fr 19093 der Pariser Nationalbibliothek* (2nd ed, Graz, 1972), pl. 6; A. Erlande-Brandenburg *et al*, *Carnet de Villard de Honnecourt* (Paris, 1986).

124. Erlande-Brandenburg, *op. cit.* (1971), 241–8; *idem.*, 'Nouvelles remarques sur le portail central de Notre-Dame de Paris', *Bulletin Monumental*, CXXXII (1974), 287–96; *idem.*, *op. cit.* (1991), 105–45.

125. Sauerländer, *op. cit.* (1959), figs 54–5, and Demus, *op. cit.* (1970), 179–80.

126. As is the case on the other portals of the west front of Notre-Dame, all the jamb figures and that of the trumeau are of the nineteenth century. Two heads survive: those of the angel to the (viewer's) right of the figure of St Denis on the left splay of the portal and of the prelate on the outside of the right embrasure, sometimes identified as Pope Leo III (see A. Erlande-Brandenburg, 'Une tête de prélat provenant du portail du Couronnement de la Vierge à Notre-Dame de Paris', *La Revue du Louvre et des Musées de France*, XI/3 (1986), 184–91; *idem*, *op. cit.* (1991), 130–1).

127. For a detailed description of the iconography of the portal see Sauerländer, *op. cit.* (1972), 454–6. The development of naturalistic foliate sculpture in the thirteenth century is traced by L. Behling, *Die Pflanzenwelt der mittelalterliche Kathedralen* (Cologne, 1964).

128. For illustrations of all the heads see Erlande-Brandenburg and Thibaudat, *op. cit.*, 47–66; for the polychromy, 121–3.

129. See above, note 48.

130. See Pressouyre, *op. cit.* (1969), figs 14–15, 17; *The Year 1200*, cat. no. 12; Sauerländer, *op. cit.* (1972), pl. 64 (bottom).

131. Sauerländer, *op. cit.* (1972), 441; see also 21–3 and Panofsky, *op. cit.* (1992), 53–63, for concise surveys of tomb sculpture at this period. The most

comprehensive study is now K. Bauch, *Das mittelalterliche Grabbild: figürliche Grabmäler des 11. bis 15. Jahrhunderts in Europa* (Berlin and New York, 1976).

132. See A. Erlande-Brandenburg, '"Cimetière des Rois" à Fontevrault', *Congrés Archéologique de France*, Anjou (1964), 482–92; *idem*, 'La sculpture funéraire vers les années 1200: les gisants de Fontevrault', in *The Year 1200: A Symposium, op. cit.*, 561–77; *idem.*, *Les Rois à Fontevrault. Mort, sépulture et sculpture (1189–1204)* (exh. cat., Fontevrault, n.d.); also T. S. R. Boase, 'Fontevrault and the Plantagenets', *Journal of the British Archaeological Association*, 3rd series, XXXIV (1971), 6–9, Sauerländer, *op. cit.* (1972), 448–9, pl. 142, and Bauch, *op. cit.*, 54–8.

133. H. Reinhardt, *La Cathédrale de Strasbourg* (Strasbourg, 1972), 17–18.

134. Although there is also a boss of St John the Baptist in the eponymous chapel on the north side of the apse, which is a product of the same workshop (*ibid.*, pl. 24).

135. The lintels are both of the nineteenth century, loosely based on Brunn's engraving, as are the figures of Solomon and the bust of Christ at the centre: the originals do not survive (see Reinhardt, *op. cit.*, 148). The original figures of *Synagoga* and *Ecclesia*, protected from the revolutionary destruction, are now kept in the Musée de l'Œuvre Notre-Dame. Both tympana appear to be almost untouched by restoration, as they were boarded up before the iconoclasm.

136. A fourth was said to be in a German private collection in 1971 (L. Grodecki and R. Recht, 'Le bras sud du transept de la cathédrale: architecture et sculpture', *Bulletin Monumental*, CXXIX (1971), 19: this article gives a well-balanced and objective account of the different views on the thirteenth-century sculpture at Strasbourg and includes the various data on the chronology). For the Brunn engraving see Sauerländer, *op. cit.* (1972), 442.

137. For Besançon and Dijon see Sauerländer, *op. cit.* (1972), pls 128–9 and 443–5; for Beaune, *idem.* (1966), figs 197–8; for a summary of the Burgundian connection see also Grodecki and Recht, *op. cit.*, 31–2. The figure of King Solomon on the Chartres north transept (Sauerländer, *op. cit.* (1972), pl. 92) has sometimes been proposed as the starting point for this Burgundian style, but the Strasbourg heads have far more pronounced expressions: it is of course certain that Chartres played a formative rôle in the make-up of much of the Strasbourg workshop.

138. The present consoles and canopies at Strasbourg are new, but copy the form of the originals shown in the 1617 engraving. For the comparable figures on the north porch at Chartres see Sauerländer, *op. cit.* (1972), pl. 98.

139. On the probable addition of the three figures see Grodecki and Recht, *op. cit.*, 21, and Reinhardt, *op. cit.*, 108–15; for the connection with the bestowal of judgement see Grodecki and Recht, *op. cit.*, 21–3.

140. The north transept had a slightly earlier Romanesque portal with the Adoration of the Magi in the tympanum (Reinhardt, *op. cit.*, 100).

141. The most detailed art-historical discussion of the portal is to be found in C. Lapaire, 'La sculpture', in J.-C. Biaudet *et al*, *La Cathédrale de Lausanne* (Bibliothèque de la Société d'Histoire de l'Art en Suisse, 3, Berne, 1975), 175–99.

142. Six of the jamb figures were taken down in 1927, replaced by copies and placed in the south transept of the cathedral until they were restored in 1974–5, after which they were moved to the Musée de l'Evêché (V. Furlan, R. Pancella, T. A. Hermanès, *Portail peint de la Cathédrale de Lausanne: analyses pour une restauration* (Lausanne, n.d. [1982]), 8, n. 1).

143. Verdier, *op. cit.*, 167–71.

144. For a drawing of the Besançon portal before its destruction see Sauerländer, *op. cit.* (1972), 445, ill. 66; see also *Catalogue sommaire de la statuaire médiévale du Musée des Beaux-Arts et d'Archéologie de Besançon* (Besançon, 1992), 10–13.

145. For an account of the reasons behind the civil unrest at Reims before 1233 see B. Abou-el-Haj, 'The urban setting for late medieval church building: Reims and its cathedral between 1210 and 1240', *Art History*, XI (1988), 17–41, who prefers the date of 1234 for the insurrection; her reading of the programme of the Calixtus portal as a response to the civil riots, and therefore dating to after 1237, disregards the stylistic evidence and seems to me speculative. The standard studies of the documentary evidence for the building at Reims at this period remain R. Branner, 'Historical aspects of the reconstruction of Reims Cathedral, 1210–1241', *Speculum*, XXXVI (1961), 23–37, and F. Salet, 'Le premier colloque international de la Société française d'Archéologie (Reims, 1er et 2 juin 1965). Chronologie de la cathédrale', *Bulletin Monumental*, CXXV (1967), 347–94.

146. P. Kurmann, *La façade de la cathédrale de Reims: architecture et sculpture des portails. Etude archéologique et stylistique* (Lausanne, 1987), 46–59.

147. The fullest description of the chevet angels is to be found in T. G. Frisch, 'The twelve choir statues of the Cathedral of Reims: their stylistic and chronological relation to the sculpture of the north transept and of the west façade', *Art Bulletin*, XLII (1960), 1–24: however, much of this article is devoted to a rather limited stylistic analysis and the connection with Amiens is overemphasised.

148. D. E. E. Kleiner, *Roman Sculpture* (New Haven and London, 1992),

177–9, figs 146–8, 162.

149. For Hadrianic caryatids see Kleiner, *op. cit.*, figs 214–15.

150. Hinkle has convincingly dismissed the idea that these two portals were originally intended for the west façade and were re-used on the north transept (W. M. Hinkle, *The Portal of the Saints of Reims Cathedral: a study in mediaeval iconography* (College Art Association of America Monograph XIII, New York, 1965); *idem.*, 'Kunze's theory of an earlier project for the west portals of the Cathedral of Reims', *Journal of the Society of Architectural Historians*, XXXIV (1975), 208–14).

151. On this point see Hinkle, *op. cit.* (1965), 6–7.

152. For a concise description of the scenes see Sauerländer, *op. cit.* (1972), 481–2; Hinkle, *op. cit.* (1965), gives a detailed description of the iconographic programme and its relation to the Coronation conflict between Reims, Saint-Denis and Sens.

153. E. Panofsky, *Renaissance and Renascences in Western Art* (reprint, New York, 1972), 62–3, figs 35–6.

154. W. Oakeshott, *Classical Inspiration in Medieval Art* (London, 1959), 107–9, pls 137–40; Demus, *op. cit.*, figs 206–7.

155. Kurmann, *op. cit.*, pls 214, 217, 225, 238, 240–1; Sauerländer, *op. cit.* (1972), pls 204, 206, 209.

156. *Ibid.*, pls 257–65, and *idem.*, 'Les statues royales du transept de Reims', *Revue de l'art*, XXVII (1975), 9–30. Many of the transept figures are now in the Musée du Tau next to the cathedral.

157. H. D. Molesworth and P. Cannon-Brookes, *European Sculpture from Romanesque to Rodin* (London, 1965), pl. 256.

158. Hahnloser, *op. cit.*, pl. 48.

159. Abou-el-Haj, *op. cit.*, 22.

CHAPTER 2

1. A concise summary of the complicated political situation in the Empire from the end of the twelfth to the middle of the thirteenth century is to be found in A. Haverkamp, *Medieval Germany 1056–1273* (2nd ed., Oxford, 1992), 225–67.

2. A. Wolff, *The Cathedral of Cologne* (Stuttgart, 1974), 107; see also T. Diederich, 'Köln im Hochmittelalter', in *Ornamenta Ecclesiae: Kunst und Künstler der Romanik* (exh. cat., Cologne, 1985), II, 5–17.

3. R. Budde, *Deutsche romanische Skulptur 1050–1250* (Munich, 1979), 61–2, pls 104–5; *Ornamenta Ecclesiae*, II, 355 (cat. no. E118); for the pricked ivories see most recently *Ornamenta Ecclesiae*, II, 428–39.

4. Budde, *op. cit.*, 68, pl. 124.

5. *Ibid.*, *op. cit.*, 64–5, pls 112–13; *Ornamenta Ecclesiae*, II, 375 (cat. no. F2).

6. O. Pächt, *Book Illumination in the Middle Ages* (London, 1986), 136–40.

7. *Ornamenta Ecclesiae*, II, 99.

8. See, for instance, those illustrated in A. Goldschmidt and K. Weitzmann, *Die byzantinischen Elfenbeinskulpturen des X–XIII Jahrhunderts*, II (Berlin, 1934, reprinted 1979), pls II, X, XXIII, XXVII, LIII; for the St. Pantaleon tympanum see Budde, *op. cit.*, 62–3, pls 106–7, and *Ornamenta Ecclesiae*, II, 304 (cat. no. E81).

9. F. Rademacher, *Die Gustorfer Chorschranken. Das Hauptwerk der romanischen Kölner Plastik* (Bonn, 1975), considers the choirscreen to date from 1130–40; Budde, *op. cit.*, 65–6, pls 114–15.

10. *The Royal Abbey of Saint-Denis in the time of Abbot Suger (1122–1151)* (exh. cat., New York, 1981), cat. no. 28.

11. W. Sauerländer, *Gothic Sculpture in France 1140–1270* (London, 1972), pl. 20.

12. Budde, *op. cit.*, 68–9, pl. 125.

13. See introduction, pp. 6–7.

14. Budde, *op. cit.*, pls 108, 122–3; for the Zülpich-Hoven Virgin see also *Ornamenta Ecclesiae*, II, 375–8, cat. no. F3.

15. For the cult statues at Essen and Paderborn see E. Steingräber, *Deutsche Plastik der Frühzeit* (Königstein im Taunus, 1961), pls 21 and 42.

16. The Mary formerly belonged to the collection of Alexander Schnütgen in Cologne: see *Monumenta Annonis: Köln und Siegburg, Weltbild und Kunst im hohen Mittelalter* (exh. cat., Cologne, 1975), 224–8; and F. Niehoff, 'Das Kölner Ostergrab: Studien zum Heiligen Grab im hohen Mittelalter', *Wallraf-Richartz-Jahrbuch*, LI (1990), 7–68. A further connection with French sculpture of the period is supplied by a fine female head (probably from a figure of the Virgin) in Lille: see D. J. Ponert in *Pantheon*, XXVIII (1975), 335 (review of *Monumenta Annonis* exhibition), and *Sculptures romanes et gothiques du Nord de la France* (exh. cat., Lille, 1978), 107–8, cat. no. 36.

17. B. Kaelble, *Untersuchungen zur grossfiguren Plastik des Samsonmeisters* (Beiträge zu den Bau- und Kunstdenkmälern im Rheinland, Band 27, Düsseldorf, 1981), 54–60.

18. As for instance in *Die Zeit der Staufer: Geschichte – Kunst – Kultur* (exh. cat., Stuttgart, 1977), I, cat. no. 472 (W. Sauerländer); Kaelble, *op. cit.*, 11–19 and *passim*, discusses previous writings on the subject.

19. The juxtaposition between one of the Mantes heads and that of Samson was made in K. Niehr's review of Kaelble (*op. cit.*) in *Zeitschrift für Kunstgeschichte*, XLVI (1983), 118–21, without the date of the latter being questioned.

20. Unfortunately the latter have been ruined by restoration, but old photographs allow a style-critical judgement (Kaelble, *op. cit.*, 70–80, 145–50, figs 46–55 and 66–9). I prefer an earlier dating for the Samson than Kaelble and would slightly revise her chronology.

21. *Ibid.*, figs 1–8, 10–21.

22. *Ibid.*, figs 58–65.

23. *Ibid.*, 151–63, figs 70–1.

24. *Rhin-Meuse: Art et Civilisation 800–1400* (exh. cat., Cologne and Brussels, 1972), 284, cat. no. J7.

25. There are also two stylistically unrelated column figures of Samson in St.-Gertrudis at Nivelles, which Timmers has connected with North Italian prototypes (J. J. M. Timmers, *De kunst van het Maasland* (Assen, 1971), 291–2, figs 416–17).

26. N. Müller-Dietrich, *Die romanische Skulptur in Lothringen* (Munich and Berlin, 1968), 103–10, wrongly identified the figure as *Ecclesia*; *Radiance and Reflection: Medieval Art from the Raymond Pitcairn Collection* (exh. cat., New York, 1982), 82–3, cat. no. 23.

27. Müller-Dietrich, *op. cit.*, 52–78. His dating of the reliefs to before 1147, the consecration of the Romanesque cathedral, is not acceptable on stylistic grounds; equally, his reconstruction of their original position as on the buttresses of the earlier building does not take into account the incomplete state of the group.

28. These sculptures include a Virgin and Child at Mont-Devant-Sassey and an odd male and female pilgrim group in Belval (*ibid.*, figs 53 and 65).

29. *Ibid.*, 151–3, fig. 99; see also *Cathédrales* (exh. cat., Paris, 1962), cat. nos 51–2.

30. M. Devigne, *La sculpture mosane du XIIe au XVIe siècle* (Paris and Brussels, 1932), 47–8; *De monumenten van Geschiedenis en Kunst in de provincis Limburg. I. De monumenten in de Gemeente Maastricht* (The Hague, 1926–38), 339–47; E. de Jong *et al*, 'Ein studie over het Bergportaal van de sint Servaaskerk te Maastricht', *Publications de la Société historique et archéologique dans le Limbourg*, CXIII (1977), 35–192; J. J. M. Timmers, *De kunst van het Maasland*, II (Assen, 1980), 93–8.

31. Timmers, *op. cit.*, 4; R. Didier, 'Sculpture, miniature et vitrail au 13e siècle', *Rhin-Meuse*, *op. cit.*, 325.

32. P. Verdier has discussed the Maastricht portal in relation to the earlier Coronation of the Virgin portals (*Le Couronnement de la Vierge. Les origines et les premiers développements d'un thème iconographique* (Montreal, 1980), 130–2.

33. Devigne, *op. cit.*, fig. 69; E. Hayot, 'La collégiale Notre-Dame à Dinant', *Bulletin de la Commission royale des Monuments et des sites*, II, 1950, 7–75; Timmers, *op. cit.* (1980), 93, fig. 134; Verdier, *op. cit.*, 99, n. 88; R. Didier, 'La Sedes, la Vierge et le saint Jean au Calvaire de l'église Saint-Jean à Liège et la sculpture mosane de la première moitié du XIIIe siècle', in J. Deckers (ed.), *La collégiale Saint-Jean de Liège: mille ans d'art et d'histoire* (Liège, 1981), 70, figs 25–8.

34. For the Liège Virgin and Child and Mosan wood sculptures generally see *Rhin-Meuse*, *op. cit.*, 327 (cat. no. L1); R. Didier, 'La Sculpture mosane du XIe au milieu du XIII siècle', *Rhein und Maas: Kunst und Kultur 800–1400, 2* (Cologne, 1973), 407–20; *idem, op. cit.* (1981), 57–76; *idem*, 'La Vierge assise à l'enfant (Sedes Sapientiae)', *Millénaire de la collégiale Saint-Jean de Liège. Exposition d'Art et d'Histoire* (exh. cat., Brussels, 1982), 123–40.

35. For the New York Virgin and Child see *The Year 1200* (exh. cat., New York, 1972), cat. no. 35; for the Cologne example, *Rhin-Meuse*, *op. cit.*, cat. no. L13, and U. Bergmann (ed.), *Die Holzskulpturen des Mittelalters (1000–1400)* (Schnütgen-Museum, Cologne, 1989), cat. no. 15.

36. Budde, *op. cit.*, 79, pls 160–2.

37. This is now in the Badisches Landesmuseum in Karlsruhe: *ibid.*, 50–1, pls 76–7.

38. R. Oursel, *Bourgogne romane* (La Pierre-qui-vire, 1979), pls 119 and 123.

39. N. Müller-Dietrich, 'Das Tympanon im Wormser Dom und seine Beziehung zur Buchmalerei', *Beiträge zur Kunst des Mittelalters: Festschrift für Hans Wentzel* (Berlin, 1975), 147.

40. Additional evidence at Worms for the migration of the Petershausen sculptor is supplied by the console heads inside the north-east tower, executed before the south portal in the 1180s (*ibid.*, fig. 3).

41. *Ibid.*, 153–6.

42. It has been suggested that the figure of Christ has not been finished in the area of the draperies (Budde, *op. cit.*, 92); however, it is possible that the surface was left in the roughed-out state in order to take paint and it should be noted that the halo and book in Christ's left hand are complete. For the most detailed discussion of the portal see M. Klewitz, 'Das Leichhofportal des Mainzer Domes', *Mainz und der Mittelrhein in der europäischen Kunstgeschichte: Studien für W. F. Volbach* (Mainz, 1966), 197–218.

43. Budde, *op. cit.*, 91, pls 216–18.

44. K.-A. Wirth, 'Das Westportal der Aschaffenburger Stiftskirche', *Aschaf-fenburger Jahrbuch*, IV (1957), 405–37.

45. P. Lasko, *Ars Sacra 800–1200* (Pelican History of Art, 2nd ed. New Haven and London, 1994), 115–21, pls 158–61, 164–7; see also *Bernward von Hildesheim und das Zeitalter der Ottonen* (exh. cat., Hildesheim, 1993), II, 503–12 (cat. no. VII.33), 540–8 (cat. no. VIII.17).

46. *Die Zeit der Staufer*, I, cat. no. 464; C. Schulz-Mons, *Die Chorschrankenreliefs der Michaeliskirche zu Hildesheim und ihre Beziehungen zur bambergisch-magdeburgischen Bauhütte. Untersuchung zur Ausbreitung und Entwicklung der sächsischen Frühgotik zu Beginn des 13. Jahrhunderts* (Hildesheim, 1979); Budde, *op. cit.*, 96–8, pls 242–4; K. Niehr, *Die mitteldeutsche Skulptur der ersten Hälfte des 13. Jahrhunderts* (Weinheim, 1992), 55–77, cat. no. 68, figs 122–6.

47. Niehr, *op. cit.*, 271.

48. E. Panofsky, *Die deutsche Plastik des 11. bis 13. Jahrhunderts* (Munich, 1924), 87–9, pls 19a–b; Budde, *op. cit.*, 36–8, pls 44–51; for a survey of German stucco work see W. Grzimek, *Deutsche Stuckplastik 800 bis 1300* (Berlin, 1975).

49. The appearance when new must have been similar to the front of the enamelled shrine of Santo Domingo from Silos, of about 1165–70 (Lasko, *op. cit.*, pls 335–7; M.-M. Gauthier, *Emaux du moyen âge occidental* (Fribourg, 1972), pl. 41). It is also worth comparing the modelled wax and brickdust reliefs from inside the St. Servatius shrine in Maastricht, of the end of the twelfth century, with the Hildesheim plasters of the same date (*Ornamenta Ecclesiae*, I, 321, cat. no. B96).

50. Niehr, *op. cit.*, 241–5, cat. no. 55; for the construction and polychromy see K. Riemann, 'Untersuchungen zur Technik und Farbigkeit mittelalterlicher Malerei und Stuckplastik', *Denkmale in Sachsen-Anhalt*, Weimar, 1983, 353–80 (367–77).

51. H. Beenken, 'Schreine und Schranken', *Jahrbuch für Kunstwissenschaft*, III (1926), 65–107; for the shrines of St Heribert and the Three Kings see *Ornamenta Ecclesiae*, II, 216–27, 314–23. The connection with the decoration of shrines and contemporary manuscript illumination is lucidly presented by W. Sauerländer, 'Spätstaufische Skulpturen in Sachsen und Thüringen. Überlegungen zum Stand der Forschung', *Zeitschrift für Kunstgeschichte*, XLI (1978), 181–216 (189–98).

52. It does not appear that glass paste gems were ever inserted; for the polychromy see A. Krohner, 'Die stuckierten Chorschranken in der Klosterkirche zu Hamersleben', *Beiträge zur Erhaltung von Bildwerken*, I (1982), 14–19. See also Niehr, *op. cit.*, 128–31, 249–52 (cat. nos 58–9), figs 88–91.

53. O. Demus, *Byzantine Art and the West* (London, 1970), 36–9, 198–204; K. Weitzmann, *Studies in Classical and Byzantine Manuscript Illumination* (Chicago, 1971), 218–21, 316–20; J. Sommer, *Das Deckenbild der Michaeliskirche zu Hildesheim* (Hildesheim, 1966); O. Demus, *Romanesque Mural Painting* (London, 1970), 614–17.

54. I disagree here with Niehr (*loc. cit.*), who prefers to date the Hamersleben screen to 1240–50.

55. Demus, *Byzantine Art and the West*, figs 224–7; Niehr, *op. cit.*, 129–31, 224–6 (cat. no. 46), proposes a later date of 1240–50.

56. This was taken out and replaced by a copy in 1984; the original is now back-to-back with the copy and faces into the church (Niehr, *op. cit.*, 266–9, cat. no. 66). See also Budde, *op. cit.*, 98–9, pl. 246.

57. Niehr, *op. cit.*, 267–8. There is a rather cruder tympanum in Goslar which is based on the St. Godehard composition but which substitutes Saints Peter and Paul for the bishop saints; Grzimek describes this as stucco (*op. cit.*, pl. 98), but it is referred to as sandstone by Niehr [218].

58. A. Goldschmidt, 'Die Stilentwicklung der romanischen Skulptur in Sachsen', *Jahrbuch der Preussischen Kunstsammlungen*, XXI (1900), 229; Goldschmidt and Weitzmann, *op. cit.*, nos 146–9 and 151, pls LII–LIII; Niehr, *op. cit.*, 100–2, figs 118–19.

59. For the Brunswick candlestick see A. Legner, *Deutsche Kunst der Romanik* (Munich, 1982), pls 306–7. The word bronze will be used throughout, although many of the objects are in fact brass: because the copper content varied and the mix of alloys was not precisely measured it is not always possible to be absolutely accurate on this point, so a consistency of nomenclature has been adopted.

60. For a transcription of all the texts and a list of the older literature see Niehr, *op. cit.*, 257–63; a useful monographic treatment will be found in K. Algermissen, *Das romanische Taufbecken des Hildesheimer Doms* (Hildesheim, 1958).

61. For good illustrations of the Osnabrück font see *Ornamenta Ecclesiae*, I, 479–80 (cat. no. C54), where the inscription is incorrectly transcribed.

62. C. Dolfen, 'Das Taufbecken des Domes zu Osnabrück', *Osnabrücker Mitteilungen*, LXXII (1964), 25–37; Niehr, *op. cit.*, 328–9 (cat. no. 107).

63. *Kirchenkunst des Mittelalters: Erhalten und erforschen* (exh. cat., Hildesheim, 1989), 183–204, cat. no. 11; O. von Falke and E. Meyer, *Romanische Leuchter und Gefässe, Giessgefässe der Gotik (Bronzegeräte des Mittelalters, I)* (Berlin, 1935; reprinted 1983), 68–73; W. Wixom, 'A Lion Aquamanile', *Bulletin of the Cleveland Museum of Art*, LXI (1974), 261–70.

64. Now replaced by a copy: the original is in the Burg Dankwarderode of the

Herzog Anton Ulrich-Museum, adjacent to the monument: G. Spies (ed.), *Der Braunschweiger Löwe* (Brunswick, 1985); P. Seiler, 'Der Braunschweiger Löwe – "Epochale Innovation" oder "Einzigartiges Kunstwerk"?' in H. Beck and K. Hengevoss-Dürkop (eds), *Studien zur Geschichte der europäischen Skulptur im 12/13. Jahrhundert* (Frankfurt am Main, 1994), I, 533-64.

65. Von Falke and Meyer, *op. cit.*, figs 407-8.

66. For good illustrations of the Magdeburg and Merseburg effigies see Budde, *op. cit.*, pls 28 and 254-5; the identification of the later effigy at Magdeburg is discussed by Niehr, *op. cit.*, 290-2, cat. no. 81.

67. C. Klack-Eitzen, *Die thronenden Madonnen des 13. Jahrhunderts in Westfalen (Denkmalpflege und Forschung in Westfalen, 6)* (Bonn, 1985), pl. 14, for examples in Minden and Berlin (destroyed). For the Halberstadt Virgin and Child see Niehr, *op. cit.*, 245-7, cat. no. 56, fig. 72.

68. R. Haussherr, 'Triumphkreuzgruppen der Stauferzeit', *Die Zeit der Staufer*, V, 131-68; idem, 'Die Triumphkreuzgruppe der Stiftskirche zu Bücken', *Niederdeutsche Beiträge zur Kunstgeschichte*, XXVI (1987), 23-50.

69. The cross and beam were moved in the fifteenth century, when the latter was shortened: there are now only ten apostles and eleven prophets; see Budde, *op. cit.*, 108-9, pls 273-9, Niehr, *op. cit.*, 233-40, cat. no. 53, figs 65-70. For an investigation into the original appearance of the cross and a reconstruction of its polychrome decoration see K. Riemann, 'Die Triumphkreuzgruppe im Dom zu Halberstadt. Beobachtungen bei der Instandsetzung', *Kunst des Mittelalters in Sachsen: Festschrift Wolf Schubert* (Weimar, 1967), 236-46.

70. For the development of the triumphal cross and connections between England and Saxony in the twelfth and thirteenth centuries see P. H. Brieger, 'England's contribution to the origin and development of the Triumphal Cross', *Mediaeval Studies*, IV (1942), 85-96; R. Haussherr, 'Triumphkreuz', *Lexikon der christlichen Ikonographie*, IV (Freiburg im Breisgau, 1972), cols 356-9; idem. (1979), 144-58.

71. For the Freiberg triumphal cross and *Lettner* see Niehr, *op. cit.*, 203-8, cat. nos 32-3, figs 41-5; Sauerländer has commented on French links with the Halberstadt cross (*op. cit.* (1978), 198-204).

72. A. Goldschmidt, 'Französische Einflüsse in der frühgotischen Skulptur Sachsens', *Jahrbuch der Preussischen Kunstsammlungen*, XX (1899), 285-300; for the fullest and most up-to-date discussion on the state of research, with illustrations of the various reconstructions of the portal see Niehr, *op. cit.*, 110-18, 296-302, cat. no. 83. See also the papers by E. Schubert, M. Gosebruch, B. Nicolai, F. Möbius and H. Sciurie in E. Ullmann (ed.), *Der Magdeburger Dom: ottonische Gründung und staufischer Neubau* (Leipzig, 1989); Nicolai's dismissal of the portal theory [152-3] does not provide a satisfactory alternative location and disregards the iconographic homogeneity of most of the sculptures.

73. For the differences in style between the statues see most conveniently the photographs in Budde, *op. cit.*, pls 258-9, and D. Schubert, *Von Halberstadt nach Meissen. Bildwerke des 13. Jahrhunderts in Thüringen, Sachsen und Anhalt* (Cologne, 1974), pls 34-6. There is no firm date for the placing of the figures in their present positions in the choir.

74. No evidence of a tympanum survives at Magdeburg, and the reconstructions of Fliedner and Burger (reproduced in Niehr, *op. cit.*, 298) prefer to place a single standing figure in this area; Goldschmidt left the space blank. For a discussion of French influence at Magdeburg see K. Niehr, 'Das Magdeburger "Goldschmidt-Portal" – Geschichte Pariser Skulptur im Spiegel der Provinz', in Beck and Hengevoss-Dürkop, *op. cit.*, I, 311-20.

75. The erroneous depiction of the Virtues at Magdeburg was pointed out by A. Katzenellenbogen (*Allegories of the Virtues and Vices in Medieval Art* (London, 1939), 83-4).

76. Niehr, *op. cit.* (1992), 108-10, figs 149-55; M. Gosebruch, 'Die Anfänge der Frühgotik in Niedersachsen', *Niederdeutsche Beiträge zur Kunstgeschichte*, XIV (1975), 9-58; idem, 'Das oberrheinisch-bambergische Element im Magdeburger Dom', in Ullman, *op. cit.*, 132-40.

77. For the fullest discussion of the early history of the Golden portal, its iconography and its original polychromy, see E. Hütter and H. Magirius, 'Studien zur Goldenen Pforte am Dom in Freiberg', in *Festschrift Wolf Schubert (op. cit.)*, 179-235. See also A. Goldschmidt, *Die Skulpturen von Freiberg und Wechselburg* (Berlin, 1924) and Niehr, *op. cit.* (1992), 197-203, cat. no. 31.

78. Sauerländer, *op. cit.* (1978), 206-14.

79. An extremely full account of these investigations and the resulting reconstruction is contained in the fundamental study of E. Hütter and H. Magirius, *Der Wechselburger Lettner: Forschungen und Denkmalpflege* (Weimar, 1983, reprinted Weinheim, 1984), which supersedes all previous writing on the subject.

80. K.-A. Wirth, *Die Entstehung des Drei-Nagel-Crucifixus, seine typengeschichtliche Entwicklung bis zur Mitte des 13. Jahrhunderts* (Dissertation typescript, Frankfurt am Main, 1953); G. Cames, 'Recherches sur les origines du crucifix à trois clous', *Cahiers Archéologiques*, XVI (1966), 185-202; M. Anczykowski, *Westfälische Kreuze des 13. Jahrhunderts* (Münster, 1992), 98-103.

81. For comparisons with sculpture at Chartres see Sauerländer, *op. cit.* (1978), 204-6.

82. This is unfortunately not securely dated, so it possibly follows the form of

Mathilda's effigy (see Niehr, *op. cit.* (1992), fig. 199); the connection with Fontevrault is presented in E. Panofsky, *Tomb Sculpture* (London, 1964), 57, but his arguments are weakened by the false assumption that the effigies of Henry and Eleanor at Fontevrault formed part of a double tomb. The fullest treatment of the Brunswick tomb is to be found in F. N. Steigerwald, *Das Grabmal Heinrichs des Löwen und Mathildes im Dom zu Braunschweig* (Brunswick, 1972); but see the critical reviews by J. Gardner in *Burlington Magazine*, CXVII (1975), 175, and G. Sommers Wright in *Art Bulletin*, LVII (1975), 128-9).

83. Niehr, *op. cit.* (1992), 353-5, cat. no. 130, fig. 223. For another, slightly later, double tomb of a similar type in Franconia see R. Kahsnitz, 'Das Grabmal des Otto von Botenlauben und der Beatrix von Courtenay in Frauenroth', in *Otto von Botenlauben: Minnesänger, Kreuzfahrer, Klostergründer (Bad Kissinger Archiv-Schriften, I)* (Würzburg, 1994), 153-202.

84. Niehr, *op. cit.* (1992), 330-3, cat. no. 109, fig. 197.

85. Klack-Eitzen, *op. cit.*, passim; Anczykowski, *op. cit.*, passim (good quality crucifixes at Cappenberg, Corvey and Osnabrück).

86. Budde, *op. cit.*, 88-9, pls 206-7.

87. Christ was probably originally surrounded by the symbols of the Evangelists. The trumeau figure is a product of the Brabender workshop, of about 1540, presumably replacing the thirteenth-century version (P. Pieper, *Heinrich Brabender. Ein Bildhauer der Spätgotik in Münster* (Münster, 1984), 399-407).

88. Panofsky, *op. cit.* (1924), 125-6; W. Sauerländer, 'Die kunstgeschichtliche Stellung der Figurenportale des 13. Jahrhunderts in Westfalen. Zum Stand der Forschung', *Westfalen*, XLIX (1971), 1-34. The original location of a small tympanum showing the Maries at the Sepulchre, dated by Budde (*op. cit.*, 87-8) to around 1235 and now sited above the door of the sacristy, is not known; it was possibly made for the earlier cathedral and seems to pre-date the laying of the foundation stone. For full photographic coverage of the porch see P. Pieper and I. Müller, *Das Paradies des Domes zu Münster in Westfalen* (Münster, 1993), and J. Poeschke, C. Syndikus and T. Weigel, *Mittelalterliche Kirchen in Münster* (Munich, 1993), 15-71.

89. On the question of the identity of this figure see H. Grundmann, 'Der hl. Theodor oder Gottfried von Cappenberg in Domparadies zu Münster', *Westfalen*, XXXVII (1959), 160-73. H. Appuhn has drawn attention to the flat surface with iron dowel above the figure's right hand and has imaginatively suggested that it held the golden head reliquary of St Paul – now in the Domschatz at Münster – on special occasions ('Beobachtungen und Versuche zum Bildnis Kaiser Friedrichs I. Barbarossa in Cappenberg', *Aachener Kunstblätter*, XLIV (1973), 159-63). St Mary Magdalene was especially venerated by Dietrich von Isenburg, who chose her feast day (22 July) on which to be consecrated bishop in 1218, laid the foundation stone for the cathedral on the same day in 1225, and even managed to die on the 22 July in 1226 (T. Rensing, 'Die Ermordung Engelberts des Heiligen und die Ehrenrettung für Dietrich von Isenburg', *Westfalen*, XXXV (1955), 139).

90. Sauerländer, *op. cit.* (1971), 19-34.

91. For the evangelist figures, *ibid.*, 51-9, and Poeschke *et al*, *op. cit.*, pls 60-3.

92. Anczykowski, *op. cit.*, 103-6.

93. The bishop has been identified as the local bishop Meinwerk or as St Julianus, whose relics were translated to Paderborn in 1243: problems arise from both theories (Sauerländer, *op. cit.* (1971), 36-7); likewise, it is unclear who is represented by the female figure, both Kunigunde and St Catherine having been suggested.

94. The chronological sequence is the most serious, as some of the French monuments put forward by B. Thomas ('Die westfälischen Figurenportale in Münster, Paderborn und Minden', *Westfalen*, XIX (1934), 1-95) actually post-date their supposed derivatives: see Sauerländer, *op. cit.* (1971), 6-8.

95. On the North Sea coast, the life-size figures from the north and south gables of the Ludgerikirche in Norden (East Friesia) are worthy of note. Although probably dating to around 1230-40 they show a similar type of reaction to French prototypes as the St Mary's Abbey and Minster figures in York (G. André, 'Die frühgotischen Skulpturen in Norden/Ostfriesland', *Niederdeutsche Beiträge zur Kunstgeschichte*, VII (1968), 95-152).

96. The most complete account of the building history is D. von Winterfeld, *Der Dom in Bamberg* (2 vols, Berlin, 1979); A. von Reitzenstein, 'Die Baugeschichte des Bamberger Domes', *Münchner Jahrbuch der bildenden Kunst*, N.F.XI (1934), 113-52, remains the most useful digest of archival material; see also idem, *Die Geschichte des Bamberger Domes von den Anfängen bis zu seiner Vollendung im 13. Jahrhundert* (Munich, 1984).

97. It has been suggested that the kneeling figure is Count Otto, Ekbert's brother (R. Suckale, 'Die Bamberger Domskulpturen. Technik, Blockbehandlung, Ansichtigkeit und die Einbeziehung des Betrachters', *Münchner Jahrbuch der bildenden Kunst*, 3rd series, XXXVIII (1987), 49).

98. See W. Pinder, *Der Bamberger Dom und seine Bildwerke* (Berlin, 1927), 42, fig. 17.

99. E. Verheyen, 'The choir reliefs of Bamberg Cathedral', *Gesta*, IV (1965), 12-13; see also R. Haussherr, 'Die Schrankenreliefs des Georgenchores –

Bemerkungen zum Stand der Forschung', *Kunstchronik*, XXVIII (1975), 431–2. The relationship of two further reliefs, showing the Annunciation and the Archangel Michael triumphing over the dragon, to the choirscreen reliefs is not clear: Verheyen's reconstruction, with the Annunciation in the midst of the prophets and the Archangel in the middle of the apostles, has not been widely accepted. All the reliefs are illustrated individually in Pinder, *op. cit.*, pls 52–65.

100. For Vézelay see M. F. Hearn, *Romanesque Sculpture: the revival of monumental stone sculpture in the eleventh and twelfth centuries* (Oxford, 1981), pl. 126.

101. For the question of stylistic division of the choirscreen reliefs see Suckale, *op. cit.*, 36–43; on the identification of certain prophets see *Die Zeit der Staufer*, I, cat. no. 440, 313–15 (W. Sauerländer).

102. M. Baxandall, *The Limewood Sculptors of Renaissance Germany* (New Haven and London, 1980), 135–42, esp. 142 and figs 82–3.

103. See the photographs in Budde, *op. cit.*, pls 228–9, and the comments of Suckale [*op. cit.*, 37–8]. On the work of the restorer Rupprecht in 1826–30 see E. Verheyen, *Die Chorschrankenreliefs des Bamberger Domes* (Würzburg, 1961), 119–25.

104. As for instance on the twelfth-century Nazareth capitals, works of a French sculptor in the Holy Land (J. Folda, *The Nazareth capitals and the Crusader Shrine of the Annunciation* (University Park and London, 1986), 6–7).

105. D. von Winterfeld, 'Zur Baugeschichte des Bamberger Fürstenportales', *Zeitschrift für Kunstgeschichte*, XXXIX (1976), 147–66, argues for a completion date of 1224–5, but see Suckale, *op. cit.*, 78, n. 93; see also E. Verheyen, 'Das Fürstenportal des Bamberger Domes. Zum Problem des Bamberger Meisters', *Zeitschrift des deutschen Vereins für Kunstwissenschaft*, XVI (1962), 1–40, and most recently, M. Schuller, *Das Fürstenportal des Bamberger Domes* (Bamberg, 1993).

106. This scheme was seen earlier in the wall paintings on the triumphal arch in S. Sebastiano al Palatino in Rome, of the late tenth century, and (in a reduced form with the four principal prophets supporting the evangelists) in the stained glass lancets of the south transept at Chartres (1217–25), which just precede the Bamberg sculptures (E. Mâle, *The Early Churches of Rome* (London, 1960), 109–10). In a German context twelve prophets support the apostles on their shoulders in a manner closer to that at Bamberg on the twelfth-century stone font at Merseburg (Budde, *op. cit.*, pl. 87).

107. It has been suggested that the iconography may reflect the power struggle between Emperor and Pope in the 1220s and indicate political interference in its creation: a king alone is shown on the side of the Blessed, whereas both the ecclesiastical figures in the tympanum are on the side of the Damned (Suckale, *op. cit.*, 52).

108. The angel, Abraham, *Ecclesia* and *Synagoga* are now displayed in the Bischöfliches Diözesanmuseum alongside the cathedral.

109. For the figures at Reims see P. Kurmann, *La façade de la cathédrale de Reims: architecture et sculpture des portails* (Lausanne, 1987), pls 249–50. The Reims-Bamberg connection is investigated in depth in W. Sauerländer, 'Reims und Bamberg. Zu Art und Umfang der Übernahmen', *Zeitschrift für Kunstgeschichte*, XXXIX (1976), 167–92, but see also the summary of the discussion held at the Bamberg symposium in 1975 in *Kunstchronik*, XXVIII (1975), 435–7, and H.-C. Feldmann, *Bamberg und Reims. Die Skulpturen 1220–1250* (Ammersbek bei Hamburg, 1992).

110. The figures were removed to the Diözesanmuseum in 1939.

111. T. Rensing, 'Die Adamspforte des Bamberger Domes', *Landschaft und Geschichte: Festschrift für Franz Petri zu seinem 65. Geburtstag* (Bonn, 1970), 421–33; O. von Simson, 'Gedanken zur Adamspforte des Bamberger Domes', *Festschrift für Ingeborg Schröbler zum 65. Geburtstag* (Tübingen, 1973), 424–39. At the Bamberg conference in 1975 Tilmann Breuer proposed that the portal originally held only the figures of Adam and Eve and that the other four figures were arranged around a ciborium over the tomb of Pope Clement II inside the cathedral (*Kunstchronik*, XXVIII (1975), 438–48): this theory has not had widespread support.

112. Sauerländer, *op. cit.* (1976), 173, fig. 9.

113. *Ibid.*, figs 4, 6, 9–11; the same method of holding the fold of drapery in the right hand is employed by one of the prophets on the right hand side of the *Fürstenportal* (*ibid.*, fig. 45).

114. The archival sources are unfortunately silent on this point, and it is not known when the figures were placed in their present positions (for the sources see R. Kroos, 'Liturgische Quellen zum Bamberger Dom', *Zeitschrift für Kunstgeschichte*, XXXIX (1976), 105–46; see also the comments of Suckale, *op. cit.*, 62–5).

115. J. Traeger, 'Der Bamberger Reiter in neuer Sicht', *Zeitschrift für Kunstgeschichte*, XXXIII (1970), 1–20.

116. Kroos, *op. cit.*, 142–6. A discussion of the Bamberg Rider and a listing of the literature up to 1977 is to be found in *Die Zeit der Staufer*, I, cat. no. 441, 315–17 (W. Sauerländer).

117. The uncarved blocks must have been mortared together in the workshop and sculpted as a whole: see J. Morper, 'Zur Technik des Reiterstandbildes im Dom zu Bamberg', *Belvedere*, VI (1924), 15–21; *Die Zeit der Staufer*, I, 315; Suckale, *op. cit.*, 27–36.

118. The reconstruction by Hamann has much to recommend it, and seems to me preferable to the Italianate scheme proposed by Breuer, which also entails the unlikely incorporation of elements from the *Adamspforte* (R. Hamann, 'Das Grab Clemens II im Bamberger Dom', *Zeitschrift des deutschen Vereins für Kunstwissenschaft*, I (1934), 16–36 (20, fig. 6); *Kunstchronik*, XXVIII (1975), 438–48, esp. figs on 446–7). The fullest discussion of the tomb remains A. von Reitzenstein, 'Das Clemensgrab im Dom zu Bamberg', *Münchner Jahrbuch der bildenden Kunst*, N.F.VI (1929), 216–75, but see also *idem*, in S. Müller-Christensen, *Das Grab des Papstes Clemens II im Dom zu Bamberg* (Munich, 1960), 9–31.

119. For a comparison with the figure of a pope from the south west portal at Reims see Sauerländer, *op. cit.* (1975), 187, figs 35–6.

120. Panofsky, *op. cit.* (1964), 62–3.

121. The figures and niche on the south side of the east wall are of the nineteenth century, made to replace the niche destroyed in the sixteenth century (A. Hubel, 'Der Skulpturenzyklus in der Kapelle der Burg Trausnitz zu Landshut', in H. Glaser (ed.), *Wittelsbach und Bayern, I/1, Die Zeit der frühen Herzöge: von Otto I. zu Ludwig dem Bayern* (exh. cat., Munich, 1980), 437–44; see also H. Brunner, *Die Trausnitz-Kapelle ob Landshut* (Munich, 1968)). For the fragments see *Wittelsbach und Bayern, I/2*, cat. nos 88–9.

122. For the Wessobrunn and Reichenbach figures see P. M. Halm and G. Lill, *Die Bildwerke des Bayerisches Nationalmuseums. I. Abteilung. Die Bildwerke in Holz und Stein vom XII. Jahrhundert bis 1450* (Munich, 1924), cat. nos 19–39, 64; also *Suevia Sacra. Frühe Kunst in Schwaben* (exh. cat., Augsburg, 1973), cat. nos 55–6 (Wessobrunn).

123. For a succinct treatment of population growth at the edges of the Empire in the period of the Hohenstaufen see Haverkamp, *op. cit.*, 298–316.

124. *Lexikon der christlichen Ikonographie*, VI (Freiburg im Breisgau, 1974), cols 473–8.

125. The unusual presence of so much sculpture in a Cistercian abbey, contrary to St Bernard's writings, may be explained by the fact that the nunnery was only incorporated into the Order after its foundation and that it also served as the Duke's mausoleum (Z. Świechowski, *Romanesque Art in Poland* (Warsaw, 1983), 65–6, 258–9).

126. D. Frey, 'Das romanische Tympanon des Westportales an der Klosterkirche in Trebnitz', in A. Zinkler, D. Frey and G. Grundmann, *Die Klosterkirche in Trebnitz* (Breslau, 1940), 115–46.

127. The connections between the sculptures of Trzebnica and Bamberg proposed by Z. Świechowski are not confirmed by stylistic analysis ('Die Skulpturen der Klosterkirche in Trebnitz und ihre Beziehung zu Bamberg', in H. Krohm and C. Theuerkauff (eds), *Festschrift für Peter Bloch* (Mainz, 1990), 77–89).

128. Compare the illustrations of the apostles in Świechowski, *op. cit.* (1990), figs 5–6, with those of the Magdeburg capitals in Niehr, *op. cit.* (1992), figs 149–55.

129. Świechowski, *op. cit.* (1983), *passim*.

130. For the development of portal design in this area see V. Mencl, 'Vývoj středověkého portálu v českých zemích', *Zprávy památkové péce*, XX (1960), 8–26. The most accessible account of sculpture in Bohemia before the middle of the thirteenth century is J. Mašín, 'Plastik', in E. Bachmann (ed.), *Romanik in Böhmen* (Munich, 1977), 171–233.

131. Mašín, *op. cit.*, 188–90, figs 140–4; *Ornamenta Ecclesiae*, I, 156, cat. no. B8.

132. Mašín, *op. cit.*, 192, figs 155–6; A. Kutal, 'Gotické socharství', in R. Chadraba, V. Denkstein, J. Krása (eds), *Dějiny českého výtvarného umění, I/1* (Prague, 1984), 217–18, fig. 159.

133. For Aschaffenburg see Budde, *op. cit.*, pl. 170; for the Salzburg portals and the late Romanesque sculpture of Austria generally see H. Karlinger, *Die romanische Steinplastik in Altbayern und Salzburg 1050–1260* (Augsburg, 1924), pls 98–103, and P. von Baldass, W. Buchowiecki, W. Mrazek, *Romanische Kunst in Österreich* (3rd ed., Vienna, 1974), 64–8, pl. II, fig. 22.

134. For the influence of Italy and Byzantium on Salzburg manuscripts and wall paintings in the twelfth century see C. R. Dodwell, *The Pictorial Arts of the West 800–1200* (Pelican History of Art, New Haven and London, 1993), 297–303.

135. The original location of the tympanum is far from certain. Various dates ranging from 1150 to the second quarter of the thirteenth century are proposed in H. Karlinger, *op. cit.*, 68–9; H. Beenken, 'Das Tympanon des städtischen Museums in Salzburg und die lombardische Plastik des 12. Jahrhunderts', *Belvedere*, VIII (1925), 97–118; F. Fuhrmann, 'Das romanische Marientympanon in Salzburger Museum Carolino Augusteum. Zur Frage seiner Entstehungszeit', *Jahreschrift Salzburger Museum Carolino Augusteum*, V (1959), 49–103; and *Die Zeit der Staufer*, I, 374–5, cat. no. 491 (W. Sauerländer).

136. *Ibid.*, 375–6, cat. no. 492.

137. R. Feuchtmüller, *Der Wiener Stephansdom* (Vienna, 1978), 35–50, pls 54, 56–64.

138. L. Gál, *L'architecture religieuse en Hongrie du XIe au XIIIe siècles* (Paris,

1929); G. Entz, 'L'architecture et la sculpture hongroises à l'époque romane dans leurs rapports avec l'Europe', *Cahiers de Civilisation Médiévale*, IX (1966), 209–19; D. Dercsényi, 'A románkor müvészete', in *A magyarországi müvészet története* (4th ed., Budapest, 1970); *Árpád-kori köfaragványok* (exh. cat., Székesfehérvár, 1978); E. Marosi, *Die Anfänge der Gotik in Ungarn. Esztergom in der Kunst des 12–13. Jahrhunderts* (Budapest, 1984), esp. 126–36; *idem.*, 'Mittelalterliche Kunst aus Buda und Pest', in G. Biegel (ed.), *Budapest im Mittelalter* (exh. cat., Brunswick, 1991), 43–70. For an overview see M. Tóth, 'Architecture et sculpture en Hongrie aux XIe–XIIe siècles', *Arte Medievale*, I (1983), 81–99 (this article actually covers the thirteenth century as well).

139. Marosi, *op. cit.* (1984), 133–5, figs 276–91.

140. L. Gerevich, 'Villard de Honnecourt Magyarországon', *Müvészettörténeti Értesítö*, XX (1971), 81–105; Hahnloser, *op. cit.*, 393–7, pls 20 and 30; Marosi, *op. cit.* (1984), 135–6, figs 318–23, rejects the idea that Villard de Honnecourt was the sculptor. On Pilis generally see L. Gerevich, 'Ausgrabungen in der ungarischen Zisterzienserabtei Pilis', *Analecta Cisterciana*, XXXIX (1983), 281–310, and *idem.*, 'Ergebnisse der Ausgrabungen in der Zisterzienserabtei Pilis', *Acta Archaeologica Academiae Scientiarium Hungaricae*, XXXVII (1985), 111–52: I am grateful to Melinda Tóth for drawing these articles to my attention.

141. Marosi, *op. cit.* (1984), figs 398–402, 405.

142. I. Hoefelmayr, 'Meister des Hauptportals von Ják', in *Forschungen zur Kunstgeschichte und christlichen Archäologie, II, Wandlungen christlicher Kunst im Mittelalter* (Baden-Baden, 1953), 305–19; D. Dercsényi, 'Zur siebenhundertjährigen Feier der Kirche von Ják', *Acta Historiae Artium Academiae Scientiarum Hungaricae*, IV (1957), 173–202; A. Mezey-Debreczeni and E. Szentesi, 'Neue Forschungen zur Abteikirche von Ják. Schriftquellen und Befunde als Hilsmittel auf der Suche nach der verlorenen Baugeschichte', *Kunstchronik*, XLIV (1991), 575–84; T. von Bogyay, 'Bamberg und Ják im Licht neuer Forschungen', in T. W. Gaehtgens (ed.), *Künstlerischer Austausch – Artistic Exchange (Akten des XXVIII. Internationalen Kongresses für Kunstgeschichte, Berlin, 1992)*, II (Berlin, 1993), 81–8.

CHAPTER 3

1. G. Zarnecki, *Romanesque Lincoln: the sculpture of the Cathedral* (Lincoln, 1988), 32.

2. See J. Larson, 'The Lincoln frieze: a problem of conservation and historical investigation', in *Romanesque: stone sculpture from medieval England* (exh. cat., Leeds, 1993), 31–4.

3. G. Zarnecki, 'Henry of Blois as a patron of sculpture', in S. Macready and F. H. Thompson (eds), *Art and Patronage in the English Romanesque* (London, 1986), 160–2, pls XLIV–XLV.

4. A. Gardner, *English Medieval Sculpture* (Cambridge, 1951), 91–2, fig. 161, suggested that the Virgin and Child formed part of a tympanum on a doorway which also contained the later column figures and the voussoirs in the Yorkshire Museum; these are in a different style, however, and it is far from certain in any case whether they should be considered together. See also *English Romanesque Art 1066–1200* (exh. cat., London, 1984), cat. no. 158 (C. Wilson).

5. This has been pointed out by Deborah Kahn in connection with the building of Canterbury Cathedral (*Canterbury Cathedral and its Romanesque sculpture* (London, 1991), 22).

6. *Idem.*, 'The west doorway at Rochester Cathedral', *Romanesque and Gothic: Essays for George Zarnecki* (Woodbridge, 1987), 129–34, who discusses the older literature.

7. This was noted by W. R. Lethaby as long ago as 1905 (W. H. St John Hope and W. R. Lethaby, 'The imagery and sculptures on the west front of Wells Cathedral Church', *Archaeologia*, LIX (1904), 182–3, pls XXXVI–XXXVII). The engravings were published in T. and G. Hollis, *The Monumental Effigies of Great Britain* (London, Part I, 1840), pls I–II.

8. G. Zarnecki, 'The sculpture of the old Moot Hall, Colchester', in P. Crummy (ed.), *Aspects of Anglo-Saxon and Norman Colchester* (Colchester, 1981), 62–7 (reprinted in G. Zarnecki, *Further Studies in Romanesque Sculpture* (London, 1992), XIII).

9. G. Zarnecki, 'A 12th century column-figure of the standing Virgin and Child from Minster-in-Sheppey, Kent', *Kunsthistorische Forschungen, Otto Pächt zu seinem 70. Geburtstag* (Salzburg, 1972), 208–14 (reprinted in G. Zarnecki, *Studies in Romanesque Sculpture* (London, 1979), XIV); P. Williamson, *Catalogue of Romanesque Sculpture* (Victoria and Albert Museum, London, 1983), no. 42.

10. R. Mair, 'The choir capitals of Canterbury Cathedral, 1174–84', *Medieval Art and Architecture at Canterbury before 1220* (British Archaeological Association conference transactions, V, 1982), 56–66.

11. *English Romanesque Art* (*op. cit.*), 195–8, cat. no. 164; Kahn, *op. cit.* (1991), 145–69; but see the reservations expressed by J. A. Franklin in her review of Kahn's book in *Burlington Magazine*, CXXXIII (1991), 547.

12. P. Tudor-Craig, 'Archbishop Hubert Walter's Tomb and its furnishings. The Tomb', *Medieval Art and Architecture at Canterbury before 1200*, *op. cit.*, 72–80.

13. See C. Wilson, 'The original setting of the apostle and prophet figures from St Mary's Abbey, York', in F. H. Thompson (ed.), *Studies in Medieval Sculpture* (Society of Antiquaries Occasional Paper (New Series) III, London, 1983), 100–21 (citing older literature); *English Romanesque Art* (*op. cit.*), 204–8, cat. nos 173–4.

14. C. Norton, 'The stone which the builders rejected . . .', in *Romanesque: stone sculpture from medieval England*, (*op. cit.*), 13–14; *idem.*, 'The buildings of St Mary's Abbey, York and their destruction', *Antiquaries Journal*, LXXIV (1994), 256–88, esp. 275–8. I am grateful to Christopher Norton for sending me a typescript of this article prior to publication.

15. The paint remains are described by A. Brodrick in *Romanesque: stone sculpture from Medieval England*, (*op. cit.*), 22–7. For Lausanne see pp. 58–9.

16. The best stylistic analysis of the York figures remains W. Sauerländer, 'Sens and York: an inquiry into the sculptures from St Mary's abbey in the Yorkshire Museum', *Journal of the British Archaeological Association*, 3rd series, XXII (1959), 53–69. Compare also the head of Moses at York with that at Mantes (*idem.*, *Gothic Sculpture in France 1140–1270* (London, 1972), pl. 50 top left).

17. See S. Oosterwijk and C. Norton, 'Figure sculpture from the twelfth century Minster', *Friends of York Minster Annual Report* (1990), 11–30; *Romanesque: stone sculpture from medieval England*, (*op. cit.*), 8–17 (C. Norton), 50–60, cat. nos 23–35 (S. Oosterwijk); and C. Norton, 'Klosterneuburg and York: artistic cross-currents at an English cathedral, c.1330', *Wiener Jahrbuch für Kunstgeschichte*, XLVI/XLVII (1993/4), 519–32 (esp. 524–8).

18. *Romanesque: stone sculpture from medieval England* (*op. cit.*), 36–44, 46 (cat. no. 18).

19. L. S. Colchester and J. H. Harvey, 'Wells Cathedral', *Archaeological Journal*, CXXXI (1974), 200–14.

20. A. Gransden, 'The history of Wells Cathedral, c.1090–1547', in L. S. Colchester (ed.), *Wells Cathedral: a History* (Shepton Mallet, 1982), 24–35, esp. 33–4.

21. J. A. Robinson, 'Effigies of Saxon Bishops at Wells', *Archaeologia*, LXV (1914), 95–112; W. J. Rodwell, 'Lead plaques from the tombs of the Saxon Bishops of Wells', *Antiquaries Journal*, LIX (1979), 407–10; *idem.*, 'The Anglo-Saxon and Norman churches at Wells', in Colchester, *op. cit.*, 17–21 (the suggestion (*ibid.*, 124) that the figures were not made as tomb effigies but were standing figures on a choirscreen does not seem to me to be tenable). For the use of the episcopal effigies as propaganda in support of the claims of Wells and their wider context see A. Martindale, *Heroes, ancestors, relatives and the birth of the portrait* (The Fourth Gerson Lecture, University of Groningen; The Hague, 1988), 12–13, fig. 6. For the tomb of Roger at Salisbury see Gardner, *op. cit.*, fig. 286.

22. The fullest discussion remains A. Gardner, *Wells Capitals* (Wells, 1956).

23. Colchester and Harvey, *op. cit.*, 203–4.

24. M. Thurlby, 'Wells Cathedral and Bristol Elder Lady Chapel revisited', *The Friends of Wells Cathedral Autumn Journal* (1991), 14–19.

25. J. A. Robinson, 'On the rebuilding at Glastonbury after the fire of 1184', *Archaeological Journal*, LXXXV (1930), 18–22; for a description of the decoration of both doorways see W. H. St John Hope, 'On the sculptured doorways of the Lady Chapel of Glastonbury Abbey', *Archaeologia*, LII (1890), 85–8.

26. For Malmesbury see K. J. Galbraith, 'The iconography of the biblical scenes at Malmesbury Abbey', *Journal of the British Archaeological Association*, 3rd series, XXVIII (1965), 39–56, pl. XVII; see also F. Saxl, *English sculptures of the twelfth century* (London, 1954), pl. LXVIII.

27. I am in disagreement here with Malcolm Thurlby, the primary supporter of an early date for the Glastonbury Lady Chapel north doorway (cf. note 29), and prefer to share Stone's opinion of its place in the development of English Gothic sculpture (L. Stone, *Sculpture in Britain: the Middle Ages* (Pelican History of Art, 2nd edition, Harmondsworth, 1972), 106). Zarnecki, who originally thought the doorway should be dated to around 1210 (*Later English Romanesque Sculpture 1140–1210* (London, 1953), 50) has since accepted Thurlby's early dating (see most recently G. Zarnecki, 'English Art around 1180', in *Actas simposio internacional sobre 'O Pórtico da Gloria e a Arte do seu Tempo'* (La Coruña, 1991), 304, where he misleadingly describes the doorway as 'a documented work of 1184–6').

28. M. Thurlby, 'Breaking away from formality: English medieval sculpture', *Country Life*, 3 June 1976, 1508–9, figs 2–3 (it should be noted that fig. 7 in this article shows the label stop in the Glastonbury Lady Chapel, not Wells).

29. *Idem.*, 'The north transept doorway of Lichfield Cathedral: problems of style', *RACAR* (Canadian Art Review), XIII/2 (1986), 121–30 (the author prefers a date of 1184–9 for the Glastonbury Lady Chapel north doorway, despite the fact that the convincing parallels which he himself provides with sculptures datable between 1210 and 1235 would seem to contradict this); see also *idem.*, *Transitional Sculpture in England* (unpublished Ph.D. thesis, University of East Anglia, 1976), 190–201.

30. J. H. Harvey, 'The building of Wells Cathedral, I: 1175–1307', in Colchester, (*op. cit.*, 1982), 61.

31. The Christ-Child and head of the Virgin were 'restored' in 1970; for

photographs before and after, and for the most comprehensive coverage see *Courtauld Institute Illustration Archives*, I, Parts 2 and 4 (London, 1977). It has been suggested that the figures in the voussoirs represent the Virtues (St John Hope and Lethaby, *op. cit.*, 177–78).

32. Most of the angels are now missing on the west face.

33. The present figure of the seated Christ flanked by seraphim is the work of David Wynne (1984); it replaced the fragmentary bottom half of the medieval Christ. For an attempted detailed identification of the sculptures at Wells see St John Hope and Lethaby, *op. cit.*, and L. S. Colchester, *The West Front of Wells Cathedral* (sixth revised edition, Wells, 1978).

34. For a coloured reconstruction of the central section of the west front see M. Hall, 'Gloria in Excelsis', *Country Life*, CLXXXIV/49 (1990), 152–4.

35. P. Z. Blum, 'Liturgical influences on the design of the west front at Wells and Salisbury', *Gesta*, XXV (1986), 145–50; see also P. Tudor-Craig, 'Bishop Grandisson's provision for music and ceremony', in M. Swanton (ed.), *Exeter Cathedral: a Celebration* (Exeter, 1991), 141–3, for the spread of the Sarum Rite and its architectural accommodation. This feature is placed in its architectural context in J. P. McAleer, 'Particularly English? Screen façades of the type of Salisbury and Wells cathedrals', *Journal of the British Archaeological Association*, CXLI (1988), 147–9.

36. J. Alexander and P. Binski (eds), *Age of Chivalry: Art in Plantagenet England 1200–1400* (exh. cat., London, 1987), cat. no. 453.

37. Compare the illustration in Stone, *op. cit.*, pl. 73, with that in *Courtauld Institute Illustration Archives*, *op. cit.*, 1/2/171.

38. Sauerländer, *op. cit.* (1972), pls 96–7, 125.

39. For a detailed discussion of the different styles of the Wells statuary see A. Andersson, *English influence in Norwegian and Swedish figure sculpture in wood 1220–1270* (Stockholm, 1949), 15–55.

40. P. Tudor-Craig, *One half of our noblest art: a study of the sculptures of Wells West Front* (Wells, 1976), caption to pl. 12.

41. For the Bristol Virgin and Child see Andersson, *op. cit.*, fig. 13; the Longespée effigy is illustrated in Stone, *op. cit.*, pl. 88.

42. H. M. Colvin (ed.), *The History of the King's Works*, Vol. I (London, 1963), 478.

43. The vault bosses in the Lady Chapel at Worcester (*c.*1230) also have points of contact with Wells sculpture: see M. Thurlby, 'The effigy of King John and the sculpture of the cathedrals of Wells and Worcester', *Transactions of the Worcestershire Archaeological Society*, 3rd series, X (1986), 55–8. The traditional tendency to tie the production of Purbeck marble sculpture to two centres only – London and Corfe – has recently been challenged (J. Blair, 'Purbeck Marble', in J. Blair and N. Ramsay, *English Medieval Industries: Craftsmen, Techniques, Products* (London and Rio Grande), 52). I do not share Andersson's view (possibly arrived at because of his misdating of the sculpture to 1216–20), that the effigy of King John owes its form to antecedents in metalwork, although this may be the case for the earlier tombs of Bishop Henry Marshall in Exeter and Archbishop Hubert Walter in Canterbury (Andersson, *op. cit.*, 58–62, and Stone, *op. cit.*, 116).

44. For the relevant building history see B. Singleton, 'The remodelling of the east end of Worcester Cathedral in the earlier part of the thirteenth century', *Medieval Art and Architecture at Worcester Cathedral* (British Archaeological Association Conference Transactions, I, 1978), 105–15; for the nineteenth-century restorations see R. B. Lockett, 'The Victorian restoration of Worcester Cathedral', *ibid.*, 170. A selection of the spandrel reliefs is illustrated in Gardner, *op. cit.*, figs 198–202, and more fully in E. Aldis, *Carvings and sculptures of Worcester Cathedral* (London, 1873).

45. P. Kidson, 'St Hugh's Choir', *Medieval Art and Architecture at Lincoln Cathedral* (British Archaeological Association Conference Transactions, VIII, 1986), 41–2; spandrel figures on the Anno shrine are illustrated in P. Lasko, *Ars Sacra 800–1200* (Pelican History of Art, 2nd ed. New Haven and London, 1994), pls 329–30.

46. For a photograph showing the relief with the four niches of the fourteenth-century reredos see N. Pevsner and P. Metcalf, *The Cathedrals of England: Midland, Eastern and Northern England* (Harmondsworth, 1985), 333, fig. 183; see also the excellent details in Saxl, *op. cit.*, pls XCIX, C.

47. Compare especially the figures on the lintel showing the Judgement of Solomon, and the draperies of the Queen of Sheba on the left jamb (Sauerländer, *op. cit.* (1972), pls 90, 92).

48. Telling comparisons in this respect are with a single Psalter leaf of around 1220 now in the British Library (Cotton Vespasian A.I, f. 1) and the slightly later Amesbury Psalter and a single leaf in Cleveland, which show the same composition as the Worcester relief (N. J. Morgan, *Early Gothic Manuscripts (I), 1190–1250 (A Survey of Manuscripts illuminated in the British Isles, IV)* (London, 1982), fig. 3, cat. no. 46, and *idem*, *Early Gothic Manuscripts (II), 1250–1285* (London, 1988), figs 1–2, cat. nos. 101, 113).

49. T. D. Atkinson ('Medieval figure sculpture in Winchester Cathedral', *Archaeologia*, LXXXV (1935), 161–2, pl. XLVII) demonstrated that the figure could be associated with the niches on the prior's house, but there is some doubt about

the original number of these (two, three or four?) and whether they did indeed exist in around 1230; for a concise description of the figure and previous literature see *Age of Chivalry* (*op. cit.*), cat. no. 245, and P. Lindley, 'The medieval sculpture of Winchester Cathedral', in J. Crook (ed.), *Winchester Cathedral: nine hundred years, 1093–1993* (Chichester, 1993), 100–1.

50. H. Roosen-Runge, 'Ein Werk englischer Grossplastik des 13. Jahrhunderts und die Antike', *Festschrift Hans R. Hahnloser zum 60. Geburtstag 1959* (Basel and Stuttgart, 1961), 103–12; I am now more inclined to see the figure as a response to a direct exposure to classical sculpture than I was in *Age of Chivalry*, *loc. cit.*

51. See P. H. Brieger, 'England's contribution to the origin and development of the Triumphal Cross', *Mediaeval Studies*, IV (1942), 85–96.

52. R. Vaughan (ed. and trans.), *Chronicles of Matthew Paris. Monastic life in the thirteenth century* (Gloucester, 1984), 49–52; P. Williamson, 'Sculpture', *Age of Chivalry* (*op. cit.*), 98.

53. *Calendar of the Liberate Rolls preserved in the Public Record Office, Henry III, Vol. II, AD 1240–1245* (London, 1930), 14; O. Lehmann-Brockhaus, *Lateinische Schriftquellen zur Kunst in England, Wales und Schottland vom Jahre 901 bis zum Jahre 1307*, vols I, II (Munich, 1955–6), nos 94 (Aldbury, Hertfordshire), 294 (Belchamp St Paul, Essex), 415 (Brent Pelham, Essex), 1271 (Drayton, Middlesex), 1804 (Furneaux Pelham, Hertfordshire), 2124 (Heybridge, Essex), 2203 (Kensworth, Bedfordshire), 2222, 2223 (Kirby-le-Soken, Essex), 2958 (London, St Pancras), 4409 (Thorpe-le-Soken, Essex), 4411 (Tillingham, Essex), 4498 (Walton-on-the-Naze, Essex), 4506 (Warley, Essex), 4597 (Wickham, Essex), 4610 (Willesden, Middlesex); see also N. Morgan, 'Texts and images of Marian devotion in thirteenth-century England', in W. M. Ormrod (ed.), *England in the thirteenth century: Proceedings of the 1989 Harlaxton Symposium* (Harlaxton Medieval Studies, I, Stamford, 1991), 69–103, esp. 81–4.

54. Stone, *op. cit.*, 2; S. E. Lehmberg, *The Reformation of Cathedrals. Cathedrals in English Society, 1485–1603* (Princeton, 1988), 67–105, for a general account of the destruction of images in all materials at this time.

55. C. J. P. Cave, *Roof bosses in medieval churches: an aspect of Gothic sculpture* (Cambridge, 1948), pl. 284; in view of these comparisons I would now amend my slightly earlier dating of 1200–20 for the Langham Virgin, as given in *Age of Chivalry* (*op. cit.*), cat. no. 249, and P. Williamson, *Northern Gothic Sculpture 1200–1450* (Victoria and Albert Museum, London, 1988), cat. no. 1.

56. For the remaining wing of a smaller English tabernacle of this type in ivory see P. Williamson, 'An English ivory tabernacle wing of the thirteenth century', *Burlington Magazine*, CXXXII (1990), 863–6; for a Norwegian example see U. Plahter and S. A. Wiik, 'The Virgin and Child from the Church of Dal (Norway) – Examination and Restoration', *Studies in Conservation*, XV (1970), 304–15.

CHAPTER 4

1. For a useful historical introduction to the Early Medieval period see the essays in E. Roesdahl and D. M. Wilson, *From Viking to Crusader: the Scandinavians and Europe 800–1200* (exh. cat., New York, 1992), especially O. Olsen, 'Christianity and churches', 152–61.

2. For the building history of Trondheim Cathedral see G. Fischer, *Domkirken i Trondheim* (2 vols, Oslo, 1966); for the heads see M. Blindheim, *Norwegian Romanesque Decorative Sculpture 1090–1210* (London, 1965), 54–6, figs 211–14.

3. For the Viklau Virgin see the comprehensive article by A. Andersson, 'Viklaumadonnans mästare', *Kungliga Vitterhets Historie och Antikvitets Akademiens Handlingar. Antikvariskt Arkiv*, XVIII (1962), 1–48.

4. *Idem.*, *Medieval wooden sculpture in Sweden*, II (Stockholm, 1966), 18–19, V (Stockholm, 1964), pls 1–4; the association with the Hereford school seems to me misplaced.

5. See M. Blindheim, 'Scandinavian art and its relations to European art around 1200', *The Year 1200. A Symposium* (New York, 1975), 429–67 (reprinted in *Festskrift til Martin Blindheim* (Universitetets Oldsaksamlings Skrifter, Ny rekke, VII (1986), 91–129; Blindheim's comparison of the head with English material (p. 95) is unconvincing and invalidated in view of the strong parallels with contemporary wood sculpture in Cologne).

6. Andersson, *op. cit.* (1962) and *idem.* (1966), 30–5; the art-historical association of the Viklau and Hemse sculptures by Andersson is confirmed by technical analysis (P. Tångeberg, 'The Crucifix from Hemse', *Maltechnik-Restauro*, XC/1 (1984), 24–34, and *idem*, *Mittelalterliche Holzskulpturen und Altarschreine in Schweden: Studien zu Form, Material und Technik* (Stockholm, 1986), 63–4). A general discussion of the earlier crucifixes is to be found in H. von Achen, 'Der König am Kreuz. Skandinavische Grosskruzifixe bis 1250', in H. Beck and K. Hengevoss-Dürkop (eds), *Studien zur Geschichte der europäischen Skulptur im 12/13. Jahrhundert* (Frankfurt am Main, 1994), I, 699–722.

7. Andersson, *op. cit.* (1966), 48–53.

8. *Idem*, 'St. Michael i Haverö, ett rhenländskt arbete', *Kungliga Vitterhets*

Historie och Antikvitets Akademiens Handlingar, Antikvariska Studier, V (1953), 83–116.

9. *English Romanesque Art 1066–1200* (exh. cat., London, 1984), cat. no. 115. The twelfth-century Madonnas of Rö and Varnum (both in Sweden) have been put forward as English in the past, although the stylistic arguments for this are not particularly persuasive (Andersson, *op. cit.* (1966), 20–3, figs 6–7).

10. For the links between Norway and England in the first half of the thirteenth century see the summary in A. Andersson, *English influence in Norwegian and Swedish figure sculpture in wood 1220–1270* (Stockholm, 1949), 95–104.

11. Fischer, *op. cit.*, I, 349, tentatively associated the relief with the west front of the cathedral. Its style, which is different from the other sculptures indubitably from the west front, would suggest that it was earlier than 1248, the date of the laying of the foundation stone of the façade (see p. 221); and the material from which it is made – soapstone – would be unsuitable for such a setting. For the identification of the figure as St Olaf see A. Anker, 'Trondheim Domkirkes vestfront i middelalderen', *Foreningen til norske fortidsminnesmerkers bevaring, Årbok 1971* (Oslo, 1972), 74, fig. 5.

12. Andersson (*op. cit.* (1949), 127–30) seems to have been unaware of the Worcester Virgin and Child, comparing the Hove Virgin instead to the effigy of King John; see also B. Kaland, 'Baldakin fra Hopperstad-Madonna fra Hove', *Årbok for Foreningen til Norske Fortidsmindesmaerkers Bevaring*, CXXV (1970), 85–98.

13. Andersson, *op. cit.* (1949), 131–4; see also J. Alexander and P. Binski (eds), *Age of Chivalry: Art in Plantagenet England 1200–1400* (exh. cat., London, 1987), cat. no. 99.

14. Andersson, *op. cit.* (1949), 118–23, 138–9; *Age of Chivalry*, (*op. cit.*), cat. no. 250.

CHAPTER 5

1. A concise historical introduction is contained in A. MacKay, *Spain in the Middle Ages: from Frontier to Empire, 1000–1500* (Basingstoke and London, 1977); see also P. de Palol and M. Hirmer, *Early Medieval Art in Spain* (London, 1967), J. D. Dodds (ed.), *Al-Andalus: the Art of Islamic Spain* (exh. cat., New York, 1992), and *The Art of Medieval Spain, AD 500–1200* (exh. cat., New York, 1993).

2. Most recently in M. Durliat, *La sculpture romane de la route de Saint-Jacques: de Conques à Compostelle* (Mont-de-Marsan, 1990).

3. MacKay, *op. cit.*, 25.

4. Most notably by E. Valdez del Alamo, 'Relaciones artísticas entre Silos y Santiago de Compostela', *Actas simposio internacional sobre 'O Pórtico da Gloria e a Arte do seu Tempo'* (La Coruña, 1991), 199–212, who lists the differences of opinion regarding the reliefs' priority over Santiago de Compostela, and *idem*, 'Triumphal visions and monastic devotion: the Annunciation relief of Santo Domingo de Silos', *Gesta*, XXIX (1990), 167–88; a later dating is argued for at length in J. Lacoste, 'La sculpture à Silos autour de 1200', *Bulletin Monumental*, CXXXI (1973), 101–28. The earlier cloister reliefs are illustrated in de Palol and Hirmer, *op. cit.*, pls 88–91, and Fr. J. Pérez de Urbel, *El Claustro de Silos* (Burgos, 1975).

5. De Palol and Hirmer, *op. cit.*, pls 198–9.

6. For the tympanum see Pérez de Urbel, *op. cit.*, 149, 158–69; the Oviedo apostles are illustrated most conveniently in de Palol and Hirmer, *op. cit.*, pls 192–6, and J. M. de Azcárate, *Las esculturas de la Cámara Santa de la Catedral de Oviedo* (Guias del Patrimonio Historico Asturiano, 8, Gijon, 1993).

7. S. Moralejo Alvarez, 'Esculturas Compostelanas del ultimo tercio del siglo XII', *Cuadernos de Estudios Gallegos*, XXVIII (1973), 294–310.

8. N. Stratford, '"Compostela and Burgundy?" Thoughts on the western crypt of the cathedral of Santiago', in *O Pórtico da Gloria e a Arte do seu Tempo* (*op. cit.*), 53–68, carefully discusses the connections between Vézelay, Avallon, Santiago de Compostela and Ávila.

9. J. L. Gutiérrez Robledo, *Las Iglesias Románicas de la Ciudad de Ávila* (Ávila, 1982), 45–89; for photographic coverage of the sculptures see J. M. Pita Andrade, *Los Maestros de Oviedo y Ávila* (Madrid, 1955). The magnificent tomb of St Vincent inside the church is also of this period (*ibid.*, pls 24–43).

10. De Palol and Hirmer, *op. cit.*, pls 232–4; C. Milton Weber, 'La portada de Santa María la Real de Sangüesa', *Principe de Viana*, XX (1959), 139ff.

11. De Palol and Hirmer, *op. cit.*, pls 235–7.

12. 'The year of the Incarnation of the Lord 1188, 1226 of the era, the first of April, the lintels of the main door of the church of Saint James were put in place by Master Mateo, who held the mastership from the foundation of this portal' (the Hispanic era was counted from 38 BC). The 1168 charter is printed in A. López Ferreiro, *Historia de la Santa A. M. Iglesia de Santiago de Compostela*, IV (Santiago, 1901), 93–4; for the inscription, *ibid.*, V (Santiago, 1902), 10.

13. There is a large body of literature on the Pórtico de la Gloria. Of the older works the most complete study is by E. H. Buschbeck, *Der Pórtico de la Gloria von Santiago de Compostela. Beiträge zur Geschichte der französischen und der spanischen Skulptur im XII. Jahrhundert* (Berlin and Vienna, 1919); more recent

works include G. L. Mellini, *Maestro Mateo a Santiago de Compostela* (Florence, 1965), M. L. Ward, 'Studies on the Pórtico de la Gloria at the Cathedral of Santiago de Compostela' (Doctoral dissertation, New York University, 1978), J. Yarza Luaces, *El Pórtico de la Gloria* (Madrid, 1983), and *O Pórtico da Gloria e a Arte do seu Tempo* (*op. cit.*).

14. Several dispersed standing figures have been associated with Mateo's scheme for the outside of the porch, most notably two apostles or prophets now in Pontevedra (*L'Art Roman* (exh. cat., Barcelona and Santiago de Compostela, 1961), cat. nos 1672–5).

15. A clear plan of the portal's layout is printed in Mellini, *op. cit.*, 6.

16. J. M. Pita Andrade, 'Un capítulo para el estudio de la formación artística del Maestro Mateo. La huella de Saint-Denis', *Cuadernos de estudios gallegos*, XXIII (1952), 371–83; see also S. Moralejo, 'Le porche de la gloire de la cathédrale de Compostele: problèmes de sources et d'interpretation', *Les Cahiers de Saint-Michel de Cuxa*, XVI (1985), 92–110.

17. Stratford, *op. cit.*, *passim.*; for Mateo's supposed involvement with the building of the Puente de Cesures in 1161 see C. Manso Porto's paper in the same volume (103–14).

18. See Valdez del Alamo, *op. cit.* (1991).

19. W. Sauerländer, '1188. Les contemporains du Maestro Mateo', in *O Pórtico da Gloria e a Arte do seu Tempo* (*op. cit.*), 18, pls 29–30, following Michael Ward (*op. cit.*).

20. *Ibid.*, 12–15, 18, pls 2, 18, 25, 31; W. Oakeshott, *Sigena: Romanesque paintings in Spain & the Winchester Bible artists* (London, 1972); *English Romanesque Art 1066–1200* (exh. cat. London, 1984), cat. nos. 64–5, 87; C. R. Dodwell, *The Pictorial Arts of the West 800–1200* (Pelican History of Art, New Haven and London, 1993), 372.

21. See *Santiago de Compostela: 1000 Ans de Pèlerinage Européen* (exh. cat., Ghent, 1985), 219–24 (cat. no. 26, with older literature); *Galicia No Tempo* (exh. cat., Santiago de Compostela, 1991), 194–6 (cat. no. 85). The most comprehensive coverage of the choirscreen is to be found in R. Otero Túñez and R. Yzquierdo Perrín, *El Coro del Maestro Mateo* (La Coruña, 1990).

22. One of these figures, now in the Metropolitan Museum of Art in New York, was even mistakenly associated – quite understandably – with the Master Mateo workshop (J. M. Pita Andrade, 'Una escultura del estilo de Maestro Mateo', *Cuadernos de estudios Gallegos*, VI (1950–1), 389–436; see also *Radiance and Reflection: Medieval Art from the Raymond Pitcairn Collection* (exh. cat., New York, 1982), cat. no. 42, and p. 28 in this volume).

23. De Palol and Hirmer, *op. cit.*, pl. 189.

24. *Ibid.*, pl. 178 for the Toro north portal; the Orense portal is fully discussed and illustrated in J. M. Pita Andrade, *La construcción de la Catedral de Orense* (Santiago de Compostela, 1954), 103–63, pls XXXI–XLIV. See also S. Moralejo Alvarez, *Escultura Gótica en Galicia (1200–1350)* (University of Santiago de Compostela, 1975).

25. The documentation and sculptural programme is fully discussed by F. B. Deknatel, 'The thirteenth century Gothic sculpture of the cathedrals of Burgos and Leon', *Art Bulletin*, XVII (1935), 245–52; see also A. L. Mayer, 'The decorated portal of the Cathedral of Túy', *Apollo*, II (1925), 8, who erroneously assigned the portal to the end of the thirteenth century.

26. The jamb figures at Laon are, with the possible exception of two prophets, now gone, but it can hardly be doubted that they closely resembled those of the central portal of the north transept at Chartres (see p. 35).

27. Buschbeck, *op. cit.*, fig. 59; J. Gudiol Ricart and J. Gaya Nuño, *Arquitectura y escultura románicas (Ars Hispaniae, Vol. 5)* (Madrid, 1948), figs 300–1; de Palol and Hirmer, *op. cit.*, pl. 238.

28. *Ibid.*, pls 222–3. The twelve figures on the south transept are even more provincial, in contrast to the accomplished late twelfth-century reliefs of Christ and the four apostles directly below. The former are erroneously dated by de Palol and Hirmer (pls 220–1) to the last quarter of the twelfth century: a date of around 1240 is more likely. For a discussion of the iconography of the Ciudad Rodrigo portal see R. Crozet, 'La cathédrale de Ciudad Rodrigo', *Bulletin Monumental*, CXXX (1972), 106–10, and J. M. Azcárate, *Arte Gótico en España* (Madrid, 1990), 145–7.

CHAPTER 6

1. For this view see J. Pope-Hennessy, *Italian Gothic Sculpture in the Victoria and Albert Museum* (London, 1952), 3.

2. L. Grodecki, *Gothic Architecture* (London, 1986), 154–7. See also R. Wagner-Rieger, *Die italienische Baukunst zu Beginn der Gotik* (2 vols, Graz-Cologne, 1956–7) and A. M. Romanini, *L'architettura gotica in Lombardia* (Rome, 1958).

3. *ANNO MILLENO CENTENO SEPTVAGENO : OCTAVO SCVLTOR PAT(RA)VIT M(EN)SE SECV(N)DO / ANTELAMI DICTVS SCVLPTOR FVIT HIC BENEDICTVS.*

4. *BIS BINIS DEMPTIS / ANNIS DE MILLE / DVCENTIS / INCEPIT DICTVS / OPVS HOC SCVLTOR / BENEDICTVS.* It is likely that this refers to work starting on the

Baptistery as a whole in 1196 rather than on just this portal, suggesting that Benedetto was both the architect and the superintending master of the sculptures.

5. There is a large literature on Benedetto, but the fundamental works are G. de Francovich, *Benedetto Antelami, architetto e scultore e l'arte del suo tempo* (2 vols, Milan-Florence, 1952) and A. C. Quintavalle, *Benedetto Antelami* (exh. cat. (Parma), Milan, 1990); a full bibliography is to be found at the end of A. C. Quintavalle, 'Antelami, Benedetto', *Enciclopedia dell'arte medievale*, II (Rome, 1991), 58–68.

6. For a possible reconstruction of the putative *pontile* see A. C. Quintavalle, 'Di un'annosa questione: il pulpito e il pontile di Benedetto Antelami nel Duomo di Parma', in *idem.*, *Romanico padano, civiltà d'Occidente* (Florence, 1969), 105–17, fig. XV.

7. Francovich, *op. cit.*, pls 38–50.

8. A. C. Quintavalle, '(A) Borgo san Donnino, dai Wiligelmici agli Antelamici: un problema di metodo (B) Appendice: la questione storiografica', in *idem.* (1969), 119–43. A concise description of the portals is given in G. H. Crichton, *Romanesque Sculpture in Italy* (London, 1954), 75–9.

9. See the photographs in *Nicholaus e l'arte del suo tempo, Atlante iconografico* (Ferrara, 1985).

10. For these figures see W. S. Stoddard, *The Façade of Saint-Gilles-du-Gard: its influence on French sculpture* (Middletown, 1973), 17–44. I would agree with Stoddard's dating of the doorways to around 1145–55 (*ibid.*, 127–74).

11. Quintavalle, *op. cit.* (1990), figs 61–2, cat. no. 21.

12. For the fable of Barlaam see *The Golden Legend of Jacobus de Voragine* (translated and adapted by G. Ryan and H. Ripperger, New York, 1941), 726.

13. See the diagram in Quintavalle, *op. cit.* (1991), 62, and *idem.*, *Battistero di Parma. Il cielo e la terra* (Milan, 1989), *passim*.

14. *Idem*, 'Il trionfale arco dell'Annunciazione e del Pantocratore nel Duomo di Parma', *op. cit.* (1969), 145–64 (with reconstruction on pl. XX); G. Capelli, *I mesi antelamici nel battistero di Parma* (Parma, 1976); Quintavalle, *op. cit.* (1990), 158–99.

15. The portal was dismantled between 1717 and 1737 and the reliefs are now in the Museo dell'Opera del Duomo. C. Gnudi, 'Il Maestro dei Mesi di Ferrara e la lunetta di San Mercuriale a Forlì', *Paragone*, 317–19 (July–September 1976), 2–14 (reprinted in *idem.*, *L'arte gotica in Francia e in Italia* (Turin, 1982), 86–95). See also Francovich, *op. cit.*, pls 308–18.

16. For the Vercelli pulpit see Francovich, *op. cit.*, 415–23, pls 285–7, and Quintavalle, *op. cit.* (1990), cat.nos 36a–d.

17. The attribution of this tympanum to Benedetto himself is out of the question for both chronological and stylistic reasons (P. Toesca, *Storia dell'Arte Italiana, I, Il Medioevo, II* (Turin, 1927, reprinted 1965), fig. 504; Francovich, *op. cit.*, 387–92, pls 268–73, 279). For a persuasive comparison of one of the angels from the Vercelli pulpit with one of the Blessed on the Last Judgement tympanum at Notre-Dame in Paris see W. Sauerländer, 'L'Europe gothique, XIIe-XIVe siècles. Points de vue critiques à propos d'une exposition', *Revue de l'Art*, III (1969), 91, figs 20–1.

18. The original angel with a weather-vane, now replaced by a copy, is in the crypt at Chartres: C. di Fabio, *Scultura romanica a Genova* (Genoa, 1984), 151–77, and *idem*, 'Scultura a Genova 1160–1259: la recezione del Gotico. Inediti e spunti di ricerca', *Bollettino d'Arte*, LXXII (1986), 143–60. See also F. Cervini, *I Portali della cattedrale di Genova e il Gotico Europeo* (Florence, 1993); P. C. Claussen, 'Il portale del Duomo di Genova. Lo stile internazionale all'antica a Genova e Milano', in V. Pace and M. Bagnoli (eds), *Il Gotico europeo in Italia* (Naples, 1994), 89–108; and *idem*, 'Zentrum, Peripherie, Transperipherie. Überlegungen zum Erfolg des gotischen Figurenportals an den Beispielen Chartres, Sangüesa, Magdeburg, Bamberg und den Westportalen des Domes S. Lorenzo in Genua', in H. Beck and K. Hengevoss-Dürkop (eds), *Studien zur Geschichte der europäischen Skulptur im 12/13. Jahrhundert* (Frankfurt am Main, 1994), I, 672–78. For the Trivulzio candlestick see P. Lasko, *Ars Sacra: 800–1200* (Pelican History of Art, 2nd ed., New Haven and London, 1994), 268–70, pl. 369.

19. Most recently by P. Verdier, *Le Couronnement de la Vierge. Les origines et les premiers développements d'un thème iconographique* (Montreal, 1980), 153–4.

20. S. G. Jones, *French Gothic influence on North Italian sculpture in the first half of the thirteenth century: a study of the Abbey of Vezzolano, S. Giustina in Padua and the Duomo of Vercelli* (doctoral dissertation, New York University, 1973), 37–8. It has been suggested that the frieze was cut down and reset at the beginning of the thirteenth century, but this does not take into consideration that the upper part does not appear to have been shortened (M. J. Hall, 'The Tramezzo in Santa Croce, Florence, reconstructed', *Art Bulletin*, LVI (1974), 336–7). M. Durliat, 'La tribune de Serrabone et le jubé de Vezzolano', *Monuments et Mémoires, Fondation Eugène Piot*, LX (1976), 79–112, raises the question of the traditional date and conveniently illustrates all the relevant sculpture at Vezzolano. For the history of the church at Vezzolano see A. Kingsley Porter, *Lombard Architecture*, III (New Haven, 1917), 539–48, and

Wagner-Rieger, *op. cit.*, I, 128–32. The most recent discussions are to be found in E. Pagella, 'Scultura gotica in Piemonte: tre cantieri di primo Duecento', in G. Romano (ed.), *Gotico in Piemonte* (Turin, 1992), 130–42, and *idem.*, 'Scultura gotica a Santa Maria di Vezzolano', in Pace and Bagnoli, *op. cit.*, 109–17.

21. There are four small figures (*c.*60 cm high) on both doorposts at S. Giustina, two on the front and two on the side (one above the other); on the left are King David and St Giustina (front) and St Paul and *Synagoga* (side), on the right King Solomon and St Prosdocimus (front) and St Peter and *Ecclesia* (side). See G. Nicco Fasola, 'L'antico portale di Santa Giustina a Padova', *Arte Veneta*, VIII (1954), 49–60, Jones, *op. cit.*, 67–108, R. Schumacher-Wolfgarten, '"Infidelitas" in der Arenakapelle', in F. N. Steigerwald (ed.), *Martin Gosebruch zu ehren: Festschrift anlässlich seines 65. Geburtstages am 20. Juni 1984* (Munich, 1984), 113, 117, figs 5–6, G. Bellinati, 'Nuova lettura iconografica dell'antico portale di Santa Giustina a Padova', *Atti e memorie dell'Accademia Patavina di Scienze, Lettere e Arte*, XCVI (1983–4), 49–54, A. Calora, 'Nuovi elementi del portale della basilica di S. Giustina', *idem.*, 13–18, and W. Sauerländer, 'Dal Gotico europeo in Italia al Gotico italiano in Europa', in Pace and Bagnoli, *op. cit.*, 14 and figs 8 and 11.

22. For comparable sculptures at Chartres see W. Sauerländer, *Gothic Sculpture in France 1140–1270* (London, 1972), pls 98, 125.

23. On the use of *spolia* at San Marco see now M. Jacoff, *The Horses of San Marco and the Quadriga of the Lord* (Princeton, 1993), *passim*.

24. See O. Demus, *The Church of San Marco in Venice: History, Architecture, Sculpture* (Dumbarton Oaks Studies, VI, Washington, D.C., 1960), 107–90; W. Wolters (ed.), *Die Skulpturen von San Marco in Venedig. Die figürlichen Skulpturen der Aussenfassaden bis zum 14. Jahrhundert* (Munich-Berlin, 1979); and R. Polacco, 'San Marco e le sue sculture nel duecento', in D. Rosand (ed.), *Interpretazioni veneziane. Studi di storia dell'arte in onore di Michelangelo Muraro* (Venice, 1984), 59–75. Further Antelamesque sculptures in Venice are the group of the Dream of Joseph, formerly associated with the central portal at San Marco and now displayed inside the basilica, the apostles in the Cappella Zen, and the Adoration of the Magi in the Seminario Patriarcale (N. Huse, 'Über ein Hauptwerk der venezianischen Skulptur des 13. Jahrhunderts', *Pantheon*, XXVI (1968), 95–103).

25. C. Fiskovic, *Radovan* (Zagreb, 1965); V. Gvozdanovic, 'Master Radovan and the lunette of the Nativity at Trogir', *Studies in Medieval Culture*, VIII–IX (1976), 85–98; *idem.* (as V. Goss), 'Parma-Venice-Trogir. Hypothetical peregrinations of a thirteenth-century Adriatic sculptor', *Arte Veneta*, XXXIV (1980), 26–40; *idem.*, 'The Romanesque sculpture in the Eastern Adriatic: between the West and Byzantium', in A. C. Quintavalle (ed.), *Romanico padano, Romanico europeo* (Parma, 1982), 176–92; O. Demus, 'Bemerkungen zu Meister Radovan in San Marco', *Jahrbuch der österreichischen Byzantinistik*, XXXVIII (1989), 389–93; J. Belamaric, 'Ciklus mjeseci radovanovog portala na katedrali u Trogiru', *Prilozi Povijesti Umjetnosti u Dalmaciji*, XXX (1990), 95–139; and now, most importantly, the essays in I. Babic (ed.), *Per Raduanum 1240–1990. Majstor Radovan i njegovo doba* (Trogir, 1994). (I am grateful to Johannes Röll for drawing these last two studies to my attention).

26. For an admirable survey of the use of marble in the Middle Ages see E. Castelnuovo (ed.), *Niveo de Marmore. L'uso artistico del marmo di Carrara dall'XI al XV secolo* (exh. cat., Sarzana; Genoa, 1992).

27. C. Smith, *The Baptistery of Pisa* (New York and London, 1978), 121ff., and *idem.*, 'Pisa: a negative case of Byzantine influence', in H. Belting (ed.), *Il Medio Oriente e l'Occidente nell'Arte del XIII secolo (Atti del XXIV congresso internazionale di storia dell'arte, 2)* (Bologna, 1982), 95–102, who considers that Byzantine influence on Pisa was minimal and limited to a short period around 1180–1200. See also G. Kopp-Schmidt, 'Die Dekorationen des Ostportals am Pisaner Baptisterium', *Münchner Jahrbuch der bildenden Kunst*, 3rd series, XXXIV (1983), 25–58, and *Niveo de Marmore*, *op. cit.*, 196, cat. no. 38, for a summary of the question of the 'Byzantine' workshop at Pisa.

28. K. Weitzmann, 'The classical in Byzantine art as a mode of individual expression', in *Studies in Classical and Byzantine Manuscript Illumination* (Chicago, 1971), 172, figs 153–4, illustrates the sixth-century head of John the Baptist in mosaic at St Catherine's monastery at Mount Sinai, which shows the same physiognomic features.

29. A. Garzelli, *Sculture toscane nel Dugento e nel Trecento* (Florence, 1969), 15–36, pls 223–35; G. Kopp, *Die Skulpturen der Fassade von San Martino in Lucca* (Worms, 1981), 96–9; *Niveo de Marmore*, *op. cit.*, 163–71, 176–9.

30. Kopp, *op. cit.*, 128–30, pls 172–3, 206–11; it is possible that this 'Guido de Como' is the same master as the 'Guido Bigarelli de Cumo' who signed the Pisa Baptistery font in 1246.

31. *Ibid.*, 8.

32. *Ibid.*, pls 162–70, 175–6, 181–2.

33. For an attempt at a detailed division of hands see Kopp, *op. cit.*, 96–120.

34. The original is now displayed inside the cathedral, mounted on the interior of the west wall between the central and south doors, and has been replaced on the exterior by a copy; see Kopp, *op. cit.*, pls 1, 183–5.

35. See p. 180.

36. O. Pächt, 'Eine Ducento-Madonna', *Belvedere*, VI (1924), 7–14; G. de Francovich, 'A Romanesque school of wood carvers in Central Italy', *Art Bulletin*, XIX (1937), 5–57; idem., 'Holzkruzifixe des 13. Jahrhunderts in Italien', *Mitteilungen des kunsthistorisches Institutes in Florenz*, V (1937–40), 152–72; idem., *Scultura medievale in legno* (Rome, 1943); E. Carli, *La scultura lignea italiana dal XII al XVI secolo* (Milan, 1960), 9–38.

37. J.-R. Gaborit, 'Un groupe de la descente de croix au Musée du Louvre', *Monuments et Mémoires. Fondation Eugène Piot*, LXII (1979), 149–83; for a figure of the Dead Christ from another Deposition ensemble in the Thyssen-Bornemisza collection and a discussion of the group as a whole see P. Williamson, *The Thyssen-Bornemisza Collection: Medieval sculpture and works of art* (London, 1987), 78–83, cat. no. 13.

38. There is a museum in Zamora dedicated entirely to these processional sculptures (the so-called *Pasos*), albeit of eighteenth- to early twentieth-century date.

39. For these see I. H. Forsyth, *The Throne of Wisdom: wood sculptures of the Madonna in Romanesque France* (Princeton, N.J., 1972), passim.

40. Carli, *op. cit.*, 24, figs XXIII–XXVI, XXIX; M. Bagnoli, 'The Brindisi Cross. Related problems in Southern Italian sculpture', in Beck and Hengevoss-Dürkop, *op. cit.*, I, 689–97.

41. For the situation in Rome at this time and the existence of classical statuary at the Lateran see R. Krautheimer, *Rome, Profile of a City, 312–1308* (Princeton, 1980), esp. 191–202.

42. The fundamental work on the Roman marble workers is now P. C. Claussen, *Magistri Doctissimi Romani. Die römischen Marmorkünstler des Mittelalters (Corpus Cosmatorum I)* (Stuttgart, 1987), the first volume of a projected three-part study (for the prefabrication of the cloister at Sassovivo see 158–65). The only general work in English (E. Hutton, *The Cosmati: the Roman marble workers of the XIIth and XIIIth centuries* (London, 1950)) is of use for its convenient photographs but has now been completely superseded. On the pavements see D. F. Glass, *Studies on Cosmatesque Pavements* (British Archaeological Reports International Series 82, Oxford, 1980).

43. P. C. Claussen, 'Scultura romana al tempo di Federico II', in A. M. Romanini (ed.), *Federico II e l'arte del duecento italiano (Atti della III settimana di studi di storia dell'arte medievale dell'università di Roma, 1978)* (Galatina, 1980), I, 325–38; A. M. d'Achille, 'La scultura', in A. M. Romanini (ed.), *Roma nel Duecento: l'arte nella città dei papi da Innocenzo III a Bonifacio VIII* (Turin, 1991), 147–79; V. Pace, '"Nihil innovetur nisi quod traditum est": sulla scultura del Medioevo a Roma', in Beck and Hengevoss-Dürkop, *op. cit.*, I, 587–603.

44. J. Osborne (trans.), *Master Gregorius: the Marvels of Rome* (Toronto, 1987), 18–19.

45. An admirably circumspect account of Frederick II's patronage of the arts is to be found in D. Abulafia, *Frederick II: A Medieval Emperor* (2nd ed., London, 1992), 251–89, where it is pointed out that the Emperor seems to have spent more time on falconry than architecture. An example of the more enthusiastic view of Frederick as a great intellectual and patron of the arts is presented by J. Meredith, 'The *Bifrons* relief of Janus: the implications of the Antique in the Court Art of Emperor Frederick II', in C. Bruzelius and J. Meredith (eds), *The Brummer Collection of Medieval Art, The Duke University Museum of Art* (Durham and London, 1991), 97–123 (esp. 101, 105–7, 112–18).

46. For photographs of all the sculptures and a reconstruction of the gateway see C. A. Willemsen, *Kaiser Friedrichs II. Triumphtor zu Capua* (Wiesbaden, 1953); the other standard monograph is C. Shearer, *The Renaissance of Architecture in Southern Italy. A Study of Frederick II of Hohenstaufen and the Capua Triumphator archway and towers* (Cambridge, 1935).

47. J. Meredith, 'The revival of the Augustan age in the court art of Emperor Frederick II', in D. Castriota (ed.), *Artistic strategy and the rhetoric of power: political uses of art from antiquity to the present* (Carbondale, Illinois, 1986), 50–1; see also F. Bologna, 'Cesaris imperio regni custodia fio: la porta di Capua e la *interpretatio imperialis* del classicismo', in *Nel segno di Federico II. Unità politica e pluralità culturale del Mezzogiorno (Atti del IV Convegno Internazionale di Studi della Fondazione Napoli Novantanove, Napoli 1988)* (Naples, 1988), 159–89, and B. Brenk, 'Antikenverständnis und weltliches Rechtsdenken im Skulpturenprogramm Friedrichs II', in R. G. Kecks (ed.), *Musagetes: Festschrift Wolfram Prinz* (Berlin, 1991), 93–103. For the figure of the Emperor see P. C. Claussen, 'Die Statue Friedrichs II. vom Brückentor in Capua (1234–1239). Der Befund, die Quellen und eine Zeichnung aus dem Nachlass von Séroux d'Agincourt', in C. Andreas, M. Bückling, R. Dorn (eds), *Festschrift für Hartmut Biermann* (Weinheim, 1990), 19–39.

48. Abulafia, *op. cit.*, 202–8, 281–5; in addition, J. Meredith, 'The Arch at Capua: the strategic use of *spolia* and references to the Antique', in W. Tronzo (ed.), *Intellectual Life at the Court of Frederick II Hohenstaufen* (National Gallery of Art, Washington, Studies in the History of Art, 44; Hanover and London, 1994), 109–26.

49. D. F. Glass, *Romanesque Sculpture in Campania: patrons, programs, and style* (University Park, Penn., 1991), 125–62; E. Bertaux, *L'art dans l'Italie méridionale* (Paris, 1903, repr. Paris and Rome, 1968), 655–9, fig. 306; A. Prandi (ed.), *L'art dans l'Italie méridionale. Aggiornamento dell'opera di Emile Bertaux* (Rome, 1978), V, 656–8.

50. C. Gnudi, 'Considerazioni sul gotico francese, l'arte imperiale e la formazione di Nicola Pisano', in Romanini, *op. cit.* (1980), I, 1–17, figs 1–4 (reprinted (with reduced illustrations) in *L'arte gotica in Francia e in Italia*, (op. cit.), 102–19; see also H. Wentzel, 'Ein gotisches Kapitell in Troia', *Zeitschrift für Kunstgeschichte*, XVII (1954), 185–8, and V. K. Ostoia, '"To represent what is as it is"', *The Metropolitan Museum of Art Bulletin*, XXIII (1965), 367–72. Although the authenticity of the New York capital has recently been questioned (as summarised by L. Castelnuovo-Tedesco, 'Il capitello e la testa di donna del Metropolitan Museum of Art di New York', in M.S. Calò Mariani and R. Cassano (eds), *Federico II: immagine e potere* (exh. cat. (Bari), Venice, 1995), 395–6), I do not believe there are sufficent grounds for rejecting it; I am grateful to Dr Charles Little of the Metropolitan Museum of Art for discussing the capital with me. See further V. Pace, 'Presenze europee nell'arte dell'Italia meridionale. Aspetti della scultura nel "Regnum" nella prima metà del XIII secolo', in Pace and Bagnoli, *op. cit.*, 230 and figs 21–6.

51. Gnudi, *op. cit.*, 4, figs 5–6; for a somewhat different view, stressing the importance of local classical sculpture, see V. Pace, 'Scultura "federiciana" in Italia meridionale e scultura dell'Italia meridionale di età federiciana', in Tronzo, *op. cit.*, 151–77. A summary of the 'French versus Antique' debate is to be found in W. Sauerländer, 'Two glances from the North: the presence and absence of Frederick II in the art of the Empire; the Court Art of Frederick II and the *opus francigenum*', idem., 200–6.

52. For a selection of these heads see *Die Zeit der Staufer* (exh. cat., Stuttgart, 1977), I, cat. nos 845–9, 851–4, II, figs 624–32; for the Barletta bust see P. Eichhorn, 'Zur Büste von Barletta: Versuch einer Ergänzung', idem., V (1979), 419–30. It is worth noting that this type of head seems to have been popular with nineteenth- and twentieth-century fakers, their work turning up from time to time on the art market; the example published by L. Quartino ('Un busto genovese di Federico II', in Romanini, *op. cit.* (1980), 289–99) is a neo-classical bust in the manner of Canova.

53. For the Castel del Monte sculptures see M. S. Calò Mariani, 'La scultura in Puglia durante l'età sveva e proto-angioina', in P. Belli D'Elia *et al*, *La Puglia fra Bisanzio e l'Occidente* (Milan, 1980), 267–72, figs 340–50, and C. A. Willemsen, *Castel del Monte* (Frankfurt, 1982); for the Reims parallels, Sauerländer, *op. cit.* (1972), pl. 263, and more particularly, J. Poeschke, 'Zum Einfluss der Gotik in Süditalien', *Jahrbuch der Berliner Museen*, XXII (1980), 91–120.

CHAPTER 7

1. For Evrard's tomb monument see W. Sauerländer, *Gothic Sculpture in France 1140–1270* (London, 1972), 467, pl. 174 and ill.88; Evrard's and his successor Geoffroi d'Eu's bronze tomb slab are illustrated and discussed in K. Bauch, *Das mittelalterliche Grabbild. Figürliche Grabmäler des 11. bis 15. Jahrhunderts in Europa* (Berlin and New York, 1976), 77–8, figs 110–11. I would prefer to date Evrard's monument later than Sauerländer, both because the building would not have been sufficiently far advanced 'soon after 1222' to receive it and because, from a stylistic point of view, it seems more advanced than that of Geoffroi, who died in 1236. A date around 1240 cannot be ruled out.

2. For a brilliant account of the building of Amiens Cathedral see D. Kimpel and R. Suckale, *L'architecture gothique en France 1130–1270* (Paris, 1990), 11–64 (esp. 32–3). A. Erlande-Brandenburg has proposed that the west front was only begun after 1236, but there are objections to his reading of the documentary sources ('Le septième colloque international de la Société française d'archéologie. La façade de la cathédrale d'Amiens', *Bulletin Monumental*, CXXXV (1977), 253–93; for a rebuttal of his views see S. Murray, 'Looking for Robert de Luzarches: the early work at Amiens Cathedral', *Gesta*, XXIX (1990), 111–31). W. Schlink has identified the Franciscan at the far left of the Blessed entering Heaven on the Judgement portal as St Francis himself: if this were accepted a date after 1228 (the year of his canonisation) would seem to follow (*Der Beau-Dieu von Amiens. Das Christusbild der gotischen Kathedrale* (Frankfurt am Main, 1991), 132–4, fig. 30.

3. Sauerländer, *op. cit.*, pls 150, 165.

4. E. Mâle, *Religious Art in France. The thirteenth century: a study of medieval iconography and its sources* (edited by H. Bober, Princeton, 1984), figs 171–2.

5. A. Katzenellenbogen, 'The prophets of the west façade of the Cathedral of Amiens', *Gazette des Beaux-Arts*, 6th series, XL (1952), 241–60.

6. Most of the figures were drastically restored in the middle of the nineteenth century. For the iconography of the gallery of kings see Mâle, *op. cit.*, 171–7, and J. G. Prinz von Hohenzollern, *Die Königsgalerie der französischen Kathedrale: Herkunft, Bedeutung, Nachfolge* (Munich, 1965), esp. 34–8, figs 7–9.

7. Sauerländer succinctly pinpoints that 'the production process leading from unhewn block to worked up figure is perceptibly curtailed' (*op. cit.*, 466, and also 57). See in addition the comments of W. Schlink, 'Planung und Impro-

visation an der Westfassade der Kathedrale von Amiens', in H. Beck and K. Hengevoss-Dürkop (eds), *Studien zur Geschichte der europäischen Skulptur im 12/13. Jahrhundert* (Frankfurt am Main, 1994), I, 75–85.

8. M. R. Rickard, 'The iconography of the Virgin portal at Amiens', *Gesta*, XXII (1983), 147–57, gives a detailed analysis of the relationship between the jamb figures and the scenes in the tympanum and quatrefoils of the socle zone.

9. Sauerländer, *op. cit.*, pl. 169.

10. For some interesting comments on the possible effect of contemporary fashion on the figure sculptors see W. Sauerländer, 'Kleider machen Leute. Vergessenes aus Viollet-le-Ducs "Dictionnaire du Mobilier français"', *Arte Medievale*, I (1983), 221–40. The many different hands identified by W. Medding (*Die Westportale der Kathedrale von Amiens und ihre Meister*, (Augsburg, 1930), *passim*), have been challenged by L. Lefrançois-Pillion, *Les sculpteurs français du XIIIe siècle* (Paris, 2nd ed., 1931), 139.

11. Sauerländer, *op. cit.* (1972), pls 157–9.

12. *Ibid.*, pls 172–3.

13. C. de Hamel, *A History of Illuminated Manuscripts* (Oxford, 1986), pls 107, 111.

14. For the Presentation group see Sauerländer, *op. cit.* (1972), pls 192, 195–6; I disagree here with Sauerländer's dating of the Amiens group at Reims to c.1230–3 (*ibid.*, 485). See also P. Kurmann, 'Nachwirkungen der Amienser Skulptur in den Bildhauerwerkstätten der Kathedrale zu Reims', in F. Möbius and E. Schubert, *Skulptur des Mittelalters. Funktion und Gestalt* (Weimar, 1987), 121–83, and idem., *La façade de la cathédrale de Reims: architecture et sculpture des portails. Etude archéologique et stylistique* (Lausanne, 1987), 174–85.

15. For the iconography of the portal see Sauerländer, *op. cit.* (1972), 494–5, and A. Katzenellenbogen, 'Tympanum and archivolts on the portal of St Honoré at Amiens', in M. Meiss (ed.), *De Artibus Opuscula XL. Essays in Honor of Erwin Panofsky* (New York, 1961), 280–90.

16. D. Kimpel and R. Suckale, 'Die Skulpturenwerkstatt der Vierge dorée am Honoratusportal der Kathedrale von Amiens', *Zeitschrift für Kunstgeschichte*, XXXVI (1973), 217–65.

17. See pp. 51–2.

18. H. R. Luard (ed.), *Matthiae Parisiensis Monachi Sancti Albani, Chronica Majora*, V (Rolls Series, London, 1880), 478–82. For illuminating accounts of the status of Paris and Louis IX's patronage see R. Branner, *St Louis and the Court Style in Gothic Architecture* (London, 1965, reprinted 1985), 1–12, E. M. Hallam, *Capetian France 987–1328* (London and New York, 1980), 224–6, 260–3, and W. Sauerländer, 'Medieval Paris, center of European taste. Fame and realities', in *Paris, center of artistic enlightenment* (Papers in Art History from the Pennsylvania State University, IV (1988)), 12–45.

19. Sauerländer, *op. cit.* (1972), ill.79, pls 178–81; the west portal at Rampillon has recently been restored and cleaned (*Bulletin Monumental*, CL (1992), 59). For an overview of the rôle of Paris at this date see A. Erlande-Brandenburg, 'La sculpture à Paris au milieu du XIIIe siècle', *Bulletin de la Société de l'histoire de Paris et de l'Ile-de-France*, 1970, 31–41.

20. W. Sauerländer, 'L'Europe gothique, XIIe–XIVe siècles. Points de vue critiques à propos d'une exposition', *Revue de l'Art*, III (1969), 89, figs 16–17.

21. Branner, *op. cit.*, 61–5; Kimpel and Suckale, *op. cit.* (1990), 404, prefer an attribution to Robert de Luzarches.

22. D. Jalabert, 'La flore sculptée de la Sainte-Chapelle', *Bulletin archéologique du Comité des travaux historiques et scientifiques* (1935), 739–47.

23. For a full description of the vicissitudes of the Sainte-Chapelle figures see F. Salet, 'Les statues d'apôtres de la Sainte-Chapelle conservées au Musée de Cluny', *Bulletin Monumental*, CIX (1951), 135–56, and idem., 'Nouvelle note sur les statues d'apôtres de la Sainte-Chapelle', *Bulletin Monumental*, CXII (1954), 357–63; also Sauerländer, *op. cit.* (1972), pls 184–5, ill. 89.

24. Branner, *op. cit.*, 57.

25. R. Branner, 'The Grande Châsse of the Sainte-Chapelle', *Gazette des Beaux-Arts*, 6th series, LXXVII (1971), 5–18.

26. The much-restored *châsse* of Saint-Romain at Rouen should probably be dated to around 1270–80 rather than the fourteenth century, a date sometimes assigned to it (it is dated slightly too early, in my opinion, in the most recent discussion in R. Recht (ed.), *Les bâtisseurs des cathédrales gothiques* (exh. cat., Strasbourg, 1989), 445, cat. no. E2). See also R. Suckale, *Studien zu Stilbildung und Stilwandel der Madonnenstatuen der Ile-de-France zwischen 1230 und 1300* (Doctoral dissertation, Munich, 1971), 138–9.

27. I am not as ready as Sauerländer (*op. cit.* (1972), 472) and others (Medding, Grodecki, Gnudi) to accept the need for more than one sculptor in the making of the apostles at the Sainte-Chapelle, and as he rightly points out the condition of the remaining original figures *in situ* militates against a confident style analysis.

28. Suckale, *op. cit.*, 109–19; D. Gaborit-Chopin, 'La Vierge à l'Enfant d'ivoire de la Sainte-Chapelle', *Bulletin Monumental*, CXXX (1972), 213–24; idem., *Ivoires du Moyen Age* (Fribourg, 1978), 137, pls 198–9.

29. I have suggested elsewhere that the natural curve of the tusk might have contributed to the initiation of this type of 'Gothic sway' (P. Williamson, *An Introduction to Medieval Ivory Carvings* (London, 1982), 18–19).

30. R. H. Randall Jr, 'The ivory Virgin of St Denis', *Apollo*, CXXVIII (1988), 394–8, 452; *Le trésor de Saint-Denis* (exh. cat., Paris, 1991), 231–7, cat. nos 45–6; Gaborit-Chopin, *op. cit.* (1978), pls 200, 205–7; idem., 'Nicodème travesti. La Descente de Croix d'ivoire du Louvre', *Revue de l'Art*, LXXXVI (1988), 31–44.

31. See the report on the polychromy of the Louvre Deposition group by A. Cascio and J. Levy appended to Gaborit-Chopin, *op. cit.* (1988), 45–6.

32. See pp. 241, 250, 260, and M. Seidel, 'Die Elfenbeinmadonna im Domschatz zu Pisa. Studien zur Herkunft und Umbildung französischer Formen im Werk Giovanni Pisanos in der Epoche der Pistoieser Kanzel', *Mitteilungen des Kunsthistorischen Institutes in Florenz*, XVI (1972), 1–50; also C. T. Little, 'Ivoires et art gothique', *Revue de l'Art*, XLVI (1979), 58–67, and D. Gaborit-Chopin, 'Une Vierge d'ivoire du XIIIe siècle', *La Revue du Louvre et des Musées de France*, IV (1983), 270–9.

33. The most comprehensive study of the transepts is D. Kimpel, *Die Querhausarme von Notre-Dame zu Paris und ihre Skulpturen* (Doctoral dissertation, Bonn, 1971). At this time in France the calendar started on 25 March, so that the date of 12 March 1257, for instance, if given in a medieval document or inscription, should be read as 1258 (see M. Brown, 'Calendars', in H. R. Loyn (ed.), *The Middle Ages: a concise encyclopaedia* (London, 1989), 67–8).

34. J. Lebeuf, *Histoire de la ville et de tout le diocèse de Paris* (Paris, 1754), I, 13. For the heads see A. Erlande-Brandenburg and D. Thibaudat, *Les sculptures de Notre-Dame de Paris au musée de Cluny* (Paris, 1982), cat. nos 240, 242 (with other fragments which may emanate from the same portal), and D. Kimpel, 'A Parisian Virtue', in C. Bruzelius and J. Meredith (eds), *The Brummer Collection of Medieval Art. The Duke University Museum of Art* (Durham and London, 1991), 125–39 (a head of one of the Virtues).

35. A bearded head which probably belonged to one of these figures is published by A. Erlande-Brandenburg and D. Thibaudat, 'Une tête inédite provenant du bras nord de Notre-Dame de Paris', *Mélanges d'archéologie et d'histoire médiévales en l'honneur du Doyen Michel Boüard* (Mémoires et documents publiés par la société de l'Ecole des Chartes, XXVII) (Geneva-Paris, 1982), 137–41, and idem., *op. cit.*, 85, fig. 29.

36. *The Golden Legend of Jacobus de Voragine* (translated and adapted by G. Ryan and H. Ripperger) (New York, 1941), 528–9; in the earlier *Miracles de Notre Dame* of Gautier de Coincy Theophilus is described as the *vidame* to the bishop of Adana in Cilicia, not Sicily (Mâle, *op. cit.*, 259–61).

37. *Ibid.*, fig. 179; for the use of the Theophilus legend in stained glass and apposite comments on the likely audience for such works see M. W. Cothren, 'The iconography of Theophilus windows in the first half of the thirteenth century', *Speculum*, LIX (1984), 308–41 (esp. 333–5: 'The full significance of the windows seems to have been directed at the small group of wealthy and powerful men who, like Theophilus or like Robert de Lisle, wielded temporal, secular authority').

38. Whether this is 'the first example of a gothic portal with niches for jamb figures' (Sauerländer, *op. cit.* (1972), 472, followed by Kimpel, *op. cit.* (1991), 127–9) is open to doubt as the *Puerta del Sarmental* at Burgos shares this feature (see p. 225).

39. See C. Wilson, *The Gothic Cathedral: the architecture of the Great Church 1130–1530* (London, 1990), 134–6.

40. The detailed stylistic analysis to be found in Kimpel's 1971 thesis (*op. cit.*) is conveniently summarised in his article in Bruzelius and Meredith, *op. cit.*, 130–4.

41. This continuity is also evident in the more modest sculptural decoration of the small *Porte rouge* to the east of the north transept, of about 1260–70 (Sauerländer, *op. cit.* (1972), 490. pl. 271).

42. For photographs of all the fragments see Erlande-Brandenburg and Thibaudat, *op. cit.*, 97–104.

43. F. de Verneilh, 'Les bas-reliefs de l'Université à Notre-Dame de Paris', *Annales archéologiques*, XXVI (1869), 96–106; H. Kraus, *The Living Theater of Medieval Art* (Bloomington and London, 1967), 3–21; M. Camille has imaginatively but unconvincingly interpreted two of the reliefs as referring to prostitution (*Image on the Edge. The margins of medieval art* (London, 1992), 139–41).

44. A. Erlande-Brandenburg, 'L'Adam du Musée de Cluny', *La Revue du Louvre et des Musées de France*, XXV (1975), 81–90; Erlande-Brandenburg and Thibaudat, *op. cit.*, 115–18.

45. See p. 171.

46. C. A. Bruzelius, *The 13th-century Church at St-Denis* (New Haven and London, 1985).

47. Sauerländer, *op. cit.* (1972), 470–1, pl. 183; for the whole portal see A. Erlande-Brandenburg, *The Abbey Church of Saint-Denis, I, History and Visit* (Bellegarde, 1984), fig. 7.

48. Bruzelius (*op. cit.*, 72–5), questions the original existence of a tympanum on the portal; for a reconstruction of the portal see J. Formigé, *L'abbaye royale de Saint-Denis. Recherches nouvelles* (Paris, 1960), 114–19, figs 91–2.

49. Two of the sixteen effigies (Odo and Hugh Capet) disappeared at the Revolution. For the Saint-Denis tombs see G. R. Sommers, *Royal tombs at Saint-*

Denis in the reign of Saint Louis (Doctoral dissertation, Columbia University, New York, 1966); idem. (as G. Sommers Wright), 'A royal tomb program in the reign of St Louis', *Art Bulletin*, LVI (1974), 224–43; A. Erlande-Brandenburg, *Le Roi est mort: étude sur les funérailles, les sépultures et les tombeaux des rois de France jusqu'à la fin du XIIIe siècle* (Geneva, 1975), *passim* and pls XXXV–XLII; idem., *The Abbey church of Saint-Denis, II, The Royal Tombs* (Bellegarde, 1984), nos 5–18; A. Teuscher, 'Saint-Denis als königliche Grablege. Die Neugestaltung in der Zeit König Ludwigs IX', in Beck and Hengevoss-Dürkop, *op. cit.*, I, 617–31; for the political context see E. M. Hallam, 'Royal burial and the cult of kingship in France and England, 1060–1330', *Journal of Medieval History*, VIII (1982), 359–80.

50. Compare the head of Robert the Pious with that of a bishop from Notre-Dame (Erlande-Brandenburg and Thibaudat, *op. cit.*, cat. no. 268), for a similar treatment of hair, beard, eyes and mouth. There does not appear to be any need to bring the sculpture of Reims into the equation (Sauerländer, *op. cit.* (1972), 491).

51. S. M. Crosby and P. Z. Blum, *The Royal Abbey of Saint-Denis from its beginnings to the death of Suger, 475–1151* (New Haven and London, 1987), 29–50.

52. These three figures are entirely nineteenth-century, the work of Geoffroy Dechaume, based on Montfaucon's engraving (Erlande-Brandenburg, *op. cit.* (1975), 142–4, fig. 83).

53. The traditional dating in the 1260s has been questioned by Erlande-Brandenburg, *op. cit.* (1975), 126–7, and M. Bidault, 'Le tombeau de Dagobert dans l'abbaye royale de Saint-Denis', *Revue de l'Art*, XVIII (1972), 27–33; for a date of 1244–8 see Wright, *op. cit.* (1974), 231–5.

54. The first reference to Louis's involvement in the rearrangement of the royal tombs at Saint-Denis dates only from the end of the thirteenth century: see Erlande-Brandenburg, *op. cit.* (1975), 81–3, 165–6, no. 96; on this question see also Wright, *op. cit.* (1974), 224–6, 242–3; Hallam, *op. cit.* (1982), 367–9, 371–2, and A. Martindale, *Heroes, ancestors, relatives and the birth of the portrait* (The Fourth Gerson Lecture, University of Groningen; The Hague, 1988), 12, 40 (note 12).

55. For the building history see R. Branner, *The Cathedral of Bourges and its place in Gothic Architecture* (Cambridge (Mass.) and London, 1989).

56. See R. Gauchery and C. Gauchery-Grodecki, *Saint-Etienne de Bourges* (Paris, 1959), 106–8; Sauerländer, *op. cit.* (1972), 504–5; T. Bayard, 'Thirteenth-century modifications in the west portals of Bourges Cathedral', *Journal of the Society of Architectural Historians*, XXXIV (1975), 215–25; idem., *Bourges Cathedral: the west portals* (Doctoral dissertation, Columbia University, 1968, published New York and London, 1976), 27–117 (prefers a date of around 1230 for the lateral portals, 1240 for the central); F. Joubert, 'Le jubé de Bourges, remarques sur le style', *Bulletin Monumental*, CXXXVII (1979), 358–62.

57. The lintel below, showing the resurrection of the Dead, had all but one of the heads – which had been broken off probably by the Huguenots in the sixteenth century – replaced by the restorer Caudron (for an account of the sculptures before restoration see A. de Girardot, 'Description des sculptures du portail de la cathédrale de Bourges avant leur restauration', *Mémoires de la Société des Antiquaires du Centre*, VII (1877), 249–72, and for diagrams see Bayard, *op. cit.* (1976), pls XIX–XXI). For other restorations see F. Joubert, 'Les voussures déposées du portail central de la cathédrale de Bourges', *Bulletin Monumental*, CXXXII (1974), 273–86.

58. O. Roger, 'L'ancien jubé de la cathédrale de Bourges', *Mémoires de la Société des Antiquaires du Centre*, XVIII (1891), 75–105; P. Gauchery, 'Restes de l'ancien jubé de la cathédrale de Bourges', idem., XXXVI (1919), 63–100; and most recently, F. Joubert, *Le jubé de Bourges* (Exposition-dossier, Musée du Louvre, Paris, 1994). The many fragments long held at the Musée du Louvre were returned to Bourges in November 1994.

59. Bayard, *op. cit.* (1976), 118–30; C. Gnudi, 'Le jubé de Bourges et l'apogée du "classicisme" dans la sculpture de l'Ile-de-France au milieu du 13e siècle', *Revue de l'Art*, III (1969), 18–36 (reprinted in Italian as 'L'apogeo del classicismo nella scultura dell'Ile-de-France nel XIII secolo: il jubé di Bourges', in C. Gnudi, *L'arte gotica in Francia e in Italia* (Turin, 1982), 21–54); Joubert, *op. cit.* (1979), 341–69, and idem., *op. cit.* (1994).

60. J.-P. Ravaux, 'Les campagnes de construction de la cathédrale de Reims au XIIIe siècle', *Bulletin Monumental*, CXXXVII (1979), 7–66, esp. 11–12; Ravaux's conclusions were anticipated, for different reasons, by R. Branner ('Reims West and tradition', in *Amici Amico. Festschrift für Werner Gross* (Munich, 1968), 55–8). The chronology is summarised in what is now the fundamental work on the Reims west façade: P. Kurmann, *La façade de la cathédrale de Reims* (*op. cit.*), 22–3. Kurmann gives a full account of the previous literature.

61. Ibid., 271–86; Ravaux's discovery particularly affects the dating sequence given in Sauerländer (*op. cit.* (1972), 474–88), where the later exterior sculptures of the west façade are placed in the years 1245–55.

62. For a convenient description of the iconography and good photographs of the main figures see Sauerländer, *op. cit.* (1972), 476–9, pls 189–228.

63. The thirteenth-century *Coronation of the Virgin* on the gable was replaced in 1955 by a sculpture of the same subject by Georges Saupique (P. Lasko, 'The principles of restoration', in D. Kahn (ed.), *The Romanesque Frieze and its Spectator (The Lincoln Symposium Papers)* (London, 1992), 161).

64. Not, as reported in Sauerländer (*op. cit.* (1972), 479), scenes from the Life of St John the Baptist; see Kurmann, *op. cit.*, 194–6.

65. See the contemporary account contained in M. Landrieux, *La cathédrale de Reims: un crime allemand* (Paris, 1919, esp. 130–74 and pls 23–7).

66. There are indications, here and elsewhere, that some of the sculptures are not now in the positions intended for them. The figure of Pope Calixtus, for instance, has installation marks showing that it should more properly be placed on the north door (Sauerländer, *op. cit.* (1972), 478); see now R. Hamann-MacLean and I. Schüssler, *Die Kathedrale von Reims, Die Architektur* (Stuttgart, 1993), I/1, 261–94, I/2, figs 349–77.

67. Kurmann, *op. cit.*, 24, 154–5, 159, 271; this of course excludes the later restorations (see note 63).

68. P. Kurmann, 'Die Pariser Komponenten in der Architektur und Skulptur der Westfassade von Notre Dame zu Reims', *Münchner Jahrbuch der bildenden Kunst*, 3rd series, XXXV (1984), 41–82, esp. figs 14–32, 42–5, 57–62.

69. Sauerländer, *op. cit.* (1972), pl. 98.

70. J.-P. Ravaux, 'The recumbent effigy of Blanche de Navarre, Countess of Champagne', *Bulletin of the International Society for the Study of Church Monuments*, IX (1983), 185–88; M. Beaulieu and V. Beyer, *Dictionnaire des sculpteurs français du Moyen Age* (Paris, 1992), 96–7.

71. Kurmann has concluded that three distinct stylistic groups (containing ten figures in total) can be recognised among the post-1255 figures at Reims and that the remaining statues are 'plus ou moins isolées' (*op. cit.* (1987), 266–71).

72. Of the two smiling angels at Reims (Sauerländer, *op. cit.* (1972), pls 200 and 211) only the former is now largely complete. The latter, on the left-hand doorway, lost its head in 1914 and has been restored with the help of a plaster cast made before the fire (Landrieux, *op. cit.*, pls 25–6).

73. Sadly the 1914 fire disfigured many of the figures on the lower part of the interior wall, especially on the south side.

74. L. Behling, *Die Pflanzenwelt der mittelalterlichen Kathedralen* (Cologne, 1964), 64–82.

75. H. Keller, 'Zur inneren Eingangswand der Kathedrale von Reims', in M. Kühn and L. Grodecki (eds), *Gedenkschrift Ernst Gall* (Munich and Berlin, 1965), 235–54. For a succinct and convenient description see Sauerländer, *op. cit.* (1972), 479–80; the most complete photographic coverage is to be found in Kurmann, *op. cit.* (1987), figs 443–560.

76. For this last see Sauerländer, *op. cit.* (1972), 468, pls 176–7, and P. Williamson, *Northern Gothic Sculpture 1200–1450* (Victoria and Albert Museum, London, 1988), cat. no. 3 (entry by P. Evelyn).

77. For Le Mans and Saint-Thibault-en-Auxois see Sauerländer, *op. cit.* (1972), 501, 503, pls 288, 290, ill. 108; also P. Quarré, 'Le portail de Saint-Thibault et la sculpture bourguignonne du XIIIe siècle', *Bulletin Monumental*, CXXIII (1965), 181–92, and D. Gillerman, 'The portal of St-Thibault-en-Auxois: a problem of thirteenth-century Burgundian patronage and founder imagery', *Art Bulletin*, LXVIII (1986), 567–80. For the doorway from Moutiers-Saint-Jean, now in the Cloisters Collection of the Metropolitan Museum of Art in New York, see W. H. Forsyth, 'A Gothic doorway from Moutiers-Saint-Jean', *Metropolitan Museum Journal*, XIII (1979), 33–74, N. Stratford, 'La Sculpture médiévale de Moutiers-Saint-Jean', *Congrès Archéologique de France, 144ème session, 1986, Auxois-Châtillonais* (Paris, 1989), 157–201, and idem., 'The Moutiers-Saint-Jean portal in the Cloisters', in E. C. Parker (ed.), *The Cloisters. Studies in honor of the fiftieth anniversary* (New York, 1992), 261–81. For an overview of Burgundian Gothic sculpture see S. Enders, *Die hochgotische Bauskulptur in Burgund* (Doctoral dissertation, Freiburg im Breisgau; Tübingen, 1984).

78. Sauerländer, *op. cit.* (1972), 502–4, pl. 291, ills 106–7; in addition, A. Prache, 'Notre-Dame de Semur-en-Auxois', *Congrès Archéologique 1986, op. cit.*, 291–301, and L. Saulnier and N. Stratford, *La sculpture oubliée de Vézelay* (Geneva, 1984), 38–42, pls IX–XI.

79. The standard work is now U. Quednau, *Die Westportale der Kathedrale von Auxerre* (Wiesbaden, 1979).

80. V. C. Raguin, *Stained glass in thirteenth-century Burgundy* (Princeton, 1982), 87 (for Guy de Mello); D. Denny, 'Some narrative subjects in the portal sculpture of Auxerre Cathedral', *Speculum*, LI (1976), 23–34 (Jean de Châlon); F. Nordström, *The Auxerre Reliefs. A harbinger of the Renaissance in France during the reign of Philip le Bel* (Uppsala, 1974), 126–7 (Pierre de Morney). See also W. Craven, 'The iconography of the David and Bathsheba cycle at the Cathedral of Auxerre', *Journal of the Society of Architectural Historians*, XXXIV (1975), 226–37, for a more sober assessment along traditional lines, following the sensible interpretation laid down in Sauerländer, *op. cit.* (1972), 499–501.

81. W. Sauerländer, 'Art antique et sculpture autour de 1200', *Art de France*, I (1961), 47–56, figs 18–20.

82. See Nordström, *op. cit.*, 128–31, for a description of the silver service of

Saint-Didier at Auxerre; his dating of the sculptures is too late throughout.

83. Denny (*op. cit.*, 31) prefers to identify the male and female pair to the right of the portal as Solomon and the Queen of Sheba, with Old Testament kings to the right; he interprets the six figures on the left as Old Testament prophets.

84. For the Sens portal see Quednau, *op. cit.*, figs 160–2; for Longpont see Sauerländer, *op. cit.* (1972), ill. 79.

85. Kimpel and Suckale, *op. cit.* (1990), 345–7, fig. 358.

86. F. Salet, 'Saint-Urbain de Troyes', *Congrès Archéologique de France, CXIIIe session, 1955, Troyes* (Orléans, 1957), 113–16, and A. Gardner, *Medieval Sculpture in France* (Cambridge, 1931), fig. 362. For England see p. 206.

87. Sauerländer, *op. cit.* (1972), 506–8, pls 296–9 (with older literature); see also Y. Blomme, *Poitou gothique* (Paris, 1993), 255–8, and *idem*, 'La construction de la cathédrale Saint-Pierre de Poitiers', *Bulletin Monumental*, CLII (1994), 7–64.

88. M. Thiollet, *Antiquités, Monuments et Vues Pittoresques du Haut-Poitou* (Paris, 1823), pl. I; this is also illustrated in Sauerländer, *op. cit.* (1972), ill. 110, and Blomme, *op. cit.* (1993), 107.

89. Many of them are displayed in the chapter house; for a selection of these reliefs see Sauerländer, *op. cit.* (1972), pls 300–3, and Blomme, *op. cit.* (1993), 106–10. A further voussoir from Charroux, containing a *Wise Virgin*, is in the Fogg Art Museum, Harvard University (D. Gillerman (ed.), *Gothic Sculpture in America, I, The New England Museums* (New York and London, 1989), cat. no. 86).

90. *Sculpture médiévale de Bordeaux et du Bordelais* (exh. cat., Bordeaux, 1976), cat. no. 131, ill.

91. Sauerländer, *op. cit.* (1972), 509–11, pls 304–6; J. Gardelles, *Bordeaux, cité médiévale* (Bordeaux, 1989), 59–65, 120–7; *idem.*, *Aquitaine gothique* (Paris, 1992), 74–5, 169–71.

92. For an illustration showing this feature clearly see *Sculpture médiévale de Bordeaux et du Bordelais* (*op. cit.*), cat. no. 135.

93. Gardelles, *op. cit.* (1992), 233–8; M. Gaborit, 'L'église souterraine de Saint-Emilion', *Congrès archéologique de France, 145e session, 1987, Bordelais et Bazadais* (Paris, 1990), 205, fig. 7; A. Prache, 'L'église haute de Saint-Emilion', *idem.*, 216–17, fig. 9.

94. I prefer a slightly later date for the portal than Jacques Gardelles, who would place it in around 1240–50 ('Les portails occidentaux de la cathédrale de Bazas', *Bulletin Monumental*, CXXXIII (1975), 285–310; 'La cathédrale de Bazas', *Congrès archéologique . . . Bordelais et Bazadais* (*op. cit.*), 33–5, figs 8–14; *Aquitaine gothique* (*op. cit.*), 66–8). See also Sauerländer, *op. cit.* (1972), 511, pl. 307.

95. Gardelles, *op. cit.* (1992), 247 (ill.).

96. The central figure of Christ in the tympanum is now missing. Sauerländer, *op. cit.* (1972), 511–12, pls 308–9; for a photograph of the portal before its move to the north transept see Gardelles, *op. cit.* (1992), 94.

97. *Ibid.*, 54–5; also E. Lambert, 'Bayonne', *Congrès archéologique de France, 102e session, 1939, Bordeaux et Bayonne* (Paris, 1941), 522–60 (a photograph of the complete portal is shown on p. 545).

98. Deknatel's statement that 'thirteenth-century Gothic sculpture in Spain has no important points of relationship with sculpture in southern France' is too categorical, although it is certainly true that direct influence from Northern France was of far greater significance (F. B. Deknatel, 'The thirteenth century Gothic sculpture of the cathedrals of Burgos and Leon', *Art Bulletin*, XVII (1935), 244). See chapter 11.

99. Sauerländer, *op. cit.* (1972), 413–14, ills 30–2. On the similarity to the Sainte-Chapelle see W. S. Stoddard, *Art and Architecture in Medieval France* (New York, 1972), 299–301.

100. For comments on the stylistic grouping of the Carcassonne sculptures see B. Mundt, 'Der Statuenzyklus von Carcassonne', *Wallraf-Richartz-Jahrbuch*, XXVII (1965), 31–54; Sauerländer, *op. cit.* (1972), 512; M. Pradalier-Schlumberger, 'Le décor sculpté de la cathédrale Saint-Nazaire de Carcassonne', *Congrès archéologique de France, 131e session, 1973, Pays de l'Aude* (Paris, 1973), 577–90, figs 3–22.

101. See the monograph on the cathedral by J. Vallery-Radot, *La Cathédrale de Bayeux* (2nd ed., Paris, 1958); a more recent discussion of the sculptures is to be found in J. Thirion, 'La cathédrale de Bayeux', *Congrès archéologique de France, 132e session, 1974, Bessin et Pays d'Auge* (Paris, 1978), 259–72, figs 14–20.

102. The seminal article on the transept portals is H. Krohm, 'Die Skulptur der Querhausfassaden an der Kathedrale von Rouen', *Aachener Kunstblätter*, XL (1971), 40–153 (the relevant documents for the execution of the work are fully discussed on pp. 51–6). For a more general account of the cathedral's building history see A. M. Carment-Lanfry, *La Cathédrale Notre-Dame de Rouen* (Rouen, 1977).

103. A Last Judgement tympanum without the Resurrection or the Separation of the Blessed and Damned would not be so striking, but leaving out the central feature would surely not have been countenanced. Michael Camille's theory (framed as a question) that the figure of Christ was left out of the tympanum because of the sinful goings-on below is to my mind eccentric (Camille, *op. cit.*

(1992), 91–2). Perhaps the upper register was completed but was subsequently damaged and removed, although the sources are silent on this point (Krohm, *op. cit.*, 66–7).

104. Rather than the nineteenth-century figure of Bishop Romanus there today; *ibid.*, 62.

105. See pp. 4 and 57. The fullest illustration of the reliefs is to be found in L. Pillion, *Les portails latéraux de la cathédrale de Rouen. Etude historique et iconographique sur un ensemble de bas-reliefs de la fin du 13e siècle* (Paris, 1907).

106. For the extent of restoration and replacement see Krohm, *op. cit.*, 102–10.

107. See p. 239. The fullest photographic coverage of gothic ivories is to be found in R. Koechlin, *Les ivoires gothiques français* (Paris, 1924; reprinted Paris, 1968).

108. For an analysis of the style of the portals see Krohm, *op. cit.*, 88–102 (*Portail des Libraires*), 114–35 (*Portail de la Calende*).

109. P. Kurmann, *La Cathédrale Saint-Etienne de Meaux: étude architecturale* (Geneva, 1971), 86–98, fig. 65.

110. For Sées, see R. Gobillot, *La cathédrale de Sées* (Paris, 1937), 53–8; for Mantes, see A. Rhein, *Notre-Dame de Mantes* (Paris, 1932), 62–70, and Krohm, *op. cit.*, 123–9, figs 76–7, 79, 81–2, 85–6.

111. For the Saint-Denis retables see J. Formigé, *op. cit.*, figs 106, 108, 118, and F. Joubert, 'Les retables du milieu du XIIIe siècle à l'abbatiale de Saint-Denis', *Bulletin Monumental*, CXXXI (1973), 17–27; for that from Saint-Germer-de-Fly see Sauerländer, *op. cit.* (1972), pl. 281. An overview of stone altarpieces at this time is provided by H. Bunjes, *Die steinernen Altaraufsätze der hohen Gotik und der Stand der gotischen Plastik in der Ile-de-France um 1300* (Würzburg, 1937).

112. F. Baron, 'Mort et résurrection du jubé de la cathédrale d'Amiens', *Revue de l'Art*, LXXXVII (1990), 29–41; for colour illustrations of the Magdalene and the torturer see F. Lernout (ed.), *Le Moyen Age au Musée de Picardie* (Amiens, 1992), cat. nos 7–8. A related relief in the Metropolitan Museum of Art in New York has been published by D. Gillerman ('The Arrest of Christ: a Gothic relief in the Metropolitan Museum of Art', *Metropolitan Museum Journal*, XV (1980), 67–90).

113. F. Baron, 'Remarques sur le décor sculpté de Saint-Denis. A propos d'une exposition', *La Revue du Louvre et des Musées de France*, XXXV (1985), 348–50; see also *Sculptures françaises du XIVe siècle* (exh. pamphlet, Paris, 1985), 5 (no. 6).

114. J.-R. Gaborit, 'Quelques remarques sur des sculptures du XIIIe siècle conservées au musée du Louvre', *Bulletin de la Société nationale des Antiquaires de France*, 1973, 100–1; D. Gillerman, *The Clôture of Notre-Dame and its role in the fourteenth century choir program* (Doctoral dissertation, Harvard University, 1973; published New York and London, 1977); *idem.*, 'The clôture of the cathedral of Notre-Dame: problems of reconstruction', *Gesta*, XIV (1975), 41–62; *idem.*, *op. cit.* (1980), 87–9; A. Erlande-Brandenburg, *Notre-Dame de Paris* (Paris, 1991), 189–202.

115. G. Sommers Wright, 'The Tomb of Saint Louis', *Journal of the Warburg and Courtauld Institutes*, XXXIV (1971), 65–82; Erlande-Brandenburg, *op. cit.* (1975), 165–6.

116. A monument was erected over the tomb containing her entrails in Cosenza Cathedral, with kneeling figures of Isabella and Philippe on each side of the Virgin and Child; this is the work of a French sculptor, presumably sent expressly from Paris to execute the monument, and it was certainly finished before 1276 (*ibid.*, 169–70, and J. Gardner, 'A Princess among Prelates: a fourteenth-century Neapolitan tomb and some northern relations', *Römisches Jahrbuch für Kunstgeschichte*, XXIII–XXIV (1988), 47–50).

117. Erlande-Brandenburg, *op. cit.* (1975), 168.

118. As in the effigy of the French Pope Clement IV in S. Francesco in Viterbo of 1271–4 (J. White, *Art and Architecture in Italy 1250–1400* (Pelican History of Art, 3rd edition, New Haven and London, 1993), pl. 49). See below, p. 253.

119. See, for instance, the shallow figures in marble illustrated in *Les Fastes du Gothique: le siècle de Charles V* (exh. cat., Paris, 1981), cat. nos 8–9, 22, 27, 30–2, etc. It has been suggested that the shallowness of the effigy of Isabella was determined by the sculptor's use of a monolithic Roman column shaft, but this would not explain other shallow effigies elsewhere (N. Penny, *The Materials of Sculpture* (New Haven and London, 1993), 55). Cost might have been a factor.

120. For the tomb of Philippe III at Saint-Denis see Erlande-Brandenburg, *op. cit.* (1975), 171–3, figs 157–9. The records specifically referring to Jean d'Arras as an imager were first published in F. Baron, 'Enlumineurs, peintres et sculpteurs parisiens des XIIIe et XIVe siècles d'aprés les rôles de la taille', *Bulletin archéologique*, IV (1968), 44, 50; for a summary of his life see Beaulieu and Beyer, *op. cit.*, 54.

121. For an admirable account of Gaignières's activity see E. A. R. Brown, *The Oxford collection of the drawings of Roger de Gaignières and the royal tombs of Saint-Denis* (Transactions of the American Philosophical Society, LXXVIII/5) (Philadelphia, 1988). See also J. Adhémar, with G. Dordor, 'Les tombeaux de la

collection Gaignières. Dessins d'archéologie du XVIIe siècle, I', *Gazette des Beaux-Arts*, 6th series, LXXXIV (1974), 1–192; II, *idem.*, LXXXVIII (1976), 1–128; III, *idem.*, XC (1977), 1–76; and J.-B. de Vaivre, 'Dessins inédits de tombes médiévales bourguignonnes de la collection Gaignières', *idem.*, CVIII (1986), 97–122, 141–82.

122. St Louis's other five children were possibly shown on the opposite wall to the north. For the drawings and a discussion of the programme see A. Erlande-Brandenburg, 'La priorale Saint-Louis de Poissy', *Bulletin Monumental*, CXXIX (1971), 85–112, figs 8–12.

123. M. Beaulieu, 'Une tête d'ange provenant du prieuré royal de Saint-Louis de Poissy', *Monuments et Mémoires. Fondation Eugène Piot*, XLVII (1953), 171–80; A. Erlande-Brandenburg, 'L'identification de la statue de Pierre d'Alençon provenant de l'église du prieuré de Saint-Louis de Poissy', *Bulletin de la Société nationale des Antiquaires de France*, 1968, 154–60; *La France de Saint Louis* (exh. cat., Paris, 1970), cat. nos 34–7; A. Erlande-Brandenburg, 'A propos d'une tête d'ange provenant de la priorale de Saint-Louis de Poissy', in *Hommage à Hubert Landais. Art, Objets d'art, collections: études sur l'art du Moyen Age et de la Renaissance, sur l'histoire du goût et des collections* (Paris, 1987), 36–8.

124. *Idem.*, 'La tête du gisant de Jeanne de Toulouse', *La Revue du Louvre et des Musées de France*, XXI (1971), 237–46.

125. This was destroyed by fire in 1618: J.-P. Babelon, *Le Palais de Justice, La Conciergerie, La Sainte-Chapelle de Paris* (Paris, 1973), 30.

CHAPTER 8

1. T. G. Frisch, *Gothic Art 1140–c.1450. Sources and documents* (Englewood Cliffs, N.J., 1971), 56. The surviving thirteenth-century sculpture at Wimpfen im Tal, in the choir and on the south portal, is much restored but shows the influence of Strasbourg rather than Paris: see A. Zeller, *Die Stiftskirche St Peter zu Wimpfen im Thal* (Wimpfen, 1903), cols 50–2, pls XX, XXVIII, XXXII). A concise survey of German Gothic architecture in the second half of the thirteenth century is contained in L. Grodecki, *Gothic Architecture* (London, 1986), 130–7.

2. On this point see E. Badstübner, 'Justinianssäule und Magdeburger Reiter', in F. Möbius and E. Schubert (eds), *Skulptur des Mittelalters: Funktion und Gestalt* (Weimar, 1987), 184–210. The different interpretations placed on the Rider are summarised by V. Roehrig Kaufmann, 'Magdeburg Rider group: state of research and preliminary suggestions for further work', in E. Ullmann (ed.), *Der Magdeburger Dom: ottonische Gründung und staufischer Neubau* (Leipzig, 1989), 205–10, and *idem.*, 'The Magdeburg Rider: an aspect of the reception of Frederick II's Roman Revival north of the Alps', in W. Tronzo (ed.), *Intellectual Life at the Court of Frederick II* (National Gallery of Art, Washington, Studies in the History of Art, 44; Hanover and London, 1994), 63–88: her dating of the Rider to before 1232 is circumstantial. Of the earlier contributions the most notable are H. von Einem, 'Zur Deutung des Magdeburger Reiters', *Zeitschrift für Kunstgeschichte*, XVI (1953), 43–60; B. Schwineköper, 'Zur Deutung der Magdeburger Reitersäule', in *Festschrift Percy Ernst Schramm* (Wiesbaden, 1964), I, 117–42; and E. Schubert, 'Magdeburg und der Magdeburg Reiter', *Wissenschaftlicher Zeitschrift der Friedrich Schiller-Universität Jena (Gesell. -sprachwiss. Reihe 30)* (1981), 363–75.

3. See the juxtaposed photographs in D. Schubert, *Von Halberstadt nach Meissen: Bildwerke des 13. Jahrhunderts in Thüringen, Sachsen und Anhalt* (Cologne, 1974), figs 110–12, and the extended discussion of the Rider on pp. 287–93.

4. The tympanum of the Paradise porch contains the Death and Assumption of the Virgin: for an illustration see E. Schubert, *Stätten sächsischer Kaiser* (Leipzig, 1990), 104.

5. For photographs of all the sculptures see D. Schubert, *op. cit.*, figs 107, 115, 120, 122–3, 127–36; the various interpretations of the seated pair up to 1974 are given on pp. 285–7. On this last point (which centres around the nineteen balls contained within the disc held by the male figure) see also W. Sauerländer in *Die Zeit der Staufer* (exh. cat., Stuttgart, 1977), I, cat. no. 460; G. Strohmaier, 'Die neunzehn Kugeln des Pantokrators. Ein orientalisches Motiv an der Sponsus-Sponsa-Plastik des Magdeburger Doms', in J. Dummer and J. Irmscher (eds), *Byzanz in der europäischen Staatenwelt* (Berlin, 1983), 30–9; H. Sciurie, 'Das thronende Kaiserpaar im Magdeburger Dom', in F. Möbius and H. Sciurie (eds), *Symbolwerte mittelalterliche Kunst* (Leipzig, 1984), 90–129; A. Krohner, 'Untersuchung des Reifens mit den 19 Kugeln-Attribut des Sponsus der Magdeburger Sitzgruppe', *idem*, 159 ff. The Coronation of the Virgin has been suggested by R. Kroos ('Quellen zur liturgischen Benutzung des Domes und zu seiner Ausstattung', in Ullmann, *op. cit.*, 89).

6. The *Lettner* hypothesis was first put forward by F. Bellmann ('Die klugen und törichten Jungfrauen und der Lettner im Magdeburger Dom', *Festschrift für Harald Keller* (Darmstadt, 1963), 87–110), and enthusiastically embraced by D. Schubert, *op. cit.*, 301–5 (for a reconstruction see p. 68).

7. E. Schubert, 'Der Magdeburger Dom. Ottonische Gründung und staufischer Neubau', in Ullmann, *op. cit.*, 38–9. In addition it is not certain that the figures shown in the drawing of the Hamburg *Lettner* (Bellmann, *op. cit.*, fig. 4) are the Wise and Foolish Virgins: one of them appears to be holding a shield.

8. The arrangement and type of the Wise and Foolish Virgins on the west 'triangle' portal of Erfurt Cathedral of about 1330, possibly based on the earlier Magdeburg portal, may support this interpretation (E. Lehmann and E. Schubert, *Dom und Severikirche Erfurt* (Stuttgart, 1988), pls 14–17). If the earlier portal theory is accepted for the Wise and Foolish Virgins and the *Lettner* hypothesis rejected, there remains the problem of the original location of the other eight figures.

9. Another Virgin and Child, in the Dommuseum in Mainz (the 'Madonna aus der Fuststrasse') is also a product of the workshop: see W. Boeck, 'Eine Muttergottes des 13. Jahrhunderts im Bamberger Dom und ihre Zusammenhänge mit Magdeburg und Mainz', in *Mainz und der Mittelrhein in der europäischen Kunstgeschichte: Studien für W. F. Volbach zu seinem 70. Geburtstag* (Mainz, 1966), 273–88. The connection between the Magdeburg Virgins and the later sculptures of the Reims west façade proposed by Sauerländer (*Zeit der Staufer, op. cit.*, I, 341) is in my opinion unconvincing, and the latter are in any case probably later than the Magdeburg figures.

10. See P. H. D. Kaplan, 'Black Africans in Hohenstaufen iconography', *Gesta*, XXVI (1987), 29–36, and G. Suckale-Redlefsen, with the collaboration of R. Suckale, *Mauritius: der heilige Mohr. The Black Saint Maurice* (Houston and Zurich, 1988) for the changing perception and representation of black Africans in the thirteenth century and later Middle Ages. Magdeburg's affiliation with St Maurice had been strengthened in 1220 with the acquisition of his cranium; this would have occupied a place of honour, encased in a reliquary, in the new choir (H. Sciurie, 'Zur Bedeutung der Chorskulpturen im Magdeburger Dom', in Ullmann, *op. cit.*, 164).

11. Wolfram von Eschenbach, *Parzifal* (translated by A. T. Hatto) (London, 1980), 26.

12. On this phenomenon see K. Brush, 'The Naumburg Master: a chapter in the development of medieval art history', *Gazette des Beaux-Arts*, 6th series, CXXII (1993), 109–22.

13. The quote is from Brush, *op. cit.*, 122, n. 59, following P. C. Claussen in R. Hamann-MacLean, *Stilwandel und Persönlichkeit. Gesammelte Aufsätze 1935–1982* (Stuttgart, 1988), 7.

14. See A. Peschlow-Kondermann, *Rekonstruktion des Westlettners und der Ostchoranlage des 13. Jahrhunderts im Mainzer Dom* (Wiesbaden, 1972), for a catalogue of the fragments and reconstruction drawings, and R. Hamann-MacLean, 'Ein Fragment vom Mainzer Westlettner aus der Sammlung Weihrauch. Neue Überlegungen zur Ikonographie des Weltgerichts-Frieses. Studien zum Problem des Naumburger Meisters IV', in *Kunst und Kultur am Mittelrhein. Festschrift für Fritz Arens zum 70. Geburtstag* (Worms, 1982), 48–65 (reprinted in Hamann-MacLean, *op. cit.* (1988), 469–86). For comments on Peschlow-Kondermann's reconstruction see D. von Winterfeld's review in *Zeitschrift für Kunstgeschichte*, XXXVII (1974), 67–78. There is in addition a doctoral dissertation by K. L. Brush, *The west choir screen at Mainz Cathedral: questions on its style, patronage and meaning* (Brown University (U.S.A.), 1987).

15. See the comparison of the Virgin of the Mainz Deesis with one of the Wise Virgins at Amiens by H. Beenken, *Der Meister von Naumburg* (Berlin, 1939), figs 6–7; he also suggests the contribution of the young Naumburg Master in the Amiens quatrefoil reliefs, following Hermann Giesau ('Der Naumburger Bildhauer in Amiens', *Jahrbuch für Kunstwissenschaft*, II (1924–25), 201–6) and Wolfgang Medding (*Die Westportale der Kathedrale von Amiens und ihre Meister* (Augsburg, 1930), 127–30).

16. H. Reinhardt, 'Die gotischen Lettner des Domes zu Mainz', in *Mainz und der Mittelrhein (op. cit.)*, 219–33; R. Hamann-MacLean, 'Der Atlant aus dem Ostchor des Mainzer Domes und Reims. Studien zum Problem des Naumburger Meisters III', *Jahrbuch der Vereinigung 'Freunde der Universität Mainz'*, XX (1971), 22–43 (reprinted in Hamann-MacLean, *op. cit.* (1988), 435–67).

17. O. Schmitt, 'Das Liebfrauenportal der Kathedrale von Metz', *Elsass-Lothringisches Jahrbuch*, VIII (1929), 92–110; R. H. L. Hamann, 'Der Naumburger Meister in Noyon', *Zeitschrift des deutschen Vereins für Kunstwissenschaft*, II (1935), 425–9 (reprinted in Hamann-MacLean, *op. cit.* (1988), 385–90), and *idem.*, *op. cit.* (1971). For a rebuttal of the Metz-Mainz-Naumburg connection see J. A. Schmoll gen. Eisenwerth, 'Mainz und der Westen. Stilistische Notizen zum "Naumburger Meister", zum Liebfrauenportal und zum Gerhardkopf', in *Mainz und der Mittelrhein, (op. cit.)*, 289–302, and W. Sauerländer, *Gothic Sculpture in France 1140–1270* (London, 1972), 496.

18. G. Bandmann, 'Zur Deutung des Mainzer Kopfes mit der Binde', *Zeitschrift für Kunstwissenschaft*, X (1956), 153–74; Peschlow-Kondermann, *op. cit.*, 36–7, fig. 181, plan I.

19. This was first published by H. Schnitzler, 'Ein unbekanntes Reiterrelief aus dem Kreise des Naumburger Meisters', *Zeitschrift des deutschen Vereins für Kunstwissenschaft*, II (1935), 399–423. A review of the subsequent literature is to be found in W. Sauerländer's catalogue entry on the relief in *Die Zeit der Staufer,*

op. cit., I, no. 451; Sauerländer questions the Mainz provenance and tentatively suggests that the relief was made for the Martinskirche at Bassenheim.

20. Compare the head of the beggar, for instance with the balding head in the north tower at Reims (Sauerländer, *op. cit.* (1972), pl. 257, middle left). The same type of bald head, with long flowing locks at the sides, was also borrowed by the Mainz sculptor for one of the figures rising from the tomb (Beenken, *op. cit.*, fig. 19, and Hamann, *op. cit.*, for a connection with Noyon).

21. For the 1249 document and the motives behind the creation of the Naumburg west choir programme see the important publications by W. Schlesinger, *Meissner Dom und Naumburger Westchor. Ihre Bildwerke in geschichtlicher Betrachtung* (Münster-Cologne, 1952), 33–97, and E. Schubert, *Der Westchor des Naumburger Doms. Ein Beitrag zur Datierung und zum Verständnis der Standbilder* (Abhandlungen der deutschen Akademie der Wissenschaften zu Berlin, Klasse für Sprachen, Literatur und Kunst, Jahrgang 1964, I), 40–50; also W. Sauerländer, 'Die Naumburger Stifterfiguren: Rückblick und Fragen', *Die Zeit der Staufer, op. cit.*, V (1979), 169–245, esp. 213–26.

22. There is a large literature on the Naumburg west choir figures, listed by D. Schubert at the end of his discussion of the sculptural ensemble, *op. cit.*, 305–16; to this should be added the succinct summary of W. Sauerländer in *Die Zeit der Staufer, op. cit.*, I, 332–5, cat. no. 452; E. Schubert, 'Zur Naumburg-Forschung der letzten Jahrzehnte', *Wiener Jahrbuch für Kunstgeschichte*, XXXV (1982), 121–38; W. Sauerländer and J. Wollasch, 'Stiftergedenken und Stifterfiguren in Naumburg', in K. Schmid and J. Wollasch (eds), *Memoria. Der geschichtliche Zeugniswert des liturgischen Gedenkens in Mittelalter* (Munich, 1984), 354–83; and E. Schubert, 'Memorialdenkmäler für Fundatoren in drei Naumburger Kirchen des Hochmittelalters', *Frühmittelalterliche Studien*, XXV (1991), 205–25.

23. The figures are comprehensively illustrated in Beenken, *op. cit.*; for Reglindis see figs 42, 49–50.

24. Brief mention should be made of the other four figures. Count Dietrich von Brehna and his wife Gerburg face each other on the easternmost piers. The identity of the remaining female figure on the north side is not clear: she could either be Gepa, wife of Count Wilhelm von Camburg (shown further west), or her mother Berchta – both are mentioned in the 1249 appeal, but the latter was not buried in Naumburg (D. Schubert, *op. cit.*, 306; for a detailed discussion see W. Sauerländer in *Die Zeit der Staufer, op. cit.*, V (1979), 199–202). The much restored male figure facing her on the south side is Konrad von Landsberg (Beenken, *op. cit.*, fig. 101, and *Die Zeit der Staufer*, V, fig. 98, for illustrations of the figure with different heads).

25. The last two reliefs are replacements in wood for the destroyed originals.

26. For illustrations of the *Westlettner* see Beenken, *op. cit.*, figs 61–98, and E. Schubert, *Der Dom zu Naumburg: Architektur und Bildwerke* (Berlin, 1990), pls 40–55. The dramatic aspect of the reliefs is commented on by P. Kidson, 'A note on Naumburg', in *Romanesque and Gothic. Essays for George Zarnecki* (Woodbridge, 1987), 143–6, and the depiction of the Jews is placed in context by A. Weber, 'Die Entwicklung des Judenbildes im 13. Jahrhundert und sein Platz in der Lettner- und Tympanonskulptur. Fragen zum Verhältnis von Ikonographie und Stil', *Städel-Jahrbuch*, new series, XIV (1993), 35–54.

27. For the foliate sculpture see L. Behling, *Die Pflanzenwelt der mittelalterlichen Kathedralen* (Cologne, 1964), 90–112; for the stained glass, E. Schubert, 'Zum ikonographischen Programm der Farbverglasung im Westchor des Naumburger Doms', in R. Becksmann (ed.), *Deutsche Glasmalerei des Mittelalters*, II, *Bildprogramme, Auftraggeber, Werkstätten* (Berlin, 1992), 43–52.

28. D. Schubert (*op. cit.*, figs 172–3) compares the gathered drapery in Uta's left hand with that of Elizabeth at Bamberg, which as we have seen in chapter 2 reflects similar treatment at Reims.

29. For the Naumburg Master as architect see R. Hamann-MacLean, 'Die Burgkapelle von Iben. Beiträge zum Problem des Naumburger Meisters II', in *Mainz und der Mittelrhein*, (*op. cit.*), 233–72.

30. K. Morand, *Claus Sluter. Artist at the Court of Burgundy* (London, 1991), 60–4, 85–9, 133–7. See also the remarks on workshop size in the introduction (pp. 6–7).

31. The three figures now in the octagonal chapel were perhaps intended for somewhere else, possibly a *Lettner* or chapel. D. Schubert (*op. cit.*, 319–22) gives a summary of previous writers' opinions on the placing of all seven figures; see also E. Schubert, *op. cit.* in note 4 (1990), 257–64, and for a full set of illustrations Beenken, *op. cit.*, figs 110–23. For a general survey of the building see E. Lehmann and E. Schubert, *Der Meissner Dom. Beiträge zur Baugeschichte und Baugestalt bis zum Ende des 13. Jahrhunderts* (Berlin, 1968), and idem, *Der Dom zu Meissen* (2nd edition, Berlin, 1975).

32. R. W. Lightbown, *Mediaeval European Jewellery, with a catalogue of the collection in the Victoria & Albert Museum* (London, 1992), 102, 143–4, figs 50–3.

33. Sauerländer, *op. cit.* (1972), 496–7, pl. 281, ill. 103; M.-C. Burnand, *La Lorraine gothique* (Paris, 1989), 176–7. Also see note 17.

34. With the exception of the tympanum and voussoirs all the sculptures on and around the west portal are modern copies; the four original prophets are now

in Berlin, and the figures of the Annunciation, *Ecclesia*, *Synagoga*, St John the Evangelist, Noah and Abraham in the Bischöfliche Dom- und Diözesanmuseum in Trier. See H. Bunjes, 'Die Skulpturen der Liebfrauenkirche in Trier', *Trierer Zeitschrift*, XII (1937), 180–226; E. M. Vetter and W. A. Bulst, 'Das Figurenprogramm am Westportal der Liebfrauenkirche in Trier', *Ruperto-Carola*, XLIII–XLIV (1968), 123–31; *Die Zeit der Staufer, op. cit.*, I, cat. no. 448; *Das neue Bischöfliche Dom- und Diözesanmuseum. Bildband zur Wiedereröffnung* (Trier, 1988), 34–7, pls 12–13; for the building history see N. Borger-Keweloh, *Die Liebfrauenkirche in Trier. Studien zur Baugeschichte* (Trier, 1986).

35. The tympanum of the north portal of the Liebfrauenkirche, showing the Coronation of the (standing) Virgin is probably slightly later, perhaps *c*.1260, showing as it does points of contact with the later Reimsian work (*Die Zeit der Staufer, op. cit.*, I, cat. no. 449, II, fig. 250).

36. Sauerländer, *op. cit.* (1972), 498–9, pl. 282 right; for the Reims angels, *ibid.*, pls 251–3.

37. Two further figures stood on consoles at the eastern corners of the north and south sides. For the drawings and engravings see O. Schmitt, 'Zum Strassburger Lettner', *Oberrheinische Kunst*, II (1926–7), 62–6, pls 35–40; J. J. Rorimer, 'The Virgin from Strasbourg Cathedral', *The Metropolitan Museum of Art Bulletin*, VII (1949), 220–7; and Sauerländer, *op. cit.* (1972), ill. 104. The interpretation of the choirscreen put forward by B. Chabrowe ('Iconography of the Strasbourg Cathedral choir screen', *Gesta*, VI (1967), 35–9) would seem to be at fault in proposing that six of the fourteen figures were prophets.

38. V. Beyer, *La sculpture médiévale du Musée de l'Œuvre Notre-Dame* (Strasbourg, 1956), cat. nos 96–105; Rorimer, *op. cit.*; J. G. Noppen, 'An unknown thirteenth-century figure', *Burlington Magazine*, LIII (1928), 250–5 (where the Toledo figure is wrongly associated with Westminster); see also R. Will, 'Le jubé de la cathédrale de Strasbourg. Nouvelles données sur son décor sculpté', *Bulletin de la Société des Amis de la Cathédrale de Strasbourg*, X (1972), 57–68; H. Reinhardt, *La Cathédrale de Strasbourg* (Strasbourg, 1972), 119–22.

39. W. Wiegand (ed.), *Urkundenbuch der Stadt Strassburg*, I (Strasbourg, 1879), 285, entry 374; the translation is that provided in Frisch, *op. cit.*, 67–8. See also H. Haug, 'Les oeuvres de miséricorde du jubé de la cathédrale de Strasbourg', *Archives alsaciennes d'histoire de l'art*, X (1931), 99–122. Bishop Walter's document of 1261 is cited in H. Reinhardt, 'Les textes relatifs à l'histoire de la cathédrale de Strasbourg depuis les origines jusqu'à l'année 1522', *Bulletin de la Société des Amis de la Cathédrale de Strasbourg*, 2nd series, VII (1960), 16.

40. For the reference to the choirscreen in 1261 see Sauerländer, *op. cit.* (1972), 498, where he also points out that the mention of an '*altare civitatis in ecclesia beatae Mariae Argentinensis*' in 1252 does not necessarily have anything to do with the choirscreen. Will (*op. cit.*, 62ff.) suggests that a relief of the Sacrifice of Abraham and the so-called '*petite église*' came originally from an earlier choirscreen contemporary with the south transept and were possibly reused on the later structure: this is unlikely (for these two sculptures see also *Die Zeit der Staufer, op. cit.*, I, cat. nos 482 and 485, II, figs 287 and 290).

41. H. Reinhardt, 'Le jubé de la cathédrale de Strasbourg et ses origines rémoises', *Bulletin de la Société des Amis de la Cathédrale de Strasbourg*, VI (1951), 18–28; P. Kurmann (*La façade de la cathédrale de Reims* (Lausanne, 1987), 26–7 and 285) accepts a direct relationship between Reims and Strasbourg and prefers a date of around 1265–70 for the choirscreen.

42. The tomb slab was repainted in oils in 1834, reputedly after the older colour scheme; see *Die Zeit der Staufer, op. cit.*, I, cat. no. 450, and F. Arens, *Der Dom zu Mainz* (Darmstadt, 1982), 88–90.

43. *Ibid.*, 90–2, fig. 30; all the medieval funerary monuments in Mainz Cathedral are fully discussed in G. Kniffler, *Die Grabdenkmäler der Mainzer Erzbischöfe vom 13 bis zum frühen 16. Jahrhundert* (Cologne-Vienna, 1978).

44. D. Schubert, *op. cit.*, 316–18, cat. no. 187, and now E. Schubert, 'Das Grabmal des Ritters von Hagen im Merseburger Dom', *Jahrbuch für Regionalgeschichte und Landeskunde*, XVII/2 (1990), 62–73.

45. A. Legner, 'Die Grabfigur des Erzbischofs Konrad von Hochstaden im Kölner Dom', in *Intuition und Kunstwissenschaft. Festschrift für Hanns Swarzenski zum 70. Geburtstag am 30. August 1973* (Berlin, 1973), 261–90, esp. 267–74.

46. K. Bauch, *Das mittelalterliche Grabbild. Figürliche Grabmäler des 11. bis 15. Jahrhunderts in Europa* (Berlin and New York, 1976), 74–8, fig. 111.

47. In addition to Legner's article cited above, reference should be made to H. Rode, 'Plastik des Kölner Doms in der zweiten Hälfte des 13. Jahrhunderts. Das Hochstaden-Grabmal und die Chorpfeilerskulpturen', in *Rhein und Maas: Kunst und Kultur 800–1400*, 2 (Cologne, 1973), 429–44; idem, 'Zur Grablege und zum Grabmal des Erzbischof Konrad von Hochstaden', *Kölner Domblatt*, XLIV–XLV (1979–80), 203–22; U. Bergmann and R. Lauer, 'Die Domplastik und die Kölner Skulptur', in *Verschwundenes Inventarium. Der Skulpturenfund im Kölner Domchor* (exh. cat., Cologne, 1984), 38.

48. N. Rogers, 'English episcopal monuments, 1270–1350', in J. Coales (ed.), *The Earliest English Brasses. Patronage, style and workshops 1270–1350* (London, 1987), 21–2, fig. 11.

49. An extremely full account of the effigy with excellent photographs is found

in *Die Gründer von Laach und Sayn. Fürstenbildnisse des 13. Jahrhunderts* (exh. cat., Nuremberg, 1992), 88–198 (essays by R. Kahsnitz, W. Haas and E. Oellermann). I would agree with Kahsnitz's dating of the effigy to 1270–80, but for an earlier date (*c*.1255) see R. Suckale, 'Die Kölner Domchorstatuen. Kölner und Pariser Skulptur in der 2. Hälfte des 13. Jahrhunderts', *Kölner Domblatt*, XLIV–XLV (1979–80), 224.

50. The standard work is now U. Bergmann, *Schnütgen-Museum. Die Holzskulpturen des Mittelalters (1000–1400)* (Cologne, 1989): for the Ollesheim and Kendenich Virgins see cat. nos 32 and 35, for a short discussion on Cologne wood sculpture of the thirteenth century see pp. 23–7. The bust in St Ursula is illustrated on p. 27, fig. 16. A. Legner was inclined to date the sculptures later than Bergmann, to around 1290–1300 ('Anmerkungen zu einer Chronologie der gotischen Skulptur des 13. und 14. Jahrhunderts im Rhein-Maas-Gebiet', in *Rhein und Maas*, 2, *op. cit.*, 445–56 (451)).

51. E. Dinkler von Schubert, *Der Schrein der Hl. Elisabeth zu Marburg* (Marburg, 1964).

52. F. Küch, 'Die Landgrafendenkmäler in der Elisabethkirche zu Marburg. Ein Beitrag zur hessischen Kunstgeschichte', *Zeitschrift des Vereins für hessische Geschichte und Landeskunde*, XXXVI (1903), 145–225; R. Hamann and K. Wilhelm-Kästner, *Die Elisabethkirche zu Marburg und ihre künstlerische Nachfolge, II, Die Plastik* (Marburg, 1929); J. A. Holladay, 'Die Elisabethkirche als Begräbnisstätte', in *Elisabeth, der Deutsche Orden und ihre Kirche. Festschrift zur 700 jährigen Wiederkehr der Weihe der Elisabethkirche Marburg* (Marburg, 1983), 323–38.

53. *Die Gründer von Laach und Sayn*, *op. cit.*, 59–65.

54. The fullest discussion is to be found in A. Hubel, 'Der Erminoldmeister und die deutsche Skulptur des 13. Jahrhunderts', *Beiträge zur Geschichte des Bistums Regensburg*, VIII (1974), 53–241 (for the Erminoldus effigy see especially 183–97, figs 19–22); see also the succinct summary in *idem*, 'Der Erminoldmeister', *Regensburger Almanach*, XXVI (1993), 197–207.

55. Hubel, *op. cit.* (1974), 120 and fig. 46 (Colmar), 124–8 and figs 49–51 (Constance), 146–60 and figs 1–13 (Basel); W. Sauerländer, 'Das Stiftergrabmal des Grafen Eberhard in der Klosterkirche zu Murbach', in K. Badt and M. Gosebruch (eds), *Amici Amico. Festschrift für Werner Gross* (Munich, 1968), 59–77.

56. Hubel, *op. cit.* (1993), 201–2, and A. Hubel and P. Kurmann, *Der Regensburger Dom: Architektur, Plastik, Ausstattung, Glasfenster* (Munich-Zürich, 1989), 40–1, fig. 23.

57. The connections mooted with sculpture in Saxony (Magdeburg, Halberstadt) do not seem to me to be convincing (D. Schubert, *op. cit.*, 323–4); in my opinion they are different reflections of the most celebrated models of the mid-century.

58. Hubel and Kurmann, *op. cit.*, 41.

59. The connection between the *Erminoldmeister* and *Magister Ludwicus* was first proposed by Alfred Schädler through the unlikely vehicle of the *Kalender 1970 der Bayerischen Versicherungskammer München* (Munich, 1969) (captions to colour plates 1 and 7).

60. R. Kahsnitz, 'Sculpture in stone, terracotta, and wood', in *Gothic and Renaissance Art in Nuremberg 1300–1550* (exh. cat., New York, 1986), 64–5, fig. 72; J. Viebig *et al.*, *Die Lorenzkirche in Nürnberg* (3rd ed., Königstein im Taunus, 1990), 29.

61. For the various drawings see R. Recht (ed.), *Les bâtisseurs des cathédrales gothiques* (exh. cat., Strasbourg, 1989), 381–9; the progress of the work is laid out in Reinhardt, *op. cit.*, 18–21.

62. The two lateral tympana, the upper tier of the central tympanum and the voussoirs of all three doorways were destroyed in 1793 and replaced in the nineteenth century.

63. Beyer, *op. cit.*, cat. nos 133–43. The most complete photographic coverage of the Strasbourg west front sculptures is to be found in O. Schmitt, *Gotische Skulpturen des Strassburger Münsters* (2 vols, Frankfurt am Main, 1924). For a recent discussion of the central portal, with a summary of the older literature, see N. Gramaccini, 'Eine Statue Vergils im Strassburger Prophetenportal', in H. Beck and K. Hengevoss-Dürkop (eds), *Studien zur Geschichte der europäischen Skulptur im 12/13. Jahrhundert* (Frankfurt am Main, 1994), I, 739–61.

64. E. Panofsky, *Tomb Sculpture* (New York, 1964, reprinted London, 1992), 63–5, figs 257–8.

65. O. Schmitt, *Gotische Skulpturen des Freiburger Münsters* (Frankfurt am Main, 1926), pl. 119; H. Reinhardt, *Das Basler Münster* (2nd ed., Basel, 1949), pls 112–14; K. Martin, *Die Nürnberger Steinplastik im XIV. Jahrhundert* (Berlin, 1927), figs 93–5.

66. Reinhardt (*op. cit.* (1972), 128–31) summarises the Parisian and *champenoise* stylistic traits.

67. H. Keller, 'Zur inneren Eingangswand der Kathedrale von Reims', in M. Kühn and L. Grodecki (eds), *Gedenkschrift Ernst Gall* (Munich and Berlin, 1965), 250–1, figs 152–7. The parallels sometimes drawn with the two prophets in Troyes are less clear-cut (Reinhardt, *op. cit.* (1972), 130–1).

68. E. Adam, *Das Freiburger Münster* (Stuttgart, 1968), 57. For the significance

of the goat's skin see R. Hamann, 'The Girl and the Ram', *Burlington Magazine*, LX (1932), 91–7.

69. For a reconstruction see A. Hubel, 'Das ursprüngliche Programm der Skulpturen in der Vorhalle des Freiburger Münsters', *Jahrbuch der Staatlichen Kunstsammlungen in Baden-Württemberg*, XI (1974), 21–45, fig. 10. The fullest treatment of the sculptures is now F. Kobler, *Der Jungfrauenzyklus der Freiburger Münstervorhalle* (Doctoral dissertation, Berlin, 1966; Bamberg, 1970), but see also O. Schmitt, *op. cit.* (1926), G. Münzel, *Der Skulpturenzyklus in der Vorhalle des Freiburger Münsters* (Freiburg im Breisgau, 1959), and W. Hart, *Die Skulpturen des Freiburger Münsters* (2nd ed., Freiburg, 1980).

70. It only became a cathedral in 1827.

71. For one of these, dated 1295, see W. Hart (with E. Adam), *Das Freiburger Münster* (Freiburg im Breisgau, 1978), pl. 108.

72. Reinhardt, *op. cit.* (1949), pls 110–17.

73. For Basel see Hubel, *op. cit.* (note 54, 1974), 154, quoting H. Reinhardt, 'Die Urkunden und Nachrichten über den Baseler Münsterbau bis zum Jahre 1300', *Oberrheinische Kunst*, III (1928), 130; for Freiburg, H. Jantzen, *Das Münster zu Freiburg* (Burg bei Magdeburg, 1929), 19.

74. The words are those of the chronicler Jean d'Outremeuse, who referred to Enguerrand as 'un très-suffisans ovriers et voloit-on dire qu'ilh n'avoit pas le parelh en monde': see M. Devigne, *La sculpture mosane du XIIe au XVIe siècle* (Paris-Brussels, 1932), 46, and R. Didier, 'Sculpture, miniature et vitrail au 13e siècle', in *Rhin-Meuse: Art et Civilisation 800–1400* (exh. cat., Cologne and Brussels, 1972), 325. For an eighteenth-century engraving of Saint-Lambert, showing the north portal (albeit indistinctly), see J. J. M. Timmers, *De kunst van het Maasland, II, De Gotiek en de Renaissance* (Assen, 1980), fig. 38.

75. Timmers, *op. cit.*, fig. 139; R. Didier, 'La sculpture mosane de la 2e moitié du XIIIe siècle', in *Rhein und Maas*, 2, *op. cit.*, 421–8.

76. C. Klack-Eitzen, *Die thronenden Madonnen des 13. Jahrhunderts in Westfalen* (Bonn, 1985); M. Anczykowski, *Westfälische Kreuze des 13. Jahrhunderts* (Münster, 1992); W. Sauerländer, 'Die kunstgeschichtliche Stellung der Figurenportale des 13. Jahrhunderts in Westfalen. Zum Stand der Forschung', *Westfalen*, XLIX (1971), 60–76.

77. U. Bergmann, *Das Chorgestühl des Kölner Domes* (2 vols, Neuss, 1987); H. Rode, *Die mittelalterlichen Glasmalereien des Kölner Domes (Corpus Vitrearum Medii Aevi)* (Berlin, 1974); *Verschwundenes Inventarium* (*op. cit.*), 43–5. For the building history see P. Clemen, *Der Dom zu Köln (Kunstdenkmäler der Rheinprovinz)* (2nd ed., Düsseldorf, 1938), and A. Wolff, *The Cathedral of Cologne* (3rd ed., Stuttgart, 1989), 11–15 and *passim*.

78. R. Branner, *St Louis and the Court Style in Gothic Architecture* (London, 1965, reprinted 1985), 128–32.

79. Rode (*op. cit.*, 440) dates the apostles to around 1270–80; Suckale (*op. cit.*, 247) prefers a date of around 1290–1300, while most of the earlier publications (notably W. Medding, 'Die Hochchorstatuen des Kölner Domes und ihr künstlerischer Ursprung', *Wallraf-Richartz-Jahrbuch*, IX (1936), 108–47) placed them just prior to the dedication of the choir, in about 1320. The designs on the garments are studied by B. Beaucamp-Markowsky, 'Zu den Gewandmustern der Chorpfeilerfiguren im Kölner Dom', *Kölner Domblatt*, XLII (1977), 75–92.

80. The surviving fragments of the tabernacle are preserved in the cathedral depot: see R. Lauer, 'Das Grabmal des Rainald von Dassel und der Baldachin der Mailänder Madonna', in *Verschwundenes Inventarium* (*op. cit.*), 11–18; see also G. Kaltenbrunner and B. Landgrebe, 'Die Mailander Madonna im Kölner Dom. Konservatorische Massnahmen und Zusammenfassung der Untersuchungsberichtes', *Kölner Domblatt*, XXIII (1978), 201–6.

81. U. Bergmann, E. Jägers and R. Lauer, 'Mittelalterliche Skulpturenfragmente aus dem Kölner Domchor', *Kölner Domblatt*, XLVII (1982), 9–50; U. Bergmann, 'Der Skulpturenfund im Kölner Domchor', in *Verschwundenes Inventarium* (*op. cit.*), 19–36.

82. Hamann and Wilhelm-Kästner, *op. cit.*, II, 75–9, figs 108–9.

83. *Ibid.*, 91–112.

84. The fullest discussion remains that of G. Grundmann ('Das gotische Portal der Hedwigskapelle in Trebnitz', in A. Zinkler, D. Frey and G. Grundmann, *Die Klosterkirche in Trebnitz* (Breslau, 1940), 149–78) but see also M. Kutzner, 'Der gotische Umbau der Klosterkirche in Trebnitz (Trzebnica)', *Kunst des Mittelalters in Sachsen: Festschrift Wolf Schubert* (Weimar, 1967), 107–16. Another, slightly earlier (*c*.1260), double-sided tympanum is to be found in the Lower Silesian church of Stary Zamek: this shows the seated figures of the Virgin and St Stanislas on the outside and the glorification of St Stanislas's martyrdom on the inside (J. Pietrusinski, 'Portal św. Staniława w Starym Zamku', *Biuletyn Historii Sztuki*, XXX (1968), 346–55; P. Crossley, 'Kasimir the Great at Wiślica', in *Romanesque and Gothic: Essays for George Zarnecki* (*op. cit.*), 47, pl. 10).

85. Grundmann, *op. cit.*, 171–2, fig. 122, and C. Gündel, *Das schlesische Tumbengrab im XIII. Jahrhundert* (Strasbourg, 1926), 17–26, pls I–IV. A further drawing of an effigy of a knight – identical with that in Merseburg Cathedral – has been tentatively associated with the Minoritenkirche at Swidnica (Schweidnitz) in Lower Silesia (*ibid.*, 52–4, pl. 16); however, no other evidence

strengthens the case for a Silesian provenance and because the drawing was once in the possession of a canon of Merseburg it is highly likely that it is simply a record of the tomb in Saxony.

86. The statue of Konrad was destroyed in 1831; see J. Kęblowski, 'Posag Ksieżny Salomei Głogowskiej' ('The statue of Princess Salomea of Głogów'), *Studia Muzealne*, V (1966), 19–48 (English summary on pp. 47–8) and M. Zlat, 'Schlesische Kunst des Mittelalters in den polnischen Forschungen seit 1945', *Kunst des Mittelalters in Sachsen, op. cit.*, 165–6, fig. 6.

87. I am inclined to date the effigy of Henry IV, Duke of Silesia, Cracow and Sandomierz (died 1290), from the collegiate church of the Holy Cross in Wrocław, to about 1320 rather than the slightly earlier date of *c.*1300 sometimes assigned to it. See Gündel, *op. cit.*, 29–48; O. von Simson (ed.), *Das Mittelalter, II (Propyläen Kunstgeschichte, VI)* (Berlin, 1972), 296, pl. 307; Bauch, *op. cit.*, 135–6, fig. 217.

88. For a summary of Bohemian sculpture in the second half of the thirteenth century see A. Kutal, 'Gotické sochařství', in R. Chadraba, V. Denkstein, J. Krása (eds), *Dějiny českého výtvarného umění*, I/1 (Prague, 1984), 216–24. The church of Our Lady in Buda is succinctly covered in G. Biegel (ed.), *Budapest im Mittelalter* (exh. cat., Brunswick, 1991), 166–8.

89. See T. Müller, *Sculpture in the Netherlands, Germany, France and Spain 1400–1500* (Pelican History of Art, Harmondsworth, 1966), 1–46; E. Bachmann (ed.), *Gothic Art in Bohemia* (Oxford, 1977), and most importantly, *Die Parler und der Schöne Stil 1350–1400. Europäischen Kunst unter den Luxemburgern* (exh. cat., 3 vols, Cologne, 1978).

CHAPTER 9

1. H. M. Colvin (ed.), *The History of the King's Works*, Vol. I (London, 1963), 131. The account of the building of Westminster Abbey contained in Colvin (130–57) remains fundamental to any further study, supplemented by the same author's *Building Accounts of Henry III* (Oxford, 1971), but an excellent survey is to be found in C. Wilson, 'The Gothic Abbey Church', in C. Wilson *et al*, *Westminster Abbey* (The New Bell's Cathedral Guides, London, 1986), 22–69. The important work of P. Binski, *Westminster Abbey and the Plantagenets: kingship and the representation of power 1200–1400* (New Haven and London, 1995) appeared only when the present book was in the press.

2. R. Branner, *St Louis and the Court Style in Gothic Architecture* (London, 1965), 124–5; M. E. Roberts, 'The relic of the Holy Blood and the iconography of the thirteenth-century north transept portal of Westminster Abbey', in W. M. Ormrod (ed.), *England in the thirteenth century (Proceedings of the 1984 Harlaxton Symposium)* (Woodbridge, 1986), 129–42 (esp. 137–9).

3. T. A. Heslop, 'The sculpture of Westminster Abbey, 1245–1272', in B. Ford (ed.), *The Cambridge Guide to the Arts in Britain: The Middle Ages* (Cambridge, 1988), 178–81.

4. For a succinct discussion of the design of the building and Henry de Reyns's use of French motifs see C. Wilson, *The Gothic Cathedral. The architecture of the Great Church 1130–1530* (London, 1990), 180–1.

5. *Idem.*, 'The English response to French Gothic architecture, *c.*1200–1350', in J. Alexander and P. Binski (eds), *Age of Chivalry: Art in Plantagenet England 1200–1400* (exh. cat., London, 1987), 75–8.

6. For an illustrated survey see D. Carpenter, 'Westminster Abbey: some characteristics of its sculpture 1245–59', *Journal of the British Archaeological Association*, 3rd series, XXXV (1972), 1–14, pls I–VII.

7. E. S. Prior and A. Gardner, *An account of medieval figure-sculpture in England* (Cambridge, 1912), 224–37; L. Stone, *Sculpture in Britain: the Middle Ages* (Pelican History of Art, 2nd ed., Harmondsworth, 1972), pls 89(A) and 91(B); S. Whittingham, *A thirteenth-century portrait gallery at Salisbury Cathedral* (2nd ed., Salisbury, 1979).

8. For different interpretations of the Clarendon head see Stone, *op. cit.*, 118, and *Age of Chivalry, op. cit.*, cat. no. 295 (P. Tudor-Craig). It has been pointed out that the smiling heads in the triforium at Westminster Abbey are on the south side, and the hideous, grinning ones on the north; likewise, in St Faith's chapel 'there is a difference of character between those on the north and the south, following the idea that these were evil and good quarters' (W. R. Lethaby, *Westminster Abbey re-examined* (London, 1925), 192). The moralising aspect of the interior decoration of Henry III's chambers has been raised by P. Binski, *The Painted Chamber at Westminster* (London, 1986), 35.

9. *Age of Chivalry, op. cit.*, cat. nos 292–4.

10. Further evidence for the movement of Wells sculptors towards London in the years immediately before 1245 is provided by the head of a bishop recently discovered in the precinct wall of Reading Abbey (L. Cram, 'A thirteenth-century sculptured stone head found in the precinct wall of Reading Abbey', *Antiquaries Journal*, LXXI (1991), 223–6).

11. Compare, for instance, the spandrels illustrated in *Royal Commission on Historical Monuments (England). An inventory of the historical monuments in London, Vol. I., Westminster Abbey* (London, 1924), pl. 6, and in Carpenter, *op. cit.*, pl. II/5–6, pl. III/10, with the Wells quatrefoil reliefs and seated figure in *Courtauld*

Institute Illustration Archives, I, Part 2 (London, 1977), 1/2/150 and 1/2/84 (for the former see also *Age of Chivalry, op. cit.*, cat. no. 244).

12. For the Westminster demi-angel amid foliage see Prior and Gardner, *op. cit.*, fig. 275, and Carpenter, *op. cit.*, pl. III/13; for the Wells angels and the foliage of the resurrection tier see *Courtauld Institute Illustration Archives*, I, Part 2, 1/2/152–1/2/61, and 1/2/12–1/2/17, 1/2/30–1/2/45.

13. W. H. St John Hope, 'Images of Kings in the Cathedral Church of Salisbury', *Wiltshire Archaeological and Natural History Magazine*, XXXIX (1917), 505. An engraving of the Salisbury nave, showing the choirscreen in 1754, is published in G. Cobb, *English Cathedrals: the forgotten centuries. Restoration and change from 1530 to the present day* (London, 1980), fig. 185; see also *Age of Chivalry, op. cit.*, fig. 52.

14. C. J. P. Cave and L. E. Tanner, 'A thirteenth-century choir of angels in the north transept of Westminster Abbey and the adjacent figures of two kings', *Archaeologia*, LXXXIV (1934), 63–67; L. E. Tanner, *Unknown Westminster Abbey* (London, 1948), pl. 30.

15. *RCHM, op. cit.*, pls 85–6.

16. Images of the Confessor and the Pilgrim were also placed on columns to each side of the Confessor's shrine, and if a thirteenth-century illustration is to be believed they gestured to one another in a similar manner to the transept figures (Wilson *et al, op. cit.*, 115–18). See also L. E. Tanner, 'Some representations of Saint Edward the Confessor in Westminster Abbey and elsewhere', *Journal of the British Archaeological Association*, XV (1952), 1–12, and Binski, *op. cit.* (1986), 40.

17. For the colouring of the angels see J. G. Noppen, 'Recently cleaned sculptures at Westminster', *Burlington Magazine*, LVIII (1931), 139–40; for a colour photograph of Lethaby's reconstruction of the polychromy of the south-west angel on a plaster cast see *Royal Westminster* (exh. cat., London, 1981), 32.

18. L. Grodecki, *Sainte-Chapelle* (Paris, n.d., but 1962), ills on pp. 55, 65, 75, 79.

19. Noppen, *op. cit.*, 140; the conflation of John of St Albans and John of St Omer proposed in J. Harvey, *English Mediaeval Architects: a biographical dictionary down to 1550* (2nd ed., Gloucester, 1984), 109, is possible but unproven; see also the comments of P. Lindley, 'Westminster and London: sculptural centres in the thirteenth century', in H. Beck and K. Hengevoss-Dürkop (eds), *Studien zur Geschichte der europäischen Skulptur im 12./13. Jahrhundert* (Frankfurt am Main, 1994), I, 240–1.

20. Colvin, *op. cit.* (1963), 139.

21. *RCHM, op. cit.*, 51, pl. 143; R. P. Howgrave-Graham, 'Westminster Abbey. Various bosses, capitals and corbels of the thirteenth century', *Journal of the British Archaeological Association*, 3rd series, VIII (1943), 1ff.; Carpenter, *op. cit.*, figs 3–4, 14.

22. Colvin, *op. cit.* (1963), 144; Harvey, *op. cit.*, 23.

23. P. Tudor-Craig, 'The Painted Chamber at Westminster', *Archaeological Journal*, CXIV (1957), 103–5; Colvin, *op. cit.* (1963), 144–6 (the late date of 1280–90 given to the shields by Stone (*op. cit.*, 133 and 253, n. 12) is conclusively rejected by Colvin on p. 146); J. Cherry, 'Heraldry as decoration in the thirteenth century', in W. M. Ormrod, *England in the thirteenth century (Proceedings of the 1989 Harlaxton Symposium)* (Stamford, 1991), 128–9. The shields are fully illustrated in *RCHM, op. cit.*, pls 102–3.

24. W. R. Lethaby, *Westminster Abbey and the King's Craftsmen: a study of mediaeval building* (London, 1906), 42; S. E. Rigold, *The Chapter House and the Pyx Chamber, Westminster Abbey* (London, 1985), 12.

25. For a photograph of its present condition see Rigold, *op. cit.*, ill. on p. 13 (the fragment of sculpture on the central corbel does not belong); older illustrations have been published in Lethaby, *op. cit.* (1906), figs 13–14 (recording its state in 1873), and in J. Carter, *Specimens of the ancient sculpture and painting now remaining in England from the earliest period to the reign of Henry VIII* (new and revised ed., London, 1887), pl. LVI (showing its condition in 1782).

26. This in turn derived from such portals at Malmesbury, Glastonbury and Wells: see M. Thurlby, 'The north transept doorway of Lichfield Cathedral: problems of style', *RACAR*, XIII/2 (1986), 121–30.

27. The jambs on the north side are foliate.

28. Rigold, *op. cit.*, pls on pp. 14, 19–1.

29. Stone, *op. cit.*, 120–1; for the accounts see Colvin, *op. cit.* (1971), 226–7, 230–1, 236–7.

30. This is the case, for instance, in the admittedly later payments for altar-pieces made to the workshop of the elder and younger Jörg Syrlin of Ulm, who were joiners: the sculpture was contracted out, and the sculptors paid by the Syrlins (M. Baxandall, *The Limewood Sculptors of Renaissance Germany* (New Haven and London, 1980), 302).

31. Compare her with one of the Maries on the reverse of the north tower at Wells, illustrated at the far left of fig. 259 in A. Gardner, *English Medieval Sculpture* (Cambridge, 1951), and pl. 169.

32. P. Williamson, 'The Westminster Abbey Chapter House Annunciation group', *Burlington Magazine*, CXXX (1988), 123–34; see also *idem*, 928 (letter by the present writer with identification of the stone types). The payment of 11s. to

a certain Warinus the painter *pro ij ymaginibus pingendis cum colore* probably, but not certainly, refers to the Annunciation group (see J. G. Noppen, 'Building by King Henry III and Edward, Son of Odo', *Antiquaries Journal*, XXVIII (1948), 147–8, and more accurately, H. M. Colvin, *op. cit.* (1971), 228–9).

33. The back of the Angel is illustrated, showing the slot for the left wing, in Williamson, *op. cit.*, fig. 49.

34. S. Gardner, *English Gothic foliage sculpture* (Cambridge, 1927), 22–33; P. Wynn-Reeves, *English stiff leaf sculpture* (Doctoral dissertation, London University, 1952).

35. Lethaby, *op. cit.* (1925), 106–8; the finest capital, showing two lions among stiff-leaf foliage, is illustrated in J. G. Noppen, 'XIIIth century sculpture at Westminster Abbey', *Apollo*, XX (1934), 215, fig. v. For closely related Purbeck marble capitals, probably executed by a Westminster workshop, see P. Williamson, 'Capitals from Chertsey Abbey', *Burlington Magazine*, CXXX (1988), 124–7.

36. Lethaby, *op. cit.* (1906), 63–85, idem, (1925), 64–80; Roberts, *op. cit.*, 129–42; Wilson *et al*, *op. cit.*, 43–8 (figs 4 and 5 for the etching and drawing); Lindley, *op. cit.*, 235–9.

37. For the problem of equating the verbal and visual descriptions concerning these life-size figures see Roberts, *op. cit.*, 130–1, esp. n. 17.

38. See p. 163.

39. Stone's description (*op. cit.*, 120) of the tympanum follows the later reconstruction of Lethaby (*op. cit.* (1925), 75, fig. 46), which to my mind is inaccurate.

40. It is possible, but unlikely, that the cinquefoil cusps were added in Dickinson's restoration in the early eighteenth century (Wilson *et al*, *op. cit.*, 47–8, fig. 8).

41. G. D. S. Henderson, 'The west portal in the porch at Higham Ferrers: a problem of interpretation', *Antiquaries Journal*, LXVIII (1988), 238–47, and idem., 'The musician in the stocks at Higham Ferrers, Northamptonshire', in Ormrod, *op. cit.* (1991), 135–47; Lethaby (*op. cit.* (1925), 70 and 75) suggested that the tympanum on the right-hand lateral porch was devoted to the Virgin, and (more tentatively) that on the left to St Peter and the Confessor.

42. N. Pevsner and P. Metcalf, *The Cathedrals of England: Midland, Eastern and Northern England* (Harmondsworth, 1985), 214–19; D. A. Stocker, 'The mystery of the shrines of St Hugh', in H. Mayr-Harting (ed.), *St Hugh of Lincoln (Lectures delivered at Oxford and Lincoln to celebrate the eighth centenary of St Hugh's consecration as bishop of Lincoln)* (Oxford, 1987), 89–124.

43. The arms and heads of Christ and the flanking angels were restored in 1895. For a photograph of the tympanum before this date see W. R. Lethaby, 'Notes on sculptures in Lincoln Minster: the Judgment porch and the Angel choir', *Archaeologia*, LX (1907), pl. facing 381; the pre-restoration state of the quatrefoil is also recorded in a plaster cast (A. Andersson, *English influence in Norwegian and Swedish figure-sculpture in wood 1220–1270* (Stockholm, 1949), figs 24–5, and Stone, *op. cit.*, 125 and pl. 98, who gives an overly pessimistic view of the condition of the tympanum: only the quatrefoil has been substantially altered).

44. The fullest set of photographs is to be found in *Courtauld Institute Illustration Archives*, 1/7 (London, 1978).

45. *Ibid.*, 1/7/30, 1/7/31; that on the left, alongside Synagogue, is barefoot and appears to be female. It may be of interest to note that Rachel and Leah, the Old Testament prototypes of *Ecclesia* and *Synagoga*, formerly appeared alongside the latter on the north transept porch at Chartres (A. Katzenellenbogen, *The sculptural programs of Chartres Cathedral* (Baltimore, 1959), 61). T. A. Heslop's thoughtful explanation for the unusual positioning of *Ecclesia* and *Synagoga* remains problematic ('The iconography of the Angel choir at Lincoln Cathedral', in E. Fernie and P. Crossley (eds), *Medieval Architecture and its intellectual context. Studies in honour of Peter Kidson* (London and Ronceverte, 1990), 152). The present trumeau figure of the Virgin and Child was added in 1926: 'The Subdean reported that a statue of the Blessed Virgin Mary and the Holy Child had been erected on a pedestal at the South door of the Cathedral; that the work had been designed by Mr Hare of London and executed in the works of Messrs Bridgman of Lichfield by William Eden Keyte' (Chapter Acts, 28 October 1926, p. 265; I am grateful to Dr John Baily and Dr Nicholas Bennett for communicating this information).

46. Stone, *op. cit.*, 126–7.

47. Iconoclastic destruction of such images in the sixteenth or seventeenth centuries would seem to be ruled out by the survival of the figures (albeit without heads) surrounding the Judgement porch itself.

48. It is shown as such in an engraving of 1784, when both figures still retained their original heads; it may be that the second figure also represented an archangel (Raphael?), although the engraving seems to depict a female figure (Carter, *op. cit.*, pl. XLIV). The Buckler restorations are described in T. Cocke, 'The architectural history of Lincoln Cathedral from the Dissolution to the twentieth century', *Medieval Art and Architecture at Lincoln Cathedral* (British Archaeological Association conference transactions, VIII, 1986), 153–4. It is especially ironic that Buckler defended his tendentious action by stating that

restoration is acceptable when the subjects are 'readily definable whether as forming parts of a group of sacred character, or connected with an event in English history' (J. C. Buckler, *A description and defence of the restorations of the exterior of Lincoln Cathedral* (Oxford and Lincoln, 1866), 75, quoted by Cocke, *op. cit.*, 154).

49. Spirited support for the authenticity of the head was led by Gardner (A. Gardner and R. P. Howgrave-Graham, 'The "Queen Margaret" statue at Lincoln', *Antiquaries Journal*, XXIX (1949), 87, and Gardner, *op. cit.*, 148–51, figs 280–1), but it has been rightly questioned by Andersson (*op. cit.*, 87, n. 1) and Stone (*op. cit.*, 253, n. 26).

50. The clearest photograph of the tympanum is found in N. Pevsner and J. Harris, *The Buildings of England: Lincolnshire* (2nd ed., revised by N. Antram, London, 1989), fig. 26, where a succinct building history is also provided. A detailed analysis of the iconography of the tympanum reliefs is given in G. Henderson, 'The imagery of St Guthlac of Crowland', in Ormrod, *op. cit.* (1986), 76–94.

51. A comparison of the photograph taken before 1912 (in Prior and Gardner, *op. cit.*, fig. 362) with that published in Henderson, *op. cit.* (1986), fig. 8, reveals the disastrous effects of weathering on the statue: the distinctive knotted cloth waistband has now completely disappeared.

52. The aisle walls of the choir are decorated with intricate traceried blind arcading supported on Purbeck marble shafts and capitals, enlivened with fine head stops, giving an appearance of impressive richness (*Courtauld Institute Illustration Archives*, 1/7, 139–64).

53. All the spandrel figures are illustrated and discussed in A. Gardner, *The Lincoln Angels* (Lincoln Minster Pamphlet (First Series), 6, 1952). A more recent brief summary is V. Glenn, 'The sculpture of the Angel Choir at Lincoln', in *Medieval Art and Architecture at Lincoln Cathedral*, *op. cit.*, 102–8.

54. Heslop (*op. cit.* (1990), 151–8) has attempted a reading of the internal distribution of the bosses and other sculptures of the Angel choir, inside and out, on the basis of the primacy of East over West. The bosses in the north choir aisle (which are excluded from his discussion) are a sticking-point in this particular interpretation; it might be argued, however, that these would have been seen only on leaving the choir by the north door, so that their grotesque subject matter was a signpost to the outside world. For the fullest illustrated discussion see C. J. P. Cave, *The Roof Bosses of Lincoln Minster* (Lincoln Minster Pamphlets (First Series), 3, 1951).

55. Compare the angels in the half-spandrels at Lincoln with the Westminster spandrel figures illustrated in Carpenter, *op. cit.*, figs 5–6, 10.

56. Analyses of the different styles in the Angel choir are found in Prior and Gardner, *op. cit.*, 265–76, and Glenn, *op. cit.*, 105–6.

57. H. G. Ramm *et al*, 'The Tombs of Archbishops Walter de Gray (1216–55) and Godfrey de Ludham (1258–65) in York Minster, and their contents', *Archaeologia*, CIII (1971), 102–20, pls XXXVI–XLIII.

58. For photographs of the Pershore knight taken from different angles see Stone, *op. cit.*, pl. 89(C), and H. A. Tummers, *Early secular effigies in England; the thirteenth century* (Leiden, 1980), pl. 52 (also his comments on pp. 92–3). The Sawley tomb fragments are illustrated and discussed in V. Sekules, 'A lost tomb from Sawley', in A. Borg and A. Martindale (eds), *The vanishing past: studies of medieval art, liturgy and metrology presented to Christopher Hohler* (British Archaeological Reports, International Series 111, Oxford, 1981), 173–7, *Age of Chivalry*, *op. cit.*, cat. nos 341–2, and P. Williamson, *Northern Gothic Sculpture 1200–1450* (Victoria and Albert Museum, London, 1988), cat. nos 5–8.

59. M. Roberts, 'The effigy of bishop Hugh de Northwold in Ely Cathedral', *Burlington Magazine*, CXXX (1988), 77–84, gives a full account of the memorial, also illustrating the effigy of William de Kilkenny (fig. 5).

60. P. Brieger, *English Art 1216–1307* (The Oxford History of English Art, IV, Oxford, 1957), 101–3.

61. M. E. Roberts, 'The Tomb of Giles de Bridport in Salisbury Cathedral', *Art Bulletin*, LXV (1983), 559–86.

62. Pevsner and Metcalf, *op. cit.*, 176 and fig. 82; another tomb was raised to Bishop Aquablanca in his homeland of Savoy, at Aiguebelle (see p. 191).

63. See p. 111.

64. The lateral doorways at Salisbury are dummies.

65. For discussion of the restorations, and illustrations made prior to them, see Cobb, *op. cit.*, 114, figs 175–6 and N. Pevsner and P. Metcalf, *The Cathedrals of England: Southern England* (Harmondsworth, 1985), 269–70, fig. 137. One of the medieval figures is illustrated in Prior and Gardner, *op. cit.*, fig. 388. The antecedents of the Salisbury screen-façade are discussed in J. P. McAleer, 'Particularly English? Screen façades of the type of Salisbury and Wells cathedrals', *Journal of the British Archaeological Association*, CXLI (1988), 124–58. See also P. Z. Blum, 'The sequence of the building campaigns at Salisbury', *Art Bulletin*, LXXIII (1991), 22, n. 79, and T. Cocke and P. Kidson, *Salisbury Cathedral: perspectives on the architectural history* (Royal Commission on the Historical Monuments of England, London, 1993), 56–9.

66. For the building history see Pevsner and Metcalf, *op. cit.* (Midland,

Eastern and Northern England), 181–2, 185–7.

67. Reproduced in Cobb, *op. cit.*, fig. 223. A large seated figure of Christ now in the church at Swynnerton in Staffordshire is possibly that shown at the top of the central gable in Hollar's engraving (*ibid.*, fig. 225), but doubts are expressed in T. Cocke, 'Ruin and restoration: Lichfield Cathedral in the seventeenth century', *Medieval Archaeology and Architecture at Lichfield* (British Archaeological Association conference transactions, XIII, 1993), 114, n. 24.

68. The 1782 illustration reproduced in Carter (*op. cit.*, pl. CXIII) confirms the appearance of the porch before the nineteenth-century restorations and shows certain details not visible in Britton's engraving of 1820.

69. Compare the way the drapery of the Virgin's robe falls in deep curves on the right side of her lower body at both Lichfield and York (for the latter see Prior and Gardner, *op. cit.*, fig. 367). The surviving female figure at Lichfield (*ibid.*, fig. 385), on the south side of the choir, has the same distinctive corkscrew curls as the York Virgin but is possibly slightly later. For the remaining much restored figures from the west front see R. K. Morris, 'The lapidary collections of Lichfield Cathedral', *Medieval Archaeology and Architecture at Lichfield, op. cit.*, 106.

70. See p. 105.

71. W. Burges, *The Iconography of the Chapter House, Salisbury* (London, 1859) (reprinted from *The Ecclesiologist*, XX (1859), 109–14, 147–62); P. Z. Blum, 'The Middle English Romance 'Iacob and Iosep' and the Joseph cycle of the Salisbury Chapter House', *Gesta*, VIII (1969), 18–34; the whole cycle is illustrated in S. Whittingham, *Salisbury Chapter House* (Salisbury, 1974). The discovery of pennies from Edward I's reign in the foundations of the chapter house, reported during the excavations of 1854, has been taken to support a post-1279 date (see Blum, *op. cit.* (1991), 22–3); however, this evidence is far from watertight. The closeness of the design to the Westminster chapter house, the practical necessity for the building, and the style of the head stops, Purbeck marble stiff-leaf capitals and stained glass, all suggest an earlier date, perhaps in the 1260s (for a rebuttal of the post-1279 date see Cocke and Kidson, *op. cit.*, 8–10; for the glass see R. Marks, *Stained Glass in England during the Middle Ages* (London, 1993), 141–3). I am most grateful to Christopher Wilson for discussing the date of the Salisbury chapter house with me.

72. The present figure of Christ was added in the nineteenth century, the whole quatrefoil obviously providing the model for Scott's restoration of the Westminster chapter house tympanum ten years later; for a photograph see Whittingham, *op. cit.* (1974), fig. 9.

73. Burges tentatively suggested that these arches contained an Annunciation and the figures of Saints Peter and Paul (*op. cit.*, 8–9).

74. R. B. Green, 'Virtues and Vices in the Chapter House vestibule in Salisbury', *Journal of the Warburg and Courtauld Institutes*, XXXI (1968), 148–58.

75. For York see N. Coldstream, 'York Chapter House', *Journal of the British Archaeological Association*, 3rd series, XXXV (1972), 15–23; *Age of Chivalry, op. cit.*, cat. no. 343; Williamson, *op. cit.* (1988), cat. no. 12; and J. Aberth, 'The sculpted heads and figures inside the chapter house of York Minster', *Journal of the British Archaeological Association*, CXLII (1989), 37–45. For Southwell see N. Pevsner, *The Leaves of Southwell* (London and New York, 1945), and N. Summers, *The Chapter House, Southwell Minster* (Derby, 1984). A useful – if brief – general discussion of English naturalistic foliate sculpture is to be found in J. Givens, 'The garden outside the walls: plant forms in thirteenth-century English sculpture', in E. B. MacDougall (ed.), *Medieval Gardens* (Dumbarton Oaks, Washington D.C., 1986), 189–98.

76. The extent of the losses is succinctly summarised, with well-chosen examples, by Stone (*op. cit.*, 1–3); in addition see S. E. Lehmberg, *The Reformation of Cathedrals: Cathedrals in English Society, 1485–1603* (Princeton, 1988), 67–122, and the excellent account in E. Duffy, *The Stripping of the Altars: Traditional Religion in England 1400–1580* (New Haven and London, 1992), 379–503 (esp. 478–503).

77. See Tummers, *op. cit.*, *passim*.

78. See the careful study by P. J. Lankester, 'A military effigy in Dorchester Abbey, Oxon', *Oxoniensia*, LII (1987), 145–72, who tentatively associates the effigy with William de Valence the younger (died 1282).

79. On the concept of 'death as sleep' in the Middle Ages see P. Ariès (translated by H. Weaver), *The Hour of Our Death* (London, 1981), *passim*.

80. The effigy of William de Valence (died 1296) in the chapel of Saints Edmund and Thomas the Martyr in Westminster Abbey was constructed of chased and enamelled copper sheets nailed over an oak core, and is an import from Limoges; another of the same type (now lost) was made for Walter de Merton, Bishop of Rochester, in about 1276 (Stone, *op. cit.*, 135, pl. 105). For the comparable but slightly earlier effigies of Jean and Blanche de France from Royaumont, now in Saint-Denis, see A. Erlande-Brandenburg, *Le Roi est mort: étude sur les funérailles, les sépultures et les tombeaux des rois de France jusqu'à la fin du XIIIe siècle* (Geneva, 1975), 110, figs 109–14; other examples include that of Blanche de Champagne now in the Musée du Louvre and Bishop Maurice in

Burgos Cathedral (A. Durán Sanpere and J. Ainaud de Lasarte, *Escultura Gótica (Ars Hispaniae, Vol. VIII)* (Madrid, 1956), fig. 47).

81. For a drawing of the Lincoln monument see *Age of Chivalry, op. cit.*, cat. no. 379.

82. The payments are recorded in B. Botfield, *Manners and Household Expenses of England* (ed. T. Hudson Turner, Roxburghe Club, London, 1841): the reference to the florins is given on p. 117.

83. The literature on the Eleanor tomb at Westminster is large, but the most useful discussions are to be found in Colvin, *op. cit.* (1963), 481–2, Stone, *op. cit.*, 142–3, N. Coldstream, 'The tomb of Queen Eleanor in Westminster Abbey: an evaluation of the documentary evidence', in Beck and Hengevoss-Dürkop, *op. cit.*, 101–7, and especially P. Lindley, 'Romanticizing reality: the sculptural memorials of Queen Eleanor and their context', in D. Parsons (ed.), *Eleanor of Castile, 1290–1990. Essays to commemorate the 700th anniversary of her death: 28 November 1290* (Stamford, 1991), 69–92, esp. 69–74.

84. S. Badham, 'A lost bronze effigy of 1279 from York Minster', *Antiquaries Journal*, LX (1980), 59–65; for a summary and the suggestion that the tomb of Bishop Robert Grosseteste (died 1253) in Lincoln Cathedral also had a bronze effigy see J. Coales (ed.), *The earliest English brasses. Patronage, style and workshops 1270–1350* (London, 1987), 20–1 (N. J. Rogers).

85. H. J. Plenderleith and H. Maryon, 'The royal bronze effigies in Westminster Abbey', *Antiquaries Journal*, XXXIX (1959), 87–8.

86. As pointed out by Lindley, *op. cit.* (1991), 71. See also P. Binski, 'The Cosmati at Westminster and the English Court Style', *Art Bulletin*, LXXII (1990), 6–34; his extended discussion of Henry III's tomb on pp. 19–28 is now the most comprehensive account of the monument.

87. On this point see J. Gardner, 'The Cosmati at Westminster: some Anglo-Italian reflexions', in J. Garms and A. M. Romanini (eds), *Skulptur und Grabmal des Spätmittelalters in Rom und Italien (Akten des Kongresses 'Scultura e monumento sepolcrale del tardo medioevo a Roma e in Italia', Rom, 4.–6. Juli 1985)* (Vienna, 1990), 211–14 (the references on pp. 213–14 to Eleanor of Aquitaine should be corrected to Eleanor of Castile); and Binski, *op. cit.* (1990), 26–8.

88. The question of Westminster's influence on Italy and the controversial association of Petrus with the Pietro di Oderisio who was responsible for the tomb of Pope Clement IV at Viterbo is dealt with by Gardner, *op. cit.*, 201–15.

89. Colvin, *op. cit.* (1963), 482–3, and Lindley, *op. cit.* (1991), 71 and 85 (n. 11).

90. *Age of Chivalry, op. cit.*, cat. no. 374 (P. Lindley), and Lindley, *op. cit.* (1991), 76. The idea that the effigy of Henry III was cast from a putative wax image of the king made by Robert of Beverley in 1276 is unlikely for both practical and stylistic reasons (P. Tudor-Craig in Wilson *et al*, *op. cit.*, 119–20; see also Harvey, *op. cit.*, 23).

91. *Age of Chivalry, op. cit.*, 361–4, cat. nos 368–76; for the accounts and names of the masons involved see Colvin, *op. cit.* (1963), 479, 483–5.

92. R. Branner, 'The Montjoies of Saint Louis', in D. Fraser, H. Hibbard and M. J. Lewine (eds), *Essays in the History of Architecture presented to Rudolf Wittkower* (London, 1967), 13–16; N. Coldstream, 'The commissioning and design of the Eleanor Crosses', in Parsons, *op. cit.*, 55–67.

93. Colvin, *op. cit.* (1963), 484; see also M. J. H. Liversidge, 'Alexander of Abingdon', in W. J. H. and M. J. H. Liversidge, *Abingdon essays: studies in local history* (Abingdon, 1989), 89–111, 100.

94. Williamson, *op. cit.* (note 58), cat. no. 15 (entry by P. Evelyn).

95. I would now wholeheartedly agree with the comments of Phillip Lindley (*op. cit.* (1991), 77–8) and no longer hold the view expressed in *Age of Chivalry, op. cit.*, 103. Three of the four Hardingstone *Eleanors* are illustrated in Parsons, *op. cit.*, figs 13–15.

96. The most detailed attempt at a biography of Alexander of Abingdon is in Liversidge, *op. cit.*

97. But there is also the distinct possibility that this effigy directly follows, rather than anticipates, the court productions of the early 1290s. For photographs see Tummers, *op. cit.*, 133, 135, 137.

98. The relationship of the Eleanor crosses, the Crouchback tomb and St Stephen's Chapel to France is admirably summarised in J. Bony, *The English Decorated Style: Gothic architecture transformed 1250–1350* (Oxford, 1979), 19–23. See also *Age of Chivalry, op. cit.*, 79–80 and cat. nos 324–6.

99. The brackets on each side of the central gable originally supported small candle-holding and censing angels, now apparently lost (see the engraving in J. Dart, *Westmonasterium, or the history and antiquities of the Abbey Church of St Peter's Westminster* (London, 1723), II, pl. 75).

100. For photographs see *RCHM, op. cit.*, pls 34, 37; Tummers, *op. cit.*, 134, 136, 138.

101. L. L. Gee, '"Ciborium" tombs in England 1290–1330', *Journal of the British Archaeological Association*, CXXXII (1979), 29–41; P. G. Lindley, 'The tomb of Bishop William de Luda: an architectural model at Ely Cathedral', *Proceedings of the Cambridge Antiquarian Society*, LXXIII (1984), 75–87.

102. N. Coldstream, 'English Decorated shrine bases', *Journal of the British Archaeological Association*, CXXIX (1976), 15–34.

CHAPTER 10

1. Excerpted from *Chronicles of Matthew Paris: Monastic life in the thirteenth century*, edited, translated and with an introduction by R. Vaughan (Gloucester, 1984), 126.
2. A. Andersson, 'The Holy Rood from Skokloster and the Scandinavian Early Gothic', *Burlington Magazine*, CXII (1970), 132–40; P. A. Young, 'The origin of the Herlufsholm ivory crucifix figure', *idem*, CXIX (1977), 12–19; N.-K. Liebgott, *Elfenben – fra Danmarks Middelalder* (National Museum, Copenhagen, 1985), 33–7; N. Stratford, 'Gothic ivory carving in England', in J. Alexander and P. Binski (eds), *Age of Chivalry: Art in Plantagenet England 1200–1400* (exh. cat., London, 1987), 111–12. A related ivory head of Christ from a Crucifixion, smaller and slightly later in date, has recently been acquired by the Musée du Louvre (*Nouvelles acquisitions du département des Objets d'art 1985–1989* (Musée du Louvre, Paris, 1990), cat. no. 19).
3. For the Matthew Paris drawing see N. J. Morgan, *Early Gothic Manuscripts (I), 1190–1250 (A Survey of Manuscripts illuminated in the British Isles, Vol. IV)* (London and Oxford, 1982), cat. no. 88, fig. 307.
4. The arms are apparently carved from walrus ivory (D. Gaborit-Chopin, *Ivoires du Moyen Age* (Fribourg, 1978), 204).
5. Liebgott, *op. cit.*, 36–49. For the Fjelstrup and Gualöf crucifixes see A. Goldschmidt, *Die Elfenbeinskulpturen aus der romanischen Zeit, XI–XIII. Jahrhundert*, III (Berlin, 1923, reprinted 1972), figs 26–7. A small oak relief (56 × 54 cm.) of the Maries at the Sepulchre in the Danish National Museum in Copenhagen possibly originally belonged to a now lost triumphal cross in Roskilde Cathedral, of a similar type to that in Halberstadt [125]: see E. Nyborg and V. Thomsen, 'Roskilde domkirkes triumfkrucifiks', *Nationalmuseets Arbejdsmark* (1983), 187–209, idem., 'Fra Paris til Sneslev. De aeldste danske krucifikser og helgenbilleder', *Nationalmuseets Arbejdsmark* (1993), 164–81, and idem., 'Dänische Holzskulptur vor 1300 – ein Forschungsprojekt', in U. Albrecht, J. von Bonsdorff, A. Henning (eds), *Figur und Raum. Mittelalterliche Holzbildwerke im historischen und kunstgeographischen Kontext* (Berlin, 1994), 35–52. Rather than the direct influence from France proposed by Nyborg and Thomsen it seems more likely that prototypes in Westphalia or Saxony provided the inspiration.
6. A. Andersson, *English influence in Norwegian and Swedish figure-sculpture in wood 1220–1270* (Stockholm, 1949), 103–4; idem, *Medieval Wooden Sculpture in Sweden, II, Romanesque and Gothic sculpture* (Stockholm, 1966), 89–90. For Uppsala see the introduction, p. 7.
7. For a photograph of the ruined façade before restoration and an engraving of 1661 showing most of the statues still *in situ*, see A. Albertsen, *Der Dom zu Drontheim* (Trondheim, 1960), figs 20–1, and G. Fischer, *Domkirken i Trondheim* (Oslo, 1966), 308–9.
8. *Ibid.*, 294–8; for Matthew Paris's own description of his journey see Vaughan, *op. cit.*, 158–61.
9. Fischer, *op. cit.*, 352–3. For the Paris sculptures see A. Erlande-Brandenburg and D. Thibaudat, *Les sculptures de Notre-Dame de Paris au musée de Cluny* (Paris, 1982), 83–104, and D. Kimpel, 'A Parisian Virtue', in C. Bruzelius and J. Meredith (eds), *The Brummer Collection of Medieval Art, The Duke University Museum of Art* (Durham, N.C., and London, 1991), 125–39.
10. Fischer, *op. cit.*, 347; see also *Age of Chivalry*, *op. cit.*, cat. nos 299–306 (N. Stratford), and the comments by W. Sauerländer in his review of the exhibition in *Burlington Magazine*, CXXX (1988), 151.
11. Andersson, *op. cit.* (1949), 108–13; *Age of Chivalry*, *op. cit.*, cat. no. 290 (N. Stratford).
12. Andersson, *op. cit.* (1949), 113–18, figs 35–6 (Austrått Virgin), 133–5, figs 52–3 (Mosvik Crucifix). The Amesbury Psalter (All Souls College, Oxford, Ms.6) is illustrated and discussed by Andersson in connection with a group of Crucifixions centred on that at Balke (*ibid.*, 185–206); see also *Age of Chivalry*, *op. cit.*, cat. no. 316 (N. J. Morgan).
13. M. Blindheim, *Main trends of East-Norwegian wooden figure sculpture in the second half of the thirteenth century* (Oslo, 1952), 12–21, pls II–V; Andersson (*op. cit.* (1949), 208–9) mistakenly dissociates the smallest female figure from the Balke Calvary from his discussion of the group and related sculptures (185–206).
14. Andersson, *op. cit.* (1949), 207–9; Blindheim, *op. cit.*, 24–6; on the physical characteristics of the form and polychromy see S. A. Wiik and U. Plahter, 'St. Olav fra Fresvik og St. Paulus fra Gausdal. To polykrome treskulpturer fra middelalderen', *Universitetets Oldsaksamling 150 år Jubileumsårbok* (Oslo, 1979), 213–27.
15. Andersson, *op. cit.* (1949), 247–56.
16. A. Andersson, 'Ein Kruzifix-Typus der zweiten Hälfte des 13. Jahrhunderts', in *Festschrift für Erich Meyer zum sechzigsten Geburtstag* (Hamburg, 1957), 88–92; idem., *op. cit.* (1966), 91–2, figs 52–3; R. Haussherr, 'Triumphkreuzgruppen der Stauferzeit', in R. Haussherr and C. Väterlein (eds), *Die Zeit*

der Staufer: Geschichte-Kunst-Kultur, V (Stuttgart, 1979), 141–4. The Fröjel cross is probably to be dated to the early fourteenth century.

CHAPTER 11

1. E. Lambert, *L'art gothique en Espagne au XII et XIIIe siècles* (Paris, 1931), 218–38; R. Branner, *The Cathedral of Bourges and its place in Gothic Architecture* (edited and annotated by S. P. Branner, Cambridge (Mass.) and London, 1989), 180–3; H. Karge, 'La cathédrale de Burgos. Organisation et technique de la construction', in R. Recht (ed.), *Les bâtisseurs des cathédrales gothiques* (exh. cat., Strasbourg, 1989), 139–63; idem., *Die Kathedrale von Burgos und die spanische Architektur des 13. Jahrhunderts. Französische Hochgotik in Kastilien und León* (Berlin, 1989).
2. The documentation is discussed in the still fundamental article by F. B. Deknatel, 'The thirteenth century Gothic sculpture of the cathedrals of Burgos and Leon', *Art Bulletin*, XVII (1935), 243–389 (252–5); also see S. Andrés Ordax et al., *Castilla y León/1 (La España Gótica, Vol. 9)* (Madrid, 1989), 89–127.
3. Lambert's view that the building was erected in two distinct campaigns, 1221–30 and 1243–60 (*op. cit.*, 222) seems to me unnecessarily rigid; see also Deknatel, *loc. cit.*
4. The figure has been identified as Bishop Maurice, although it seems unlikely that a contemporary bishop – even the founder of the present cathedral – would be represented in this position. Although St Indalecio does not seem to have been especially venerated at Burgos the fact that St Firmin, the first bishop of Amiens, is shown on the trumeau of the left portal of the west front of the French cathedral might indicate that a lead had been taken from that source. His presence on the trumeau may have served to underline the antiquity of the bishopric and the independence of Burgos from Toledo.
5. The most detailed and convincing stylistic analysis of the *Puerta del Sarmental* is to be found in Deknatel, *op. cit.*, 260–73.
6. The suggested presence of King Ferdinand III on the lintel, if accepted, would indicate a date after his death in 1252 for the completion of the lintel at least. For the iconography in general see Deknatel, *op. cit.*, 277–81, who dates the portal to around 1240 (298). A trumeau figure of Christ probably supported the lintel but this would have been destroyed when the entrance was modified at the time of the building of the 'Golden Staircase' on the inside of the north transept wall at the beginning of the sixteenth century.
7. *Ibid.*, 283–97, figs 23–37.
8. *Ibid.*, 282–3; S. Andrés Ordax, *Burgos Cathedral* (León, 1993), 20.
9. The relevant dates for the construction of the cloister are discussed in Deknatel, *op. cit.*, 298–303, and C. Welander, 'The architecture of the cloister of Burgos Cathedral', in E. Fernie and P. Crossley (eds), *Medieval Architecture and its intellectual context: Studies in honour of Peter Kidson* (London and Ronceverte, 1990), 159–68; for illustrations of the fourteenth-century portals see Andrés Ordax, *op. cit.*, 95–6.
10. Deknatel was at a loss to explain the presence of these figures (*op. cit.*, 304); they are perhaps simply representative of the concept of salvation through Baptism. The choice of the Baptism of Christ for a tympanum was extremely rare, and suggests that the sacrament was at one time performed in the cloister.
11. One of these attendants is now headless.
12. In addition, their good condition precludes the suggestion by J. M. Azcárate (*Arte Gótico en España* (Madrid, 1990), 158–9) that some of the figures originally belonged to the western portals, which is known to have been decayed by the seventeenth century. For excellent illustrations see H. Mahn, *Kathedralplastik in Spanien* (Reutlingen, 1935), figs 51–68.
13. Deknatel, *op. cit.*, 307, fig. 53.
14. *Ibid.*, 311–22.
15. *Ibid.*, 323–4.
16. Lambert, *op. cit.*, 242–8.
17. As a result the methodology of Deknatel, successful in its application to the sculpture of Burgos, is far less convincing for León (*op. cit.*, 357–87). Likewise, the detailed stylistic analysis of Franco Mata is in certain areas problematic (M. A. Franco Mata, *Escultura gótica en León* (León, 1976)).
18. The left doorway of the south transept was apparently never finished; only its archivolts and doorposts are carved, with the arms of Castile and León.
19. For the angel see Deknatel, *op. cit.*, fig. 86. Franco Mata would prefer to identify the prophet as Samuel, and considers its original position to be on the right jamb of the north portal of the west front (*op. cit.*, pl. LXXXIV).
20. Franco Mata's reconstruction of the figures on the south door of the west portal is difficult to accept without reservations as there are great differences in the style of adjoining figures and the figure of Simeon from the Presentation faces away from the Virgin and Child (*op. cit.*, pl. LXXXIV).
21. The original trumeau figure – the so-called *Virgen Blanca* – has been replaced by a copy and is now displayed in the eponymous chapel in the ambulatory. It has now lost most of its colouring, for which see the illustration in Deknatel, *op. cit.*, fig. 68.

22. *Ibid.*, 372, figs 90, 92. On the extent of the Last Judgement master's work at León my views differ considerably from those of Franco Mata (*op. cit.*, 361–81).

23. Deknatel's association of this particular style at León with German sculpture, such as that of the Erminoldmeister in Regensburg, is not convincing (*op. cit.*, 369–73). An ivory Virgin and Child in a similar style to both the León and Lincoln stone sculptures is in the Wadsworth Atheneum in Hartford, Connecticut (R. H. Randall Jr, *The Golden Age of Ivory: Gothic carvings in North American collections* (New York, 1993), cat. no. 31: 'Spanish, 1270–90').

24. M. Gómez-Moreno, *Catálogo Monumental de España. Provincia de León (1906–1908)*, plates vol. (Madrid, 1926), figs 290, 305–6.

25. Deknatel, *op. cit.*, 377–8.

26. See p. 256.

27. Z. García Villada, *Catálogo de códices y documentos de la catedral de León* (Madrid, 1919), item no. 11261, and Deknatel, *op. cit.*, 323, n. 170.

28. For the history of the building see Andrés Ordax *et al*, *op. cit.*, 201–7.

29. The figures now occupying the niches on the jambs at Sasamón are of poorer quality than the sculptures above. Those representing prophets and queens may be original, but others are obviously clumsy insertions, including the female figure on the trumeau.

30. There does not seem to be any compelling reason to place it as late as around 1300, a date which has sometimes been assigned to it (Andrés Ordax *et al*, *op. cit.*, 137–43 (esp. 141); Azcárate, *op. cit.*, 173–4); see also T. López Mata, *El Barrio e Iglesia de San Esteban* (Burgos, 1946).

31. For the building history see J. M. Martínez Frías in Andrés Ordax *et al*, *op. cit.*, 340–7.

32. For an illustration of the whole portal, *ibid.*, fig. 5.

33. For the Reims figures see W. Sauerländer, *Gothic Sculpture in France 1140–1270* (London, 1972), pls 230, 233.

34. Perhaps the principal interest of the portal at Toro lies in its coloured decoration, which has been the subject of a long conservation campaign still in progress in 1993.

35. A. Durán Sanpere and J. Ainaud de Lasarte, *Escultura Gótica (Ars Hispaniae, Vol. 8)* (Madrid, 1956), fig. 43; Andrés Ordax *et al*, *op. cit.*, 274–9, pls 88–9, 91.

36. See for instance the portal of San Martín of Noya, dated 1434, which is based on the Pórtico de la Gloria (J. M. Caamaño Martínez, 'Pervivencia y ecos del Pórtico de la Gloria en el Gotico Gallego', in *Actas simposio internacional sobre 'O Pórtico da Gloria e a Arte do seu tempo'* (La Coruña, 1991), 439–56).'

37. Mahn, *op. cit.*, 33, figs 100–1; F. B. Deknatel, 'Sculptured columns from Sahagún and the Amiens style in Spain', W. R. W. Koehler (ed.), *Medieval Studies in memory of A. Kingsley Porter* (Cambridge, Mass., 1939), I, 301–10; W. Sauerländer, 'L'Europe gothique, XIIe–XIVe siècles. Points de vue critiques à propos d'une exposition', *Revue de l'Art*, III (1969), 87, figs 6–7. Two other column figures of Saints Paul and Michael from Sahagún are now in the Fogg Art Museum of Harvard University (D. Gillerman (ed.), *Gothic Sculpture in America, I, The New England Museums* (New York and London, 1989), cat. no. 141).

38. The portal was originally on the west front of the cathedral, but was moved to its present position in the fifteenth century (Andrés Ordax *et al*, *op. cit.*, 460; for a full discussion of Ávila Cathedral see M. Gómez Moreno, *Catálogo monumental de la provincia de Ávila* (edition revised by A. de la Morena and T. Pérez Higuera (Ávila, 1983), 65–132).

39. Because the scenes on the left side of the bottom band do not appear to be iconographically compatible with those on the right it has been suggested that they were wrongly put together in the fifteenth-century relocation of the portal (Azcárate, *op. cit.*, 170). There are problems with this interpretation. The figures on the left appear to represent the Blessed, in the manner of those on the lintel of the central portal of the west front at León, while the right side depicts the Washing of the Feet and Christ in the House of Levi; see N. Panadero Peropadre, *Estudio iconográfico de la portada norte de la Catedral de Ávila* (Ávila, 1982).

40. A full investigation of the iconography will be found in M. T. Pérez Higuera, *La Puerta del Reloj en la Catedral de Toledo* (Toledo, 1987).

41. See Durán Sanpere and Ainaud de Lasarte, *op. cit.*, 103–7, figs 88, 92, 104.

42. *Ibid.*, figs 145–6. Deknatel proposed that the Vitoria apostles provided the training for one of the León workshops, but it is more likely that this relationship should be reversed. He also suggested a link between the jamb figures of the cathedral at Vitoria and those at León: this is completely out of the question, the Vitoria portal being considerably later in date (Deknatel, *op. cit.* (1935), 378–79). See also M. J. Portilla, 'Parroquia de San Pedro Apostol', in *Catalogo Monumental Diocesis de Vitoria, III, Ciudad de Vitoria* (Vitoria, 1968), 151–5, figs 262–84, who considers the portal to be of late fourteenth-century date.

43. W. W. S. Cook and J. Gudiol Ricart, *Pintura e Imaginería Románicas (Ars Hispaniae, Vol. 6)* (Madrid, 1950), 294–389. See also the large collection in the

Museu Marès in Barcelona (*Catàleg d'escultura i pintura medievals (Fons del Museu Frederic Marès/1)* (Barcelona, 1991)).

44. For these Annunciation groups see Deknatel, *op. cit.* (1935), 383–6, figs 94–101, and Mahn, *op. cit.*, figs 208–25.

45. For the Toledo *Virgen Blanca* see now W. Sauerländer, 'Von der Glykophilousa zur "Amie Graciouse". Uberlegungen und Fragen zur "Virgen Blanca" in der Kathedrale von Toledo', in *De la création à la restauration: travaux d'histoire de l'art offerts à Marcel Durliat pour son 75e anniversaire* (Toulouse, 1992), 449–61.

46. For the Compiègne Virgin see Sauerländer, *op. cit.* (1972), pl. 275. The attribution of the Tarragona Virgin to Maestro Bartomeu, who is recorded as working at Tarragona between 1277 and 1295, is contentious; stylistically it is far in advance of the works that are demonstrably his at Gerona, Tarragona and Santa Creus (Durán Sanpere and Ainaud de Lasarte, *op. cit.*, 181–87; see also J. Sureda Pons *et al*, *Cataluña/1 (La España Gótica, Vol. 2)* (Madrid, 1987), 128–37). An alternative attribution to Reinard des Fonoll is likewise unconvincing (J. Vives i Miret, *Reinard des Fonoll. Escultor i arquitecte anglès renovador de l'art gòtic a Catalunya (1321–1362)* (Barcelona, 1969), 125–6).

CHAPTER 12

1. P. Toesca, *Il Medioevo* (Turin, 1927, reprinted Turin, 1965), 807–8, n. 29, tentatively considered the date of the Ferrara Last Judgement to be 'tra la fine del Dugento e il principio del Trecento'. I would prefer an earlier date, around 1250. See also A. Giglioli, 'Il Duomo di Ferrara nella storia e nell'arte', in *La Cattedrale di Ferrara 1135–1935* (Verona, 1937), 202–8, pls XXXII–XLIV, and R. Rossi-Manaresi and O. Nonfarmale, *Notizie sul restauro del protiro della cattedrale di Ferrara/Report on the conservation of the porch of Ferrara cathedral* (Bologna, 1981).

2. J. White, 'The reliefs on the façade of the Duomo at Orvieto', *Journal of the Warburg and Courtauld Institutes*, XXII (1959), 254–302; *idem*, *Art and Architecture in Italy 1250–1400* (Pelican History of Art, 3rd ed., New Haven and London, 1993), 455–64.

3. Translation from J. Pope-Hennessy, *Italian Gothic Sculpture* (3rd ed., Oxford, 1986), 177–8.

4. The identification of the angle figures remains a matter of debate: different interpretations are given in G. Jászai, *Die Pisaner Domkanzel. Neue Versuch zur Wiederherstellung ihres ursprünglichen Zustandes* (Munich, 1968), 11ff, and E. Angiola, 'Nicola Pisano, Federico Visconti and the classical style in Pisa', *Art Bulletin*, LIX (1977), 1–27, esp. 13–19. Pithy summaries of the problem are to be found in Pope-Hennessy, *op. cit.*, 273–4, and White, *op. cit.* (1993), 619. For a fully-illustrated monograph see E. Carli, *Il Pulpito del Battistero di Pisa* (Milan, 1971).

5. Pope-Hennessy, *op. cit.*, 170.

6. *Ibid.*, 169; M. L. Testi Cristiani, *Nicola Pisano, architetto, scultore: dalle origini al pulpito del battistero di Pisa* (Pisa, 1987), 9–10, 304 (n. 1). For the documents in full see G. Nicco Fasola, *Nicola Pisano* (Rome, 1941), 214–15, nos 6–7.

7. For the Campanian examples see D. F. Glass, *Romanesque Sculpture in Campania: patrons, programs, and style* (University Park, Penn., 1991), figs 57, 139–40, 181–3, 190–3.

8. Testi Cristiani, *op. cit.*, figs 375, 382–3.

9. *Ibid.*, 43–84; see also A. Middeldorf Kosegarten, *Sienesische Bildhauer am Duomo Vecchio. Studien zur Skulptur in Siena 1250–1330* (Munich, 1984), 35–43.

10. *Ibid.*, fig. 66; for another related capital from the arcade of the Baptistery see A. Kosegarten, 'Die Skulpturen der Pisani am Baptisterium von Pisa. Zum Werk von Nicola und Giovanni Pisano', *Jahrbuch der Berliner Museen*, X (1968), figs 34–5, and for an overview C. Gnudi, 'Considerazioni sul gotico francese, l'arte imperiale e la formazione di Nicola Pisano', in A. M. Romanini (ed.), *Federico II e l'arte del Duecento italiano (Atti della III settimana di studi di storia dell'arte medievale all'università di Roma, 1978)* (Galatina, 1980), I, 1–17 (reprinted in C. Gnudi, *L'arte gotica in Francia e in Italia* (Turin, 1982), 102–19).

11. M. Seidel, 'Studien zur Antikenrezeption Nicola Pisanos', *Mitteilungen des Kunsthistorischen Institutes in Florenz*, XIX (1975), 307–92.

12. *Ibid.*, 337–44.

13. For the similarity of Nicola's drapery to Byzantine-inspired Northern models see A. Middeldorf Kosegarten, 'Nicola Pisano, das "Wolfenbütteler Musterbuch" und Byzanz', *Münchner Jahrbuch der bildenden Kunst*, 3rd series, XXXIX (1988), 29–50.

14. M. Seidel, 'A sculpture by Nicola Pisano in the "Studiolo" of Cosimo I de' Medici', *Burlington Magazine*, CXV (1973), 599–600.

15. See principally A. Kosegarten, 'Nicola Pisano a Lucca', *Antichità Viva*, VI/3 (1967), 19–32; an erroneous late dating, around 1300, is set out by J. Polzer, 'The Lucca reliefs and Nicola Pisano', *Art Bulletin*, XLVI (1964), 211–16. Pope-Hennessy (*op. cit.*, 169–70) gives a summary of the different views regarding the Lucca reliefs; in addition see Testi Cristiani, *op. cit.*, 222–8.

16. The most recent detailed account of the tomb is A. F. Moskowitz, *Nicola*

Pisano's Arca di San Domenico and its legacy (University Park, Penn., 1994), but see also C. Gnudi, *Nicola, Arnolfo, Lapo: l'Arca di S. Domenico in Bologna* (Florence, 1948) and S. Bottari, *L'Arca di S. Domenico in Bologna* (Bologna, 1964).

17. J. Pope-Hennessy, *Italian High Renaissance and Baroque sculpture* (2nd ed., London and New York, 1970), 301–2.

18. G. Swarzenski, 'Das Auftreten des Eglomisé bei Nicolo Pisano', *Festschrift zum sechzigsten Geburtstag von Paul Clemen* (Düsseldorf, 1926), 326–8.

19. The inclusion of three single figures (two in the Victoria and Albert Museum in London, the other in the Louvre in Paris) as caryatids for the Arca would appear to be contradicted by the way in which the backs of the figures have been finished: they would surely have been carved in the round if they had been intended for a free-standing position and, like the three-figured groups, would have had small capitals above their heads. In addition, the provenance of the London pieces (purchased in Florence in 1859 and said to have come from a church in the neighbourhood of Pisa) is not encouraging for a Bolognese origin. On this question see principally C. Gnudi, *op. cit.* (1948), 85 (note 2), 99–105; J. Pope-Hennessy, 'The Arca of St Dominic: a hypothesis', *Burlington Magazine*, XCIII (1951), 347–51 (reprinted in *idem.*, *Essays on Italian Sculpture* (London, 1968), 11–15); A. F. Moskowitz, 'The Arca di S. Domenico caryatids: supports for a hypothesis', *Source: Notes in the History of Art*, VI/3 (Spring 1987), 1–6; *idem.*, in D. Gillerman, *Gothic Sculpture in America. I. The New England Museums* (New York and London, 1989), cat. no. 68; *idem.*, *op. cit.* (1994), 9.

20. For the documents see Nicco Fasola, *op. cit.*, 209–14, items 4–6.

21. Nicco Fasola, *op. cit.*, 208, item 3.

22. For the S. Giovanni Fuorcivitas pulpit see G. Swarzenski, *Nicolo Pisano* (Frankfurt am Main, 1926), pls 109–13. The division of labour postulated by Gnudi (*op. cit.* (1948), 97–105), attributing sculptures to Lapo and a 'Quinto Maestro', seems to me unverifiable even if possible.

23. A. Moskowitz, 'Giovanni di Balduccio's Arca di San Pietro Martire: form and function', *Arte Lombarda*, 96/97 (1991), 7–18, and *idem.*, *op. cit.* (1994).

24. Nicco Fasola, *op. cit.*, 215–19, item 8; see also E. Carli, *Il Pulpito di Siena* (Bergamo, 1943) and J. Poeschke, *Die Sieneser Domkanzel des Nicola Pisano. Ihre Bedeutung für die Bildung der Figur im 'stile nuovo' der Dante-Zeit* (Berlin and New York, 1973).

25. M. Seidel, 'Die Verkündigungsgruppe der Sieneser Domkanzel', *Münchner Jahrbuch der bildenden Kunst*, 3rd series, XXI (1970), 19–72.

26. See the relevant essays reprinted in Gnudi, *op. cit.* (1982). The possible influence of French Gothic ivories on Nicola Pisano is put forward in M. Seidel, 'Die Elfenbeinmadonna im Domschatz zu Pisa. Studien zur Herkunft und Umbildung französischer Formen im Werk Giovanni Pisanos in der Epoche der Pistoieser Kanzel', *Mitteilungen des Kunsthistorischen Institutes in Florenz*, XVI (1972), 1–50, esp. 24–30.

27. For the various opinions see Pope-Hennessy, *op. cit.* (1986), 172.

28. A. Kosegarten, 'Nicola und Giovanni Pisano 1268–1278', *Jahrbuch der Berliner Museen*, XI (1969), 36–80.

29. For the inscription see Pope-Hennessy, *op. cit.* (1986), 173.

30. The fountain has been dismantled and reconstructed at least twice. See G. Nicco Fasola, *La Fontana di Perugia* (Rome, 1951); K. Hoffmann-Curtius, *Das Programm der Fontana Maggiore in Perugia* (Düsseldorf, 1968; also review by J. White in *Art Bulletin*, LII (1970), 437–9); J. White, 'The reconstruction of Nicola Pisano's Perugia fountain', *Journal of the Warburg and Courtauld Institutes*, XXXIII (1970), 70–83.

31. Pope-Hennessy, *op. cit.* (1986), 174: I find it difficult to accept the confident attribution of the June and July reliefs to Nicola; see also White, *op. cit.* (1993), 91.

32. In view of the North Italian precedents there is no need to seek direct French prototypes for the reliefs of the Months, although it is probable that model-books with designs from the French cathedrals were circulating at this time (see Nicco Fasola, *op. cit.* (1941), pls X–XI, for parallels with Notre-Dame in Paris and Sens).

33. See J. Gardner, *The Tomb and the Tiara: Curial tomb sculpture in Rome and Avignon in the later Middle Ages* (Oxford, 1992), 95–6. The literature on Arnolfo di Cambio is now of some size, the majority of work being done in the last twenty-five years; for a useful general account and a recent bibliography see A. M. Romanini, 'Arnolfo di Cambio', in *Enciclopedia dell'Arte Medievale*, II (Rome, 1991), 504–14.

34. The original location of the figure was discussed by P. Cellini, 'L'opera di Arnolfo all'Aracoeli', *Bollettino d'Arte*, XLVII (1962), 180–95, and M. Weinberger, 'Arnolfo und die Ehrenstatue Karls von Anjou', in *Studien zur Geschichte der europäischen Plastik. Festschrift Theodor Müller* (Munich, 1965), 63–72; the results of a recent technical investigation into the restorations suffered by the statue are given in an important article by G. Martellotti ('Il Carlo d'Angiò capitolino. Riflessioni dopo il restauro', *Arte Medievale*, 2nd series, V/2 (1991), 127–47).

35. See Cellini, *op. cit.*; E. Carli, *Arnolfo* (Florence, 1993), 60–1, summarises the question of the original provenance.

36. It might be compared with the second-century figure of a magistrate seated on a *sella curulis*, now in the Palazzo Falconieri in Rome (see T. F. Mathews, *The Clash of Gods: a reinterpretation of Early Christian Art* (Princeton, 1993), fig. 77).

37. V. Pace, 'Questioni arnolfiane: l'Antico e la Francia', *Zeitschrift für Kunstgeschichte*, LIX (1991), 335–8, relates the statue of Charles of Anjou to Late Antique prototypes.

38. Martellotti, *op. cit.*, fig. 3.

39. V. Martinelli, 'Arnolfo a Perugia', *Atti del sesto convegno di Studi Umbri, Gubbio 26–30 maggio 1968. I, Storia e arte in Umbria nell'età communale* (Perugia, 1971), 1–42 (esp. 41, Doc. XVII).

40. G. Nicco Fasola, 'La fontana di Arnolfo', *Commentari*, II (1951), 98–105; F. Santi, 'Considerazioni sulla Fontana di Arnolfo a Perugia', *Commentari*, VI (1960), 220–30; *idem.*, 'Un altro "scriba" di Arnolfo per la fontana perugina del 1281', *Paragone*, 225 (1968), 3–10; A. Reinle, 'Zum Programm des Brunnens von Arnolfo di Cambio', *Jahrbuch der Berliner Museen*, XX (1980), 121–51; G. Cuccini, *Arnolfo di Cambio e la fontana di Perugia 'pedis platee'* (Perugia, 1989); F. Santi, 'Postilla allo studio della fontana di Arnolfo a Perugia', *Bollettino della Deputazione di Storia Patria per l'Umbria*, LXXXVII (1990), 179–89. An excellent succinct account of the fountain, reproducing Santi's reconstruction and with a summary of the literature, is given in Carli, *op. cit.*, 77–80.

41. See the persuasive comparisons provided by Pace, *op. cit.*, 341–5, figs 5–13, and the further comments of M. di Fronzo, 'I modelli degli "assetati" di Arnolfo di Cambio', *Arte Medievale*, 2nd series, III/2 (1989), 93–113. The identification of the reclining male figure as a 'paralitico' has been discussed at length by A. M. Romanini ('Gli occhi di Isaaco: classicismo e curiosità scientifica tra Arnolfo di Cambio e Giotto', *Arte Medievale*, 2nd series, I (1987), 19–25, 48–51). The christological reconstruction of the fountain proposed by Reinle (*op. cit.*) seems to me less plausible than a purely secular one.

42. The Cardinal hailed from Bray-sur-Somme, so the traditional spelling of his name, handed down from author to author, is incorrect (Gardner, *op. cit.*, 97, n. 16).

43. The inward lean of the acolytes and the position of their feet indicate that they are closing, not opening, the curtains; consequently I prefer the interpretation of White (*op. cit.* (1993), 96) to that of Gardner ('Arnolfo di Cambio and Roman tomb design', *Burlington Magazine*, CXV (1973), 424, n. 19, and *op. cit.* (1992), 100).

44. An admirable account of the de Bray tomb is given in Gardner, *op. cit.* (1992), 97–102; further discussion of the original layout of the tomb is to be found in A. M. Romanini, *Arnolfo di Cambio e lo 'stil novo' del gotico italiano* (Milan, 1969; reprinted Florence, 1980), 23–56, *idem.*, 'Nuove ipotesi su Arnolfo di Cambio', *Arte Medievale*, I (1983), 157–202, and *idem.*, 'Ipotesi ricostruttive per i monumenti sepolcrali di Arnolfo di Cambio. Nuovi dati sui monumenti De Braye e Annibaldi e sul sacello di Bonifacio VIII', in J. Garms and A. M. Romanini (eds), *Skulptur und Grabmal des Spätmittelalters in Rom und Italien. Akten des Kongresses 'Scultura e monumento sepolcrale del tardo medioevo a Roma e in Italia' (Rom, 4.–6. Juli 1985)* (Vienna, 1990), 107–28. For the tomb of Clement IV see A. M. D'Achille, 'Sulla datazione del monumento funebre di Clemente IV a Viterbo: un riesame delle fonti', *Arte Medievale*, 2nd series, III/2 (1989), 85–91; *idem.*, 'Il monumento funebre di Clemente IV in S. Francesco a Viterbo', in Garms and Romanini, *op. cit.*, 129–42; P. C. Claussen, 'Pietro di Oderisio und die Neuformulierung des italienischen Grabmals zwischen *Opus Romanum* und *Opus Francigenum*', in Garms and Romanini, *op. cit.*, 173–200.

45. Pace, *op. cit.*, 345–7, figs 14–21; *idem.*, 'Arnolfo a Orvieto: una nota sul sepolcro de Braye e sulla ricezione dell'Antico nella scultura del duecento', *Quaderni dell'Istituto di Storia dell'Architettura*, n.s., 15–20 (1990–2), 187–94. See also *Le trésor de Saint-Denis* (exh. cat., Paris, 1991), cat. no. 65. A. M. Romanini's dramatic recent attempt to attribute the Virgin to the second century AD, arguing that it was re-used and adapted by Arnolfo on the tomb, is unconvincing ('Une statue romaine dans la Vierge De Braye', *Revue de l'Art*, 105 (1994), 9–18).

46. Good photographic coverage is to be found in Carli, *op. cit.*, figs 82–104.

47. Pace, *op. cit.* (1991), 348, figs 22–3.

48. For the inscription see A. M. Romanini's introduction in *Roma anno 1300 (Atti della IV Settimana di Studi di storia dell'arte medievale dell'Università di Roma 'La Sapienza', 19–24 maggio 1980)* (Rome, 1983), 9–10, fig. 1.

49. The figures of St Cecilia and St Urban are obvious, but there is some doubt about whether it is St Valerian or St Tiburtius shown on horseback: White (*op. cit.* (1993), 106) erroneously describes this figure as St Martin. For a discussion of the problem and a proposal in favour of Valerian see V. Pace, 'Il ciborio di Arnolfo a S. Cecilia: una nota sul suo stato originario e sulla sua committenza', *Studi di storia dell'arte sul medioevo e il rinascimento nel centenario della nascita di Mario Salmi (Atti del Convegno Internazionale Arezzo-Firenze, 16–19 Novembre 1989)* (Florence, 1993), 389–92.

50. For illustrations see Carli, *op. cit.*, figs 105–25.

51. See I. Herklotz, *'Sepulcra' e 'Monumento' del Medioevo. Studi sull'arte*

sepolcrale in Italia (Rome, 1985), 170–80; the study of J. Gardner ('The tomb of Cardinal Annibaldi by Arnolfo di Cambio', *Burlington Magazine*, CXIV (1972), 136–41) remains of use for its careful analysis of the tomb's precursors, but see now *idem., op. cit.* (1992), 104–6.

52. The inclusion of the figure with mitre and crozier – surely only appropriate in a funeral procession of a bishop or cardinal – would appear to present difficulties in accepting the frieze as belonging to the tomb of a papal notary (see Herklotz, *op. cit.*, 176–9, and *idem.*, 'Paris de Grassis *Tractatus de funeribus et exequiis* und die Bestattungsfeiern von Päpsten und Kardinälen in Spätmittelalter und Renaissance', in Garms and Romanini, *op. cit.*, 236).

53. The reconstructions proposed by A. M. Romanini (*op. cit.* (1983), 157–202, (1990), 115–19) are for various reasons unacceptable.

54. Gardner, *op. cit.* (1992), figs 97–8, 108, 110–12. The tomb of Pope Hadrian V (d.1276) in San Francesco in Viterbo, sometimes associated with Arnolfo, was executed by another Roman workshop (*ibid.*, 72–4, figs 34–8, and T. Iazeolla, 'Il monumento funebre di Adriano V in S. Francesco alla Rocca a Viterbo', in Garms and Romanini, *op. cit.*, 143–57). A fragment from a further tomb produced by the Arnolfo workshop, showing a small deacon holding back a curtain, is now in the Walker Art Gallery in Liverpool (J. Gardner, 'A relief in the Walker Art Gallery and thirteenth-century Italian tomb design', *Bulletin of the Walker Art Gallery Liverpool*, XIII (1968–70), 5–19).

55. Arnolfo's workshop also executed other portraits of Boniface VIII, including the half-length relief now in the Papal apartments of the Vatican which was once associated with the tomb: see J. Gardner, 'Boniface VIII as a patron of sculpture', in *Roma anno 1300* (*op. cit.*), 513–21, and N. Rash, 'Boniface VIII and honorific portraiture: observations on the half-length image in the Vatican', *Gesta*, XXVI (1987), 47–58).

56. Gardner, *op. cit.* (1992), figs 106–7.

57. S. Romano, 'Giovanni di Cosma', in Garms and Romanini, *op. cit.*, 159–71.

58. See W. Messerer, 'Zur Rekonstruktion von Arnolfo di Cambios Praesepe-Gruppe', *Römisches Jahrbuch für Kunstgeschichte*, XV (1975), 25–35, and more convincingly, F. Pomarici, 'Il Presepe di Arnolfo di Cambio: nuova proposta di ricostruzione', *Arte Medievale*, 2nd series, II/2 (1988), 155–75.

59. All earlier studies have been superseded by A. M. Romanini, 'Nuovi dati sulla statua bronzea di San Pietro in Vaticano', *Arte Medievale*, 2nd series, IV/2 (1990), 1–50, and the articles by S. Angelucci, P. Réfice, R. Caglianone and A. Iazeolla, *idem.*, 51–71; the results of the thermoluminescence testing of the core of the bronze, giving a reading of 1323 ± 57 years (i.e. 1265–1379), are summarised in S. Angelucci *et al*, 'La datazione con termoluminescenza del San Pietro in bronzo della Basilica Vaticana: alcune precisazioni di metodo e di prassi sulle indagini tecnico-scientifiche applicate alle opere d'arte', *Arte Medievale*, 2nd series, VI/2 (1992), 157–65 (164).

60. Carli, *op. cit.*, 177–9, figs 151–4.

61. Romanini, *op. cit.* (1990), 11–16; see also the comments of Valentino Pace on the unusual employment of red on the apostle's mantle (*op. cit.* (1991), 373, n. 67).

62. The surviving sculptures in Florence are catalogued by L. Becherucci and G. Brunetti, *Il Museo dell'Opera del Duomo a Firenze*, I (Florence, 1969), 215–28. The literature on the early building history is summarised in Pope-Hennessy, *op. cit.* (1986), 181, 182–3, and White, *op. cit.* (1993), 618, n. 9. A recent survey is provided by K. Christian, *Arnolfo di Cambio's sculptural project for the Duomo façade in Florence: a study in style and context* (Doctoral dissertation, New York University, 1989).

63. The clearest reproduction of the Poccetti drawing is to be found in fig. 37 of the second edition (1972) of Pope-Hennessy's *Italian Gothic Sculpture*. The turning of the Virgin's head, directing her glance over her shoulder, suggests that she was originally either looking towards the Angel of the Annunciation, as on the Pisa Baptistery pulpit, or towards a necessarily small subsidiary scene such as the Washing of the Christ-Child, as seen on the Siena pulpit.

64. G. Richa, *Notizie istoriche delle chiese fiorentine*, VI (Florence, 1757), 53; G. Poggi, *Il Duomo di Firenze. Documenti sulla decorazione della chiesa e del campanile tratti dall'archivio dell'opera (Italienische Forschungen vom Kunsthistorischen Institut in Florenz, II)* (Berlin, 1909), xxix, lxii.

65. For discussion and illustration of the Berlin fragments, which were badly damaged by fire at the end of the Second World War, see M. Seidel, 'Der Marientod des Arnolfo di Cambio: Erhaltungszustand und Forschungsgeschichte', *Forschungen und Berichte, Staatliche Museen zu Berlin*, XV (1973), 41–4; the fragment of Christ and the Virgin's Soul is illustrated in Becherucci

and Brunetti, *op. cit.*, pl. 23.

66. P. Lasko, *Ars Sacra: 800–1200* (Pelican History of Art, 2nd ed., New Haven and London, 1994), pl. 141.

67. The chronology of the upper part of the façade proposed in the fundamental study by Middeldorf Kosegarten (*op. cit.* (1984), *passim.*) has been questioned in a review by John White in *Art History*, VIII (1985), 485–6.

68. Middeldorf Kosegarten, *op. cit.* (1984), 75–7.

69. The decorative programme was continued in the lintel of the central portal, which shows scenes from the Infancy of the Virgin, and in the inhabited scroll work of the two major columns flanking the central portal, now removed (*ibid.*, figs 111–19, and M. Seidel, 'Die Rankensäulen der Sieneser Domfassade', *Jahrbuch der Berliner Museen*, XI (1969), 81–157). The standing figures are illustrated in E. Carli, *Giovanni Pisano* (Pisa, 1977), pls 41–63.

70. J. Pope-Hennessy, 'New works by Giovanni Pisano – I', *Burlington Magazine*, CV (1963), 529–33 (reprinted in *idem., op. cit.* (1968), 1–5). White's negative view of the *Haggai* as 'a weakly constructed workshop production' (*op. cit.* (1993), 117), is contradicted by the sculpture itself.

71. Pope-Hennessy, *op. cit.* (1968), 5.

72. P. Williamson, 'Avori italiani e avori francesi', in V. Pace and M. Bagnoli (eds), *Il Gotico europeo in Italia* (Naples, 1994), 293–8. For a French ivory Virgin and Child in Lugnano see L. Mortari, 'Un avorio gotico francese nel Lazio', *Bollettino d'Arte*, XLV (1960), 313–19.

73. R. Barsotti, 'Nuovi studi sulla Madonna eburnea di Giovanni Pisano', *Critica d'Arte*, IV (1957), 47–56; J. Pope-Hennessy, 'An ivory by Giovanni Pisano', *Victoria and Albert Museum Bulletin*, I/3 (1965), 9–16 (reprinted in *idem., op. cit.* (1968), 6–10); Seidel, *op. cit.* (1972), 1–6; J. Tripps, 'Giovanni Pisano e l'influsso francese sulla scultura in Italia', in Pace and Bagnoli, *op. cit.*, 141–52.

74. See p. 150. It is of interest in this connection that the Rouen angels also originally had silver-gilt wings.

75. The head of the Christ-Child, the right hand of the Virgin and other small pieces of the statue were restored by Giovan Battista Riminaldi in 1634 (Seidel, *op. cit.* (1972), 3).

76. Pope-Hennessy, *op. cit.* (1965), figs 8–9. The association of the figure with Giovanni di Balduccio by M. Lisner (*Holzkruzifixe in Florenz und in der Toskana von der Zeit um 1300 bis zum frühen Cinquecento* (Munich, 1970), 44, n. 39) is difficult to understand. A related ivory figure of Christ has been published in M. Seidel, '"Opus heburneum". Die Entdeckung einer Elfenbeinskulptur von Giovanni Pisano', *Pantheon*, XLII (1984), 219–29.

77. M. Seidel, *La scultura lignea di Giovanni Pisano* (Florence, 1971); *idem.*, 'Ein verkanntes Meisterwerk des Giovanni Pisano: das Kreuz aus S. Maria a Ripalta in Pistoia', *Pantheon*, XXXIV (1976), 3–13; *idem.*, 'Das prateser Kruzifix: Einblicke in die Werkstattorganisation Giovanni Pisanos', *Gesta*, XVI (1977), 3–12; the division of the group into two by Seidel, with the Siena and Pisa crucifixes dated to 1270–80, the others to around 1300, is open to debate. See also Carli, *op. cit.* (1977), pls 75–8.

78. A convenient juxtaposition of the three panels is provided in Seidel, *op. cit.* (1976), figs 12–14.

79. The inscription is given in full and translated in Pope-Hennessy, *op. cit.* (1986), 177.

80. The reliefs show the Annunciation, Nativity and Annunciation to the Shepherds, the Adoration of the Magi, the Dream of the Magi and the Angel warning the Holy Family to flee, the Massacre of the Innocents, the Crucifixion, and the Last Judgement; the angle-figures consist of a deacon (St Stephen?), the Apocalyptic Christ, the Prophet Jeremiah, the Symbols of the Evangelists, the Writers of the Canonical Epistles, and four angels. A sumptuously illustrated monograph by E. Carli provides the fullest photographic documentation (by A. Amendola) of the pulpit: *Giovanni Pisano: il pulpito di Pistoia* (Milan, 1986).

81. The original and actual dispositions of the pulpit are juxtaposed in the plans published in Carli, *op. cit.* (1986), 16–17; for remains of the *verre églomisé* inlay, *ibid.*, pls 62–3, 67, 69 and 88; for a detail of the unfinished area in the Crucifixion relief see pl. 120.

82. M. Seidel, 'Studien zu Giovanni di Balduccio und Tino di Camaino: die Rezeption des Spätwerks von Giovanni Pisano', *Städel Jahrbuch*, V (1975), 37–83; G. Kreytenberg, 'Giovanni Pisano oder Tino di Camaino?', *Jahrbuch der Berliner Museen*, XX (1978), 29–38; *idem.*, *Tino di Camaino* (Lo specchio del Bargello, 30; Florence, 1986), 8–12; *idem.*, *Die Werke von Tino di Camaino* (Liebieghaus Monographie, 11; Frankfurt am Main, 1987), 29–32.

83. White, *op. cit.* (1993), 133–9 (Pisa cathedral pulpit), 438–45 (Tino di Camaino).

Select Bibliography

References to books and articles devoted to specific buildings or sculptures will be found in the Notes, chapter by chapter. The list below contains material intended to provide a wider background, and most of the works contain extensive bibliographies.

GENERAL

BAUCH, K. *Das mittelalterliche Grabbild. Figürliche Grabmäler des 11. bis 15. Jahrhunderts in Europa*, Berlin and New York, 1976.

BECK, H. and HENGEVOSS-DÜRKOP, K. (eds). *Studien zur Geschichte der europäischen Skulptur im 12./13. Jahrhundert*, 2 vols, Frankfurt am Main, 1994.

BEHLING, L. *Die Pflanzenwelt der mittelalterlichen Kathedralen*, Cologne, 1964.

BENSON, R. L. and CONSTABLE, G. (eds, with C. D. Lanham). *Renaissance and renewal in the twelfth century*, Oxford, 1982.

CAMILLE, M. *The Gothic Idol. Ideology and Image-making in Medieval Art*, Cambridge, 1989.

CAMILLE, M. *Image on the Edge. The margins of medieval art*, London, 1992.

CAVINESS, M. H. '"The simple perception of matter" and the representation of narrative, ca. 1180–1280', *Gesta*, XXX (1991), pp. 48–64.

ERLANDE-BRANDENBURG, A. *Le Monde Gothique: la conquête de l'Europe 1260–1380*, Paris, 1987.

L'Europe Gothique, XIIe–XIVe siècles (exh. cat.), Paris, 1968.

FRANKL, P. *The Gothic. Literary sources and interpretations through eight centuries*, Princeton, 1960.

HENDERSON, G. *Gothic*, Harmondsworth, 1967.

HOFFMANN, K. (ed.). *The Year 1200*, exh. cat. and supplementary volume, New York, 1970.

HURTIG, J. W. *The Armored Gisant before 1400*, New York, 1979.

MALE, E. *Religious Art in France. The twelfth century: a study of the origins of medieval iconography*, ed. H. Bober, Princeton, 1978.

MALE, E. *Religious Art in France. The thirteenth century: a study of medieval iconography and its sources*, ed. H. Bober, Princeton, 1984.

PANOFSKY, E. *Gothic Architecture and Scholasticism*, Latrobe, Penn., 1951.

PANOFSKY, E. *Tomb Sculpture*, New York, 1964 (new ed., London, 1992), pp. 51–63.

SAUERLÄNDER, W. *Le Monde Gothique: le siècle des cathédrales 1140–1260*, Paris, 1989.

SCHNEIDER BERRENBERG, R. *Studien zur monumentalen Kruzifix-gestaltung im 13. Jahrhundert*, 2 vols, Munich, 1977.

VERDIER, P. *Le Couronnement de la Vierge. Les origines et les premiers développements d'un thème iconographique*, Montreal, 1980.

WILSON, C. *The Gothic Cathedral. The Architecture of the Great Church 1130–1530*, London, 1990.

FRANCE

AUBERT, M. *La Sculpture française au Moyen-Age*, Paris, 1946.

BEAULIEU, M. 'Essai sur l'iconographie des statues-colonnes de quelques portails du premier art gothique', *Bulletin Monumental*, CXLII (1984), pp. 273–307.

BEAULIEU, M. and BEYER, V. *Dictionnaire des sculpteurs français du Moyen Age*, Paris, 1992.

Cathédrales (exh. cat.), Paris, 1962.

CLAUSSEN, P. C. 'Antike und gotische Skulptur in Frankreich um 1200', *Wallraf-Richartz-Jahrbuch*, XXXV (1973), pp. 83–108.

CLAUSSEN, P. C. *Chartres-Studien: zu Vorgeschichte, Funktion und Skulptur der Vorhallen*, Wiesbaden, 1975.

ERLANDE-BRANDENBURG, A. *Le Roi est mort: étude sur les funérailles, les sépultures et les tombeaux des rois de France jusqu'à la fin du XIIIe siècle*, Geneva, 1975.

GARDNER, A. *Medieval Sculpture in France*, Cambridge, 1931.

GRODECKI, L. 'La "Première sculpture gothique". Wilhelm Vöge et l'état actuel des problèmes', *Bulletin Monumental*, CXVII (1959), pp. 265–89 (reprinted in L. Grodecki, *Le Moyen Age retrouvé. De l'an mil à l'an 1200*, Paris, 1986, pp. 409–31).

HENDERSON, G. *Chartres*, Harmondsworth, 1968.

JALABERT, D. 'La flore gothique: ses origines, son évolution du XIIe au XVe siècle', *Bulletin Monumental*, XCI (1932), pp. 181–246.

JALABERT, D. *La flore sculptée des monuments du Moyen Age en France*, Paris, 1965.

KATZENELLENBOGEN, A. *The sculptural programs of Chartres Cathedral*, Baltimore, 1959.

KERBER, B. *Burgund und die Entwicklung der französischen Kathedralskulptur im 12. Jh.*, Recklinghausen, 1966.

LAPEYRE, A. *Des façades occidentales de Saint-Denis et de Chartres aux portails de Laon*, Mâcon, 1960.

LEFRANCOIS-PILLION, L. *Les sculpteurs français du XIIe siècle*, Paris, 1931.

LEFRANCOIS-PILLION, L. *Les sculpteurs français du XIIIe siècle*, 2nd ed., Paris, 1931.

MALE, E. *Religious Art in France. The twelfth century: a study of the origins of medieval iconography*, ed. H. Bober, Princeton, 1978.

MALE, E. *Religious Art in France. The thirteenth century: a study of medieval iconography and its sources*, ed. H. Bober, Princeton, 1984.

SAUERLÄNDER, W. 'Beiträge zur Geschichte der "frühgotischen" Skulptur', *Zeitschrift für Kunstgeschichte*, XIX (1956), pp. 1–34.

SAUERLÄNDER, W. 'Die Marienkrönungsportale von Senlis und Mantes', *Wallraf-Richartz-Jahrbuch*, XX (1958), pp. 115–62.

SAUERLÄNDER, W. 'Die kunstgeschichtliche Stellung der westportale von Notre-Dame in Paris. Ein Beitrag zur Genesis des hochgotischen Stiles in der französischen Skulptur', *Marburger Jahrbuch für Kunstwissenschaft*, XVII (1959), pp. 1–56.

SAUERLÄNDER, W. *Von Sens bis Strassburg. Ein Beitrag zur kunstgeschichtlichen Stellung der strassburger Querhausskulpturen*, Berlin, 1966.

SAUERLÄNDER, W. 'Sculpture on Early Gothic churches: the state of research and open questions', *Gesta*, IX (1970), pp. 32–48.

SAUERLÄNDER, W. *Gothic Sculpture in France 1140–1270*, London, 1972.

SCHREINER, L. *Die frühgotische Plastik Südwestfrankreichs*, Cologne-Graz, 1963.

Sculptures romanes et gothiques du Nord de la France (exh. cat.), Lille, 1978.

STODDARD, W. S. *The Sculptors of the West Portals of Chartres Cathedral*, New York and London, 1987.

SUCKALE, R. *Studien zu Stilbildung und Stilwandel der Madonnenstatuen der Ile-de-France zwischen 1230 und 1300*, Munich, 1971 (dissertation typescript).

VITRY, P. *French Sculpture during the reign of Saint Louis 1226–1270*, Florence-New York, n.d. (1929).

VÖGE, W. *Die Anfänge des monumentalen Stiles im Mittelalter*, Strasbourg, 1894.

THE HOLY ROMAN EMPIRE

ANCZYKOWSKI, M. *Westfälische Kreuze des 13. Jahrhunderts*, Münster, 1992.

BEENKEN, H. *Romanische Skulptur in Deutschland*, Leipzig, 1924.

BUDDE, R. *Deutsche romanische Skulptur 1050–1250*, Munich, 1979.

FUTTERER, I. *Gotische Bildwerke der deutschen Schweiz 1220–1440*, Augsburg, 1930.

GRZIMEK, W. *Deutsche Stuckplastik 800–1300*, Berlin, 1975.

HAUSSHERR, R. and VÄTERLEIN, C. (eds). *Die Zeit der Staufer* (exh. cat.), 4 vols, Stuttgart, 1977.

HAUSSHERR, R. and VÄTERLEIN, C. (eds). *Die Zeit der Staufer, Band V Supplement, Vorträge und Forschungen*, Stuttgart, 1979.

HENGEVOSS-DÜRKOP, K. *Skulptur und Frauenklöster. Studien zu Bildwerken der Zeit um 1300 aus Frauenklöstern des Fürstentums Lüneburg*, Berlin, 1994.

JANTZEN, H. *Deutsche Bildhauer des 13. Jahrhunderts*, Leipzig, 1925.

KAHSNITZ, R. (ed.) *Die Gründer von Laach und Sayn. Fürstenbildnisse des 13. Jahrhunderts* (exh. cat.), Nuremberg, 1992.

KLACK-EITZEN, C. *Die thronenden Madonnen des 13. Jahrhunderts in Westfalen (Denkmalpflege und Forschung in Westfalen, 6)*, Bonn, 1985.

LEGNER, A. *Deutsche Kunst der Romanik*, Munich, 1982.

LEGNER, A. (ed.). *Ornamenta Ecclesiae. Kunst und Künstler der Romanik* (exh. cat.), 3 vols, Cologne, 1985.

MAROSI, E. *Die Anfänge der Gotik in Ungarn. Esztergom in der Kunst des 12.–13. Jahrhunderts*, Budapest, 1984.

MAROSI, E. 'Das Figurenportal in Ungarn vor und nach 1200', in Beck and Hengevoss-Dürkop (*op. cit.* in General Bibliography), pp. 725–38.

NIEHR, K. *Die mitteldeutsche Skulptur der ersten Hälfte des 13. Jahrhunderts*, Weinheim, 1992.

PANOFSKY, E. *Die deutsche Plastik des 11. bis 13. Jahrhunderts*, Munich, 1924.

Rhin-Meuse: Art et Civilisation 800–1400 (exh. cat.), Cologne and Brussels, 1972 (also German edition).

Rhein und Maas: Kunst und Kultur 800–1400; 2, Berichte, Beiträge und Forschungen zum Themenkreis der Ausstellung und des Katalogs, Cologne, 1973.

SAUERLÄNDER, W. 'Die kunstgeschichtliche Stellung der Figurenportale des 13.

Jahrhunderts in Westfalen. Zum Stand der Forschung', *Westfalen*, XLIX (1971), pp. 1–76.

SAUERLÄNDER, W. 'Spätstaufische Skulptur in Sachsen und Thüringen. Überlegungen zum Stand der Forschung', *Zeitschrift für Kunstgeschichte*, XLI (1978), pp. 181–216.

SCHUBERT, D. *Von Halberstadt nach Meissen. Bildwerke des 13. Jahrhunderts in Thüringen, Sachsen und Anhalt*, Cologne, 1974.

SIMSON, O. VON. 'Deutsche Plastik', in O. von Simson (ed.), *Das Mittelalter II (Propyläen Kunstgeschichte, VI)*, Berlin, 1972, pp. 225–59.

ENGLAND

ALEXANDER, J. and BINSKI, P. (eds). *Age of Chivalry: Art in Plantagenet England 1200–1400* (exh. cat.), London, 1987.

ANDERSSON, A. *English influence in Norwegian and Swedish figure-sculpture in wood 1220–1270*, Stockholm, 1949 (reprinted 1950).

BONY, J. *The English Decorated Style: Gothic architecture transformed 1250–1350*, Oxford, 1979.

BRIEGER, P. *English Art 1216–1307* (Oxford History of English Art, Vol. IV), Oxford, 1957.

COALES, J. (ed.). *The earliest English brasses. Patronage, style and workshops 1270–1350*, London, 1987.

COLDSTREAM, N. 'English Decorated shrine bases', *Journal of the British Archaeological Association*, CXXIX (1976), pp. 15–34.

COLVIN, H. M. (ed.). *The History of the King's Works. Vols I–II: the Middle Ages*, London, 1963.

GARDNER, A. *English Medieval Sculpture*, Cambridge, 1951.

GARDNER, S. *English Gothic Foliage Sculpture*, Cambridge, 1927.

GEE, L. L. '"Ciborium" tombs in England 1290–1330', *Journal of the British Archaeological Association*, CXXXII (1979), pp. 29–41.

GIVENS, J. 'The garden outside the walls: plant forms in thirteenth-century English sculpture', in E. B. MacDougall (ed.), *Medieval Gardens*, Dumbarton Oaks, Washington, D.C., 1986, pp. 189–98.

LINDLEY, P. 'Westminster and London: sculptural centres in the thirteenth century', in Beck and Hengevoss-Dürkop (*op. cit.* in General Bibliography), pp. 231–50.

LINDLEY, P. *Gothic to Renaissance: Essays on sculpture in England*, Stamford, 1995.

PARSONS, D. (ed.). *Eleanor of Castile 1290–1990. Essays to commemorate the 700th anniversary of her death: 28 November 1290*, Stamford, 1991.

PRIOR, E. S. and GARDNER, A. *An Account of Medieval figure-sculpture in England*, Cambridge, 1912.

STONE, L. *Sculpture in Britain: the Middle Ages* (Pelican History of Art), 2nd ed., Harmondsworth, 1972.

TUMMERS, H. A. *Early secular effigies in England: the thirteenth century*, Leiden, 1980.

ZARNECKI, G. *Later English Romanesque Sculpture 1140–1210*, London, 1953.

ZARNECKI, G. 'The transition from Romanesque to Gothic in English sculpture', *Studies in Western Art, I, Romanesque and Gothic Art* (Acts of the 20th International Congress of the History of Art) Princeton, 1963, pp. 152–8 (reprinted in *Studies in Romanesque Sculpture*)

ZARNECKI, G. 'English 12th-century sculpture and its resistance to St Denis', *A tribute to an Antiquary: Essays presented to Marc Fitch by some of his friends*, London, 1976, pp. 83–92 (reprinted in *Studies in Romanesque Sculpture*).

ZARNECKI, G. *Studies in Romanesque Sculpture*, London, 1979.

ZARNECKI, G. *Further Studies in Romanesque Sculpture*, London, 1992.

SCANDINAVIA

ANDERSSON, A. *English influence in Norwegian and Swedish figure sculpture in wood 1220–1270*, Stockholm, 1949 (reprinted 1950).

ANDERSSON, A. *Medieval Wooden Sculpture in Sweden, II, Romanesque and Gothic Sculpture*, Stockholm, 1966.

ANDERSSON, A. 'The Holy Rood from Skokloster and the Scandinavian Early Gothic', *Burlington Magazine*, CXII (1970), pp. 132–40.

ANDERSSON, A. and RYDBECK, M. *Medieval Wooden Sculpture in Sweden, IV, The Museum Collection Catalogue*, Stockholm, 1975 (Plates volume, V, 1964).

BECKETT, F. *Danmarks Kunst, II, Gotiken*, Copenhagen, 1926.

BLINDHEIM, M. *Main trends of East-Norwegian wooden figure sculpture in the second half of the thirteenth century*, Oslo, 1952.

BLINDHEIM, M. *Norwegian Romanesque Decorative Sculpture 1090–1210*, London, 1965.

BLINDHEIM, M. 'Scandinavian art and its relations to European art around 1200', *The Year 1200: A Symposium*, Metropolitan Museum of Art, New York, 1975, pp. 429–67 (reprinted in *Festskrift til Martin Blindheim*, pp. 91–129).

BLINDHEIM, M. *Festskrift til Martin Blindheim* (Universitetets Oldsaksamlings Skrifter, Ny rekke, VII), Oslo, 1986.

FETT, H. P. *Billedhuggerkunsten i Norge under Sverreaetten*, Kristiania, 1908.

LIEBGOTT, N.-K. *Elfenben – fra Danmarks Middelalder*, National Museum, Copenhagen, 1985.

NYBORG, E. and THOMSEN, V. 'Fra Paris til Sneslev. De aeldste danske krucifikser og helgenbilleder', *Nationalmuseets Arbejdsmark* (1983), pp. 164–81.

NYBORG, E. and THOMSEN, V. 'Dänische Holzskulptur vor 1300–ein Forschungsprojekt', in U. Albrecht, J. von Bonsdorff, A. Henning (eds), *Figur und Raum. Mittelalterliche Holzbildwerke im historischen und kunstgeographischen Kontext*, Berlin, 1994, pp. 35–52.

TÅNGEBERG, P. *Mittelterliche Holzskulpturen und Altarschreine in Schweden: Studien zu Form, Material und Technik*, Stockholm, 1986.

SPAIN

ANDRES ORDAX, S. *et al. Castilla y León/1 (La España Gótica, Vol. 9)*, Madrid, 1989.

AZCARETE, J. M. *Arte Gótico en España*, Madrid, 1990.

BERTAUX, E. 'La sculpture chrétienne en Espagne des origines au XIVe siècle', in A. Michel, *Histoire de l'Art*, II/1, Paris, 1906, pp. 214–95.

BUSCHBECK, E. H. *Der Pórtico de la Gloria von Santiago de Compostela. Beiträge zur Geschichte der französischen und der spanischen Skulptur im XII. Jahrhundert*, Berlin and Vienna, 1919.

DEKNATEL, F. B. 'The thirteenth century Gothic sculpture of the cathedrals of Burgos and Leon', *Art Bulletin*, XVII (1935), pp. 243–389.

DE PALOL, M. and HIRMER, M. *Early Medieval Art in Spain*, London, 1967.

DURAN SANPERE, A. and AINAUD DE LASARTE, J. *Escultura Gótica (Ars Hispaniae, Vol. 8)*, Madrid, 1956.

FRANCO MATA, M. A. *Escultura Gótica en León*, León, 1976.

FRANCO MATA, A. 'Gotische Skulptur in Kastilien und León (13.–14. Jahrhundert)', in S. Hänsel and H. Karge (eds), *Spanische Kunstgeschichte. Eine Einführung. I: von der Spätantike bis zur frühen Neuzeit*, Berlin, 1992, pp. 133–54.

FRANCO MATA, A. 'Influence française dans la sculpture gothique des cathédrales de Burgos, Léon et Tolède', in Beck and Hengevoss-Dürkop (*op. cit.* in General Bibliography), pp. 321–33.

FREIGANG, C. 'Gotische Architektur und Skulptur in Katalonien und Aragón (13–14. Jahrhundert), in Hänsel and Karge (*op. cit.*), pp. 155–71.

GUDIOL RICART, J. and GAYA NUÑO, J.A. *Arquitectura y escultura románicas (Ars Hispaniae, Vol. 5)*, Madrid, 1948.

LAMBERT, E. *L'art gothique en Espagne aux XII et XIII siècles*, Paris, 1931 (Spanish ed., *El arte Gótico en España en los siglos XII y XIII*, Madrid, 1977).

MAHN, H. *Kathedralplastik in Spanien. Die monumentale Figuralskulptur in (Alt-) Kastilien, León und Navarra zwischen 1230 und 1380*, Reutlingen, 1935.

PIQUERO LOPEZ, M. A. B. *Las Catedrales Góticas Castellanas*, Salamanca, 1992.

ITALY

BERTAUX, E. *L'art dans l'Italie méridionale*, Paris, 1904 (reprinted in three vols, Paris and Rome, 1968: see also Prandi, A.).

BIEHL, W. *Toskanische Plastik des frühen und hohen Mittelalters*, Leipzig, 1926.

CALO MARIANI, M. S. 'La scultura in Puglia durante l'età sveva e proto-angioina', in P. Belli D'Elia *et al, La Puglia fra Bisanzio e l'Occidente*, Milan, 1980, pp. 254–316.

CARLI, E. *La scultura lignea italiana dal XII al XVI secolo*, Milan, 1960.

CARLI, E. *Arnolfo*, Florence, 1993.

CASTELNUOVO, E. (ed.). *Niveo de Marmore. L'uso artistico del marmo di Carrara dall'XI al XV secolo*, (exh. cat., La Cittadella, Sarzana), Genoa, 1992.

CLAUSSEN, P. C. *Magistri Doctissimi Romani. Die römischen Marmorkünstler des Mittelalters (Corpus Cosmatorum I)*, Stuttgart, 1987.

CRICHTON, G. H. *Romanesque Sculpture in Italy*, London, 1954.

CRICHTON, G. H. and E. R. *Nicola Pisano and the revival of sculpture in Italy*, Cambridge, 1938.

D'ACHILLE, A. M. 'La scultura', in A. M. Romanini (ed.), *Roma nel Duecento: L'arte nella città dei papi da Innocenzo III a Bonifacio VIII*, Turin, 1991, pp. 145–235.

FRANCOVICH, G. DE. *Benedetto Antelami, architetto e scultore e l'arte del suo tempo*, 2 vols, Milan and Florence, 1952.

GARDNER, J. *The Tomb and the Tiara. Curial tomb sculpture in Rome and Avignon in the later Middle Ages*, Oxford, 1992.

GARDNER, J. 'The effigial tomb in Rome: a local style?', in Beck and Hengevoss-Dürkop (*op. cit.* in General Bibliography), pp. 605–16.

GARMS, J. and ROMANINI, A. M. (eds). *Skulptur und Grabmal des Spätmittelalters in Rom und Italien (Akten des Kongresses 'Scultura e monumento sepolcrale del tardo*

medioevo a Roma e in Italia' (Rom, 4.–6. Juli 1985)), Vienna, 1990.

GLASS, D. F. *Italian Romanesque Sculpture: an annotated bibliography*, Boston, 1983.

JONES, S. G. *French Gothic influence on North Italian sculpture in the first half of the thirteenth century. A study of the Abbey of Vezzolano, S. Giustina in Padua and the Duomo of Vercelli*, Doctoral dissertation, New York University, 1973.

JULLIAN, R. *L'éveil de la sculpture italienne. La sculpture romane dans l'Italie du nord*, 2 vols, Paris, 1945–9.

JULLIAN, R. 'Les persistances romanes dans la sculpture gothique italienne', *Cahiers de civilisation médiévale*, III (1960), pp. 295–305.

PACE, V. and BAGNOLI, M. (eds). *Il Gotico europeo in Italia*, Naples, 1994.

POESCHKE, J. 'Zum Einfluss der Gotik in Süditalien', *Jahrbuch der Berliner Museen*, XXII (1980), pp. 91–120.

POPE-HENNESSY, J. *Italian Gothic Sculpture*, 3rd ed., Oxford, 1986.

PRANDI, A. (ed.). *L'art dans l'Italie méridionale. Aggiornamento dell'opera di Emile Bertaux*, 3 vols (numbered IV–VI), Rome, 1978.

ROMANINI, A. M. *Arnolfo di Cambio e lo 'stil novo' del gotico italiano*, Milan, 1969 (reprinted Florence, 1980).

ROMANINI, A. M. (ed.). *Federico II e l'arte del duecento italiano (Atti della III settimana di studi di storia dell'arte medievale dell'Università di Roma, 1978)*, 2 vols, Galatina, 1980.

ROMANINI, A. M. (ed.). *Roma Anno 1300 (Atti della IV settimana di studi di storia dell'arte medievale dell'Università di Roma 'La Sapienza', 1980)*, Rome, 1983.

ROMANO, G. *Gotico in Piemonte*, Turin, 1992.

SEIDEL, M. 'Studien zur Antikenrezeption Nicola Pisanos', *Mitteilungen des Kunsthistorischen Institutes in Florenz*, XIX, (1975), pp. 307–92.

TESTI CRISTIANI, M. L. *Nicola Pisano, architetto, scultore: dalle origini al pulpito del battistero di Pisa*, Pisa, 1987.

TOESCA, P. *Storia dell'Arte Italiana, Il Medioevo*, II, Turin, 1927 (reprinted Turin, 1965).

TRONZO, W. (ed.). *Intellectual Life at the Court of Frederick II Hohenstaufen* (National Gallery of Art, Washington, Studies in the History of Art, 44), Hanover and London, 1994.

VENTURI, A. *Storia dell'Arte Italiana*, III, Milan, 1904.

WEINBERGER, M. 'Remarks on the role of French models within the evolution of Gothic Tuscan sculpture', in *Romanesque and Gothic Art. Studies in Western Art. Acts of the twentieth international congress of the History of Art, Volume I*, Princeton, 1963, pp. 198–206.

WHITE, J. *Art and Architecture in Italy 1250–1400* (Pelican History of Art), 3rd ed., New Haven and London, 1993.

Index

Names which include the particles 'of', 'de', 'di', 'the' etc. (e.g. Jean de Chelles) or where the second element is an adjective (e.g. Nicola Pisano) are usually indexed under the forename. For simplicity's sake, sculptures are often indicated by their locations only, and possibilities are treated as certainties. Notes are indexed only if there is no obvious reference from the text and they contain substantial information.

Photographic Acknowledgements

© Photo RMN: titlepage, 20, 21, 34, 35, 36, 78, 209, 219, 222, 223, 230, 257; author: 1, 2, 4, 5, 13, 14, 15, 16, 17, 18, 45, 51, 52, 74, 139, 161, 164, 165, 166, 167, 183, 250, 310, 332, 333, 334, 341, 343, 344, 345, 348, 349, 350, 351, 355, 357; Photo N. D. Roger-Viollet: 7, 217, 232, 234, 251; Hirmer Fotoarchiv: 8, 28, 38, 41, 46, 50, 54, 55, 56, 58, 60, 61, 63, 76, 77, 80, 81, 103, 112, 113, 114, 117, 118, 119, 125, 127, 128, 129, 130, 138, 140, 142, 144, 182, 184, 186, 210, 214, 218, 221, 224, 226, 231, 233, 236, 227, 239, 240, 244, 245, 246, 267; © The Board of Trustees of the Victoria and Albert Museum: 9, 36, 122, 174, 253, 305, 306, 316, 317, 323, 324, 381, 383; © James Austin: 19, 26, 31, 37, 40, 48, 57, 62, 64, 65, 73, 90, 91, 92, 93, 94, 97, 98, 211, 212, 213, 215, 216, 220, 225, 227, 229, 238, 241, 243, 248, 249, 252, 305, 306, 323, 324; Conway Library: 23, 39, 66, 68, 95, 137, 152, 155, 159, 160, 168, 169, 171, 172, 196, 197, 263, 289, 300, 308, 309, 312, 313, 318, 342, 352, 361, 368, 369, 370; Devonshire Collection Chatsworth. Reproduced by permission of the Chatsworth Settlement Trustees: 24; Forschungsarchiv für Antike Plastik Köln: 24; Bildarchiv Foto Marburg: 25, 79, 85, 106, 123, 135, 136, 150, 242, 247, 255, 260, 261, 268, 271, 272, 275, 277, 278, 282, 284, 286, 287, 292, 293, 294, 295, 296; Musées de Châlons-sur-Marne, photo Hervé Maillot: 42, 43, 44, 235; Musées de Sens, J. P. Elie: 47; courtesy Professor Jeoraldean McClain: 53; Sonia Halliday: 59; Musées de la Ville de Paris © by SPADEM 1995: 71; Photo de Jongh/Musée de l'Elysée, Lausanne: 88; André Held: 89; © Arch. Phot. Paris/SPADEM: 96, 228, 254; Rheinisches Bildarchiv Köln: 100, 101, 104, 107; Rijksdienst der Monumentenzorg: 108; Copyright

IRPA-KIK, Brussels: 109, 110; Dom- und Diözesanmuseum Hildesheim Schoepe: 120, 121; Klaus Beyer: 126, 132, 134, 258, 262, 270, 274, 276, 283; Landesamt für Dankmalpflege Sachsen: 131; Brandenburgisches Landesamt für Denkmalpflege Messbildarchiv: 141; Bayerisches Landesamt für Denkmalpflege: 143, 147, 148; © Ingeborg Limmer: 145, 146, 259; Copyright © Winchester Excavations Committee: 153; Warburg Institute, University of London: 154, 158; George Zarnecki: 156; National Monuments Record: 162, 170, 302, 308, 314, 315, 321, 325; T. A. Heslop: 163; Courtesy of the Dean and Chapter of Winchester: 175; Antikvarisk-Topografiska Arkivet/Photo Henrik Hultgren: 176, 331; Ann-Marie Olsen: 177, 179, 180; Scala: 185, 273, 360, 375, 376, 385; Arixiu MAS: 188, 335, 336, 337, 338, 339, 340, 346, 347, 353, 354, 356, 358, 359; Alinari: 189, 190, 197, 198, 200, 201, 202, 362, 363, 364, 365, 371, 372, 373, 374, 377, 378, 384; Sharon Cather: 191; Photo Marco Zurla courtesy Fulvio Cervini: 194; G. Gallarate, Oleggio: 195; ICCD, Rome: 208; Courtesy Bernadette Dieudonné, Cercle d'Etudes Historiques et Archéologiques de Poissy: 256; Graphische Sammlung Staatsgalerie Stuttgart: 279; Lala Aufsberg: 288, 290; By courtesy of the Dean and Chapter of Westminster: 299, 320, 322; Lincoln Cathedral Works Department: 311; A. F. Kersting: 319; National Museum, Copenhagen: 326, 327; Nidaros Domkirkes Restaureringsarbeider, Trondheim: 328; UNIT-Vitenskapmuseet Archaeological Department, Trondheim, photo Per E. Frederiksen: 329; Soprintendenza Beni Artistici e Storici, Bologna: 366; Grace M. Edwards Fund. Courtesy Museum of Fine Arts, Boston: 367.